Thomas Eakins

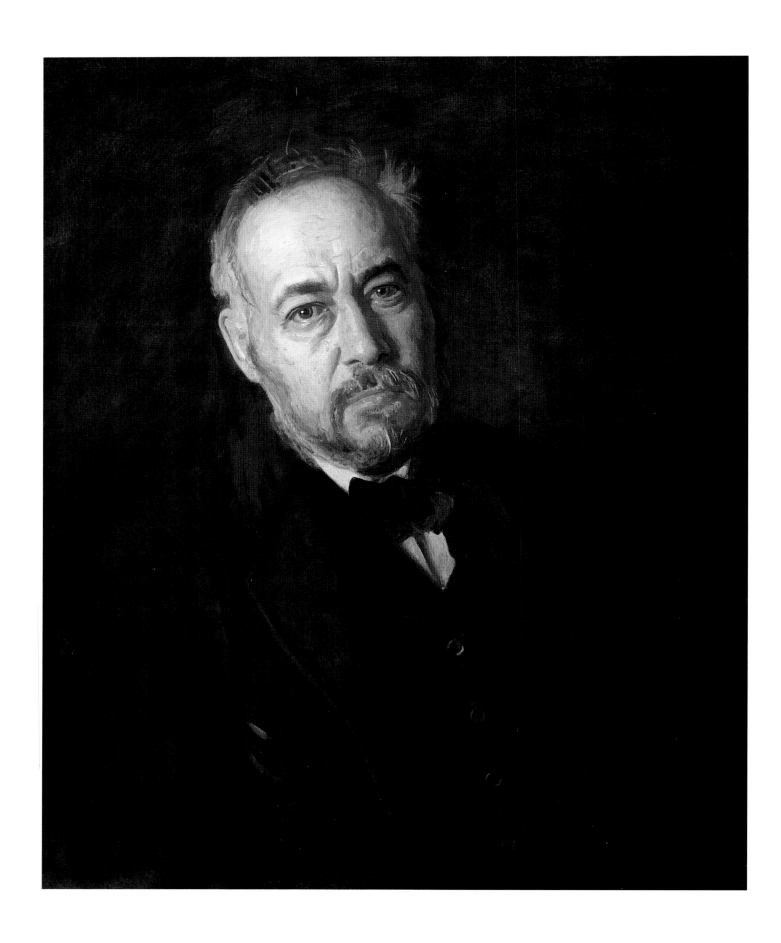

THOMAS EAKINS

ORGANIZED BY DARREL SEWELL

With essays by

Kathleen A. Foster
Nica Gutman
William Innes Homer
Elizabeth Milroy
W. Douglass Paschall
Darrel Sewell
Marc Simpson
Carol Troyen
Mark Tucker
H. Barbara Weinberg
Amy B. Werbel

Chronology by Kathleen Brown

PHILADELPHIA MUSEUM OF ART

IN ASSOCIATION WITH YALE UNIVERSITY PRESS

Published on the occasion of the exhibition *Thomas Eakins: American Realist*, organized by Darrel Sewell with the assistance of W. Douglass Paschall at the Philadelphia Museum of Art

Philadelphia Museum of Art
October 4, 2001, to January 6, 2002

Musée d'Orsay, Paris
February 5 to May 12, 2002

The Metropolitan Museum of Art, New York
June 18 to September 15, 2002

The exhibition is made possible by Advanta and Strawbridge's.

ADVANTA® **strawbridge's**

Additional funding was provided by generous grants from The Henry Luce Foundation, Inc., the Robert J. Kleberg, Jr. and Helen C. Kleberg Foundation, The Pew Charitable Trusts, and the National Endowment for the Arts, with initial funding from The William Penn Foundation. Additional support was provided by NBC 10 WCAU and Amtrak.

The catalogue is supported by an endowment for scholarly publications established by grants from CIGNA Foundation and the Andrew W. Mellon Foundation at the Philadelphia Museum of Art and an initial grant from The Women's Committee of the Philadelphia Museum of Art.

Cover/jacket: Thomas Eakins, *Starting Out after Rail*, 1874. Oil on canvas mounted on Masonite, 24¼ x 19⅞ inches. Museum of Fine Arts, Boston. The Hayden Collection.

Back: Circle of Thomas Eakins (attributed to Susan Hannah Macdowell), *[Thomas Eakins at About Age Thirty-Five]*, 1880. Albumen print, 4½ x 3¼ inches. Bryn Mawr College Library, Pennsylvania. Seymour Adelman Collection.

Frontispiece: Thomas Eakins, *Self-Portrait*, 1902. Oil on canvas, 30 x 25 inches. National Academy of Design, New York.

Produced by the Department of Publishing
Philadelphia Museum of Art
Benjamin Franklin Parkway at 26th Street
P.O. Box 7646
Philadelphia, Pennsylvania 19101-7646
www.philamuseum.org

Edited by Jane Watkins with Jane Boyd
Bibliographic assistance by Jessica Murphy
Production managed by Rich Bonk
Designed by Bruce Campbell
Type set by Aardvark Type, Hartford, Connecticut
Color separations by Professional Graphics Inc., Rockford, Illinois
Printed and bound in Belgium by Snoeck Ducaju & Zoon

Library of Congress Cataloging-in-Publication Data

Sewell, Darrel, 1939–
 Thomas Eakins / organized by Darrel Sewell with essays by Kathleen A. Foster . . . [et al.].
 p. cm.
 Exhibition held at Philadelphia Museum of Art, Oct. 4, 2001 to Jan. 6, 2002, Musée d'Orsay, Paris, Feb. 5 to May 12, 2002, the Metropolitan Museum of Art, New York, June 18 to Sept. 15, 2002.
 Includes bibliographical references and index.
 ISBN 0-87633-143-6 (PMA : cloth)—ISBN 0-87633-142-8 (PMA : pbk.)—ISBN 0-300-09111-7 (Yale : cloth)
 1. Eakins, Thomas, 1844–1916—-Exhibitions. I. Eakins, Thomas, 1844–1916. II. Foster, Kathleen A. III. Philadelphia Museum of Art. IV. Musée d'Orsay. V. Metropolitan Museum of Art (New York, N.Y.) VI. Title.
N6537.E3 A4 2001
759.13–dc21 2001053142

Sponsor's Statement

On behalf of my Advanta colleagues and our customers, I wish to express how honored we are to be the presenting sponsor of this groundbreaking exhibition—a retrospective of the work of Philadelphia's own Thomas Eakins.

Thomas Eakins was a world-class artist whose Philadelphia roots and influence were woven throughout his works and his teachings. He was particularly known for his great insight into his subjects and his remarkable honesty of approach.

At Advanta we, too, strive to truly understand our customers and develop services to meet their unique needs. Advanta's roots are also deeply connected to Philadelphia—our founder and my father, Jack Alter, began this company out of a spare bedroom in our West Philadelphia home. Today, we are one of the nation's largest issuers of MasterCard small business credit cards.

As Advanta celebrates its 50th Anniversary, our commitment to Philadelphia continues. Over the years we have been proud to partner with the venerable Philadelphia Museum of Art, now marking its 125th Anniversary, to bring to life such outstanding exhibitions as *Cézanne*, *Delacroix: The Late Work*, and *The Splendor of Eighteenth-Century Rome*.

On behalf of Advanta, I extend our thanks to the outstanding professionals at the Philadelphia Museum of Art whose hard work and dedication inspire us and enrich all our perspectives.

I'd like to leave you with a thought from the great artist himself:

> *"The big artist . . . keeps a sharp eye on Nature & steals her tools"* (Thomas Eakins).

Enjoy the show!

Dennis Alter
Chairman and CEO, Advanta

Lenders to the Exhibition

Addison Gallery of American Art, Phillips Academy,
Andover, Massachusetts

Amon Carter Museum, Fort Worth, Texas

The Armand Hammer Collection, UCLA Hammer
Museum, Los Angeles

The Art Institute of Chicago

The Art Museum, Princeton University

Ball State University Museum of Art, Muncie, Indiana

Brooklyn Museum of Art, New York

Bryn Mawr College, Miriam Coffin Canaday Library

Cincinnati Art Museum

The Cleveland Museum of Art

The Corcoran Gallery of Art, Washington, D.C.

The Detroit Institute of Arts

Daniel W. Dietrich II

Gilcrease Museum, Tulsa, Oklahoma

Gilman Paper Company Collection, New York

Hirshhorn Museum and Sculpture Garden,
Smithsonian Institution, Washington, D.C.

Honolulu Academy of Arts

The Hyde Collection Art Museum, Glens Falls, New York

The J. Paul Getty Museum, Los Angeles

Jefferson Medical College, Thomas Jefferson University,
Philadelphia

Maier Museum of Art, Randolph-Macon Woman's College,
Lynchburg, Virginia

John J. Medveckis

Memorial Art Gallery of the University of Rochester,
New York

The Metropolitan Museum of Art, New York

Harvey S. Shipley Miller and J. Randall Plummer

Collection of John R. and Eleanor R. Mitchell Foundation,
Mount Vernon, Illinois

Museum of Art, Rhode Island School of Design, Providence

Museum of Fine Arts, Boston

National Academy of Design, New York

National Gallery of Art, Washington, D.C.

The National Museum of Health and Medicine of the Armed
Forces Institute of Pathology, Washington, D.C.

Pennsylvania Academy of the Fine Arts,
Philadelphia

Philadelphia Museum of Art

The Phillips Collection, Washington, D.C.

Reynolda House, Museum of American Art,
Winston-Salem, North Carolina

San Diego Museum of Art

Sheldon Memorial Art Gallery, University of Nebraska,
Lincoln

Sterling and Francine Clark Art Institute,
Williamstown, Massachusetts

University of Pennsylvania, Philadelphia

Wichita State University Libraries, Kansas, Charles Grafly
Papers

Yale University Art Gallery, New Haven, Connecticut

Three private collections

Contents

Note to the Reader

Thematic essays addressing specific topics are arranged chronologically by decade: the 1870s, the 1880s, the 1890s, and 1900 to 1916. The plate sections illustrating works by Thomas Eakins and his circle have been divided into these four decades, arranged, for the most part, chronologically.

The dimensions of the works are given in inches, with the height preceding the width.

Duplicate photographic prints borrowed from different lenders—a necessary measure to bring these fragile works before audiences in the three venues of the exhibition—are not illustrated but are listed on page 441 under Works Not Illustrated.

Eakins's photographic activities raise special issues in attribution and titling. None of his own photographs, and only a few of those made by his students and friends, are signed. When a work may be firmly assigned or attributed to Eakins, or with confidence to one of his associates, this is indicated. The remainder are assigned to the circle of Thomas Eakins.

Eakins was reluctant to title his photographs. The titles given to his photographs in recent decades vary widely. For consistency in this catalogue, we have used generic descriptive titles, bracketed to indicate that choice. We thank the lenders, who have graciously permitted us to use these titles.

The Pennsylvania Academy of the Fine Arts, Philadelphia, made available, from its collection of Eakins material preserved by his student Charles Bregler, twenty-five of the original 4-by-5-inch glass negatives produced by Eakins and his colleagues, so that modern digital prints could be made of images for which vintage prints do not survive. As most of these images were studies for paintings or teaching aids, we have sought to approach the color and tonal range of albumen prints, Eakins's preferred process for such works.

Notes for the essays are grouped together in back matter, beginning on page 385. For each essay, initial references for books are given in full; later citations of the same source are shortened to the author's last name and year of publication. A listing of sources is also given in back matter, beginning on page 435, as Selected Bibliography.

Preface

One hundred and twenty-five years ago, the Centennial Exhibition's vast diversity of art and manufactured goods, instruments and engines, from three continents drew more than ten million visitors in six months to Philadelphia's Fairmount Park. The year 1876 also marked the decisive emergence of thirty-two-year-old Thomas Eakins as a great and distinctively American artist. The scale of his ambition was revealed in *The Gross Clinic* (despite its relegation to obscurity in a hospital building on the fairgrounds), and the range of his talent was clear from all the paintings he showed that same year. His French academic training was now fully absorbed into a decidedly individual approach to his subjects.

To present Eakins's work afresh, in this first retrospective in almost twenty years is, in itself, an invigorating challenge and an honor and delight to share with our colleagues at the Musée d'Orsay in Paris and The Metropolitan Museum of Art in New York, cities in which Eakins found himself, respectively, much at home as a student and admired as a mature painter. Second-guessing an irascible genius is futile, but it is hard to imagine that Eakins would not have delighted equally in the attention from his native city of Philadelphia, from the Metropolitan Museum, which mounted his memorial exhibition in 1917, and from the French museum that houses the work of Jean-Léon Gérôme, Léon Bonnat, and Thomas Couture, all of whom he much admired. The pleasure and adventure of bringing Eakins to Paris were taken up with enthusiasm by Henri Loyrette, then director of the Musée d'Orsay and recently named successor to Pierre Rosenberg as director of the Louvre. It has been twenty-five years since M. Rosenberg welcomed to Paris the major survey of late eighteenth- and nineteenth-century American art that he organized with Theodore Stebbins at the Museum of Fine Arts, Boston, and this will be the first monographic exhibition of a nineteenth-century American painter (other than expatriate artists Whistler and Sargent) to be shown in France. The opportunity to see Eakins's work in a French context reminds us that he shared a lifelong fascination with the human body and its awkward beauty with his near contemporary Edgar Degas. One question to be explored by French viewers will be the precise quality of Eakins's "Americanness" as a painter (as opposed, for example, to that of another close contemporary, Winslow Homer).

We are grateful to our colleagues at The Metropolitan Museum of Art, its inimitable director, Philippe de Montebello, and H. Barbara Weinberg, the Alice Pratt Brown Curator of American Paintings and Sculpture, for their enthusiastic commitment to this project from its inception. To the distinguished array of the scholars who contributed to the catalogue, undertaking to disentangle many tightly woven strands of Eakins's art while never losing sight of the complex whole, go heartfelt thanks and admiration.

From the outset of planning for the celebrations of the 125th anniversary of the Philadelphia Museum of Art, itself an outgrowth of the Centennial, the prospect of an Eakins retrospective seemed perfect, and Darrel Sewell (who has been devoted to the artist's work for the nearly thirty years of his curatorship of American art at the Museum) embarked on a mission of rediscovery. Since he organized the last large retrospective for this Museum in 1982, scholarship on Eakins's life and work has proliferated dramatically, fueled in part by the emergence into the public domain of Charles Bregler's invaluable collection of Eakins material, acquired by the Pennsylvania Academy of the Fine Arts in 1985 with the help of the Pew Memorial Trust. Important monographs on Eakins have appeared, including thoughtful studies by Gordon Hendricks, Elizabeth Johns, William Innes Homer, Kathleen A. Foster, and Michael Fried, while exhibitions have focused attention on individual works such as *Swimming* and on the series of rowing pictures. The English public was treated to a notable survey at the National Portrait Gallery, orchestrated by John Wilmerding. Great strides have also been made in the technical analysis of Eakins's complex working methods, and his use of photography can now be seen as crucial to his technique and his composition.

To the extraordinarily generous lenders to this exhibition, all of whom are listed at the front of this book, we owe profound gratitude for their willingness to share beloved works of art with a new generation of museum-goers. A special salute is due to the Pennsylvania Academy of the Fine Arts and its staff not only for invaluable loans but for the alacrity with which they shared information from their rich archives, and to the Hirshhorn Museum and Sculpture Garden, Smithsonian Institution; The Metropolitan Museum of Art; and The J. Paul

Getty Museum, whose collections are especially rich in Eakins's work. Dr. Paul C. Brucker, president of Jefferson University, and Judith Rodin, president of the University of Pennsylvania, graciously supported the loans of *The Gross Clinic* and *The Agnew Clinic* from their respective institutions. Those great paintings continue to be a pride of the teaching hospitals where their subjects were revered professors.

Over the decades, the Philadelphia Museum of Art has been fortunate in its staff, donors, and trustees whose fascination with Thomas Eakins has resulted in an unparalleled collection of his work and a rich trove of study material. Director Fiske Kimball's early visit to "the widow Eakins" led to Susan Eakins's decision together with family friend Mary Adeline Williams to give what remained in her hands to the Museum, and the passionate interest of his successor, Evan H. Turner, and Mr. Turner's esteemed colleague, conservator Theodor Siegl, led to their collaboration on the first thorough handbook of the Museum's Eakins collection in 1978. In turn, Darrel Sewell's thoughtful and meticulous approach to his responsibility as curator charged with our Eakins holdings inspired the distinguished scholar Lloyd Goodrich to entrust the wealth of materials from his lifetime of Eakins research to the Museum in 1987. In the project at hand, Mr. Sewell has been most ably and enthusiastically joined by W. Douglass Paschall, Research Associate and Coordinator, Thomas Eakins Projects, who has catalogued and arranged the Goodrich Papers, provided much helpful information for the catalogue authors, and with the aid of his own expertise in photography, sorted out many intricacies of the various versions and prints of Eakins's photographs.

The exhibition and catalogue also benefited greatly from the wholehearted involvement and lively intelligence of the Conservation Department at the Philadelphia Museum of Art, not only in the handsome results of the study, technical analysis, and treatment of many Eakins paintings and sculptures over the past several years, but in the fresh insights into Eakins's technique and uses of photography contributed by Mark Tucker, Senior Conservator of Paintings, and Nica Gutman, Assistant Curator of Paintings. As is often the case, the Conservation Department's effort was a collegial one, also involving Teresa Lignelli, Associate Conservator of Paintings, and Melissa S. Meighan, Conservator of Decorative Arts and Sculpture, in research and treatments, as well as the skills of Joseph Mikuliak, Conservation Photographer, and Michael J. Stone, Conservation Framer. Suzanne P. Penn, Conservator of Paintings, oversaw the creation of a video devoted to the conservators' discoveries about Eakins's working methods, funded by a grant from the Andrew W. Mellon Foundation.

Any major project at the Philadelphia Museum of Art relies upon the talents of a great many staff members, each of whom is committed to its success, and together with Darrel Sewell, I thank them all most warmly. Suzanne F. Wells, Coordinator of Special Exhibitions, has ably guided this international effort from its beginnings, working closely with her colleague, Irene Taurins, Senior Registrar. This book owes its handsome form to Bruce Campbell, its designer, and its complex contents were attentively orchestrated by the Museum's Senior Editor, Jane Watkins.

Without the substantial financial support that makes such extended research and complex preparation possible, the exhibition and catalogue could never have assumed their appropriate form. We are hugely grateful to the corporate sponsors in Philadelphia: Advanta, which has been our partner in so many spectacular projects at the Philadelphia Museum of Art, and Strawbridge's, to which we extend a warm welcome on the occasion of their first sponsorship here. The Henry Luce Foundation, Inc., gave a major grant at an early stage of the exhibition's development, and The William Penn Foundation supported initial research. The Pew Charitable Trusts' long-term support for exhibition and education programs of the Museum has once again been vital to bringing a Philadelphia treasure to an international audience, and we are profoundly grateful that they were generously joined by the Robert J. Kleberg, Jr. and Helen C. Kleberg Foundation and the National Endowment for the Arts. The catalogue is also supported by an endowment for scholarly publications established by grants from CIGNA Foundation and the Andrew W. Mellon Foundation at the Philadelphia Museum of Art and an initial grant from The Women's Committee of the Philadelphia Museum of Art. In New York the exhibition was sponsored by Fleet.

Thomas Eakins loved his native city, and recorded the look of its rivers and environs, and the character of its professional citizens, with penetrating, affectionate attention. There is a reciprocal devotion to his art that continues to flourish among both public institutions and private collectors and feels remarkably fresh despite the distance of more than eighty years across which we look at his work. Among the citizens of Philadelphia who have loved and understood Eakins at his most brilliant and contrary are Daniel W. Dietrich II and his late wife, Jennie. To her memory, and to the passion of so many Philadelphians for their great native son, this book is lovingly dedicated.

Anne d'Harnoncourt
The George D. Widener Director
Philadelphia Museum of Art

Thomas Eakins and American Art

DARREL SEWELL

I N JUNE 1881, Mariana Griswold van Rensselaer, one of America's most sophisticated art critics, traveled to Philadelphia to visit Thomas Eakins, who had his studio in the town house at 1729 Mount Vernon Street, where he lived with his widowed father, two sisters, and an aunt. Eakins's reputation as a painter and teacher had been growing since the mid-1870s, and Mariana van Rensselaer, scouting out young talent, had admired his work in exhibitions in Philadelphia and New York. Reviewing *The Biglin Brothers Turning the Stake-Boat* (pl. 6) in 1880, she had written, "There is, perhaps, no artist in the country who can rival him for originality of conception, for adapting the matter-of-fact elements of our surroundings to artistic use, no one who imprints a sign-manual of individuality so strongly on everything he touches."[1] Van Rensselaer was to remain one of the most perceptive champions of Eakins's work, but her face-to-face meeting with the artist himself took her by surprise and profoundly challenged her assumptions.

The purpose of Van Rensselaer's visit was to research an article about Eakins she was writing for a recently founded, intellectually ambitious periodical, *The American Art Review*. (Van Rensselaer was thirty years old at the time; Eakins was thirty-five.) The day after her encounter in Philadelphia she reported her impressions to the editor of the *Review*, S. R. Koehler:

> I went yesterday to Phil[adelphia] but fear I can give you little idea in words—especilly [sic] written ones—of the strong contrast between the real Mr. Eakins & the one I had picture[d] to myself. He was very polite & pleasant, & ready to do all he could to further our wishes. But he was not the clever man I had anticipated in any thing out side of his immediate work. He seems to understand his own aims & ideas & sort of work very well—as indeed, could hardly fail to be the case. But outside of that he is almost absurdly ignorant.... he did not know foreign artists, outside of Paris where he studied, even by name—had never heard of [Wilhelm] Leibl, for instance, or of [Franz von] Lenbach. Still more curiously he was, not only not a gentleman in the popular acceptance of a "swell", but not even a man of tolerably good appearance or breeding. His home & surroundings & family were decidedly of the *lower* middle class, I should say, & he himself a big ungainly young man, very untidy to say

> the least, in his dress—a man whom one would not be likely to ask to dinner, in spite of the respect one has for his work! I used to wonder why he did not put better clothes & furniture into his pictures, but now I wonder how he even managed to see anything so good! His want of a sense of beauty apparent in his pictures is still more so in his surroundings. His studio was a garret room without one single object upon which the eye might rest with pleasure—the sole ornaments some skeletons & some models of the frame & muscles which looked, of course like the contents of a butchers shop! Things very necessary to him, of course, & also interesting, but which I had expected to see supplemented by others of a different kind.... He is most modest & unassuming, like a big, enthusiastic schoolboy about his work. I do not believe he knows how good it is or how peculiar.... I hope I have not given you a very disagreeable account of him. He is interesting in his way, but it was such a different way to the one I had imagined that I could not get used to it & fancied myself all the time talking to someone else than the real Mr. Eakins! Of course his pictures are none the less good in my eyes—indeed, they seem more remarkable when I consider the source & place of their production!... He seems not to have much on hand just now & I doubt whether he is a prolific worker or works with an idea to making money or in an ambitious way of any sort. He seemed to me much more like an inventor working [out] curious & interesting problems for himself than like an average artist.... He has a clever face in a way but a most extraordinry [sic] one. If you met him in the street you would say a clever but most eccentric looking mechanic![2]

Not surprisingly, Van Rensselaer, the daughter of an old Connecticut family, married to the son of an equally old and wealthy New York family, allowed what she perceived as clear-cut class differences to color her perception of Eakins. She seems to have decided that he was a sort of skilled tradesman. Unimpressed by the substantial three-story house owned by Benjamin Eakins in the prosperous Fairmount neighborhood, where the neighbors were the families of successful merchants and professional men, scientists, engineers, and the skilled workers from the Baldwin locomotive factory a few blocks away, she did not ask herself why the artist would choose to have his studio at home.

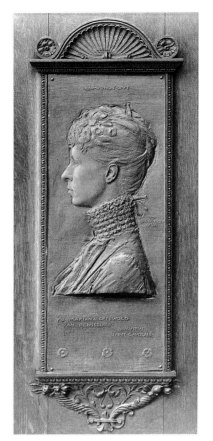

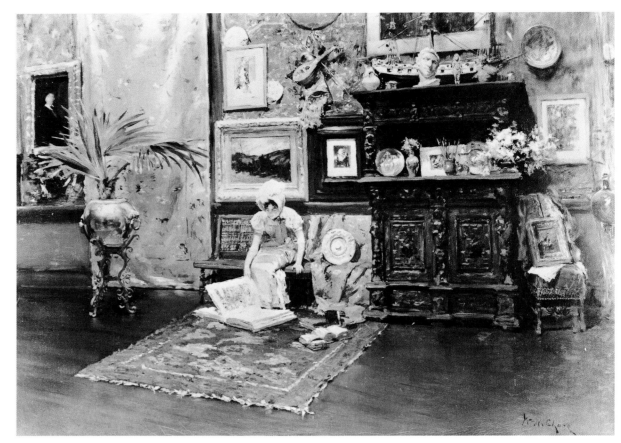

Augustus Saint-Gaudens, *Mrs. Schuyler van Rensselaer (Mariana Griswold)*, 1890. Bronze, 20⅜ x 7¾". The Metropolitan Museum of Art, New York. Gift of Mrs. Schuyler van Rensselaer, 1917.

William Merritt Chase, *In the Studio*, c. 1882. Oil on canvas, 28⅛ x 40¹/₁₆". Brooklyn Museum of Art, New York. Gift of Mrs. Carll H. de Silver in memory of her husband.

Affronted by Eakins's untidy appearance—he may have looked much as he did in a photograph probably taken by his future wife (pl. 52)—Van Rensselaer also did not question why an artist should choose to dress in such a way to meet an important critic. That Eakins could present a sprucer face to the world is confirmed by another photograph taken at about the same time (pl. 59). So untypical of the late nineteenth-century American artist was Eakins in appearance and in his choice of studio that Van Rensselaer overlooked the possibility that he might purposely have decided upon such a lifestyle.

On his part, Eakins seems to have been remarkably un-forthcoming. With his legendary taciturnity, he must have done nothing to hint that he had been an excellent student in the rigorous program at Philadelphia's elite Central High School—as Amy Werbel describes in her essay, "The Early Years," in this volume—or to indicate the intellectual and cultural interests evident in the letters he wrote from Paris—outlined by William Innes Homer in his essay, "Eakins as a Writer," also in this volume. Nor did he convey the depth of his admiration for Spanish art of the seventeenth century.

Eakins allowed Van Rensselaer to conclude that he was unambitious, despite the fact that he had been exhibiting his paintings aggressively for several years and investigating a wide variety of subjects in his art. Far from having "not much on hand," Eakins only two months earlier had begun the intensive campaign of photography along the Delaware River that he would use in the series of shad-fishing scenes painted over the summer. These canvases must have been on his easel at the moment he was talking with Van Rensselaer. That Eakins did not share with her his enthusiasm for a new method of using photographs as studies for his paintings may confirm a wariness about publicizing it, as Mark Tucker, Nica Gutman, and Douglass Paschall propose in their essays in this volume.

Possibly sensing Van Rensselaer's discomfort, perhaps amused by it, Eakins seems to have allowed her to talk herself out: "I got tired of suggesting," she wrote of her efforts to get him to think about subjects for black-and-white drawings for the article. Her assumption that an artist's life and work were not necessarily connected, that Eakins could make the kind of art he did without living the life he did in his daily surroundings, would have surprised him. But he might well have found her characterization of him as an "inventor working [out] curious & interesting problems for himself," in the guise of "a clever but most eccentric looking mechanic" to be a fitting description.

Van Rensselaer's astonishment at Eakins's appearance and surroundings implies that other artists with whom she was acquainted exhibited different, well-defined patterns of dress and deportment. She may have been comparing him mentally to his near-contemporary William Merritt Chase (1849–1916), whose work had been the subject of a two-part article she recently had published in *The American Art Review*.[3] As an artist and a personality, Chase was the polar opposite of Eakins and the paradigm of young American artists recently returned from study in Europe. Although he had left school at age sixteen to work as a clerk in his father's shoe store in Indianapolis, Chase had studied art from 1872 to 1878 at the Royal Academy in Munich (where he would have known the work of Leibl and Lenbach) and returned to live in New York. Recognizing the value of publicity, Chase exploited many avenues of self-promotion, creating for himself the image of the urbane, genteel, yet intriguingly bohemian artist. He was adept at "flaunting his artistic identity," as one writer has described him recently.[4]

Chase met—and no doubt helped to define—Van Rensselaer's criteria for an artist. He was socially engaging and dressed like a dandy. His large space in the famous Tenth Street Studio Building in New York City was filled with the exotic furnishings and objects he collected obsessively, beginning in his student years. In contrast to Eakins's studio, there were many things "upon which the eye might rest with pleasure," in Van Rensselaer's phrase. The studio not only contained *objets d'art* that inspired Chase's work, it was itself an object of art, and Chase made it the subject of numerous paintings over the next two decades. This fabricated environment served him as the "ultimate marketing tool" to captivate the media and art-buying visitors.[5]

As photographs in this exhibition reveal, Eakins's studio changed little over time. In later years, when the two artists had become friends, Eakins contrasted their spaces: "Chase's studio is an atelier; this is a workshop."[6] In comparison with Chase, who worked hard making paintings, teaching at the Art Students' League of New York, and ceaselessly promoting himself as an arbiter of taste to support his professional style, Eakins might well have appeared unambitious to Van Rensselaer.

Although Chase represented an extreme example, most of his American contemporaries from the mid-1870s through the 1890s shared to some degree a concern with the presentation of themselves and their work.[7] As his succinct comparison of his workshop to Chase's atelier suggests, Eakins was clearly aware that he was selecting a path that differed from the norm. Through the distorting prejudices of class and taste, Van Rensselaer failed to realize that she had confronted a carefully constructed artistic personality.

Eakins's persona was remarkably at odds with other American artists of his generation, and while it defined the kind of art that he made, it had a distinctly negative impact upon his career. At the time, few critics or patrons could, like Van Rensselaer, look past the trappings of the artist to the significance of the art. Clues to the interests and personality of this famously private artist may be found in the state of the arts in Philadelphia during his formative years; in the letters Eakins, his friends, and family wrote from Europe; and in the rapid evolution of American art during the last three decades of the nineteenth century.

By the early 1860s, when Thomas Eakins was considering a career as an artist, the nation's center of art and culture had shifted from Philadelphia to New York, and landscape painted in the style later known as the Hudson River School was heralded as the first truly American subject for art. New York's population of more than 800,000, with 266,000 additional souls in neighboring Brooklyn far exceeded Philadelphia's 565,529 inhabitants.

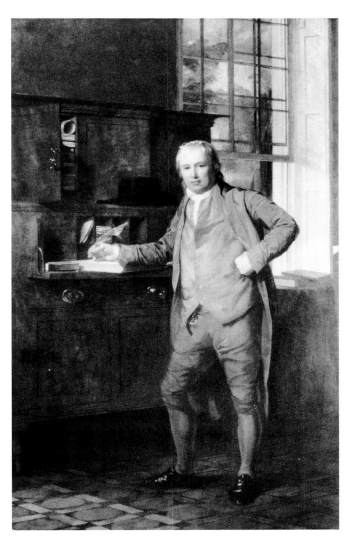

Thomas Sully, *Samuel Coates*, 1813. Oil on canvas, 94 x 64".
Pennsylvania Hospital Historic Collections, Philadelphia.

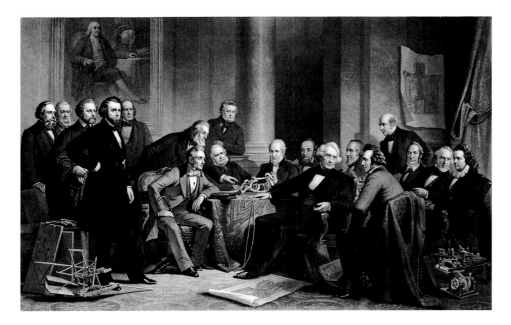

John Sartain after Christian Schussele, *Men of Progress: American Inventors*, 1862. Mezzotint and etching, 21⅜ x 35⅝". Historical Society of Pennsylvania, Philadelphia.

Yet Philadelphia remained the fourth-largest city in the Western world, the second largest in the United States, and boasted a glorious past in the arts.[8] Its importance as the seat of revolutionary government and as the nation's capital from 1790 to 1800 had attracted such artists as Charles Willson Peale, Gilbert Stuart, and Thomas Sully to paint official portraits of revolutionary leaders, government officials, and statesmen as well as scientific and business worthies and local merchants. Philadelphia had continued to prosper after the national government moved to Washington, D.C. In 1811 the architect Benjamin Henry Latrobe, speaking to the Society of Artists of the United States, predicted that "the days of Greece may be revived in the woods of America, and Philadelphia become the Athens of the Western world."[9]

Even by 1844, however, the year Eakins was born, one of the leading figures in the city's art life, Joseph Sill, could bemoan the fact that "Philadelphia is not the place for an artist's success. Indeed the taste for the arts seems to be waning away in this City; and with our commerce we shall lose our refinement also."[10] At the time Sill made this notation in his diary, the city was well on its way to becoming "the dynamic center of the most highly industrialized area in the United States,"[11] and new artists and collectors soon would appear to transform the nature of the visual arts in Philadelphia.

A vital new element in this transformation was the community of artist-artisans who worked for the printing industry. As a national center for publishing and fine art printing, Philadelphia supported a large community of illustrators and engravers, including Eakins's father, Benjamin, who specialized in fine lettering; his friend George Holmes, shown in *The Chess Players* (pl. 19), who may have given Eakins his first art lessons; and his future father-in-law, William H. Macdowell, an engraver. Talented colleagues continued to immigrate to

Philadelphia to find employment in the printing industry.[12] Many of these artists came from Europe to escape the political turmoil of the late 1840s, bringing with them the experience of traditional academic training and an acquaintance with new styles of art. Among them was Christian Schussele (1826–1879), who arrived in 1848 seeking work as a chromolithographer. A native of Alsace, trained in Paris, where he may have been a studio-mate of Eakins's teacher Jean-Léon Gérôme, Schussele brought a brightly colored, late neoclassical style of painting and skills equal to a variety of subjects, ranging from genre scenes to historical tableaux such as *The Iron Worker and King Solomon* (1863, Pennsylvania Academy of the Fine Arts, Philadelphia), to groups of black-suited nineteenth-century inventors and scientists, as in *Men of Progress: American Inventors* (1861, Cooper-Hewitt National Design Museum, Smithsonian Institution, New York). Schussele's highly finished style of figure painting and his abilities as a private art instructor made him a popular figure, and he was hired as the first professor at the Pennsylvania Academy of the Fine Arts in Philadelphia in 1868. Eakins worked as his assistant when he began to teach there in 1876.

Another recent immigrant, John Sartain, father of Eakins's Central High School classmate and lifelong friend William Sartain, also was at the center of the Philadelphia artistic com-

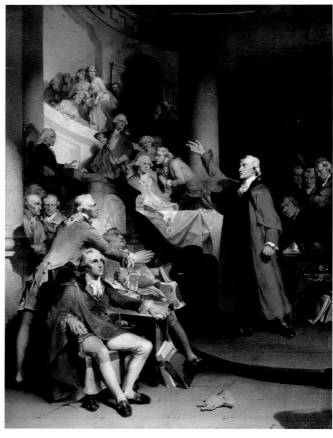

Peter Frederick Rothermel, *Patrick Henry Before the Virginia House of Burgesses*, 1851. Oil on canvas, 79 x 61". Red Hill, The Patrick Henry National Memorial, Brookneal, Virginia.

munity.[13] A skilled mezzotint engraver, Sartain had emigrated from London in 1830. He was one of the few practitioners in the United States with the expertise to make large reproductive engravings of complex compositions, such as Schussele's *Men of Progress,* which were popular at mid-nineteenth century. Capable of painting oils or watercolors, and possessed of a large collection of prints, drawings, and paintings, he quickly established a network of contacts among both artists and collectors. Energetic and gregarious, with talents as an entrepreneur, he became a fixture on Philadelphia boards and committees, serving as one of the few artist members of the Pennsylvania Academy's board of directors from 1855 to 1877. Sartain went back to Europe in 1854 to investigate art schools with the goal of improving the Pennsylvania Academy's curriculum, and he took an interest in Eakins's student days and early career.

Partly as a result of the influx of European academically trained artists, Philadelphia artists and collectors alike eschewed the Hudson River landscapes popular in New York. In Philadelphia, the taste for figure painting of all kinds, by Europeans and Americans, was much more pervasive,[14] and the city continued to be a bastion of academic history painting in the grand manner. The example of the great historical canvases of Benjamin West (1738–1820), a native son who studied in Rome, remained influential. West, who served as president of the Royal Academy in London from 1792 until his death, was a force in the establishment of the Pennsylvania Academy of the Fine Arts in 1805. As late as 1836, the Academy directors mortgaged the building to purchase West's vast canvas *Death on a Pale Horse* (1817). And Philadelphia-born and trained Peter Frederick Rothermel (1812–1895)—whom Eakins later would recall having known from childhood—continued the tradition of large-scale history painting in such canvases as *Patrick Henry Before the Virginia House of Burgesses* (1851).

This was the community of artists that shaped Eakins's understanding of art and his goals as an artist, in both positive and negative ways. He shared these artists' admiration for technical skill, their commitment to depicting the human figure, and their industrious application to the task at hand. Throughout his life, however, Eakins avoided the kind of work-to-order that he experienced when he assisted with his father's calligraphy jobs or witnessed John Sartain's labors over a reproductive engraving, and he completely rejected the persona of the artist/entrepreneur embodied by Sartain, whose instinct for self-promotion equaled that of William Merritt Chase in the next generation.

Although the fortunes of the Pennsylvania Academy of the Fine Arts waxed and waned in its early decades, by mid-century both its exhibition programs and provisions for instruction had been revived, and it remained at the center of artistic life in the city. Thanks to the efforts of a new generation of collectors who served on the Academy's board, and of artists on the Committee on Instruction—among them Rothermel, Schussele, and Sartain—the Academy's life and cast drawing programs were reinvigorated following traditional European models.

Eakins registered in this revised program on October 7, 1862. After a few months of cast drawing, he was promoted to the life class to draw from the live model three evenings a week. He began by working in the traditional academic drawing style practiced by Schussele and Rothermel, who, like other mature artists, honed their drawing skills side by side with beginners in the life classes. Over the next three years, as Kathleen Foster has demonstrated,[15] Eakins devised a distinctive technique that effectively renders the figure as solid form. This personal drawing style—strong and masterful but deliberately blunt and unbeautiful—so differed from the norm of the time that Eakins's Parisian master Gérôme would deem it "barbarous."[16] Nevertheless, it exhibits a level of talent that later would win Eakins acceptance by his colleagues in the Ecole des Beaux-Arts.

In the best of the drawings, such as the *Study of Seated Nude Woman Wearing a Mask,* Eakins achieved an expressiveness rare in academic figure drawing and unequaled in American

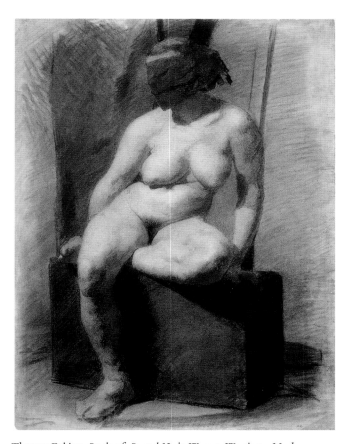

Thomas Eakins, *Study of Seated Nude Woman Wearing a Mask,* c. 1863–66. Charcoal on paper, 24¼ x 18⅝". Philadelphia Museum of Art. Gift of Mrs. Thomas Eakins and Miss Mary Adeline Williams, 1929.

art until this time. The intensely studied, boldly drawn, fleshy woman, wearing a large mask tied so tightly across her face that it constitutes a blindfold, provokes a wide range of responses and speculations. Perhaps even at this early point in his career, Eakins was considering the shock value of the nude figure, carefully manipulating an ostensibly realistic study to create dramatic effects as he did later in such paintings as *The Gross Clinic* (pl. 16), *William Rush Carving His Allegorical Figure of the Schuylkill River* (pl. 41), *The Crucifixion* (pl. 54), *Swimming* (pl. 149), or the late boxing pictures such as *Taking the Count* (pl. 213). Eakins's paintings of the nude throughout his career retain something of the ability to startle the viewer, as if recapturing the astonishment he must have felt in his first encounter with a nude figure in the life classes at the Academy. These early drawings suggest that Eakins's artistic sensibility was formed to a large extent before he went abroad.

Eager to explore the resources of European academic teaching, Eakins traveled to Paris in September 1866. There, his personal style of dress and deportment, already formed back home in Philadelphia and unapologetically nonconformist, suited his needs. His sister Frances reported during her visit to him in the summer of 1868: "He has changed very little, he's just the same old Tom he used to be, and just as careless-looking. His best hat (I don't know what his common one can be) is a great big grey felt steeple, looks just like an ash-man's; his best coat is a brown sack, and his best pantaloons are light with the biggest grease spot on them you ever saw. And then he most always wears a colored shirt. But he's the finest looking fellow I've seen since I left Philadelphia."[17]

That this look was both intentional and unique is confirmed in a series of articles about the art schools of Paris that appeared in *The Nation* in 1879. Written by Earl Shinn, an acquaintance from the Pennsylvania Academy of the Fine Arts, the first of the articles takes as its protagonist a fictional Tom East, based on Eakins, whom Shinn portrayed as "a cultivated creature, dressed like a fireman."[18] The characterization was perhaps not coincidental. Eakins had been so taken with a youth he met on board the ship to Paris that he described him admiringly in a letter to his mother as "the picture of a Philadelphia fireman, and not a Phoenix boy but a good Fairmount or Shiffler rough."[19] Neither Shinn nor Eakins was referring to a professional firefighter in a protective uniform but to members of Philadelphia's volunteer fire companies, many of whom were working-class youths notorious for their rowdiness and grubby nonchalance. The garb of a Philadelphia fireman apparently adapted well to the bohemian life of an art student in Paris. In combination with such a demeanor, Eakins's intelligence, athleticism, deliberate Americanness, and working knowledge of French allowed him to fit comfort-

John Singer Sargent, *Portrait of William Merritt Chase*, 1902. Oil on canvas, 62½ x 41⅜". The Metropolitan Museum of Art, New York. Gift of the pupils of William Merritt Chase, 1905.

ably into the occasionally rambunctious studio life at the Ecole des Beaux-Arts to a degree unusual for an American artist. As Shinn summed it up: "This is a combination which pleases the Latin Quarter, and I found him high in favor."[20]

One of the friends Eakins made in Gérôme's studio was Germain Bonheur (1848–1880), half-brother of Rosa Bonheur, the famous painter of animal subjects whose large canvas *The Horse Fair* (1853–55, The Metropolitan Museum of Art, New York) had caused a sensation when it was shown in New York in 1857.[21] Eakins was a frequent visitor to the Bonheur house and was especially fond of their informal welcome: "Once or twice a week in the evenings I go to the Bonheurs and they let me come into the sitting room: we drink cider. The old lady & daughter the painter knit and scold their big brothers for not putting on a collar or a clean one. They smoke & nurse the cat and if a fellow dont want to talk or dont feel like it he sits and looks into the fire and feels just as comfortable as he can knowing he cant go to bed without turning out into the cold again."[22]

After one such visit, he wrote his mother, "I took my gun & pistol around to show their cousin who was there who is a good mechanic. He said he never saw such beautiful arms & so

they are. America beats the world in machinery."[23] William Sartain, who was present at the time, recalled that "Tom was speaking of our national mechanical skill and to illustrate his point he pulled out from his pocket his Smith & Wesson revolver (I know of no other person in Paris who ever carried one!)—Rosa put *her* hand into her pocket and pulled out one of the same make."[24] Eakins's experiences in Paris and Spain can be re-created from the vivid letters he wrote to his family and friends during those years. As Van Rensselaer discovered, Eakins was famously laconic, and the letters from Europe (of which at least one hundred and twenty-three are known) constitute one of the rare instances in which Eakins's voice can be heard. They are unusually detailed and revealing, as Eakins adopted a different persona for each individual he wrote. Because of his intimate and trusting relationship with his primary correspondent, his father, Eakins addressed him as an intellectual equal and a sporting companion as well as a formidable authority figure whom he wanted to please.

Van Rensselaer noted that Eakins "seems to understand his own aims & ideas and sort of work very well," and, in fact, in one of his most famous letters, he states a completely formulated realist art theory, in vernacular phrasing, using sustained imagery based upon sailing, the sport both he and his father enjoyed: "The big artist does not sit down monkey like & copy a coal scuttle or an ugly old woman like some Dutch painters have done nor a dungpile, but he keeps a sharp eye on Nature & steals her tools. He learns what she does with light the big tool & then color then form and appropriates them to his own use. Then he's got a canoe of his own smaller than Nature's but big enough for every purpose....With this canoe he can sail parallel to Nature's sailing."[25] For completeness, originality of expression, and modernity of its ideas, this statement is unmatched by any other American artist of Eakins's day. In addition to what it reveals about his aesthetic, this letter provides insight into the intellectual interests that Eakins shared with his father. It is clear that he wrote these sentences in response to a discussion Benjamin Eakins had had with his friends about the nature of art. Eakins referred in the same letter to Herbert Spencer, suggesting that both he and his father were acquainted with the theories of the British philosopher whose ideas were popular in the United States in the latter third of the nineteenth century. Spencer also influenced the young French philosopher Hippolyte Taine, whose lectures on the history of art and aesthetics Eakins attended at the Ecole des Beaux-Arts.[26]

While Eakins enjoyed Paris for the advantages it offered an artist and for its culture, he especially liked the freedom to be himself. As he wrote to his sister, "Americans are looked on in Europe as a people who may be allowed to do as they please."[27]

But unlike many young American art students, Eakins did not conform to the models of style and sophistication he saw in the French capital. Nor did he feel any impetus later to return to Europe to find the source of his artistic inspiration, and he never went back. In this, he was an exception among his contemporaries. William Merritt Chase, voicing the more typical sentiment, had famously declared: "I would rather go to Europe than go to Heaven."[28]

Eakins, twenty-five years of age, returned from Paris in the summer of 1870. He arrived at the beginning of a revolutionary period in American art, which can be charted by the series of international exhibitions held from 1867 through 1900. Eakins visited the Exposition Universelle in Paris in 1867, but like most visitors he did not comment in his letters about the American art, a relatively modest showing of eighty-two paintings dominated by landscapes of the Hudson River School. The few genre paintings on display illustrated American domestic scenes;[29] the six history paintings were weighted toward British subjects rather than American history or literature.[30] The only American painting to receive a medal—silver not gold—was Frederick Edwin Church's *Niagara* (1857, Corcoran Gallery of Art, Washington, D.C.), painted a decade earlier. The American art contribution generally was perceived as a disappointment compared with the United States' brilliant showing in the industrial section or the European art on view.[31] As James Jackson Jarves, one of America's most outspoken art critics, remarked, "The Great Exposition of 1867 at Paris taught us a salutary lesson by placing the average American sculpture and painting in direct comparison with the European, thereby proving our actual mediocrity."[32] Of the American painters who showed at the 1867 exposition, only four—G.P.A. Healey, John LaFarge, William Morris Hunt, and James McNeill Whistler—had exhibited or spent significant time abroad.[33] But the vanguard (Eakins among them) of American artists to come, the painters and sculptors who would represent the United States in subsequent expositions, was already studying in Paris and Munich.

Nearly a decade later at the Centennial Exhibition in Philadelphia in 1876, paintings by established landscape artists still received the major share of attention, as they had in Paris in 1867, but the younger artists made a distinct impression. As one of the senior members of this new generation, Eakins in effect made his professional debut at the Centennial. In addition to *The Gross Clinic*, which was banned from exhibition in the art galleries and provoked criticism ranging from admiration to outrage, he showed five contemporary scenes intimately connected to his own life: *The Chess Players* (pl. 19), the *Portrait of Benjamin Howard Rand* (Jefferson Medical College, Thomas Jefferson University, Philadelphia), *Elizabeth at*

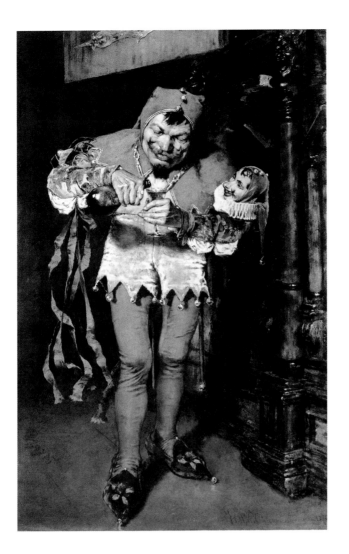

William Merritt Chase, *"Keying Up"—The Court Jester*, 1875. Oil on canvas, 39¾ x 25". Pennsylvania Academy of the Fine Arts, Philadelphia. Gift of the Chapellier Galleries, 1969.

the Piano (pl. 13), *Baseball Players Practicing* (pl. 14), and *Negro Whistling Plover* (Brooklyn Museum of Art, New York). They received little notice. Other artists won favorable comments for work that was recognized as new without being controversial, such as Chase's for his medal-winning historical genre scene, sent from abroad, of a jester pouring himself a fortifying drink, *"Keying Up"—The Court Jester*, painted in the richly colored, freely brushed Munich style.

Equally important in these expositions were the large selections of foreign art of all kinds that challenged contemporary taste. Describing the influence of the Centennial on American culture, Van Rensselaer recalled: "the pictures and marbles of Europe, the stuffs and brasses and carvings of India, the keramics [*sic*] of the Flowery Kingdom, the grotesque lovelinesses and the majestically splendid trifles of Japan, flung their challenge in the face of Yankee steam and steel, and said (with none to contradict), *You are a means towards living: we are an end to live for.*"[34]

The central issue in American art during the first two decades of Eakins's career, bracketed by the two Paris expositions of 1867 and 1889, was the conflict between the older landscapists of the Hudson River School and younger artists recently returned from academic training in Paris or Munich, who were committed to figure painting, as displayed in the variety of allegorical, historicizing, and peasant genre subjects popular in European academic art.[35] The main arenas of combat were in New York at the exhibitions of the established National Academy of Design, representing the old guard, and the new Society of American Artists, founded in 1877. As Van Rensselaer, who championed the younger artists, later characterized it: "In 1877, the torpid National Academy precincts saw the advent of certain young men from Munich who caused a great rattling of dry bones at the moment, and who proved but the advance guard of a whole battalion of fresh and eager painters."[36]

In his first years back in the United States, Eakins was as eager as his contemporaries to promote his work. Unlike many of them, however, he did not move to New York to continue the bohemian life he enjoyed in Paris. Instead, Eakins remained in Philadelphia and resumed his life much as it had been before he went abroad. Initially, he may have done this because of his mother's poor health—she died in 1872, shortly after Eakins's return from Europe—or because of diffidence about his painting skills or reluctance to be a financial burden on his father. Nevertheless, as his confidence in his abilities grew, Eakins exhibited his work aggressively and far afield, and he began showing with the Society of American Artists in 1878. One of the founders of that organization was his classmate and friend William Sartain, who, with no more financial support from his family than Eakins, had returned from Europe in 1877 and immediately moved to Manhattan. Yet even then Eakins did not join Sartain to locate himself at the center of the nation's art life and plunge into what Sarah Burns has vividly described as "the phenomenon of 'modernization': that process through which artists responded, reacted to, and were remodeled by new conditions of producing and marketing their work, and themselves, in a rapidly urbanizing and incorporating society."[37] In choosing to have his studio at home and not to embellish his working space, Eakins was rejecting the precedents with which he was familiar, such as John Sartain's art-filled house, Gérôme's splendid studio, or even the more modest example of his Philadelphia friend, the landscape painter Thomas Moran.

Van Rensselaer interpreted Eakins's decision to stay in Philadelphia as a negative influence on his art and felt that he needed help to escape his environment: "I believe that with proper encouragement he could do even better than he has done—that is if he had some one to order his pictures & some one to give him a little insight into the aesthetics of life & take him away from that 'milieu' where he now finds himself."[38] Instead, Eakins more firmly rooted himself into his surroundings.

In 1884 he married Susan Hannah Macdowell, a talented student at the Pennsylvania Academy of the Fine Arts who—far from challenging Eakins's aesthetics and convincing him to alter his style of living—came from a similar family background and shared his goals in art. The newly married couple set up housekeeping in a studio at 1330 Chestnut Street. Shortly thereafter, Eakins painted Susan's portrait in their impromptu dwelling (pl. 158). As collaboration between husband and wife, artist and sitter, and two artists of the same mind, the painting amounts to a manifesto about the artistic beliefs they shared. Instead of the welter of carefully arranged, exotic bric-a-brac shown in Chase's studio interiors, Susan Eakins sits in an American eighteenth-century chair. To one side is a mid-nineteenth-century American dresser, with Eakins's paintings, and possibly one of Susan's, on display. A nondescript damask drapery hangs behind her, and on the right side of the painting can be seen a plaster cast of one of Eakins's recently completed Arcadian subjects—the *Pastoral* relief (pl. 120). Eakins's setter Harry sprawls at Susan's feet. The only acknowledgment of the contemporary taste in the decoration of artists' studios is Susan's "artistic" gown, an interpretation of Empire style, her red stockings, and the book of Japanese woodblock prints that she holds.

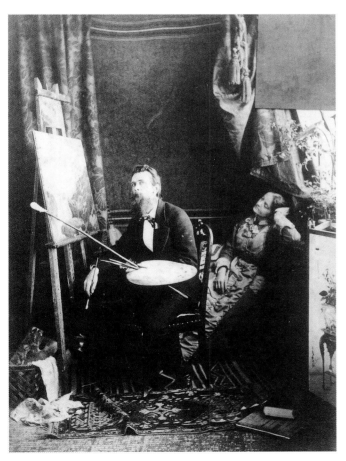

Unknown photographer, *Thomas Moran in His Studio with Mary*, 1876. East Hampton Library, New York.

Van Rensselaer included *The Artist's Wife and His Setter Dog* in the *Book of American Figure Painters*, published in 1886. The book illustrates paintings by thirty-five of the new generation of European-trained artists, accompanied by poems relating to their subjects. Among these, Eakins's painting is notably different. It is the only one identified as a portrait (Chase posed his wife as a Spanish dancer, with a tambourine), and Susan Eakins is one of the few women in contemporary dress, instead of being shown nude, seminude, draped, or in foreign costume. In featuring this work instead of one of Eakins's genre or historicizing subjects, Van Rensselaer seems to have been celebrating the milieu that she had denigrated in 1881. The poem she selected to accompany the painting, Shakespeare's sonnet 47, suggests that she was aware of its personal significance to the recently married artist and model. One of the most serious of the poetic accompaniments, the romantic connection between the painted portrait and love— "Betwixt mine eye and heart a league is took...thy picture in my sight/Awakes my heart to heart's and eye's delight"—is particularly apt.

Yet in her review of portraits at the Society of American Artists exhibition in 1887, Van Rensselaer described *The Artist's Wife and His Setter Dog* as "extremely interesting, despite its lack of charm."[39] The paradox evident in this judgment— admiration for the work in spite of its manner—echoes the dismay that she had experienced during her visit to Eakins's studio six years earlier and informs all of Van Rensselaer's writing about the painter. She stated this position most clearly, perhaps, in a review that appeared in *The Atlantic Monthly* in August 1881, two months after her visit to Philadelphia:

> Of all American artists he is the most typically national, the most devoted to the actual life about him, the most given to recording it without gloss or alteration. That life is often ugly in its manifestations, no doubt; but this ugliness does not daunt Mr. Eakins, and his artistic skill is such that he can bring good results from the most unpromising materials. In spite of a deficient power of coloring, his brush-work is so clever, his insight into character so deep and his rendering of it so clear, his drawing is so firm, and his management of light so noteworthy that he makes delightful pictures out of whatsoever he will,—even, as in this case, out of three homely figures with ugly clothes in an "undecorative" interior. This Lady Singing a Pathetic Song [pl. 63] was so impressive because it was admirably painted, and because it was at the same time absolutely true to nature,—a perfect record of the life amid which the artist lives....All possible renderings of Italian peasants and colonial damsels and pretty models cannot equal in importance to our growing art one such strong and real and artistic work as this one I have noted.[40]

The sophistication of Van Rensselaer's point of view, which allowed her to admire Eakins's painting intensely while

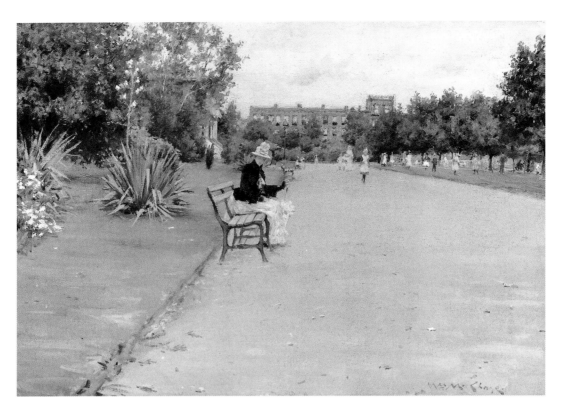

feeling disdain for his middle-class, contemporary subjects, was shared by few critics and almost no collectors. And she made her preference for other kinds of work clear. In the same 1887 review that briefly mentioned *The Artist's Wife and His Setter Dog*, Van Rensselaer lauded two portraits by Eakins's contemporaries Thomas Wilmer Dewing and Wyatt Eaton: "Not every man who paints brilliantly can paint a woman so that she will look as though she were a lady and had chosen a gentleman to paint her. But this exhibition proves that both Mr. Dewing and Mr. Eaton can do this. Two more high-bred looking portraits than theirs it would be difficult to find."[41] Although Eakins's works did receive critical attention during the seminal period in American art between 1877 and 1886, few of his viewers could accept his subject matter in spite of their admiration for his technique. As Marc Simpson demonstrates in his essay "Eakins's Visions of the Past and the Building of a Reputation" in this volume, it was almost exclusively Eakins's "old-fashioned" subjects, more in line with the historical genre pictures produced by his contemporaries, that found buyers during this period.

In the fine arts, an American spirit of competition with Europe was firmly established by this time, and at the Exposition Universelle in Paris in 1889, a mature generation of foreign-trained American artists deliberately challenged their French counterparts on their own ground. In the American section, 572 works were shown, including 336 paintings by 189 painters.[42] So many Americans were resident in Paris that their work was shown in a separate gallery from that of American artists living in the United States. Figure painting instead of landscape predominated, and very few of the subjects were of native American subject matter. The trend toward European style was rewarded by 57 awards and 24 honorable mentions given to the American artists. Eakins showed two portraits and *The Dancing Lesson* (pl. 45), which went unnoticed. Chase won a silver medal for his group of eight paintings, including *A City Park*, which illustrates that Chase, like many of his American contemporaries, had altered his style to incorporate elements of Impressionism. American art truly had become cosmopolitan, and "in some ways virtually indistinguishable from that . . . of the hundreds of French, English, Swiss, Scandinavian, and other nationals who had learned most of their lessons in Parisian studios."[43] Two years before the 1889 fair, Henry James, writing about John Singer Sargent, had pointed out that "it sounds like a paradox, but it is a very simple truth, that when to-day we look for 'American art' we find it mainly in Paris. When we find it out of Paris, we at least find a great deal of Paris in it."[44]

At the World's Columbian Exposition held in Chicago in 1893, the exhibition of American painting and sculpture was nearly four times as large as the representation at the 1889 Paris fair, with 1,200 paintings and sculptures in addition to other works. To emphasize the competition, the galleries for American art were placed directly adjacent to the French. And the call for a return to American subjects had begun to be heard. New styles and more homely subjects were, in fact, to be seen. *Breaking Home Ties*, depicting an American farm boy leaving the homestead for work in the city, by Thomas Hovenden, a former instructor at the Pennsylvania Academy, was

voted the most popular work at the exhibition. As a tribute of respect for Eakins by his fellow artists, ten of his paintings, including his controversial works *The Gross Clinic* (pl. 16) and *The Agnew Clinic* (pl. 175) were featured in the Art Gallery of the Columbian Exposition, making him one of only a dozen painters—together with Americans Winslow Homer, George Inness, Elihu Vedder, and R. Swain Gifford—whose work was shown in such numbers.

With the growing popularity of an American art that was distinctly national, it might be expected that Eakins would have found a larger audience during the 1890s. Sympathy for his work began to increase slowly during this decade; Carol Troyen traces this trend in her essay "Eakins in the Context of the Twentieth Century." But after his dismissal from the Pennsylvania Academy in 1886, Eakins chose to create even greater challenges for his viewers.[45] He became preoccupied with the introverted, psychologically penetrating portraits that consumed the majority of his efforts for the rest of his career. At a time when fashionable portraiture was commissioned to display the status of the subject and the technical skill of the artist, such as the *Portrait of William Merritt Chase* commissioned by Chase's students from America's most famous portraitist, John Singer Sargent, and presented to the Metropolitan Museum of Art, Eakins seems to have painted portraits to please himself. He investigated portraiture of his friends and acquaintances as he had other subjects that held a personal resonance, such as rowing or shad fishing, at other points in his career. While many of these sitters had distinguished public careers, and all may have been heroic in Eakins's opinion,[46] they belonged to the middle-class or working-class worlds he knew intimately. In the few commissions Eakins did receive—almost exclusively from men in the professional and business communities, such as Asbury W. Lee (pl. 235)—his efforts to portray individuals whom he did not know personally were unsympathetic and occasionally seem deliberately cruel.

Eakins may originally have been inspired to concentrate on portraits by the large exhibition of historical portraits held at the Academy in 1887, soon after his dismissal. Considering his devotion to the subject at this time, it must have been especially painful for him when the Pennsylvania Academy purchased Chase's full-length portrait of Emily Clark, *Portrait of Mrs. C. (Lady with a White Shawl)* in 1895. Technically subdued and painted in tones of black, brown, and white, Chase's work is very much like Eakins's work in its conception, yet reinterpreted in an appealing way. The smiling, beautiful woman Chase portrayed is entirely different from the somber, introspective sitters Eakins favored. Chase was hired to teach the portrait classes at the Academy in 1896; he remained until 1909.

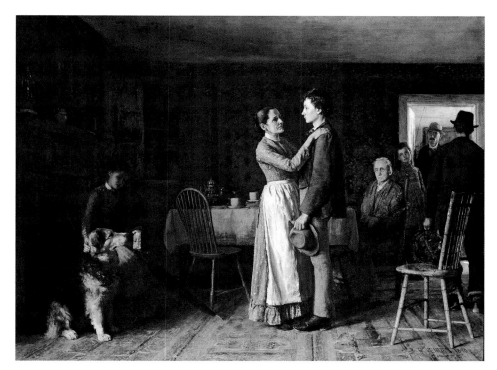

Thomas Hovenden, *Breaking Home Ties*, 1890. Oil on canvas, 52⅛ x 72¼". Philadelphia Museum of Art. Gift of Ellen Harrison McMichael in memory of C. Emory McMichael, 1942.

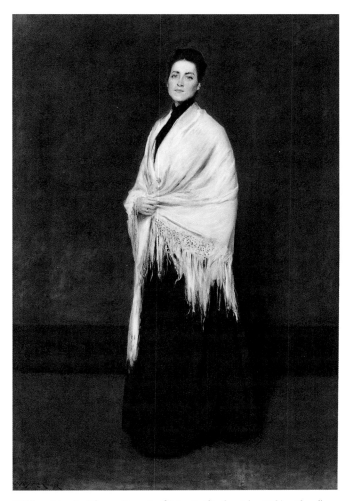

William Merritt Chase, *Portrait of Mrs. C. (Lady with a White Shawl)*, 1893. Oil on canvas, 75 x 52". Pennsylvania Academy of the Fine Arts, Philadelphia. Joseph E. Temple Fund, 1895.

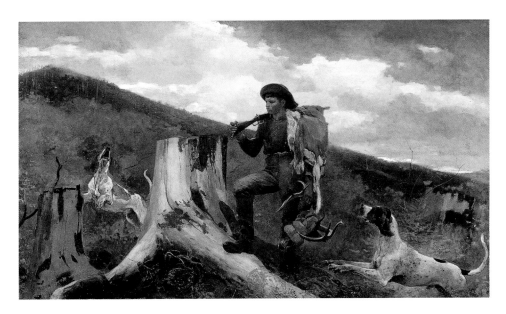

Winslow Homer, *A Hunts-man and Dogs*, 1891. Oil on canvas, 28⅛ x 48". Philadelphia Museum of Art. The William L. Elkins Collection, 1924.

Eakins's moody portraits of middle-class individuals were not easily marketed as works of art. Although some of them, such as his own self-portrait (pl. 229) are painted with beautiful technique, Eakins's ordinary people may have reminded his urban audience too keenly of their own origins or states of mind. In contrast, the most popular American artist in the 1890s, Winslow Homer (1836–1910), allowed city dwellers to escape from their surroundings by imagining themselves in rugged landscapes, triumphing over the elemental forces of nature.[47] By the time of the Exposition Universelle held in Paris in 1900, the American art exhibition was administered by the U.S. Department of State, and the express purpose was to stake "a new position for the United States as an art-producing nation" free from "foreign trammels."[48] To ensure a predominance of specifically American subjects, it was stipulated that at least 70 percent of the works were to have been made in the United States.[49] Foreign narratives and genre subjects, which had been popular in 1889, were notably sparse. Chase's *Portrait of Mrs. C. (Lady with a White Shawl)* instead represented "the wholesome ideal of American womanhood,"[50] while paintings of men received more attention as an antidote to what was perceived as the French-influenced femininity of the art of the previous decades.[51] Undeniably American and masculine, the two paintings Eakins exhibited, *The Cello Player* (pl. 206) and *Salutat* (pl. 214), fulfilled these criteria. Elizabeth Pennell's praise for these paintings—*The Cello Player* as a "straightforward, vigorous and uncompromising rendering of a strong type as you could find," and *Salutat* as "astonishing in its vigor and truth as his portrait"[52]—represents the tone of favorable criticism and the revival of Eakins's reputation during these years. Eakins's portraits won gold medals at the Pan-

American Exposition in Buffalo in 1901 and the Louisiana Purchase Exposition in Saint Louis in 1904. The Pennsylvania Academy purchased Eakins's *Cello Player* in 1897. Yet, for the most part, there was still no market for Eakins's portraits, as there had not been for his subject pictures for three decades. Only after World War I did American museums begin to buy his art with any regularity.

In the early 1900s, the art critic and historian Walter Pach encountered Chase and Eakins together in conversation at an exhibition. Chase's career was at the beginning of an eclipse that would last for nearly fifty years. Eakins was on the brink of his modern fame. Pach recalled: "The personal verve and distinction of the brilliant technician [Chase] were arresting, even as his paintings were conspicuous in the exhibitions of his time. But the memory that comes back most vividly to me is that of the heavy figure of the older artist (older only by a few years, yet seeming of another generation) in whose slow impassive gestures there was something of the depth and dignity of his art."[53]

A decade or more later, Pach made a visit to Eakins's widow in Philadelphia in a very different frame of mind from that of Van Rensselaer more than forty years before:

Imagine the quiet dignity of an old private house in one of Philadelphia's lovable streets, where old brick and white marble tell of modest but stable prosperity. On the door is still the metal plate saying, "B. Eakins," just as the painter's father put it there. There was no reason for the son to change it when he became the owner of the house. Still less would Mrs. Eakins have considered touching it after 1916 when her husband died. Everything about the old house tells of his presence there, his pictures on the walls, his studio with sketches that served for great pictures and that pointed his way to new ones.[54]

For Pach, Chase represented the art of his day; Eakins had become an old master, and his being and surroundings symbolized the nature of his art.

More than four decades before, Mariana Griswold van Rensselaer had struggled with "the strong contrast between the real Mr. Eakins & the one I had picture[d] to myself." At the time of Van Rensselaer's visit, American art was well on the way to transforming itself from a distinctive provincial phenomenon to a more sophisticated, competitive presence in the international world of art. Eakins's career spanned these decades. Remarkably, as Van Rensselaer was puzzled to realize, he chose to play a different game by rules he set for himself. Thomas Eakins remains one of the most fascinating creative personalities in American art.

Chronology

KATHLEEN BROWN

1818

February 22

Thomas Eakins's father, Benjamin, is born to Frances Fife (c. 1778–1836) and Alexander Eakins (originally Akens or Akins, c. 1771–1839), a tenant farmer and itinerant weaver living in Valley Forge, Pennsylvania. Benjamin is the third of four children.

1820

Eakins's mother, Caroline Cowperthwait, is born to Margaret Jones (c. 1780–1864) and Mark Cowperthwait (1767–1822), a Quaker cobbler. Caroline is the youngest of ten children.

1828

September 16

Alexander Eakins, who lived in the United States since at least 1812 and possibly as early as 1802, petitions to become a citizen. It seems likely that at this time the spelling of the family name is officially changed from Akens or Akins to Eakins (The Lloyd Goodrich and Edith Havens Goodrich, Whitney Museum of American Art, Record of Works by Thomas Eakins, Philadelphia Museum of Art; hereafter Goodrich Papers).

1843

McElroy's Philadelphia Directory lists Benjamin Eakins's residence as 10 Sergeant Street in Philadelphia. His profession is given as "teacher."

October 19

Benjamin Eakins marries Caroline Cowperthwait. The couple resides at the home of Caroline's mother, 4 Carrolton Square (now 539 Tenth Street) in Philadelphia.

1844

July 25

Thomas Cowperthwait Eakins is born. He is the first of five children.

1848

November 1

Frances Eakins Eakins ("Fanny") is born. According to the birth records listed in the Eakins's family bible, three of the five children are given this middle name. The other two children, Thomas and Margaret, are given Cowperthwait for their middle name (Archives, Pennsylvania Academy of the Fine Arts, Philadelphia).

1849

Benjamin Eakins's occupation is listed as "teacher writing" in *McElroy's Philadelphia Directory*.

1850

October 27

Benjamin Eakins Eakins is born, but dies five months later.

1852

The Eakins family moves to 1201 Green Street.

1853

Fall

Eakins, age nine, enters Zane Street Grammar School, located at Zane (now Filbert) Street between 7th and 8th Streets.

November 3

Margaret Cowperthwait Eakins ("Maggie") is born.

Oliver H. Willard, *Benjamin Eakins*, early 1860s. Albumen carte-de-visite. Private Collection.

Oliver H. Willard, *Caroline Cowperthwait Eakins*, early 1860s. Salt print. Collection of Daniel W. Dietrich II.

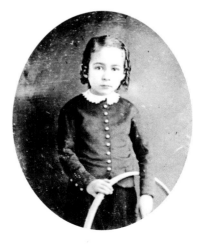

Photographer unknown, *Eakins at About Age Six,* c. 1850. Daguerreotype. Pennsylvania Academy of the Fine Arts, Philadelphia. Charles Bregler's Thomas Eakins Collection, purchased with the partial support of the Pew Memorial Trust (1985.68.2.1) (hereafter Bregler Collection).

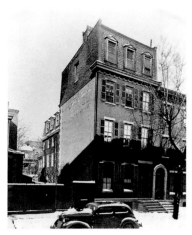

The Eakins House at 1729 Mount Vernon Street, Philadelphia, c. 1940. Historical Society of Pennsylvania, Philadelphia.

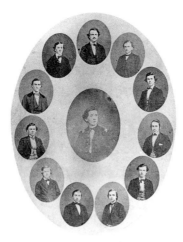

Oliver H. Willard, *Central High School Graduating Class,* 1861. Composite salt print. Bregler Collection (1985.68.2.3).

Admission ticket to Dr. Pancoast's anatomy class, Jefferson Medical College, Philadelphia, 1864–65. Hirshhorn Museum and Sculpture Garden, Smithsonian Institution, Washington, D.C. Charles Bregler Archival Collection, 1966.

1855

The Eakins family moves to 505 Green Street.

1857

July 11

Benjamin Eakins buys a house at 1725 Washington Court (now 1729 Mount Vernon Street).

Fall

Eakins succeeds in passing the entrance examination to the Central High School in Philadelphia.

1861

July 11

Eakins graduates from the Central High School. He ranks fifth among fifteen students receiving bachelor of arts degrees, having a four-year average of 88.4 with marks especially high in mathematics, science, and languages, particularly French. Every year he receives a mark of 100 in drawing. Eakins is listed in the commencement program as giving the "scientific address."

After graduation, Eakins assists his father as a calligrapher and teacher of penmanship.

1862

September 5–6

Eakins competes for the position of professor of drawing, writing, and bookkeeping at the Cen-

tral High School. Out of the original four applicants he is one of only two to complete the arduous two-day examination. Former schoolmate Joseph Boggs Beale is awarded the position.

October 7

Eakins registers at the Pennsylvania Academy of the Fine Arts in Philadelphia to draw from antique casts and attend lectures on anatomy given by Dr. A. R. Thomas.

1863

McElroy's Philadelphia Directory lists Eakins as "teacher" until 1866, when he appears as "writing teacher."

February 23

Eakins is admitted to the life drawing classes at the Pennsylvania Academy. He probably continues his studies there through the 1865–66 season. Though the Academy had no formal faculty at this time, students benefit from the advice and criticism of established Philadelphia artists Peter F. Rothermel and Christian Schussele.

1864

August 26

Eakins, who had become eligible for the Civil War draft on his twenty-first birthday a month earlier, pays the twenty-four-dollar fee required to avoid conscription into the Union Army.

October 10–February 28, 1965

Eakins attends anatomy lectures taught by Dr. Joseph Pancoast at Jefferson Medical College, the leading medical school in Philadelphia.

1865

February 1

Caroline Eakins Eakins ("Caddie") is born.

1866

September 11

Albert Lenoir, the Secretary of the Ecole des Beaux-Arts in Paris, responds to Eakins's inquiries regarding admission and advises him that the Ecole is accepting foreign students. Lenoir writes that Eakins need only "pick up a letter from your embassy to solicit permission from the Superintendent to study at the school, which he will accord you on presentation of your letter.... As soon as the Superintendent writes us to admit you, I will inscribe you on the list of whichever atelier you would like to choose." Although Lenoir mentions that many Americans were turned away the previous year owing to lack of available spaces, he reassures Eakins that "today there is no more reason to raise obstacles" (Lenoir to Eakins, September 11, 1866, transcribed in French by Eakins into his account book, Philadelphia Museum of Art; translation by David Sellin).

Detail of illustrated letter from Eakins to his mother, November 8–9, 1866. Hirshhorn Museum and Sculpture Garden, Smithsonian Institution, Washington, D.C. Charles Bregler Archival Collection, 1966.

Charles Reutlinger, *Jean-Léon Gérôme*, c. 1867–68. Albumen carte-de-visite. Collection of Daniel W. Dietrich II.

Frederick Gutekunst, *Christian Schussele*, 1860s. Albumen carte-de-visite. Collection of Daniel W. Dietrich II.

September 12

Eakins applies for a United States passport. His father apparently agrees to finance his study at the Ecole des Beaux-Arts, and seems to support his son's decision wholeheartedly.

September 22

Eakins boards the steamship *Pereire*, which sets sail from New York to Le Havre, France. Eakins takes a second-class cabin, and his letters home express his prejudices: "The second cabin is I think prefereable [*sic*] to the first at least on this trip....I forget to thank Heaven that all the Englishmen are in the first cabin, and a nastier looking set of young snobs I never saw in my life. They avoid coming near us but we sometimes see them. They keep close back to the rudder for the second class passengers often overstep their limits" (Eakins to Caroline Eakins, October 1, 1866, Pennsylvania Academy of the Fine Arts, Philadelphia, Charles Bregler's Thomas Eakins Collection, purchased with the partial support of the Pew Memorial Trust; hereafter Bregler Collection).

October 3

Eakins arrives in Paris and locates Lucien Crépon, an alumnus of the Pennsylvania Academy, who helps him find lodgings (Eakins to Caroline Cowperthwait Eakins, October 8, 1866, Bregler Collection).

October 29

Eakins is accepted into Jean-Léon Gérôme's atelier at the Ecole des Beaux-Arts.

November

Eakins begins his studies at the Ecole by drawing from the nude for the next five months, building upon the educational foundation he received at the Pennsylvania Academy.

1867

March 21

In a letter to his father, Eakins reports that "Gerome has at last told me I might get to painting & I commence Monday" (Eakins to Benjamin Eakins, March 21, 1867, Bregler Collection).

May

Eakins visits the Exposition Universelle several times. His letters home express particular admiration for the machinery and the success of the American department, but he scarcely mentions the art exhibitions: "I have been to the Great Exhibition twice I think since I last wrote....One of the most amusing things in the American department is the soda water fountains. The foreigners above all the French have begun to taste the ice cream soda water and its fame has spread so that there is a long tail like at a theatre all waiting their turns" (Eakins to Benjamin Eakins, May 31, 1867, Goodrich Papers).

August–September

At his father's recommendation, Eakins travels to Switzerland, where he is joined by his close friends and Central High School classmates William J. Crowell and William Sartain. The group stops in Strasbourg to visit Christian Schussele, who had returned to Europe for medical treatment.

Late September

Eakins moves to a studio at 64, rue de l'Ouest (street name and number changed to 90, rue d'Assas in July 1868) to paint independently, while continuing to attend the Ecole: "The studio will enable me to commence to practice composing and to paint out of school which I could not do before. As soon as I can get knowledge enough to enable me to paint quickly I will make pictures, but I have been only 4 months at the brush and can't do it yet" (Eakins to Benjamin Eakins, September 20, 1867, Bregler Collection).

1868

January

Eakins begins to paint compositions and writes to his father of his progress: "Color is becoming little less of a mystery than it was & more of a study in proportion. When it ceases altogether to be a mystery and it must be very simple at the

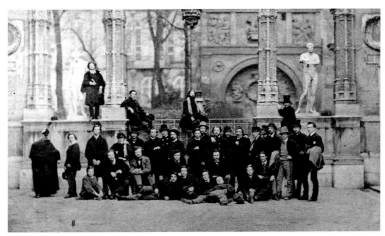

Photographer unknown, Detail of *Students in the Courtyard of the Ecole des Beaux-Arts, Paris*, c. 1868. Albumen print. Collection of Daniel W. Dietrich II.

Frederick Gutekunst, *Thomas Eakins at About Age Twenty-Four*, c. 1868. Gelatin silver print. Collection of Daniel W. Dietrich II.

Photographer unknown, *William Sartain*, c. 1870. Albumen carte-de-visite. Collection of Daniel W. Dietrich II.

bottom, I trust I will soon be making pictures. One consolation is that I am composing, it was hard to begin, I felt I ought to know more, but now I am at it and whatever I can gain in it, is straight towards making a selling picture" (Eakins to Benjamin Eakins, January 17, 1868, Goodrich Papers).

February

Eakins reads *Méthode et entretiens d'atelier (Conversations on Art Methods*, 1867), written by the French academic painter Thomas Couture. It is one of the few instructional manuals on painting that he ever mentioned: "Tell Bill Sartain that Couture has written a book on art. It is curious & very interesting. I had read it as soon as it came out" (Eakins to Benjamin Eakins, February 1868, Bregler Collection).

March 5

Eakins begins to study sculpture at the Ecole with Augustin-Alexandre Dumont.

March 17

Although he only recently has begun painting compositions, Eakins confidently informs his father of his progress: "I am less worried about my painting now than at one time last spring and consequently am in better order to study. . . . I am getting on faster than many of my fellow students and could even now earn a respectable liv-ing I think in America" (Eakins to Benjamin Eakins, March 17, 1868, Bregler Collection).

Early May

Eakins visits the Salon and finds that "there are not more than twenty pictures in the whole lot that I would want. The great painters dont care to exhibit there at all. Couture Isabey Bonnat Meissonnier [*sic*] have nothing. The rest of the painters make naked women, standing sitting lying down flying dancing doing nothing which they call Phrynes, Venuses, nymphs, hermaphrodites, houris & Greek proper names" (Eakins to Benjamin Eakins, May 9, 1868, Collection of Daniel W. Dietrich II).

June 13

Benjamin and Fanny Eakins set sail from New York to Liverpool, England. They arrive on June 24 and travel to London, where they spend ten days before leaving for Paris to meet Thomas.

July 4

Benjamin and Fanny Eakins reach Paris. Fanny sends a report on Thomas's health and appearance to their mother: "He has changed very little, he's just the same old Tom he used to be, and just as careless-looking" (Frances Eakins to Caroline Cowperthwait Eakins, July 7, 1868, Thomas Eakins Research Collection, Philadephia Museum of Art). The three travel together in Italy, Germany, and Belgium before Benjamin and Fanny return to Philadelphia in September.

Fall

Eakins still has not produced a finished painting. Possibly in reply to his father's concern, he writes, "There is a common mistake made by those who do not know drawing, and that it [*sic*] that one should have the habit of finishing studies. This is a great mistake. You work at a thing only to assure yourself of the principle you are working on & the moment you satisfy yourself you quit it for another. Gerome tells us every day that finish is nothing that head work is all & that if we stopped to finish our studies we could not learn to be painters in a hundred life times & he calls finish needle work and embroidery & ladies' work to deride us" (Eakins to Benjamin Eakins, October 29, 1868, Bregler Collection).

Late December

Eakins returns to Philadelphia for Christmas and stays for more than two months.

1869

March 6

Eakins sails from New York; he arrives in Brest, France, on March 16.

Ferdinand Mulnier, *Léon Bonnat*,
c. 1868. Albumen carte-de-visite.
Collection of Daniel W. Dietrich II.

Thomas Eakins, *Portrait of Margaret
Eakins in a Skating Costume*, 1871. Oil on
canvas, 24⅛ x 20⅛". Philadelphia
Museum of Art. Gift of Mrs. Thomas
Eakins and Miss Mary Adeline Williams,
1929.

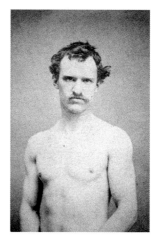

Schreiber and Son, *Max Schmitt*,
c. 1871. Albumen carte-de-visite.
Collection of Daniel W.
Dietrich II.

April
Eakins and William Sartain move into a new studio at no. 8, rue de Rennes (formerly rue Cassette) (Eakins to Caroline Cowperthwait Eakins, April 14, 1869, Archives of American Art, Smithsonian Institution, Washington, D.C.).

August
For one month, Eakins joins Sartain in the atelier of the painter Léon Bonnat, a fashionable portraitist.

September 8
In reference to the time he spent in Bonnat's studio, Eakins writes to his father: "I have now given up going to Bonnat, he is in the country. . . . I am very glad to have gone to Bonnat & to have had his criticisms, but I like Gerome best I think" (Eakins to Benjamin Eakins, September 8, 1869, Goodrich Papers).

September 14
Eakins considers leaving Paris and contemplates a trip to Algiers to be "in the sunlight & paint landscape. Open air painting is now important to me to strengthen my color & to study light" (Eakins to Benjamin Eakins, September 14, 1869, Goodrich Papers).

November 29
After debilitating illness and depression, Eakins leaves Paris: "I am going to Spain. I have been pretty sick here in spite of my precautions against the weather and feel worn out. I will go straight to Madrid, stay a few days to see the pictures and then go to Seville" (Eakins to Benjamin Eakins?, November 29, 1869, Goodrich Papers).

December 1
Eakins arrives in Madrid where he studies the work of Velázquez in the Prado.

December 3
Eakins leaves Madrid for Seville. He is joined by Harry Humphrey Moore, a fellow Philadelphian and classmate from Gérôme's studio.

1870

Early January
William Sartain joins Eakins and Moore in Seville.

Late January
Eakins begins his first finished composition, *A Street Scene in Seville* (fig. 32), which will occupy him for at least three months.

Late May
Eakins departs Seville and returns to Madrid to study the paintings in the Prado. He records his observations in the Spanish notebook (Bregler Collection).

June
Eakins leaves Madrid for Paris. On the eve of the Franco-Prussian War, the city is politically volatile, and he stays for only two weeks. On the 18th, Eakins sets sail for the United States.

July 4
Eakins arrives in Philadelphia and establishes a studio in his family's home. There he takes family members as his subjects and paints works such as *Home Scene* (pl. 5), *Portrait of Margaret Eakins in a Skating Costume* (Philadelphia Museum of Art), and *Elizabeth Crowell with a Dog* (pl. 9). Concurrently, he undertakes *The Champion Single Sculls (Max Schmitt in a Single Scull)* (pl. 1), the first of the rowing scenes that will occupy him for the next four years.

1871

April 26–May 6
Eakins has his first public exhibition at the Union League of Philadelphia's third art reception. He shows *The Champion Single Sculls* and a portrait (now lost), which receive mixed reviews.

1872

Eakins paints his first full-length portrait, titled *Kathrin* (Yale University Art Gallery, New Haven). His sitter is Kathrin Crowell, who would become his fiancée in 1874.

Frederick Gutekunst, *Frances Eakins*, c. 1868. Albumen carte-de-visite. Pennsylvania Academy of the Fine Arts, Philadelphia. Purchased with funds donated by the Pennsylvania Academy's Women's Committee (1988.10.7).

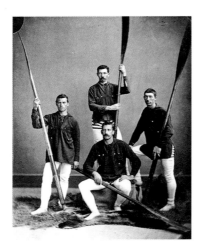

William Notman, *The Biglin Crew, International Regatta at Halifax, August 31, 1871*. Modern print from original collodion wet-plate negative. McCord Museum of Canadian History, Montreal. Notman Photographic Archives.

Thomas Eakins, *Kathrin*, 1872. Oil on canvas, 62¾ x 48¼". Yale University Art Gallery, New Haven. Bequest of Stephen C. Clark, B.A. 1903.

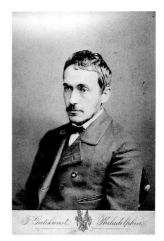

Frederick Gutekunst, *Thomas Eakins*, mid-1870s. Albumen cabinet card. Philadelphia Museum of Art. The Lloyd Goodrich and Edith Havens Goodrich, Whitney Museum of American Art, Record of Works by Thomas Eakins.

June 4
Eakins's mother dies. The cause of death is given as "exhaustion from mania." Three days later she is buried in Woodlands Cemetery in Philadelphia.

August 15
Fanny Eakins marries William J. Crowell. The couple settles in the Eakins home at 1729 Mount Vernon Street.

Autumn
Eakins paints a portrait of photographer Henry Schreiber's dog, titled *Grouse* (fig. 138). It is the first known Eakins painting based on a photograph.

1873
Eakins paints *The Biglin Brothers Turning the Stake-Boat* (pl. 6).

January 27
Eakins exhibits a rowing picture, entitled *Boating on the Schuylkill*, at the Ladies' Day Reception of the Lotos Club in New York City. This is the first documented instance of the public exhibition of an Eakins painting in New York.

May 10
By the spring, Eakins completes a watercolor of a rower that he feels confident enough to send to his teacher Gérôme, who compliments him on his progress: "I have received the watercolor that you sent me, I accept it with pleasure and thank you for it. It has been so much more agreeable to me because in this work I have been able to ascertain singular progress and above all a manner of proceeding which can only lead you to good" (Gérôme to Eakins, May 10, 1873, Goodrich Papers; translation by Lloyd Goodrich).

Early Autumn
While out hunting, Eakins contracts malaria and is bedridden with a fever for two months.

1874
Eakins becomes engaged to Kathrin Crowell.

Eakins completes *The Schreiber Brothers* (Yale University Art Gallery, New Haven), two works called *Starting Out after Rail* (pl. 12 and a watercolor at the Wichita Art Museum, Kansas), *Sailboats Racing on the Delaware* (pl. 10), *Pushing for Rail* (pl. 11), and two versions of *Whistling Plover* (a lost oil painting and a watercolor at the Brooklyn Museum of Art, New York).

Hoping to attract public portrait commissions, Eakins begins the first in a series of life-size, full-length portraits of prominent professionals. His first sitter is Professor Benjamin Howard Rand, who teaches at Jefferson Medical College and was one of Eakins's instructors at the Central High School (portrait at the Jefferson Medical College of Thomas Jefferson University, Philadelphia).

February
Eakins exhibits for the first time with the American Society of Painters in Water Colors (later the American Water Color Society), and secures his first sale, *The Sculler*, for eighty dollars (location unknown).

April
Eakins, who began attending life classes at the Philadelphia Sketch Club in the winter, agrees to provide criticism, without pay, for fellow students—his first teaching position. He teaches there until the Pennsylvania Academy reopens in its new building in 1876.

April–June
Eakins registers at Jefferson Medical College for surgical demonstrations with Dr. Samuel David Gross and for lectures on anatomy with Dr. Joseph Pancoast.

May
In his first exhibition held in Paris at Goupil's, Eakins shows two hunting subjects, one of them *Starting Out after Rail* (pl. 12).

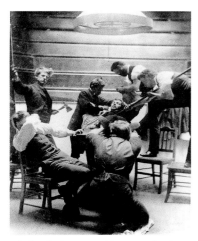

Circle of Thomas Eakins, *Parody of "The Gross Clinic,"* 1875 or later. Modern gelatin silver copy print. Philadelphia Museum of Art. Gift of George Barker.

Frederick Gutekunst, *Pennsylvania Academy of the Fine Arts*, c. 1878. Albumen cabinet card. Collection of Daniel W. Dietrich II.

John Lewis Krimmel, *Fourth of July in Centre Square*, 1812. Oil on canvas, 22¾ x 29". Pennsylvania Academy of the Fine Arts, Philadelphia. Purchased from the estate of Paul Beck, Jr.

1875

February

At the eighth annual exhibition of the American Society of Painters in Water Colors, Eakins exhibits *Whistling Plover* (Brooklyn Museum of Art, New York), *Baseball Players Practicing* (pl. 14), and *Drifting* (private collection).

March

Eakins submits *The Schreiber Brothers* as his first contribution to the annual exhibition of the National Academy of Design in New York; it is rejected.

April

Eakins begins *The Gross Clinic* (pl. 16), which will occupy much of his time over the next six months.

Spring

Eakins exhibits two paintings—one of them probably *Starting Out after Rail* (pl. 12)—in the Paris Salon and four others at Goupil's galleries in Paris and London. At Goupil's, the oil painting *Whistling Plover* sells for sixty dollars.

1876

Eakins begins his painting *William Rush Carving His Allegorical Figure of the Schuylkill River* (pl. 41). He completes *The Chess Players* (pl. 19) and

Baby at Play (pl. 18), a portrait of his niece Eleanor ("Ella") Crowell.

March 7

At a Penn Club reception, Eakins exhibits a photograph of his painting *The Gross Clinic*, giving the public a preview of this major work.

April

Eakins exhibits *The Gross Clinic* at Haseltine's Gallery in Philadelphia.

April 22

At the first exhibition in the Pennsylvania Academy of the Fine Arts' new building at Broad and Cherry streets, Eakins exhibits *The Zither Player* (The Art Institute of Chicago) and a photograph of *The Gross Clinic*.

May 10

The Centennial International Exhibition opens in Philadelphia with widespread celebration. Eakins shows five works in the ambitious art exhibition, but *The Gross Clinic* is rejected as unsightly and relegated to the United States Army Post Hospital.

September

When classes commence at the Pennsylvania Academy, Eakins volunteers his services both as an assistant to Christian Schussele, the professor

of drawing and painting, and as a dissection assistant for the anatomist Dr. William W. Keen.

Eakins meets Susan Hannah Macdowell, a new student at the Pennsylvania Academy.

1877

April 3–June 2

The National Academy of Design in New York accepts *Rail Shooting on the Delaware* (Yale University Art Gallery, New Haven) as Eakins's first successful submission to its annual exhibition.

April 22–June 4

Eakins exhibits *The Chess Players* and portraits of Archbishop James Wood (Saint Charles Borromeo Seminary, Overbrook, Pa.) and Dr. John H. Brinton (pl. 17), at the annual exhibition of the Pennsylvania Academy.

May 14

A decree issued by the board of the Pennsylvania Academy demands that Christian Schussele not delegate his teaching responsibilities. Eakins is forced to stop assisting in Schussele's life classes but continues to assist Dr. Keen in the Academy's anatomy lectures. In the following months, Eakins assumes the role of unpaid instructor at the Art Students' Union, created by students who have left the Pennsylvania Academy.

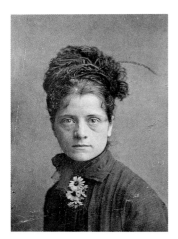

Photographer unknown, *Susan Mac-dowell*, 1877–80. Tintype. Bregler Collection (1985.68.2.80).

Wood engraving after a drawing by Thomas Eakins, in "Truthful James" [Bret Harte], "The Spelling Bee at Angel's," *Scribner's Monthly*, vol. 17, no. 1 (November 1878), p. 38.

June
Eakins receives a commission from the Union League of Philadelphia to paint a portrait (now lost) of the new United States president, Rutherford B. Hayes.

August
Writing from Washington, D.C., Eakins complains to his fiancée, Kathrin, about his progress on the portrait of President Hayes: "The President gave me two sittings. He posed very badly. However, I had good results with a sketch in which I was able to give enough animation" (Eakins to Kathrin Crowell, August 29, 1877, Bregler Collection).

1878

February
Eakins exhibits at the American Water Color Society's eleventh annual exhibition, where his work receives favorable notice.

March
Eakins resumes his position as Christian Schussele's assistant at the Pennsylvania Academy.

March 6–April 5
Eakins participates in the first exhibition of the Society of American Artists in New York. He shows *William Rush Carving His Allegorical Fig-*ure of the Schuylkill River, In Grandmother's Time (fig. 83), and a photograph of *The Gross Clinic*.

September 2–November 2
In the exhibition at the Massachusetts Charitable Mechanics' Association in Boston, Eakins receives a silver medal for *Fifty Years Ago, Young Girl Meditating* (pl. 43), and *The Dancing Lesson (Negro Boy Dancing)* (pl. 45).

Autumn
For Fairman Rogers, Eakins adapts Eadweard Muybridge's photographic sequences of animal locomotion for display in a zoetrope.

November
Eakins's illustrations for Bret Harte's "The Spelling Bee at Angel's" are published in *Scribner's Monthly*.

1879

During the course of the year, Eakins sends works to various exhibitions nationwide, including the Louisville Industrial Exhibition, the Inter-State Industrial Exposition of Chicago, annual exhibitions at the National Academy of Design, the Pennsylvania Academy, and art club exhibitions throughout the Northeast.

February 3–March 1
Eakins receives critical acclaim for *A Quiet* Moment, his entry to the American Water Color Society's twelfth annual exhibition.

February 6
Eakins is elected an honorary member of the Philadelphia Sketch Club.

March 10–29
Eakins exhibits *The Gross Clinic* at the second exhibition of the Society of American Artists.

April
For the first time, Eakins serves on the jury for the Pennsylvania Academy's annual exhibition. It awards Susan Macdowell the newly established Mary Smith Prize, which is given to the best female painter in the exhibition.

April 6
Fiancée Kathrin Crowell dies of meningitis.

May
The Smith College Museum of Art purchases *In Grandmother's Time* (fig. 83), Eakins's first work to enter a public collection.

June
Eakins visits Fairman Rogers at his Newport home and begins painting *A May Morning in the Park (The Fairman Rogers Four-in-Hand)* (pl. 51).

August 21
Christian Schussele dies.

Photographer unknown, *[Male Students at the Pennsylvania Academy]*, c. 1878. Gelatin silver copy print. Philadelphia Museum of Art. Gift of George Barker.

Circle of Thomas Eakins, *[Male Students at the Pennsylvania Academy]*, c. 1882. Albumen print. Bregler Collection (1985.68.2.804).

September 8

The Pennsylvania Academy's Committee on Instruction recommends Eakins as professor of drawing and painting at a salary of six hundred dollars a year; the board accepts the recommendation.

December

Eakins serves on the jury for the McCreary Prizes at the Philadelphia Sketch Club.

1880

March

Eakins delivers the first of his formal series of lectures on perspective at the Pennsylvania Academy.

May 1

Eakins is elected to the Society of American Artists.

June 9

The Mutual Assurance Company pays Eakins the first of two installments of two hundred fifty dollars for a commissioned portrait of General George Cadwalader.

Summer

Eakins purchases his first camera, which enables him to use photographs as one would use a sketchbook.

November 1–December 6

Eakins exhibits *The Biglin Brothers Turning the Stake-Boat* and *A May Morning in the Park* in the second annual exhibition of the Philadelphia Society of Artists.

Eakins paints *The Crucifixion* (pl. 54).

1881

Spring

Eakins presents *The Chess Players* to the Metropolitan Museum of Art in New York.

April

Eakins makes the first of several photographic studies of shad fishermen in Gloucester, New Jersey (pls. 69–71, 73, 74).

June

Eakins completes two paintings titled *Shad Fishing at Gloucester on the Delaware River* (pls. 72, 76). Both are composed from photographic studies taken in April and May.

September

Eakins completes *Mending the Net* (pl. 85), another painting composed from photographs.

The Brooklyn Art Guild announces that it has hired Eakins to teach classes two days a week from October to April. He continues to teach there until 1885.

1882

Eakins receives his first sculpture commission—panels representing *Spinning* (pl. 92) and *Knitting* (pl. 93)—from merchant James P. Scott of Philadelphia.

February

The Pennsylvania Academy decides to charge tuition, beginning in October, with the intention that its classes will become self-supportive. Eakins is given the new title of director of the schools. His salary is raised to twelve hundred dollars, with a promise that it will rise to twenty-five hundred dollars as tuitions come in.

April 11

An angry mother writes to James Claghorn, president of the Pennsylvania Academy, to protest the use of nude models in Eakins's life classes. While this is the first recorded condemnation of Eakins's emphasis on study from the nude model, it will not be the last (R. S. to James L. Claghorn, April 11, 1882, Archives, Pennsylvania Academy of the Fine Arts, Philadelphia).

September 27

Eakins becomes engaged to Susan Macdowell.

December 22

Eakins's sister Margaret dies of typhoid fever at the age of twenty-nine. She is buried two days later at Woodlands Cemetery in Philadelphia.

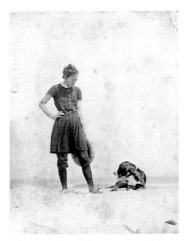

Thomas Eakins, [*Margaret Eakins and Harry at Manasquan, New Jersey*], c. 1880. Albumen print. Bregler Collection (1988.10.12).

Eadweard Muybridge, *"Abe Edgington" Trotting*, 1878–79. Photograph courtesy William Innes Homer.

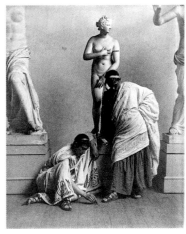

Circle of Thomas Eakins, [*Two Male Students in Classical Costume at the Pennsylvania Academy*], c. 1883. Albumen print. The J. Paul Getty Museum, Los Angeles (84.XM.254.3).

1883

In a written agreement with his father, Eakins formalizes his use of the top floor of the family home as his private studio, with the proviso that he be allowed "the right to bring to his studio his models, his pupils, his sitters, and whomsoever he will, and both Benjamin Eakins and Thomas Eakins recognizing the necessity and usage in a figure painter of professional secresy [*sic*], it is understood that the coming of persons to the studio is not to be the subject of comment or question by the family" (Written agreement between Eakins and Benjamin Eakins, undated, Hirshhorn Museum and Sculpture Garden, Smithsonian Institution, Washington, D.C.).

Eakins explores pastoral themes in photographs using his students as models. From these photographs and life study, he begins a series of sculptural reliefs and paintings with classical subject matter.

February 12 and 16

Eadweard Muybridge demonstrates his photographs of animal locomotion in lectures at the Pennsylvania Academy.

March

Pennsylvania Academy students organize the Academy Art Club as an additional venue to exhibit and sell their works. Eakins is elected the club's single honorary member.

July 2–late October

Eakins exhibits *Singing a Pathetic Song* (pl. 63), *Mending the Net*, and an unidentified genre drawing (probably a watercolor) in an international exhibition at the Munich Glaspalast.

August 7

The University of Pennsylvania agrees to provide grounds for Muybridge's project to photograph human and animal locomotion.

Autumn

Thomas B. Clarke commissions Eakins to paint *Professionals at Rehearsal* (pl. 121).

November 2

Eakins loses his strongest advocate at the Pennsylvania Academy when Fairman Rogers resigns as chairman of the Committee on Instruction. Rogers is replaced by Edward H. Coates.

December 5

At a meeting of the Photographic Society of Philadelphia, Eakins demonstrates a camera equipped with his own design for "an ingenious exposer for instantaneous work" (Robert S. Redfield, "Society Gossip: Photographic Society of Philadelphia," *The Philadelphia Photographer*, vol. 21, no. 241 [January 1884], p. 15).

1884

January 19

Eakins marries Susan Macdowell at her parents' home. The couple moves to the former studio of Arthur B. Frost at 1330 Chestnut Street.

March

Eakins is one of nine overseers appointed to the Muybridge Commission to "insure its thoroughly scientific character" (Minutes of the Board of Trustees, April 1, 1884, Archives, University of Pennsylvania, Philadelphia).

May

Eakins considers resigning from the Society of American Artists when his two reliefs *Spinning* and *Knitting* are rejected as exhibition submissions.

June

Muybridge's photographic experiments begin in Philadelphia, and initially Eakins provides advice and assistance. After a few months, however, their methods diverge, and Eakins embarks on separate, parallel experiments.

June 14

Eakins's youngest sister Caddie marries his student Frank Stephens.

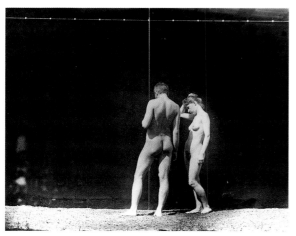

Circle of Thomas Eakins, *[Eakins and Female Nude at the University of Pennsylvania]*, 1885. Modern print from original gelatin dry-plate negative. Bregler Collection (1985.68.2.1006).

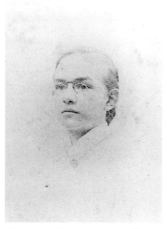

Thomas Eakins, *Caroline Eakins*, c. 1883. Albumen cabinet card printed by Louis Blaul. Private Collection.

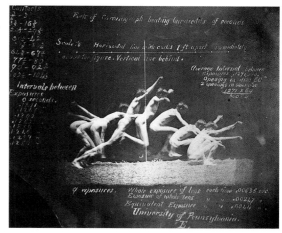

Thomas Eakins, *[Motion Study: "History of a Jump"]*, 1885. Albumen print. Hirshhorn Museum and Sculpture Garden, Smithsonian Institution, Washington, D.C. (83.59)

December 1, 1884–May 31, 1885
Eakins exhibits *The Crucifixion* and *Shortening Sail* (current title and location unknown) at the World's Industrial and Cotton Centennial Exposition in New Orleans.

1885

Eakins completes *Swimming* (pl. 149), but Edward H. Coates, who commissioned the painting, asks to exchange it for *Singing a Pathetic Song*.

March
Eakins exhibits *William Rush Carving His Allegorical Figure of the Schuylkill River*, *Baseball Players Practicing*, *Elizabeth at the Piano* (pl. 13), and a rail-shooting picture at a loan exhibition held by the Ontario Society of Artists in Toronto.

May 22
Using Muybridge's motion studies in a zoetrope, Eakins lectures at the Pennsylvania Academy on equine movement.

November 10
Eakins begins lecturing on anatomy at the Art Students' League of New York. His lectures on perspective follow in the spring 1886 term.

1886

Early January
During one of his anatomy lectures at the Pennsylvania Academy, Eakins removes a loincloth from a male model in the presence of female students. After receiving complaints, Edward H. Coates, chairman of the Committee on Instruction, writes Eakins and informs him that there should be "no removal of the band worn by the male model, for purpose of Demonstration in class, until such change is decided upon by the Committee of Instruction. I write this personally believing it *very important* for the welfare and present success of the schools, and also because it is of great moment that at this time *you* should act in carrying out the wishes expressed above rather than that the Directors should do so" (Coates to Eakins, January 11, 1886, Bregler Collection).

January 11–16
Eakins exhibits one of his motion photographs, entitled *History of a Jump* (pl. 153), at an exhibition held by the Photographic Society of Philadelphia at the Pennsylvania Academy.

February 8
Edward H. Coates writes to Eakins and asks him to tender his resignation as the Director of the Schools and Professor of Painting at the Pennsylvania Academy.

February 9
Responding to the request made by Coates on behalf of the board of the Pennsylvania Academy, Eakins resigns, and his post is abolished. Eakins passionately defends his use of nude models: "The thing is a nightmare. . . . It seems to me that no one should work in a life class who thinks it wrong to undress if needful. . . . Was ever so much smoke for so little fire? I never in my life seduced a girl, nor tried to, but what else can people think of all this rage and insanity" (Eakins to Coates, February 15, 1886, Bregler Collection).

February 22
Thirty-eight students resign from the Pennsylvania Academy and establish the Art Students' League of Philadelphia to provide Eakins with a forum for his life classes.

March 6
Eakins's detractors, led by his brother-in-law Frank Stephens, seek to expel him from the Philadelphia Sketch Club on the vague charge of "conduct unworthy of a gentleman & discreditable to this organization" (Thomas P. Anshutz, G. F[rank] Stephens, and Charles H. Stephens to the president and members of the Philadelphia Sketch Club, March 6, 1886, private collection).

G. C. Potter and Co., *Frank Stephens*, c. 1880. Albumen print. Pennsylvania Academy of the Fine Arts, Philadelphia. Purchased with funds donated by the Pennsylvania Academy's Women's Committee (1988.10.38).

George B. Wood, *Stephens Family in Germantown*, 1888. Gelatin silver copy print by unknown photographer. Philadelphia Museum of Art. Purchased with funds contributed by the Daniel W. Dietrich Foundation, the J. J. Medveckis Foundation, and Harvey S. Shipley Miller and J. Randall Plummer.

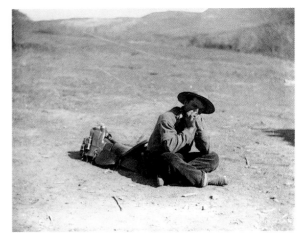

Thomas Eakins, *[Cowboy Playing Harmonica]*, 1887. Modern print from original gelatin dry-plate negative. Bregler Collection (1985.68.2.1085).

March 13

In correspondence with John V. Sears, the chairman of the committee investigating charges made before the Philadelphia Sketch Club, Eakins indicts his accusers: "The action of the club in advising me as it has done, without stating what the charges are, or by whom they are preffered [*sic*], is so inconsistent with the principles of plain and fair dealing that I can only regret that the club has permitted itself to be put in such an equivocal position. It is evident that there is an organized movement to do me mischief, and that its course is reckless and extravagant" (Eakins to John V. Sears, March 13, 1886, private collection).

March 22

Eakins receives notification of his expulsion from the Academy Art Club.

April 17

The members of the Philadelphia Sketch Club vote against proceedings to expel Eakins from the club.

April 23

Eakins is paid the first installment for a portrait of Dr. Horatio C. Wood (The Detroit Institute of Arts), professor of materia medica and an authority on nervous diseases at the University of Pennsylvania.

Late June–Early July

Eakins takes a two-week pleasure trip to the Lake Champlain summer home of University of Pennsylvania engineering professor William D. Marks, of whom he is painting a portrait (fig. 157).

July

Benjamin Eakins has turned his daughter Caddie and her husband, Frank Stephens, out of the house on Mount Vernon Street in response to their attacks on his son. Thomas and Susan Eakins move into the home.

August 28–October 23

At the Southern Exposition in Louisville, Kentucky, Eakins exhibits *Swimming*, *The Veteran (Portrait of George Reynolds)* (Yale University Art Gallery, New Haven), and watercolors *Drawing the Seine* (pl. 87) and *Mending the Net* (private collection).

September 18

In a vote, the members of the Philadelphia Sketch Club officially censure Eakins and ask for his resignation from honorary membership. Eakins does not resign.

1887

Muybridge's plates of *Animal Locomotion* are published by the University of Pennsylvania.

February 15

In a special exhibition for the opening of the Art Club of Philadelphia's new building, Eakins shows *The Crucifixion*, *Portrait of Professor William D. Marks*, *The Dancing Lesson*, and bronze casts of *Spinning* and *Knitting*.

July 10

Edward H. Coates purchases bronze casts of *Spinning* and *Knitting*, which he donates to the Pennsylvania Academy.

Late July–September

Suffering from acute depression following his dismissal from the Pennsylvania Academy, Eakins sojourns at the B-T Ranch in the Bad Lands of the Dakota Territory, where he makes photographs and oil sketches of cowboy life (pls. 159–63).

Early August

Eakins writes to his wife, "I am in the best of health.... The living on a round up is better than in the palace Pullman dining cars. A fine beef is killed as needed, we eat beef three times every day, and beans & bacon, and canned corn, canned tomatoes, rice and raisins, and everything of the very best. I think you would laugh to see me devour a big hunk of meat lifted out of the big fat pot it was fried in" (Eakins to Susan Eakins, early August 1887, Bregler Collection).

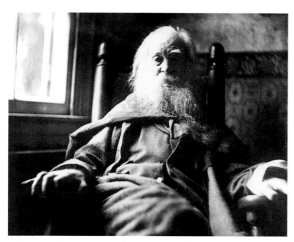

Thomas Eakins or Samuel Murray, *Walt Whitman*, 1891. Modern gelatin silver print. Philadelphia Museum of Art. Bequest of Mark Lutz.

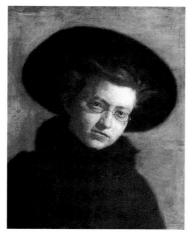

Thomas Eakins, *Girl in a Big Hat (Portrait of Lilian Hammitt)*, 1888. Oil on canvas, 24⅛ x 20⅛". Hirshhorn Museum and Sculpture Garden, Smithsonian Institution, Washington, D.C. Gift of Joseph H. Hirshhorn, 1966.

August 28

In correspondence with his wife, Eakins reports on his departure from the Dakotas: "I am going to bring my own horse back with me for a model. He is a broncho, a very beautiful and a good type of cow boy horse, also a mustang, a small Indian pony, the ugliest you ever saw but a fine cow horse. This Indian pony is exceedingly tough, funny, and good natured and is for Fanny and the children to ride and drive" (Eakins to Susan Eakins, August 28, 1887, Bregler Collection).

October 18

Eakins returns to Philadelphia.

Late October

Eakins begins lecturing part-time on anatomy at the Women's Art School of the Cooper Union in New York.

Winter

Eakins begins a portrait of Walt Whitman (pl. 165). When it was finished the following spring, Whitman would state, "Of all the portraits of me made by artists I like Eakins' best: it is not perfect but it comes nearest being me." A few days later he added, "The Eakins portrait gets there— fulfills its purpose: sets me down in correct style, without feathers—without any fuss of any sort. I like the picture always—it never fades—never weakens" (quoted in Lloyd Goodrich, *Thomas*

Eakins, 2 vols. [Cambridge, Mass.: Harvard University Press for the National Gallery of Art, 1982], vol. 2, p. 34).

1888

A volume of essays to accompany Muybridge's plates, *Animal Locomotion. The Muybridge Work at the University of Pennsylvania—The Method and the Result,* is published by the University of Pennsylvania. Eakins's description of his methods is incorporated into the essay by William D. Marks.

March

Eakins abruptly halts his work on a portrait of his former student Lilian Hammitt, *Girl in a Big Hat* (Hirshhorn Museum and Sculpture Garden, Smithsonian Institution, Washington, D.C.), after receiving a disturbing letter (now lost) in which Hammitt stated her belief that Eakins would soon divorce Susan to marry her. Eakins responds immediately, reiterating his devotion to his wife. "I was inexpressibly shocked to read the letter you left in my box. You have through your companionship with my dear wife seen the great love that exists between us and heard from me many expressions of my devotion to her. You are laboring under false notions and will surely injure your reputation if you give expression to them.... There is wisdom in your decision to stay away from my studio now for a long time, and I have abandoned my portrait of you and taken up

other work" (Eakins to Hammitt, March 2, 1888, Bregler Collection).

Fall

Eakins begins lecturing on artistic anatomy at the National Academy of Design in New York.

Eakins's restored spirits are evident in several Western subjects, including his last landscape painting, *Cowboys in the Bad Lands* (pl. 164), and portraits of friends: "I have nearly completed a little cow boy picture, and hope to make more. The... cow boy subject is a very picturesque one, and it rests only with the public to want pictures" (Eakins to John Laurie Wallace, October 22, 1888, Bregler Collection).

1889

Late February

Students in the medical school of the University of Pennsylvania commission Eakins to paint a portrait of Dr. David Hayes Agnew. Eakins completes *The Agnew Clinic* (pl. 175), his largest painting, in three months.

May 1

At the commencement ceremony, held at the Academy of Music, the graduating class presents *The Agnew Clinic* to the University of Pennsylvania Medical School.

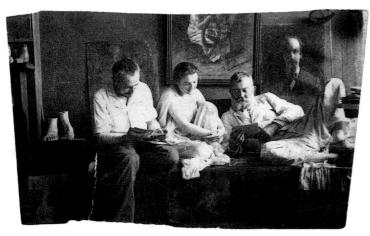

Circle of Thomas Eakins, *[Thomas Eakins, Unidentified Woman, and William R. O'Donovan in Eakins's Studio]*, c. 1891. Platinum print. Bryn Mawr College Library, Pennsylvania. Seymour Adelman Collection.

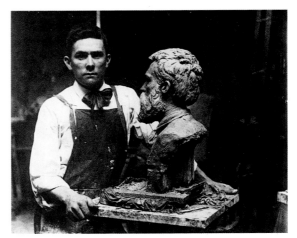

Thomas Eakins, *[Samuel Murray with His Bust of Franklin Louis Schenck in the Chestnut Street Studio]*, c. 1892. Modern gelatin silver print. Philadelphia Museum of Art. Bequest of Mark Lutz.

May 5–November 5

Eakins exhibits three works—a *Portrait of Professor George F. Barker* (Mitchell Museum at Cedarhurst, Mount Vernon, Ill.), *The Dancing Lesson*, and *The Veteran*—at the Exposition Universelle in Paris.

November 30

Caddie Stephens dies at the age of twenty-four of typhoid fever. At the time of her death, she and Eakins had not reconciled.

1890

April 7

Eakins's nieces Eleanor ("Ella") and Margaret ("Maggie"), children of Fanny and William Crowell, come to stay with the Eakinses to study painting.

Autumn

Eakins, up to now only a visiting lecturer at the Women's Art School of the Cooper Union in New York, is promoted to faculty, a position he will retain through the spring of 1897.

1891

January

For the first time since his dismissal from the Pennsylvania Academy, Eakins submits six works to its annual exhibition (including pls. 165, 172,

173). *The Agnew Clinic*, nevertheless, is rejected on a technicality.

Eakins collaborates with the sculptor William R. O'Donovan on a commission to sculpt equestrian statues of Ulysses S. Grant and Abraham Lincoln for the Soldiers' and Sailors' Memorial Arch in Brooklyn (pl. 198).

June 4–July 13

Eakins exhibits *Retrospection* (Yale University Art Gallery, New Haven), *The Veteran*, and *The Artist's Wife and His Setter Dog* (pl. 158), at the Galerie Durand-Ruel in Paris.

1892

Eakins completes *The Concert Singer* (pl. 192).

Samuel Murray, a sculptor and former student, begins to share Eakins's studio at 1330 Chestnut Street.

March 26

Walt Whitman dies. Four days later, Eakins is one of twenty-three honorary pallbearers at Whitman's funeral, which is held at Harleigh Cemetery, near Camden, New Jersey.

May 7

Eakins resigns from the Society of American Artists when his works, including *The Agnew*

Clinic, are rejected three years in succession: "For the last three years my paintings have been rejected by you, one of them the Agnew portrait, a composition more important than any I have ever seen upon your walls. Rejections for three years eliminates all elements of chance; and while in my opinion there are qualities in my work which entitle it to rank with the best in your society, your society's opinion must be that it ranks below much that I consider frivolous and superficial. These opinions are irreconcilable" (Eakins to the Society of American Artists, May 7, 1892, Goodrich Papers).

Autumn

Eakins receives a commission to sculpt historical relief panels commemorating the Revolutionary War for the Trenton Battle Monument in New Jersey (pls. 199, 200).

December 5–25

Despite his formal resignation from the Society of American Artists, Eakins submits nine works (including pls. 10, 85, 96, 158) to its Retrospective Exhibition.

1893

Enrollment at the Art Students' League of Philadelphia declines sharply, and it is closed. Around this time, Eakins begins to lecture at the Art Students' League of Washington, D.C.

Thomas Eakins, *[Differential-Action Study]*, 1885. Modern print from original gelatin dry-plate negative. Bregler Collection (1985.68.2.1004).

City Gallery of Union Photograph Company, *Harry*, 1880. Tintype. Bryn Mawr College Library, Pennsylvania. Seymour Adelman Collection (Special Collections SA 107).

Thomas Eakins, *[William Crowell Family]*, c. 1890. Modern gelatin silver copy print. Pennsylvania Academy of the Fine Arts, Philadelphia. Purchased with funds donated by the Pennsylvania Academy's Women's Committee.

May 1–October 30

Eakins exhibits eleven paintings—constituting a small survey of his work—at the World's Columbian Exposition in Chicago and receives a medal for *Mending the Net*. His submissions represent the second largest number of paintings by a single Pennsylvania artist.

1894

During this year, Eakins paints relatively little and invests considerable effort both in promoting Samuel Murray as a sculptor and in assisting him with large-scale commissions.

May 1

Eakins lectures at the Academy of Natural Sciences in Philadelphia on "The Differential Action of Certain Muscles Passing More Than One Joint."

June 18

Eakins's beloved dog Harry dies.

1895

Eakins ceases to lecture at the National Academy of Design in New York.

Eakins increasingly concentrates on producing portraits of friends, his primary artistic activity for the next decade.

Art critic, poet, and novelist Sadakichi Hartmann publishes *Conversations with Walt Whitman*, "Dedicated to Artist Thomas Eakins of Philadelphia, as an Admirer of Walt Whitman, in his own Native Independence, Simplicity and Force, without Crankiness and Subserviency."

February

Eakins begins a course of lecture on artistic anatomy at the Drexel Institute of Art, Science, and Industry in Philadelphia (now Drexel University).

March 13

The Drexel Institute dismisses Eakins amid controversy over his use of a nude model in coeducational classes.

1896

May 11

Eakins's first and only solo exhibition during his lifetime opens at the Earles Galleries in Philadelphia. The show of twenty-nine paintings is a critical success, but no works are sold.

August

Eakins's niece Ella Crowell is committed to a hospital for an undisclosed mental illness.

September 9

Samuel Murray is awarded a commission to sculpt figures of prophets for the exterior of an office building in Philadelphia, a project on which Eakins will assist him for more than a year.

November 5, 1896–January 1, 1897

Eakins submits three works to the first annual exhibition of the Carnegie Art Galleries (later the Carnegie Institute) in Pittsburgh. Only one, *The Writing Master (Portrait of the Artist's Father)* (pl. 96), is exhibited.

1897

February 17

The Pennsylvania Academy purchases *The Cello Player* (pl. 206), the first painting by Eakins to enter its collection.

Spring

With the end of his lectures at the Cooper Union, Eakins officially stops teaching. He continues to take private students on a sporadic basis.

July 2

Ella Crowell commits suicide at her family home in Avondale. Recriminations following her death lead to a severance of ties between Eakins and the Crowell family.

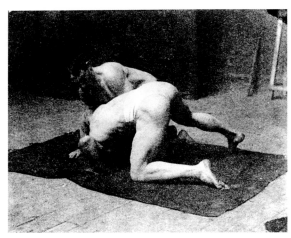

Circle of Thomas Eakins, *[Wrestlers]*, 1890s. Modern gelatin silver copy print. Philadelphia Museum of Art. Gift of Charles Bregler.

Circle of Thomas Eakins, *[Benjamin Eakins and Samuel Murray]*, c. 1895. Platinum print. Bregler Collection (1985.68.2.233).

Mid-July
Eakins travels to Maine to work on a portrait of Professor Henry A. Rowland (pl. 211).

1898
Eakins returns to sporting subjects, this time boxing and wrestling, for his paintings *Taking the Count* (pl. 213), *Salutat* (pl. 214), *Between Rounds* (pl. 215), *Wrestlers* (unfinished, 1899, Philadelphia Museum of Art), and *The Wrestlers* (1899, The Columbus Museum of Art, Ohio).

1899

January 2
Eakins's aunt Eliza Cowperthwait dies.

Autumn
For the first time, Eakins serves on the jury for the fourth annual exhibition at the Carnegie Institute.

December 29
Benjamin Eakins dies at the age of eighty-three.

1900
The Eakinses invite long-standing family friend Mary Adeline Williams ("Addie") to live with them at Mount Vernon Street.

Sunday afternoon visits to the Saint Charles Borromeo Seminary in nearby Overbrook with Samuel Murray influence Eakins's choice of Catholic clerics as subjects for a series of portraits.

April 14–November 12
Eakins receives an honorable mention at the Exposition Universelle in Paris for *The Cello Player* and *Salutat*.

October
Eakins and Samuel Murray vacate the studio at 1330 Chestnut Street, which is scheduled for demolition.

Autumn
Eakins serves on the jury for the Carnegie Institute's fifth annual exhibition.

1901

January
Eakins serves on the jury for the annual exhibition at the Pennsylvania Academy for the first time since 1879.

February 16
Stewart Culin organizes a large exhibition of Eakins's paintings and Murray's sculptures at the Faculty Club at the University of Pennsylvania.

May 1–November 1
At the Pan-American Exposition in Buffalo, New York, the jury awards Eakins a gold medal for his *Portrait of Professor George F. Barker*.

May 29
Eakins begins constuction of a new studio on the top floor of the Mount Vernon Street house.

Autumn
Eakins serves on the jury for the Carnegie Institute's sixth annual exhibition.

1902

February
Eakins travels to Washington, D.C., to paint a portrait of Sebastiano Cardinal Martinelli (pl. 226).

March
Eakins is elected an associate of the National Academy of Design and, in May, an academician. He is the only artist ever to receive both honors in the same year.

1903

January
Eakins serves as a juror for the annual exhibition at the Pennsylvania Academy.

Thomas Eakins, *Portrait of Robert C. Ogden*, 1904. Oil on canvas, 72¼ x 48⅜". Hirshhorn Museum and Sculpture Garden, Smithsonian Institution, Washington, D.C. Gift of the Joseph H. Hirshhorn Foundation, 1966.

Photographer unknown, *Thomas Eakins with Sculpture by Samuel Murray*, c. 1914. Silver print. Archives, Pennsylvania Academy of the Fine Arts, Philadelphia.

January 19–February 28
Several of Eakins's ecclesiastical portraits, including that of Cardinal Martinelli, are exhibited at the Pennsylvania Academy.

Autumn
Eakins serves as a juror for the Carnegie Institute's annual exhibition.

December
Eakins travels to Ohio to paint the *Portrait of Archbishop William Henry Elder* (pl. 227): "I have just finished in Cincinnati a full length, life sized portrait of the venerable Archbishop Elder which I did in one week" (Eakins to Frank W. Stokes, December 15, 1903, Hirshhorn Museum and Sculpture Garden, Smithsonian Institution, Washington, D.C.).

Eakins receives a rare commission to paint a portrait of businessman Robert C. Ogden in New York (Hirshhorn Museum and Sculpture Garden, Smithsonian Institution, Washingon, D.C.).

1904

January
Eakins's *Portrait of Archbishop William Henry Elder* earns him the coveted Temple Gold Medal at the Pennsylvania Academy's annual exhibition. However, when Eakins arrives to receive the award from Edward H. Coates, he remarks, "I think you've got a heap of impudence to give me a medal." Afterward, he and Samuel Murray ride their bicycles to the United States Mint, where Eakins cashes the medal for seventy-three dollars (cited in Goodrich 1982, vol. 2, p. 201).

Spring
Eakins serves on the jury for the United States section of the Louisana Purchase Exposition held in Saint Louis. He exhibits seven works, including *The Gross Clinic*, which is awarded a gold medal.

1905
Eakins receives commissions from Jefferson Medical College students and alumni for a portrait of Professor William Smith Forbes, from the Fidelity Trust Company for a portrait of John B. Gest (The Museum of Fine Arts, Houston), and for a portrait of Asbury W. Lee (pl. 235), who pays for, but refuses, the picture.

Eakins assists Samuel Murray on a statue of Commodore John Barry for Independence Square in Philadelphia.

January
Eakins receives the Thomas R. Proctor Prize for his *Portrait of Leslie W. Miller* (pl. 225) at the annual exhibition of the National Academy of Design.

Autumn
Eakins serves on the jury for the Carnegie Institute's tenth annual exhibition.

1906

January
Eakins serves on the jury for the annual exhibition at the Pennsylvania Academy.

January–February
Eakins exhibits *Singing a Pathetic Song* in the sixth exhibition of the International Society of Sculptors, Painters and Gravers, held at the New Gallery in London.

1907
Eakins donates a bald eagle he has found in New Jersey to the Academy of Natural Sciences of Philadelphia in order to have its skeleton preserved.

April
At the eleventh annual exhibition of the Carnegie Institute, Eakins is awarded a second-class medal for *Portrait of Leslie W. Miller*.

October
At the American Art Society of Philadelphia annual exhibition, held at the Haseltine Galleries,

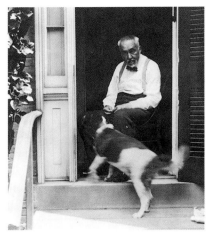

Circle of Thomas Eakins, *[Thomas Eakins at About Age Seventy]*, c. 1914. Gelatin silver print. Bregler Collection (1985.68.2.70).

Eakins receives a gold medal for a portrait of Admiral George W. Melville (private collection).

1908

Eakins revisits the theme of William Rush and his model (pls. 238, 239).

November 12
Eakins declines membership in the National Institute of Arts and Letters, writing to them, "Although I had the honor of an invitation to join your Institute of Arts and Letters, I did not feel that I could afford to do so and made *no* application. Will you kindly scratch off my name and oblige" (Eakins to Hamilton W. Mabie, November 12, 1908, American Academy of Arts and Letters, New York).

1909

January
Eakins serves on the jury for the annual exhibition at the Pennsylvania Academy.

1910

January
Eakins tries to interest curator Bryson Burroughs at the Metropolitan Museum of Art to purchase his work. "I have always felt inadequately represented in the Metropolitan Museum. Hearing that the Museum was now buying some American pictures I have hopes that something of mine may be included" (Eakins to Burroughs, January 12, 1910, Archives, The Metropolitan Museum of Art, New York).

February 25
Former student Charles Henry Fromuth visits Eakins, whom he finds "dispirited." Fromuth adds that "his wife told me that he had abandoned all hope of recognition. I left the more sorrowfull [*sic*] than ever as to American possibilities of recognition of art which aims higher than the capacity of American comprehension" (retrospective journal, Fromuth Papers, Library of Congress).

1911

April 22–November 1
Eakins exhibits *The Thinker (Portrait of Louis N. Kenton)* (pl. 220) at the Esposizione Internazionale in Rome.

1912

With his wife's assistance, Eakins works on his last completed painting, a second commissioned portrait of Rutherford B. Hayes (Philipse Manor Hall State Historic Site, Yonkers, N.Y.).

November
In a rare moment of public recognition, Eakins receives a spontaneous ovation at an exhibition of portraits, including *The Agnew Clinic*, in Lancaster, Pennsylvania.

1913

October 6
Artist and critic Charles E. Dana presents his portrait by Eakins to the Pennsylvania Academy.

1914

Eakins's eyesight deteriorates, and he is essentially housebound.

February 8–March 29
The *Portrait of Dr. Agnew* (Yale University Art Gallery, New Haven), a study for *The Agnew Clinic*, draws unexpected attention when it is shown at the annual exhibition of the Pennsylvania Academy. The art collector Dr. Albert C. Barnes purchases the portrait for four thousand dollars.

Thomas Eakins Memorial Exhibition at the Metropolitan Museum of Art, New York, November 5–December 3, 1917. The Metropolitan Museum of Art, New York.

1915

February 7–March 28

Eakins's portrait of Mrs. Talcott Williams (*The Black Fan*, Philadelphia Museum of Art), painted in the early 1890s, is accorded a place of honor in the annual exhibition of the Pennsylvania Academy, earning consistent praise in the press.

February 20–December 4

At the Panama-Pacific International Exposition in San Francisco, Eakins exhibits *The Bohemian* (*Portrait of Franklin Louis Schenck*) (Philadephia Museum of Art), *The Veteran*, *The Concert Singer*, *The Crucifixion*, *Home Ranch* (pl. 191), and *Portrait of Henry Ossawa Tanner* (pl. 212).

1916

April

The Metropolitan Museum of Art purchases *Pushing for Rail*. Eakins writes to thank curator Bryson Burroughs, but adds, "I sincerely wish the Museum had chosen a larger and more im-portant picture, such as 'The writing master.' The portrait of Henry A. Rowland of the Johns Hopkins University, Prof. George Barker of the University of Pennsylvania—and others" (Eakins to Burroughs, April 23, 1916, Archives, The Metropolitan Museum of Art, New York).

April 25

Eakins is elected an honorary member of the Art Club of Philadelphia.

June 25

Eakins dies; there is no service. His ashes are later buried in Woodlands Cemetery in 1939 with those of his wife. At the time of his death, his estate is appraised for $33,805.61 and includes many of his finest works, valued together at $2,860.

December

In an exhibition of members' works, the National Association of Portrait Painters includes Eakins as an honorary member (deceased).

1917

November 5

The Metropolitan Museum of Art opens a memorial exhibition of sixty paintings by Eakins.

December 23

The Pennsylvania Academy of the Fine Arts, responding to considerable local pressure, opens its own memorial exhibition of 139 works by Eakins.

Eakins's Early Years

AMY B. WERBEL

T HOMAS EAKINS was born in Philadelphia on July 25, 1844. Both the place and time of his birth were significant preconditions for the development of one of this nation's most insightful, revered, and enigmatic painters. An established center for arts and sciences, Philadelphia at mid-nineteenth century provided rich and rigorous educational opportunities. Instruction by esteemed professors at the city's excellent public Central High School, lectures on anatomy at Jefferson Medical College, and cast and life drawing at the Pennsylvania Academy of the Fine Arts, for example, are just three of the resources that nourished Eakins before he left home for formal artistic training in Paris in 1866. But perhaps the most important early factor that influenced Thomas Eakins was the example of his father Benjamin.

Thomas Eakins was the eldest of the four surviving children of Benjamin Eakins and Caroline Cowperthwait Eakins. Although little is known about Caroline, who died in 1872, Benjamin lived a long and relatively well-documented life.[1] He grew up on a farm in Valley Forge, Pennsylvania, in the home of his father Alexander, who had emigrated from Ireland before the War of 1812. Alexander produced cloth from his working farm, like most early nineteenth-century weavers. At his death in 1839 the list of chattels left behind included corn "in the ear" and "in the ground," hay, wheat, rye, straw, farm tools, a loom, two cows, and a few household furnishings.[2]

When Alexander arrived in the United States, his skills as a weaver were readily marketable. Until the 1840s, "nimble hands in Northern and Southern homes yielded more yarn and cloth than textile factories."[3] As mid-century neared, however, industrialization in the textile industry rendered farms like Alexander Eakins's increasingly unprofitable. Like many second-generation Americans, his son Benjamin desired to improve his fortunes by pursuing a new, more lucrative career in the city. Calligraphy, Benjamin's chosen profession, imparted to Thomas Eakins an aesthetic, and an ethic, which was to mark his life and work.

THE ROLE OF CALLIGRAPHY IN THE DEVELOPMENT OF EAKINS'S ARTISTIC STYLE

Calligraphy held many advantages for the son of a weaver. The craft could be learned by studying widely available manuals and copybooks rather than by formal education, and required a fairly short apprenticeship. Like Alexander, Benjamin could work at home, manage his own time, and see the results of his daily work in satisfying and visible ways. In addition to similar work habits, calligraphy promised a more comfortable, urban life, and greater monetary reward than weaving. In his instruction manual of 1813, John Jenkins noted that calligraphic skills were lucrative:

> A handsome chirography has frequently been the means of introducing many young gentlemen, of indigent circumstances, into business, which has procured them support and affluence.[4]

Benjamin indeed enjoyed far greater economic benefits as a result of his labors than his father. He received good wages throughout his career, both as payment for inscribed documents and from his private teaching practice.[5] Benjamin's financial fortunes were also largely improved by his own shrewd skill in managing money. Investments in railroads and real estate, most likely the dowry of Caroline, provided financial security for the Eakins family during Benjamin's life and support for them after his death.[6] Although Thomas Eakins did not always earn steady income as an artist and a teacher, he lived his entire life in the modestly affluent middle-class lifestyle he enjoyed as a child and celebrated in his paintings such as *The Chess Players* (fig. 1). In this painting, we see Benjamin Eakins observing his friends playing chess, surrounded by the fashionable comforts of a bourgeois parlor. As an artist, Eakins would express the environment of this class, "so comfortable with its materialism, so confident about its own progress and artful civilization."[7] Although Eakins did

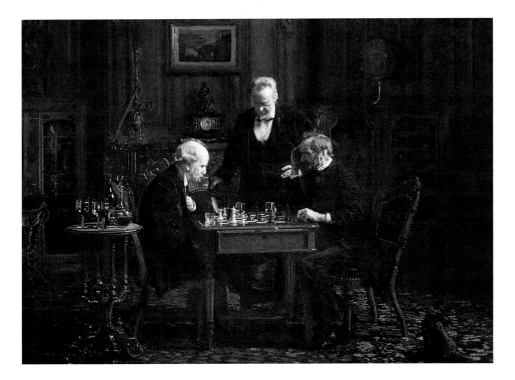

Fig. 1. Thomas Eakins, *The Chess Players*, 1876. Oil on wood, 11¾ x 16¾". The Metropolitan Museum of Art, New York. Gift of the artist, 1881 (pl. 19).

around the same time. The light, illuminating only the working figures and the model's clothing, intensifies the impression of quiet labor. All of these paintings bathe the vision of artisanal labor in a glowing light, reflecting the nostalgia for the preindustrial world that was pervasive around the time of the 1876 Centennial.[8]

The work depicted in these images—isolated, intensive, self-directed, and creative—clearly held appeal for Thomas Eakins. Familiar with this manner of work from observing his father, Eakins also had other strong positive role models in his youth who may have encouraged his decision to become an artist. The Sartain family were close friends of the Eakinses through many decades and were highly regarded by Philadelphia's art community: John Sartain, a friend of Benjamin, was an engraver and a publisher, as well as an administrator at the Pennsylvania Academy of the Fine Arts. John's son William attended grammar and high school with Thomas, followed his friend to Paris for art study, and also became a teacher in several American art schools. John's daughter Emily Sartain, an early romantic interest of Eakins, also became an artist and a teacher, eventually assuming the post of director at the Philadelphia School of Design for Women, then a women's technical arts academy, now called Moore College of Art and Design.

Although Benjamin did not practice the fine arts professionally as did the Sartains, his work as a calligrapher nonetheless served a critical role in formulating his son's idea of what it meant to be an artist.[9] Benjamin Eakins's practice filled the house with hand-penned documents. Thomas's younger sister Frances, known as Fanny, complained in an 1868 letter to her brother that she had not been able to write him because all the table surfaces were taken up with documents. She noted in the same letter that fourteen-year-old Maggie had become "quite a 'dabster' at putting in hair lines."[10]

not share the financial concerns of his father and grandfather, he nevertheless maintained a similar relationship between process, product, and payment. These men of three generations worked primarily in their homes and were responsible for contracting their own work and selling their products. Thomas Eakins adopted this mode of work personally and celebrated it in his paintings.

Thomas Eakins's paintings of women spinning, such as *In Grandmother's Time* of 1876 (Smith College Museum of Art, Northampton, Mass.) and *Homespun* of 1881 (pl. 90), depict artisanal practices similar to those of Alexander and Benjamin Eakins. Both women concentrate intently on their spinning in a stilled atmosphere tempered by the whirring of the foot-driven wheel. This attitude of quiet intent and interior manual labor is also seen in the version of *William Rush Carving His Allegorical Figure of the Schuylkill River* (pl. 41) painted

Thomas probably also helped to prepare documents in his early teen years. As a student at the Zane Street Grammar School, near the family's home in Philadelphia, at the age of twelve or thirteen, he drew a map of Switzerland (fig. 2) that shows considerable skill in drawing straight and curving lines, and in penning both script and block letters.[11] Eakins entered the school in 1853 at the age of nine and graduated four years later with a high average, completing the program two years earlier than most students.[12] Calligraphy lessons at home undoubtedly assisted him in this first academic success.

Thomas Eakins also probably was inspired to practice his penmanship skills by mid-nineteenth-century calligraphy manuals. George Becker's 1854 manual, part of Philadelphia's public school curriculum, would have particularly encouraged Eakins if he had thoughts of an artistic career at this early age. The frontispiece of Becker's manual was inscribed, in finest

Fig. 2. Thomas Eakins, *Map of Switzerland*, c. 1856. Ink, watercolor, and graphite on paper, 16 x 20". Hirshhorn Museum and Sculpture Garden, Smithsonian Institution, Washington, D.C. Gift of Joseph H. Hirshhorn, 1966.

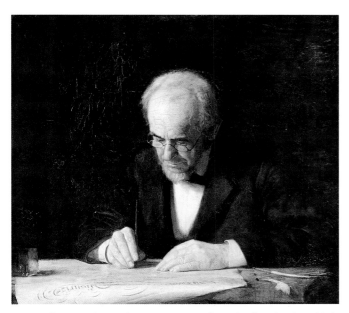

Fig. 3. Thomas Eakins, *The Writing Master (Portrait of Benjamin Eakins)*, 1882. Oil on canvas, 30 x 34¼". The Metropolitan Museum of Art, New York. John Stewart Kennedy Fund, 1917 (pl. 96).

hand: "Writing and Drawing are Twin Sisters and Handmaids to the Useful and Ornamental Arts."[13]

At home, Benjamin's practice was a daily lesson in graphic arts for his son. Leaning over his document, as we see him doing in *The Writing Master* (fig. 3), Benjamin perfectly demonstrates the correct, even "healthful," posture of the model penman, a posture as suitable to drawing as to writing. John Jenkins's calligraphy manual of 1811 advised the following pose: "1. Place your book exactly square before the right shoulder. 2. Let your left arm form a square on the writing table, and lean wholly on your left elbow."[14] Jenkins published endorsements of this posture by "prominent physicians" to promote his cause. Benjamin Rush and three other physicians put their signatures to the following praise published in the first leaves of Jenkins's 1813 edition:

> We, the subscribers, having examined Mr. Jenkins' directions for the position of the body and limbs in writing, are satisfied that it is easy and natural, and that the action of the muscles, and the circulation of blood, are less interrupted by it, than by any of the usual positions in writing.[15]

Benjamin's left shoulder bears the weight of his upper torso; his right hand is poised in a direct line in front of his right shoulder, allowing freedom of movement to the working hand.

Calligraphy taught Thomas Eakins the skills necessary to make controlled, fluid marks, design the composition of a sheet, and measure lines and forms accurately. *The Lord's Prayer* (fig. 4), a document created by Benjamin Eakins as a sample of the scripts he could produce, displays many of the calligraphic skills that may have influenced Thomas Eakins. Each letter in this large, impressive sheet is formed with con-

tinuous strokes. Thick, thin, and tapering lines demonstrate the calligrapher's skillful control of pen and ink. Arched, waving, straight, and fluid lines exemplify a variety of design possibilities for the client. Following this example, Thomas could not help but learn disciplined mark-making skills.

His father's example also afforded an early introduction to compositional design: the text of *The Lord's Prayer* is centered and symmetrical, and includes decorative flourishes to enhance the overall composition. To center his text precisely, Benjamin Eakins had to construct a preliminary plan that would regulate the proportions of varying scripts and design styles. In *The Lord's Prayer*, each letter occupies a set amount of space within its line, and each letter maintains a perfect distance from the others in its row. Calligraphers used a variety of means to control their designs, as John Jenkins wrote in his copybook: "Let the Pupil rule the lines at the top and bottom, and fill the spaces at a proper distance."[16]

Rembrandt Peale, a member of the Peale family of painters and author of the Philadelphia public-school system's ubiquitous textbook, *Graphics: A Manual of Drawing and Writing*, had advised a similar scheme. His demonstration of an oblique alphabet (fig. 5) reveals the calligrapher's best tool for "observing proper distances" in an overall composition—the use of a grid.

Composing within a grid required that a network of ruled and measured lines were first added to the empty sheet, as Peale's illustration demonstrates. Drawn with a straight edge or french curves, these lines served as fields for the script to

Fig. 4. Benjamin Eakins, *The Lord's Prayer*. Ink on paper, 22⅛ x 17⁹⁄₁₆". Pennsylvania Academy of the Fine Arts, Philadelphia. Charles Bregler's Thomas Eakins Collection, purchased with the partial support of the Pew Memorial Trust.

follow. This system required the formal qualities of the letters to be considered after the overall spatial requirements of the composition. Vertical and horizontal parameters for the variously shaped letters were set, and a predetermined rightward slope (generally 45 or 55 degrees, depending on the script) established comparable diagonal rules.

Only when these parameters were drawn could attention be paid to the shape of the letters themselves, a process that required geometrical calculation. George Becker's plate *Analytical Roman Alphabet* (fig. 6) demonstrates the construction of the "Roman capital." Over his neatly drawn grid for each letter, Becker superimposed geometrical forms to help the student perfect the various shapes within the letters. Peale's *Graphics* also taught students to use geometry to correct the forms of their letters (fig. 7). These geometrical calculations ensured not only correct proportions but also proper dimensions. Both Peale and Becker stressed measurement as a necessary skill in calligraphy and drawing, believing that it had to be mastered before either discipline could be seriously attempted. Peale wrote: "The measurement of lines, and their mechanical execution, forming an essential part of the system which is to be learnt, the teacher should see that they are properly done, before any use of them be attempted."[17] Then, quoting the influential Swiss educator Johann Pestalozzi, Peale suggested that "Writing is no more, nay even less, than drawing, to be taught without a previous proficiency in the measuring of lines."[18]

Fig. 5. Rembrandt Peale, *Oblique Alphabet*, plate 39 from *Graphics: A Manual of Drawing and Writing* (Philadelphia: J. Whetham, 1838).

Fig. 6. George Becker, *Analytical Roman Alphabet*, page 3 from *Becker's Ornamental Penmanship* (Philadelphia: U. Hunt & Son, 1854).

Fig. 7. Rembrandt Peale, *Letters*, plate 10 from *Graphics: A Manual of Drawing and Writing* (Philadelphia: J. Whetham, 1838).

The caption of Becker's *Analytical Roman Alphabet* also places emphasis on measurement: "In this Analysis of the Roman Capital, the space which each letter occupies is divided into squares, showing the proportion of its width to its height."[19] Echoing Peale's emphasis on mensuration, Becker's text introduces calligraphy as a mode of drawing forms based on calculation.

Eakins's first lessons in graphic arts thus taught him a system that demanded calculation and an aesthetic that placed value on the display of diligent and skilled manual labor, and he carried aspects of the craft of calligraphy into his art. Throughout his career, he would exploit such lessons in making gridded perspectival drawings that transposed a three-dimensional world onto a two-dimensional surface, from *Perspective Drawing for "The Pair-Oared Shell"* in 1872 (fig. 8) to a series of diagrams made for the portrait *Monsignor James P. Turner* in 1906.[20] Eakins followed the calligraphic model by constructing gridded layouts of the space of his pictures and sculptural reliefs before adding measured subject matter.[21] In his *Perspective Drawing for "The Chess Players"* (fig. 9), for example, the artist moved objects, like letters (or chess pieces), into a spatial grid he had created at the bottom of the sheet. He even boxed difficult objects like the chair in a manner similar to the way George Becker used boxes to organize irregular letters like *Q* in his *Analytical Roman Alphabet* (fig. 6).

As another link in the continuity between Benjamin Eakins's calligraphy and his son's art, examples of ornamental lettering frequently appear in Eakins's oil paintings, such as the chalkboard and music sheets in *Home Scene* (pl. 5). In at least seventeen instances, Eakins cast his own signature into perspective.[22]

Thomas's paintings of his father also provide strong evidence of their close emotional bond. In *The Writing Master*, Benjamin's head and hands and the document he is constructing emerge radiantly from a dark black background. Velvet textures soften our impression of Benjamin as we perceive his form.[23] We are equally drawn to admire Benjamin's craft, as all lines in the painting point toward his paper, including the axis of the calligrapher's gaze. Overall, the painting is a tribute to the aging calligrapher's mind, hand, and profession.

Thomas also paid tribute to his father by emulating his life in many ways. He adopted the calligrapher's compositional devices as the foundation of his painting style, directed equal efforts to teaching and practicing art as his father did, stayed in the family home, and enjoyed a similar lifestyle. Benjamin encouraged his son to pursue art and supported him financially.[24] Thomas Eakins's consistent and confident belief in himself throughout his turbulent career was no doubt nourished by his stable family life and the continuity in habits and values that had held through three generations.

CENTRAL HIGH SCHOOL: MEASUREMENT FOR "OUR AGE AND COUNTRY"

Thomas Eakins's steady family life must also have contributed to his educational success. Following his early completion of grammar school in 1857, Eakins earned entry to Central High School, the "crowning glory" of the state's free school system.[25] During most of the nineteenth century, only about one percent of lower-school students in Philadelphia succeeded in entering Central High School. Entrance requirements were

Fig. 8. Thomas Eakins, *Perspective Drawing for "The Pair-Oared Shell,"* 1872. Graphite, ink, and wash on paper, 31 1/16 x 47 1/8". Philadelphia Museum of Art. Purchased with the Thomas Skelton Harrison Fund, 1944 (pl. 2).

Fig. 9. Thomas Eakins, *Perspective Drawing for "The Chess Players* [fig. 1]," 1875–76. Graphite and ink on cardboard, 24 x 19". The Metropolitan Museum of Art, New York. Fletcher Fund, 1942.

based on performance in elementary school, recommendation of the principal, and an examination, which fifty percent of Philadelphia's best elementary students typically failed.[26]

The anxiety produced by such stiff competition could be overwhelming. George Alfred Townsend, a student two years ahead of Eakins, recounted the following in his diary:

> January 2, 1856: "All my thoughts are bent on one thing,— to reach the High school."
> Monday, 21st: "if I fail to get in, nothing is left but to go to work."
> Friday, February 1: "Vowed this morning that if I were allowed to enter the High School, I would forsake everything but my studies, and be a better boy."

And following the exam:

> February 6: "The algebra exam utterly unfit for boys so little prepared as we are."
> February 9: "Admitted to the Central High School to-day at about one o'clock; average 75.5. Number sixteen in one hundred and forty-two admitted. The greatest day in my life."[27]

Once admitted, Central students were greeted with an administrative structure and curriculum designed by the school's first principal, Alexander Dallas Bache.[28] Bache's experience as a student at West Point largely influenced his decision to create a curriculum and disciplinary code designed to produce useful citizens—practical-minded and resourceful soldiers, engineers, surveyors, and scientists. Bache also had seen and admired a similar type of curriculum during a two-year tour of Europe's schools as president of Girard College.[29]

Following these various examples, Bache's program at Central High School featured a curriculum heavily weighted toward advanced study of the sciences and technical skills, including optics, calculus, and surveying. This emphasis on science was particularly appropriate in Philadelphia, where civic heroes included Benjamin Rush, Benjamin Franklin, and Charles Willson Peale.[30] A practical and marketable education also agreed entirely with the needs of the expanding city and with the professional ambitions of middle-class, tax-paying parents like Benjamin Eakins. As a self-employed writing master, Benjamin Eakins was the archetypal father of a typical Central High School student. The school routinely listed the occupations of parents, and the one-hundred-and-twenty-four parents and guardians listed for Eakins's entering class included eight clerks, eight storekeepers, seven cordwainers, six carpenters, six printers, four clergymen, and three grocers.[31]

Professors at Central High School were chosen from among the city's best teachers and scholars and divided into the literary, mathematical, scientific, and technical departments.[32] In his first year of attendance, 1857–58, Eakins studied general his-

tory, Latin, algebra, and physics five times per week, phonography (a system of shorthand) three times per week, and composition and writing once per week. In the second semester, the writing course included instruction in drawing. In his second year, Eakins's program was more diverse; it included composition and elocution, trigonometry, geometry, Latin, surveying, writing, drawing, bookkeeping, "moral science," chemistry, French, and German. Eakins's third-year course schedule included differential calculus and engineering, mechanical and perspective drawing, and political economy. In the fourth year, Eakins learned integral calculus, astronomy, organic chemistry, and "mental philosophy" in addition to mechanical drawing, ornamental writing, and designing. Throughout his four years, Eakins followed the program mandated for the entire class; no electives were available to students.[33]

The inclusion of phonography and surveying in Central's curriculum is a good example of the specificity of the program in providing technologically useful knowledge. Even academic courses were focused on meeting the "requirements of our age and country."[34] The prestigious faculty of the school espoused the principle of "utility" in nearly every discipline.[35] Eakins's mathematics professor, William Vogdes, wrote in the preface to the school's mathematics textbook:

> It has been the design of the author, in the following pages, to compile a work adapted, by its practical character, to the wants of those of the rising generation, who, not being able to command a collegiate education, are fitting themselves to fill useful stations in society as mechanics, merchants, &c.[36]

The lengthy title of this text, *An Elementary Treatise on Mensuration and Practical Geometry; Together with Numerous Problems of Practical Importance in Mechanics*, indicates quite clearly the author's presentation of mathematics as a science applicable to useful industries. In lieu of theory, Vogdes taught mathematics as a series of mensurational systems. Students measured the areas of geometrical shapes and advanced to measuring solids, such as the volume of a cone. Finally, students learned the measuring systems used by bricklayers, carpenters, plumbers, glaziers, and painters.

Texts such as Gummere's *Astronomy*, which was "revised and adapted to the present state of the science" in 1851 by E. Otis Kendall, professor of mathematics and astronomy at Central High School, presupposed a knowledge of algebra, plane and spherical trigonometry, logarithms, and conic sections. Students used these mathematical systems "To convert Time into Degrees, Minutes and Seconds," "To compute Solar Eclipses, Occultations and Transits," "To calculate an Eclipse of the Moon," and to measure many other astronomical bodies and events.[37] Gummere's astronomy text, along with others such as Charles Davies's *Elements of Surveying* (New York:

J. & J. Harper, 1830), ensured students understood that the earth and the heavens were ruled by mathematical laws. The universe could be divided, mapped, and comprehended through mensuration, calculation, and computation, using the latest and most accurate measuring devices. Eakins's early introduction to the importance of calculation as a calligrapher's son was thus reconfirmed through his study at Central High School. Measurement was even further glorified in the school's elaborate grading and disciplinary system, in which students were constantly judged and compared, generating a maze of numbers guaranteed to rank them "fairly," to within tenths of a percent.

According to this system, developed by Bache and his successor John Hart, pupils were graded twice every day by each teacher in their classes. One grade was given for scholarship and one for conduct. This amounted to sixteen hundred grades by the end of each term.[38] In this way, principal John Hart wrote:

> The pupil is trained to look forward to the end of the quarter, the end of the term, the end of the year, the end of the course. At each of these points, he is made to feel the consequences of every neglected lesson, of every misspent hour. These consequences are found to follow with almost the certainty of natural laws. The young man who has grown up in the habit of regarding such consequences and of governing his conduct by an accountability yet future, has already within him the elements of successful resistance to most of the temptations of life.[39]

Professor E. W. Vogdes's lectures on moral behavior further reinforced lessons about the merits of good discipline.[40] Any "neglected lesson," or infringement of proper behavior, was sure to yield prompt punishment within this strict code. In the minute books of the faculty committee that oversaw conduct, we find the following episodes in which students were "marked" down for bad behavior. On March 27, 1857, "Jefferies, accused by Mr. Howard of throwing beans, was marked 25. Hay, accused by Mr. Howard of having beans in his possession was marked 10." Later in the year, "Mahoney, accused by Dr. McMurtrie of throwing a spit-ball on the diagram, was marked 50."[41] Eakins was never disciplined or even mentioned in these minute books recording untoward conduct.

Considering that students were marked down for such minor infractions as humming, laughter, idleness, impertinent gesticulations, "making a noise with a pen," and "meddling with an inkstand" (all in 1857), we can assume that Eakins must have been a model of virtue, reserving whatever mischievous impulses he may have had for outside the classroom.[42] On the face of it, this early conformity with strict regulation forms a striking contrast with Eakins's later, often truculent opposition to conventional standards of behavior. In later years, the artist's rumpled appearance, blunt speech, and defiant insistence on full nudity for models in his life classes at the Pennsylvania Academy of the Fine Arts and other institutions earned him a reputation as a man unwilling to conform.

This conflict between conformity and freedom is a hallmark of Eakins's mature painting style. After Eakins had created his gridded and measured preparatory studies, he then painted over this structure with broad, textural strokes sometimes applied with a palette knife.[43] The tension between these modes in Eakins's work has been interpreted by generations of scholars and enthusiasts as relating to a variety of circumstances in the artist's life, but the foundations for this tension may well have been laid in the halls of Central High School. At the very least, Eakins's unwillingness to abandon calculation and grids was likely a result of Central's systematic and pervasive obsession with measurement (combined with the influence of his father). The drawing methods Eakins learned in the school's "useful" arts curriculum provided him with an advanced education in perspectival and mechanical drawing that he relied upon throughout his career.

Drawing: A Useful Discipline

The drawing program at Central High School incorporated the same preoccupation with utility and measurement as the rest of the program, and provided advanced education in drafting three-dimensional forms on a two-dimensional surface using calculation. Eakins's professor of writing and drawing, Alexander Jay MacNeill, like many Central professors of his time, was also a graduate of Central and a student of its first two drawing professors, Rembrandt Peale and George Becker; MacNeill promised marketable skills.[44] Elizabeth Johns has described the first two years of Eakins's course of study:

> Eakins's specific four-year curriculum followed Peale's and Bache's plan with only one exception. In semester H (the first semester) he studied writing using Becker's *Penmanship* as a text. In semester G, Eakins began and finished Peale's *Graphics*. . . . In semester E, he finished *Penmanship* and learned to draw from solid objects. . . . Throughout the four years of study, Eakins and fellow students met for drawing and writing three times per week for one hour.[45]

Peale's influence was strongly felt in the drawing curriculum, where his *Graphics* was used, along with his student Becker's text *Ornamental Penmanship*. Throughout the first two years of the program, the connection between writing and drawing, which Peale prominently advanced in this country, remained strong. After studying Peale's *Graphics*, students progressed to perspective and mechanical drawing and ornamental writing. Becker's *Penmanship* continued to serve as a text for ornamental

Fig. 10. Thomas Eakins, *Perspective Drawing: The Icosahedron*, 1859. Ink, wash, and graphite on paper, 11⅜ x 16⅞". Pennsylvania Academy of the Fine Arts, Philadelphia. Charles Bregler's Thomas Eakins Collection, purchased with the partial support of the Pew Memorial Trust and the John S. Phillips Fund (1985.68.4.4).

Fig. 11. A. Cornu, *Projections*, plate 5 from *A Course of Linear Drawing* (Philadelphia: A. S. Barnes, 1842).

writing and also taught basic bookkeeping and accounting skills. In his senior year, Eakins also studied mechanical drawing, ornamental writing, and designing.[46]

Judging from Eakins's surviving school drawings, his instructor seems to have moved fairly quickly from Peale's *Graphics* to the second drawing treatise systematically used in Central's curriculum—Alexander Bache's translation of *A Course of Linear Drawing* by A. Cornu, a French civil engineer. Cornu's text, published in 1842 in Philadelphia, much more clearly embodied Central's pedagogical ideals in the 1850s than such texts as James Duffield Harding's *Lessons on Trees* (London: Bogue, 1850), selected by Peale a decade earlier, which relied on vague concepts related to training the eye to help amateurs draw "picturesque" landscapes and cottages.

Cornu, in contrast, taught students a mathematical system that provided them with rudimentary skills as mechanical draftsmen. Cornu described his text, "adopted in the Royal Schools of France" as:

> an eminently practical book, methodically divided, intended to bring within the reach of every capacity, the principles of the composition of machines, &c., and by means of fixed rules, to render easy the representation of objects in general.[47]

Cornu began his discussion with "preliminary principles of geometry," describing the properties of lines, angles, and circles. Students were next instructed in use of the principal tools of mechanical drawing: compasses, squares, sectors, and scales, with which they could measure and divide the complex geometrical forms they would represent in the more advanced lessons.

Several of Eakins's high school drawings are directly copied from Cornu's examples. Eakins's projection of *The Icosahedron* (fig. 10) follows the example of Cornu's *Projections* (fig. 11) in casting a three-dimensional geometric form above a diagrammatic ground plan. Eakins's *Mechanical Drawing: Three Spirals* (fig. 12) is a close copy of Cornu's *Delineation of Spirals* (fig. 13).

Throughout these exercises, Cornu emphasized measurement as the chief tool of the draftsman. Unlike Peale, who taught his students to eyeball proportional divisions of lines by practicing free-form halving and quartering, Cornu provided systematic instruction in applying the measurement of objects to representation.[48] Like Central's scientific curriculum and disciplinary system, Cornu's drawing manual relied on calculation. The point of drawing in Cornu's text was "to represent objects in all points of view, with exact proportions and dimensions, so as to enable us to execute them, which is the chief design of this book."[49]

Cornu's demand for drawing that surpassed what the individual eye could see from one point of view was in direct opposition to most nineteenth-century drawing treatises, which aimed chiefly to educate and refine the operations of the eye. Cornu recommended his linear, numerical system of drawing and advised that the inaccurate estimation of the eye and mind needed to be overcome:

> An idea frequently presents itself, it at first appears confused in the imagination, but if we have the faculty of reproducing it on paper, this idea assumes a shape, becomes more perfect, and is made susceptible of being executed. Such are the advantages of linear drawing.[50]

Fig. 12. Thomas Eakins, *Mechanical Drawing: Three Spirals*, 1860–61. Ink and wash on paper, 11 x 16⅜". Pennsylvania Academy of the Fine Arts, Philadelphia. Charles Bregler's Thomas Eakins Collection, purchased with the partial support of the Pew Memorial Trust and the John S. Phillips Fund (1985.68.4.9).

Fig. 13. A. Cornu, *Delineation of Spirals*, plate 6 from *A Course of Linear Drawing* (Philadelphia: A. S. Barnes, 1842).

In Cornu's system, measurement helped ease the confusion of the imagination, and multiple views allowed the draftsman to present more information than the naked eye could assimilate. As in astronomy, navigation, surveying, and chemistry, only fastidious measurement and calculation guaranteed accuracy. The Central program thus provided Eakins with a comprehensive education in using quantified vision for rendering and all the skills he needed to measure the world accurately.

Later in his career, Eakins did just that, as he began his painting projects with measurement and calculation of the space and subject matter in his works. Such measurements are especially evident in drawings of the 1870s and early 1880s, including *Measured Drawings of a Gunning Skiff, Oar, and Pushing Pole* (fig. 14), which was made in preparation for *Starting Out after Rail* (pl. 12).[51] The anatomical studies and experimental photography that Eakins undertook in those decades further expanded the traditions he had been imbued with at Central High School. Eakins's high regard for his school is evident in his meticulously rendered class assignments and his later artistic practice.

Shortly after his graduation in 1861, Eakins took the examination by which Alexander MacNeill's successor for the post of professor of writing, drawing, and bookkeeping would be chosen. Elizabeth Johns noted that the examination, published by Philadelphia's Board of Controllers, provides an "important indication of the…content of Eakins' curriculum" at Central.[52] Tasks such as "Show, by an example, how circular steps are drawn in perspective" and "Draw a pair of bevel wheels whose axis are inclined to each other at an angle

of 18 degrees" indicate the comprehensive measured-drawing skills expected of Central's graduates. Unfortunately for Eakins, he placed second behind Joseph Boggs Beale in the competition. He had "measured up" 6.5 points short.[53]

Many of the influential people of Eakins's early years— Benjamin Eakins, William Vogdes, Alexander MacNeill, and A. Cornu—taught him that success was determined by the

Fig. 14. Thomas Eakins, *Measured Drawings of a Gunning Skiff, Oar, and Pushing Pole*, c. 1873–76. Graphite on paper, 17¹/₁₆ x 14". Pennsylvania Academy of the Fine Arts, Philadelphia. Charles Bregler's Thomas Eakins Collection, purchased with the partial support of the Pew Memorial Trust and the John S. Phillips Fund (1985.68.10.4r).

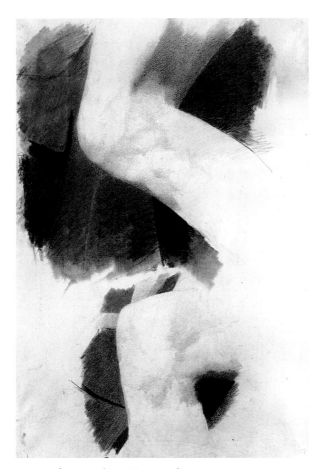

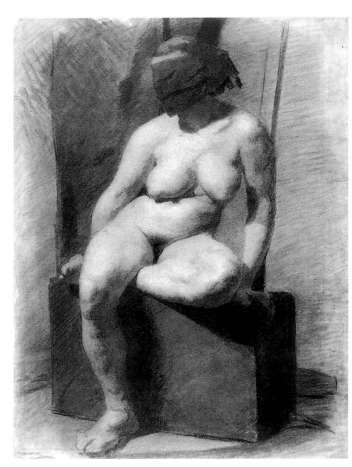

Fig. 15. Thomas Eakins, *Figure Study: Two Knees*, c. 1863–66. Charcoal on paper, 24 x 18¹⁄₁₆". Pennsylvania Academy of the Fine Arts, Philadelphia. Charles Bregler's Thomas Eakins Collection, purchased with the partial support of the Pew Memorial Trust and the John S. Phillips Fund (1985.68.35.6).

Fig. 16. Thomas Eakins, *Study of Seated Nude Woman Wearing a Mask*, c. 1863–66. Charcoal on paper, 24¼ x 18⅝". Philadelphia Museum of Art. Gift of Mrs. Thomas Eakins and Miss Mary Adeline Williams, 1929.

quality of the measurement that students could ultimately perform and that measured representation was the correct method with which to apprehend the world. Thomas Eakins graduated from Central High School in 1861, confident in this paradigm.

STUDY AT THE PENNSYLVANIA ACADEMY OF THE FINE ARTS

The next six years in Eakins's life are less well documented. In the years directly following graduation, Thomas Eakins is listed in Philadelphia city directories in 1863 and 1864 as a "teacher," and in 1866 as a "writing teacher," indicating that he did, to some extent, pursue his father's profession.[54] Eakins's first post–high school art training began in 1862, when he enrolled at the Pennsylvania Academy of the Fine Arts to "draw from the casts from the antique and attend the lectures on anatomy."[55] Eakins was admitted to the life class in February 1863. There was no standing faculty at the time, although practicing local artists often coached less-experienced col-

leagues. Peter Rothermel and Christian Schussele, members of the Academy's Committee on Instruction during this period, may have taught young Thomas Eakins as he struggled to master the human figure at this time, but "their presence in Eakins's classes seems to have been at best irregular."[56] In both antique and life classes, Eakins practiced modeling individual forms in chalk or charcoal, gaining insight into rendering mass and texture and the gesture of the human form.

The skill and confidence exhibited in drawings attributed to Eakins from this time vary widely, from promising but relatively unaccomplished studies like *Figure Study: Two Knees* (fig. 15) to the masterful *Study of a Seated Nude Woman Wearing a Mask* (fig. 16).[57] These uneven studies are reminders that the proficiency Eakins had gained in precise, often gridded calligraphic documents and mechanical drawings was difficult to apply to the study of a warm, moving, three-dimensional human body. Yet these drawings also reveal that Eakins had a gift for describing volume, tone, and atmosphere that augmented his more mathematical talents. For the next thirty

years, Eakins maintained the integrity of both stylistic approaches in balanced juxtaposition.[58]

Eakins used some of his time during his years at the Pennsylvania Academy of the Fine Arts to study anatomy. It may have been the Pennsylvania Academy's anatomy lecturer, Dr. A. R. Thomas, or his former high school professor B. Howard Rand who directed Eakins to the more comprehensive course in anatomy offered by famed surgeons Joseph and William Pancoast at Philadelphia's celebrated Jefferson Medical College.[59] This course of instruction was the beginning of an intensive, decades-long study of the subject that produced hundreds of drawings, casts, and photographs of humans and animals. Eakins later insisted on intensive anatomical study for art students during his tenure from 1879 to 1886 as professor and director of the schools at the Pennsylvania Academy of the Fine Arts. Despite the haphazard arrangements at the Pennsylvania Academy during his own student years, Eakins had learned enough at this time to devote himself to every study that could contribute to painting. In 1866 he set off for Paris, to broaden his skills and vision.

Studies in Paris and Spain

H. BARBARA WEINBERG

THOMAS EAKINS'S mature works conjoin intellect with eloquence, meticulous composition and detail with suggestive tone and color. This duality reflects his instruction in Paris and his six-month visit to Spain. Since 1969 when Gerald M. Ackerman published a groundbreaking article on Eakins in relation to his French painting teachers—Jean-Léon Gérôme, arbiter of modern academic naturalism, and Léon Bonnat, advocate of Spanish Baroque expressiveness—scholars have increasingly acknowledged the importance of Eakins's experiences in Europe for his formation and lifelong enterprise.[1]

Eakins pioneered his generation's pursuit of French art training, going to Paris in September 1866, well before hundreds of Americans flocked there.[2] His decision to study abroad was probably inspired by his contact with the Alsatian-born Christian Schussele, one of several French émigré painters in Philadelphia; by ties that artist John Sartain had established with French academic painters and officials, including Albert Lenoir, secretary of the Ecole impériale et spéciale des Beaux-Arts (the French government school); and by the fact that the Pennsylvania Academy of the Fine Arts in Philadelphia had reorganized its curriculum in the late 1850s in emulation of the Ecole's.[3] Acquaintances who preceded Eakins to Paris included Robert Wylie, the curator of the academy and its de facto life-class instructor from 1858 to 1863, who went in December 1863, and Eakins's friend Earl Shinn, who worked with Wylie in Pont-Aven, Brittany, in the summer of 1866 and would try his luck at getting into the Ecole in the fall.[4] Eakins's ability to write and speak French, his association with Lucien Crépon, a French painter who had studied at the Pennsylvania Academy before returning home (and who would assist him in Paris), and his father's friendship with the Central High School French teacher Bertrand Gardel may also have prompted him to go to Paris.[5] That Benjamin Eakins was keenly interested in the venture and inquired repeatedly about his son's progress may be deduced from the explanations and justifications that pervade Thomas Eakins's long biweekly letters. Young Eakins's continual reassurances that he was wasting neither time nor money as an apprentice in Paris tacitly acknowledged his father's financial and emotional support and

may have salved his own ego as he fielded his teachers' criticisms, struggled to master technique, failed the examination for matriculation in the Ecole des Beaux-Arts, and never showed works in the Salons.

Eakins sailed from New York on September 22, 1866, and arrived in Paris on October 3. Except for a visit home from mid-December 1868 to March 6, 1869, he studied and traveled in Europe until June 15, 1870. At first, he found a room in a "respectable and reasonable" hotel near the Louvre, as he told his mother on October 6,[6] and immediately sought admission to an atelier in the Ecole. Armed with letters of introduction from John Sartain, he spent "ten days of great anxiety and suspense" tangled in administrative red tape; he described his problems to his father in excruciating detail.[7] Although the school was open tuition-free to men of any nationality, it had been closed to foreigners for about a year because of overcrowding. Moreover, few Americans had preceded Eakins in entering Parisian art schools, and he was unfamiliar with the bureaucratic requirements. Eakins told his father that he regretted the maneuvering involved—"this pushing business," he called it—but he was pleased to have been admitted, with Secretary Lenoir's advice and endorsement, to Gérôme's atelier on October 25.[8] This painting class, along with classes supervised by Alexandre Cabanel and Isidore Pils, had been installed at the Ecole in 1863, when the school's curriculum expanded to include practical instruction.[9] Eakins was only Gérôme's second American pupil, after New York–born Lemuel E. Wilmarth.[10] His admission opened the doors for several other Americans, including Howard Roberts, who studied with sculptor Augustin-Alexandre Dumont, and three painters who joined Gérôme's atelier: friends from Philadelphia Harry Humphrey Moore (inscribed on October 29) and Earl Shinn (November 3), and Alabama-born Frederick Arthur Bridgman (February 10, 1867).[11]

By October 29, Eakins had moved to 46, rue de Vaugirard, across from the Palais du Luxembourg, a few blocks from the Ecole.[12] "The first thing a traveller does on reaching Paris is to visit the Louvre," Eakins wrote to his sister Fanny on October 30. Of the paintings galleries he observed, using the jesting tone that typified his letters to her: "There must have been half

a mile of them, and I walked all the way from one end to the other, and I never in my life saw such nice funny old pictures."[13]

Eakins's early letters home from Paris reflected his enthusiasm for getting to work and his appreciation of Gérôme's acumen. He told his father on November 11: "The studio contains some fine young artists, and it is an incalculable advantage to have all around you better workmen than yourself.... I will never forget the first day that Gerome criticized my work. His criticism seemed pretty rough, but after a moments consideration, I was glad. I bought Géromes photograph that very night.... What he wants to see is progress. Nothing escapes his attention" (fig. 17).[14]

Even before Eakins arrived in Paris, he must have recognized Gérôme's critical and commercial stature and set his sights on working with him. Gérôme himself had studied from 1840 to 1844 under Paul Delaroche, who instilled in him the ability to execute meticulous historical tableaux with lapidary finish, and in 1844–45 with Charles Gleyre, who initiated his interest in classical and Orientalist genre scenes.[15] Gérôme's first great success was *Cock Fight*, which won a third-class medal in the 1847 Salon (fig. 18). Contrived to present a study of contrasting male and female anatomies, not a narrative,[16] the canvas announced Gérôme's devotion to the primacy of the nude, the essential academic subject. Gérôme's fondness for portraying animals, apparent in *Cock Fight* and many later paintings, reflects his friendship with the *animalier* Emmanuel

Frémiet, who may also have stimulated Gérôme to work in sculpture as an independent medium and aid in painting volumetric forms, a practice Gérôme would recommend to students, including Eakins.

Along with critical approval, Gérôme began to receive commissions that expanded his repertoire and his reputation. For example, an order for a huge allegory of the Age of Augustus (Musée d'Orsay, Paris) for the 1855 Exposition Universelle prompted him to travel to the Balkans and Turkey to study ethnic types. In 1855–56 Gérôme spent eight months in Egypt on the first of seven visits to North Africa and the Middle East. These journeys inspired the contemporary ethnographic subjects that made Gérôme one of his era's most probing, prolific, and popular Orientalists.

Gérôme's works epitomized modern academic naturalism, enlisting lucid composition, correct drawing, and almost photographic technique to portray historical and exotic subjects for a journalistic effect, not for moral instruction. He usually executed his varied canvases in his Paris studio, enlisting French models and using sketches, photographs, costumes, and props collected on his travels as well as information from scholars. A technically conservative painter, Gérôme was an innovative sculptor, combining colored materials to produce three-dimensional counterparts of the sculpturesque forms that appear on his canvases. Conversely, his oils reflect his interest in sculpture; they sometimes por-

Fig. 17. Charles Reutlinger, *Jean-Léon Gérôme*, c. 1867–68. Albumen carte-de-visite. Archives, Pennsylvania Academy of the Fine Arts, Philadelphia.

Fig. 18. Jean-Léon Gérôme, *Cock Fight*, 1846. Oil on canvas, 56¼ x 80⅜". Musée d'Orsay, Paris.

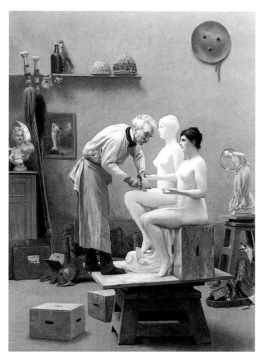

Fig. 19. Jean-Léon Gérôme, *The Artist and His Model*, 1895. Oil on canvas, 20⅛ x 15⅛". Haggin Collection, The Haggin Museum, Stockton, California.

Fig. 20. Photogravure of Jean-Léon Gérôme, *Egyptian Recruits Crossing the Desert*, 1857. Location unknown. From Edward Strahan [Earl Shinn], ed., *Gérôme: A Collection of the Works of J. L. Gérôme in One Hundred Photogravures* (New York: Samuel L. Hall, 1881), vol. 2, pl. xc.

tray sculptors at work, and their coloration often suggests tinted stone (fig. 19).

Especially after Gérôme's marriage in 1863 to Marie Goupil, a daughter of the art dealer and publisher who showed his paintings and distributed photogravures after them, his works became widely known. That Gérôme's extreme literalism was attuned to his era's empirical spirit is evident in the first major assessment of him in an American journal, published in 1866. Artist and critic Eugene Benson observed: "Gérôme...is closest to the moral spirit and best shows the intellectual traits of his time.... Like the modern mind, he travels, he explores, he investigates, and he tries to exhaust his theme."[17]

Gérôme's anecdotal, modestly scaled, seemingly documentary images of the past and the exotic present attracted many American collectors, including Philadelphians Joseph Claghorn, Joseph Harrison, and Henry Gibson.[18] His *Egyptian Recruits Crossing the Desert*, a replica of his 1857 Salon painting depicting either conscripts for the caliph's army or workers on the Suez Canal, was shown in New York three times between 1857 and 1864 and at the Pennsylvania Academy's annual exhibitions from 1860 to 1862 (fig. 20).[19] The unpretentious canvas may have appealed to Eakins. In May 1866, as Eakins was planning study abroad, he may have read Benson's claim that Gérôme was the artistic "man of the hour."[20]

Although Eakins had drawn for years at the Pennsylvania Academy, Gérôme made him spend five months drawing in charcoal, sometimes from casts housed in the Ecole's central court but more often from life in the atelier, before allowing him to touch paints, and probably voiced stiff criticism during that time (fig. 21). Eakins told his father on January 16, 1867, that he had had the advantage of having "a professor who corrects sharply when one makes a hippopotamus of himself."[21] Two months later Gérôme seemed more approving. Eakins wrote home on March 12, 1867: "Last time he made no change in my work, said it was not bad, had some middling good parts in it, but was a little barbarous yet. If barbarous and savage hold the same relation to one another in French that they do in English I have improved in his estimation."[22] Drawings that might illustrate the pupil's problems and the master's admonitions have been lost, but Eakins's letters suggest that he established a fruitful relationship with Gérôme, although he was probably distinguished from his classmates more by the novelty of his citizenship than by the quality of his work.

Gérôme would become the most popular teacher of Americans in the Ecole, despite or because of his rigorous standards, and despite the fact that he spoke no English.[23] He treated his pupils impartially; reviewed their works in his own studio; counseled them on Salon submissions and interceded with juries; advised them about extracurricular study; and assisted them after their student years. Such practices set Gérôme apart from other teachers and attracted disciples, who sought him out although they could receive identical technical instruction

Fig. 21. *Gérôme in Antique Class*, c. 1889. Engraving from Alexis Lemaistre, *L'Ecole des Beaux-Arts, dessinée et racontée par un élève* (Paris: Librarie Firmin-Didot, 1889), fig. 12.

in almost any other academic atelier in Paris. Gérôme's pupils spent five mornings each week drawing or painting an *académie*—a representation of a nude model—and receiving his critiques during semiweekly visits (figs. 22, 23). Life study and fidelity to the model's physiognomy and pose were central to Gérôme's method. Writing to Eakins in February 1877, when Eakins sought his support for the reinstitution of life classes at the Pennsylvania Academy, Gérôme would state: "It is only direct from nature, that it is possible to form the artists and by constand [*sic*] study from the nude that the painter arrives to be really strong, deep and true."[24]

Students in the Ecole's ateliers could attend lectures on anatomy and perspective; mathematics and science in relation to art; aesthetics and archaeology; and the history and philosophy of art, which from 1864 until 1870 were given by the young French philosopher Hippolyte Taine.[25] They, like pupils in private studios or independent academies, could also try to matriculate in the Ecole proper by passing the semiannual *concours des places*, a rigorous multipart examination (fig. 24).[26] Matriculation conferred distinction and admission to a late afternoon life-drawing class that between 1864 and 1883 was supervised by the history painter Adolphe Yvon, one of Schussele's teachers. The last American to matriculate before Eakins arrived in Paris had been Daniel Ridgway Knight,

Fig. 22. J. Alden Weir, *Male Nude Preparing to Strike*, 1873. Charcoal on paper, 23⅞ x 18⁷⁄₁₆". Museum of Art, Brigham Young University, Provo, Utah.

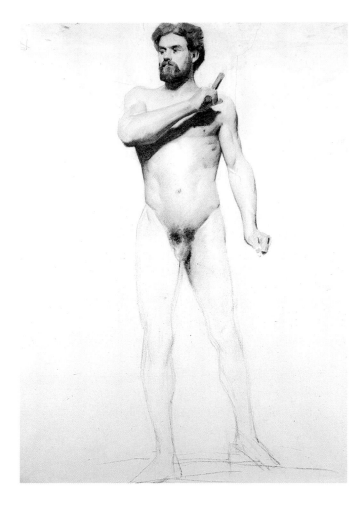

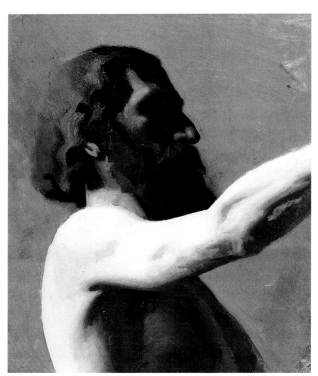

Fig. 23. Thomas Eakins, *Study of a Nude Man*, c. 1869. Oil on canvas, 21½ x 18¼". Philadelphia Museum of Art. Gift of Mrs. Thomas Eakins and Miss Mary Adeline Williams, 1929.

Fig. 24. *In Loges for the Sketch Competition*, 1889. Engraving from Alexis Lemaistre, *L'Ecole des Beaux-Arts, dessinée et racontée par un élève* (Paris: Librarie Firmin-Didot, 1889), fig. 58.

a Philadelphia-born student of Gleyre's, who was accepted in October 1861.[27] Eakins's attempt to matriculate in the spring of 1867 was exceptional, even daring, for an American. It was also futile.

Eakins recorded his misgivings about his prospects—and preempted disappointment at possible failure—in a letter to his father on March 12: "This week I am running the concourse of places, and if I can get in I will be able to draw in the evening also under Prof. Yvon. But there is but a very little chance of my getting in, as the concourse is public, that is anyone can try. There are over 240 painters alone inscribed and of these but 70 at most perhaps only 65 can be admitted." He added the next day: "Today my drawing has got a little dirty, but I will try to fetch it up again tomorrow. It is a poor comfort

to me to see a good many drawings better than my own, all around me."[28] The results, posted on March 25, included only one American: Moore, who placed fifty-ninth among the 70 matriculants accepted from among 209 competitors.[29]

On March 21, 1867, however, Eakins shared good news: "Gerome has at last told me I might get to painting & I commence Monday."[30] Two weeks later he asserted: "I am working in color now and succeed in getting off some beastly things but hope to do better."[31] Few of Eakins's early paintings survive, and none can be indisputably associated with his studies in the Ecole, so it is difficult to assess how "beastly" his initial efforts were. However, his failure in the *concours des places* and his self-denigrating remarks suggest only modest progress.

A highlight of the summer of 1867 was the Exposition Universelle (fig. 25). By May 31, Eakins wrote to his father, he had visited the fair twice, but he was enthusiastic only about machinery, pianos, restaurants, and national exhibits of crafts.[32] When he finally wrote home in early August about the huge fine arts display, he—like most of the critics—reserved his greatest praise for the French works. He noted that William Sartain, who had come to Paris to see the exposition, "agrees with me that the French far exceed all the others in beauty correctness variety of subjects."[33] Eakins made no mention of the private pavilions in which Gustave Courbet and Edouard Manet had arranged to show their works outside the fairgrounds. The American canvases consisted of eighty-two works by forty-one artists, mostly born in the 1820s and 1830s. These painters reflected the transitional period of the late 1850s and 1860s, when Americans began to seek instruction in

Fig. 25. Edouard Manet, *View of the Exposition Universelle, Paris*, 1867. Oil on canvas, 42½ x 77⅞". Nasjonalgalleriet, Oslo.

Paris, usually with independent teachers such as Thomas Couture, a painterly colorist rather than a strict academic. Included were examples by Edward Harrison May, Daniel Huntington, William Morris Hunt, and Eastman Johnson, all students of Couture's, and Edwin White and James McNeill Whistler, who had studied with Gleyre. But the American works made under French influence were far outnumbered by those in the Hudson River School tradition by Frederic E. Church, Sanford R. Gifford, and John F. Kensett. The critics' indifference to this nationalistic—perceptibly provincial—show, and their conspicuous enthusiasm for the French display, would have verified the wisdom of Eakins's decision to study in Paris.[34]

After a walking tour in Switzerland with William Sartain and William Crowell in the late summer of 1867, and a visit with them to the ailing Schussele in his native Strasbourg, Eakins returned to Paris in early September. In an effort to resolve his technical difficulties, he rented a studio at 64, rue de l'Ouest, off the avenue du Maine in Montparnasse, and worked independently with only occasional critiques from Gérôme. He explained to his father: "The studio will enable me to commence to practice composing & to paint out of school which I could not do before. As soon as I can get knowledge enough to enable me to paint quickly I will make pictures, but I have been only 4 months at the brush & cant do it yet."[35]

Eakins attributed his problems in painting from life to Gérôme's emphasis on laying in only the principal shades and deferring investigation of halftones until students were more advanced. As the subtle halftones of flesh eluded Eakins, he decided to paint instead "bright colored objects" with strong tonal contrasts. He wrote home optimistically on September 21: "Gérôme ... lent me some of his Eastern stuffs which are very brilliant & I am learning something from them, faster than I could from the life studies."[36]

From January 1 to mid-April 1868 Gérôme was absent from Paris to attend the opening of the Suez Canal with several other painters and to travel in Egypt and the Middle East. "There is mourning in France among students" because Gérôme and the others were going abroad, Eakins had remarked to his father at New Year's,[37] but he reassured him two weeks later that he was still gaining ground: "Color is becoming little less of a mystery than it was & more of a study in proportion. When it ceases altogether to be a mystery ... I trust I will soon be making pictures. One consolation is that I am composing. It was hard to begin, I felt I ought to know more, but now I am at it & whatever I can gain in it, is straight towards making a selling picture."[38]

While Gérôme was away, the teacher's friend and artistic alter ego, Gustave-Rodolphe Boulanger, oversaw his class, but

Eakins did not seek Boulanger's counsel. Rather, he altered his pattern of working independently by enrolling on March 5, 1868, for three months in the atelier that the respected sculptor Dumont supervised in the Ecole.[39] He announced to his father: "I am going to model in clay every once in a while. I think I will thus learn faster. When I am tired of painting I will go to the class & be fresh & I will see more models & choose."[40]

Eakins had studied modeling at the Pennsylvania Academy and may have been urged by Gérôme to improve his grasp of anatomy by working in clay. Dumont's tutelage would have echoed Gérôme's emphasis on close observation and naturalistic recording. It also provided lessons that would affect Eakins's work later as a sculptor.[41] However, in March 1868, Eakins was not exploring sculpture for its own sake; he was still focused on painting. He told his father on March 17: "I am less worried about my painting now than at one time last spring.... I am getting on faster than many of my fellow students and could even now earn a respectable living I think in America painting heads." New self-confidence notwithstanding, he argued that he needed to remain in Paris: "There are advantages here which could never be had in America for study and I will improve more this year than ever before."[42]

If Eakins really were "getting on faster than many of [his] fellow students," he might have assayed a submission to the jury for the Salon of 1868. Sixteen Americans, more than ever before, showed works that year, which signaled the growing appeal of Parisian study, especially in orthodox academic ateliers of the sort that would increasingly attract additional American pupils. The American exhibitors in 1868 included a few who lacked French training, several who were pupils of nonacademic French teachers, and a handful who were enrolled in the Ecole. For example, Edward Harrison May, a Salon veteran since 1855, had studied with Couture; Elizabeth Jane Gardner was a student of Hugues Merle; Eliza Jane Haldeman, of Paul Soyer; and Mary Cassatt (who showed as Mary Stevenson), of Soyer and Charles Chaplin. American representatives of the Ecole's ateliers were Cabanel's students Howard Helmick and Henry Bacon and Gérôme's pupil Frederick Arthur Bridgman.[43]

Eakins disdained what he saw in the 1868 Salon, fulminating to his father in a letter of May 9:

> There are not more than twenty pictures in the whole lot that I would want. The great painters don't care to exhibit there at all. Couture Isabey Bonnat Meissonier have nothing. The rest of the painters make naked women, standing sitting lying down flying dancing doing nothing which they call Phrynes, Venuses, nymphs, hermaphrodites, houris & Greek proper names.... I hate affectation & what you may stand in a child is unbearable in a man and so one is pleased to escape such a mass of trash & run back to the old Louvre pictures.[44]

Eakins's remarks about the Salon may be interpreted as either objective or defensive. That he does not appear to have submitted a canvas for consideration may reflect any of several factors: his principled repudiation of the juries' standards; his abiding technical difficulties and consequent fear of the sort of failure he had experienced in the *concours des places;* his belief that affiliation with a rigorous and distinguished teacher such as Gérôme would certify his study in Paris and obviate the need to show in the Salon; or the absence of the competitive pressure that in later decades would require the numerous American students in Paris to distinguish themselves by sending works to the Salons.

The nineteen Americans who showed in the 1869 Salon would again represent a miscellany of ateliers and would include from the Ecole only Howard Helmick and Henry Bacon from Cabanel's studio and Bridgman and John H. Niemeyer from Gérôme's.[45] Eakins wrote to his mother on April 14: "The exhibition will soon be open. Its only two weeks to the first of May. We are very anxious for the opening."[46] No other record of his response to the Salon has been preserved, and he was, once again, only a spectator.

During the summer of 1868, Eakins's father and sister Fanny visited him in Paris, spending nine days touring sites that included the Notre Dame Cathedral and the Luxembourg Gardens before setting off for the Continent. Thomas caught up with them in Genoa on August 1 and traveled with them to Naples, Rome, Florence, and other cities in Italy; visited Germany and Belgium; and returned to Paris on August 31.[47] Seeing only academic exercises in his son's studio, not finished works,[48] Benjamin Eakins must have voiced doubts about his progress. On September 8, 1868, the young artist reassured him once again: "My hard work since I have been back here is telling on me & my studies are good. . . . So I am in good spirits & am sure now of one thing, being able to learn [to] paint from life better."[49] Even more fervently, on October 29, Eakins tried to assuage misgivings that his father had stated in his recent letters and to affirm his faith in himself and in Gérôme: "I am working as hard as I can & have always the advice of a great painter who does all he can for his scholars & of boys friends who can paint the figure as well or better than any man in America. I have made progress and can equal the work of some of the big painters done when they had only been studying as long as I have."[50]

By the spring of 1869, Eakins's appreciation of Gérôme was undiminished. In a long letter of April 1 to Fanny, he responded to their friend William Crowell's skepticism about Gérôme and rhapsodized about the variety and veracity of his works: "You wanted to know the Romans. There they are real. Gerome knows them. He knows all men. . . . Who that has read

the Arabian nights or the Bible or any travellers' stories but wants to see the east. Gerome can help you see it if you cant go there."[51] On June 24, 1869, after two-and-a-half years of study with Gérôme, Eakins yet again assured his unconvinced father of his progress: "I am getting on as fast as anyone I know of. . . . One terrible anxiety is off my mind. I will never have to give up painting, for even now I could paint heads good enough to make a living anywhere in America, I hope not to be a drag on you a great while longer."[52]

The best place in Paris to learn to "paint heads" was not the Ecole, which emphasized naturalism and held school-wide competitions in rendering "expressive heads" but did not teach portraiture. Anticipating the need to support himself as a portraitist in Philadelphia, Eakins enrolled in late July or early August 1869, during the Ecole's summer recess and perhaps on Gérôme's advice, in Bonnat's independent class in Montmartre where William Sartain was working.[53] The fact that Bonnat's reputation then was as a rising realist, not as the painter of fashionable sitters he would become in the 1870s, may have increased his appeal. Eakins's esteem for the painterly manner of Couture, whom he often praised, also anticipated his seeking out Bonnat.[54]

Born in 1833 in Bayonne in the Pyrenees and raised in Spain, Bonnat (fig. 26) learned academic principles in Madrid at the Royal Academy of San Fernando and in the studios of

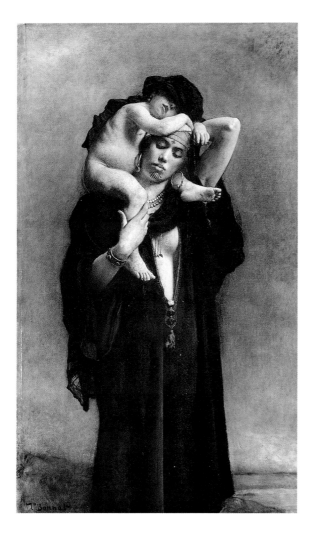

Fig. 27. Léon Bonnat, *An Egyptian Peasant Woman and Her Child*, 1870. Oil on canvas, 73½ x 41½". The Metropolitan Museum of Art, New York. Catharine Lorillard Wolfe Collection, Bequest of Catharine Lorillard Wolfe, 1887.

his father in February 1874: "Standing up against the wall was the large cross with the subject crucified on it, a horrid sight; but it shows how these French artists believe in truth."[59] Bonnat's controversial *Crucifixion* stressed agony in the manner of Jusepe de Ribera and was meant to strike terror into the hearts of the condemned.[60]

Bonnat's investigative approach to portraits sometimes required as many as eighty sittings[61] and relied on photographs for reference. He favored natural poses, plain dark backgrounds, and few accessories. His portraits of men are monumental, severe, and almost photographic, as in *John Taylor Johnston* (fig. 29), a likeness of a leading art patron and first president of New York's Metropolitan Museum of Art. His images of women are more graceful and include lovingly scrutinized costume details, as in *Madame Pasca* (fig. 30), which one critic was reported to have called "the portrait of the dress and the right arm of Mme. Pasca."[62]

By 1865 when a group of young artists asked Bonnat to teach them, he was admired as a painter who mediated between academic and realist tendencies. The diverse pupils in Bonnat's independent atelier between 1865 and 1883 included many Americans, possibly because he spoke French, Spanish, Italian, and English.[63] His instruction signified "a new order of things," as Edwin H. Blashfield noted: "Here we had Bonnat, a novelty, a young man with lots of paint, a forceful fist, fiery enthusiasm for Velasquez and almost as much for Ribera."[64] Bonnat was unusually young among Parisian teachers, thirty-two in 1865, in contrast to the *chefs d'atelier* in the Ecole des Beaux-Arts: Gérôme (forty-one in 1865), Alexandre Cabanel (forty-two), and Pils (fifty).

Bonnat's teaching studio was as noisy, smoky, and dirty as any in the Ecole, and its instruction followed the Ecole's pattern of semiweekly critiques of drawn and painted *académies* in the ateliers.[65] However, Bonnat's class included fewer than fifty students rather than the seventy usually enrolled in the Ecole's packed ateliers; free of bureaucratic obstacles, it determined students' places in relation to the model by rotation, not competition, and minimized work from casts.[66] When William Sartain sought Bonnat's advice on the curriculum for the Art Students' League of New York, the master affirmed his emphasis on life study (and echoed Gérôme's February 1877 letter to Eakins): "Let the student abandon himself to the study of Nature, of the living model.... Let him study anatomy, and understand the causes that swell or diminish the muscles. Let him know that there is beauty only where there is truth."[67]

Like many of Bonnat's other pupils, Eakins remarked on his leniency, telling his father on September 8, 1869, just after he finished his studies with him: "If you ask him the simplest question about what he thinks the best way to do a thing, he wont tell

Paris-trained José de Madrazo and his son, Federico.[55] Equally important to Bonnat's formation was Spanish Baroque art in the Prado.[56] Bonnat furthered his academic studies in Paris under Léon Cogniet and in the Ecole des Beaux-Arts from 1854 to 1857 and spent three years in Italy painting biblical, historical, and genre subjects; sketching landscapes; and communing with the old masters.[57] Returning to Paris in 1862, he frequently exhibited at the Salons and earned a reputation for serious works executed with energetic brushwork and a strong, dark "Spanish" palette.

Bonnat's visit with Gérôme to the opening of the Suez Canal in early 1868 revived his interest in genre subjects, such as *An Egyptian Peasant Woman and Her Child* (fig. 27), a somber image reminiscent of Velázquez. Shown in the 1870 Salon, the painting was purchased by the New York collector John Wolfe. Such genre scenes were the first of Bonnat's works to attract substantial patronage; by 1882 ten of them had entered American collections.[58]

Bonnat also continued to depict historical subjects with nearly repulsive realism. To paint a *Crucifixion* for a courtroom in the Palais de Justice in Paris, for example, he purchased a cadaver and had the body nailed to an immense cross (fig. 28). An American student J. Alden Weir (see fig. 22) recounted to

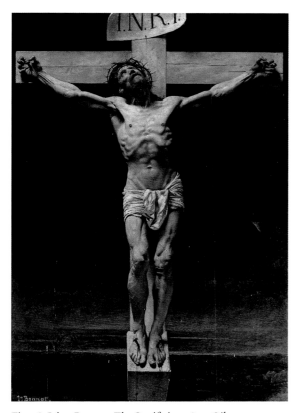

Fig. 28. Léon Bonnat, *The Crucifixion*, 1874. Oil on canvas, 90⅛ x 63". Musées du Petit Palais, Paris.

Fig. 29. Léon Bonnat, *John Taylor Johnston*, 1880. Oil on canvas, 52½ x 44". The Metropolitan Museum of Art, New York. Gift of the Trustees, 1880.

Fig. 30. Léon Bonnat, *Madame Pasca*, 1874. Oil on canvas, 87⅝ x 52". Musée d'Orsay, Paris.

you. He says do it just as you like. He will never impose any way of working on his boys.... He never finds fault with any thing but the result.... Bonnat is still so young, his troubles [as a student] are fresh in his mind & this is why he has no system."[68] Truth to nature was paramount. Most vividly, American painter H. Siddons Mowbray, a student from 1878 to 1881, recalled: "At Bonnat's, stern realism was the law. A view of the output of crude torsos, legs, feet and heads suggested a butcher's shop. No one did a thing without the model. It was pure still life."[69]

Eakins's commitment to study with Bonnat presented difficulties, as he wrote to his mother on August 30, 1869: "It takes an hour to walk to school which is between 3 & 4 miles.... We go get our breakfast Bill & me & then go to school & get there in time. Then I eat again & come back to my own studio & work till 6 o'clock. Then I get my dinner & don't feel like doing anything at all not even reading but going right to bed so as to get up again in time the next morning." This regimen was brief, however, as he added: "Bonnat is now gone to the country & I will stop his studio at the end of this week probably & work only on my own for in 3 weeks from then our own school is open."[70]

Eakins's later works and teaching methods suggest that he found more inspiration from Bonnat than might have been expected from their brief contact or from the neutral summary he provided to his father on September 8, 1869: "I am very glad

Fig. 31. Carolus-Duran, *Woman with a Glove*, 1869. Oil on canvas, 89¾ x 64⅝". Musée d'Orsay, Paris.

The realists could see canvases by Ribera, Bartolomé Esteban Murillo, and Francisco de Goya y Lucientes in the Louvre or in provincial French collections. Others were in private homes or on view at auction; for example, several sales of Spanish private collections were held at the Hôtel Drouot in Paris between 1867 and 1869.[75] In the yearly Salons, paintings created by French artists under Spanish influence had begun to appear, such as Carolus-Duran's *Woman with a Glove* (fig. 31), an homage to Velázquez (and Titian) that was shown in 1869. But the respect for Spanish art that realists—and even academics such as Gérôme[76]—expressed could hardly be nourished by the Spanish canvases in France. Pictures by Velázquez, who was revered as the greatest Spanish master, were lacking. To see a profusion of Spanish works and absorb their lessons, painters journeyed to Madrid and, after immersing themselves in the treasures of the Prado, spent time in picturesque cities such as Seville, the birthplace of both Murillo and Velázquez.

Eakins had declared his desire to go to Spain as early as October 1866 and took some Spanish lessons toward that end. William Sartain claimed credit for prompting the trip in 1869, and the successful young Spanish painter Mariano Fortuny, who frequented Gérôme's studio, may have been influential in encouraging it.[77] However, Bonnat's passion for Velázquez and Ribera energized the plan. Eakins left Paris by train on the night of Monday, November 29, 1869, arrived in Madrid the following evening, and spent the next three days sightseeing and looking at paintings. After weeks of dismal weather in Paris, he was rejuvenated by Madrid's bright sunlight, cleanliness, and pleasant, picturesque people. He was also overwhelmed by the Spanish Baroque masterpieces in the Prado. He wrote to his father on Thursday, December 2: "I have seen big painting here. . . . O what a satisfaction it gave me to see the good Spanish work so good so strong so reasonable so free from every affectation. It stands out like nature itself." The next day he added: "I have been going all the time since I have been here and I know Madrid now better than I know Versailles or Germantown and tonight I leave for Seville. I have seen the big work every day and I will never forget it. It has given me more courage than anything else ever could."[78]

In January, William Sartain and Harry Moore joined Eakins in Seville. Eakins's principal project there was a large multi-figure canvas, *A Street Scene in Seville* (fig. 32). The picture recalls the stagelike arrangement of Gérôme's *Pifferari* (fig. 33), of which Eakins had obtained a photograph in Paris, but displays Bonnat's freer brushwork. Eakins struggled with the daunting task of working in sunlight on an ambitious composition. "Picture making is new to me," he fretted to his father at the end of March, "there is the sun & gay colors & a

to have gone to Bonnat & to have had his criticisms, but I like Gerome best I think. . . . He [Bonnat] is the most timid man I ever saw in my life & has trouble to join three words together."[71]

Returning briefly to Gérôme's atelier in the fall of 1869, Eakins realized that dark, chilly, damp Paris undermined his spirit and his health, and he began to think of finishing his studies. He wrote to his father on November 5: "If I had to live in water & cold mist I had rather be a cold blooded fish & not human. I made a good drawing at school this week & if I can keep my health I think I can make a name as a painter for I am learning to make solid heavy work. I can construct the human figure now as well as any of Geromes boys counting the old ones."[72] In another letter he concluded: "I feel now that my school days are at last over and sooner than I dared hope, what I have come to France for is accomplished. . . . I am as strong as any of Geromes pupils, and I have nothing now to gain by remaining. What I have learned I could not have learned at home, for beginning Paris is the best place."[73]

Eakins ended his sojourn in Europe with a six-month visit to Spain, a favored pilgrimage destination for artists in Paris during the 1860s. The widespread French appreciation of Hispanic culture initiated by Napoleon Bonaparte's occupation of the Iberian peninsula reached a peak with the burgeoning of realism. Courbet, Manet, Carolus-Duran, Bonnat, and others found their own efforts validated by the naturalistic works of seventeenth-century Spanish painters.[74]

Fig. 32. Thomas Eakins, *A Street Scene in Seville*, 1870. Oil on canvas, 72¾ x 42". Collection of Erving and Joyce Wolf.

Fig. 33. Photogravure of Jean-Léon Gérôme, *The Pifferari*, 1859. Location unknown. From Edward Strahan [Earl Shinn], ed., *Gérôme: A Collection of the Works of J. L. Gérôme in One Hundred Photogravures* (New York: Samuel L. Hall, 1881), vol. 1, pl. xii.

hundred things you never see in a studio light & ever so many botherations that no one out of the trade would ever guess at."[79]

After a stay in picturesque Ronda, Moore journeyed to Granada while Sartain and Eakins returned to Madrid for a few days before traveling back to Paris. In his Spanish notebook, Eakins wrote his impressions of works in the Prado. Although his comments focus on technique and surface effects, he was clearly thrilled by the expressive power of Velázquez and Ribera. Calling "the tapestry weaver" (*The Fable of Arachne*, or *The Spinners*, fig. 34) by Velázquez "the finest piece of painting I have ever seen," he analyzed the artist's method of defining the mass of the main figure before indicating her features, and added: "I think Ribera and Rembrandt proceeded in the same way, the only [method], in my opinion, that can give both delicacy and strength at the same time."[80] From the lessons of the old and modern masters he deduced a personal method and recorded it in his Spanish notebook: "As soon as my things [that is, my preliminary arrangements] are in place, I shall aggressively seek to achieve my broad effect from the very beginning." His aim, it seems, was to recombine the best aspects of the French academic and Spanish Baroque traditions, to unite composition and "broad effect," careful structure and tactile surface, much as Bonnat had done:

> I must resolve never to paint in the manner of my master [Gérôme].... One can hardly expect to be stronger than he, and he is far from painting like the Ribera or the Velasquez works, although he is as strong as any painter of polished surfaces....
>
> The Weaver of Velasquez, although having much impasto, has no roughness at all to catch the light....

Fig. 34. Diego Rodriguez de Silva y Velázquez, *The Fable of Arachne (The Spinners)*, 1657. Oil on canvas, 86½ x 113¾". Museo del Prado, Madrid.

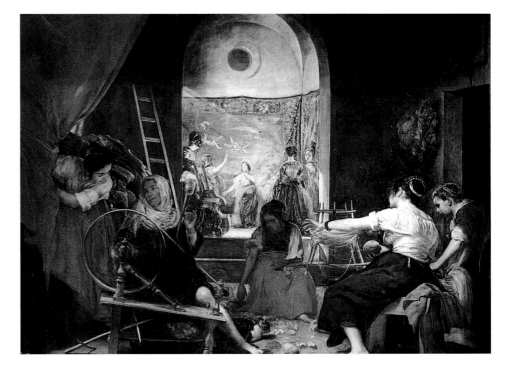

Fig. 35. Jean-Léon
Gérôme, *Ave Caesar,
Morituri Te Salutant*, 1859.
Oil on canvas, 36⅝ x 57¼".
Yale University Art
Gallery, New Haven. Gift
of C. Ruxton Love, Jr.,
B.A., 1925.

So, paint as heavily as I like, but never leave any rough-
ness. The things of Velasquez are almost made to slide
on.…

Velasquez does a lot of glazing with quite transparent
color in the shaded areas, but it is very solidly painted
underneath.[81]

Eakins returned to Philadelphia in the summer of 1870. His
subsequent accomplishments as an artist and his work as a
teacher would always reflect what he had learned abroad. As
he prepared to conclude his studies in Paris, he had belittled
Gérôme's influence, noting in a letter to his father: "I have had
the benefit of a good teacher with good classmates. Gerome is
too great to impose much, but aside his overthrowing com-
pletely the ideas I had got before at home, & then telling me
one or two little things in drawing, he has never been able to
assist me much & oftener bothered me by mistaking my trou-
bles."[82] Yet Eakins carried on a cordial correspondence with
Gérôme once he was home, sought his advice on paintings,
and enlisted his help with dealers and juries when he finally
sent canvases to the Salon in 1875. As a teacher, Eakins chal-
lenged Gérôme's emphasis on draftsmanship by encouraging
his students to paint rather than draw, but the curriculum he
established at the Pennsylvania Academy otherwise emulated
the Ecole's. He told his students that Gérôme was "the great-
est painter of the nineteenth century."[83] When his own teach-
ing career was in jeopardy in 1886, Eakins invoked him: "My

dear master Gérôme who loved me had the same ambition [to
make good pupils], helped me always and has to this day inter-
ested himself in all I am doing," he wrote to Edward Hornor
Coates, chairman of the Pennsylvania Academy's Committee
on Instruction.[84] Susan Eakins recalled: "He loved and admired
his master."[85]

Eakins's paintings document his debt to French academic
standards, as contemporary observers noted. When *Starting Out
after Rail* (pl. 12) and another hunting subject appeared in the
Salon of 1875—having been chosen by Gérôme from Goupil's
stock to represent Eakins—the critic for the *Revue des Deux
Mondes* remarked: "These two canvases…resemble photo-
graphic prints covered with a light watercolor tint to such a
degree that one asks oneself whether these are not specimens of
a still secret industrial process, and that the inventor may have
maliciously sent them to Paris to upset M. Detaille and frighten
the *école française*."[86]

Ackerman revived awareness of Eakins's dependence on
Gérôme in his 1969 article. He noted how Eakins astutely
adapted to American contexts themes and pictorial strategies
that appear in the paintings by Gérôme that Eakins would have
seen in the master's studio, the Salons, or the 1867 Exposition
Universelle, as Goupil photogravures or reproductions in
major monographs published by Philadelphia-based writers
Shinn and Fanny Field Hering.[87] Ackerman remarked, for
example, on Eakins's reiterations of Gérôme's gladiatorial

amphitheaters in his clinic paintings and fight scenes. He compared Eakins's *Salutat* (pl. 214) specifically with Gérôme's *Ave Caesar, Morituri Te Salutant* (fig. 35), as it shares a Latin title and depicts similar activities and poses. *Ave Caesar* appeared in 1859 in the Paris Salon and Goupil's gallery in New York, and was among the thirteen canvases that Gérôme showed in the 1867 Exposition Universelle. Eakins was enthusiastic about *Ave Caesar* in a letter of April 1, 1869, to his sister Fanny,[88] and depicted a photogravure of it over the mantel in *The Chess Players* (pl. 19).[89]

Eakins recalled seeing another amphitheater scene, *Pollice Verso* (1872, Phoenix Art Museum), while Gérôme was working on it. In January 1875, after the New York collector A. T. Stewart had acquired the canvas, Eakins told Shinn he wished to have a look at it: "I am going to write to Stewart & see if he wont let us see his pictures. I will tell him how Gerome used to get out his Pollice Verso to illustrate to me his principles of painting & how much therefore I ought to see it now that it is here & finished & how Gerome calls me his favorite pupil & is proud of having in the New World one doing him so much honor & if he dont let us in then he is a damned hog (the same says you as he always was)."[90]

Eakins's rare forays into historical subject matter also suggest Gérôme's influence. His Arcadian images of the early 1880s recall Gérôme's idyllic visions of antique life. His pictures of sculptor William Rush are American counterparts of the portrayals of artists in their studios that many nineteenth-century French painters, including Gérôme, produced.[91] Eakins's fastidious research of settings and costumes for the Rush series, and its evidence of his interest in sculpture, echo Gérôme's methods and concerns. Like Gérôme, Eakins made sculpted versions of certain paintings, used wax maquettes as well as photographs for reference, and recommended that his students attempt sculpture—as he had done under Dumont—to assure volume in painted images.

In retrospect, Bonnat's influence upon Eakins was as significant as Gérôme's. Although Eakins did not maintain a personal relationship with Bonnat after his return home, he remained curious about his works. On April 2, 1874, he wrote to Shinn: "Did you think to ask any picture men about that *Femme Fellah de Bonnat* [*An Egyptian Peasant Woman and Her Child*, fig. 27].... I would like to go with you to see that picture." Bonnat, he said, had told him it was in New York, but Eakins could not remember the owner's name.[92] Planning to visit New York in January 1875 to show his pictures to several dealers, he reminded Shinn: "I want to see that Bonnat."[93]

Through Gérôme, with whom Eakins corresponded in 1874, or William Sartain, who returned from Paris in 1876, he may have learned how Bonnat had crucified a cadaver, and

may have heard or read about the resulting canvas when it was shown in the 1874 Salon (fig. 28). In 1880, to paint his own *Crucifixion* (pl. 54), Eakins would strap his student John Laurie Wallace to a cross to create a painting motivated, as was Bonnat's, by an interest in anatomy, not devotion.[94]

Many of Eakins's late portraits such as that of Episcopal Archbishop William Henry Elder (pl. 227) recall in their heavy figures, candid poses, and neutral backdrops *John Taylor Johnston* (fig. 29), Bonnat's best-known portrait then in America, as well as Velázquez's *Innocent X* (fig. 36), a widely reproduced masterpiece both artists would have admired.[95] Occasionally Eakins's treatment of drapery recalls Bonnat's, as Ackerman observed. Weda Cook's gown in *The Concert Singer* (pl. 192), for example, displays the same tactile verisimilitude that appears in Bonnat's *Madame Pasca* (fig. 30). Eakins's two years of work on *The Concert Singer* recall the numerous sittings that Bonnat required for his portraits. Even Eakins's method of studying side-by-side his subjects and the canvases on which he depicted them reiterated Bonnat's.[96] Finally, Eakins's reluctance to impose specific methods on his pupils emulated Bonnat's liberality.

Although Eakins's efforts as an art student in Paris and Spain are documented more by his letters home than by surviving works, there is little doubt that he struggled, despite his inherent abilities and his long preparation at the Pennsylvania Academy. He received stern criticism from Gérôme, failed the *concours des places* for matriculation in the Ecole, showed no

Fig. 36. Diego Rodriguez de Silva y Velázquez, *Innocent X*, 1650. Oil on canvas, 55 x 47¼". Galleria Arti Doria-Pamphili, Rome.

works in the Salons, and felt forever obliged to justify his progress to his sometimes dubious father and to himself. His unaccountable disappointments notwithstanding, Eakins's student years in Europe profoundly affected his later accomplishments. Most notably, his experiences abroad inspired the astute balance that he struck between the linear and painterly, contrasting modes he had learned to appreciate in Paris and Madrid. Whereas his effort to reconcile the two traditions failed in *Street Scene in Seville* (fig. 32), it was much more—almost uncannily—successful in *The Champion Single Sculls* (pl. 1). Supreme examples of Eakins's masterful conjoining of the Beaux-Arts and the Baroque are late portraits such as *The Thinker (Portrait of Louis N. Kenton)* (pl. 220), which rivals, not just recalls, works by the greatest masters. Such canvases proclaim fully the extent of Eakins's assimilation of his French and Spanish lessons, his distinctive responses to American thematic resources, and his singular eloquence and originality.

The 1870s

MARC SIMPSON

FTER FOUR YEARS in Europe, Thomas Eakins returned to Philadelphia on July 4, 1870. He moved back into the family home at 1729 Mount Vernon Street, where he lived—barring a short period from 1884 to 1886—until his death nearly half a century later. Eakins's oeuvre for the 1870s—paintings, watercolors, and the works necessary for their preparation—reveals a young man of ambition and originality intent on making realistic images of the world around him.

Throughout the decade, he set for himself an array of technical challenges. Consistently, he created spaces using rigor and system rather than perceptual generalization; he shaped his figures in light of thorough anatomical knowledge and psychological observation; and he calculated detailed effects beyond the range of observation in the depiction of color and motion. Simultaneously he established novel iconographies of pointedly modern activities. Yet for all his experimentation, his basic goals did not vary: to paint the American figure with a power and an artfulness comparable to the greatest contemporary French academic masters, to inculcate his philosophy of art in a rigorous program of teaching, and to win recognition for these achievements from the public.[1]

Eakins's paintings of the 1870s fall into four thematic clusters: athletes and sportsmen; fashionable young women or older men in interiors; historical works evocative of Philadelphia in the decade just after 1800; and portraits.[2] To judge by their number and their place in his exhibition history, Eakins's greatest early enthusiasm was for pictures of sport.

From boyhood, Eakins had been active and athletic; he rowed, ice-skated, sailed, hunted, swam, rode horseback, wrestled, and practiced gymnastics. While abroad he had praised Philadelphia's "advantages," lauding "the skating, the boating on our river, the beautiful walks in every direction."[3] His letters home frequently mentioned the popular sport of rowing, noting not only his entire family's recreational involvement in the exercise but also the races in which his friend and Central High School classmate Max Schmitt competed.[4] In 1869, for example, he wrote to his sister Frances: "I've got your letter announcing Max's victory. I am glad he beat & you give him my congratulations next time you see him."[5]

By the time Schmitt was victorious in his most important race of 1870—a three-mile course along the Schuylkill River on October 5—Eakins could offer congratulations personally. He also presented Schmitt with an enduring testament of admiration: a large painting called The Champion Single Sculls (pl. 1). With its exhibition—Schmitt lent it for a few days in late April 1871 to the Third Art Reception of the Union League of Philadelphia—Eakins inaugurated his public professional career.[6] The work is an astonishing debut. In the foreground, Schmitt stares across open water in the direction of the viewer, squinting into late afternoon sunlight. Shadows mask his gaze and serrate his white shirt, emphasizing the torsion of his lean body. In the middle distance, another rower pulls away down the river. Like Schmitt, he is delineated by strongly contrasting lights and darks. His sunstruck face, rendered in great detail, reveals the straining figure to be a self-portrait of the young artist—an identification wittily underscored by the signature and date of the work on his scull's stern panel.

At least two critics took note of the painting. The review in the *Philadelphia Evening Bulletin* was the more sanguine, remarking that Eakins:

> who has lately returned from Europe and the influence of Gérôme, has also a picture entitled The Champion Single Sculls (No. 137), which, though peculiar, has more than ordinary interest. The artist, in dealing so boldly and broadly with the commonplace in nature, is working upon well-supported theories, and, despite somewhat scattered effect, gives promise of a conspicuous future.[7]

The "scattered effect" is presumably Eakins's calculated effort, through patches of selective focus, to direct the viewer's attention across the surface of the canvas: to the copse of trees at the left with their lean, improbably extended branches; to the rhyming, overlapping ironwork of the bridges at the center; and, across the picture's lower half, to the wakes and eddies, magically extended in time, that track the rowers' courses.[8] The writer's recognition of the "commonplace" nature of the theme is noteworthy. In choosing to paint the modern world, Eakins subscribed to realist tenets advocating contemporary, local subject matter. Prior to *The Champion Single Sculls*, contemporary American scullers had appeared only in the

commercial realm of prints and the periodical press.[9] This search for innovative material was a key element of Eakins's early career.[10]

Eakins reveled in his "peculiar" theme of rowing, producing six large oil paintings as well as a series of detailed watercolors.[11] For most of these, he took as his subjects two brothers from New York who came to Philadelphia in 1872 to race for the world championship of pair-oared shells: Bernard (Barney) and John Biglin. The arrival of the "dapper fellows" created a stir in the local papers.[12] Eakins made their acquaintance and painted them repeatedly over the next two years.

In *The Pair-Oared Shell* (pl. 4), the first oil to feature the Biglins, Eakins reduced the panorama of *The Champion Single Sculls* to focus on the men, their craft, the weathered bridge pier, and the rippled surface of the water. Dusk shrouds the background, providing a mute backdrop for the rowers' practice session. Both men look toward the viewer—to judge from the low vantage point, a fellow rower—casting their faces into shadow. This distancing strategy, reinforced by the work's overall dark tonality, lends the picture a seamlessness and an apparent modesty of ambition. But the impression of simplicity is illusory, for although the figures of the Biglins are largely shadowed, the tones of gray and brown that form them have been carefully discriminated to suggest the anatomy of their straining bodies and their distinct physiognomies. The bands of sunlight that define the Biglins' left-hand contours—what Shinn would later call the "strong effect of late golden light playing around the knotted muscles of the oarsmen"[13]—undulate to lend the men depth. The complex geometries of the joins in the shadowed portion of the pier gradually reveal themselves, as do details along the distant shore. There is more to perceive than first meets the eye.

Two perspective drawings for *The Pair-Oared Shell* (pls. 2, 3)—the earliest extant, probably incomplete group showing the artist's distinctive and characteristic working method—reveal his deliberation in plotting the spatial arrangement of the painting's few elements. The first, which calculates the relative positions of the shell, the oars, and the bridge pier, is sufficiently detailed to allow scholars to determine the length of the boat, its distance from the viewer, and even the precise time of day and season represented, 7:20 on an evening within weeks of the summer solstice.[14] This follows Eakins's own, often-quoted prescription for effective art-making: "In a big picture you can see what o'clock it is afternoon or morning if it's hot or cold winter or summer and what kind of people are there and what they are doing and why they are doing it."[15] In the second drawing Eakins was concerned with the reflections of the rowers, which he calculated precisely, rather than approximating their placement as many painters of his era

would have done. He would later write: "There is so much beauty in reflections that it is generally well worth while to try to get them right."[16]

Eakins put *The Pair-Oared Shell* on public exhibition only in 1879, at the National Academy of Design in New York. There the painting found vocal supporters. The writer for *The Nation*, although questioning its tonality as too dark for sunlight, called it "broad, pure, and inexorably true."[17] The lengthiest review appeared in *The New York Times*, whose writer found it to be "remarkable for good drawing, natural and quiet composition, and a pleasant feeling in the color—speaking of the picture as a whole." He continued:

> In a less technical sense, it is also an entrance into a sphere of human activity where one might have expected that artists would have sought for subjects long ago.... and if it were possible to conceive that an artist who paints like Mr. Eakins had a poetic impression, we would like to think that in this composition he had tried to express the peculiar charm that every one has experienced when rowing out of the sunlight into the shadow of a great bridge.[18]

The subject of rowing was appreciated for its novelty, the treatment noted for its rigor, and the possibility of a poetic mood and empathetic sensation was even considered. On the occasion of the painting's Philadelphia debut in 1881, the art critic William J. Clark, Jr., described the innovative subject of contemporary rowing as "a shock to the artistic conventionalities" of the city—a reproof to the community, not the artist.[19]

Eakins's next two paintings of the Biglins show an imaginative re-creation of their five-mile race on May 20, 1872, a professional contest with a prize purse of two thousand dollars. Contemporary newspaper accounts detailed the costumes of the opposing teams, the conditions, and the run of the event, including the opinion that both crews "despite a heavy rain rowed finely."[20] In *The Biglin Brothers Racing* (1872, National Gallery of Art, Washington, D.C.) and *The Biglin Brothers Turning the Stake-Boat* (pl. 6), the seeming fidelity to observed nature and Eakins's careful preparations to plot perspective and placement lure the viewer into thinking that the painter merely replicated the scene he had witnessed. But Eakins almost always moved parallel to nature, selecting and appropriating rather than transcribing a given whole. His method, articulated early and maintained throughout his career, was to isolate individual artistic problems, study them thoroughly, and then synthesize the results. As he wrote to his father, an artist "combines and combines, never creates."[21]

The Biglin Brothers Turning the Stake-Boat—the largest by far of Eakins's rowing scenes—exemplifies this method. The Biglins are mainly in shadow, their convincing anatomies enlivened by slivers of golden sunlight. Barney is in the midst

of a stroke that will place the shell in position for the push to the finish line; John's oar backs water to pivot. The moment balances action and pause in the two principal figures, while revealing the past and predicting the outcome of the larger narrative. And yet the picture departs from the recorded facts of the event in many details: the midpoints of the course are shown as stakes in the water rather than the more complex actual stake boats; the costumes of the Biglins' opponents include white shirts and red kerchiefs, while they in fact rowed bare-chested and hatless; the weather is clear rather than stormy. The work is filled with closely observed and carefully studied visual truths, which conspire to disguise the fact that it is a studio production, its elements chosen by the artist and assembled into a coherent whole. So successful was Eakins that writers from his day to ours have been tempted to assign reportorial status to his outdoor works.

When Eakins finally exhibited the painting in Boston in 1878 and in Philadelphia in 1880, it prompted widely divergent opinions. The writer for *The American Art Review* found it "not only utterly without color, but also utterly lifeless."[22] Mariana Griswold van Rensselaer, by contrast, published a long appreciation illustrated with a line drawing after the painting: "Amongst home works the first place belongs, I think, to the strong and intensely characteristic work of Mr. Eakins. There is, perhaps, no artist in the country who can rival him for originality of conception, for adapting the matter-of-fact elements of our surroundings to artistic use, no one who imprints a sign-manual of individuality so strongly on everything he touches."[23]

Eakins also made watercolors of rowers. Although he had used the medium as a boy, only in 1873, apparently, did he turn to it as a professional.[24] His presentation of four sporting scenes—three of them showing sculling—in January 1874 at the American Society of Painters in Water Colors was Eakins's first public exhibition in New York, and only his second such anywhere.[25] The watercolors were noted by just a few keen critics. The writer for *The Daily Graphic* called them "fine muscular studies," adding that they "may not be of a very high class of art, but they are exceedingly well done."[26] The writer for the *New York Daily Tribune* praised the group as being "of great merit," especially the

> portraits of rowing and sculling celebrities in their boats, and set in landscapes that are as much to be enjoyed as the men, with their beautifully ugly muscles, or the skeleton boats the only exquisitely artistic production of the American nineteenth century mind thus far.... Mr. Eakins has struck out a new vein in these subjects, and, barring some slight exaggerations and some signs of timidity his work is very clever.... Mr. Eakins's drawings will be looked for with interest. It is not every year there is so prominent a first appearance.[27]

Eakins prepared well for the watercolor *John Biglin* (fig. 67). Still extant are a perspective drawing (Museum of Fine Arts, Boston) and an oil version of the figure (pl. 7), both twice the scale of the finished work.[28] Among American artists Eakins was unusual in his practice of preparing oil studies for his watercolors; and this canvas is a rarity in his choice to develop and, in the next year, to sign and date it as an independent work. This signals a particular engagement with Biglin. Although artist and subject are documented as being in the same place only during the few weeks before the race of May 1872, Eakins painted him more frequently than all but a few of his closest family members and students. In 1874, before he sent the exhibition watercolor as a gift to his teacher Jean-Léon Gérôme, he made a slightly varied replica of it (pl. 8)—again, an unusual practice for Eakins that testifies to his pride in the work. This was well placed. Gérôme responded: "Your watercolor is entirely good and I am very pleased to have in the New World a pupil such as you who does me honor."[29]

The Sculler, the other watercolor of a single rower that was shown in January 1874, was purchased from the exhibition for eighty dollars—Eakins's first known sale.[30] The theme of rowing had occupied Eakins for three-and-a-half years, providing him with his earliest exhibition works, critical attention, admiration from his teacher, and a sale. In spite of this, he turned from rowing as a subject and never revisited the theme.

Instead, Eakins began to explore the subject related to the fourth of the watercolors shown in New York in 1874—*Harry Young, of Moyamensing, and Sam Helhower, "The Pusher," Going Rail Shooting* (Wichita Art Museum). In the sheet and the oil painting that replicates it at scale, *Starting Out after Rail* (pl. 12), two men sail a small boat. One turns toward us, while the other, hand on rudder, bends to peer beneath the boom, checking his passage. A gun and the pole strapped into the boat show that the subject of this rigorously plotted painting is rail shooting, a sport Eakins and his father had long enjoyed.

The subject presented one of Eakins's favorite technical challenges: "I know of no prettier problem in perspective than to draw a yacht sailing," he wrote in the early 1880s. "Now it is not possible to prop her up on dry land so as to draw her or photograph her, nor can she be made to hold still in the water in the position of sailing. Her lines though, that is a mechanical drawing of her can be had from her owner or her builder, and a draughtsman should be able to put her in perspective exactly."[31] Eakins evidently set great store by *Starting Out after Rail,* for he sent the oil version to Paris in 1874 for Gérôme's approval. The Frenchman praised the work and arranged for its display in Paris.[32]

Eakins had begun devising pictures showing the next phase of the hunt—shooting the gamebirds in the marshes—in the fall of 1873, but he contracted malaria and was incapacitated for months:

> I would have made the details of the marsh better if I had been able to finish my studies. While waiting for the season that I represented in my picture I caught malaria pursuing this same hunt, and the fever took me badly. I was bedridden 8 weeks, senseless most of the time. They believed that I would die.... I was going to keep my painting until this fall, but the doctor forbids me to go hunting this year even though I have been used to going there since childhood. It will be dangerous to me.[33]

Even without being able to revisit the site, Eakins completed at least three major oils on the theme of rail hunting in the marshes by 1876.

One characteristic of Eakins's early genre groups is his orchestration of various moods and formats within similarly themed works. An obvious example of this quest for novelty is the frieze-like *Pushing for Rail* (pl. 11), with a canvas shape popular with such landscapists as Worthington Whittredge and William Trost Richards but unusual for figural artists. Each of the three pairs of hunters, individually characterized in nearly microscopic detail—the red-and-white plaid shirt and diamond-pane patterned scarf of the man at the right are particularly striking—and equipped with guns and poles, acts out a different phase of the hunt: shooting at the right, poling at the center, and reloading at the left. This involved narrative picture, with its crustily textured landscape setting, was apparently another of the paintings that Eakins sent to Gérôme in Paris for submission to the Salon in 1875.[34]

Philadelphia's great Schuylkill and Delaware rivers flow through and beside the city, and for Eakins, sailing their waters was a great joy. He even reminisced from Paris that sailing "is much better than rowing."[35] Unable to go to the marshes because of his malaria, in 1874, Eakins turned several times to sailing subjects. *Sailboats Racing on the Delaware* (pl. 10) is one of his most joyous outdoor scenes.[36] Beneath a bright blue sky, the dark waves are moderately choppy. But the sleek boats seem to smooth out the roughness as they glide over the water. A shadow coming into the scene at left and the cropped hiker at right lend momentum and competitive thrust to the principal craft (clearly identified by the number 25 on the sail—although none of the individualized crew, other than Eakins's friend Harry Lewis who leans out over the side, can now be named).[37] Eakins devoted great care to the portrayal of the boats, which he declared to be "the hardest thing I know of to put into perspective," explaining that a boat "is so much like the human figure, there is something alive about it."[38] *Sailboats*

Racing was one of four works Eakins sent to Gérôme for counsel and approval in 1875. He reported to Earl Shinn, however, that their master "pitched into the water of the big one said it was painted like the wall."[39] Perhaps this is one reason why the work, shown in Europe in 1875, made its American debut only at the end of 1883 in Philadelphia and in New York at the Society of American Artists in 1884—when Eakins had more confidence and the public had been acclimated to looser finish. It thus appeared years after Winslow Homer's similarly themed sailing scene, *Breezing Up (A Fair Wind)* (1876, National Gallery of Art, Washington, D.C.), had in 1876 delighted critics and public alike.[40]

Eakins continued to search for innovative subjects. In the late nineteenth century, baseball was evolving as a professional sport; with his watercolor *Baseball Players Practicing* (pl. 14), Eakins became one of the first artists to perceive its pictorial potential. He described the scene simply:

> The ball players [are] practising. The moment is...just after the batter has taken his bat, before the ball leaves the pitcher's hand. They are portraits of Athletic boys, a Philadelphia club. I conceive that they are pretty well drawn.
> Ball players are very fine in their build. They are the same stuff as bull fighters only bull fighters are older and a trifle stronger perhaps. I think I will try [to] make a base ball picture some day in oil. It will admit of fine figure painting.[41]

His pride in the work was manifest in his decision to show it repeatedly for a full decade, at venues including the American Society of Painters in Water Colors (1875) and the Centennial International Exhibition (1876).[42] Critics responded to the watercolor's "repressed action"[43] favorably, finding the sheet "excellent in drawing, attitude, and expression"; while they disagreed about the quality of the color—which some found "crude" but others, "pure and strong"[44]—it was notable enough to suggest comparison to another great American original, Winslow Homer: "Mr. Eakins enters the lists with Mr. Homer, in his 'Ball Players,' with its vigorous contrasts of bright green grass, and the illuminated white and blue of the players' costumes against a well-devised back-ground."[45] Shinn responded to the work at length:

> The most admirable figure-studies, however, for pure natural force and virility, are those of Mr. Eakins, in which the method of Gérôme is applied to subjects the antipodes of those affected by the French realist.... The selection of the themes in itself shows artistic insight, for American sporting-life is the most Olympian, beautiful, and genuine side of its civilization from the plastic point of view; and the treatment, though a little stiff and labored, is pre-eminently sincere.... The business of the scene...is attended to with the religious fidelity which a Greek sculptor would show in a commemo-

rative athletic statue; and the forms of the youthful ball-players, indeed, exceed most Greek work we know of in their particular aim of expressing alert strength in a moment of tension.[46]

Eakins, admiring Gérôme's imagined scenes of gladiatorial combat in ancient Roman amphitheaters,[47] had found a modern American analogue to express his admiration of athletes, outdoor activity, and the peculiarly modern developments of sport.

During the years before 1875, Eakins had other pictures under way. Rather than featuring active men in the open air, these show quiet, reflective women in shadowed interiors. Spaces in these works are shallow and bounded by large pieces of furniture; physical action is limited. One of the earliest, *Home Scene* (pl. 5), shows a young woman seated at a piano, dressed in black with a startling magenta-trimmed gray vest. She turns from the keyboard to watch a young girl draw on a slate in the foreground. The child wears vivid plaid, the patterning of which minimizes the twist and foreshortening of her body at the same time as it pits itself against the floral design of the broadloom rug. The painting possesses a mute narrative: the woman has evidently stopped her music-making to pick up a kitten that now nestles on her shoulder; she watches the girl draw, the line of her gaze continued by the child's attention to her slate. A second strand of narrative is the presence of the black cat at the left who looks up toward the kitten the woman holds. These expressions add spatial and dramatic depth to the work, suggesting parallel demonstrations of maternal observation.

Eakins's small canvas has an aptly Victorian, claustrophobic character. He suggested this, however, not so much by a welter of objects and contrasting textile patterns—although these are factors—as by the way in which woman and child twist to squeeze into its confines. The girl's three-point support on elbows and hip, and the tension between her position in space and its denial by her plaid, animates the lower range of the canvas. The improbable angle of the woman's left wrist and the tilt of her large head fill its upper reaches. This is very different from comparably scaled works of Eastman Johnson, for example, whose figures quietly loom from a similar darkness but fit easily into their spaces.

Music-making among the daughters of a family was an important part of middle-class modernity.[48] An element of female socialization, accomplished playing, then as now, was considered an admirable skill.[49] But in *Home Scene* the piano is not in use. It is the web of relationships that stands at the picture's center. And because of the cat's attention to the kitten, the implication is that the woman at the piano is the child's mother, yet the sitters are two of the painter's three younger sisters: Margaret at the piano and Caroline drawing. Which raises the ques-

tion of why Eakins did not enlist his mother to pose and make the parallel neat. Sorority replaced maternity for good cause; Eakins's mother, shortly after his return from France, increasingly lost her mental faculties. In April 1871 a family friend wrote: "Tom Eaken has been at home since July 4th. Since early autumn he has never spent an evening from home as it worried his Mother... they never leave her a minute."[50] She died on June 4, 1872, her death certificate citing "exhaustion from mania" as the cause.

In addition to his own sisters, Eakins also painted the two younger sisters of his friend William Crowell, Kathrin and Elizabeth. Kathrin, who would become his fiancée in 1874 (she would die five years later of meningitis, still unmarried), was the subject of his first large, full-length portrait, signed and dated in 1872.[51] In this same year, Will Crowell married Eakins's third sister Frances and moved into the Eakins home, where the young family stayed for five years.[52] Naturally, therefore, the Crowell sisters were often in Eakins's company. The younger, Elizabeth, was said to be "very vivacious as well as pretty."[53] Eakins painted her twice. The earlier canvas is the small *Elizabeth Crowell with a Dog* (pl. 9). The young woman, wearing a black skirt, red blouse with black stripes, and elaborate white hat, sits on the floor, training a dark poodle. She seems to have just come from outside—a bundle of books strapped together rests beside her, and coats and wraps of various kinds unceremoniously drape over the furniture. Intimate and informal, the small picture subsumes the girl's firm hand gesture of command within a warm and somber atmosphere.

In 1875 Eakins undertook a very different kind of painting of Elizabeth, a full-length seated portrait at life scale showing her at the keyboard (pl. 13). She was a skillful pianist who studied at the Philadelphia Musical Academy (graduating in 1878) and later taught the instrument.[54] Eakins made the light fall from behind the figure, highlighting her cheek, ear, and hand, and illuminating the sheet music, which in turn casts reflected light back onto her face. The effect is of glowing form emerging from palpable atmosphere—a much more suggestive evocation than the more linear visages of his outdoorsmen. And yet the coarseness of other passages, such as the wall behind her, emphasizes the act of painting rather than illusionism.[55] These extremes of technique borrow from various old masters—Rembrandt and Velázquez—no less than from Eakins's own Parisian master Léon Bonnat.

The large canvas—part portrait, part genre scene—was one of Eakins's favorites. It is the only early work of a woman that he put on exhibit; he showed no other portrait of a woman until 1887.[56] When first on public view at the Centennial, it was considered "strongly painted," with its "action... rendered with the utmost refinement and there is superb painting

in it.... It can be seen at a glance, however, that the artist has attempted something more than the mere making of recognizable likeness and has aimed to make his portraits pictures in every sense of the word."[57] In 1880, when the painting was exhibited at the Society of American Artists, S.G.W. Benjamin coined a new category for it, calling it "one of the most striking, carefully executed semi-portrait compositions of an artist whose works always command our respect, if they do not enlist our sympathies."[58] The idea of the picture's straddling the divide between portrait and genre scene is important: Eakins's radical approach to subject matter included not only finding new themes but testing the boundaries between them.

The work's low tone was also continually spoken of, and must have been pronounced in exhibitions where some of the leading young painters, such as John Singer Sargent, sought to capture the impression of bald sunlight. Phrases such as "a blackish fog" or "blackness descended like a blight" were applied to *Elizabeth Crowell at the Piano* in 1880.[59] Most writers, however, went on to note that, with time, the picture "seems to develop depth on depth of life, sweetness, delicacy, and well-understood subtle movement."[60]

After years of exploring original subjects of men in the outdoors, or new and broodingly intense images of women in interiors, Eakins felt himself on the cusp of a new advance. In late March 1875, he wrote to Shinn: "I feel to myself that I am going soon to do work so much better than anything that I have made yet, that if I had my own way entirely, I would destroy or keep to myself everything I have done this far, but there is no particular harm done by exhibiting if it calls any attention to my name or causes any expectations from me, or will bring me in a little money of my own." He closed, "I am doing far better work just now, at least it is ten times better commenced."[61]

It seems likely that the work that so sparked Eakins's enthusiasm was the painting that occupied him for nearly all the year—the portrait of Dr. Samuel D. Gross (1805–1884), surgeon and teacher at Jefferson Medical College, author, inventor, and statesman for the discipline of surgery (pl. 16). Eakins's choice of subject reveals an appreciation of the individual stature of Gross, the importance of medical advances as a marker of modern culture, and Philadelphia's role in those advances.[62] Eakins, who initiated the project, did not seek to paint a traditional portrait. Instead, his goal was to portray Gross in the surgical arena, healing and teaching simultaneously, surrounded by his assistants and his students. As with his paintings of athletes, this was a new type of subject, virtually unknown in American art and with few precedents even in the European tradition.[63]

The artist's motives in undertaking the work were complex. He may have hoped that the large, ambitious canvas would appeal to the alumni of the Jefferson Medical College, who had in 1871, at Gross's urging, begun a program to "adorn the halls" with portraits of its distinguished teachers.[64] Probably even more compelling to the young painter, however, was the opportunity for notice offered by the international art fair to be held in conjunction with the Centennial Exhibition of 1876.

Up to that time, Eakins's exhibition works had been modest in scale. With the challenges of the Centennial, however, and his own advancing confidence, he sought to rival the grandest portraits and history paintings of the European and American traditions. He was at work on the painting by April 13, writing Shinn: "What elates me more is that I have just got a new picture blocked in & it is very far better than anything I have ever done."[65]

The Gross Clinic shows the surgeon standing, head raised and looking out toward the students seated in the amphitheater. Strong light from the operating theater's skylight falls on his brow, nose, and right hand, which holds a scalpel. He is momentarily still, although the aureole of light-struck grizzled hair around his head conveys the impression of crackling activity and energy. Beside him, five doctors attend to the patient, whose cut thigh, bony buttocks, and sock-clad feet are all that is visible to the viewer.[66] At least twenty younger men stand or sit in the background, presenting a veritable catalogue of seated poses and lounging postures; they observe or take notes concerning the procedure, as is the case with the clinic clerk to the left and the artist's intensely eager self-portrait at the far right, which is probably based on a photograph.[67] The setting implies that the viewer, too, is in the vast amphitheater, which could seat six hundred.[68] In the lower left corner of the canvas, behind Gross and the obscured attending physician, sits a woman in black, her gnarled, aged hands held up before her downturned face.[69] In terms of subject, Eakins seems to have been intent on conveying the likeness of Gross and the specifics of the operation and its technologies, entwining them into an emblematic moment of modern heroism. Gross was known particularly for this operation, a hallmark of conservative, limb-retaining surgery.[70]

Aesthetically, the greatest challenge Eakins set for himself was the discrimination of tones: in a predominantly dark work, using clearly graduated darks so as to model and distinguish forms while relating them to the more crucial, lightly toned narrative elements of head, hand, and operating table. The importance of the tonal relations within the work is clear in the *Sketch for "The Gross Clinic"* (pl. 15), in which the light elements of the canvas are already in place, including such seemingly small details as the parted hair of the anesthesiologist; Eakins's concern at this early stage with the impact of a gilt frame—he simulated its effect with a gold border painted

around the sketch—likewise testifies to his early conceptualization of the whole. In the finished work, the virtuosic differentiation of blacks in the lower left corner, portraying the dark suits of three men—this is just prior to the widespread adoption of the antisepsis principle—and the woman's dress, readily reveals distinct underlying forms as well as the fall and pull of varying textiles under stress of movement.[71]

Given the scale of the painting, Eakins anticipated that it would be seen from a distance and hence painted much of it with bold, broad work. The most finely detailed passages, which help aim the viewer's attention, are Gross's grizzled hair and the glinting highlights on the metal of his scalpel, his watchchain, and the retractors that hold apart the sides of the incision he has just made.

In addition to tonality and specificity, Eakins also used hue to direct the viewer's attention within the painting. There are relatively few touches of bright color anywhere in the large work: pinks, teals, and reds in the foreground still life; the blue-gray of the patient's socks; and the brilliant red passages that depict blood on the hands of the surgeons and in the wound itself. These last, through color, detail, and theme, drew a great deal of attention during the early years of the painting's public exhibitions.

Eakins submitted four oils and two watercolors to the Centennial Exhibition jury: *The Gross Clinic*, *Portrait of Dr. Benjamin H. Rand* (Jefferson Medical College), *The Chess Players* (pl. 19), *Elizabeth Crowell at the Piano*, *Baseball Players Practicing*, and *Whistling for Plover* (Brooklyn Museum of Art). *The Gross Clinic* was rejected.

Somehow, probably through the machinations of Gross and his colleagues, the painting and a collotype after it were nonetheless put on view in the Centennial grounds at the United States Army Post Hospital, in a ward filled with hospital bedding and furniture. Commentators wondered at the placement: "It was one of the most powerful and life-like pictures to be seen in the Exhibition, and should have had a place in the Art Gallery, where it would have been but for an incomprehensible decision of the Selecting Committee."[72] The critic Clark—who had earlier written, "This portrait of Dr. Gross is a great work—we know of nothing greater that has ever been executed in America,"[73] returned to his defense of the picture:

> There is nothing so fine in the American section of the Art Department of the Exhibition, and it is a great pity that the squeamishness of the Selection Committee compelled the artist to find a place for it in the United States Hospital building. It is rumored that the blood on Dr. Gross' fingers made some of the members of the committee sick, but, judging from the quality of the works exhibited by them we fear that it was not the blood alone that made them sick.

Artists have before now been known to sicken at the sight of pictures by younger men which they in their souls were compelled to acknowledge were beyond their emulation.[74]

Eakins sold *The Gross Clinic* on February 23, 1878, to Jefferson Medical College for two hundred dollars. At the time, the college was the most logical home for the large painting.[75] Eakins nonetheless believed that the work represented his most ambitious efforts and borrowed the painting from the college for exhibitions throughout his lifetime. The earliest of these was the second annual exhibition of the Society of American Artists in New York in March 1879. There the critics' responses were extensive and extreme. Some few were favorable. The writer for the generally sympathetic *Daily Graphic*, for example, in addition to reproducing a line drawing of the work with his column, proclaimed: "The entire picture is a serious, thoughtful work, and we can readily understand what a fascination a subject like this must have for an artist who is himself a profound student of anatomy. There is thought and feeling of a high order in this painting, and in this respect it is in marked contrast with many of the works that surround it."[76]

A majority of the writers, however, drew harshly negative conclusions. It was, wrote the critic for the *New York Daily Tribune*:

> one of the most powerful, horrible and yet fascinating pictures that has been painted anywhere in this century—a match, or more than a match, for David's "Death of Marat," or for Géricault's "Wreck of the Medusa." But the more one praises it, the more one must condemn its admission to a gallery where men and women of weak nerves must be compelled to look at it. For not to look at it is impossible.[77]

Two weeks later the same writer returned to the subject, unable to purge his mind of the image:

> The more we study Mr. Thomas Eakins's "Professor Gross," No. 7, the more our wonder grows that it was ever painted, in the first place, and that it was ever exhibited, in the second. As for the power with which it is painted, the intensity of its expression, and the skill of the drawing, we suppose that no one will deny that these qualities exist.... It is a picture that even strong men find it difficult to look at long, if they can look at it at all, and as for people with nerves and stomachs, the scene is so real that they might as well go to a dissecting-room and have done with it.
>
> ...No purpose is gained by this morbid exhibition, no lesson taught—the painter shows his skill and the spectator's gorge rises at it—that is all.[78]

Controversy continued to swirl around the painting when, upon its return to Philadelphia and in contravention of all agreements, it was excluded from the gallery where other pictures from the Society of American Artists' exhibition had been gathered as a special component of the Pennsylvania

Academy of the Fine Arts' annual. Instead, it was hung in a distant hallway. Eakins and representatives of the society protested the arrangement, which was noted in newspapers up and down the Eastern seaboard, but to little avail.[79] The fact that by 1879 Eakins was teaching at the Academy only added to the awkwardness of this deliberate slight against his largest and most important work to date.

Of the six paintings and watercolors that Eakins showed at the Centennial, only one was dated to 1876: *The Chess Players* (pl. 19).[80] This was in many ways the diametric opposite of his portrayal of Gross's surgical clinic. Painted on a small wooden panel, which encouraged a fine and detailed technique, it shows a private moment of leisure set within a shadowed, middle-class parlor, filled with Renaissance revival furniture and various *objets d'art*—the wicker work table, hookah, mantel clock, framed engraving of Gérôme's *Ave Caesar, Morituri Te Salutant* (original 1859, fig. 35), and globe are particularly prominent, as are the contents of the two tables in the foreground.[81] Although many writers have identified the setting as the Eakins family parlor on Mount Vernon Street, Susan Eakins, who came to live in that house in the 1880s, asserted that the scene was set elsewhere.[82] The room itself is subordinate to the figures: French teacher Bertrand Gardel, father and writing master Benjamin Eakins, and artist George W. Holmes. Their serious, wise faces are focused on the game, while their dark-clad bodies reveal distinctly informal postures. Holmes, who seems to be winning the chess match, straddles a leg of the game table while Gardel crosses his legs and folds into himself; most surprisingly, Benjamin Eakins stands on one leg, his other knee resting on the seat of the chair at his side. Strong light falls from the right to illuminate Gardel's head most directly, the senior Eakins next, and Holmes the least, prompting the movement of the viewer's attention from left to right, echoing the action in Gérôme's *Ave Caesar* in the background. But Eakins handled the parallels between gladiatorial and intellectual combat, as well as the homage to both father and artistic master, lightly; they are present (he even signed the work *Benjamini.Eakins.Filius)* but unforced. Viewers can appreciate the scene, its atmosphere of tranquil thought and the fragility induced by time's passage without recognizing the work's welter of autobiographical references.

From its first public appearance at the Centennial, up to five years later when the artist donated the work to the Metropolitan Museum of Art, *The Chess Players* gained appreciative audiences. When on view at the Metropolitan Museum in 1880, Shinn praised the painting in the very highest terms:

> Eakins's masterpiece, the "Chess-players," is hung between a "real" Meissonier and a "real" Zamaçois. Though voluntarily low in tone, it is obviously and decidedly superior

to either. It has a deep and wizard-like power of making a harmony out of the most horrible scroll-sawn and wholesale warehouse furniture; a twilight of poetry and feeling envelops it, out of which emerge three heads as solid, real, and well characterized as were ever done.... Out of the very burgher-like and commonplace everyday air of these characters the painter has managed to construct an art-sympathy of the greatest elevation and purity.[83]

In 1881 a writer claimed that no other Eakins work "has been so unreservedly admired by artists. It requires a special lighting, being painted in a mistakenly low key; but treated fairly, and well flooded with light, it is found to equal in quality the very best Meissoniers."[84]

The Chess Players was, in nearly every way, a strikingly successful work for Eakins: critically appreciated for its craft no less than for its message, favorably compared with works of the most famous of modern masters, and accepted into the halls of a prominent new museum. He never did another work quite like it.

This behavior recurred throughout Eakins's career: he continually searched for new themes or fresh variants in presentation. Those that were successful, and readily accepted, he frequently moved away from, leaving a string of masterful, *sui generis* works. Those that were controversial he pursued, seemingly provoking his viewers until they came to understand and appreciate his particular melding of craft and vision. Among the most striking of the singular works is a family portrait of 1876—*Baby at Play* (pl. 18).

The painting shows his niece Ella Crowell (1873–1897), portrayed at life scale, in the brick-paved backyard of the Eakins family home. Although executed in 1876, in some sense this work continued the earlier series that focused on his sisters, such as *Home Scene*: it features an intimate environment, a female relative absorbed in a solitary activity, and an emphasis on details of costume and textiles. And, as with the portraits of his sisters, this was a private work that Eakins never exhibited to the public. It expands the parameters of the series, however, in several ways. First, it takes place outdoors; it is one of the very few works in his oeuvre to feature both the "sunlight & children" that he claimed to love in the often-quoted letter to his father of 1868.[85] Second, it includes a bounty of still-life objects—toys of various kinds—in a well-defined space. And the canvas is surprisingly large; at just over four feet across, it is broader than all but one of his known outdoor sporting paintings and much larger than any of the paintings of the Eakins sisters.

This scale, taken in conjunction with the child's eye-level viewpoint, lends the painting an unnerving monumentality that erases the sentimentality that might otherwise adhere to

the picture's subject. The absorptive intensity the child dedicates to her task has prompted recent writers to interpret the painting as an emblem of learning and educational reform.[86] These, and others who are concerned with the "essentially conflictual nature of Eakins's art," have rightly posited that in spite of their seemingly disparate subjects, *Baby at Play* and *The Gross Clinic* share significant thematic and structural elements: the acquisition and disposition of knowledge, the will to alter the givens of the world, and the intense play of formal and thematic oppositions.[87] Serious purpose informs even the most elementary of Eakins's subjects.

During the 1870s, Eakins painted occasional portraits, removed from the dramatic and narrative framework of the sporting scenes and *The Gross Clinic*, of people beyond the circle of his immediate family and close friends. The single portrait from this era that Eakins seems to have favored most was that of John Hill Brinton (1832–1907, pl. 17). Brinton, whom Eakins painted in the summer and fall of 1876,[88] had a distinguished career as medical director on various campaigns in the Civil War. When painted by Eakins, he had been surgeon of the Philadelphia Hospital for nearly a decade.[89] Eakins first showed the portrait at the Pennsylvania Academy of the Fine Arts Annual of 1877, where the critic for *The Art Journal* praised it as "the finest work that Mr. Eakins has yet executed."[90] In 1879 Eakins borrowed the painting and submitted it to the National Academy of Design. The painter evidently felt that the portrait of Brinton represented the more traditional side of his character, and, indeed, the work—which compares well with portraits by such painters as Eastman Johnson in conveying the specifics of individual physiognomy within a dignified, informal setting—attracted favorable notice from several of the more conservative critics. The writer for *The Art Journal* called it "a very vigorous full-length likeness," stating that the "pose is natural and effective, and it is in every respect a more favourable example of this artist's abilities than his much-talked-of composition representing a dissecting-room."[91]

Later Eakins painted at least two other small works for Brinton: a panel, *The Brinton House* (c. 1876, private collection), an imaginative reconstruction of Brinton's ancestral home in Chester County,[92] and a portrait of Sarah Ward Brinton in 1878 (pl. 44) showing her head downturned, studying a red fan. She sits in the carved Jacobean-style chair that Eakins would use in portraits throughout his career.[93] Here, because of the angle at which it is presented and the format of the canvas, the chair seems a sheltering, protective entity encasing the small, slumping body of the sitter. Mrs. Brinton's large head and left hand are detailed with a precision and close focus Eakins lavished on few outside his family. With its deep color

harmonies of mahogany browns, blacks, whites, and reds, the painting attains a luminous richness of effect parallel to that in works by Henri Fantin-Latour or Gustave Courbet.

In the years around the American Centennial of 1876, many artists began to make scenes based on America's past— sometimes as re-creations of historic moments, sometimes as genre evocations of the everyday life of past times, sometimes as a blending of the two. Eakins, too, succumbed to the romance of what has since been called the Colonial Revival. Beginning no later than 1876, Eakins undertook what would become one of his most involved and complex projects of the decade: *William Rush Carving His Allegorical Figure of the Schuylkill River* (pl. 41). Rush, a Philadelphia-based shipcarver and sculptor born in 1756, was best known in the later nineteenth century for his allegorical figures, then still in situ at the Fairmount Waterworks, and the full-length *George Washington* (1814) at Independence Hall. The sculptor had also fought in the Revolutionary War and contributed to Philadelphia's municipal life, playing roles in the development of the city's waterworks and the founding of the Pennsylvania Academy of the Fine Arts. As the engaged citizen-artist, Rush readily served as an exemplary figure for the young painter.

Atypically, Eakins wrote about his project several times. His fullest text explicates several of the reasons why he was drawn to the theme as well as some of the avenues he explored in its realization:

William Rush was a celebrated Sculptor and Ship Carver of Philadelphia. His works were finished in wood, and consisted of figureheads and scrolls for vessels, ornamented statues and tobacco signs called Pompeys. When after the Revolution American ships began to go to London, crowds visited the wharves there to see the works of this Sculptor.

When Philadelphia established its Water-works to supply Schuylkill water to the inhabitants, William Rush then a member of the Water Committee of Councils was asked to carve a suitable statue to commemorate the inauguration of the system. He made a female figure of wood to adorn Centre Square at Broad Street and Market, the site of the waterworks, the Schuylkill water coming to that place through wooden logs. . . .

Rush chose for his model, the daughter of his friend and colleague in the water committee, Mr. James Vanuxem, an esteemed merchant.

The statue is an allegorical representation of the Schuylkill River. The woman holds aloft a bittern, a bird loving and much frequenting the quiet dark wooded river of those days. A withe of willow encircles her head, and willow binds her waist, and the wavelets of the wind-sheltered stream are shown in the delicate thin drapery, much after the manner of the French artists of that day whose influence was powerful in America. The idle and unobserving have called this statue Leda and Swan and it is now generally so

miscalled.

The shop of William Rush was on Front Street just below Callowhill and I found several very old people who still remembered it and described it. The scrolls and the drawings on the walls are from an original sketch book of William Rush preserved by an apprentice and left to another ship carver.

The figure of Washington seen in the background of the painting is in Independence Hall. Rush was a personal friend of Washington and served in the Revolution. Another figure of Rush's in the background now adorns the wheel house at Fairmount. It also is allegorical. A female figure seated on a piece of machinery turns with her hand a water wheel, and a pipe behind her pours water into a Greek vase.[94]

During an initial preparatory stage, Eakins made a series of at least six wax figurine maquettes, which were easily manipulated and studied in varying light conditions (pls. 33–37).[95] Three of the wax models were based on the principal sculptures by Rush to be featured in Eakins's canvas: *George Washington*, *The Schuylkill Freed*, and the centerpiece of the narrative, *Water Nymph and Bittern*. He also made a model of the nymph's head and, largest and most detailed of all, a portrait of Rush taken from the sculptor's self-portrait of 1822.

As part of his ambitious, multiple-stage art-making process—what the painter's friend Shinn enumerated as the "apparatus of hiring properties, arranging incidents, and employing models, by which conscientious works of art are elaborated"[96]—Eakins made oil studies, such as that showing an interior of a woodworking shop (pl. 38), to help set the scene. He must also have used plans and perspective drawings to establish the position of the principal objects in the murky room, although none are now known. His wife later indicated that he had photographs of Rush's works, but they, too, are unlocated.[97]

Eakins's extent of wrestling with the project is manifested in a good-sized canvas now in the Yale University Art Gallery (pl. 40); this is not so much a study for the project as an abandoned first version. In it, the roughly finished *Water Nymph and Bittern* and the nude model, who stands on a hastily suggested stump in the foreground, share the picture's center; both have their backs to the viewer. To the left, in workman's shirtsleeves, Rush—bald and aged, as in his self-portrait and Eakins's wax model after it—carves the statue's knee. On the other side, a woman in dark clothes of the 1870s faces the far right corner of the workshop, emotionally removed from the central thematic activity. Eakins brought the figures of the two women to a fairly high finish and effectively sketched in the rest of the composition. Yet something caused him to abandon the canvas and start anew.

The scope of this reconsideration is unusual in Eakins's oeuvre. Throughout his career there is often a startling congruence between the artist's earliest extant compositional study and finished version. But here, when Eakins began again, he recast the whole entirely. He turned the slimmer model slightly to the left, providing a more elegant outline for the nude; another study (pl. 39) marks a moment of experimentation in this direction. He likewise decided to reorient the chaperone to face toward the center of the room, imparting a shared psychological moment to the three figures. He furthered this effect by rotating the *Water Nymph and Bittern* to look forward, so that model and statue reflect one another. Most obviously he made the sculptor younger—departing from the wax maquette after Rush's late self-portrait—the chaperone older, and, dressing them both in garb appropriate to about 1810, re-emphasized the setting in the past by placing a still life of the model's old-fashioned clothing atop a Chippendale chair in the foreground.

This emphasis on clothing and everyday props from the past implies that only toward the end of the project, after the canvas now at Yale was well begun, did the painter decide to cast the work into a decidedly historicist mode. His reasons for this change are not recorded, but it seems likely that the range of historicizing art on display at the Centennial Exhibition, from both North America and Europe, may have influenced him. Likewise, the reopening of the Pennsylvania Academy in the spring of 1876 and Eakins's own affiliation with the Academy in September may have opened up opportunities for research within its holdings.

Pages taken from a variety of sketchbooks and other drawings (pls. 20–32) document the wealth of historical materials, in addition to Rush's works, that Eakins studied as he conceived and prepared for this phase of the painting: John Lewis Krimmel's *Fourth of July at Centre Square* (by 1812, on view in the Pennsylvania Academy of the Fine Arts from the spring of 1876), costume and historical prints from the Academy's collection, a portrait of Rush now attributed to Rembrandt Peale (by 1813, Independence Hall, Philadelphia), eighteenth-century furniture (a chair lent by Eakins's friend Dr. S. Weir Mitchell), and a now-lost notebook of designs once owned by Rush, among others.[98]

The theme of William Rush fits within the tradition of the "artist in his studio," a series that extends back to at least the seventeenth century and forward to include many of the painters Eakins most admired: Velázquez, Ingres, Fortuny, and Gérôme.[99] Eakins's choice of an American sculptor of the early nineteenth century, however, was characteristically innovative, charged with issues of American patriotism, Philadelphia chauvinism, and academic principle. It is not a record of a real event: Miss Vanuxem probably did not pose nude for the sculptor, and the collection of works on view in the workshop spans the full range of Rush's career. But the scene epitomizes Eakins's belief in the centrality of the human figure as the basis for art-making and the propriety possible in that situation.

When Eakins exhibited the painting, first in the Boston Art Club in January 1878, then in the inaugural exhibition of the Society of American Artists in New York, it proved controversial. Despite its status as a history painting, the figure of the nude enflamed critical opinion. While some accused the model of ugliness,[100] it was the writer for *The New York Times* who identified the problem of the work's reception as accurately as anyone: "What ruins the picture is much less the want of beauty in the model, (as has been suggested in the public prints) than the presence in the foreground of the clothes of that young woman, cast carelessly over a chair. This gives the shock which makes one think about the nudity—and at once the picture becomes improper!"[101]

Eakins showed the painting several times over the next five years. Probably the most interesting response came from Van Rensselaer, who often found virtues in Eakins's work where others found dross:

> The Sculptor Rush Carving his Allegorical Figure of the Schuylkill, has been exhibited before, but is always welcome. The intense sincerity, the truth to actual life, the neglect of all "decorative" elements and all embellishing of a homely subject, which characterize this painter are nowhere to be more clearly seen. It is not an attractive, still less a beautiful subject. But the homely figures, including the rather ugly back of the model, are wonderfully painted. And the heap of clothes on the chair, and the unconcerned air of the knitting attendant, are touches which we should not get from any artist less loyal to the realities of life, less naïvely truthful, less straightforward and unself-conscious than Mr. Eakins. It is called an ugly picture. Perhaps it is; but it is a very good one all the same, and worth a hundred dozen of "studio arrangements" or designedly picturesque compositions,—foreign, archaeological, sentimental, "decorative" or other. It is as vivid, as truthful, as "naturalistic," at the same time as artistic as a page of Balzac.[102]

The critic's appreciation of Eakins's sincerity—a key element in the realist credo[103]—and his craft leads naturally to the association with Balzac, especially apt in light of Balzac's dual allegiance to observation and imagination. But whether or not the artist could be considered naive and unself-conscious is another matter. The involved preparations initiated to ground the painting within an illusionistic space and with veristic details speak of an intent purpose. The choice of subject, with its emphasis on the nude model—picturing an episode that almost certainly never occurred and was probably not even rumored before Eakins imagined it—likewise bespeaks a catalyst within Eakins's life in the 1870s rather than the re-creation of Rush's in 1809.[104]

Indeed, in 1876 and 1877, Eakins had been actively considering how best to teach figural art. The principal art instruction in the city took place at the Pennsylvania Academy of the

Fine Arts, the "oldest and richest in America."[105] In May 1876, after having been closed since 1870 as its new Frank Furness–designed building was erected, the Academy reopened its galleries; the schools followed in the fall.[106] Eakins then volunteered to assist the ill and partly paralyzed professor of painting and drawing, Christian Schussele, in the evening life class. During his short tenure—he resigned in May 1877 when the board determined that Schussele could not delegate his responsibilities—Eakins wrestled to improve the caliber of the life models. He wrote to the board of the Academy in January:

> The Life Schools are in great need of good female models.
> I desire that an advertisement similar to the following be inserted in the Public Ledger.
> "Wanted Female Models for the Life Schools of the Pennsylvania Academy of the Fine Arts.
> Apply to the Curator of the Academy Broad & Cherry at the Cherry St. entrance.
> Applicants should be of respectability and may on all occasions be accompanied by their mothers or other female relatives. Terms $1 per hour."
> > John Sartain
> > Chairman of Com. on Instruction"
> The privilege of wearing a mask might also be conceded & advertised.
> The publicity thus given in a reputable newspaper at the instance of an institution like the Academy will insure in these times a great number of applicants among whom will be found beautiful ones with forms fit to be studied.
> The old plan was for the students or officers to visit low houses of prostitution & bargain with the inmates.
> This course was degrading & would be unworthy of the present academy & its result was models course [*sic*], flabby, ill formed & unfit in every way for the requirements of a school, nor was there sufficient change of models for the successful study of form.[107]

No public action was taken on Eakins's request.[108] He seems to have conflated the fact that Louisa Vanuxem, a woman of good family, had in 1809 posed for Rush, with the educational principles he had imbibed in France on the academic dependence on the nude, concocting an exemplary native "tradition" to assist his current need. As Shinn wrote in response to the work: "The painter of the fountain seemed to have a lesson to deliver—the moral, namely, that good sculpture, even decorative sculpture, can only be produced by the most uncompromising, unconventional study and analysis from life, and to be pleased that he could prove his meaning by an American instance of the rococo age of 1820."[109] The work was not as unself-conscious as Van Rensselaer supposed.

Eakins undertook a cluster of works based on historical themes while he worked on the William Rush. Some of these are independent of the larger work, such as the watercolor *Fifty*

Years Ago (pl. 43), which purports to show a figure of the later 1820s. Others are closely related to the William Rush campaign. The watercolor *Seventy Years Ago* (pl. 42)—which Eakins showed to wide acclaim in Philadelphia and New York,[110] selling it at the annual exhibition of the American Society of Painters in Water Colors in 1878—nearly replicates the figure of the chaperone in William Rush as seen from a different angle, featuring the same model, activity, and a closely related costume.

Another branch of genre painting, popular at exhibitions and with collectors, was the portrayal of African-American life. Eakins had earlier shown African Americans as hunters or polemen, active in the outdoors and in public. But with *The Dancing Lesson* (pl. 45; also known as *Study of Negroes*, *The Negroes*, and *Negro Boy Dancing*), he chose to show an interior, private moment of African-American life, parallel in subject to contemporary works by Winslow Homer, Thomas Hovenden, William Magrath, and others.[111] Works by those artists often had education or music as themes; Eakins blended the two.

The ambitious multifigure sheet was a great success at its debut in New York. Clarence Cook, for example, praised it at the expense of the popular French master Detaille:

> Mr. Eakins, as a scientific draughtsman, is just a baby compared to the learned young Frenchman, but he sees as far into human nature and can just as well represent that nature in action. Here are three living human beings, each distinctly marked in character and each absolutely truthful in the presentment. So far as the drawing has to do with the representation of bodily action and that action the result of thinking and will, drawing here does all that it can ever do. Other charms may be wanting, beauty of color, skill of handling, but here is life, and when an artist has this he has all.[112]

The writer for *The Independent* noted that many thought *The Dancing Lesson* was "the most telling, effective, and characteristic figure piece in the North Room. They are right. It is all this and more."[113] Shinn paid homage to, and attempted to defuse any criticism of, the sketchiness of the work:

> the sketchiness seems to have been in some sort a necessity; the painting somehow suggests that the artist might not have been able to carry a labor of such a size much further in finish without stirring up mud. As it is, there is not the slightest concession to the eye of the conventional spectator demanding evenness of manipulation.... These telling strokes and sweeps, these foreground forms felt as mere blots of color, these nearer members without outline while farther features are modelled and hardened with all precision, give the system of painting a perspectiveless look when seen close, and a look of pure atmospheric harmony when seen from the proper distance.[114]

The admiring technical notice, granting the painter the right to control viewing distance and calculate effect based on an ideal, compliant spectator, was meant to win over the reader-viewer accustomed to the mode of exhibition watercolor in which all was highly and consistently finished across the sheet. But the same critic also addressed the subject, providing a reading of the work quite different from the one we would readily ascribe today:

> The comedy of plantation life is felt by the painter of this picture with a quiet intensity that makes every onlooker sympathetic. The precocious solemnity of the child who is learning to dance, and whose bare legs have absorbed all the liveliness away from his face; the weight of warning in the countenance of his grandfather, who "pats" for him with the foot, and is ready to pounce on an error; and the serpentine insinuation of the banjo-player, who writhes and twists involuntarily to help on the motion, make up a group of goblin humor so true and intense as to notch a pretty high mark in the degrees of comedy.[115]

In spite of clear signs that the scene is post–Civil War—the picture of Lincoln and his son Tad in the background—and the serious look on all three faces, Shinn found humor: an ascription that seems to be cultural rather than inherent, and depended on grouping the work with the era's more stereotypical, broadly comedic views of African Americans.[116] Although it achieved considerable critical acclaim, Eakins did no more works in this vein.

In 1879 Eakins undertook yet another new theme, a subject not simply fresh to him but to the field of American painting as a whole—*A May Morning in the Park (The Fairman Rogers Four-in-Hand)* (pl. 51). The work was important, not simply for the decade-long broadening of his personal horizons, nor for the addition of another sporting iconography to American fine arts. In addition to these, the work, his most lucrative commission to date, solidified Eakins's association with the latest scientific and technological advances of registering the reality of things observed in this world.

The painting is a small canvas almost covered by green paint to suggest lawn and foliage. The bosky background, which depicts a recognizable drive in Philadelphia's Fairmount Park, accentuates the warm reds, browns, and lustrous black of the painting's focus: a private coach of the type known as a park drag pulled by four fine bay horses. Sunlight floods the foreground roadway and sparkles off the gleaming animals, the enamel-like coach, and the glistening trappings. Atop the coach ride a party of six and two grooms in livery.

The social group can be identified. In the front, Fairman Rogers drives the drag and turns toward the viewer,[117] while Rebecca Gilpin Rogers, wearing a minutely detailed costume

with tassels and feathers, turns toward her husband. Behind them, seated four abreast—in seeming defiance of the width of the coach—are Mrs. Rogers's brother and sister with their spouses: Mr. and Mrs. George Gilpin and Mr. and Mrs. Franklin A. Dick. The horses, too, thanks to notes on a surviving perspective drawing, can be named, as Williams, Chance, Peacock, and, nearest the viewer, Josephine, Rogers's favorite mare.[118] Even the day and event shown can perhaps be specified: the first outing of the New York Coaching Club, which drove from New York to Philadelphia on May 4, 1878. Rogers, as the only Philadelphia-based member of the club and hence host, would have driven the final leg of the approach to the city through Fairmount Park.[119]

Rogers, Eakins's most important supporter on the board of the Pennsylvania Academy of the Fine Arts, commissioned the work for five hundred dollars. To a degree unprecedented elsewhere in Eakins's oeuvre, *A May Morning in the Park* seems to have been a collaboration—at least conceptually—with the patron. Rogers's private means allowed him independence and access to positions of social prestige; in addition to his position at the Academy, he played significant roles at the University of Pennsylvania, the Franklin Institute, the National Academy of Sciences, and the Academy of Music. A civil engineer, an avid horseman, and an amateur coachman, he ultimately wrote in his *Manual of Coaching* (1899), which still serves as a definitive account of the sport, "There is something so exhilarating in the motion behind four horses, through the fresh air, that even stupid people wake up, and for once make themselves agreeable."[120]

Rogers was also interested in the motion of horses and by 1871 had explored the possibilities of photographing it. He was well prepared, therefore, when in 1878 the photographer Eadweard Muybridge announced his successful photographic campaign of tracking the precise movements of a horse as it trotted or galloped—movements too fast for the human eye to perceive. The accomplishment elicited admiration from around the world. Rogers immediately acquired Muybridge's photographs, donating a set to the Academy in early 1879.[121]

Eakins, too, was excited by Muybridge's work. He wrote, probably to Rogers, of "the sharp & blurred motion in these photographs. They mark so nicely the relative speed of the different parts.... These are a few things that strike me & you will discover many more."[122] Eakins wanted to extrapolate drawings from the photographs so that the continuous shape of the horse's action could be seen and appreciated by his students.[123] As Rogers wrote:

> Shortly after the appearance of the photographs, Mr.
> Thomas Eakins of Philadelphia, Instructor in the Pennsylvania Academy of the Fine Arts, who had long been

studying the horse from an artistic point of view, and whose accurate anatomical knowledge fitted him especially for the investigation, took them up for examination.... To obtain a perfectly satisfactory result, drawings must be made based upon the information given in the photographs.[124]

While the physical structure of the horse was indeed part of Eakins's artistic curriculum as both student and teacher, the earliest extant manifestations of Eakins's specific interest in equine anatomy is a series of plaster reliefs, showing both live and dissected animals, dating to 1878 (pl. 46). Under the impetus of Muybridge's work, however, he threw himself into the investigation with drawings and models, magic lantern slides, and lecture notes.[125]

By the late spring of 1879 Eakins was in direct contact with the photographer. Muybridge replied to him on May 7: "I am much pleased to hear the few experimental photos we made last year have afforded you so much pleasure.... I invited Mr. Rogers to come out here during the time we shall be at work.... Cannot you persuade him to come out? Newport will always be there, but probably our experiments will terminate this summer."[126] Rogers instead went to Newport, Rhode Island; Eakins joined him.

Rogers's decision to travel north rather than west was purposeful. He had ended his article on Muybridge by noting: "There are many interesting speculations as to how this new information may be utilised by the painter, for which we have not space at present."[127] Among the "speculations" were surely discussions between Rogers and Eakins resulting in the commission for *A May Morning in the Park*—an ideal merger of their joint interests: equine anatomy, motion studies, and a sport newly fashionable in America.

Eakins labored on the commission in both Philadelphia and Newport during the early summer of 1879, preparing with studies in multiple mediums, parallel in breadth and intensity to those of the *William Rush* project. Chief among these, early in the process, were wax sculptures of the moving horses (bronze versions of 1946, pls. 47–50), their foot positions based on Muybridge's photographs.[128] These are not so much portraits of Rogers's individual horses as motion studies, akin to Edgar Degas's later equine figures. Eakins was again in Rhode Island for much of September and early October. Most of the work on the final canvas was probably done there;[129] his record book notes that the painting was finished in January 1880.

When *A May Morning in the Park* was shown, first in Philadelphia in late 1880 and thereafter at the Boston Art Club and the National Academy of Design, it was the rare commentator who praised the work unequivocally:

> Mr. Thomas Eakins is seen at his best in a "May Morning in the Park." The coach and four of Mr. Fairman Rogers are rat-

tling along a drive in the Park. The spirit of swift motion is admirably caught, while the composition shows an enormous amount of hard, earnest study. This picture is one of the gems of the collection so far as good painting is concerned.[130]

Many, recognizing the depiction of motion as a primary element of the work, questioned the appropriateness of incorporating the latest science into art. The critic for *The North American*, while calling it a "brilliantly painted coaching scene, admirable in most of its details," voiced "grave misgivings" over the use of Muybridge's discoveries: "The fact is that the human eye cannot follow the swiftly moving limbs of the horse, and any attempt to arrest them on canvas can but result in disaster."[131] Even the generally supportive Van Rensselaer, noting the discussions provoked by the painting and finding numerous points to praise, concluded that, as regards the horses' motion, the "result may be scientifically true; but it is apparently, and so, I think, artistically false. . . . One must confess to wishing that Mr. Eakins had denied himself the pleasure of a fascinating little experiment, and had painted his horses in the time-worn way."[132] All of this controversy positioned Eakins in the midst of the debate over issues of reality and its perception that were current among such scientists and philosophers as William James and Charles Sanders Peirce during these years.

As the decade ended, and as interest in American art grew among critics and collectors, S.G.W. Benjamin set about summarizing the state of the field in "Present Tendencies of American Art," an essay published in *Harper's New Monthly Magazine*—one of the largest-circulation periodicals in the English-speaking world. Including a reproduction of "The Professor"—a detail of *The Gross Clinic* showing Gross's head, torso, and scalpel-wielding hand—the article placed Eakins as "prominent" among the "powerful allies" of the new movement of American art. Benjamin summarized him as "a pupil of Gérôme, and at present professor in the Philadelphia Academy of Art. He is a fine colorist, and has very few equals in the country in drawing of the figure. Some of his compositions, both in oil and watercolor, give remarkable promise."[133]

Eakins's first decade as a professional artist came thus to an auspicious close. From his return to Philadelphia in 1870 as an unknown student, without a single work shown to the public, he had made and exhibited a significant number of paintings and watercolors featuring a wide variety of new or radically reinterpreted subjects. His European master, one of the most celebrated painters of the era, approved of his work and praised him unreservedly. Major critics in Philadelphia, Boston, and, especially, New York identified him as a leading—albeit controversial—exponent of modern American art. Collectors had purchased a number of works, and, in 1879, he received a major commission from a patron who was able to render him both financial and professional advancement. Finally, he was named professor of painting at the Pennsylvania Academy of the Fine Arts, the nation's most prestigious art academy. Eakins could look back over the decade as one of great professional achievement.

Eakins in the 1870s

PLATE I. Thomas Eakins, *The Champion Single Sculls (Max Schmitt in a Single Scull)*, 1871.
Oil on canvas, 32¼ x 46¼ inches. The Metropolitan Museum of Art, New York. Purchase,
The Alfred N. Punnett Endowment Fund and George D. Pratt Gift, 1934.

PLATES 2, 3. Thomas Eakins, *Perspective Drawings for "The Pair-Oared Shell,"* 1872.
PLATE 2 (upper): Graphite, ink, and wash on paper, 31¹⁄₁₆ x 47⅛ inches.
PLATE 3 (lower): Graphite, ink, and watercolor on paper, 31¹³⁄₁₆ x 47⁹⁄₁₆ inches.
Philadelphia Museum of Art. Purchased with the Thomas Skelton Harrison Fund, 1944.

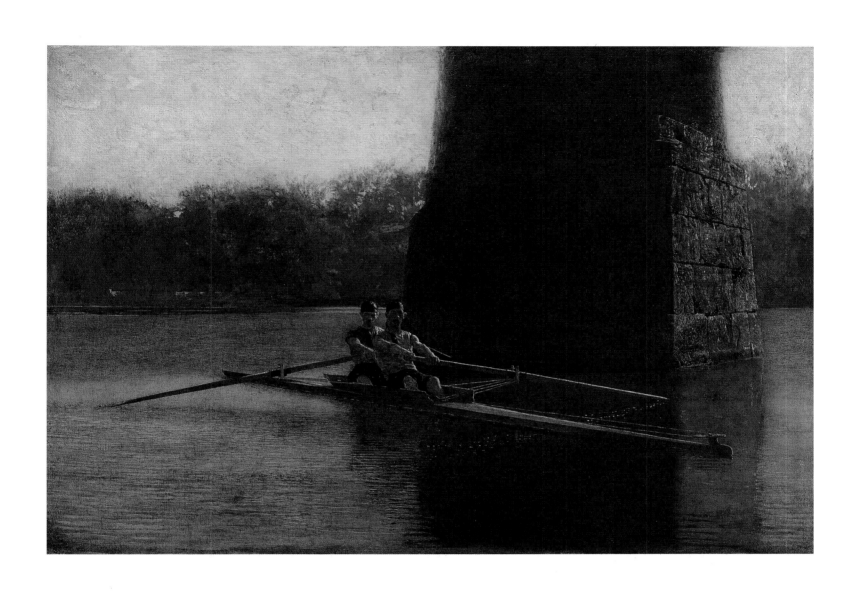

PLATE 4. Thomas Eakins, *The Pair-Oared Shell*, 1872.
Oil on canvas, 24 x 36 inches. Philadelphia Museum of Art.
Gift of Mrs. Thomas Eakins and Miss Mary Adeline Williams, 1929.

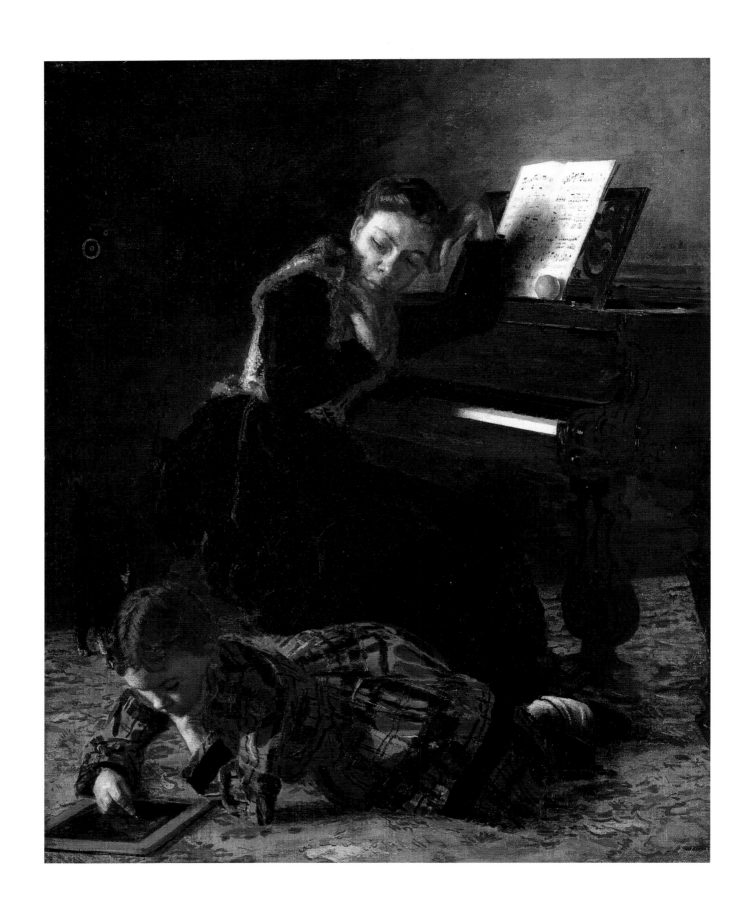

PLATE 5. Thomas Eakins, *Home Scene*, c. 1871.
Oil on canvas, 21¹/₁₆ x 18¹/₁₆ inches. Brooklyn Museum of Art, New York.
Gift of George A. Hearn, Frederick Loeser Art Fund, Dick S. Ramsay Fund, Gift of Charles A. Schiern.

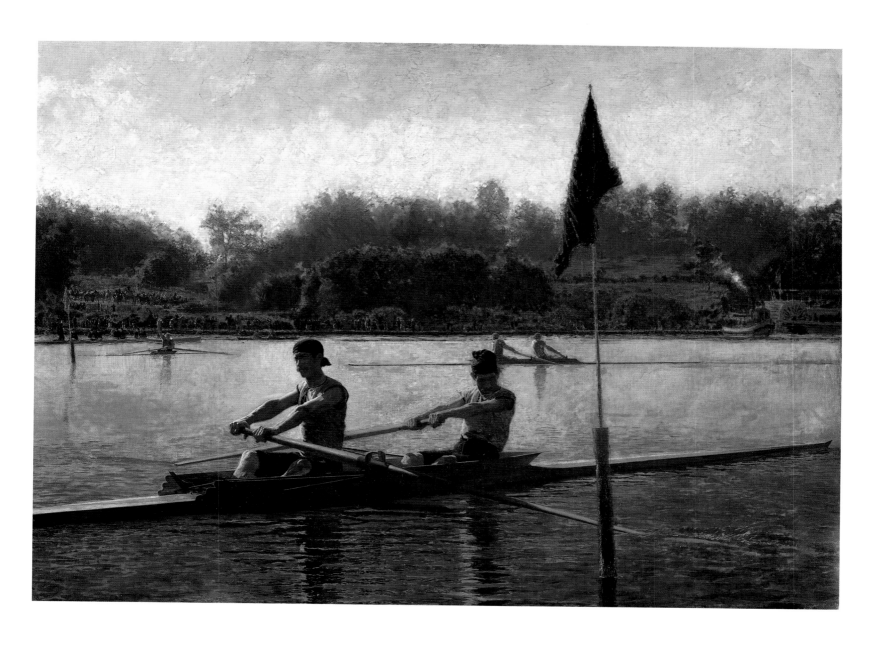

PLATE 6. Thomas Eakins, *The Biglin Brothers Turning the Stake-Boat*, 1873.
Oil on canvas, 39⅞ x 59⅝ inches.
The Cleveland Museum of Art. Hinman B. Hurlbut Collection.

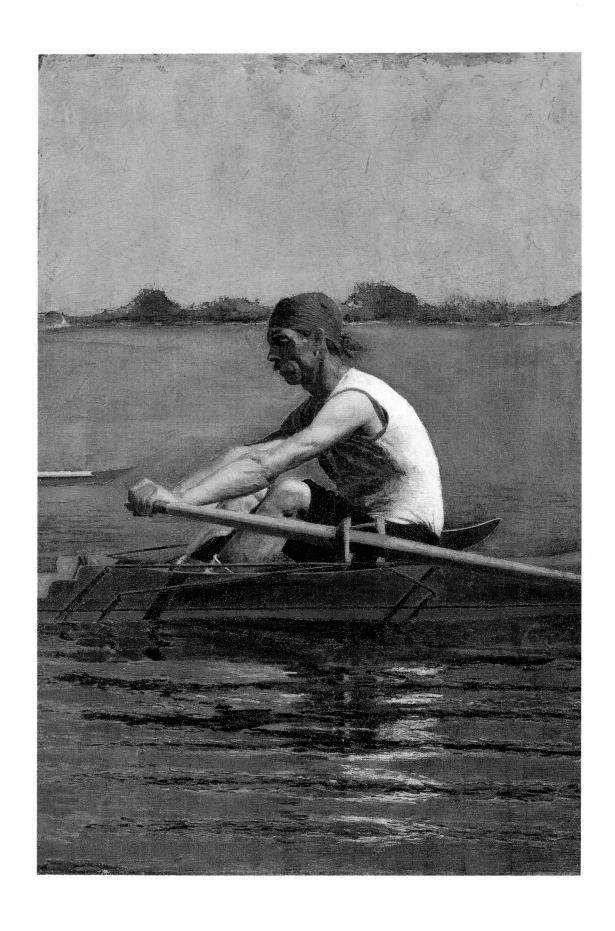

PLATE 7. Thomas Eakins, *John Biglin in a Single Scull*, 1873–74.
Oil on canvas, 24 5/16 x 16 inches. Yale University Art Gallery, New Haven, Connecticut.
Whitney Collections of Sporting Art, given in memory of Harry Payne Whitney, B.A. 1894, and
Francis Payne Whitney, B.A. 1898, by Francis P. Garvan, B.A. 1897, M.A. (Hon.) 1922, June 2, 1932.

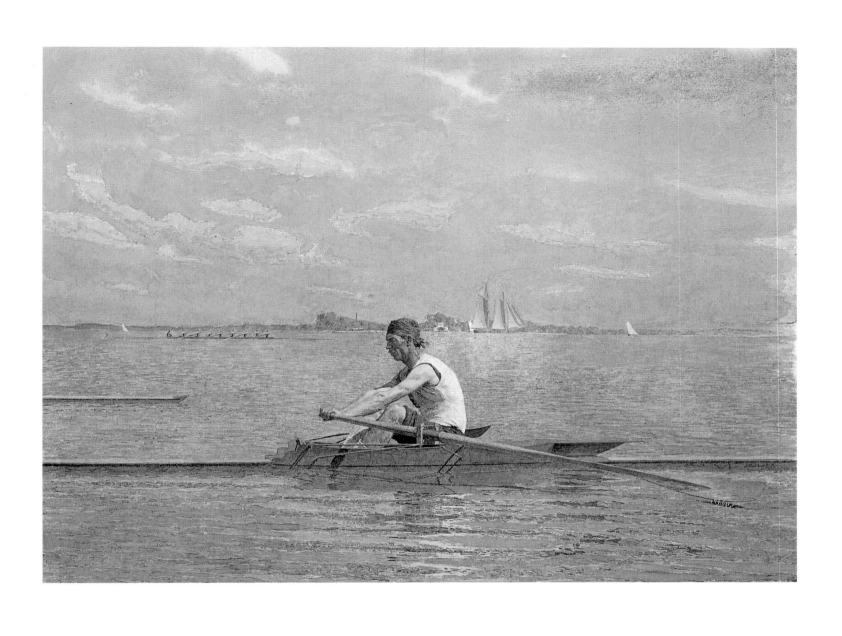

PLATE 8. Thomas Eakins, *John Biglin in a Single Scull*, 1873–74.
Watercolor on paper, 19 ⁵⁄₁₆ x 24 ⅞ inches.
The Metropolitan Museum of Art, New York. Fletcher Fund, 1924.

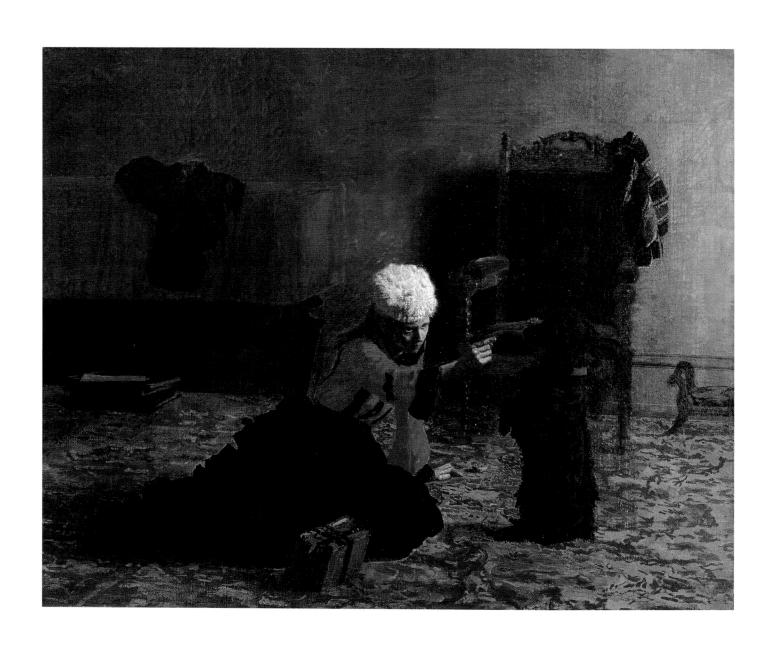

PLATE 9. Thomas Eakins, *Elizabeth Crowell with a Dog*, probably 1873–74.
Oil on canvas, 14 x 17¼ inches. San Diego Museum of Art.
Purchased by the Fine Art Society.

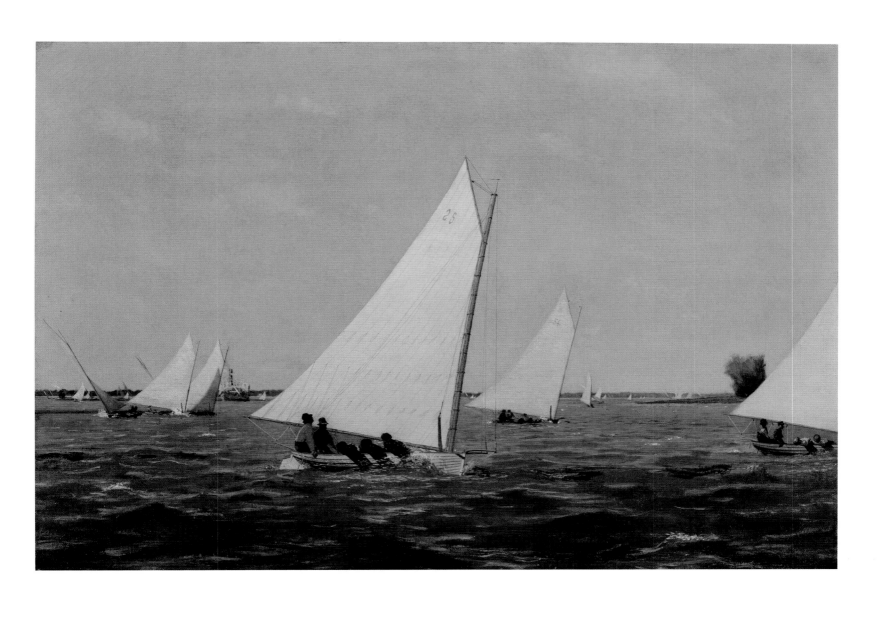

PLATE 10. Thomas Eakins, *Sailboats Racing on the Delaware*, 1874.
Oil on canvas, 24 x 36 inches. Philadelphia Museum of Art.
Gift of Mrs. Thomas Eakins and Miss Mary Adeline Williams, 1929.

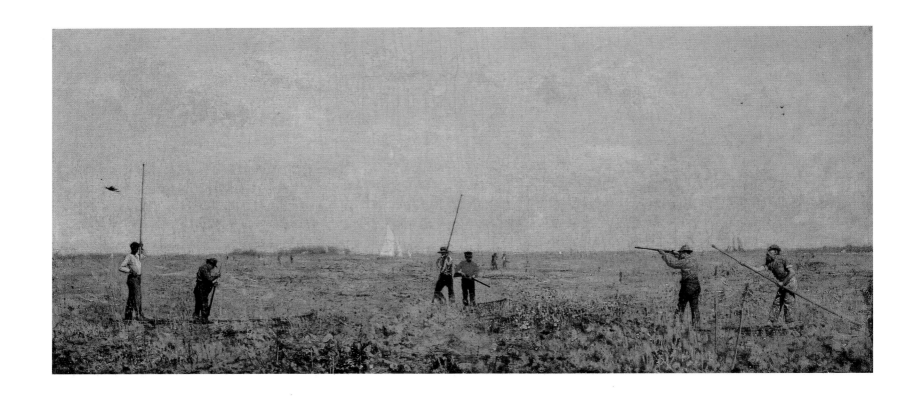

PLATE 11. Thomas Eakins, *Pushing for Rail*, 1874.
Oil on canvas, 13 x 30 1/16 inches. The Metropolitan Museum of Art, New York.
Arthur Hoppock Hearn Fund, 1916.

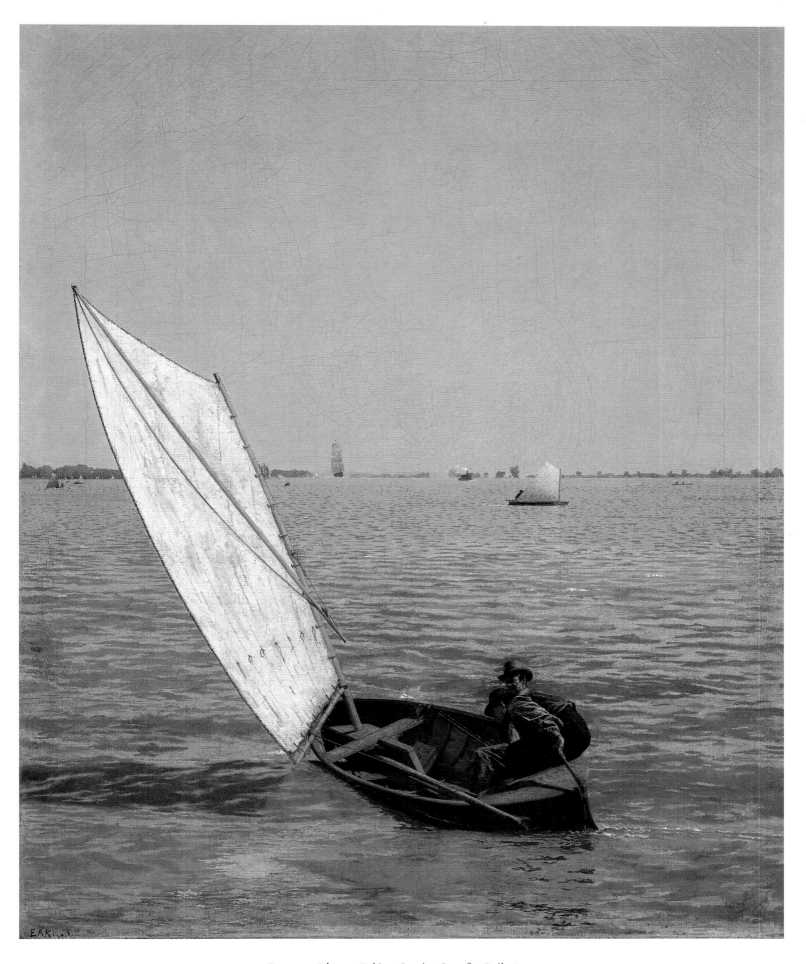

PLATE 12. Thomas Eakins, *Starting Out after Rail*, 1874.
Oil on canvas mounted on Masonite, 24¼ x 19⅞ inches. Museum of Fine Arts, Boston.
The Hayden Collection.

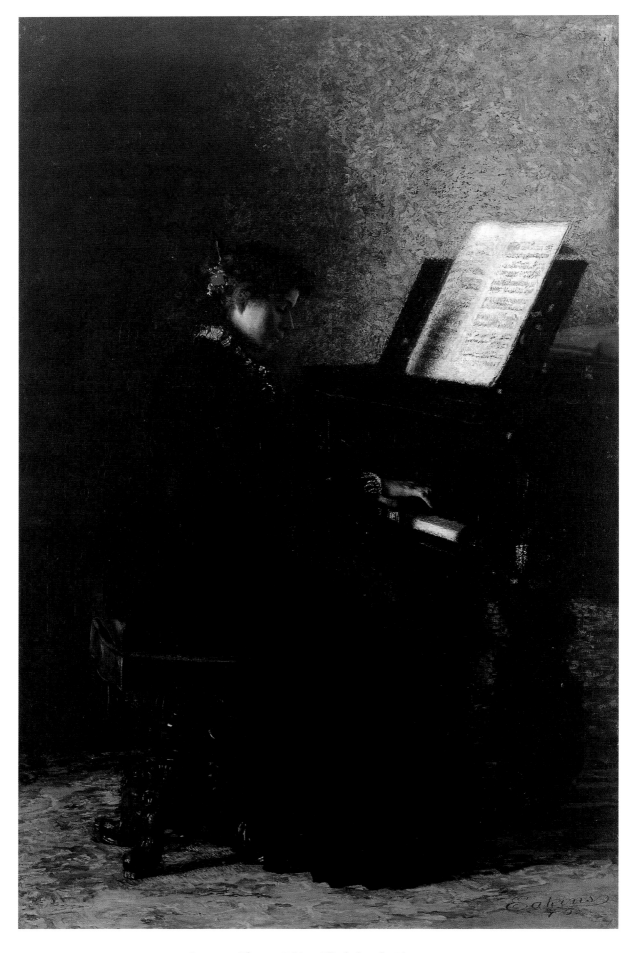

PLATE 13. Thomas Eakins, *Elizabeth at the Piano*, 1875.
Oil on canvas, 72⅛ x 48³⁄₁₆ inches.
Addison Gallery of American Art, Phillips Academy, Andover, Massachusetts. Gift of an anonymous donor.

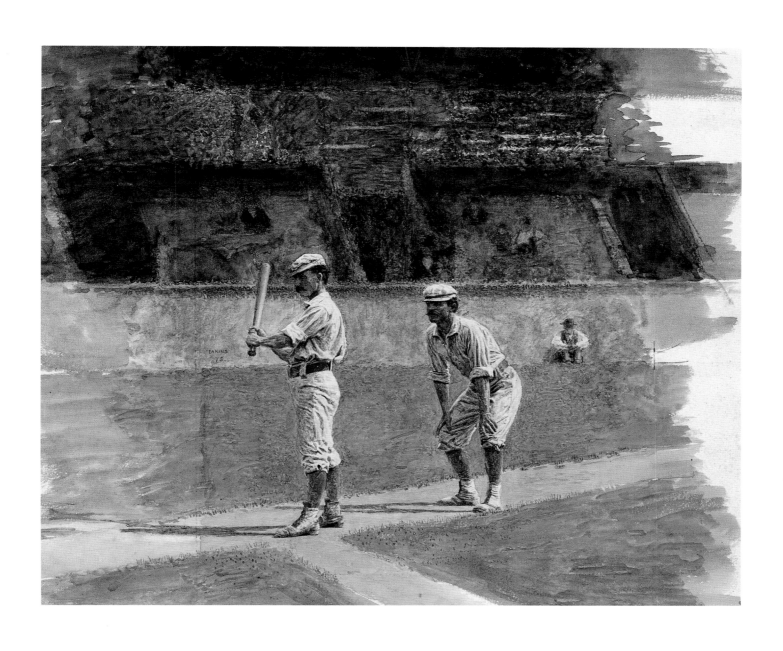

PLATE 14. Thomas Eakins, *Baseball Players Practicing*, 1875.
Watercolor on paper, 10¾ x 13 inches.
Museum of Art, Rhode Island School of Design, Providence, Rhode Island. The Jesse Metcalf Fund and the Walter H. Kimball Fund.

PLATE 15. Thomas Eakins, *Sketch for "The Gross Clinic,"* 1875.
Oil on canvas, 26 x 22 inches. Philadelphia Museum of Art.
Gift of Mrs. Thomas Eakins and Miss Mary Adeline Williams, 1929.

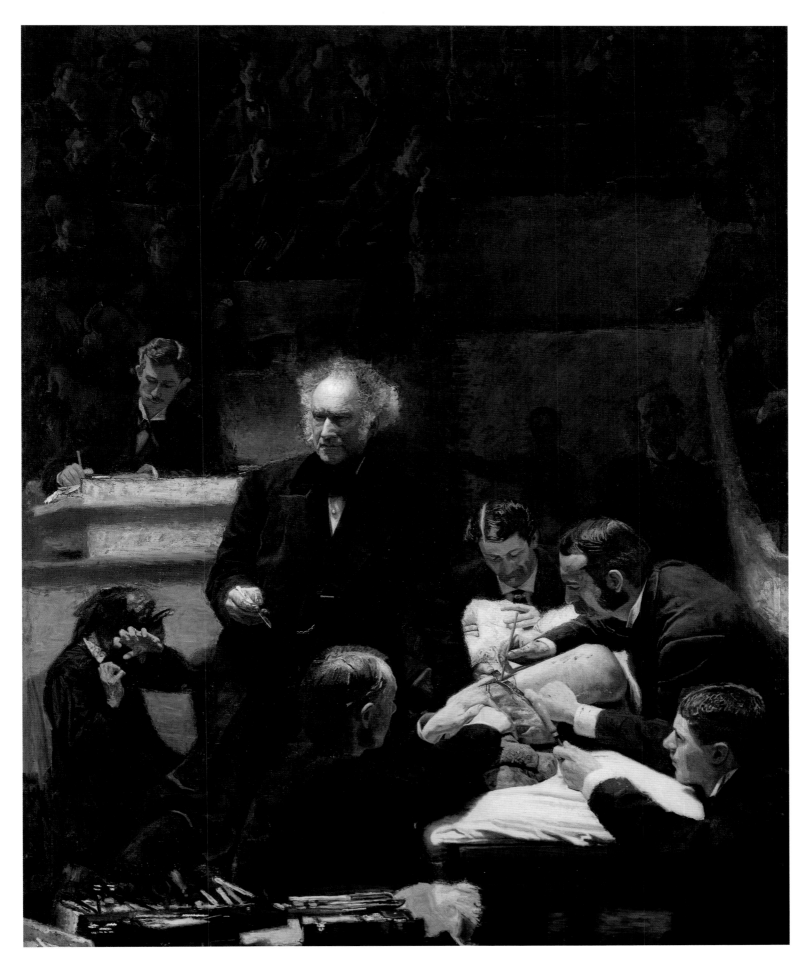

PLATE 16. Thomas Eakins, *The Gross Clinic*, 1875.
Oil on canvas, 96 x 78½ inches.
Jefferson Medical College, Thomas Jefferson University, Philadelphia.

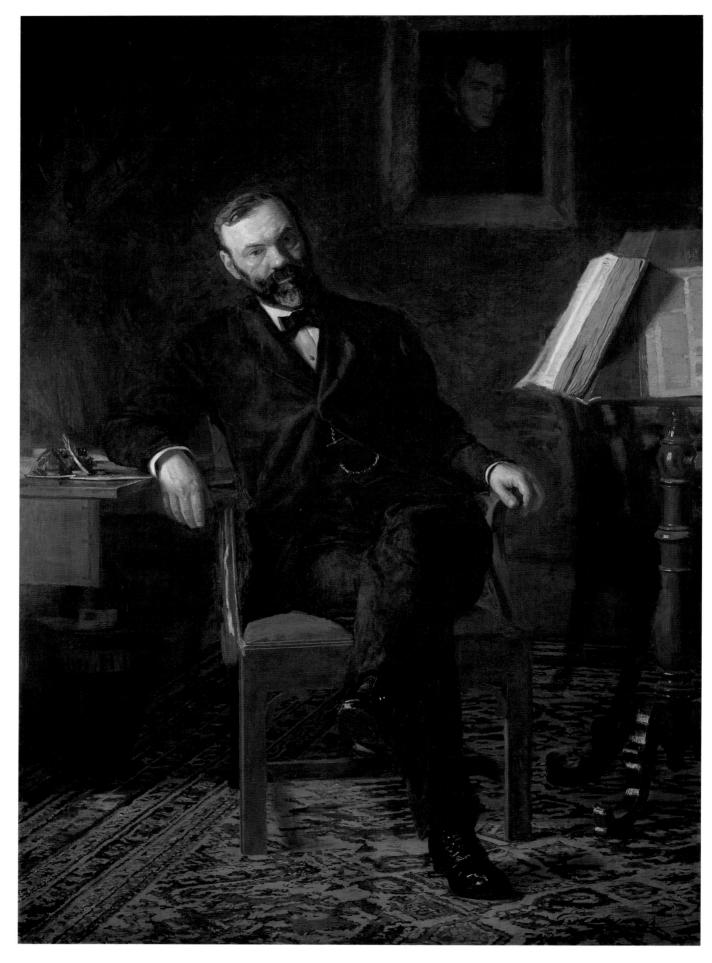

PLATE 17. Thomas Eakins, *Portrait of Dr. John H. Brinton*, 1876.
Oil on canvas, 81 x 60 inches.
The National Museum of Health and Medicine of the Armed Forces Institute of Pathology, Washington, D.C.

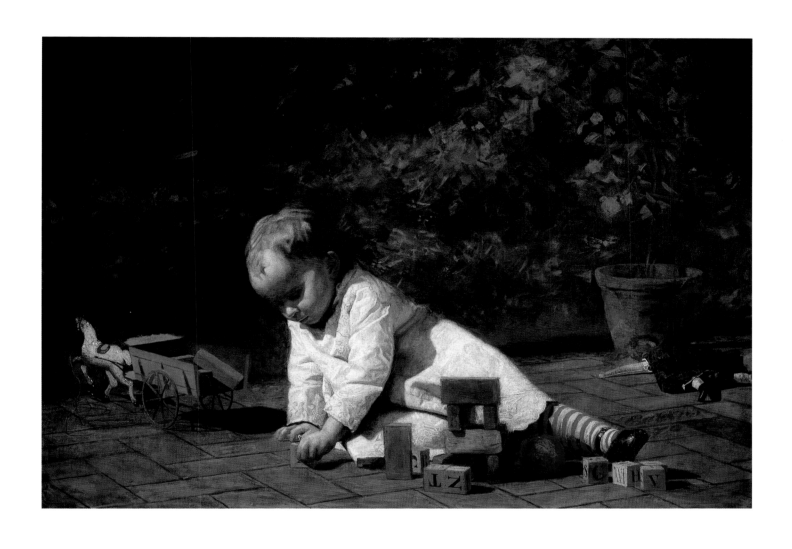

PLATE 18. Thomas Eakins, *Baby at Play*, 1876.
Oil on canvas, 32¼ x 48 inches.
National Gallery of Art, Washington, D.C. John Hay Whitney Collection.

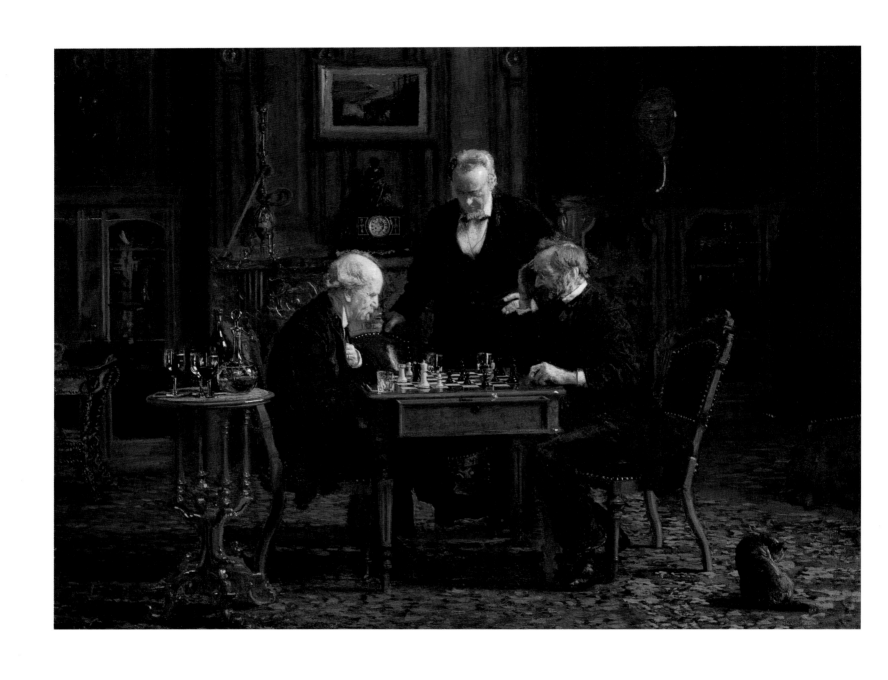

PLATE 19. Thomas Eakins, *The Chess Players*, 1876.
Oil on wood, 11¾ x 16¾ inches.
The Metropolitan Museum of Art, New York. Gift of the artist, 1881.

PLATES 20–23. Thomas Eakins, *Sketches for "William Rush Carving His Allegorical Figure of the Schuylkill River,"* 1875–76.
Graphite on paper.
PLATE 20 (upper left): *Two Women in Costume.* 14½ x 4¹¹⁄₁₆ inches, folded to 7¼ x 4¹¹⁄₁₆ inches.
PLATE 21 (upper right): *Mrs. Madison.* 14⅝ x 4¹¹⁄₁₆ inches, folded to 7³⁄₁₆ x 4¹¹⁄₁₆ inches.
PLATE 22 (lower left): *Laetitia Bonaparte.* 14⅝ x 4¹¹⁄₁₆ inches, folded to 7³⁄₁₆ x 4¹¹⁄₁₆ inches.
PLATE 23 (lower right): *Three Figures.* 14⅝ x 4¹¹⁄₁₆ inches, folded to 7³⁄₁₆ x 4¹¹⁄₁₆ inches.
Hirshhorn Museum and Sculpture Garden, Smithsonian Institution, Washington, D.C. Gift of Joseph H. Hirshhorn, 1966.

PLATES 24–27. Thomas Eakins, *Sketches for "William Rush Carving His Allegorical Figure of the Schuylkill River,"* 1875–76.
Each 7¼ x 4¹¹⁄₁₆ inches.
PLATE 24 (upper left): *Woman with Parasol*. Ink, graphite, and watercolor on paper.
PLATE 25 (upper right): *Nymph*. Graphite on paper.
PLATE 26 (lower left): *The Schuylkill Freed*. Graphite on paper.
PLATE 27 (lower right): *George Washington*. Graphite on paper.
Hirshhorn Museum and Sculpture Garden, Smithsonian Institution, Washington, D.C. Gift of Joseph H. Hirshhorn, 1966.

PLATES 28–31. Thomas Eakins, *Studies of William Rush's "Water Nymph and Bittern,"* 1876–77.
PLATE 28 (upper left): *Studies of Figure, Arm, Claw.* Graphite on paper, 3 9/16 x 5 5/16 inches.
PLATE 29 (upper right): *Four Views.* Graphite on paper, 3 9/16 x 5 inches.
PLATE 30 (lower left): *Rear View.* Graphite on paper, 6 3/16 x 3 13/16 inches.
PLATE 31 (lower right): *Frontal View.* Graphite on paper, 14 x 8½ inches.
Pennsylvania Academy of the Fine Arts, Philadelphia. Charles Bregler's Thomas Eakins Collection,
purchased with the partial support of the Pew Memorial Trust and the John S. Phillips Fund.

61

PLATE 32. Thomas Eakins, *Scrollwork, Foreshortened (Study for "William Rush Carving His Allegorical Figure of the Schuylkill River")*, 1876–77.
Ink over graphite on paper, 12 $\frac{7}{16}$ x 7 $\frac{13}{16}$ inches.
Pennsylvania Academy of the Fine Arts, Philadelphia. Charles Bregler's Thomas Eakins Collection,
purchased with the partial support of the Pew Memorial Trust and the John S. Phillips Fund.

PLATES 33, 34. Thomas Eakins, *Models for "William Rush Carving His Allegorical Figure of the Schuylkill River,"* 1876–77.
PLATE 33 (upper): *Water Nymph and Bittern*. Pigmented wax, wood, muslin, wire, and nails, 9¾ x 6¾ x 3⅞ inches.
PLATE 34 (lower): *The Schuylkill Freed*. Pigmented wax, wood, wire, and nails, 4½ x 8½ x 2½ inches.
Philadelphia Museum of Art. Gift of Mrs. Thomas Eakins and Miss Mary Adeline Williams, 1929.

PLATES 35, 36. Thomas Eakins, *Models for "William Rush Carving His Allegorical Figure of the Schuylkill River,"* 1876–77.
PLATE 35 (upper): *Head of the Water Nymph.* Pigmented wax, wood, and metal tubing, 7¼ x 4⅜ x 3¾ inches.
PLATE 36 (lower): *George Washington.* Pigmented wax, wood, wire, and nails, 8⅛ x 4 x 2¾ inches.
Philadelphia Museum of Art. Gift of Mrs. Thomas Eakins and Miss Mary Adeline Williams, 1929.

PLATE 37. Thomas Eakins, *Head of William Rush (Model for "William Rush Carving His Allegorical Figure of the Schuylkill River")*, 1876–77.
Pigmented wax, wood, plaster, and nails, 7¼ x 4¼ x 4⅞ inches.
Philadelphia Museum of Art. Gift of Mrs. Thomas Eakins and Miss Mary Adeline Williams, 1929.

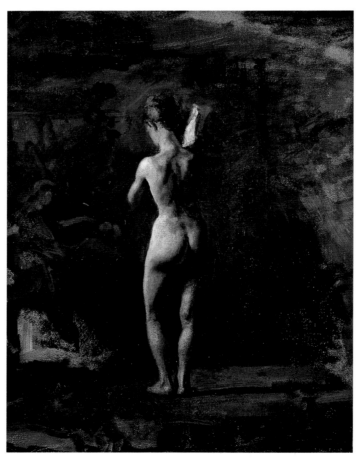

PLATES 38, 39. Thomas Eakins, *Studies for "William Rush Carving His Allegorical Figure of the Schuylkill River,"* 1876–77.
PLATE 38 (upper): *Interior of a Woodcarver's Shop (Sketch)*. Oil on canvas, 8⅝ x 13 inches.
Philadelphia Museum of Art. Gift of Charles Bregler, 1946.
PLATE 39 (lower): *Study*. Oil on canvas, 14⅛ x 11¼ inches.
The Art Institute of Chicago. Bequest of Dr. John J. Ireland.

66

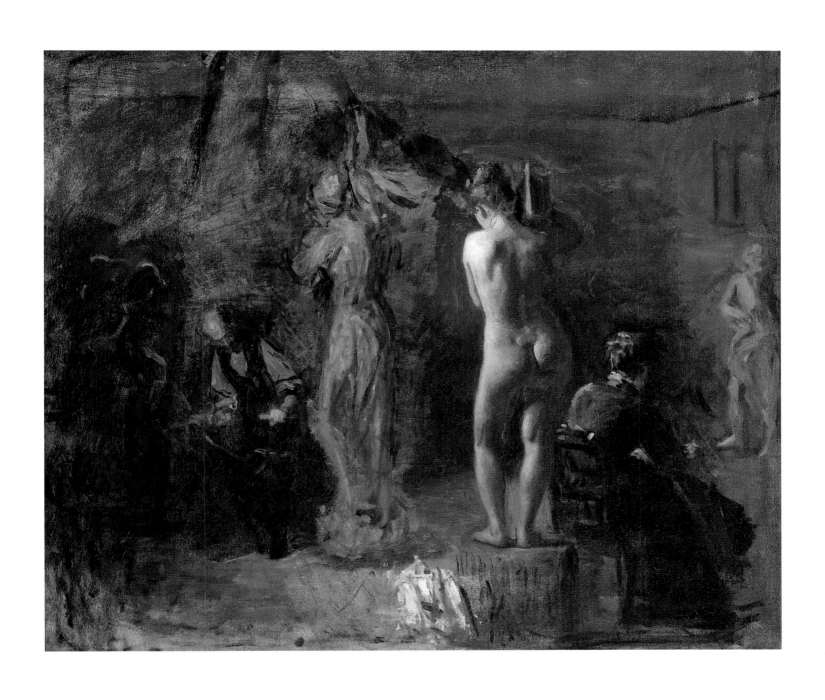

PLATE 40. Thomas Eakins, *Study for "William Rush Carving His Allegorical Figure of the Schuylkill River,"* 1876.
Oil on canvas, 20 3/16 x 24 inches.
Yale University Art Gallery, New Haven, Connecticut. Collection of Mary C. and James W. Fosburgh, B.A. 1933, M.A. 1935.

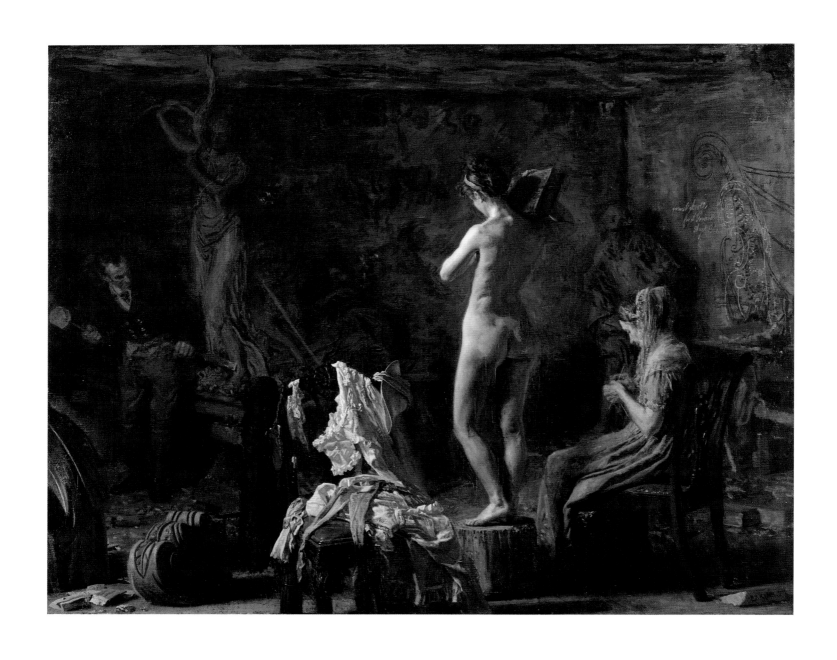

PLATE 41. Thomas Eakins, *William Rush Carving His Allegorical Figure of the Schuylkill River*, 1876–77.
Oil on canvas, 20⅛ x 26⅛ inches.
Philadelphia Museum of Art. Gift of Mrs. Thomas Eakins and Miss Mary Adeline Williams, 1929.

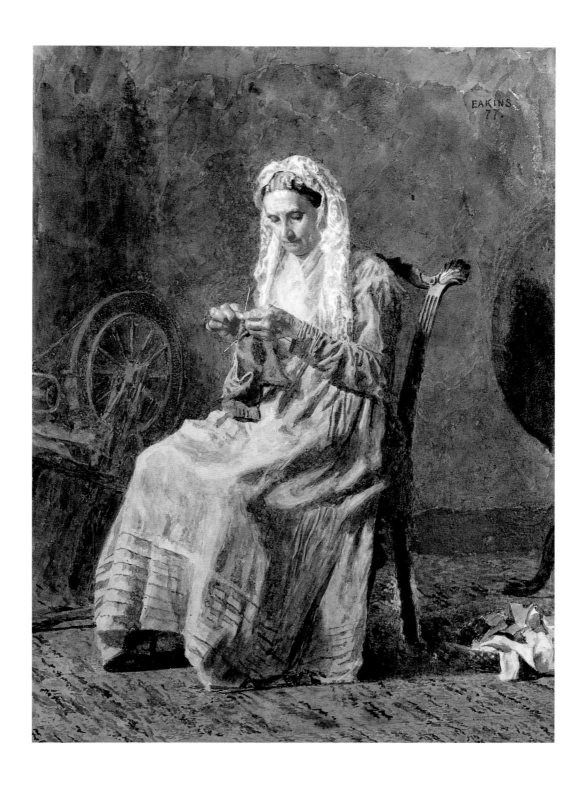

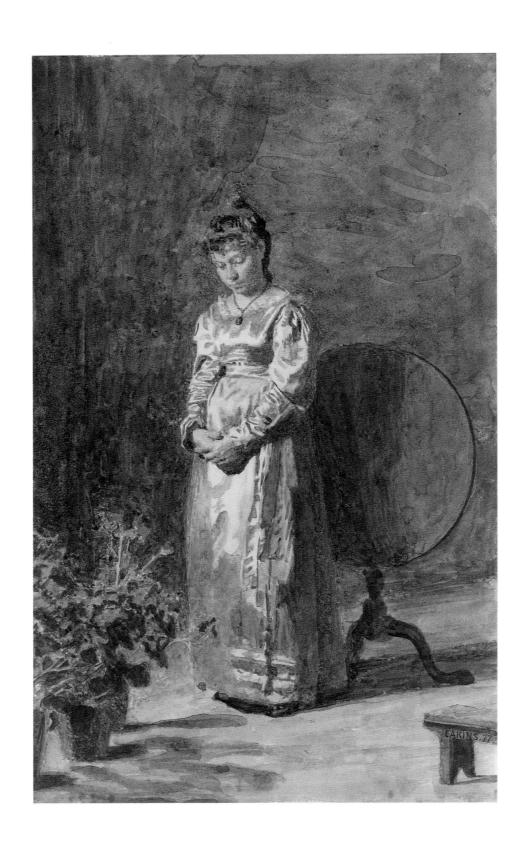

PLATE 43. Thomas Eakins, *Fifty Years Ago (Young Girl Meditating)*, 1877.
Watercolor and gouache on paper, 9 9/16 x 6 1/8 inches.
The Metropolitan Museum of Art, New York. Fletcher Fund, 1925.

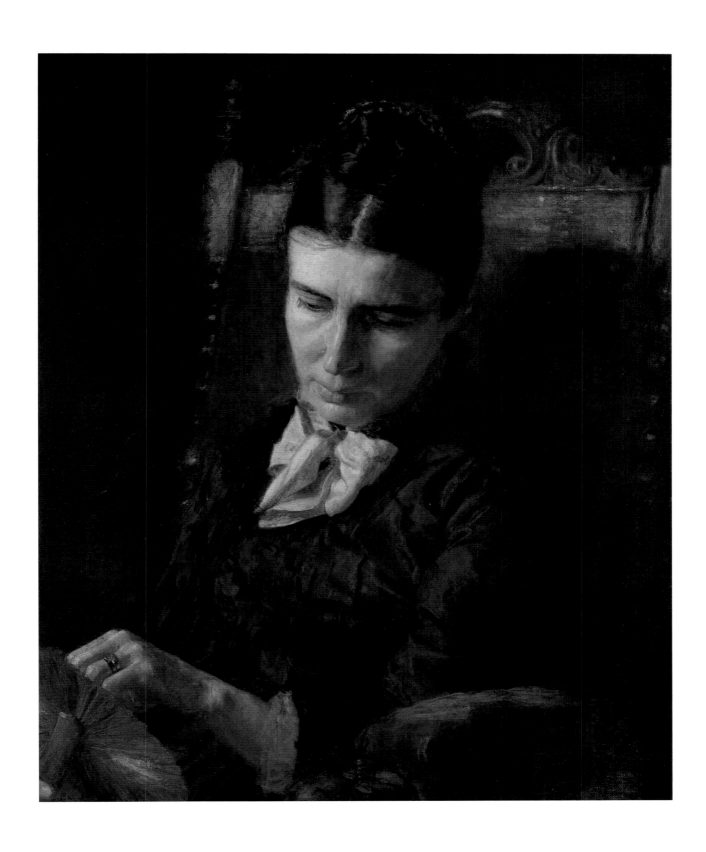

PLATE 44. Thomas Eakins, *Portrait of Sarah Ward Brinton (Mrs. John H. Brinton)*, 1878.
Oil on canvas, 24¼ x 20⅛ inches.
Private Collection.

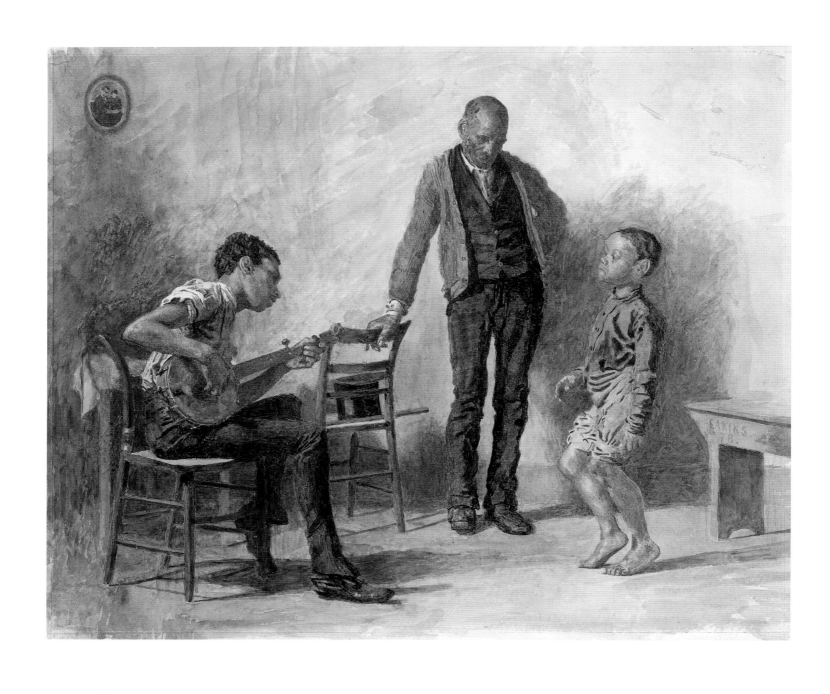

PLATE 45. Thomas Eakins, *The Dancing Lesson (Negro Boy Dancing)*, 1878.
Watercolor on paper, 18 1/16 x 22 9/16 inches.
The Metropolitan Museum of Art, New York. Fletcher Fund, 1925.

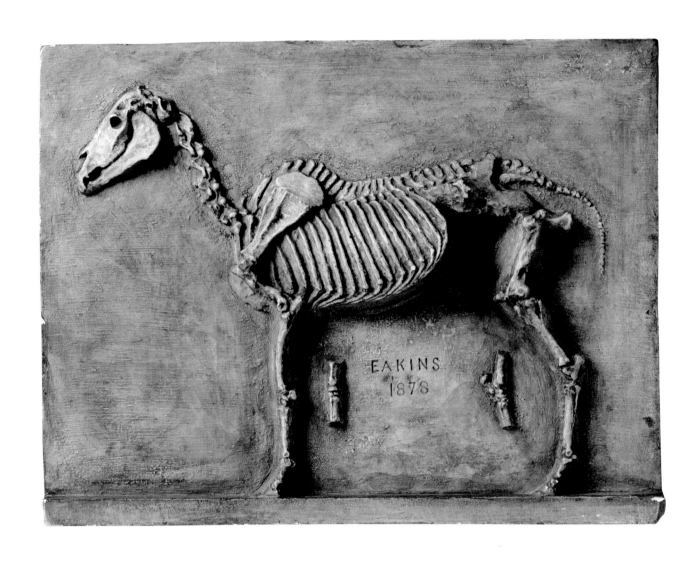

PLATE 46. Thomas Eakins, *Horse Skeleton*, 1878.
Plaster, 11¼ x 14¼ x 2⅛ inches.
Philadelphia Museum of Art.
Purchased with Museum Funds and with the partial gift of Amy and David Edward Dufour, 2000.

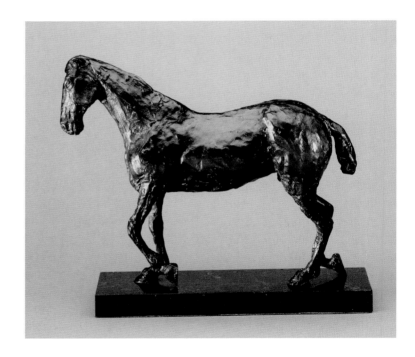

PLATES 47–50. Thomas Eakins, *Models of Horses for "A May Morning in the Park (The Fairman Rogers Four-in-Hand),"*
1879 (cast 1946).
Bronze, marble bases.
PLATE 47 (upper left): *Left Leader Horse.* 9½ x 12¼ x 2¾ inches.
PLATE 48 (upper right): *Right Leader Horse.* 9 7/16 x 11 7/8 x 2¾ inches.
PLATE 49 (lower left): *Left Wheeler Horse.* 9 5/16 x 11¾ x 2¾ inches.
PLATE 50 (lower right): *Right Wheeler Horse.* 9 7/16 x 11 15/16 x 2⅞ inches.
Philadelphia Museum of Art. Bequest of Mr. and Mrs. William M. Elkins, 1950.

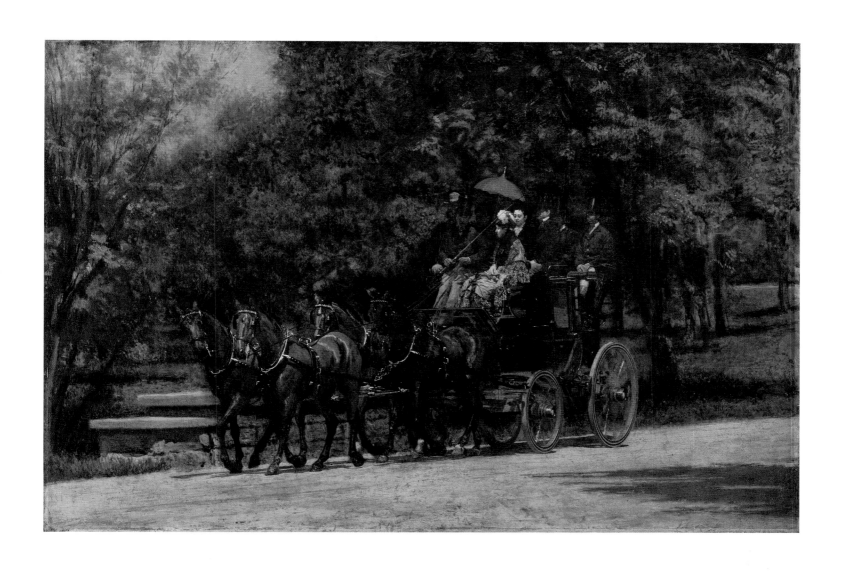

PLATE 51. Thomas Eakins, *A May Morning in the Park (The Fairman Rogers Four-in-Hand)*, 1879–80.
Oil on canvas, 23¾ x 36 inches.
Philadelphia Museum of Art. Gift of William Alexander Dick, 1930.

Images of Fairmount Park in Philadelphia

ELIZABETH MILROY

"Are we in an enchanted forest? No, we are in Fairmount."

Edward Strahan [Earl Shinn], *A Century After* (Philadelphia, 1875)[1]

IN APRIL OF 1871, Thomas Eakins made his professional debut at the last in a series of three art receptions sponsored by the Union League of Philadelphia. He exhibited two canvases: a portrait lent by league member Matthew Messchert and *The Champion Single Sculls*, a portrait of the prizewinning oarsman Max Schmitt (fig. 37). Recently returned from three-and-a-half years of study in Paris, Eakins was eager to launch his career and this was a singular opportunity. The city's leading artists, many of them Union League members, contributed as did important local collectors. Lenders included Joseph Harrison, Jr., William B. Bement, Henry C. Carey, and Fairman Rogers, all of whom also belonged to the Union League.[2] Eakins selected his submissions with care. The Messchert portrait (now lost) advertised that the young artist had already established a professional relationship with at least one league member. The Schmitt portrait was an astute piece of civic boosterism certain to appeal to the Union League audience.

The Champion Single Sculls celebrated a boyhood friend and local sports hero who had won a prestigious rowing race on the Schuylkill River in the fall of 1870. In this adaptation of a subject popular in sporting prints, Eakins introduced the portrait device he would deploy so effectively throughout his career—showing his subject in the place where that individual had gained distinction.[3] Schmitt sits in his racing shell near the east bank of the Schuylkill, glancing over his shoulder as he rests his oars and the boat glides across the water. Just beyond Schmitt, Eakins shows himself propelling a single shell with other rowers farther downriver. In the middle distance, we see the Girard Avenue and Connection Railroad bridges spanning the river. Smoke rises from a locomotive crossing the connection bridge from the west bank. Nearby, the roof of the eighteenth-century summer villa called Eaglesfield looms above a line of trees.[4] An excursion steamboat in the far distance was one of several that plied the Schuylkill; in

fact, the slightly elevated vantage point from which we view the rowers suggests that Eakins imagined the viewer looking down from the deck of a similar vessel. Although only two preparatory sketches for this painting survive, the composition is tightly plotted, with the rowers carefully positioned atop the receding river surface and the geometry of perspectival recession deftly anchored by the bridge structures.

Oarsmen and their sport had been a trope in Schuylkill River views since the 1830s, when competitive rowing first became popular on the river.[5] Eakins simply zoomed in, as it were, to focus his attention on what artists previously had treated only as incidental embellishments. But this picture is not only a tribute to a champion athlete, it is also a meditation on the *location* of Schmitt's victory. Schmitt and his companions exercise in a landscape in which nature, technology, and history coexist—a new kind of public space available only in

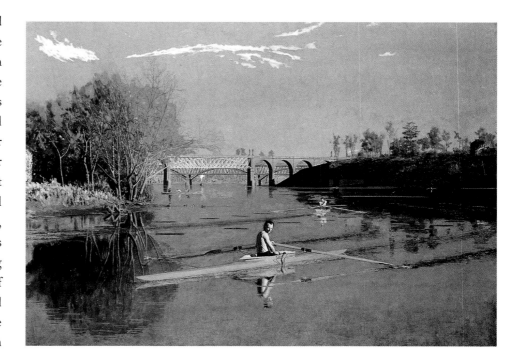

Fig. 37. Thomas Eakins, *The Champion Single Sculls (Max Schmitt in a Single Scull)*, 1871. Oil on canvas, 32¼ x 46¼". The Metropolitan Museum of Art, New York. Purchase, The Alfred N. Punnett Endowment Fund and George D. Pratt Gift, 1934 (pl. 1).

Fig. 38. John Bachman, *Panoramic Map of Philadelphia*, 1857. Lithograph, 26⅜ x 35⁷⁄₁₆". Historical Society of Pennsylvania, Philadelphia.

was this type of plan outdated and unsuitable for the evolving city? What about threats to public health and declining living standards in the increasingly overcrowded city?

Many American cities eased the strain of such growth by creating public parks, in the belief that natural beauty would benefit the urban populace by providing moral uplift as well as recreational space. The development of Philadelphia's modern public park system began in 1844, the year of Eakins's birth, with the purchase of a former estate on the banks of the Schuylkill River, the western boundary of Penn's original city. The river was already a popular recreational site, and, typical of their generation, Thomas Eakins and his sisters, who lived in the nearby Spring Garden district, grew up along its banks, swimming and rowing in summer and skating when the river froze in winter. The Eakins family looked to the river for spiritual and emotional uplift as well as physical recreation. In one

the modern city—a setting Eakins's contemporaries would have recognized instantly as a section of the Schuylkill River, lately incorporated into the massive and unique public works project that was Philadelphia's grand new Fairmount Park.

Eakins was native to one of America's most spatially self-conscious cities, described by Henry James as "the vast, firm chess-board, the immeasurable spread of little squares, covered *all* over by perfect Philadelphians"[6] (fig. 38). The grid plan laid down by founder William Penn had informed the city's identity since its founding. During the eighteenth century, visitors praised the regular streets lined with neat brick row houses as a model of the rational and commodious colonial town. But during Eakins's lifetime, Philadelphia exploded out from the tidy center-city grid, only two square miles, to become a sprawling modern metropolis, the largest city by area in the United States and one of the most densely industrialized. In 1850 the population of center city and surrounding districts was just over 400,000; by 1880 the consolidated and enlarged city covered 128 square miles, with a population of almost 850,000. By 1908 Philadelphia's population had passed a million and a half.[7] Such growth predictably strained the urban infrastructure and, in particular, imposed severe pressure on the once-orderly grid. Eakins's generation, faced with the challenge of managing this burgeoning growth, was confronted with the task of devising ways to preserve the most civilized characteristics of the modern city while still supporting the industrial production on which the urban economy depended.[8] Could the grid be extended indefinitely to accommodate such growth, or

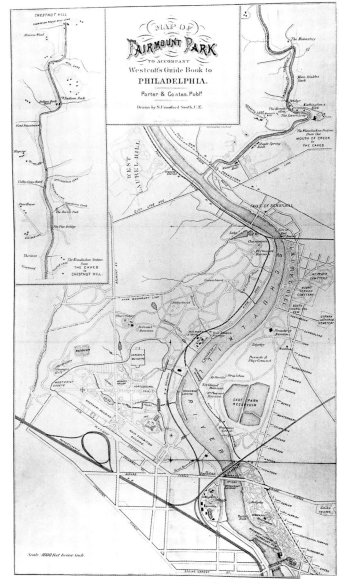

Fig. 39. S. Crawford Smith, *Map of Fairmount Park Including the Wissahickon*. From *Westcott's Guide to Philadelphia* (Philadelphia: Porter and Coates, 1875). Historical Society of Pennsylvania, Philadelphia.

letter written from Europe, Eakins advised his sister Fanny to "take a walk to Fairmount or a row up the river" when she was feeling downhearted.[9]

Eakins's beloved Schuylkill became the centerpiece of an even larger park system in April 1867, when the Pennsylvania State Legislature passed an Act of Assembly approving the expropriation of more than two thousand acres within the city limits "to be laid out and maintained forever, as an open public place and park, for the health and enjoyment of the people of said city, and the preservation of the purity of the water supply."[10] Capping more than a quarter century of lobbying by private citizens' groups to establish a municipally governed public park, this legislation and a second act passed in 1868 empowered a sixteen-man commission to transform hundreds of acres of real estate once slated for industrial and residential development (fig. 39). When complete, city-owned parkland would encompass property for three miles along the east and west banks of the Schuylkill River and for six miles along its tributary, the Wissahickon, forming the nucleus of what would become, in time, the world's largest urban park system.[11]

Philadelphia's park was unique in origin as well as form. The other great nineteenth-century American parks developed at this time were artificial spaces invented by landscape architects who excavated and reconfigured a demarcated section of urban topography according to a preconceived plan. By contrast, Fairmount Park was created when the city took control of picturesque landscapes and historic properties long celebrated by artists and travel writers, as well as preexisting recreational areas, in an effort to protect the quality of the municipal water supply and to preserve what landscape architect Frederick Law Olmsted called "the best series of beautiful landscape pictures that can be included in a tract of ground."[12] To the world at large, the park advertised that Philadelphia was a modern and desirable place to live. "To the people of Philadelphia its opening was a revelation of unsuspected beauty; to them and to the people of the whole Union it is destined to prove a joy forever," boasted the park commissioners; "To-day it has no match on the American continent; in a few years it will be recognized as foremost among the parks of the world."[13]

Many Philadelphians believed Fairmount Park could simply be left as is, once transferred to the public trust. But the preservation of large areas of natural landscape dramatically altered the ratio of public and private space in the city, challenging the efficacy of the grid and raising questions about boundaries, access, and management. For whom was the park truly intended? How should these properties be improved and maintained? When Eakins arrayed the entities of nature, history, technology, and humanity in the neatly plotted space of *The Champion Single Sculls,* he was also circumscribing the

Fig. 40. Thomas Birch, *The Fairmount Waterworks,* 1821. Oil on canvas, 20¼ x 30¼". Pennsylvania Academy of the Fine Arts, Philadelphia. Bequest of the Charles Graff Estate, 1845.

herculean task that confronted the newly appointed administrators of Fairmount Park.

The ornamental gardens laid out next to the waterworks at Fairmount on the Schuylkill, the source of Philadelphia's fresh water supply, were the city's best-known park facilities. After operation began in 1815, the waterworks became a popular attraction for tourists eager to see this marvel of modern technology nestled benignly in the landscape. Images of the waterworks such as Thomas Birch's 1821 view (fig. 40) looking upriver to the eighteenth-century summer villas that lined the riverbanks became trademarks for Philadelphia, reproduced in countless prints, paintings, china patterns, and, later, in photographs.[14] Construction of the waterworks also heralded the Schuylkill's increased use as an industrial thoroughfare. Barges carrying anthracite coal from Western Pennsylvania moved down the Schuylkill Navigation Canal along the west bank. As wharves, warehouses, rolling mills, gasworks, and icehouses multiplied, open land disappeared. Nearby textile mills and breweries consumed the Schuylkill's fresh water. By the 1840s, huge machine shops, foundries, and railroad car and wheel factories filled the districts just east of the river, along the railroad lines penetrating the city from the north and west.[15] Cholera epidemics during the 1830s raised concerns about mounting threats to the city's water supply, and members of the local medical profession petitioned City Hall to act. In 1844 the city purchased the forty-five-acre Lemon Hill estate, visible at the center in the background of Birch's view, in an effort to forestall industrial development.[16]

Leading the efforts to develop an expanded public park in the city were members of Philadelphia's elite who were eager to promote the city as the cultural as well as economic equal of Europe's capitals. But active planning for the park did not go ahead until the Consolidation Act of 1854 conjoined the tiny area of center city Philadelphia with more than two dozen neighboring communities, where much of the underdeveloped property suitable for park use was located. Once this was accomplished, the concept of a centralized public park became even more attractive as a common civic space that might act as a hub around which to unify the expanded city. In 1855 Lemon Hill was dedicated to public use as "Fairmount Park."[17] Expansion of the park continued in 1857, when dozens of leading citizens—including industrialists Joseph Harrison and William Sellers, banker Jay Cooke, physician William Pepper, engineer Fairman Rogers, and journalist Morton McMichael—contributed to a fund to assist the city in the purchase of the Sedgeley estate, just north of Lemon Hill. In 1859 a landscaping plan was commissioned to unify the two estates with the waterworks gardens.[18]

The immediate beneficiaries of this collaboration between the city and private citizens were residents of the Spring Garden district, just to the east of Lemon Hill and the Schuylkill.[19] When Benjamin Eakins purchased a house on Mount Vernon Street in the late 1850s, he was moving his family to a fast-growing and progressive neighborhood, as evidenced by the wide variety of denominations served by churches in the area. In the 1820s, Spring Garden was still considered sufficiently remote to provide a site for Eastern State Penitentiary, opened in 1829 less than a mile from the waterworks. By the 1830s, construction of the grand neoclassical campus of Stephen Girard's progressive school for orphans on Girard Avenue signaled the start of the district's transformation into an attractive and uniquely diverse neighborhood, conveniently located within walking distance just to the north of the industrial areas then being laid out below Spring Garden Street. By the mid-1850s, the gently rolling meadows and vineyards in the area had been obliterated as developers replicated the center-city street grid across the district. The buildings "both public and private" in the Spring Garden district "evince cultured architectural taste," declared one admirer, "and the 'enchanter's wand of thrift' has made its mark of use and beauty, of utility and ornament in every part of this District until it may favorably compare with and even surpass others in the general character of its improvements."[20] Housing reflected economic diversity, ranging from mansions of wealthy industrialists built along North Broad Street and Girard Avenue to row houses of workers clustered in the western section of the district. The Eakins house, on a street named for George Wash-ington's Virginia estate, was typical of the substantial row houses occupied by prosperous artisans and merchants of the middle class, designed in a traditional style to provide continuity with Philadelphia's oldest colonial neighborhoods.

For Benjamin Eakins, proximity to the new municipal park doubtless enhanced Spring Garden's desirability. The growing importance of what has been called "the new urban landscape"[21] was fueled by the writings of nineteenth-century landscape architect and theorist Andrew Jackson Downing. In his influential books and essays in *The Horticulturist*, Downing explained and promoted the park movement. He envisioned parks as spaces in which nature and culture would combine to "soften and humanize" America's city dwellers, to "educate and enlighten the ignorant, and give continual enjoyment to the educated."[22] Statues, monuments, and buildings "commemorative at once of the great men of the nation, of the history of the age and country, and the genius of our highest artists" would embellish forests and greensward. Zoos and horticultural societies could be housed within its precincts, and exhibition halls like London's Crystal Palace would showcase "great expositions of the arts...far more fittingly than in the noise and din of the crowded streets of the city."[23]

Philadelphia's park advocates were piqued by the successful progress of New York's Central Park, though they took heart in the knowledge that the Manhattan park could not compete with the Schuylkill riverscape.[24] "For inherent pastoral beauty, and sublime surrounding scenery, Fairmount Park is a gem," declared William Saunders, a local landscape architect, "compared to which the Central Park, of New York, is as a granite boulder.... [The] Schuylkill River presents all the serenity and calm seclusion of a lake, [and] its river existence induces to further and deeper reflection." Saunders continued, "The poetical mind will trace it to its brooklet source—an infant river—now coursing along smoothly in the open light, refreshing itself by an occasional dip under a shady bank...or as it frets and foams down the rocky cataract indistinctly visible through the canopy, until, as it nears the haunts of busy man it expands its proportions and assumes the appearance of placid maturity—a fitting emblem of human progress. So much are the beauties of nature dependent upon association of ideas."[25] Indeed, the presence of a river wending through Philadelphia's park lent symbolic importance to the landscape not available in New York's man-made design.

By the early 1860s, as new oil refineries and industrial plants increased the threat of pollution along the Schuylkill, citizens' groups lobbied the city to acquire more land on both the east and west banks of the river to create a huge central park.[26] "It is clear, it is undoubted, that Philadelphia wants a large Park," declared a local legislator, "a Park where there is

Fig. 41. Hugo Sebald, *Advertisement for Clarenbach & Herder, Manufacturers of Skates*, 1862. Wood engraving with hand coloring, 11⅞ x 18⅛". Private Collection.

room for the architect and engineer as well as the landscape gardener to develope [sic] the richness and beauty of their respective professions; room for carriage roads, bridle paths and walks; room for lakes, cascades and fountains; skating ponds, play grounds and rambles; for bridges, archways, terraces and corridors...casts and statues—room for all these without cramping or contracting."²⁷ Careful design and administration of open spaces would satisfy the recreational needs of all classes. Most important, the park would herald Philadelphia's status as a world-class city, surpassing in scale parks in rival American cities, to compete with the greatest parks of Europe, terrains like Hyde Park in London or the Bois de Boulogne in Paris.

For Philadelphians, the expanded park was easy to visualize because its boundaries replicated the scene looking upriver from the reservoir at Fairmount, a standard touristic view in Philadelphia iconography treated by local painters, printmakers, and photographers. Moreover, despite industrial incursions, popular and easily accessible recreational sites had sprung up along the river (fig. 41). By the 1860s, recreational facilities on the river included the boathouses of the Schuylkill Navy rowing clubs and the Philadelphia Skating Club (Benjamin Eakins was an early member), which provided rescue services for hapless skaters who fell through the ice. Lawns near Lemon Hill and Strawberry Mansion were used as playing fields and the mansion itself was leased by the city to a tavernkeeper. It was a popular destination among local German Americans, many of whom worked in nearby breweries and who frequently held community picnics and singing festivals by the river.

The expanded park plan was realized when a group of citizens purchased the Lansdowne estate on the west bank and re-

sold it to the city at cost. This precipitated the state legislation in 1867 and 1868 that created the Fairmount Park Commission and authorized the systematic expropriation of additional properties, incorporating suggestions made by landscape architect Frederick Law Olmsted, who, after a visit to study the park, recommended adding more land on the west bank. In particular, he urged the acquisition of the Wissahickon Creek to provide a convenient approach offering "unparalleled attractions for pleasure driving" that would connect with the shoreline drive planned for the east side of the Schuylkill.²⁸

Like the Schuylkill, the Wissahickon was threatened by industry. Gristmills, paper mills, and tanneries had been dumping effluents into the creek for over a century. In spite of this, the Wissahickon was a popular destination for landscape painters and photographers, who haunted the "majestic woods of every vigorous green...a boundless deep immensity of shade."²⁹ Among frequent visitors were artists William Trost Richards and Eakins's family friend Thomas Moran, who exhibited Wissahickon views at the Pennsylvania Academy's annual exhibitions during the 1860s (fig. 42). Thomas Eakins himself was an admirer. In a letter to Emily Sartain written from Paris soon after his arrival in the fall of 1866, Eakins confessed that thoughts of the Wissahickon made him homesick: "I envy you your drive along the Wissahickon among those beautiful hills with which are connected some of my most pleasant reminiscences," he wrote wistfully. "Philadelphia is certainly a city to be proud of," he then declared, reporting

Fig. 42. Thomas Moran, *Cresheim Glen, Wissahickon, Autumn*, 1864. Oil on canvas, 29⅛ x 36⅜". Hevrdejs Collection, Houston.

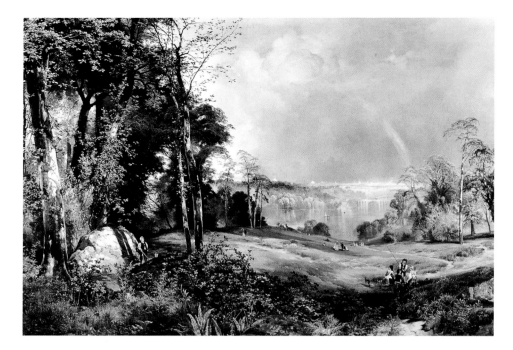

Fig. 43. Thomas Moran, *View of Philadelphia from Belmont Plateau, Fairmount Park*, 1871. Oil on canvas, 31½ x 47". Hirschl & Adler Galleries, New York.

that he boasted often of his native city to fellow students at the Ecole des Beaux-Arts, "[for it] has advantages for happiness only to be fully appreciated after leaving it."[30]

The Park Commission was specifically charged to protect some of the most picturesque of those "advantages" by authorizing the expropriation of as much land alongside the creek as was necessary to "preserve the beauty of its scenery."[31] The Wissahickon section of Fairmount Park thus became the first piece of publicly owned land in the United States to be set aside principally to preserve its scenic attributes.

Personal sentiments certainly informed *The Champion Single Sculls*, on which Eakins began work soon after returning from Europe. But he may also have created the portrait for a very specific audience. Since its founding early in the Civil War, the Union League had become the most influential political club in the city and headquarters for the newly powerful Republican business elite. League members recognized the political value of cultural programs, and they envisioned their 1870–71 art receptions expressly as opportunities to "add to the renown of Philadelphia, and spread her reputation among her sister cities."[32] Paintings of views along the Schuylkill River and the Wissahickon, newly incorporated into Fairmount Park, figured prominently in all three art receptions—not surprising given that eight of the sixteen members of the Park Commission were also members of the Union League.[33] Eakins's portrait of Schmitt fit in neatly with these other images. Indeed, older colleagues may have encouraged or facilitated Eakins's participation. Thomas Moran was a member of the art reception organizing committee and sent a canvas, *View on the Schuylkill*, to the third reception. Another exhibitor was George Holmes, who often accompanied Eakins and his father on sketching trips, and who had exhibited *Land-*

scape on the Schuylkill at the first art reception in December 1870, while Eakins was at work on the Schmitt portrait.[34]

The novelty of Eakins's combined portrait and Schuylkill River view becomes evident when compared to a more conventional rendering such as Moran's 1871 panorama looking east from the Lansdowne Plateau in the West Park (perhaps the canvas exhibited at the third art reception; fig. 43). In contrast to Eakins's focused view, Moran emphasized the size of Philadelphia's park. The lush and pastoral landscape surrounds and protects the azure waters of the Schuylkill, which link the rolling meadows and deep copses of the parkland to the spires and rooftops of the city skyline. Strollers and picnickers occupy the plateau in the middle ground, while in the foreground children outfitted with long sticks and buckets harvest chestnuts. On the river beyond, a steamboat passes scullers at practice, and a train crosses the Connection Railroad Bridge. Above arches a rainbow, signifying Philadelphia's prosperity; higher in the sky a bird (an eagle?) soars, symbolizing the optimism and promise of the city's new parklands.

In both canvases we see roughly the same section of the Schuylkill, with the distinctive paired bridges and passing locomotive. But Moran's idealized view isolates the Schuylkill from time; the landscape is genteel and nostalgic, a place of escape separate from the city on the horizon. Moran's sculler is simply a detail, in marked contrast to the blunt specificity of Schmitt's portrait. Both compositions convey the symbolic implications of the Schuylkill as the river of life alluded to by Saunders, but in Eakins's picture there is a greater sense of constant and directed movement—expressed most emphatically by the other scull propelled by the artist himself—that is absent from Moran's more static view. Both canvases are the same size, but the sense of space described in the Eakins is more immediate, tangible, and expansive. Moran closes off his composition with framing trees in the left foreground, maintaining a sense of distance from the viewer. Eakins, by comparison, pulls the viewer into his composition. The deep recession opens up the landscape from the bridges, echoing the broadening of the river and the parklands as one proceeds north.

Schmitt and his fellow rowers, the passengers on the steamboat—and the viewer—enjoy the privilege of sitting at the heart of Fairmount Park, the new heart of the expanded city. At this time the only way to view the park's full extent along the Schuylkill was by traveling upriver. Here Eakins alluded to an important task facing the park managers—how to bring the park, still relatively distant from the most populated sections of the city, to the citizens of Philadelphia. A contemporary photograph documents the new East River Drive already under construction along the same section of river Eakins depicted (fig. 44). The artist and Schmitt had to make their

way through construction in order to launch their racing shells from the riverside boathouses, because the park commission had begun extensive demolition along the east bank of the Schuylkill to open up entrances and drives into the park. The commissioners reported: "Whole blocks of buildings, including large hotels, have disappeared, railway tracks have been taken up; furnaces, foundries and iron mills have been removed; huge ditches and broad canals have been obliterated; the adjacent banks of the Schuylkill have been relieved from contaminations; cluttered streets and dusty highways have been vacated; and in place of these are seen rural sights, already beautiful, and soon to be rendered tenfold more so."[35]

These demolition and construction sites along the Schuylkill must have reminded Eakins of scenes he had witnessed recently in Paris, then undergoing the culminating phases of the massive modernization under Napoleon III (fig. 45). Entire neighborhoods, some centuries old, had been systematically razed to make way for upgraded sewer systems, bridges, government buildings, and grand new boulevards lined with modern multistoried apartment houses. Parks were a major component of the rebuilding strategy. Before this urban renewal, there were fewer than forty-seven acres of public parkland in the French capital; by 1870, forty-five hundred acres had been redesignated for public use, turning Paris into a veritable "Arcadia" according to admiring visitors.[36] Among the most noteworthy park projects was the transformation of the Bois de Boulogne into a picturesque arrangement of rolling lawns, reflecting lakes, and winding paths. Eakins was an alert observer of the urban environment, and several of his letters from Paris contain detailed descriptions of that city's parks and public spaces, in particular the Bois, which he visited on several occasions.

In his subsequent rowing pictures, Eakins expanded upon the theme of motion through ordered space, adding a more explicit competitive dimension that informs not only the champion athletes portrayed therein but also the landscape in which they compete.[37] In all of the rowing pictures set on the Schuylkill, Eakins included sufficient background detail to locate these scenes explicitly in Fairmount Park. In *The Pair-Oared Shell*, John and Barney Biglin row past the distinctive piers of the Columbia Bridge (fig. 46). In *The Biglin Brothers Racing* (National Gallery of Art, Washington, D.C.), painted to commemorate a race in the spring of 1872, Eakins showed some of the thirty thousand spectators reported to have watched the contest lined up along the new East River Drive, just below the Columbia Bridge; one equestrian takes advantage of the new road surface to gallop his horse downriver with the rowers.[38] In *The Biglin Brothers Turning the Stake-Boat*, we see the west bank of the Schuylkill in the background, lined with crowds of cheering onlookers, as pedestrians jostle riders and carriages for the best view (pl. 6). The landscape is expansive, public, and emphatically egalitarian.

Philadelphians took pride in the relaxed informality and the spirit of accessibility of Fairmount Park as compared with more

Fig. 44. James Cremer, *View from Mount Pleasant*, c. 1871. Stereograph. Fairmount Park Commission, Philadelphia (Cremer 130).

Fig. 45. Charles Marville, *The Piercing of L'Avenue de l'Opéra*, c. 1865. Albumen print. Bibliothèque Historique de la Ville de Paris.

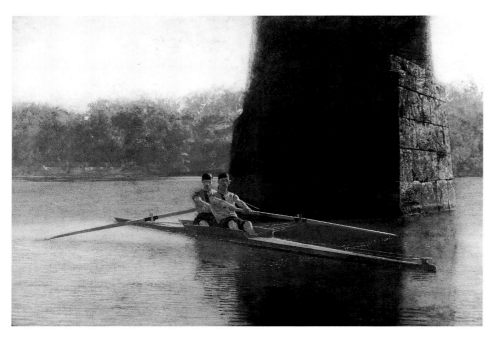

Fig. 46. Thomas Eakins, *The Pair-Oared Shell*, 1872. Oil on canvas, 24 x 36". Philadelphia Museum of Art. Gift of Mrs. Thomas Eakins and Miss Mary Adeline Williams, 1929 (pl. 4).

strictly regulated spaces such as New York's Central Park. Eakins's close friend and early supporter, the art critic Earl Shinn, described the Sunday crowds at Lemon Hill in the lavishly illustrated guide to Philadelphia and its grand park he penned in 1875, *A Century After: Picturesque Glimpses of Philadelphia and Pennsylvania:* "Nothing makes the ordinary citizen feel so much like a landed proprietor, strolling on his own lawn, as this freedom of range over the green sod. He proudly points out to his visitor from other regions that 'there is no *keep off the grass* [sign] in Fairmount Park.'" Shinn boasted, "[it is] foot-beaten, crowded and democratic."[39]

Many Philadelphians assumed that the preservationist purpose of Fairmount Park would minimize the need for intrusive landscape management. "It is the amazement of every visitor who is taken there," Earl Shinn wrote of the Devil's Pool, a marvelous site in the Wissahickon (fig. 47): "Though but a morning's walk from the city, this barbaric scene is a taste of the primitive wilderness in its rudest expression. A Park containing such a bit of Nature is already full-furnished, and hardly needs the hand of 'improvement.'"[40] But it was wishful thinking on Shinn's part to assume that such landscapes could simply be left alone. As expropriations proceeded and the boundaries of the park consolidated, patterns of use changed, and the process of managing and regulating the park became increasingly complex.

The Fairmount Park Commission governed a remarkably rich and diverse territory, ranging from the manicured gardens of the Old Park (around the waterworks and Lemon Hill) to the rolling meadows of the East and West Parks and the deep

forests of the Wissahickon. Unlike their counterparts in other cities, who typically followed a landscape architect's design for development of a specific territory, Philadelphia's park commissioners had no single plan or strategy for the management of an ever-expanding assemblage of contiguous properties in various stages of "improvement." Indeed, the park had no consistent boundaries: in the East and West Parks, existing roads and railbeds formed clear perimeters; in the Wissahickon, boundaries between private and public properties were obscured in the forested ravines.

The commissioners consolidated their authority, and purchase negotiations with property owners began. New surveys confirmed boundaries and furnished data for maps. Existing roadways were scheduled for repair, while new roadways and pedestrian paths were laid out. Trees in the East and West Parks were inventoried. Buildings were demolished or renovated. Staff for the Fairmount Park Guard, separate from the city police force, was recruited to enforce new rules. Recreational activities in park areas were most dramatically affected, as fields and riverbanks once relatively unsupervised were now regulated, although enforcement seems to have been intermittent. Swimming in the Schuylkill was prohibited. The Schuylkill Navy rowing clubs were permitted to remain but only if they built permanent boathouses along the river. Croquet was permitted, while baseball and football were discouraged, and park users frequently complained to the commissioners about ballplayers interrupting more sedate activities. In 1878 Eakins joined members of the Philadelphia Sketch Club in a series of games of "shinny" (similar to field hockey) on the parade ground near Strawberry Mansion against men from the Undine rowing club. Shinny was ostensibly prohibited, but the players were able to circumvent commission rules by obtaining a license to play polo, having conveniently neglected to inform the commission that they had no horses. The commission and Park Guard apparently overlooked the infraction: the games were reported in the press but no punishment was imposed.[41]

The commissioners also had to deal with outright resistance to the park. Some citizens thought it too large. Others pointed out that while land values may have increased in some adjoining neighborhoods, the park was still inaccessible for many poorer residents. Fairmount was nearly an hour's walk from the center of the city and many working-class Philadelphians could not afford the expense of a trolley ride. Calling the park "a rich man's playground," critics challenged the legality of the commission and derided the park as an impractical and expensive conspiracy of land developers and idle dilettantes to make profits from useless property at the taxpayer's expense. "Dogs are not allowed in to run at large in the Park," declared

one pamphleteer, "least [*sic*], when discovering the extraordinary expenditure of people's money they become mad."[42]

The commissioners were determined to make the park accessible and useful, arguing that a single large park preserved the natural landscape more effectively, and was cheaper and safer, than many dispersed smaller parks because it was more easily supervised.[43] Laudatory articles in the local and national press as well as guidebooks to the city emphasized the park's accessibility and orderly informality. Regulations were enforced for the benefit of park users, avowed one writer, as the commissioners "thoughtfully sought to furnish to the masses of the people every facility of access to their property, and have only imposed such restraints to their enjoyment of it as were necessary to prevent unwarranted license."[44] All classes were welcome. And whereas no respectable woman would enter a European park without a chaperone, female visitors to Fairmount Park were assured that they would not encounter "nuisances" or harassment.[45]

The commissioners considered themselves cultural entrepreneurs, bringing art and science into the park as industry and agriculture were eradicated. In 1871 Joseph Harrison, Jr., a prominent art collector, convinced his fellow commissioners to initiate planning for a free civic art museum at Lemon Hill by erecting a temporary facility near the waterworks. "If we as a nation are to keep pace with the civilization and refinement of the older states of the Christian world, we, too, must have our free Art Galleries and Museums, owned by, enjoyed by, and cared for by the people," Harrison declared. "Being the property of the people, [such] will stimulate a just pride amongst all classes, in their maintenance, their conservation, and their endowment."[46] In 1871 Randolph Rogers's monument to Abraham Lincoln, the park's first commissioned work of sculpture, was unveiled near the entrance to the East Park (fig. 48). Additional artistic embellishments were purchased through the efforts of the Fairmount Park Art Association, a private citizens' group chartered in 1872 to raise funds to commission works of sculpture.[47] The commissioners worked with the Zoological Society to complete plans for the country's first zoo, which opened in the West Park in 1874. Later in the decade, the American Philosophical Society contributed funds to establish an oak grove in the park.

The commissioners were able to develop productive collaborations with citizens' groups and cultural organizations in the city because most of them also belonged to these organizations; indeed, some commissioners served on several boards of directors, providing them with unique opportunities to act as cultural power brokers. Moreover, alternate funding sources became crucial when city appropriations began to dwindle. Although the commissioners could point to the dramatic

Fig. 47. After Thomas Moran, *Devil's Pool*, 1875. Wood engraving. From Edward Strahan [Earl Shinn], ed., *A Century After: Picturesque Glimpses of Philadelphia and Pennsylvania* (Philadelphia: Allen, Lane & Scott and J. W. Lauderbach, 1875).

Fig. 48. James Cremer, *Green Street Entrance to Fairmount Park*, c. 1872. Stereograph. Fairmount Park Commission, Philadelphia (Cremer 256).

Fig. 49. David J. Kennedy, *Mount Pleasant*, 1870s. Watercolor on paper, 4⁹⁄₁₆ x 7⅝". Historical Society of Pennsylvania, Philadelphia.

Fig. 50. *Map of the Centennial Grounds and Vicinity*, 1876. From Charles Keyser, *Fairmount Park and the International Exhibition at Philadelphia* (Philadelphia: Claxton, Remsen & Haffelfinger, 1876).

increase in the value of properties adjoining the park, they had to plead for funding. In 1871 Frederick Law Olmsted and Calvert Vaux, then the country's leading landscape architects, were invited to develop an updated plan for the Old Park, but their report was not acted upon, apparently because of lack of funds. By 1873 an economic depression had hit the country, and Philadelphia's city government appropriated only enough funds for basic maintenance of the park.[48]

In the late 1860s, the governing boards of several of the city's premier institutions—including the Pennsylvania Academy of the Fine Arts, the Academy of Natural Sciences, the American Philosophical Society, and the Franklin Institute—considered relocating to new facilities in a single "cultural district" at Centre or Penn Square. This plan was abandoned when Centre Square was selected for the new City Hall. But the concept of a "cultural district" did not die out; instead cultural leaders looked toward Fairmount Park.[49]

Not only did Fairmount Park provide open space, it also offered significant cultural resources in the many historic houses that still stood on estates incorporated into the park: the "colonial chain" included such imposing structures as Mount Pleasant, once briefly owned by traitor Benedict Arnold (fig. 49).[50] "Every foot of ground teems with association," wrote Earl Shinn. "It is no raw creation, laid down in an inert and sleeping suburb, far in advance of a city's march of improvement, and ignorant of a history. Long before we were a nation, this garden was trodden by footsteps that are now historic; its very sods are sensitive; they vibrate to the memories of near two hundred years."[51]

This historical resonance, in part, inspired the idea that Philadelphia should host a world's fair to mark the centenary of American independence. It was the logical site: the Declaration of Independence was read in Philadelphia in 1776; the city had hosted the Constitutional Convention in the 1780s; and Philadelphia had served as the new nation's capital from 1790 to 1800. Civic boosters eagerly embraced the concept. Acts of Congress in 1871 authorized planning for the fair and established the Centennial Commission and Centennial Board of Finance to manage the event.[52] Recognizing that this event would provide a matchless opportunity not only to promote Philadelphia as a world-class city but also to fund new cultural facilities as well as physical improvements in the West Park, several commissioners worked for the Centennial, most notably John Welsh, who served as chairman of the Centennial Board of Finance.

Four hundred and fifty acres on the Lansdowne and Belmont plateaus on the west side of the Schuylkill were set aside for an innovative "village" of separate exhibition pavilions (fig. 50). Under the capable supervision of chief engineer Hermann

Schwarzmann, who had been seconded from the Fairmount Park Commission staff, parklands were excavated for the complex infrastructure needed to service the exhibition grounds: a new waterworks facility was constructed, new gas and water lines and a sewer system were laid out, and a telegraphic network was erected to connect the exhibition grounds to police and fire departments and other offices in center city.[53] Schwarzmann also supervised the construction of the exhibition buildings. Some foreign countries erected their own buildings, as did participating states as well as several domestic manufacturers. When the exhibition opened in May 1876, one hundred and eighty buildings of iron, glass, and stone covered two hundred and thirty-six acres in the West Park, effectively obliterating the Lansdowne Plateau pictured in Thomas Moran's view just five years before. By the time the exhibition closed in November 1876, more than ten million people had passed through the entrance turnstiles, bringing Philadelphia the international recognition for which community leaders had so long worked.

When completed, the exhibition grounds formed a powerful counterpoint to Penn's grid at Philadelphia's center.[54] James Cremer was one of dozens of photographers who climbed the viewing tower erected atop George's Hill in the West Park near the exhibition grounds to document the orderly yet expansive site (fig. 51). The largest, most imposing exhibition halls were located along two main intersecting axes; the smaller pavilions—many designed to look like comfort-able upper middle-class houses—were situated more informally along winding roads, "to produce an almost suburban atmosphere."[55] Visitors typically arrived via the Pennsylvania Railroad at a temporary station erected at the main entrance, which can be seen in the background of the photograph. They could walk to the main exhibition pavilions or transfer to a narrow-gauge railroad (visible in the foreground) that made a touring circuit of the exhibition grounds. In Cremer's panorama looking east, Memorial Hall, which housed the art gallery, can be seen to the left of the Avenue of the Republic just beyond the ornamental lake. Across stands Machinery Hall, in the foreground, and behind this, the Main Building—the largest building in the world at this date—which housed more than 13,720 exhibitors over a twenty-acre area.

Here America celebrated the nation's technological progress as native designers and manufacturers measured their products against foreign rivals. Visitors perused thousands of exhibits, from prize livestock to Japanese porcelain, from Alexander Graham Bell's new telephone apparatus to George Washington's uniform, arranged according to a classification system designed by exhibition organizers to educate as well as to entertain the middle-class public. The cultivation of a discriminating gaze was an important function of the Centennial, which according to one official publication, provided a "vast system of eye education."[56] Indeed, as several historians have observed, the Centennial displays heralded the advent of modern consumer culture, as Americans were encouraged to enter

Fig. 51. James Cremer, *Centennial Exhibition from the Observatory, George's Hill,* 1876. Albumen print. The Library Company of Philadelphia.

Fig. 52. C. H. Graves, *Sunken Gardens, Fairmount Park, Philadelphia,* 1903. Stereograph. The Library Company of Philadelphia (P9047.159).

a "universe of consumption possibilities," where they would come to self-understanding through the examination and acquisition of consumer goods. "The goods shown at world's fairs did not just cater to middle-class taste, they helped form that taste. People were to be educated about what to buy, but more basically they were to be taught to want more things, better quality things and quite new things."[57]

So successful was the Centennial that the fair's organizers as well as the Fairmount Park Commission hoped that the "village" of exhibition pavilions could be maintained,[58] following the example set in London, where several museums and other public institutions were spawned by the 1851 Crystal Palace Exhibition, the first true world's fair. During the late 1870s, the Main Building was managed by a private firm that attempted to develop profit-making lecture programs and exhibitions, but these efforts were thwarted by the costs incurred in maintaining the vast building and the opposition of political and religious leaders in the community to the scheduling of events on Sundays. By the time the Main Building was dismantled in 1882, most of the Centennial buildings had been demolished or sold and relocated. Ironically, when ongoing financial problems prevented the commissioners from re-landscaping the Centennial grounds, roads laid down for the exhibition were retained, forming a ghost outline of the world's fair that survives to this day.

The ideological effects of the Centennial were demonstrated in the relatively successful transition of the two Centennial buildings specifically built to outlive the event: Memorial Hall and Horticultural Hall. Joseph Harrison's ambitions for a large civic art museum were realized when Memorial Hall was re-opened in 1877 as the Pennsylvania Museum and School of Industrial Art. Modeled on London's popular South Kensington Museum, one of the institutions that had originated with the 1851 Crystal Palace Exhibition, the new museum would provide "the best examples of Industrial Art, manufactures, free lectures to artisans upon subjects connected with their work and schools for proper education upon all subjects which are essential to the successful production of works into which design in every way enters."[59]

The Pennsylvania Museum deliberately targeted a broad audience and advertised itself as a place for ordinary citizens, in contrast to New York's young Metropolitan Museum, which cultivated a more exclusive image. In 1879 the secretary of the Pennsylvania Museum's board declared that its primary purpose was to "benefit ... that vast majority of our citizens, the artizans [*sic*] and mechanics, for whom it is the only resort of the kind accessible."[60] The park commissioners, in keeping with these egalitarian aims, embraced this philosophy. Horticultural Hall, still filled with exotic specimens donated from around the world for the Centennial Exhibition, operated as a facility for research, education, and entertainment (fig. 52). In addition to its main hall, the facility comprised greenhouses to supply the park and a lecture hall, as well as extensive gardens and an arboretum.[61] Complaints about Fairmount Park's accessibility and exclusivity were momentarily stilled by the success of the Centennial. By the end of the 1870s, annual attendance in the park averaged more than six and a half million people from all economic classes and sections of the city.

Funding and facilities generated by the Centennial enabled the Fairmount Park commissioners to transform the park into a public resource that incorporated the informed display of art and science within a natural setting. However, even as the new board of directors of the Pennsylvania Museum at Memorial Hall was assembling collections for display, Fairmount Park was beginning to lose its appeal for members of Philadelphia's artistic community. It is curious to note that despite the pictorialist origins of Fairmount Park, only two views of Fairmount Park were displayed in Memorial Hall during the Centennial: William Trost Richards's *Wissahickon* and Edmund Darch Lewis's *East Park*, notwithstanding a preponderance of painted views of the Adirondacks, the White Mountains, and other picturesque national sites.[62]

The consolidation of the park commission's authority and expanded landscape maintenance programs alarmed many landscape artists. In 1879 members of the Philadelphia Sketch Club, the Artists' Fund Society, and the Photographic Society

of Philadelphia joined forces to protest recent tree cutting and dynamiting of rock outcroppings to clear a new bridle path along the upper bank of the Wissahickon in the northern section of the park. Noting that this area had long been a favorite destination for artists, Sketch Club members expressed regret that its incorporation into the park system should have exposed the scenery to insensitive "defacement." The Wissahickon was a "marvel of picturesque beauty," echoed Isaac Williams for the Artists' Fund Society, who beseeched the commissioners to proceed with caution. "Should the Commission still adhere to this purpose of opening up the solitude now lying between the present termination of the path and the red bridge, this Society respectfully urges, that it shall be by continuing the path around the bluff, on the lower side of the creek, crossing beyond with a light foot bridge." Williams concluded, "It is no place for equestrians!"[63] For the time being, the artists took heart when they were informed that construction had been suspended indefinitely for lack of funds. As the commission endeavored to make the park more convenient for the wider public, it risked alienating the very constituency that first drew attention to sites most deserving of preservation.

Perhaps adding to the concern of artists was a decline in the demand for painted or printed views of the park because of the ready availability of inexpensive photographs. By the late 1870s, thanks to advances in camera design and mass-production

Fig. 53. James Cremer, *Fairmount Park Gardens and Lemon Hill*, c. 1876. Stereograph. Fairmount Park Commission, Philadelphia (Cremer 224).

printing-press technologies, photographers had extensively documented American cities, and pictures of most cities were widely circulated, often in the form of stereographs.[64] City parks were particularly popular subjects, and the many picturesque sites within Fairmount Park, like those of Central Park in New York, were among the most frequently reproduced. Painters and printmakers had depicted sites throughout Fairmount Park selectively, whereas these photographers were voracious, comparatively indiscriminate image makers. By the mid-1870s, the park had been systematically and exhaustively photographed by a succession of practitioners who produced hundreds of views, with copies sold to vendors across the country (fig. 53). Countless photographs of local historical sites and the fairgrounds that were produced for tourists during the Centennial year added to the surfeit of Philadelphia views. Painters and printmakers were hard-pressed to compete with proliferating stereographs and penny postcards marketed individually or sold in sets.

Like their counterparts in other American cities, the Fairmount Park commissioners encouraged photographers. Photographic views emphasized stability over energy, celebrating the American city as "a place of perpetual presence rather than mutation and change."[65] Parks were portrayed as healthful, regulated spaces for constructive relaxation or recreation, with visitors shown sedately posed along well-maintained paths, or seated comfortably in a rowing boat on a picturesque stream, to convey the idea that the park was attractive but not overgrown. Sites in the Wissahickon such as the Devil's Pool, once celebrated as "primitive" treasures of the Philadelphia region, became just one more view in a photographic tour. The park commission was fairly successful at preserving the wilderness character of the Wissahickon, notwithstanding artists' concerns, but the area's remoteness and uniqueness was a thing of the past.

One noted local artist had abandoned the park altogether for more majestic locations. Early in the 1870s, Thomas Moran had accompanied government survey expeditions to Yellowstone, the Grand Canyon, and the Colorado River, compiling sketches and watercolors that he incorporated into monumental oil paintings of the Western landscape upon his return to the East. His *Grand Canyon of the Yellowstone*, painted in 1872, was purchased by the U.S. government to hang in the Senate Wing of the Capitol and is said to have convinced Congress to pass legislation designating Yellowstone as the country's first national park (fig. 54). Moran would focus on paintings of the West for the remainder of his career—he even adopted the nickname "Yellowstone," and inserted a "Y" into the monogram with which he signed his pictures.[66] It seems that he stopped painting Philadelphia scenes even before he moved to

Fig. 54. Thomas Moran, *The Grand Canyon of the Yellowstone*, 1872. Oil on canvas, 84 x 144¼". United States Department of the Interior, Office of the Secretary, Washington, D.C.

Newark, New Jersey, to be closer to New York. And he sent only Western pictures to the Centennial, including *The Mountain of the Holy Cross, Colorado; Hot Springs of the Yellowstone, Wyoming Territory;* and *Fiercely the Red Sun Descending, Burned His Way Along the Heavens,* as well as five drawings from the legend of Hiawatha.

By the later 1870s, Eakins, too, had redefined his relationship to the park. He had stopped painting rowing scenes by 1874 and sent none of these to the Centennial. Later in the Centennial year, he began work on *William Rush Carving His Allegorical Figure of the Schuylkill River* (fig. 55). In this tribute to an admired predecessor, Eakins portrayed Rush working from a live model to carve the figure of a nymph and bittern, an allegory of the Schuylkill River that Rush had made for Philadelphia's first waterworks at Centre Square. By 1876 Rush's *Nymph and Bittern* had been moved to the Fairmount Waterworks, where Eakins made sketches of it, but he made no reference to this site in his painting. His purpose was to describe the intimate space of the working artist, concentrating fully on the task at hand, and thereby to convey his own commitment to study from the live model and his sense of connection to Philadelphia's artistic traditions. The river that inspired Rush's figure is only alluded to because the physical landscape had been subsumed into the personification, a carved figure that is the product of the artist's creative imagination.[67]

Eakins next depicted Fairmount Park in *A May Morning in the Park*, a portrait of Fairman Rogers driving family and friends in a four-in-hand coach along a park drive, perhaps near Horticultural Hall (fig. 56).[68] Rogers was chairman of the Board of Directors' Committee on Instruction at the Pennsylvania Academy of the Fine Arts and, as Eakins's direct superior, an important advocate for the innovative curriculum Eakins had devised at the school. An engineer by training and

former member of the faculty of the University of Pennsylvania, Rogers shared Eakins's fascination with human and animal physiology and kinetics. Rogers was an expert equestrian and coaching enthusiast as well as an accomplished amateur photographer. After acquiring examples of Eadweard Muybridge's motion photographs of horses published in the summer of 1878, Rogers and Eakins conceived a portrait of Rogers to test whether Muybridge's discoveries would translate to traditional hand-drawn modes of representation. Rogers may have taken the initiative in devising this portrait by encouraging Eakins to combine the study of Muybridge's photographs with extensive anatomical studies and dissections in preparation for his rendering of the moving horses. It was probably Rogers who selected Fairmount Park as the location.[69]

As in the rowing pictures and his other sporting scenes, Eakins described an activity that required discipline, strength, and intellect, here directed to controlling a "drag" drawn by four powerful thoroughbred horses. Rogers believed that successful horsemanship was built on a scientific foundation of fixed rules and correct principles. The "art" of coaching arose when, having mastered these principles, the skilled driver combined technique with effective presentation. "Visually, there was tremendous satisfaction for Rogers in the appearance of his four-in-hand, the horses well trained, matched, and groomed, the drag elegantly painted and polished, the grooms attired in spotless, color-coordinated liveries.... Most compelling, even intoxicating, however, was the pleasure of Rogers himself, as coachman, in managing the ensemble gracefully, correctly, 'smartly.'" Here Eakins again celebrated the excellence he described in his portrait of Max Schmitt and other distinguished individuals, acknowledging the mental and physical

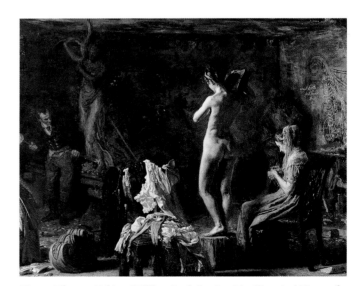

Fig. 55. Thomas Eakins, *William Rush Carving His Allegorical Figure of the Schuylkill River*, 1876–77. Oil on canvas, 20⅛ x 26⅛". Philadelphia Museum of Art. Gift of Mrs. Thomas Eakins and Miss Mary Adeline Williams, 1929 (pl. 41).

discipline, the "commitment to 'science' and 'genius' that matches their art with his own."[70]

The portrait may have commemorated a May 1878 outing to Philadelphia by members of the New York Coaching Club, of which Rogers was a member, during the final leg of which Rogers may have diverted his companions to tour Fairmount Park and, in particular, to admire the new roadways in the West Park.[71] The choice of Fairmount Park as the setting of the Rogers portrait reinforced this theme of science wedded to art, because as cultural institutions moved to the park, it had become the primary public site in Philadelphia for the restorative and didactic interaction of art, science, and recreation. Moreover, Rogers was typical of the upper-class Philadelphians who had worked to establish and nurture Fairmount Park since the 1850s. Rogers's and Eakins's grandfathers had come from the same artisan class, but Rogers's father had made a fortune in industry, and by the 1860s, thanks also to an astute marriage, the younger man had joined the tightly knit elite that governed culture in Philadelphia. Both he and his father had contributed to the Sedgeley purchase fund in 1857. As a founder of the Union League and a member of such organizations as the American Philosophical Society and the Franklin Institute, Rogers would have socialized regularly with members of the park commission. He had served on the board of the Zoological Society when that institution opened the new zoo in the West Park, and he was also an early and active member of the Fairmount Park Art Association. Rogers doubtless took a professional interest in the park, too, as a civil engineer and recognized authority on road construction. Although Rogers was never a member of the Fairmount Park Commission, he could take justifiable pride in having contributed to Fairmount Park's success.[72]

Preparatory drawings indicate that Eakins first planned to set Rogers's coach within a richer narrative setting (fig. 57). For example, in two of these sketches, he included a Conestoga wagon in the background to enhance the historical dimension of Rogers's hobby. The popularity of four-in-hand coaching was fueled by nostalgia for the golden age of coaching, superseded by such new modes of transportation as the railroad. In particular, because horse-drawn vehicles were slower, they were considered to provide passengers with a more intimate view of and connection with nature and the passing landscape. Thus, "modern life, from the box of a four-in-hand, seemed too fast, too anaesthetized, and too dangerous while lacking in teamwork, sociability and opportunities for the display of traditional skills.... The romantics of the coaching movement wished to enjoy the ride as much as the destination, to experience the outdoors at a 'healthful, delightful and invigorating' pace, to command a complex team of horses and

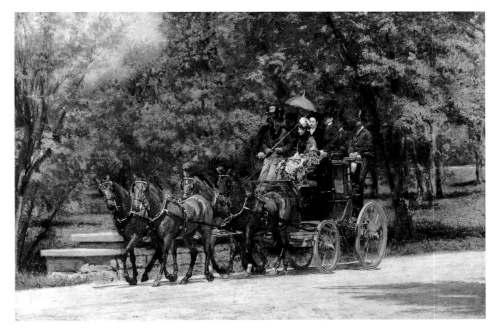

Fig. 56. Thomas Eakins, *A May Morning in the Park (The Fairman Rogers Four-in-Hand)*, 1879–80. Oil on canvas, 23¾ x 36". Philadelphia Museum of Art. Gift of William Alexander Dick, 1930 (pl. 51).

equipment, all endangered pleasures snatched back from oblivion."[73] Similarly, a single horse and rider shown passing the coach might allude to older modes of transportation.

A troubling element in these drawings is the figure of a tramp, carrying his possessions in the familiar handkerchief tied to a pole, who also walks along the road taken by Rogers's carriage—a detail that might indicate Eakins's sensitivity to the debates about social class. As contemporary views document, it was not unusual to see four-in-hand coaches in Fairmount

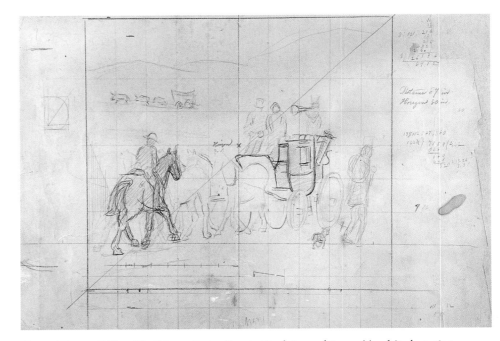

Fig. 57. Thomas Eakins, *The Fairman Rogers Four-in-Hand: Squared Compositional Study*, c. 1879. Graphite on paper, 12⅛ x 18¾". Pennsylvania Academy of the Fine Arts, Philadelphia. Charles Bregler's Thomas Eakins Collection, purchased with the partial support of the Pew Memorial Trust and the John S. Phillips Fund.

Park, but this mode of transportation was restricted to the very wealthy. Like modern-day high-performance sports cars, few people could afford to maintain a coach and the four horses needed to lead the vehicle, as well as to pay the grooms who cared for the animals and equipment. This was exactly the kind of vehicle that had attracted the ire of those critics who derided Fairmount Park as a playground for the wealthy. In the unsettled economy of the late 1870s, when strikes broke out against the transportation industry in particular, another common sight in Philadelphia and other American cities was unemployed transients who often camped illegally in city parks because of a lack of affordable shelter.[74] Tramps might be romanticized as self-reliant vagabonds; but they also embodied threats of civil unrest—hardly a detail the prosperous engineer would have wanted in a portrait that included his wife and in-laws. Indeed, the presence of the tramp calls into question the theme of teamwork in this portrait, because Rogers is not a team member in this picture of a single coach; rather he acts as a director accompanied and admired by passive passengers and attendant subordinates. Significantly, Eakins drew the tramp walking in the direction opposite to the coach—perhaps to symbolize an individualist who defies conformity.

Did Eakins even show these drawings to Rogers, who then rejected any allusions to class conflict? Or did so much added narrative simply detract from the "scientific" purpose of the portrait? As many observers have remarked, the final version of *May Morning in the Park* is a curiously bloodless portrait, as if Eakins were so focused on describing the motion of the carriage that he paid little attention to integrating the carriage into the landscape. Eakins did produce at least one oil sketch of the background while preparing the portrait, but in the final canvas the park was no longer a carefully described place, as had been the riverscapes in which Schmitt and the Biglins sought glory less than a decade before. In particular, there is no sense of community—no spectators or opponents are present in the

Fig. 58. Circle of Thomas Eakins, [*Thomas Anshutz at Bartram's Garden*], c. 1882. Archives of American Art, Smithsonian Institution, Washington, D.C. Thomas Anshutz Papers.

Rogers portrait, even though the West Park drives were typically crowded on spring mornings.

A May Morning in the Park was the last painting in which Eakins explicitly depicted Fairmount Park. We know that he continued to use the park: both Eakins and his father were avid cyclists who must have rejoiced when the park commissioners finally removed the prohibition against cycling on park roads early in the 1880s.[75] But by this time, Eakins's artistic vision of landscape had changed as he turned inward, embarking on a series of paintings, sculptures, and photographs that treated states of mind embodied in the mythic space of Arcadia. He did not entirely abandon references to the Philadelphia landscape, but he now ventured farther afield. The culminating work in this series was *Swimming*, a subject first broached in photographs and studies made outside the city, near Bryn Mawr in the still semirural suburbs of the Main Line (pl. 149).

By the mid-1880s, citizens' groups seeking to establish more accessible neighborhood parks throughout the city revived challenges to the concept of a single central park. Thanks to lobbying by the newly formed City Parks Association, the city purchased more properties, ranging from such historic sites as the Logan family homestead at Stenton and horticulturist John Bartram's house and garden in southwest Philadelphia—where some of Eakins's students photographed each other during a visit in the 1880s (fig. 58)—to recreational areas such as Juniata Park in the Frankford district.[76] Soon after the turn of the century, the Fairmount Park Commission joined these expansionist efforts when it purchased sizable territories along Cobbs Creek in West Philadelphia and Pennypack Creek in the northeastern district. As land acquisitions accelerated, the city's park system changed from a central chain of territories once heralded as a unifying force in the community to a network of dispersed parks inserted into the urban grid that more accurately mirrored the diversity of Philadelphia's neighborhoods. By 1916, when the commission gained jurisdiction over the original city squares laid out by William Penn, the park system had expanded to encompass more than six thousand acres and was still growing.

During the same period, the area around Fairmount was transformed when the City Parks Association joined forces with the Fairmount Park Art Association and the park commission to provide better access from the center of the city to the park. During the first decade of the new century, hundreds of row houses and industrial buildings northwest of Logan Square were demolished to make way for a parkway (later named after Benjamin Franklin), modeled after the Champs Elysées in Paris (fig. 59).[77] When completed in 1918, the Parkway inserted a dramatic diagonal into the repetitive grid of streets, facilitating access to the park and creating a

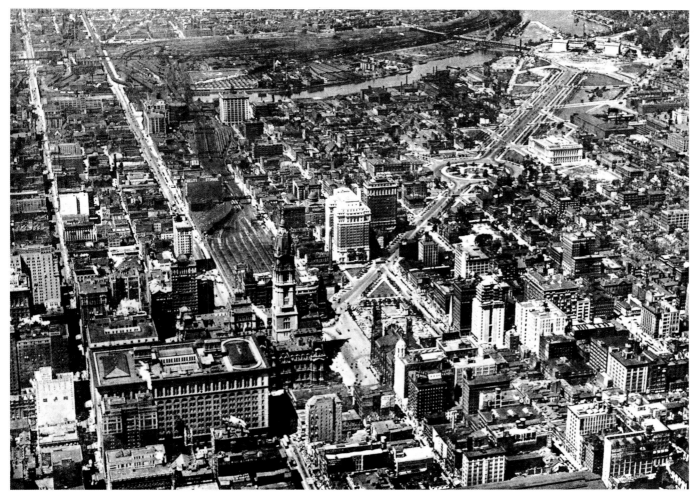

Fig. 59. *The Parkway from the Southeast* (with the end pavilions of the art museum roofed but only the foundations of the central block in place), August 22, 1925. CIGNA Archives, Philadelphia.

clear physical and conceptual link between the public and private institutions of culture and governance in center city with the park. In the meantime, the now-obsolete Fairmount Waterworks, once the premier symbol of progress and industry in Philadelphia, was scheduled for decommissioning.[78] No sooner was this announced than long-standing plans to transfer the Pennsylvania Museum collections from Memorial Hall to a large new edifice were reformulated, and Philadelphian Joseph Harrison's dream was realized when a temple of art was designed to surmount the Fairmount reservoir at the end of the Parkway. When opened in 1928, the grand steps of the Pennsylvania Museum of Art (now the Philadelphia Museum of Art) became the new main entrance to Philadelphia's parks (fig. 60).[79]

Thomas Eakins and his wife Susan had always lived within walking distance of the East and West Parks and doubtless continued to frequent these areas during the expansion of Philadelphia's park system. The extensive demolition of nearby neighborhoods during construction of the Parkway was disconcerting, though both Eakins and his wife must have observed these improvements with interest and some pride.

Fig. 60. Sigurd Fischer, *View of the Pennsylvania (Philadelphia) Museum of Art and the Fairmount Waterworks,* 1928. Archives, Philadelphia Museum of Art.

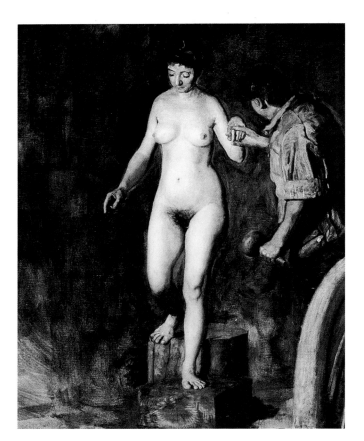

Fig. 61. Thomas Eakins, Detail of *William Rush and His Model*, c. 1908. Oil on canvas. Honolulu Academy of Arts. Gift of the Friends of the Academy, 1947 (pl. 239).

Fig. 62. Circle of Thomas Eakins, *Thomas Eakins at About Age Seventy at 1729 Mount Vernon Street*, c. 1914–15. Silver gelatin print, 4½ x 3½". Hirshhorn Museum and Sculpture Garden, Smithsonian Institution, Washington, D.C. Samuel Murray Archival Collection (EM 24).

About the same time that the city of Philadelphia had announced that the Fairmount Waterworks would be decommissioned, Eakins returned to a Schuylkill River theme. He revisited *William Rush Carving His Allegorical Figure of the Schuylkill River* in a series of oil sketches and paintings. In what may be the last canvas in this late reworking, showing Rush assisting his model down from the podium, he eliminated the figure of the chaperone and the background detail of Rush's workshop to focus on the artist, whose burly physique and stooped shoulders were enough like those of the aging Eakins to suggest a self-portrait (fig. 61). Eakins departed from his previous practice by turning the female nude around to face the viewer. The elimination of the studio setting is another departure: model and artist are now silhouetted

against an undifferentiated brown background rather than within the carefully drawn space of a workshop. In the earlier canvases, the model acted as Rush's inspiration—she mirrors the carving on which the artist labors. In the late canvas, as the workshop interior dissolves and the young woman turns to face us, she becomes the Schuylkill enlivened and personified, interacting directly with the artist, who now is Eakins himself (fig. 62). Forty years had passed since Eakins announced his return from art study in Europe with the exhibition of a Schuylkill River scene. Now, as the elderly artist took stock of his career, he turned not just to the memory of an admired predecessor but also to the embodiment of the *place* that was dear to his heart—the river along which he lived a long and productive life.

Eakins and the Academy

KATHLEEN A. FOSTER

INDIVIDUALIST, nonconformist, truth-teller, Thomas Eakins has been seen by American art historians as a hero and an outcast, representing national traits of independence, egalitarianism, and pragmatism. In his legendary role as defender of artistic freedom and opponent of Victorian prudery, born in the scandal of his forced departure from the Pennsylvania Academy of the Fine Arts in 1886, he is seen as firmly set against the mainstream of his day. Proud of his heritage as an American and a Philadelphian, and dedicated to his role as a national realist, Eakins cultivated aspects of this reputation, but was surprised to be judged an outsider—at best stubborn and "peculiar," at worst immoral. Leader as well as collaborator, perpetual student as well as dedicated teacher, Eakins considered himself the consummate insider. He carried himself with the principled seriousness of a guild master charged with the maintenance of professional standards and the education of artists, linked in an academic community dating back to ancient Greece and across the Atlantic to France. Sometimes characterized as a "single sculler" (as he depicted himself in *The Champion Single Sculls*, pl. 1), he also wished to be recognized as a team player. On the surface an American independent, he held at his core the values of a committed French academic.[1]

The combination produced odd, sometimes uncomfortable results, and the "team" was often invisible to everyone but Eakins. The confusion of "American" and "academic" identities and expectations, eventually leading to his bitter sense of "misunderstanding, persecution, and neglect,"[2] points to a tangle of attitudes that had an enduring, glorious, and frequently troublesome impact on his career. The most confusing threads in this knot were colored by his experiences as student and teacher at two institutions, the Ecole des Beaux-Arts in Paris and the Pennsylvania Academy of the Fine Arts in Philadelphia. On each side of the Atlantic, the academy represented inherited wisdom, sometimes fallen into stale convention. It guarded the ideals of art and scholarship, frequently corrupted by commerce or vanity, and it offered a rhetorical platform, often at the service of the status quo. Some of Eakins's contemporaries, trained in academies and appalled by official art, rebelled in search of fresh, subjective approaches,

drawing inspiration from modern life and the realist art of the Baroque, or seeking the "impression" of visual perception. Dedicated individualists, such artists—including Gustave Courbet, Edouard Manet, Edgar Degas, and Claude Monet— rarely became teachers or formed schools. Eakins instead sought radical reform within the system, using the same realist techniques and sources to attack decadence from inside the academy. Upraising science to discipline subjectivity, he called upon modern "study" to rejuvenate the visual arts. Eakins had developed such convictions in America, but they existed in France in the 1860s: many of his most "American" subjects and "independent" behaviors were inspired by the practice of his European teachers, Jean-Léon Gérôme, Léon Bonnat, and Augustin-Alexandre Dumont. Taking their academic method to extremes, Eakins fused contradictory strains—American and French, independent and collective, modern and traditional, real and ideal—into a vital and inevitably tense, idiosyncratic system of teaching and creating art.[3]

A wider view of the academy as an arena for research, instruction, and intellectual exchange in all the arts and sciences also guided Eakins's sense of his role in the broad scheme of his culture. His status in society was granted by the artist's academy, which, like a medieval guild, trained and effectively licensed new professionals. He was proud of his academic credentials, which gave him a respected place within the community of artists and also made him the peer—and potentially the friend—of distinguished scientists and humanists in wider fields of academic endeavor. In the last two decades of his life, as Eakins's teaching career waned, this larger community would sustain his spirits and inspire some of his finest paintings.

Born to be a scholar, a teacher, and a craftsman, Eakins learned the ways of the schoolroom and the workshop from his father, Benjamin, a writing master. His studious side was developed in the public schools of Philadelphia, where he followed a progressive curriculum that matched the ambition of many colleges of the period. Central High School, a model of American meritocratic education, reinforced his conceptual skills, his obsession with measurement, his delight in languages, and his respect for accomplishment. An excellent student, Eakins

applied for the position of drawing master when his own teacher retired in 1862. He failed to win this job but persisted at others in the same line: soon after graduation, the city directories list him as "writing teacher" and "teacher."[4]

Eakins's public school education taught him "academic" habits: orderly planning, disciplined work, scientific precision. As Elizabeth Johns and Michael Fried have noted, this training encouraged patterns of mind and hand that linked writing, drawing, thinking, and research.[5] Enrolling in evening drawing classes at the Pennsylvania Academy in 1862, Eakins brought his linear, conceptual style to the task of seeing and recording the material world. Accustomed to copying prints and inventing geometric constructs, Eakins found the complex, three-dimensional reality of the human body fascinating and difficult to draw. The shock of this encounter had a lasting impact on his work. Struggling for years to make charcoal "painterly," he turned with relief in 1867 to brush and oils. To Eakins, drawing represented the realm of research and planning; for working from life, he would develop a more visual and plastic technique in paint. From the conflict of these two earliest "academic" contexts in Philadelphia, the tension of Eakins's art would unfold: the unreconciled coexistence, as Barbara Novak first noted, of the mathematical and the visual, of "science and sight," or, as Michael Fried proposed, of the "graphic" and the "pictorial."[6] For Eakins, strength, rather than conflict, emerged from this pairing: "You ought to take up the study of higher mathematics," he told his student Charles Bregler. "It is so much like painting."[7]

Such insights were lost on most students at the Pennsylvania Academy, where as a student Eakins had encountered the standard curriculum of the Western art academy, invented in the Renaissance. Students began by copying prints, progressed to drawing from statues (usually plaster casts of antique or Renaissance masterworks), and graduated to work from live, nude models. This course of study taught the priority of drawing over painting, tonal value over color, classic over modern, and human form above all other subjects. As an artist and a teacher, Eakins would object to all of these principles save the last, but he did not reject the academic enterprise. Out of the struggles with his charcoal and stump in the basement of the old Academy, a reformer was born.

Life class at the Academy presumed the human figure to be the main focus of a painter's work; if the nude figure could be drawn well, everything else would follow. This emphasis on nude studies, established by the first art academies in Italy in the sixteenth century, formed the cornerstone of Eakins's own value system, underpinning his work, his teaching, and, eventually, his scandal-ridden reputation. His stubborn, lifelong insistence on his right to study and teach from the nude began

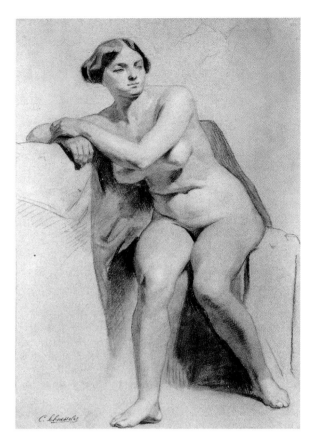

Fig. 63. Christian Schussele, *Figure Study: Seated Nude Woman, Resting on Right Arm*, c. 1855–56. Charcoal on paper, 17⅛ x 11½". Pennsylvania Academy of the Fine Arts, Philadelphia. John S. Phillips Collection.

with the sense of mission and professional privilege established by these first life classes in Philadelphia. Drawings from similar sessions in Philadelphia about 1855, attended by teachers and mentors such as Christian Schussele (fig. 63) and Peter Rothermel (fig. 64), illustrate the firmness of this academic tradition at mid-century in Philadelphia, the caliber of the work done, and the freedom from covered faces or coy postures.[8] In Eakins's day, although female models were usually masked (fig. 65), he pressed the tradition forward in a bold, confrontational realism that disdained conventional notions of ideal beauty or gentility.

In the autumn of 1866, Eakins entered the Ecole des Beaux-Arts in Paris and encountered the same course structure on a grander scale. By this time he hated drawing from casts and would cut class when such work was assigned, and he chafed while waiting to be promoted from charcoal to brush and paint. But he appreciated the rest of the experience and its advantages for students—which Eakins would remember when he later developed his own curriculum in Philadelphia. Working daily from professional models, students also benefited from supplementary lectures on perspective, anatomy, art history, and aesthetics, and had access to dissection labs as well as the libraries and art collections of Paris. More subtly, the

Fig. 64. Peter F. Rothermel, *Figure Study: Nude Woman, Seated, Leaning Left*, c. 1855–56 (from a portfolio in Eakins's studio). Charcoal on paper, 23⁹⁄₁₆ x 18⁷⁄₁₆". Pennsylvania Academy of the Fine Arts, Philadelphia. Charles Bregler's Thomas Eakins Collection, purchased with the partial support of the Pew Memorial Trust.

Fig. 65. Thomas Eakins, *Study of Seated Nude Woman Wearing a Mask*, c. 1863–66. Charcoal on paper, 24¼ x 18⅝". Philadelphia Museum of Art. Gift of Mrs. Thomas Eakins and Miss Mary Adeline Williams, 1929.

mix of competitive spirit and camaraderie in the atelier instilled a sense of serious purpose and professional legitimacy. But most important was the superior tuition at the Ecole, where "twice a week our work is corrected by the best professors in the world."[9] After the informal sessions at the Pennsylvania Academy, where guidance came for the most part from senior students with occasional critiques by local artists like Schussele and Rothermel, the focused (and frequently devastating) attention of Gérôme galvanized Eakins and forever shaped his own teaching style.

Eakins revered Gérôme from the moment of their introduction in 1866 to the end of his life. Ushered into his elegant studio, where Gérôme was working from a model, Eakins was impressed by his businesslike but sympathetic air.[10] Before him stood a vision of success in the art world: technical skill allied to intelligence and sophistication, married to affluence and good connections, crowned by honors. At the age of forty-two, Gérôme was already a member of the Institut de France, an officer in the Légion d'honneur, winner of many medals at the Salon, and master of an atelier at the Ecole. Writing home to his father after his own skills began to improve, Eakins dared to imagine himself as successful and "even rich" as an artist.[11] The American government would never elect artists to

a legion of honor, and Eakins would never have Gérôme's savoir faire, but he could hope for a future in America as master of his own workshop and professor at the country's finest art school.

Gérôme's professional example would inspire Eakins more than his polished style of painting, which he rejected in favor of the richer surface of another teacher, Léon Bonnat, and the tradition of the Spanish Baroque. But while criticizing Gérôme's color and handling, Eakins absorbed his values and the principles of his method and subject matter, which mixed the academic and the modern. Gérôme's vision of history and the exotic, detailed with archaeological or ethnographic exactitude, brought the past or the faraway to life, peopled with, as Eakins wrote in 1869, "the living thinking acting men, whose faces tell their life long story." Gérôme's Arab soldiers emerged in Eakins's work as Dakota ranch hands, and his oarsmen on the Nile turned up as Schuylkill rowers; Gérôme's *Ave Caesar, Morituri Te Salutant* (fig. 35), which enraptured Eakins in Paris, remained in the student's imagination for thirty years, inspiring his own treatment of American "gladiators," *Salutat*, in 1898 (pl. 214).[12]

Eakins's ability to rediscover Gérôme's subject categories on American soil went unrecognized for decades, in part

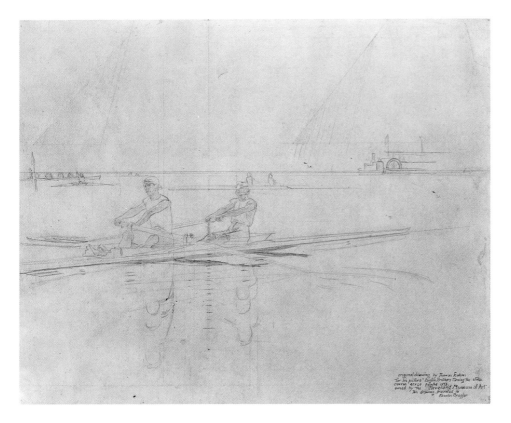

betrays the passion for measurement and accuracy first cultivated at Central High School. Extravagantly precise, these drawings betray the pleasure Eakins found in his own craftsmanly processes, and the satisfaction he gained from unassailable correctness. From the marriage of the academic method of Gérôme and the industrial, scientific drawing tradition of Eakins's American education comes the great, hallucinatory series of perspective drawings for the rowing pictures of 1871–74 (fig. 66). Variations on a theme of figures in space—at different times and seasons, alone and in groups, from different angles—the rowing pictures can be seen as an academic enterprise at once scientific and artistic. Many of Eakins's personal and artistic interests (figures in action, outdoor light, modern American life, problems in perspective) are captured in an homage to Gérôme; it is not surprising, then, that he sent two of these pictures to his master as evidence of his progress (fig. 67). Unequaled in American history, these drawings and paintings required an intensity that was difficult to sustain, and Eakins never produced such a body of work again. Full of the energy and ambition of a young man, they express his eagerness to show the value of academic training.

Eakins's efforts to bring his work before the public stalled in Philadelphia in the absence of the Pennsylvania Academy's annual "salon," which was suspended from 1870 to 1876 during construction of its new building. Looking for other venues, he saw his work rejected by the hidebound National Academy of Design in New York until 1878, the same year he began to show with the rebel Society of American Artists. Beginning in 1874, he found a welcome at the newly formed American Society of Painters in Water Colors (later the American Watercolor Society) and then turned his sights on more prestigious venues in Paris, sending several of his hunting and sailing paintings to his teacher. Gérôme, in a move that elated Eakins, forwarded the work—including *Starting Out after Rail*

because his national versions of peasants and athletes were so novel or—to some contemporary viewers—so dull and unartistic. Only Earl Shinn—who had also been a student in Paris in the 1860s—recognized Gérôme's complex academic method beneath the surface of Eakins's work. Fully imagined in the mind, then sketched quickly in oil to capture the composition, images were developed through a series of specialized campaigns: perspective drawings for the space; figure studies from models; landscape sketches or architectural studies; and the assemblage of costumes, textiles, furniture, and other props or useful photographs.[13] In academic practice, as followed by both Eakins and Gérôme, the final canvas was then painted from these studies, with props and live models at hand.

This elaborate, fragmented procedure matured in Eakins's work in the decade after his return from Paris in 1870, when his own predilections—such as his affection for perspective or his aversion to figure drawing—transformed the academic model into an extremely rationalized personal method. Both laborious and efficient, Eakins's method put every medium and study to specialized use; no one study duplicated the work of any other, and almost every seemingly random sketch had a purpose. In this system, the painter, like the mathematician, broke a complex problem into simpler parts, and the American craftsman joined with the French academic to redouble control. Eakins stretched his own canvases and made some of his own frames; Gérôme could afford to delegate this work to others. Gérôme could also hire draftsmen to make his perspective layouts, while Eakins made his own with a lavish care that

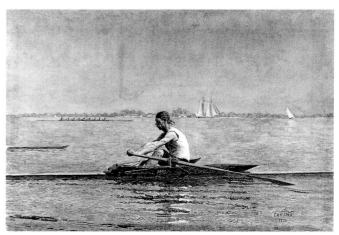

Fig. 67. Thomas Eakins, *John Biglin in a Single Scull*, 1873. Watercolor on paper, 16⅞ x 23⁵⁄₁₆". Yale University Art Gallery, New Haven, Connecticut. Gift of Paul Mellon, in honor of Jules T. Prown, the first director of the Yale Center for British Art, 1998.

Fig. 68. Thomas Eakins, *Pushing for Rail*, 1874. Oil on canvas, 13 x 30¹⁄₁₆". The Metropolitan Museum of Art, New York. Arthur Hoppock Hearn Fund, 1916 (pl. 11).

(pl. 12), *Pushing for Rail* (fig. 68), *Sailboats Racing on the Delaware* (pl. 10), and *Ships and Sailboats on the Delaware* (1874, Philadelphia Museum of Art)—to Goupil's gallery and the Salon of 1875.[14]

While waiting for recognition from the American academic establishment, Eakins began to develop his teaching career. The suspension of regular classes at the Pennsylvania Academy prompted the members of the Philadelphia Sketch Club to form a class in the winter of 1873–74 "for study from the living model" and to secure "the services of Thomas Eakins, who gave gratuitous instruction" until life classes resumed at the Academy in 1876. "It is always a pleasure to teach what you know to those who want to learn," he wrote to Earl Shinn, when invited to "give corrections."[15] By volunteering, Eakins established his authority as a teacher and advertised his willingness to serve, just at the moment when the Academy's new facility opened. The ailing Schussele, who had been hired in 1868 to supervise classes in the old building, returned as professor of drawing and painting, and Eakins again volunteered to assist him as instructor for the evening life classes, three nights a week. In January of 1877 he offered to assist Dr. W. W. Keen in the weekly anatomy lectures, and as Schussele's health declined, Eakins began to oversee the modeling class—also as a volunteer—with the title "assistant professor." Following Schussele's death in August 1879, Eakins won the job he must have dreamed about for almost a decade: professor of painting and drawing. His new role (salaried at last) inspired no pompousness on his part, recalled his wife: he "always disliked forms and medals and rules—under no circumstances would he use the title professor."[16] But he clearly relished the job and must have been exhilarated when, two years later, he received the grander title: director of the schools.

As Eakins ascended the ranks, his painting overtly engaged the methods, topics, and principles of his profession. Between 1875 and 1885 he produced the most complex "academic" projects of his career, involving elaborate procedures, historical or scientific research, and imbedded references to his masters, ancient and modern. His respect for tradition was veiled, however, by the novelty of American subjects or the startling intrusiveness of modern, scientific realism. With his first entries to the Paris Salon launched and the prospect of the Centennial International Exhibition in Philadelphia in 1876 before him, he undertook his first ambitiously scaled "statement": the portrait of Dr. Samuel Gross conducting surgery before students at Jefferson Medical College (pl. 16). Just thirty-one years old when he completed it in 1875, Eakins wished to make an éclat at the American Centennial exposition with the painting, which summarized his commitments as a modern academic to science, teaching, and the realist tradition. Overtly a tribute to Gross and the progress of medicine and surgery in Philadelphia, the painting also showcased a professor amidst colleagues and students, and invoked the grand tradition of Baroque realism that led from Velázquez and Rembrandt to Bonnat.

Like Bonnat's sensational *Crucifixion* (fig. 28), seen at the Salon of 1874, *The Gross Clinic* took contemporary French naturalism to extremes. Unflinchingly observed and aggressively modern, both paintings intended to heroize their subjects while rooting them in the real world; both were criticized as unfeeling or deliberately shocking.[17] Eakins certainly knew of Bonnat's picture and its reception, and he may have wished to assert his allegiance to the radical academic realism of Paris. He took pains to have a good photographic reproduction of *The Gross Clinic* prepared overseas for distribution to his

Fig. 69. Thomas Eakins, *A May Morning in the Park (The Fairman Rogers Four-in-Hand)*, 1879–80. Oil on canvas, 23¾ x 36". Philadelphia Museum of Art. Gift of William Alexander Dick, 1930 (pl. 51).

locomotion by Eadweard Muybridge, realizing that new territory had opened for artists: the correct depiction of bodies in motion. Rogers's commission, bestowed just a few months before he recommended Eakins's promotion to professor, resulted in *A May Morning in the Park (The Fairman Rogers Four-in-Hand)* (fig. 69), a study of Rogers's custom coach and his superb team of horses. Overtly a record of Rogers's fashionable enthusiasm for coaching, the painting was transparently a pretext for portraits of his prize horses, shown in four poses derived from Muybridge's studies.[21]

At last a "professor," Eakins took on the tradition of heroic, academic figure painting with his own version of the *Crucifixion* (pl. 54). Like Bonnat, he wished to study the "reality" of this most compelling of all Christian images; unlike Bonnat, he used a live model (and perhaps a camera) outdoors, not a cadaver nailed to a cross in a studio. Washed with natural light, the effect was gentler and homelier than Bonnat's theatrically lit figure, but the result was nonetheless strikingly eccentric in Protestant America, expressing Eakins's sense of his larger transatlantic community. Again, the critics were divided and confused: as with *The Gross Clinic* and *A May Morning in the Park*, Eakins's program to improve realist painting with modern study seemed to some viewers more akin to "science" than to "art."[22]

In 1885, at the height of his academic career, Eakins made a similar effort to update tradition in *Swimming* (fig. 70), a Greek pediment come to life at the edge of a creek in suburban Philadelphia. The new chairman of the Committee on Instruction, Edward Hornor Coates, commissioned the picture and hinted that it would eventually be given to the Academy's permanent collection. With this destination in view, *Swimming* became a catalogue of Eakins's academic techniques—using photographic studies, landscape sketches, and life modeling sessions—and a manifesto of his academic principles. Into it he packed his belief in the splendor of the human body, the presence of beauty in modern American life, and the pleasures of sunlight, bathing, and friendship in the spirit of Plato's original Academy.[23]

The vision of art and nature, past and present, united in *Swimming* and the other "Arcadian" subjects from the early 1880s, represented Eakins's ideal of modern academic art as well as the school he shaped to produce such work. The basic French academic system was already in place at the Pennsylvania Academy, expanded since the era of Eakins's student years to include day and evening classes, sculpture and painting as well as drawing, and both male and female students. Under cover of Schussele's benign regime as professor, from 1876 to 1879, Eakins instituted his reforms, beginning with an ambitious program in anatomy and dissection that rivaled the thor-

friends, and he must have imagined exhibiting the picture in France to demonstrate his skill as well as the validity of contemporary American subjects in the grand tradition of European art. But Philadelphia was not Paris: Bonnat's work, while criticized, was exhibited at the Salon and later installed at the Palais de Justice; Eakins's painting, by contrast, was refused by the art jury at the Centennial and eventually displayed only among the army medical exhibits.[18]

Learning from the Centennial experience, Eakins tried more popular academic material. First, he essayed a painting of a baby at play (pl. 18), in the vein of Bonnat's picture of a peasant toddler that won much praise at the Centennial exhibition.[19] Then he turned to historical genre in *William Rush Carving His Allegorical Figure of the Schuylkill River* (pl. 41), which paid homage to Gérôme in terms of its subject, composition, technique, and scholarly presentation. By depicting an early American sculptor working from a nude model, it addressed the "uncompromising, unconventional study and analysis from life" at the center of the academic method. The subject must have been on Eakins's mind, for life classes at the Academy recommenced, after much urging, as the painting took shape.[20]

Anatomical study, closely related to life class in the curriculum, inspired Eakins's next project, sponsored by Fairman Rogers, a former engineering professor and then trustee at the University of Pennsylvania. Rogers served on the Academy's board of directors and headed the Committee on Instruction, which was charged with managing the curriculum. In 1878 the two men pored over the novel photographic studies of animal

oughness of medical schools. Advanced students studied human and animal cadavers, creating plaster casts of their subjects that served as permanent didactic displays (fig. 71); all students attended twice-weekly anatomy lecture-demonstrations led by Dr. Keen. Similar study was "encouraged" but not provided by Gérôme in Paris, and nothing comparable was offered at any other art school in the United States. W. C. Brownell, who interviewed Eakins about this curriculum in 1879, concluded that "exhaustive is a faint word by which to characterize such instruction." To Brownell's concern that the work might become inappropriately scientific, if not repulsive, Eakins responded that "to draw the human figure it is necessary to know as much as possible about it, about its structure and its movements, its bones and muscles, how they are made, and how they act." An artist "dissects simply to increase his knowledge of how beautiful objects are put together, to the end that he may be able to imitate them."[24]

In the same spirit, Eakins transformed the modeling class from the study of antique sculpture to work from life and opened the class to painters as well as sculptors, following the practice he had known at the Ecole under Dumont. "When Mr. Eakins finds any of his pupils, men or women, painting flat, losing sight of the solidity, weight and roundness of the figure, he sends them across the hall to the modeling-room for a few weeks," noted Brownell.[25] As soon as he gained control

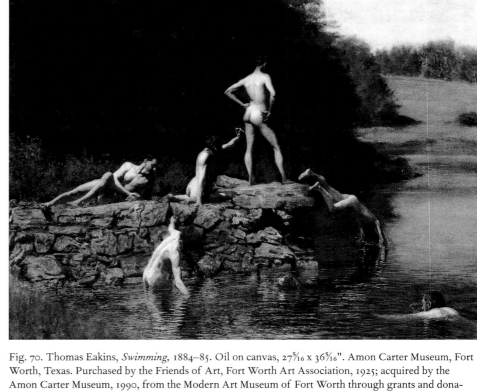

Fig. 70. Thomas Eakins, *Swimming*, 1884–85. Oil on canvas, 27⁵⁄₁₆ x 36⁵⁄₁₆". Amon Carter Museum, Fort Worth, Texas. Purchased by the Friends of Art, Fort Worth Art Association, 1925; acquired by the Amon Carter Museum, 1990, from the Modern Art Museum of Fort Worth through grants and donations from the Amon G. Carter Foundation, the Sid W. Richardson Foundation, the Anne Burnett and Charles Tandy Foundation, Capital Cities/ABC Foundation, *Fort Worth Star-Telegram*, The R. D. and Joan Dale Hubbard Foundation, and the people of Fort Worth (pl. 149).

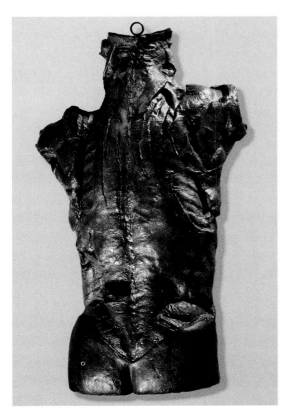

Fig. 71. Thomas Eakins, *Back of Male Torso (Anatomical Cast)*, 1880 (cast 1930). Bronze, length 30¼". Philadelphia Museum of Art. Gift of R. Sturgis Ingersoll, 1944 (pl. 53).

of the painting and drawing curriculum, Eakins snubbed the antique again: impatient with drawing from sculpture himself, he quickly promoted students to life study, and even more swiftly from charcoal to paint—a practice recognized as "almost revolutionary" in its disdain for traditional academic procedure. "The brush is a more powerful and rapid tool than the point or stump," noted Eakins in defense of his "radical" method: students "should learn to draw with color" and seize "the grand construction of a figure" in broad strokes.[26]

> Mr. Eakins teaches that the great masses of the body are the first thing that should be put upon the canvas, in preference to the outline, which is, to a certain extent, an accident, rather than an essential; and the students build up their figures from the inside, rather than fill them up after having lined in the outside. The practice of modeling leads the painter-student in this direction also, as in it the outline is not that which strikes the student most forcibly. It is not believed that the difficulties of painting are either lessened or more quickly surmounted by the substitution of the arbitrary colors, black and white, for the true color; and as a painted study is more like the model than a translation into black and white can be, the comparison with nature is more direct and close, and an error in drawing is more manifest. The materials for drawing on paper, except charcoal, which is dirty and

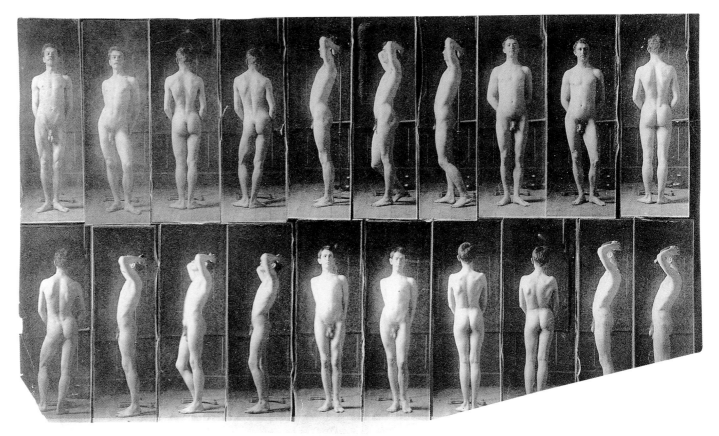

Fig. 72. Circle of Thomas Eakins, *[Naked Series: Four Male Models]*, c. 1883. Composite albumen print, 6½ x 11⅛". Pennsylvania Academy of the Fine Arts, Philadelphia. Charles Bregler's Thomas Eakins Collection, purchased with the partial support of the Pew Memorial Trust (1985.68.2.350).

too easily rubbed off, do not admit of the strength, breadth, and rapidity of treatment, which are considered important; so that oil paint and clay are the real tools of the school.[27]

Eakins contributed to—or invented—the entire school program. Beginning in 1880, he composed an annual series of lectures on perspective, documented in an illustrated manuscript that he planned to publish as a textbook. In addition to supervising the work in the life classes and the dissection room, he also taught the students to use photography as an aid to the study of anatomy, the analysis of motion, and composition.[28] Overall, he enjoyed hands-on control that far exceeded Gérôme's stately presence at the Ecole. His authority over the staff, the students, and the curriculum was immediate, mitigated only by the conservative scruples of the board of directors. Although the board resisted many of his ideas, Eakins—with the help of either Schussele or Rogers—was able to build his vision of a modern art academy within a matter of years. As he had personalized his academic procedures in painting, Eakins revised the curriculum he experienced at the Ecole in favor of his own sometimes controversial opinions and enthusiasms. "The course of study is purely classical, and is believed to be more thorough than in any other existing school," he wrote in a draft for the school circular in 1881. "Its basis is the nude human figure."[29] As at the Ecole, there were no classes in composition or "picture-making," for it was pre-

sumed that students would independently study those subjects at home, outdoors, or in libraries and museums. Effectively, the school did not even "teach" painting, it simply gave students an opportunity to learn for themselves from resources that few individuals could gather on their own. "The Academy does not undertake to furnish detailed instruction, but rather facilities for study, supplemented by the occasional criticism of the teachers," noted the circular of the Committee on Instruction.[30] Preferring to teach by example and let the students struggle independently, Eakins gave critiques that, like Gérôme's, were terse and sometimes cryptic. "A teacher can do very little for a pupil & should only be thankful if he don't hinder him," wrote Eakins, "and the greater the master, mostly the less he can say."[31]

With this mission, the life classes ran all day long, and evening programs on anatomy, dissection, and perspective expanded far beyond the offerings of "any art school in the world." At the same time, Eakins suppressed everything he disliked about standard academic training, such as working from casts, drawing, and prize competitions.[32] He added classes he might have wished for at the Ecole, such as portraiture (which he had to go to Bonnat's atelier to study) and still life, or techniques he realized were useful and fashionable in America, such as watercolor. Eakins also encouraged students to participate in extracurricular—and highly unconven-

tional—sessions modeling for photographic nude studies, often in the Academy's studios (fig. 72).

Also novel, especially by comparison with the Ecole, was the presence of women students (fig. 73). First welcomed into the antique drawing classes in the 1850s, women lobbied for access to the anatomy lectures and won their own daytime life classes under Schussele's sponsorship in 1868. During Eakins's tenure, life classes and dissection sessions would remain segregated, but women gained the opportunity to study from male models and had access to all aspects of the curriculum. It would be decades before women artists in Europe would enjoy such comprehensive professional training.[33]

As women joined the classes in increasing numbers and the school grew large, its mission became more explicit. Like the Ecole, the Academy stressed the training of professional "fine" artists only: "that is, persons who expect to devote themselves to the production of pictures and statuary as a business or means of livelihood." Commercial artists and amateurs were offered "pure art education," without specialized vocational instruction. Illustrators, "lithographers, china-painters and decorators" and the like, who "need nearly the same kind of education for their pursuits, are cordially welcomed, and amateurs are at liberty to make what use of the school they can, as far as its means and space permit."[34] Even so, the rigorous curriculum drew many students—so many that by 1881 the expenses of the school had created a large deficit and the board decided to charge fees. Free tuition, in the French tradition, vanished in the absence of government subsidy.

Other differences between Philadelphia and Paris emerged as Eakins adapted the practices of Gérôme and the Ecole to local conditions. The lack of a diverse pool of professional models inspired Eakins to suggest recruiting younger, healthier females by advertising for more "respectable" candidates (with chaperones) in the newspaper, but nothing came of his proposal.[35] Eventually, to find more attractive bodies (and to save money), the students began to model for one another and for their teacher, much to the alarm of parents. The tuition charges, like the presence of women, set up additional constraints. The fees paid expenses—such as Eakins's long-promised salary—but this source of income also left the directors more accountable to the students and their parents. A curriculum offered at no charge could hardly be challenged, but once the students became tuition-paying "customers," the idiosyncrasies of Eakins's autocratic regime began to draw complaints. Progressive in the 1860s, his naturalism seemed outmoded to the more "poetic," subjective, and decorative tastes of the 1880s. Within a few years, grumbling was heard from a few senior students, including some of his friends and assistants, who wanted to see more "modern" (or practical) course offerings, such as land-

scape painting and composition. Their restlessness joined the complaints of those who objected to the rigorous and effectively mandatory anatomy and dissection program.

Women, and their parents, were also likely to plead for "delicacy" in the presentation of completely nude bodies in the life class, anatomy lectures, or dissection lab. Concerned about the impact of such "horrid nakedness" on "the morals of our young students," one woman addressed the Academy's president, James L. Claghorn, in 1882. Defining *"true art"* as that which "enobles [sic] and purifies the mind," the writer questioned the cost of nude study at the expense of *"womanly refinement and delicacy."*

> Now, Mr. Claghorn, does this pay? Does it pay, for a young lady of refined, godly household to be urged as the only way of obtaining a knowledge of true Art, to enter a class where every feeling of *maidenly* delicacy is violated, where she becomes so hardened to indelicate sights and words, so familiar with the persons of degraded women and the sight of nude males, that *no possible* art can restore her lost treasure of *chaste and delicate thoughts!*[36]

Hardened by years of life classes and lectures at Jefferson Medical College, Eakins dismissed these complaints as "overrefinement," ridiculous in a professional art school. But the autonomy and privacy of modeling sessions in the 1850s enjoyed by Schussele and Rothermel in Philadelphia (figs. 63, 64), or the professional protection gained in Paris from officially

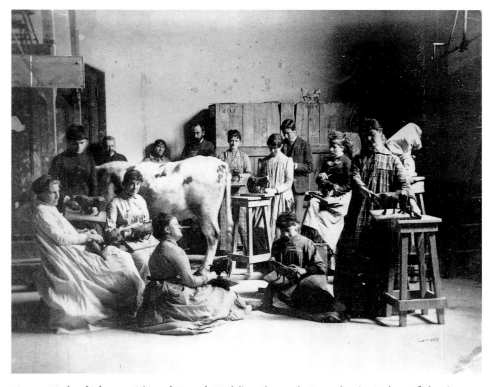

Fig. 73. Circle of Thomas Eakins, *[Women's Modeling Class at the Pennsylvania Academy of the Fine Arts]*, c. 1882. Albumen print, 3¹¹⁄₁₆ x 4¹⁵⁄₁₆". Pennsylvania Academy of the Fine Arts, Philadelphia. Charles Bregler's Thomas Eakins Collection, purchased with the partial support of the Pew Memorial Trust (pl. 122).

sanctioned (and all-male) classes had been broken open by the consumer-supported, coeducational profile of the Academy in the 1880s.

And Eakins could not have picked a worse time to insist on his principles and prerogatives. The liberality of Philadelphia in the 1850s became more constrained, degenerating to extreme Victorian prudishness in the 1880s and 1890s. Anthony Comstock's campaign against vice, launched in New York in the mid-1870s, stirred public opinion against all forms of licentiousness. The cautious directors of the Academy instructed Eakins to keep "fig leaves" on men who posed in life-class or anatomy lectures, and they forbade the use of student models in the school. However, the figures in *Swimming* (fig. 70), seen at the Pennsylvania Academy's annual in the autumn of 1885, clearly showed that Eakins's students—all too recognizable and all nude—were posing for him "off-campus." Rumors circulated that Eakins had asked his female students to model, or that they were modeling for one another and bringing their studies to him to critique. When the news reached the board that Eakins had removed the loincloth from a male model in an anatomy lecture attended by women in January of 1886, he was summoned before the Committee on Instruction, interrogated, and asked to resign.[37]

The loincloth episode would become the defining moment in Eakins's teaching career and a *cause célèbre* in American art history. From a distance, the forces of good (artistic freedom) and evil (Victorian repression) stand opposed like black and white. From a closer perspective, the events and personalities take on a much murkier—and drearier—tone. The loincloth incident undoubtedly gave the Academy's board reason to fire Eakins for insubordination, but discontent and suspicion had been building for years. The resentment of a few senior students, who chafed under his authoritarian practices and disliked his manner (variously described as coarse, boorish, and ungentlemanly), launched a whispering campaign that further poisoned the opinions of the directors. In a horrifying escalation of charges, Eakins found himself accused of crimes ranging from telling off-color jokes to incest and bestiality. Civil war broke out at the Academy and in the Eakins family. His father and sister Frances and her husband issued affidavits in Eakins's defense, while his brother-in-law Frank Stephens instigated many of the worst charges and led a campaign to oust Eakins from the Sketch Club. His wife's sister, the painter Elizabeth Macdowell, and many of his women students caught in the "nude posing business" also sided against him. Although the full misery of this moment will never be known, recently discovered documents help us map the darkness from which rose the bright image of Eakins as hero and martyr.[38]

The crisis of 1886 has been interpreted along two lines,

both stemming from the use of nude models. The "official" defense, which Eakins himself took, argued from the position of academic freedom and "private or professional" prerogative. As a serious painter with a scientific, naturalistic agenda, Eakins—like his masters in Paris—presumed the necessity of nude models in his private studio. As a teacher insistent on the merits of anatomical study, he felt it was imperative that students have access to the nude, to learn about the human body without "false modesty." This defense came close to the core of Eakins's values as a modern academic, his ambitions as a student of the Ecole, and his pride as the director of the most progressive art school in the United States. "It is not a rare ambition in a painter to want to make good pupils," he wrote the week after his resignation; "My dear master Gérôme who loved me had the same ambition."[39] Although based on Gérôme's example, the principles upon which Eakins built his case have endured as part of his American legend: freedom of expression, integrity of purpose, independence in the face of "prudish affectation."[40] In this frame, the disastrous conclusion of his career at the Academy emerges as a tragedy, devastating to Eakins's hopes for the kind of honor that his own teachers had won by adhering to the same principles. Born to be a teacher and trained to be an American Gérôme, Eakins was suddenly an outsider.

A second perspective on the "troubles" from a more intimate and psychological angle has examined the ways Eakins used the aegis of "scientific," academic principles to protect private, even unconscious, perhaps questionable agendas. In this view, a flawed Eakins brought tragedy upon himself. The recurrence in his life of scandals associated with nudity and sexuality—for the Academy furor was only the first of at least four situations involving nude models and young, inflamed women students—points to the uniquely charged quality of his personality, which inspired loyalty or antipathy in equally fervid measure. The warmth of his supporters, who marched in the street in his defense and immediately withdrew from the Academy to form a rival school with Eakins at its head, conveys something about his authority and charisma. Many of Eakins's "girl students were crazy about him," remembered one female acquaintance,[41] and some of his men students—Samuel Murray, Charles Bregler, John Laurie Wallace—remained loyal and reverent for the rest of their lives. The venom of his enemies, however, and the reservations of even his oldest friends suggest the controversial quality of his behavior. Was he blindly committed and obtuse? Deliberately confrontational? Certainly Eakins should have anticipated difficulties as he pressed his obsessions—life class, anatomical dissection—upon a young and inexperienced audience. Would Gérôme have lowered his trousers to demonstrate a point of

anatomy to a female student? Would Bonnat have posed before the camera in nude sessions with students, and then shared these photographs with non-artist friends (fig. 74)? At the very least, the survival of such stories and photographs indicates that Eakins was careless, even disdainful of public opinion. For someone charged with the education of young adults—particularly women—this was a dangerously insensitive, not to mention politically inept (and, from the point of view of the directors, economically foolhardy) position. Such behavior could be called poor judgment, or inflexibility; less generously, it might be labeled arrogant, coercive, and intentionally provocative. When the directors described Eakins's departure as a response to the need for a "change in the management of the schools," they had a point.[42]

Eakins resigned on February 9, 1886, and spent the next two years struggling to defend his position and expose or counter "infamous rumors industriously spread" by his enemies.[43] It was a grim period that divided his family, depressed his health, and slowed his work. The Academy that meant so much to him had rejected him, and the wound would remain sore: "I think you've got a heap of impudence to give me a medal," he growled twenty years later in 1904, when the Academy tried to make amends by awarding him the Temple Prize.[44] Courted by yet another generation of new management at the Academy in the 1890s, he exhibited there regularly after 1894 and often served on its annual exhibition jury after 1901, but a certain grudge remained; after his death in 1916 the Pennsylvania Academy had to be pressured to host a memorial exhibition of his work.

During the bleak months that followed his departure from the Academy in February 1886, Eakins was sustained by a more intimate and informal circle of support that reconfirmed his abiding "academic" values. The first members of this team created a school: the Art Students' League of Philadelphia, a cooperative formed by a loyal following of Academy students. The league had little prestige, but it reestablished Eakins's role as leader and teacher, bolstered his sense of righteousness, and offered the familiar, bohemian camaraderie of the atelier. Formed as a life class, the Art Students' League defiantly persisted in the practices that had gotten Eakins in trouble: students—sans loincloths—modeled for one another, frequently in front of the camera. Meanwhile, Eakins's value as a professor was reinforced by regular invitations to lecture on anatomy or perspective at schools in New York and Washington, D.C.

Eakins also ventured outside the art world, seeking the reassuring company of academics in other circles. He maintained ties to the faculty at the University of Pennsylvania, and in the mid-1890s began to spend time with Catholic intellectuals, including the Jesuit teachers at Saint Charles Bor-

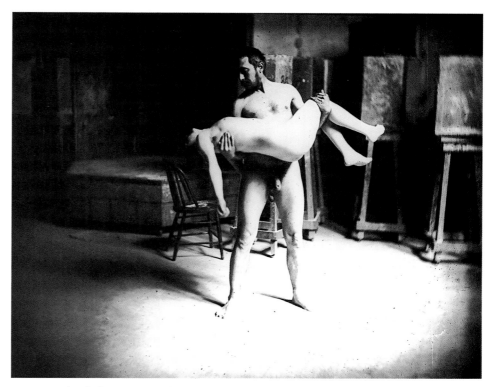

Fig. 74. Circle of Thomas Eakins, *[Thomas Eakins Carrying a Nude Woman at the Pennsylvania Academy of the Fine Arts]*, c. 1885. Modern print from original gelatin dry-plate negative, 4 x 5". Pennsylvania Academy of the Fine Arts, Philadelphia. Charles Bregler's Thomas Eakins Collection, purchased with the partial support of the Pew Memorial Trust (1985.68.2.847).

romeo Seminary. This intimate academic community of artists and scholars brought Eakins out of the slough of 1886 and carried him though the 1890s, despite the disintegration of his teaching. The Art Students' League of Philadelphia dwindled away and closed in 1893, and the lecture offers dried up after 1895, when the use of nude models in his Drexel Institute anatomy lectures shut them down for the second time. An infatuated female student was hospitalized in the mid-1890s after claiming to be Eakins's wife, and in 1897 the suicide of his niece Ella Crowell was blamed on the corrupting influence of Eakins's life class, which she had attended from 1890 to 1893. His sister's family banished him forever, and Eakins withdrew from teaching entirely.[45]

But while his identity as a professor waned, his professional stature enlarged as Eakins began to win the official, academic recognition that he had sought earlier: prizes at American exhibitions, medals at four world's fairs (Chicago in 1893, Paris in 1900, Buffalo in 1901, Saint Louis in 1904), and at last, belated election to the National Academy of Design in 1902. Perhaps most gratifying of all were the repeated invitations to the jury of the Carnegie International exhibition, determined by the vote of the participating artists.[46] This respect from his peers, including many younger artists, marked the first signs of a cult of Eakins as the "painter's painter," which would be fostered by Robert Henri and New York's progressive realist artists.

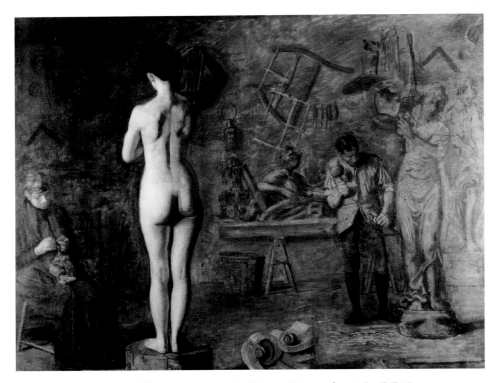

Fig. 75. Thomas Eakins, *William Rush Carving His Allegorical Figure of the Schuylkill River*, 1908. Oil on canvas, 36⁷⁄₁₆ x 48⁷⁄₁₆". Brooklyn Museum of Art, New York. Dick S. Ramsay Fund (pl. 238).

This official support may have inspired Eakins to a late flowering of work; liberated from teaching, he perhaps felt free to take up again the study of the nude. In 1898, the year after he ceased teaching, he commenced a new series of academic figure paintings that revisited the themes of his youth and revived the memory of his "dear master," Gérôme. The great boxing pictures, particularly *Salutat* (pl. 214), return to the arena of the modern athlete, reinterpreting Gérôme's gladiators as Philadelphia's sports heroes. After Gérôme's death in 1904, Eakins began to reprise the subject of William Rush, the early nineteenth-century American neoclassical sculptor. Like Gérôme's self-portrait as a sculptor in the 1890s, which quoted from his own painting *Pygmalion and Galatea* (c. 1890, The Metropolitan Museum of Art, New York), Eakins's late "portraits" of Rush (figs. 75, 76) assert a layered co-identity. As the artist pays homage to the power of the model, who represents the truth of nature, the beautiful, and the source of artistic inspiration, Eakins's features merge with those of Rush. Rush, in turn, echoes the reverence of the Greek sculptor Pygmalion, reiterated by the values of the French painter and sculptor, Gérôme. Alone in his studio with a model, but allied with his invisible colleagues in the Western tradition, Eakins depicted himself at the age of sixty-four as an unrepentant academic, still dedicated to the "uncompromising, unconventional study and analysis from life."[47]

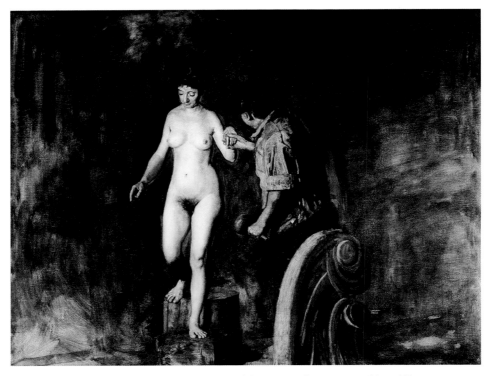

Fig. 76. Thomas Eakins, *William Rush and His Model*, c. 1908. Oil on canvas, 35¼ x 47¼".
Honolulu Academy of Arts. Gift of the Friends of the Academy, 1947 (pl. 239).

The 1880s

MARC SIMPSON

THOMAS EAKINS began the decade of the 1880s as "the first of Philadelphia artists" according to several critics, including one New Yorker who added, "and surely one of the very first among Americans in any place."[1] A major component of this stature was his appointment in September 1879 as professor of drawing and painting at the Pennsylvania Academy of the Fine Arts, followed in early 1882 by his elevation to the post of director of schools. His academic position—newspaper critics throughout the era referred to him as Professor Eakins[2]—accorded local recognition to the national reputation he had developed over the previous five years for his innovative pictures. The singularity of Eakins's art was often written about: one writer in 1881 noted the "positive individuality this artist has, how strongly marked his own style is, and how peculiarly his own his methods of picture-making are";[3] another coined the term "Eakinsish" to describe an expression in which "mere thinking is portrayed without the aid of gesture or attitude."[4] The painter promoted and expanded this reputation with a series of startling exhibition works over the decade. He also continued to develop the ways in which he understood the world and made his art. One principal tool in both was photography; having previously used others' photographs in the development of his paintings, he acquired his own camera by 1880 and became increasingly immersed in the medium. Teaching, art making, and photography were to be the constants of the decade, punctuated by momentous personal events.

Eakins's appointment to the professorship of the Academy established his position in Philadelphia.[5] The opportunity to articulate his pedagogic philosophy came just at the moment he assumed his position.[6] In a series of *Scribner's Magazine* articles on America's art schools, William C. Brownell sketched the history of the Academy and admiringly described the generous resources provided by its board. He surveyed the collections of casts and study photographs and the architectural spaces. He then turned to the thirty-five-year-old Eakins, "who is a radical," and allowed him to explicate the elements of his teaching. The results are among the most articulate justifications of artistic practice by any late nineteenth-century American painter.[7]

Eakins began by explaining his preference for encouraging students to paint at once rather than spend semesters drawing after the antique casts in the collection:

> I think [the student] should learn to draw with color....
> The brush is a more powerful and rapid tool than the point or stump....
>
> I don't like a long study of casts even of the sculptors of the best Greek period. At best, they are only imitations, and an imitation of imitations cannot have so much life as an imitation of nature itself.... The beginner can at the very outset get more from the living model in a given time than from study of the antique in twice that period.[8]

Brownell found the program's greatest innovation to be the dissection and anatomy courses offered to the advanced students. "Don't you," he asked Eakins, "find your interest becoming scientific in its nature, that you are interested in dissection as an end in itself, that curiosity leads you beyond the point at which the aesthetic usefulness of the work ceases?"

> "No," replies Mr. Eakins, smiling, "no one dissects to quicken his eye for, or his delight in, beauty. He dissects simply to increase his knowledge of how beautiful objects are put together to the end that he may be able to imitate them."

Seemingly against his will, Brownell reported that "the visitor begins to be impressed by the extreme sense of this."[9]

To a more specialized audience, *Report on Art Schools* by Frank Waller, also published in 1879, confirmed Brownell's affirmation of Eakins's educational method, concluding that the Academy was "a model pioneer for a National School."[10] A circular promoting the school described the program, probably in Eakins's own words: "The object of the School is to afford facilities and instruction of the highest order to those persons—men and women—who intend making painting and sculpture their profession.... The course of study is believed to be more thorough than that of any other existing school. Its basis is the nude human figure."[11] In 1884, calling the Academy "the oldest and, perhaps, on the whole, the most important art school in America," Earl Shinn praised the facilities and the collections, but remarked that "the main claim of the institution to respectful consideration rests, however, upon the education system which is followed in its class rooms."[12]

Early on there were dissenters who feared that the program was too narrow. Eakins's friend William J. Clark, Jr., for example, wanted students to be sketching on the streets and in the countryside, observing life around them: "Mr. Eakins is not a sketcher himself and he appears to have inspired most of his students with his lack of predilection in that direction.... While he has not deprecated the kind of out-of-school study we have indicated, he has given little active encouragement to it."[13] Eakins did, over time, institute portrait and still-life classes. But it was in the life classes that Eakins, described by one student as "a small nervous black and tan looking fellow; short hair and black eyes," anchored the school.[14]

Eakins also taught elsewhere: at the Students' Guild of the Brooklyn Art Association from 1881 to 1885, with classes twice a week; and, in 1885, at the Art Students' League of New York.[15] He took his responsibilities seriously, developing his lectures and preparing them for publication.[16] All this took time: "Mr. Eakins' work as an instructor has occupied so much of his time for several years past and he has in addition put in so much of his leisure outside of his class-rooms in preparing for certain lines of subjects...that he has not exhibited a great deal."[17] His dedication in the educational arena, however, did not preclude other activities.

During the summer of 1880, after his first year as professor, Eakins began a painting of significant scale and historic weight: *The Crucifixion* (pl. 54).[18] In it, Jesus hangs at an oblique angle to the picture plane, his face hidden by deep shadow. A crown of intimidatingly long, interwoven thorns—detailed with ultra-realist precision—forms an aureole that catches the light. The transfixed hands, the loincloth knotted at protuberant navel, the blood-engorged feet, all capture attention by their specificity.

The circumstances of the painting's creation have been often repeated since Lloyd Goodrich interviewed John Laurie Wallace (1864–1953), the model, in 1938. Goodrich reported that Wallace, a sixteen-year-old student at the Academy when he posed, told him that Eakins

made a cross, and they ferried over the Delaware to southern New Jersey, found a secluded spot and set up the cross, digging a hole for it. Wallace was beginning to pose on it, nude, when some hunters appeared; so they went to a still more secluded spot, set up the cross again, and Wallace got up on it. "Eakins was thorough," he said, "he had a crown of thorns too."[19]

The Academy's new professor could not have chosen a more fitting subject to demonstrate his power and authority than this life-size portrayal of a male body in the open air. Not only did it reveal his mastery of the core of his pedagogy, but it augmented and updated one of Western painting's most revered

traditions.[20] It also entered him into competition with some of his most ambitious contemporaries: large-scale religious works were frequently noted as part of many art exhibitions of the era, especially in Paris.[21] Several among European-trained Americans—Eakins's direct competitors for reputation and fame—showed biblical scenes in major American exhibitions at which Eakins participated in the late 1870s and early 1880s. At least one writer noted the unusual surge of current interest in religious art, until then "a rare phenomenon in an American exhibition."[22]

With negative criticisms of *The Gross Clinic* (pl. 16) still reverberating from the fall and winter shows in New York and Philadelphia in late 1879, Eakins must have wondered if the reviewers' loathing of the blood, wounds, and naked flesh of that work could be moderated by a sacral theme; if, as the writer for *The New York Times* wrote, "a high subject" could "redeem" the art.[23] By and large, Eakins found, it could not. When he exhibited *The Crucifixion* at the Society of American Artists supplemental exhibition in 1882, critics were nearly uniform in finding in it too much science, not enough sentiment. The depth of feeling that he generally provoked can be sensed in one condemnation:

Revolting beyond expression is Thomas Eakins's "Crucified Christ," a bold piece of realism, in which there is some good painting and much bad color. Mr. Eakins finds in this picture the worst possible excuse for making a study of the nude figure. His Christ is the subject of the dissecting-room table—sickening, repulsive to the last degree. It is a fault of the Pennsylvania Academy of Fine Arts' system that the study of anatomy is so zealously pursued there that many of the pupils come away better anatomists than artists.[24]

There were, however, differing readings. Mariana Griswold van Rensselaer, for one, claimed that "the canvas was something more than a mere anatomical study of a martyred form seen under bright light. It was this of course; and those who know Mr. Eakins's anatomical science and mastery over effects of light need hardly be told that in this way it was very striking. But," she continued:

in spite of the manner in which the physical agony was insisted upon, in spite of details certainly repulsive, in spite of the almost hideous attenuation of the body and limbs, in spite, too, of the fact that, death having already come, the head had fallen forward upon the breast, and so no spiritual or psychical expressiveness had been attempted,—in spite of all these things, the picture expressed in strong language some of the main ideas which we connect with the crucifixion of Christ.

For her, loneliness, abandonment, isolation, and pathos were all "suggested with force and impressiveness."[25]

When Eakins presented *The Crucifixion* in Philadelphia later in the year, the writer for the *Philadelphia Evening Bulletin* began by noting that the artist's works were "sure to be invested with polemical qualities," before concluding that he had "approached his work with the same feelings that might agitate the breast of a clinical surgeon."[26] Clark, on the other hand, declared it the "most important canvas in this exhibition, size, subject, and treatment all being taken into consideration." He tossed aside the technical merits of the work as a matter of course and defended instead its literalism:

> This artist is the greatest draughtsman in America. He is a great anatomist as well....We can, therefore, dismiss certain elements of the picture in question with very few words—it is a superb piece of drawing, while in brushwork, color, and other matters it is up to the artist's very best standard of excellence. But how does it figure the true sentiment of the theme? This is an important query, for Mr. Eakins has commonly been accounted an extremely unsentimental sort of person....What he has done primarily has been to conceive the Crucifixion as an actual event....Certainly, if that event meant all that Christendom believes...it would seem that, if it is to be represented at all, the most realistic treatment ought to be the most impressive.[27]

Considered logically, Clark averred, one must know the physical realities of a crucifixion in order to appreciate whatever else transpired. This follows directly upon such positivist histories of the Holy Land as Ernest Renan's *Vie de Jésus* (*Life of Jesus*, 1863), a search for historic truths rather than accrued traditions. Eakins's own appreciation of Christianity seems to have run in a parallel, search-for-origins path. Describing a painting of a praying Muslim by Gérôme, he wrote: "How simple & grand. How Christ like. Then think of the contemptible catholic religion the three in one & one in '3'.... Its beyond all belief."[28]

Eakins surely did invest his paintings with polemic. Each major exhibition work advanced a new element that challenged the viewer. In subject, he had urged the incorporation of modern themes into the canon of high art topics. As Van Rensselaer noted, "There is no one who is doing more than Mr. Eakins to show how our native material, unglossed and unpoeticized, may be made available in artistic work. No more necessary lesson can be taught our students than this."[29] But Eakins's ambition exceeded the role of "painter of modern life." He sought to show that he could turn his hard-won skills to all fields of figural art. His campaigns included history painting, mood works of beautiful women, and genre scenes of colonial, African American, and contemporary life. Moreover, not only did he exhibit many of the more fashionable modes of working during these years, he experimented and tested their boundaries.

Two watercolors of 1881 show this latter tendency: *Spinning* and *Homespun* (pls. 90, 91). In each a young woman—modeled by Eakins's sister Margaret—sits on a low stool beside a spinning wheel, intent on her work. In the smaller of the two, *Spinning*, the grained floorboards lead to the spinner, with her carefully stippled face and articulate hands. The spareness of the setting and the girl's downward glance focus attention on her action. In *Homespun*, by contrast, Eakins moved Margaret closer to the viewer but turned her so that her face and hands were nearly hidden. The sheet seems to concentrate not on the act of spinning but on the room, in which a variety of simple, antique things with rounded shapes create a seamless, integral whole with the young woman.

While these watercolors refer to early American times, both through props and activity, they differ from Eakins's historical works of the 1870s in at least one significant fashion: instead of a period costume, Maggie wears a simple garment of gathered material, belted and tied into place, comparable to that worn by models in so-called classical dress (see, for example, pls. 126, 127). The works, especially the pared-down *Spinning*, evoke a generalized past, archaic activity, and quiet mood, parallel to the ahistorical efforts of such painters as Thomas Wilmer Dewing, rather than striving for a more authentic Colonial Revival air.[30]

Signed and dated 1881, the watercolors were on view by the end of January. Eakins exhibited them widely that year and the next. They prompted short lines of admiring comment from the critics. *Spinning* showed "a solid flesh-and-blood young woman intent upon her work," and was "executed with singular refinement" "in the Millet-like breadth of drawing he so especially understands."[31] *Homespun* was, of the three watercolors he showed in Philadelphia in April 1882, "much the best.... The picture is small and quite innocent of color, but it is pervaded by the same atmosphere of quiet concentration and simplicity which characterized his [William] Rush at the last Academy exhibition."[32] In many instances Eakins kept his successful watercolors in circulation for long periods of time, but neither *Spinning* nor *Homespun* was offered to the public after 1882. It seems likely that Eakins reserved the sheets, both of which he knew as "Maggie spinning," for himself and his family as memorials.[33] For on December 22, 1882, Maggie—his favorite sister and close friend—died of typhoid fever.

Spinning appeared as the subject for one more work in Eakins's oeuvre—another expansion of boundaries, this time challenging the restraint of medium. In 1882 Eakins was asked to create a suite of ornaments for a fireplace mantel in a house being designed by Theophilus Chandler. He later recalled that the architect "easily induced me, for the work was much to my taste. We settled that the price might be 3 or 4 hundred dollars

for a figure."[34] Eakins immediately undertook two oval reliefs, *Spinning* (pl. 92) and *Knitting* (pl. 93), modeled on *Homespun* and *Seventy Years Ago* (pl. 42, with elements taken from the chaperone in *William Rush Carving His Allegorical Figure of the Schuylkill River*, pl. 41).

Relief sculpture was a field of particular interest to Eakins: his lecture on the subject, "Laws of Sculptured Relief," grew out of his abiding interest in perspective and the means of constructing an illusion of space.[35] As he wrote to his patron, relief sculpture "has always been considered the most difficult composition and the one requiring the most learning. The mere geometrical construction of the accessories in a perspective which is not projected on a single plane but in a variable third dimension is a puzzle beyond the sculptors whom I know."[36] The challenge suited him.

Modeled in clay (although intended ultimately to be carved in stone), the reliefs progressed slowly. The knitter's head—posed for, as with other figures of knitters, by Sally King—was redone several times. The model for the spinner, Academy student Ellen Ahrens, only slowly learned her craft: "In the spinning panel after I had worked some weeks, the girl in learning to spin well became so much more graceful than when she had learned to spin only passably, that I tore down all my work and recommenced." The artist could honestly declare: "I have taken great pains to do my work well."[37]

In the early summer of 1883, the patron began to dispute the projected costs of the campaign and ultimately declined the reliefs; the project lapsed. Discussions concerning recompense dragged on until the summer of 1885.[38] Meanwhile, to Eakins's surprise and outrage, the reliefs were rejected for exhibition by the Society of American Artists in 1884.[39] He never again received a commission for domestic sculptural decoration.

In 1880 and 1881 Eakins pushed his public exposure in another direction. As he was painting *The Crucifixion*, he was also working on a picture that could, at least in terms of thematic appeal, be considered its diametric opposite—*Singing a Pathetic Song* (also known as *The Pathetic Song;* pl. 63), a female-dominated genre scene set in a contemporary American parlor. Unlike his earlier pictures of music-making, this was not meant as a group portrait (although the figures are recognizable: Academy art students Margaret Harrison and Susan Macdowell sing and play the piano, respectively, with cellist Charles F. Stolte); it is an imagined event of everyday life.[40]

Eakins used several tools in his construction of *Singing a Pathetic Song:* both an oil study (Hirshhorn Museum and Sculpture Garden, Smithsonian Institution, Washington, D.C.) and a perspective drawing (Charles Bregler's Thomas Eakins Collection, Pennsylvania Academy of the Fine Arts, Philadelphia; hereafter Bregler Collection) are extant.[41] Of even more moment, however, is an extensive suite of at least eleven photographs that recorded Harrison wearing this dress, taken in Eakins's studio while the painting was under way (pl. 62).[42]

In spite of these tools, however, there are curious elements in the painting, which are also replicated in the watercolor that Eakins made after the work (The Metropolitan Museum of Art, New York). The relationship of the musicians to one another is atypical for a chamber ensemble, with the cellist blocked from making eye contact with his fellow performers. Likewise, the position of the audience is unsettling—not surrounding the viewer but, to judge by the direction of the singer's attention, off to the right at the foot of the piano. The proportional relationship between the two women also begins to look odd, as if the pianist—who is documented as being a tiny woman—were much larger than the singer. Even the hanging of the oval painting seems unduly high. Eakins continually made choices as he constructed his paintings, sometimes in the direction of effective picture-making rather than the accurate reconstruction of lived experience.

Singing a Pathetic Song was shown as Eakins's sole submission in New York at the Society of American Artists in March 1881, and the critics responded. For his friend Earl Shinn, it was a failure: "Eakins, for the first time in his history, becomes 'banale,' and gives us a commonplace, Constant-Mayer-like woman in the worst-fitting of reach-me-down dresses, executing a song with the fixity and rigidity of taxidermy."[43] But for most, the canvas was a triumph, a "quiet but effective domestic scene in this artist's happiest vein."[44] For the writer of *The Art Journal*, the work—"one of the best in the collection and also one of the best that Mr. Eakins has exhibited in New York"—was comparable to the foremost painting of the year, Jules Bastien-Lepage's *Joan of Arc* (The Metropolitan Museum of Art, New York), in the "haunting pathos" of the heroine and "the expression of an intelligent soul transforming what is popularly considered ugliness into beauty."[45] Van Rensselaer, too, who had visited the artist in June 1881, praised the work unreservedly for the way in which the painter transformed middle-class ugliness into transcendent truth:

> Of all American artists he is the most typically national, the most devoted to the actual life about him, the most given to recording it without gloss or alteration. That life is often ugly in its manifestations, no doubt; but this ugliness does not daunt Mr. Eakins, and his artistic skill is such that he can bring good results from the most unpromising materials...—even, as in this case, out of three homely figures with ugly clothes in an "undecorative" interior....The Lady Singing a Pathetic Song was so impressive because it was admirably painted, and because it was at the same time absolutely true to nature,—a perfect record of the life amid which the artist lives.[46]

As the generally negative writer for *The New York Times* summed up his lengthy review of the work, "this realist has, in the present case, tried no unsuccessful experiment; and has been, perhaps in spite of his artistic theories, an idealist."[47]

Late in 1882 Eakins showed the work in Philadelphia at the Academy Annual, along with *The Crucifixion*, the watercolor of *Spinning*, and the meditative mood piece known as *Retrospection* (Yale University Art Gallery, New Haven). With controversy swirling around *The Crucifixion*, Philadelphia's critics found that *Singing a Pathetic Song* was "particularly successful," showing him "in a more generally pleasing light" with his "technical skill...particularly prominent."[48] For Leslie Miller, the work showed Eakins "at his very best....There is almost an utter absence of accessories, and no attempt at anything like prettiness; indeed everybody knows that Mr. Eakins seems rather to enjoy making his sitters look a little homelier than they really are. There is no nonsense anywhere, but plenty of downright earnest sentiment. There is nothing in the whole collection," he concluded, "that seems quite so genuine and sincere."[49]

Yet another subject newly explored by Eakins in the early 1880s focused on the fishermen active near Gloucester, New Jersey. Men working out-of-doors was a peculiarly modern subject. J. G. Brown, with such scenes as *Pulling for Shore* (1878, Chrysler Museum, Norfolk, Va.) and other North Atlantic fishing themes, and the more urban *Longshoremen's Noon* (1879, Corcoran Gallery of Art, Washington, D.C.), had found critical and commercial success with it. Winslow Homer, too, was exploring the daily lives of fisherfolk in both Gloucester, Massachusetts, and, beginning in 1881, in Cullercoates, England. Even Eakins's student and assistant in the Academy, Thomas Anshutz, received considerable attention for his *Ironworkers' Noontime* (1880, Fine Arts Museums of San Francisco) when it was shown in Philadelphia in 1881.[50] As Eakins's friend Clark noted in October 1881, in what was a clear attempt to generate interest in upcoming exhibition works:

> Mr. Thomas Eakins is an artist who has theories. One of his theories is that an American artist cannot do better than to treat American subjects, for the reason that no better subjects than American subjects exist. Another of his theories is that the best subjects are very apt to be those very near at hand to the artist, wherever the artist may happen to be.... He is now putting the finishing touches upon a couple of pictures, intended for the approaching exhibitions, the studies on which were made at Gloucester during the shad season.... The artist has not attempted to deal dramatically with either theme, and the merits of the pictures, consist in their being accurate transcripts of the commonplaces of fishermen's lives, and in the masterly manner in which sunlight effects are reproduced.[51]

Eakins's campaign for Gloucester's commonplaces and sunlight included watercolors and oil paintings. To assist in their development, he made plein-air studies.[52] His largest contingent of works from the site, however, consisted of more than seventy photographs that, with his own newly acquired camera, he took mostly in April and May 1881.[53] Eakins's use of photographs in the development of this suite of paintings was extensive, as two small canvases, each titled *Shad Fishing at Gloucester on the Delaware River*, demonstrate. Both have raking diagonal foregrounds and a group of fishermen working close to the shore in the middle ground. In the work with the more cluttered foreground (pl. 72), Eakins based his composition on two photographs: one of shad fishermen setting a net at Gloucester (pl. 71), selectively edited of bystanders, established the figural group and near shoreline; another photograph (pl. 70) provided the steamboat pier to the right, the horizon, and the foreground. By combining and editing his photographs through traced projections on the canvas, and with continual reference to photographic prints for interior forms, he was able to paint the finished painting back in his Philadelphia studio.[54]

Gloucester had two principal industries in the early 1880s: shad fishing and tourism. Eakins brought the two together in the second of the small canvases, *Shad Fishing at Gloucester on the Delaware River* (pl. 76). His basic mode of composition followed a more complicated variant of photographic dependence, with at least two photographs contributing to the group of the fishermen (pls. 73, 74) and one to the landscape (Bregler Collection). The tourists—Eakins's father, at least one sister, and friends—came from a different photograph (pl. 75); the dog from yet another (Bregler Collection).

Eakins sent both works to exhibitions throughout the eastern United States in 1881 and 1882. When the picture with the family group—"a party of very commonplace citizens"— was in Philadelphia, critics singled out its local and original subject no less than its color and composition, finding it "genuine, fresh, and clever."[55] Shinn praised its "great calmness, breadth of treatment, and harmony," claiming that "seldom does a landscape painter find such vital and authentic figures, seldom does a figure-painter succeed in throwing his figures so integrally into the conditions of the landscape which forms his setting."[56] The painting caused the writer from *The New York Times*, on the other hand, "to ask what ails Mr. Eakins of late. His old vigor and point are gone. Probably shad fishermen on the Delaware are not particularly picturesque creatures at the best, but why need Mr. Eakins make them so utterly dull and uninteresting that they have not even action? There is little or no effort at composition, little color, and some good drawing."[57]

Although Eakins made progressively fewer watercolors through the 1880s, fishing at Gloucester prompted three of them, at least two of which—those showing groups of fishermen—trace the same compositionally dependent relation to photographs as the oils (see pls. 86, 87). When two were shown in Philadelphia,[58] Miller criticized the "hard, photographic little figures" as being "as depressingly commonplace as they could possibly be made. . . . In their labored feebleness of execution, as well as their singularly inartistic conception, one wonders what relation they can possibly bear to art."[59] Miller, condemning both matter and manner, confronted the subject and the painter's penchant for highly detailed work; did he know or suspect how closely tied to photographs these watercolors were?[60]

The largest of Eakins's Gloucester works initially stands apart from the rest of the group. While depicting the same site and still centered on the shad fishing industry, *Mending the Net* (pl. 85) affects many viewers as being Eakins's most poetic work. And yet even its organic, coherently realized vision was a willed fabrication drawn from photographs (pls. 77–84) and oil studies (Bregler Collection and private collections). The focus is a group of ten men and boys, along with a half-dead tree and a disassembled capstan crossing the horizon. Seven men are dressed in working clothes, with shirtsleeves and suspenders clearly visible. Two young children, having abandoned a toy sailing boat, peer at the net mending. An eighth man, wearing a dark suit, sits in the shade reading his paper—he is an outsider to the fishing community. With his presence, Eakins once more brought together fishing and tourism to epitomize Gloucester.

As in his earlier friezelike *Pushing for Rail* (pl. 11), Eakins used a series of formal devices to direct attention to the figures: they contain the painting's greatest variations of color and range of lights and darks, as well as the allure of their varied stances and precision of handling as light and shadow carve out the forms. He further accentuated their impact by starkly silhouetting them against the sky. They are, in the words of Van Rensselaer in 1881, "as various as they are lifelike and individual. Each of these span-high figures is a treasure in itself, broadly yet delicately touched, with a mastery of form and expression unrivalled, I think, among our native artists, and unexcelled by similar work from any brush."[61]

Commentators on the work were divided as to its merits. Shinn, calling it Eakins's "latest picture, and probably his best," proceeded to enthusiastic, almost giddy, hyperbole:

> The filmy webs of the fishermen form the strangest "decoration" over the brow of a gentle hill or incline near a river; they rise into the air like Corot exhalations, and festoon the horizon-out-look like gossamer cobwebs. . . . Every fisherman is a statuette, most realistic, most varied in movement, finished like ivory carving, yet bathed in the misty river-side

air. The mere back view of a series of boatmen's pantaloons, whether of oil-cloth or of worn linsey-wolsey, broken into folds that explain a motion, or patched or stained with accidents that explain a toilsome life, are a positive revelation.[62]

For the writer from *The Philadelphia Press*, however, "the tame flatness of the awkward Yankees" (evidently confusing the Gloucesters of New Jersey and Massachusetts) led him to believe that Eakins "somehow misses in this picture the real dignity and beauty" of the subject.[63] For another, it was "the severe, unpoetical, uncompromising style which has characterized work by him of late years" that prompted condemnation.[64] Perhaps the most pointed attack—if Eakins was uneasy about his use of photography and projection—came with the statement that the work included "some exquisitely drawn and intensely real figures in miniature, uncompromising as photographs and quite as innocent of pictorial qualities. Nobody doubts their 'conscientiousness,' and all that; one only asks what this has to do with painting."[65] In the end, Eakins did not heed the negative criticisms; he continued to lend the painting extensively throughout the decade, including exhibitions in Washington, D.C., and Munich. His faith in the work was rewarded: in 1893 *Mending the Net* earned a bronze medal at the World's Columbian Exposition.[66]

Eakins's one pure, large-scale exhibited landscape, *The Meadows, Gloucester* (pl. 88)—yet another attempt to conquer new artistic territory—grew from his work along the Delaware shore. It was not a critical success. On its debut in Philadelphia, one writer asserted: "He also has a green landscape, wholly commonplace and without feature demanding notice."[67] No reviewer now known took exception to this disregard. The painting, with its fashionably French emptiness and lack of incident, brought Eakins's Gloucester series to a close.

During the same years that Eakins studied the fishermen of Gloucester in the outdoors, he continued to work with large figures in interiors. One of these, a work that again presses accepted boundaries and categories, is *The Writing Master* (pl. 96). The canvas could be an unusual genre work, a scene of professional skill epitomized by the earnest diligence of the aged practitioner surrounded by the modest tools of his trade—stylus in hand, quill pens and inkwell waiting to each side (a later critic caricatured the work as "mainly a pair of well-drawn and well-colored hands").[68] As such, it would serve as a masculine foil to the knitters and spinners from earlier in his career[69] or a sedentary complement to the craftsmen that other painters as diverse as Louis Moeller, Henry Alexander, and Charles Ulrich, among many others, were exhibiting during these years. But the work is also a portrait, showing the artist's father and friend, Benjamin Eakins (1818–1899), whose profession as writing master sustained his family and, with the

investment of his income, allowed the painter lifelong financial security.[70] The painter's decision to celebrate the man through his activity parallels the monumental canvas of *The Gross Clinic*, blurring the boundaries between portrayal of the individual and recording of a characteristic, laudable action.

Eakins clearly valued the painting over the decades. In 1890 it was the first of his works to be seen in the Paris Salon since 1874. He later submitted it to such significant exhibitions as the World's Columbian Exposition in 1893 and the first Carnegie International in 1896–97. In 1916, when the Metropolitan Museum of Art purchased *Pushing for Rail*, Eakins wrote to say, "I sincerely wish the Museum had chosen a larger and more important picture such as 'The writing master.'"[71]

In late 1883 Eakins undertook another painting of a man seated at a table, looking down intently at his hands. But nearly every other element of the two paintings is different. *Professionals at Rehearsal* (pl. 121) is a small upright canvas only sixteen inches high, which shows two men at full-length seated in Victorian-era sidechairs around an eighteenth-century tilt-top table. The scene is set in the same corner of the studio where Eakins had positioned Margaret for the watercolor *Spinning*; the ornamented cupboard, shelf, and hook that in the watercolor had suggested a colonial kitchen also loom here. Now, however, with the addition of piled books and portfolios, an open bottle of wine, the rhyming forms of corkscrew and tuning key, the mishmash of old and new furniture, and general darkness, the space has been transformed into a bohemian garret for two musicians practicing their instruments.

The oil painting was a commission to the painter from the New York collector Thomas B. Clarke, the era's foremost patron of American art.[72] The oil recapitulates a watercolor of 1876, *The Zither Player* (Art Institute of Chicago), for which Eakins's friends Max Schmitt and William Sartain had posed as decorous, middle-class men of the mid-1870s, taking their ease.[73] For Clarke's commission, Eakins recast the subject, selecting two students—John Laurie Wallace and George Agnew Reid—to play zither and guitar, while transforming them, through the oil's title, into professional musicians.[74] Viewers were able to see it by December 1883 in a public showing of Clarke's collection in New York and, in the fall of 1884, at the Pennsylvania Academy of the Fine Arts. It was judged to be "certainly one of the strongest paintings in the [Clarke] collection" and was lauded as "a highly wrought, honest, good work" on a par with the best of seventeenth-century Dutch genre scenes.[75] Coming about the time of the commission for the *Knitting* and *Spinning* reliefs, and just after his elevation to director of the Academy schools, Clarke's patronage must have made Eakins feel well set on a path toward professional and financial success.

Having received in the early 1880s a significant quantity of praise for his paintings of daily modern life as lived in America, it seems fitting that Eakins would, perversely, turn elsewhere. One place he visited briefly was Arcadia, or, at least, an imaginative state of natural simplicity, idyllic music-making, and poetry parallel to the one made famous in the writings of Theocritus. Part of Eakins's project continued the experiences of photographing figures in the outdoors, but instead of the fishermen of Gloucester, he now focused on friends, family, students, and himself, often nude and holding shepherds' pipes to lend a veneer of mythological distance, or conscious artiness (pls. 112, 113, 117, 118). Among the fruits of this excursion to Arcady was a small cluster of oil paintings, the largest being *Arcadia* (pl. 119).[76]

Based on an extensive body of preparatory works, *Arcadia* remained unfinished and, in his lifetime, unexhibited. Eakins was not, however, wholly dissatisfied with it. He presented it to his colleague, William Merritt Chase, evidently feeling that a painter would appreciate the work's achievement and promise. Although the painting is related in a general way to the antiquarianism prevalent in the popular works of Lawrence Alma-Tadema, Frederic Leighton, or even James McNeill Whistler, Eakins eschewed careful archaeological reconstruction or preciosity to focus instead on the simplest of themes and settings. Oil studies and photographs help trace the development of the project through a variety of poses and arrangements, and identify the site and at least two of the figures.[77] The model for the standing piper was John Laurie Wallace and the girl, thanks to photographs in the Bregler Collection, can be identified as Academy student Susan Hannah Macdowell, Eakins's fiancée since September 1882 and the pianist in *Singing a Pathetic Song*—although Eakins manipulated the figure of Macdowell to bring her nearer to Wallace's age of nineteen. The site is recognizable as the Crowell farm in Avondale, about thirty-five miles southwest of Philadelphia. Accessible by rail, the farm was a bucolic retreat that Eakins often visited during the first twenty or so years after the Crowells moved there in 1877 (pls. 106–9, 111).[78]

The sole multifigure Arcadian work that Eakins brought to completion was a sculptural relief (pl. 120). The principal inspiration for the format of the work was Phidias's Pan-Athenaic procession from the Parthenon, casts of which were in the Pennsylvania Academy's collection and which Eakins called "the highest perfection of relief."[79] Eakins surely had this in mind when he lectured: "The simple processions of the Greeks viewed in profile or nearly so are exactly suited to reproduction in relief sculpture.... There is a limit in relief; if you keep inside of it, it is a powerful instrument to work with."[80] If the form of *Arcadia* was based on fifth-century

marble carving, however, the handling, with its nervous, light-catching surfaces and striations, seems more akin to the sensibilities embodied in Tanagra figurines—third-century Greek ceramics of lightness and delicacy that were being excavated and published to great acclaim in the 1870s and 1880s.[81]

Eakins apparently valued this Arcadian relief: he included it in photographs of his studio and in a later painting of his wife (pls. 127, 158), as well as providing casts to friends and students.[82] More tellingly, in late 1883 he submitted it—calling it *Sketch in Plaster (Pastoral)*—to the second Annual Exhibition of Sketches and Studies at the American Art Association in New York.

But Eakins did not linger in Arcadia. By the summer of 1884, under the pressure of a lucrative, eight-hundred-dollar commission—more money than the painter had yet received for any one work—he set about locating a local, idyllic substitute. He found it at Dove Lake, near Bryn Mawr, where he made photographic and painted studies for *Swimming* (pl. 149), a work that stands as a pictorial manifesto of Eakins's academic ambitions.[83] The commission came from Edward H. Coates, who had replaced Fairman Rogers as the head of the Academy's Committee on Instruction in November 1883.[84]

Eakins in 1883 and 1884 was focusing intently on the photographic study of the nude. For his classes at the Academy, he and his students launched a rigorous comparative study of models, themselves included, in the so-called Naked Series (pls. 128, 129, 132, 133). They photographed each figure in a standardized series of seven poses, which the artist then analyzed with outline drawings (pls. 130, 131) to determine "the general axes of weight and of action."[85] During the summers of 1884 and 1885, he worked at the University of Pennsylvania alongside the pioneer of motion photography, Eadweard Muybridge, to record a wide range of human motion (pls. 150–57). At the Academy and in his own studio, he and his students were, during these same years, taking still photographs of nude and draped figures, in a variety of poses and levels of artistic pretension, both indoors (pls. 123, 126, 127, 134–44) and out (pls. 145, 146).

Swimming integrated the rigorous anatomical program of the Academy, the decidedly modern photographic investigation of figures stilled and in motion, and Eakins's own progressive exploration of landscape painting. As a commission from the head of the Academy's Committee on Instruction, it must have seemed an ideal choice of subject—a fully realized and carefully calculated composition, modern in subject and execution but classical in intent, that revealed the rewards of the Academy's program as Eakins had developed it: a "course of study...believed to be more thorough than that of any other existing school. Its basis is the nude human figure."[86]

In *Swimming* six men lounge on, dive and twist from, and swim toward the stone foundation of a destroyed mill. Their animated poses suggest both a catalogue of actions appropriate to the site and challenges to the painter-anatomist, with complicated foreshortenings, shifting weights, and the nearly unparalleled effort of portraying a diving figure caught midair. The composition, however, subsumes the pyrotechnics of the individuals into a stable pyramidal form—the standing figure at the center of the canvas as the apex of a pedimental sculpture group—that imposes a hierarchical distance and stillness over the whole. The men were all students and friends of the painter. Eakins himself swims into the scene from the right, joined by his dog Harry.[87] Given the complexity of the design and the importance of the commission, Eakins made careful preparations for the work, visiting Dove Lake several times with camera (pls. 147, 148) and paintbox (private collections and the Amon Carter Museum, Fort Worth, Tex.).[88]

The debut of *Swimming* in late October 1885 ought to have been a splendid moment.[89] It was not to be. Among the generally tepid responses greeting his major new work was the opinion that the painting "evidently intended to show the results of instantaneous photography, but it does not convey the impression of any possible motion."[90] Eakins was trying to reorient his audience's way of seeing, paralleling the efforts to record transient moments undertaken by the Impressionists. The French painters, however, forged a new style congruent to the instantaneity they sought to capture. Eakins, instead, tried to parse the smallest moment within an accomplished and fully achieved academic technique. Few art writers appreciated the effort.

But the criticism of the painting that Eakins undoubtedly judged most vital never saw print. It came as a letter from Coates declining, in the nicest possible way, to accept *Swimming* for his commission:

> I want to make a proposal which may be a surprise to you but which I take the liberty of making relying on our kindly relations and knowing that we may talk frankly....[A]s you will recall one of my chief ideas was to have from you a picture which *might* some day become part of the Academy collection. The present canvas is to me admirable in many ways, but I am inclined to believe that some of the pictures you have are even more representative, and it has been suggested would be perhaps more acceptable for the purpose which I have always had in view. You must not suppose from this that I depreciate the present work—such is not the case.[91]

Instead of *Swimming*, Coates took *Singing a Pathetic Song*.

Leslie Miller, art instructor and critic, in finding fault with *Swimming*, expanded the criticism to question the very center of Eakins's position in Philadelphia—his role as a teacher:

Mr. Eakins has done some very strange things. . . . In nothing that he has done, however, has his work been so persistently and inexcusably bad as in the landscapes which he has introduced as backgrounds for his figures. That in the "Swimming," shown at the present exhibition, will serve as a fair illustration, and the extent of the mischief which such an example exerts is only to be judged by these reflections of it which disfigure the work of most of the older students.[92]

Eakins's influence on the younger artists around him and his establishment of a pervasive aesthetic was widely recognized— Shinn called him, simply, "the responsible originator of the new movement in Philadelphia."[93] As early as 1881 his advocates asserted that this influence was healthy rather than overwhelming: "very few of his pupils come before the public as his imitators. Their works are strongly marked by his influence, of course, but they are not repetitions of his pictures, either in matter or manner."[94] Miller, however, had been complaining of the nature of Eakins's impact for years. In late 1883 he berated a young artist's work as manifesting "that melancholy and common-place kind" of execution "which Mr. Eakins has succeeded in making his students believe to be the proper thing in painting."[95]

Discontent concerning Eakins's tenure and program also came from within the Academy. Some of the trouble was financial.[96] There was also a long-standing concern over the nudity to which students were subjected. Letters from as early as 1882 protested the inevitable loss of "*womanly* refinement and delicacy" resulting from the study of "*male and female figures* . . . in their horrid nakedness."[97] Eakins's own easy acceptance of nudity, as an element essential for study, did not abide easily in Victorian Philadelphia.[98]

In early January 1886, in an anatomy class with women students, Eakins, lecturing upon the pelvis—which he later described as "in an artistic sense the very basis of the movement and balance of the figure"[99]—removed a loincloth from a male model so that he could trace the full course of a muscle. Some students, probably backed by senior students and junior teaching staff, complained. At the same time, rumors surfaced about Eakins's personal as well as his professional life, including the fact that some female students had posed nude for one another and sometimes for their instructor (albeit "with the knowledge and consent of their mothers").[100] On February 8 Coates asked for Eakins's resignation.[101] An official interview was held on Saturday, February 13; at its end, Eakins's resignation was accepted.[102] Within the week Eakins wrote to Coates:

I hope that you yourself will not mistake the agony you saw me in at your examination, for any shame at what I have done, but simply as it was, to having to tell things which were a surprise to people unprepared to understand.

. . . It seems to me that no one should work in a life class who thinks it wrong to undress if needful. . . . Was ever so much smoke for so little fire? I never in my life seduced a girl, nor tried to, but what else can people think of all this rage and insanity.[103]

Newspapers in Philadelphia devoted significant column space to the resignation. Some reported it objectively, calling it the "culmination of a trouble that has been brewing for some time. It had its beginning through objections to his method of instruction."[104] Others were more partisan.[105] They all coalesced within the week, however, when a group of fifty-five, mostly male students drew up a petition for Eakins's reinstatement (following the example of "all but a dozen" female students earlier in the day). "Upwards of forty" students, each wearing "a large E on the front of his hat as a symbol that he was for Eakins first, last, and all the time," marched down Chestnut Street to Eakins's home and "cheered lustily for their head instructor."[106] They then threatened to leave the Academy and establish a new school in which Eakins could continue his teaching. Eakins was quoted as saying, "I would take no steps to organize such a school. That I can say positively, and I don't believe any will be organized."[107]

He was mistaken. On February 18 students met for the purpose of organizing an Art Students' League.[108] Classes, with a roster of thirty-eight men, were in session by the next week (pls. 166–71). Most of the local newspaper reports on the league were negative or cautionary—revolt against the generosity of the Academy directors was deemed rude or foolish. The national art press was more inclined to favor the students and their enterprise, as well as to downplay the accusations against Eakins: "The best wishes of all who love truthful study will attend the formation of the students' class, and whatever Mr. Eakins' errors may have been, we most earnestly wish that he may be forgiven by his enemies, whom it is to be hoped will never commit any greater sins than those of which he has been accused."[109] In June the league completed its first, successful season. Eakins was quoted as being "proud of the progress made by Philadelphia's new art school," and he was of the opinion that "his pupils have more than fulfilled his most earnest hopes by their progress."[110] In 1888 he could write: "I hear that at our old Academy they do not paint at all any more. They only draw outlines and shade them up occasionally." Then, in a new paragraph, he added, possessively, "My own little school has gone into good quarters at 1816 Market St., and is exempt from all impertinent interference of the ignorant."[111]

Eakins came to believe that the leader in the cabal against him was his brother-in-law, Frank Stephens, who ultimately voiced allegations of incest between Eakins and his dead sister, Margaret.[112] The result was traumatic for all. Frank Stephens and his wife, Caroline, left the Mount Vernon Street home,

reportedly at the insistence of Benjamin Eakins; Eakins and his wife, who had been living in his studio on Chestnut Street since their marriage, moved back to Mount Vernon Street to care for his father and Aunt Eliza. The break with Caroline was unreconciled when she died in 1889.

In September 1886 Eakins again wrote to Coates, professing a credo that placed the human form at the center of his art:

> I see no impropriety in looking at the most beautiful of Nature's works, the naked figure....
>
> I believe I have the courage of my convictions. I am not heedless. My life has been full of care and thought, and governed by good moral principles, and it is very wicked and unjust to misfit my doings to motives which a very little consideration would show did not govern them.[113]

Eakins addressed letters to defenders and accusers throughout 1886 and into 1887.[114] The extent of the trauma he endured for his beliefs, as well as his refusal to accommodate what he viewed as false modesties and hypocritical niceties, was great.

One of the mainstays for Eakins during his Academy "troubles" was his wife, Susan Hannah Macdowell (1851–1938), whom he had met in 1876, taught from 1876 to 1882, and married on January 19, 1884.[115] A talented painter and photographer, Macdowell was one of the leading pupils at the Academy, winning prizes as well as serving as secretary-petitioner for the women students.[116] She had, before their marriage, posed for Eakins, but always as an ancillary figure. Sometime between 1884 and 1886, he set out to make a portrait of her: *The Artist's Wife and His Setter Dog* (pl. 158).[117] He based the painting on a project that he had evidently begun to consider about 1883. Photographs (pls. 105, 124–25) show an unidentified woman in archaizing dress seated in a Queen Anne–style chair with a dog at her feet and an oriental rug set diagonally to the picture plane. It was an apt format for a portrait of Susan Eakins, since the composition bears a striking resemblance to one of her own most successful paintings—*Portrait of Gentleman and Dog* (1878, private collection), showing her father and his pet. Eakins's portrait, through its composition, becomes an homage to her earlier work. He seems, at least, to have considered it a Macdowell family painting, since by 1887 he had given it to them.

The painting shows an interior at 1330 Chestnut Street where the couple lived and Eakins worked: "my own little home...where I have been very happy," he wrote in June 1886.[118] Four paintings (none of which can be identified) and the Arcadian relief adorn the walls.[119] Susan Eakins holds a Japanese picture book open on her lap.[120] She twists in the chair onto her near hip, extending one leg forward and leaning her head down while twisting it to look straight out of the canvas. The pose stretches the figure and, in spite of the appearance of relaxation, is difficult to maintain. The disguised tension of the

position is echoed in the dress, an old-fashioned gown whose reflective surface gleams in the light and cuts sharp, crisp lines of shadow that pull at shoulder and upper arm—a strain intensified by the shortness of the sleeves. Eakins detailed the deep lace cuffs, ruffled hem, gathered bodice, and inner seam of the far sleeve. Through the red stocking and shiny black slipper, as well as the intense red of her ear, he ensured that the viewer studies the full length of the figure.

Both lady and utterly relaxed dog stare easily out at the viewer, neither stirring, implying that the viewer is the artist at home in his studio. Here again Eakins seems to be challenging another fashionable mode of painting: the work of William Merritt Chase, whose studio interiors and aestheticized portraits of his wife and such other friends as Dora Wheeler and Harriet Hubbard Ayer were centerpieces of exhibitions throughout the 1880s.[121] The elements of Eakins's painting all speak to a comparable intent: the idle woman in fancy dress, set in an Aesthetic-movement melange of classical, Asian, and colonial props—a mode of painting that such artists as Chase, Dewing, and Childe Hassam would continue to practice well into the twentieth century.

Eakins inflected the work, however, denying it a reading as the embodiment of timeless, universal beauty. Part of this is a result of the specificity in his presentation of the sitter and the things gathered around her: their sheer physical presence prevents them from winging off in flights of fancy. Likewise, the stark, merciless light that shines down from the skylight reduces any chance of idealization, catching the lines and creases of Susan Eakins's face and neck and highlighting the strength of her large, pianist's hands (the "wonderfully painted hands" were what caught the attention of the art writer Charles de Kay when he saw the painting in 1887).[122]

The first appearance of *The Artist's Wife and His Setter Dog* was as a reproduction accompanying Shakespeare's sonnet forty-seven in the *Book of American Figure Painters* (1886), the collection as a whole meant to signal "a faithful representation of the excellence of our Art."[123] The pairing of the work with the poem, a paean to the love-inducing power of the beloved's portrait, demonstrates that the painting was initially interpreted as being about the pleasures of love.[124] A comparison of the book's photogravure and the painting reveals that Eakins reworked several passages of the canvas after it was photographed in the fall of 1886, notably the sitter's face and hairdo, the position of her right knee and leg, various elements of the dress, and the curtain.[125] Perhaps this continuing evolution was one of the reasons Eakins never signed the painting—an unusual feature among his exhibited works.

Eakins first exhibited the painting in 1887, as *Portrait of Lady and Dog*, at the Society of American Artists' spring exhi-

bition in New York. The picture did not fare well critically. "Mr. Thomas Eakins, of Philadelphia, who used to be one of the most prominent of the irreconcilables, is falling into comparative obscurity, although he has five exhibits on the walls.... [H]is portrait of a lady and dog, pushed into a corner is a striking example of the disastrous effects that may attend the importation of a scientific theory into the art of the painter."[126] Nevertheless, in later years the painting was one of Susan Eakins's favorites among her husband's works.[127]

Throughout 1886 and 1887, while Eakins continued his campaign to confront his vilifiers and redress his position in the city, he did not sit isolated in his studio. Instead, he started work on portraits of prominent scientists in Philadelphia: George F. Barker, professor of physics, and William D. Marks, professor of engineering, both at the University of Pennsylvania, were among the subjects of ambitious paintings of which he was particularly proud.[128] He also, in 1887, tried something new—rough life in the great outdoors.

In late July Eakins set out for a ten-week stay at the B-T Ranch, Dakota Territory (near Grassy Butte in present-day North Dakota), which he characterized beforehand as "a little trip to the West."[129] Some of this was probably a deliberate respite from the strain of his dismissal and defense of his professional and social self and may have come at the suggestion of his friends Drs. S. Weir Mitchell and Horatio C. Wood.[130] Wood—who eventually owned several of Eakins's paintings and was, from the time of his own Western trip during the summer of 1886, a shareholder in the B-T Ranch—was particularly renowned for the notion of the "camp cure," used to treat nervous ailments in overly urbanized men by subjecting them to physical labor and rough conditions.[131] The doctor's letter of introduction to the ranch manager, however, reads simply: "Mr. Eakins is an especial friend of mine who proposes to spend some time with you studying cowboy life in order to paint pictures of it."[132]

Eight surviving letters from Eakins—six to Susan Eakins and two to John Laurie Wallace—describe his adventures on the range: herding cattle, horseback riding, sharing food and a cabin with a horse thief, participating at a distance in the subsequent hunt for that thief, and admiring the skills involved in tracking.[133] He had a splendid time; the letters brim with enthusiasm for the activities and the hardiness of his life. He summarized the trip just as he was about to return: "I have been out here living, sleeping and working with the cowboys since July to learn their ways that I might paint some. A nicer set of fellows I never met with.... I am in perfect health and so feel moderately happy."[134] Walt Whitman, whom the painter had met just before the trip West, later observed that Eakins had been "sick, rundown, out of sorts: he went right among the cowboys: herded: built up miraculously.... it must have done much toward giving him or confirming his theory of painting: he has a sort of cowboy broncho method: he could not have got that wholly or even mainly in the studios of Paris."[135]

In fact, it appears that Eakins's method of research for art making continued much in the Dakotas as it had in New Jersey. He had a camera and paintbox with him, using both—often in tandem—to record the landscape, buildings, and, especially, the men of the area (pls. 159–63). Eakins used these and later studies, as well as his souvenirs of the trip—a buckskin outfit that he sometimes wore,[136] lariat (both now in the Hirshhorn Museum and Sculpture Garden, Smithsonian Institution, Washington, D.C.), saddle, guns, and other gear, as well as two horses—in his superb large work of 1888, *Cowboys in the Bad Lands* (pl. 164). Once again Eakins set his figures—two carefully studied, minutely worked cowboys and their horses—in a landscape, this time the most expansive, pastel-tinted view of his entire career.

In the very years when Frederic Remington and Thomas Moran were making their names with paintings of the West, Eakins, too, considered this a marketable subject that—with his expertise in human and equine anatomy and motion—seemed tailor-made for him. While on site, he wrote, "If I can sell any cowboy pictures at all they will be a good investment for me."[137] A year later, the ambition lingered: "I have nearly completed a little cowboy picture, and hope to make more. The cowboy subject is a very picturesque one, and it rests only with the public to want pictures."[138] Yet the painting, in spite of these high hopes, was not put before the public.[139] Nor, apparently, was he ever to paint another outdoor subject.

Walt Whitman (1819–1892) claimed, with more poetry than fact, that Eakins "needed the converting, confirming, uncompromising touch of the plains" for his work, emphasizing the painter's Americanness and passing over the European stylistic roots of even his most local scenes.[140] Part of the poet's confidence in the statement came from personal acquaintance, which began in the spring of 1887, when Talcott Williams took Eakins to Camden, New Jersey, and introduced them.[141] They hit it off. For the next five years, until the poet's death, they were friends. Eakins reportedly said, "Whitman never makes a mistake."[142] He attended the poet's birthday party in 1891 and, in the next year, supervised the making of Whitman's death mask and served as an honorary pallbearer. Whitman, for his part, had claimed, "All that Eakins does has the mark of genius," concluding, "Eakins is not a painter, he is a force."[143]

In describing their meeting, Whitman remarked that Eakins "seemed careless, negligent, indifferent, quiet; you would not say retiring, but amounting to that." After two or three weeks of silence:

Then Eakins turned up again—came alone: carried a black [blank?] canvas under his arm: said he had understood I was willing he should paint me: he had come to start the job. I laughed: told him I was content to have him go ahead: so he set to: painted like a fury. After that he came often—at intervals, for short stretches.[144]

Whitman expatiated that those "stretches" tended to last "from half an hour to an hour—and he was a man good to have around—possessed of marked peculiarities."[145]

The resulting painting (pl. 165)—done mostly between November 1887 and April 1888[146]—forms one of the initiatory touchstones of Eakins's late career: a pantheon of portraits that record notable men and women.[147] The ruddy face, lit from the left, emerges from a swirl of varied grays, its structure suggested rather than detailed, a visual parallel to a line from "Song of Myself": "Walt Whitman, a kosmos, of Manhattan the son, Turbulent." Eakins set the poet's wisps of long hair and unkempt beard into relief by a few inches of detailed lace edging the collar of his open-necked shirt. An oil study only five-and-a-quarter inches square (Museum of Fine Arts, Boston) is the one known preparatory work for the portrait; photographs of the poet (pls. 183, 184) made by Eakins and his student Samuel Murray probably date from later visits to Camden, in 1891.[148]

Whitman's frequent responses to the work are well recorded. While it was yet under way, he wrote of it as "a portrait of power and realism ('a poor, old, blind, despised and dying king')."[149] In May, having lived with it for a month, Whitman said, "Of all portraits of me made by artists I like Eakins' best: it is not perfect but it comes nearest being me."[150] The picture remained in the poet's possession until his death, although Eakins borrowed it for exhibition at the Pennsylvania Academy of the Fine Arts in 1891, when one critic singled it out as "by odds and far the best portrait yet made of an heroic figure in our letters."[151]

While cowboys and masculine bards occupied much of Eakins's time in 1888, on May 2 he turned in yet another new direction—the portrait of a woman as a vision of elegance.[152] His *Portrait of Letitia Wilson Jordan* (pl. 172), reportedly grew from a chance sighting at a party that both artist and sitter (1852–1931) attended. The next day Eakins approached her brother, David Wilson Jordan, a friend and former student, to say he wished to paint her as she had appeared the evening before.[153] The resulting work became the first clearly unequivocal portrait—rather than mood piece or genre scene—of a woman outside his immediate family circle to be seen by the public.

The painting is a striking innovation within Eakins's oeuvre. In none of his earlier works, public or private, had he so bla-

tantly adopted the mode of fashionable French-inspired portraiture—stylish clothing and neutral background—that such artists as Carolus-Duran or his own teacher Léon Bonnat had popularized. There were many French-trained American artists who sought to achieve fame through society portraiture in the later 1880s. But the form and timing of *Letitia Wilson Jordan* suggest that Eakins may have been responding to one artist in particular: John Singer Sargent. After years of notoriety gained from his spectacular Salon entries, the Paris-trained, London-based artist in 1887 made a ten-month visit to the United States, during which time he undertook twenty-four lucrative portrait commissions from some of the most noted families of the Eastern Seaboard.[154] Eakins certainly would have had the chance to see the two of these canvases that Sargent showed in New York in the spring of 1888: *Mrs. Charles Inches* (Museum of Fine Arts, Boston) at the National Academy of Design[155] and *Mrs. Richard H. Derby* (private collection) at the Society of American Artists. Prominent elements of Jordan's costume—red bow, overlarge buff-colored gloves, black gauze at neck and shoulder—echo details from both.[156]

The critics, when they saw *Letitia Wilson Jordan* in 1891, responded to it not as a society portrait, however, but within the limits they expected from the painter. It was, said one—perhaps making reference to Jordan's set mouth and slight double chin (she was in her mid-thirties)—"painted, apparently, with that unsparing realism for which Mr. Eakins is famous."[157] Eakins might adopt the vocabulary of a fashionable society painter, but his canvas still spoke of real things pressing on all too human flesh and spirit. He would rarely again make such a concerted attempt at glamour.

Teaching continued to be important to Eakins. In 1887 he was instructing at both the Art Students' Leagues in New York and in Philadelphia and began lecturing in anatomy at the Women's Art School of the Cooper Union in New York. In the fall of 1888 he began a course on artistic anatomy at the National Academy of Design. The seriousness of Eakins's interest in the students, particularly those of the Art Students' League of Philadelphia, can be sensed in his head-and-bust portraits of them, especially those of Douglass Morgan Hall (pl. 174) and Samuel Murray (pl. 173). Both have strongly modeled heads, with the structures of face, neck, and shoulders clearly marked. Their overall mood varies, however, as if they were exercises in character ranging from poetic reverie to barely contained anger. Eakins made these works for the pleasure of the activity—he apparently initiated the sittings and presented the paintings to the models or their families as gifts of mentorship and friendliness. The portrait of Hall (1867–1912) is the more dynamic, with pursed lips and red-rimmed eyes countered by a confident, dynamic pose. The costume

Murray (1869–1941) wears, especially his flamboyant tie, lends the work a bohemian air initially at odds with his serious expression. When Murray's portrait was exhibited at the Pennsylvania Academy of the Fine Arts in 1891, Eakins whimsically titled it *Portrait of a Student*, although Murray—whose talents ran to sculpture—had by 1889 become Eakins's studio assistant and in 1890 was an instructor at the Philadelphia School of Design for Women (now Moore College of Art and Design). He and Eakins remained close friends and collaborators throughout the rest of the painter's life.[158]

The decade of the 1880s ended on an ambitious note. In the spring of 1889, students from the University of Pennsylvania's School of Medicine commissioned Eakins to make a portrait of the retiring professor of surgery Dr. D. Hayes Agnew (1818–1892). They offered the painter seven hundred and fifty dollars to portray their teacher, who was acclaimed to be, as the Latin motto that Eakins carved on the finished work's frame asserted, "the most experienced surgeon, the clearest writer and teacher, the most venerated and beloved man."[159] Eakins, accepting the project, countered their proposal with one of his own: "delighted to paint Dr. Agnew, [he] immediately offered to paint them, for the same sum, a clinic picture, with not only Dr. Agnew and his assistant physicians, but also portraits of the class."[160] The resulting work, *The Agnew Clinic* (pl. 175), thus turned into an echo of *The Gross Clinic* of fourteen years earlier.[161]

But Eakins did not reiterate the format of the earlier picture. Working now on a broad horizontal canvas—the largest of his career—he placed his focal points across the foreground, Agnew isolated on the left, the nearly completed operation for breast cancer on the right. The scene's architecture and the collective weight of the auditors' faces—added to the white clothing of the doctors (principles of antisepsis had begun to take hold in American operating rooms)—invariably focus attention on the foreground. The balance between Agnew's illuminated, rhetorical pose and the larger and more complex operation (where only the nurse's placid face, her presence another sign of modernization, is in the light) is evenly struck.

Eakins more distinctly limned the auditors, too, bringing them closer to the picture plane and lavishing care on their individual features. They are all—barring the figure of Eakins himself at the far right, which was painted by Susan Eakins[162]—identifiable as Agnew's students and collaborators.[163] The postures and attitudes of the listeners vary from studious attention to extreme casualness. This specificity enlivens what could otherwise have become a sea of regularly spaced, dark-suited bodies differentiated only by mustaches and hair partings.[164]

The painting was done quickly. The principal figure, Agnew, would appear in Eakins's studio claiming, "I can give you just one hour," but he reportedly stayed longer and came often.[165] The others followed suit. Eakins worked on the picture throughout full days and evenings, sometimes falling asleep on the studio floor (the canvas was too large to fit on his easel, so he sat on the floor to work on the lower, most important sections). It was ready for presentation at the commencement exercises of May 1, 1889.

In late 1890, preparing for the annual exhibition at the Pennsylvania Academy of the Fine Arts scheduled to open on January 29, 1891, the Jury and Hanging Committee asked Eakins to contribute six works to the show, including *Walt Whitman, Letitia Wilson Jordan, Samuel Murray,* and *The Agnew Clinic*. He did so. This was the first official contact between the institution and the painter since his forced resignation of 1886. Then on January 20, 1891, the directors' Committee on Exhibitions asked that *The Agnew Clinic* not be hung. Eakins was given various bureaucratic reasons for the decision, prompting him to recall—and write down on his copy of his letter to the Academy—an extended passage concerning lies and animadversions from Rabelais's *Pantagruel*.[166] Susan Eakins later wrote that "The directors gave privately other reasons for not wishing to hang the picture. Some thought the picture not cheerful for ladies to look at."[167]

Insult was added to injury when the Society of American Artists rejected all but one of Eakins's submissions for 1890, 1891, and 1892, one of which was *The Agnew Clinic*. The artist wrote on May 7, 1892:

> Gentlemen: I desire to sever all connection with the Society of American Artists....
>
> For the last three years my paintings have been rejected by you, one of them the Agnew portrait, a composition more important than any I have ever seen upon your walls.
>
> Rejections for three years eliminates all elements of chance; and while in my opinion there are qualities in my work which entitle it to rank with the best in your society, your society's opinion must be that it ranks below much that I consider frivolous and superficial. These opinions are irreconcilable.[168]

The Agnew Clinic was first widely seen only in the exhibition of American works shown at the Chicago World's Columbian Exhibition in 1893, as well as at an anticipatory exhibition of the relevant works at the Pennsylvania Academy.[169] One Boston critic noted the presence of the work, as well as that of *The Gross Clinic*, at the Philadelphia show, calling them "strong, well-drawn works of art" and "good examples of a wonderful power of managing color and position." He concluded: "It is said that these pictures were refused by committees at Philadelphia.... But judging from their now being on the line, there has come from the good men of Philadelphia a change of

heart."[170] This was overly optimistic, for the works were not welcomed by the local press. "The advisability of including his portraits of Dr. Agnew and Dr. Gross, which are merely excuses for depicting the horrors of the dissecting table, will be severely questioned. While the portraits and the technique of a difficult composition are really excellent, the surroundings and accessories are scarcely in good taste for a public exhibition."[171] Even in Chicago they generated intense criticism. Montague Marks, frequently a hostile critic, could not contain himself when faced with Eakins's "hospital class of picture": "it is impossible to escape from Mr. Eakins's ghastly symphonies in gore and bitumen. Delicate or sensitive women or children suddenly confronted by the portrayal of these clinical horrors might receive a shock from which they would never recover. To have hung the pictures at all was questionable judgment. To have hung them where they are is most reprehensible."[172] Eakins's most ambitious subject pictures continued to irritate or puzzle many of the era's viewers.

At the end of the 1880s, the forty-five-year-old artist could look back over an eventful decade of joy and trauma. Two of his three sisters had died, one as his best friend, the other unreconciled to him. He had married and established his own household but returned to the family home two years later. He had explored new subjects and processes, making some of the era's most notable American paintings. After 1887, however, he focused almost exclusively on portraiture, directly and simply painted, circling back to reconsider in *The Agnew Clinic* his previously most controversial theme. From the acme of professional recognition—head of his city's art academy, recipient of lucrative commissions, and colleague with the University of Pennsylvania's ablest researchers into motion photography—he had fallen, suffering calumny and ostracization; yet in that moment his students created a new school for him. Through these many changes, he persevered in and through his art.

Eakins in the 1880s

Plate 52. Circle of Thomas Eakins (attributed to Susan Hannah Macdowell), *[Thomas Eakins at About Age Thirty-Five]*, 1880.
Albumen print, 4½ x 3¼ inches.
Bryn Mawr College Library, Pennsylvania. Seymour Adelman Collection (Special Collections SA 4).
See also list of Works Not Illustrated

Plate 53. Thomas Eakins, *Anatomical Casts*, 1880 (cast 1930).
Bronze. *Right Shoulder, Arm, and Hand*, length 27½ inches; *Back of Male Torso*, length 30¼ inches; *Right Thigh, Leg, and Foot*, length 39 inches.
Philadelphia Museum of Art. Gift of R. Sturgis Ingersoll, 1944.

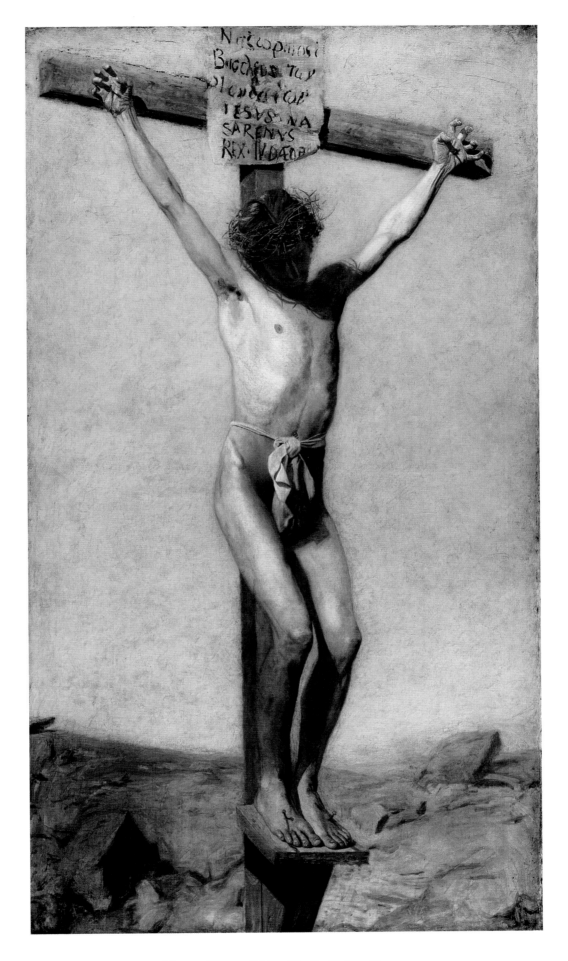

Plate 54. Thomas Eakins, *The Crucifixion*, 1880.
Oil on canvas, 96 x 54 inches.
Philadelphia Museum of Art. Gift of Mrs. Thomas Eakins and Miss Mary Adeline Williams, 1929.

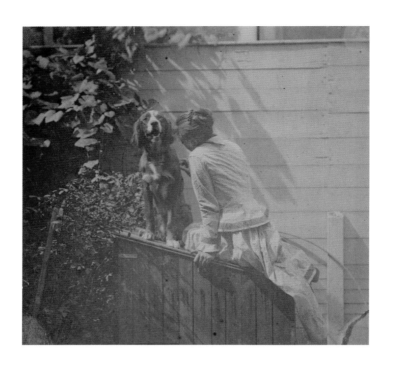

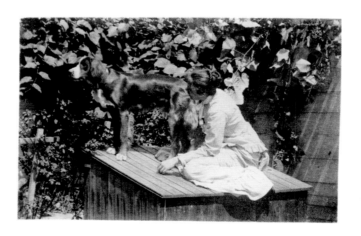

Plate 55. Thomas Eakins, *[Margaret Eakins and Harry]*, c. 1881.
Albumen print, 3⁵⁄₁₆ x 3⅝ inches.
Bryn Mawr College Library, Pennsylvania. Seymour Adelman Collection (Special Collections SA 63).

Plate 56. Thomas Eakins, *[Margaret Eakins and Harry]*, c. 1881.
Platinum print, 2³⁄₁₆ x 3⅜ inches.
Collection of Daniel W. Dietrich II.

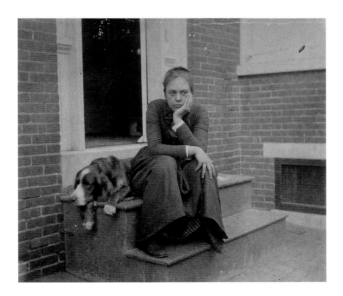

Plate 57. Attributed to Thomas Eakins, *[William J. Crowell and His Daughter Ella]*, 1880.
Albumen print, 3¾ x 2¹³⁄₁₆ inches.
The Metropolitan Museum of Art, New York. Gift of Harry D. Nelson, Jr., 1985 (1985.1027.24).

Plate 58. Thomas Eakins, *[Margaret Eakins and Harry]*, c. 1881.
Albumen print, 2¹³⁄₁₆ x 3¼ inches.
Pennsylvania Academy of the Fine Arts, Philadelphia. Charles Bregler's Thomas Eakins Collection,
purchased with the partial support of the Pew Memorial Trust (1985.68.2.75).

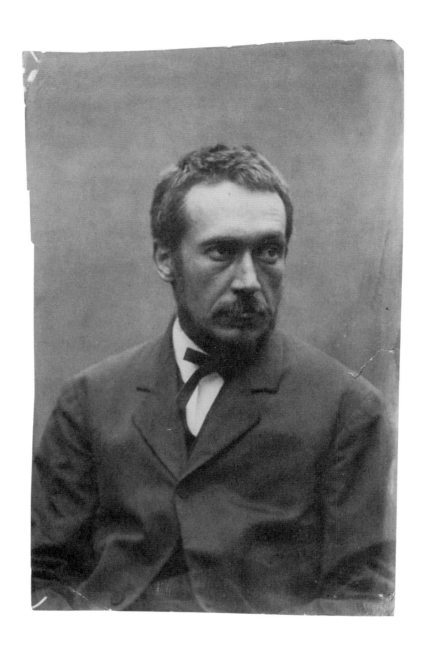

Plate 59. Circle of Thomas Eakins, *[Thomas Eakins at Age Thirty-Five to Forty]*, 1879–84.
Platinum print, 6³⁄₁₆ x 3¹⁵⁄₁₆ inches.
Gilman Paper Company (83.921).

Plate 60. Thomas Eakins, *[Margaret Eakins and Friends at Manasquan, New Jersey]*, c. 1880.
Digital inkjet print from original gelatin dry-plate negative, 4 x 5 inches (1985.68.2.859).
Plate 61. Thomas Eakins, *[Margaret Eakins and Elizabeth Macdowell at Manasquan, New Jersey]*, c. 1880.
Digital inkjet print from original gelatin dry-plate negative, 5 x 4 inches (1985.68.2.856).
Pennsylvania Academy of the Fine Arts, Philadelphia. Charles Bregler's Thomas Eakins Collection,
purchased with the partial support of the Pew Memorial Trust.

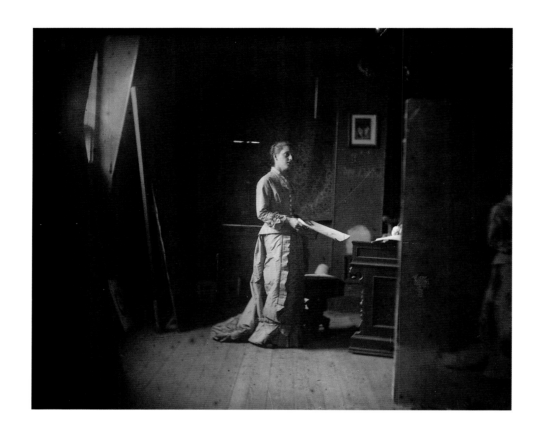

Plate 62. Thomas Eakins, *[Margaret Harrison Posing for "Singing a Pathetic Song"]*, 1881.
Digital inkjet print from original gelatin dry-plate negative, 4 x 5 inches.
Pennsylvania Academy of the Fine Arts, Philadelphia. Charles Bregler's Thomas Eakins Collection,
purchased with the partial support of the Pew Memorial Trust (1985.68.2.867).

Plate 63. Thomas Eakins, *Singing a Pathetic Song*, 1881.
Oil on canvas, 45 x 32½ inches.
The Corcoran Gallery of Art, Washington, D.C. Museum Purchase, Gallery Fund.

Plate 64. Thomas Eakins, *[Elizabeth Macdowell in an Empire Dress]*, 1881.
Albumen print, 3⅝ x 4⁷⁄₁₆ inches.
Hirshhorn Museum and Sculpture Garden, Smithsonian Institution, Washington, D.C.
Transferred from Hirshhorn Museum and Sculpture Garden Archives, 1983 (83.10).

Plate 65. Thomas Eakins, *[Elizabeth Macdowell and Susan Macdowell in Empire Dresses]*, 1881.
Albumen print, 7⁵⁄₁₆ x 5¾ inches.
Bryn Mawr College Library, Pennsylvania. Seymour Adelman Collection (Special Collections SA 96).

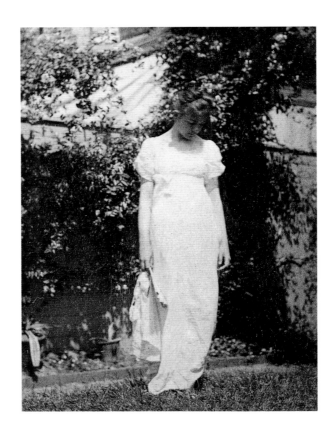

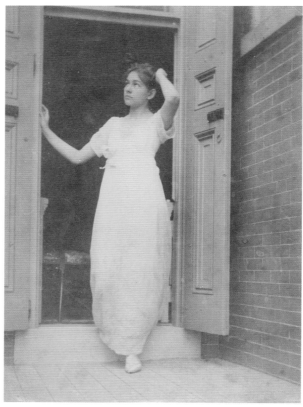

Plate 66. Thomas Eakins, *[Caroline Eakins in an Empire Dress]*, 1881.
Albumen print, 4³⁄₁₆ x 3³⁄₁₆ inches.
The J. Paul Getty Museum, Los Angeles (84.XM.201.26).

Plate 67. Thomas Eakins, *[Caroline Eakins in an Empire Dress]*, 1881.
Albumen print, 6¼ x 4⅝ inches.
Philadelphia Museum of Art. Purchased with funds contributed by the Daniel W. Dietrich Foundation,
the J. J. Medveckis Foundation, and Harvey S. Shipley Miller and J. Randall Plummer (1999-138-1).

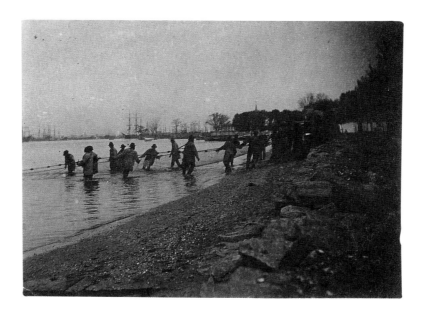

Plate 68. Thomas Eakins, *[Sailboats on the New Jersey Shore]*, c. 1881.
Albumen print, 3³⁄₁₆ x 3⁷⁄₈ inches.
Philadelphia Museum of Art. Gift of Seymour Adelman (1968-203-4).

Plate 69. Thomas Eakins, *[Shad Fishermen Hauling the Net at Gloucester, New Jersey]*, 1881–82.
Cyanotype, 2⁷⁄₈ x 3⁷⁄₈ inches.
Philadelphia Museum of Art. Purchase, Lola Downin Peck Fund (1991-64-1).

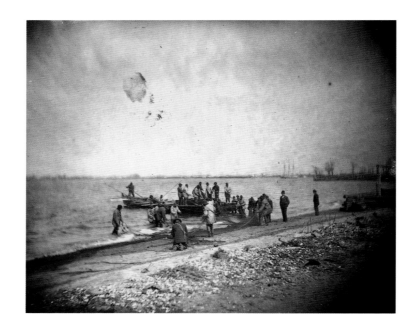

Plate 70. Thomas Eakins, *[Shoreline of the Delaware River at Gloucester, New Jersey]*, 1881.
Digital inkjet print from original gelatin dry-plate negative, 4 x 5 inches (1985.68.2.926).
Plate 71. Thomas Eakins, *[Shad Fishermen Setting the Net at Gloucester, New Jersey]*, 1881.
Digital inkjet print from original gelatin dry-plate negative, 4 x 5 inches (1985.68.2.887).
Pennsylvania Academy of the Fine Arts, Philadelphia. Charles Bregler's Thomas Eakins Collection,
purchased with the partial support of the Pew Memorial Trust.

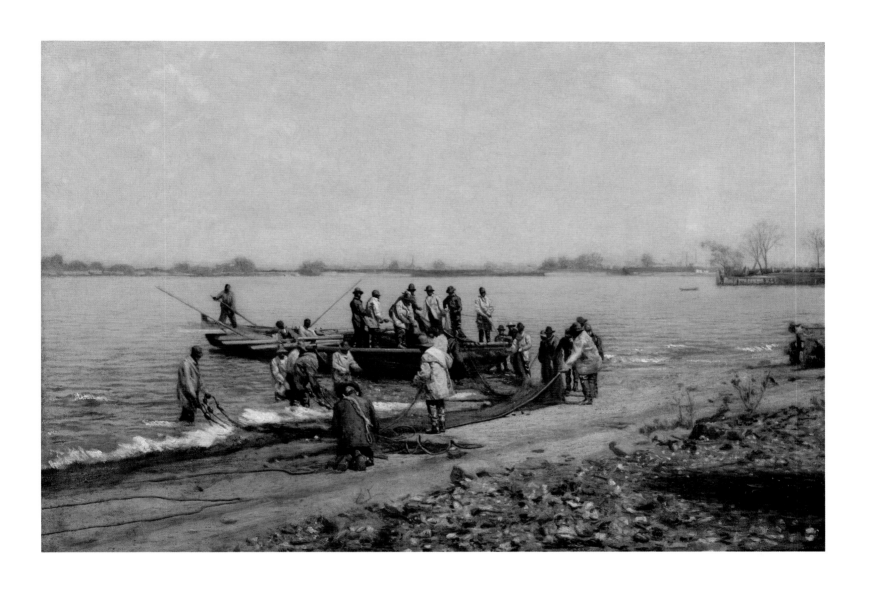

Plate 72. Thomas Eakins, *Shad Fishing at Gloucester on the Delaware River*, 1881.
Oil on canvas, 12 x 18¼ inches.
Ball State University Museum of Art, Muncie, Indiana. Elisabeth Ball Collection,
partial gift and promised gift of the George and Frances Ball Foundation.

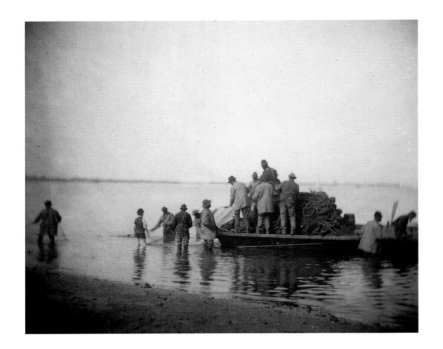

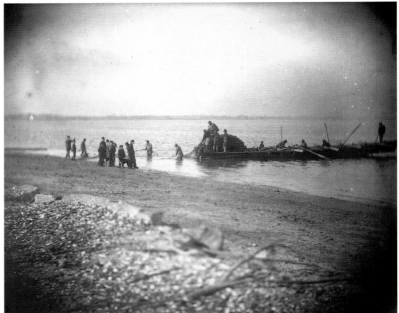

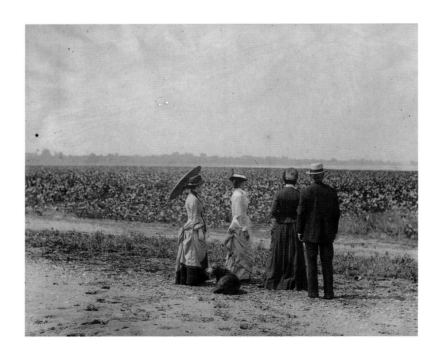

Plate 73. Thomas Eakins, *[Shad Fishermen Setting the Net at Gloucester, New Jersey]*, 1881.
Digital inkjet print from original gelatin dry-plate negative, 4 x 5 inches (1985.68.2.888).
Plate 74. Thomas Eakins, *[Shad Fishermen Setting the Net at Gloucester, New Jersey]*, 1881.
Digital inkjet print from original gelatin dry-plate negative, 4 x 5 inches (1985.68.2.886).
Plate 75. Thomas Eakins, *[Eakins Family and Harry at Gloucester, New Jersey]*, 1881.
Digital inkjet print from original gelatin dry-plate negative, 4 x 5 inches (1985.68.2.923).
Pennsylvania Academy of the Fine Arts, Philadelphia. Charles Bregler's Thomas Eakins Collection,
purchased with the partial support of the Pew Memorial Trust.

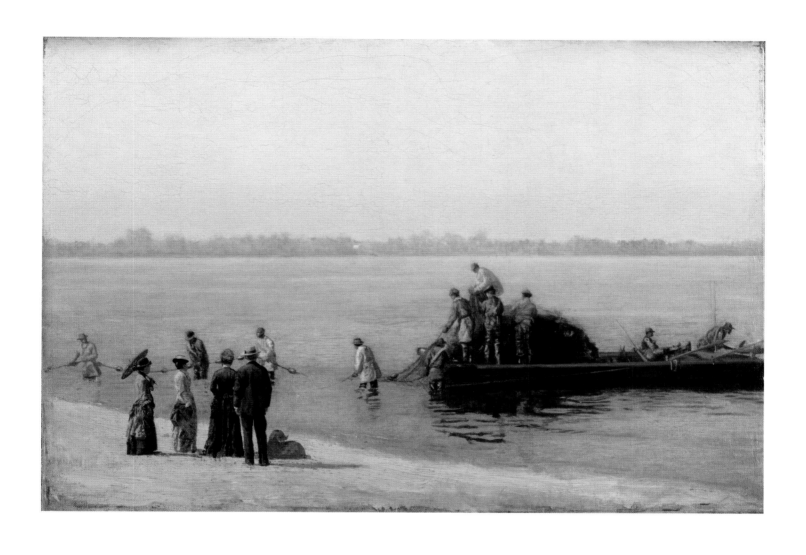

Plate 76. Thomas Eakins, *Shad Fishing at Gloucester on the Delaware River*, 1881.
Oil on canvas, 12⅛ x 18⅛ inches.
Philadelphia Museum of Art. Gift of Mrs. Thomas Eakins and Miss Mary Adeline Williams, 1929.

Plate 77. Thomas Eakins, *[Three Fishermen Mending Nets at Gloucester, New Jersey]*, 1881.
Digital inkjet print from original gelatin dry-plate negative, 4 x 5 inches.
Pennsylvania Academy of the Fine Arts, Philadelphia. Charles Bregler's Thomas Eakins Collection,
purchased with the partial support of the Pew Memorial Trust (1985.68.2.910).

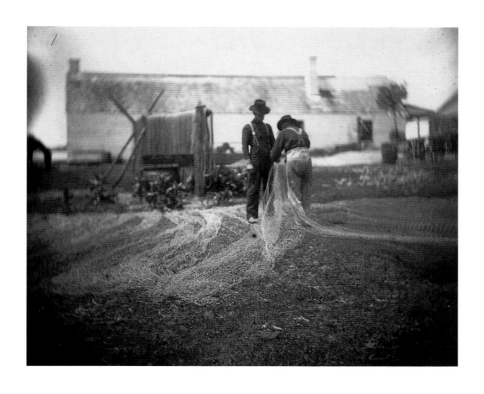

Plate 78. Thomas Eakins, *[Two Fishermen Mending Nets at Gloucester, New Jersey]*, 1881.
Digital inkjet print from original gelatin dry-plate negative, 4 x 5 inches.
Pennsylvania Academy of the Fine Arts, Philadelphia. Charles Bregler's Thomas Eakins Collection,
purchased with the partial support of the Pew Memorial Trust (1985.68.2.918).

Plates 79. Thomas Eakins, *[Geese at Gloucester, New Jersey]*, 1881.
Digital inkjet print from original gelatin dry-plate negative, 4 x 5 inches (1985.68.2.948).
Plate 80. Thomas Eakins, *[Geese at Gloucester, New Jersey]*, 1881.
Digital inkjet print from original gelatin dry-plate negative, 4 x 5 inches (1985.68.2.947).
Pennsylvania Academy of the Fine Arts, Philadelphia. Charles Bregler's Thomas Eakins Collection,
purchased with the partial support of the Pew Memorial Trust.

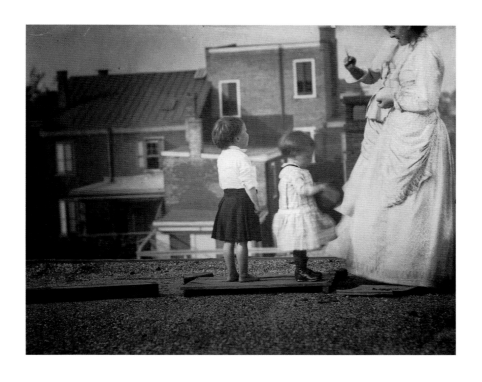

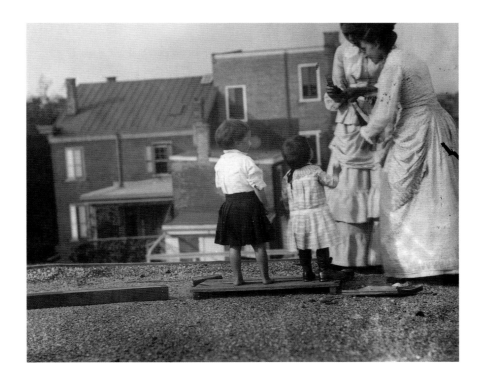

Plate 81. Thomas Eakins, *[Two Crowell Children, Frances Crowell, and Margaret Eakins on a Rooftop]*, 1881.
Digital inkjet print from original gelatin dry-plate negative, 4 x 5 inches (1985.68.2.864).
Plate 82. Thomas Eakins, *[Two Crowell Children, Margaret Eakins, and Frances Crowell on a Rooftop]*, 1881.
Digital inkjet print from original gelatin dry-plate negative, 4 x 5 inches (1985.68.2.863).
Pennsylvania Academy of the Fine Arts, Philadelphia. Charles Bregler's Thomas Eakins Collection,
purchased with the partial support of the Pew Memorial Trust.

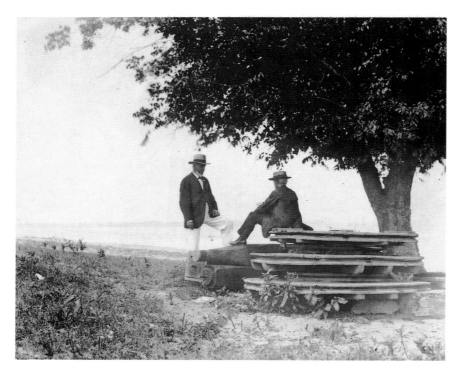

Plate 83. Thomas Eakins, *[Tree and Capstan at Gloucester, New Jersey]*, 1881.
Digital inkjet print from original gelatin dry-plate negative, 5 x 4 inches (1985.68.2.966).
Plate 84. Thomas Eakins, *[Two Men Under a Tree at Gloucester, New Jersey]*, 1881.
Digital inkjet print from original gelatin dry-plate negative, 4 x 5 inches (1985.68.2.924).
Pennsylvania Academy of the Fine Arts, Philadelphia. Charles Bregler's Thomas Eakins Collection,
purchased with the partial support of the Pew Memorial Trust.

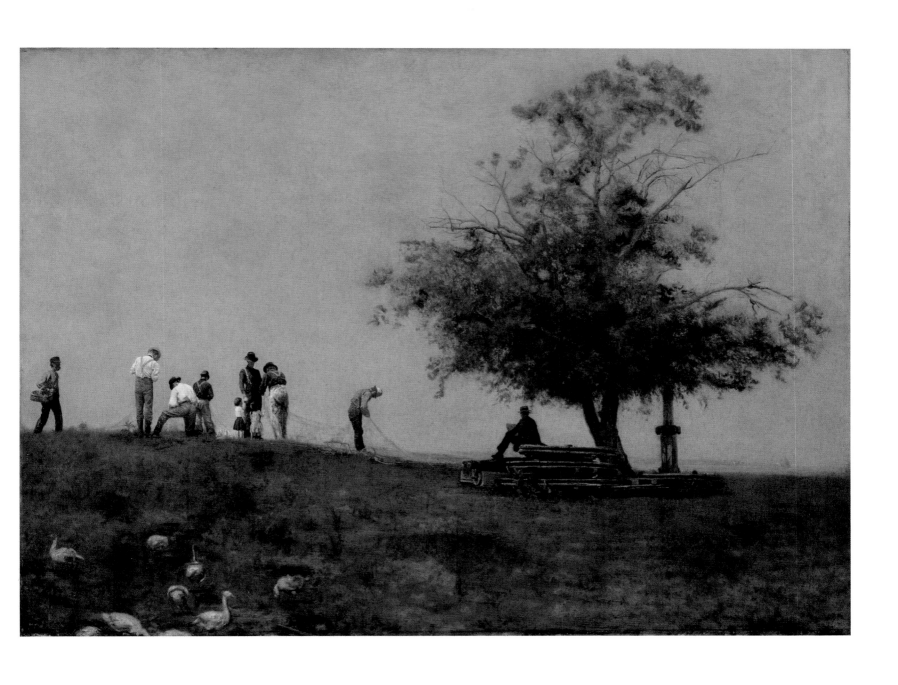

Plate 85. Thomas Eakins, *Mending the Net*, 1881.
Oil on canvas, 32⅛ x 45⅛ inches.
Philadelphia Museum of Art. Gift of Mrs. Thomas Eakins and Miss Mary Adeline Williams, 1929.

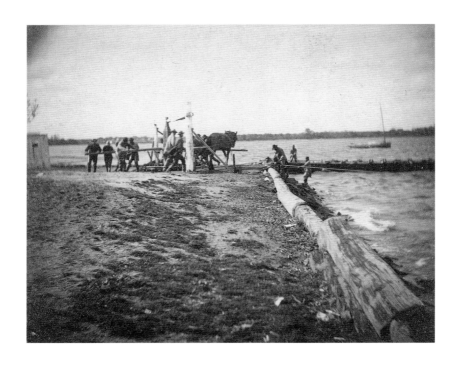

Plate 86. Thomas Eakins, *[Shad Fishermen Hauling the Net with a Capstan at Gloucester, New Jersey]*, 1881–82.
Albumen print, 3⅜ x 4⁵⁄₁₆ inches.
Collection of John J. Medveckis.

Plate 87. Thomas Eakins, *Drawing the Seine*, 1882.
Watercolor on paper, 11¼ x 16½ inches.
Philadelphia Museum of Art. John G. Johnson Collection, 1917.

Plate 88. Thomas Eakins, *The Meadows, Gloucester*, 1882–83.
Oil on canvas, 31¹⁵⁄₁₆ x 45⅛ inches.
Philadelphia Museum of Art. Gift of Mrs. Thomas Eakins and Miss Mary Adeline Williams, 1929.

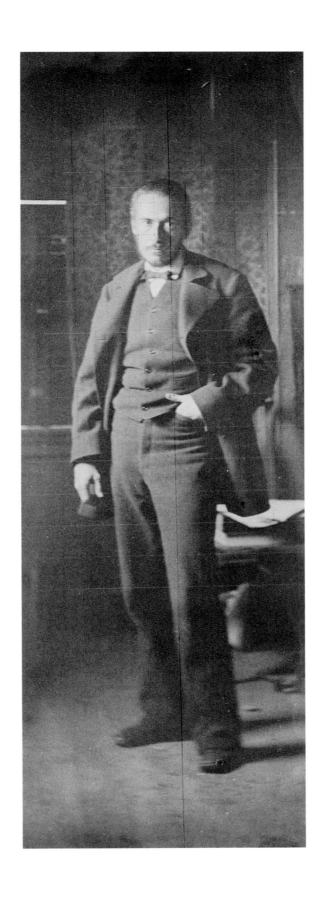

Plate 89. Circle of Thomas Eakins, *[Thomas Eakins at About Age Forty]*, 1880s.
Albumen print, 8¼ x 3 inches.
Thomas Eakins Research Collection, Philadelphia Museum of Art. Gift of Mrs. Elizabeth M. Howarth, 1984.

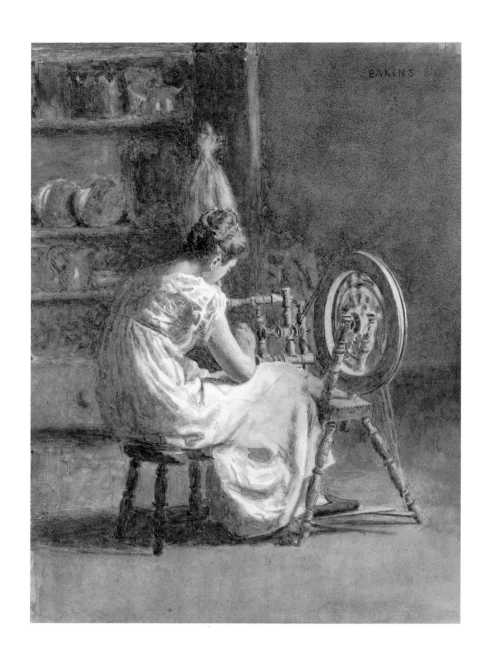

Plate 90. Thomas Eakins, *Homespun*, 1881.
Watercolor on paper, 13⅞ x 10¾ inches.
The Metropolitan Museum of Art, New York. Fletcher Fund, 1925.

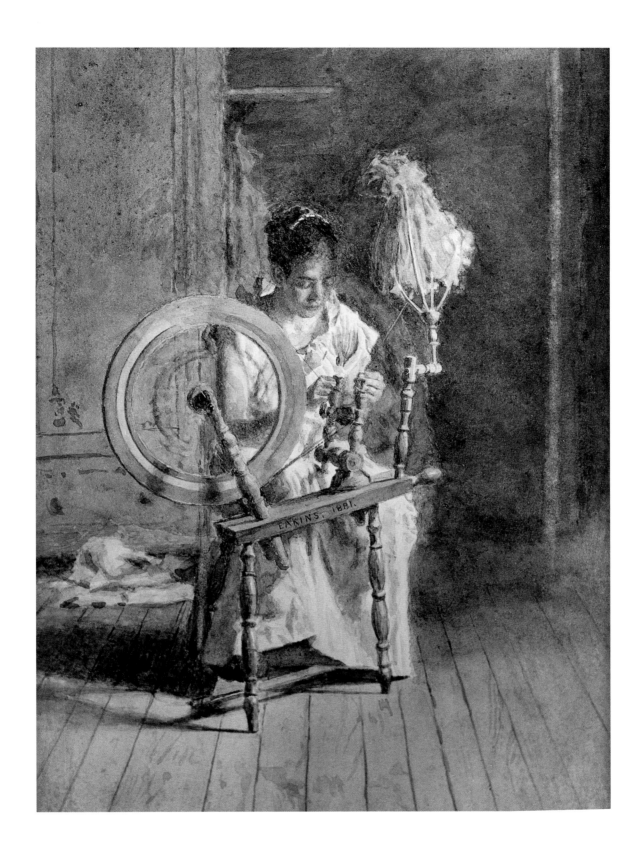

Plate 91. Thomas Eakins, *Spinning*, 1881.
Watercolor on paper, 15⅝ x 10⅝ inches.
Private Collection.

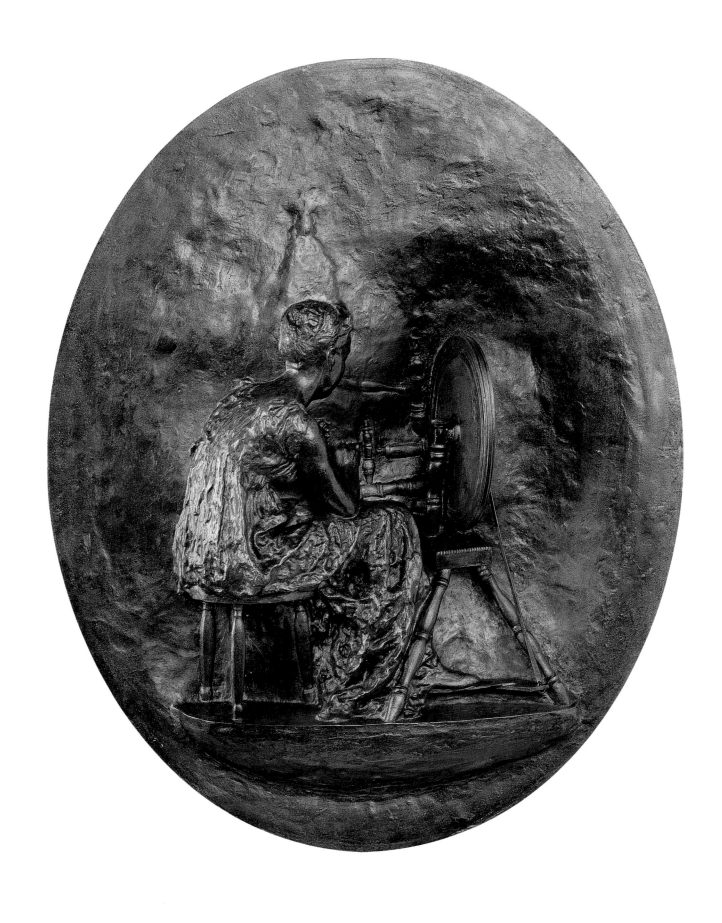

Plate 92. Thomas Eakins, *Spinning*, 1882–83.
Sand-cast bronze, 18¼ x 14¹¹⁄₁₆ x 2¹¹⁄₁₆ inches.
Philadelphia Museum of Art. Gift of Charlene Sussel in memory of her husband, Eugene Sussel, 1992.

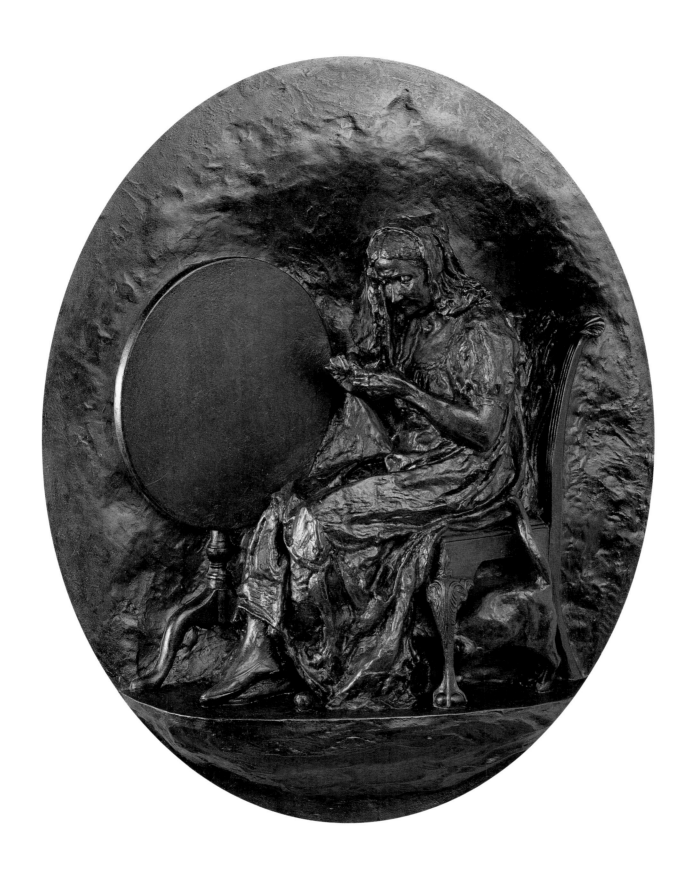

Plate 93. Thomas Eakins, *Knitting*, 1882–83.
Sand-cast bronze, 18⁷⁄₁₆ x 14¾ x 3½ inches.
Philadelphia Museum of Art. Gift of Charlene Sussel in memory of her husband, Eugene Sussel, 1992.

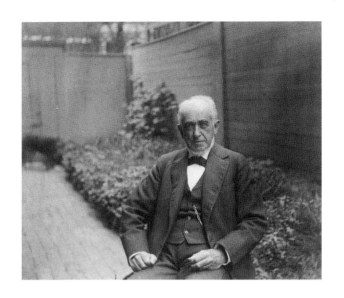

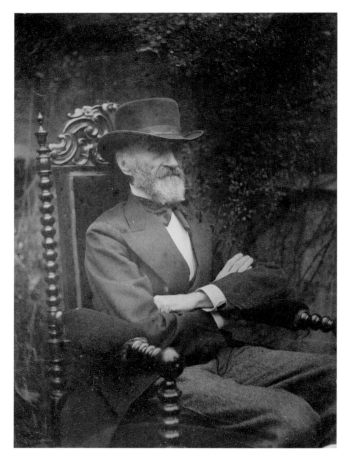

Plate 94. Thomas Eakins, *[Benjamin Eakins]*, 1880s.
Platinum print, 2⅝ x 3⅛ inches.
Collection of Daniel W. Dietrich II.

Plate 95. Thomas Eakins, *[George W. Holmes]*, 1880s.
Albumen print, 4⁹⁄₁₆ x 3⅜ inches.
Philadelphia Museum of Art. Gift of Theodore T. Newbold (1985-60-1).
See also list of Works Not Illustrated

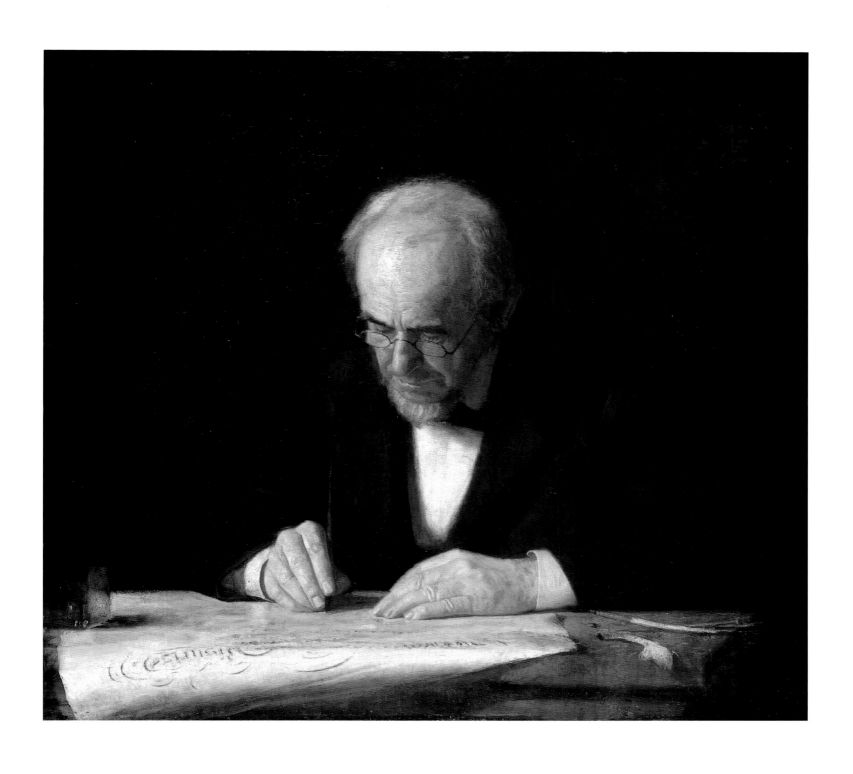

Plate 96. Thomas Eakins, *The Writing Master (Portrait of Benjamin Eakins)*, 1882.
Oil on canvas, 30 x 34¼ inches.
The Metropolitan Museum of Art, New York. John Stewart Kennedy Fund, 1917.

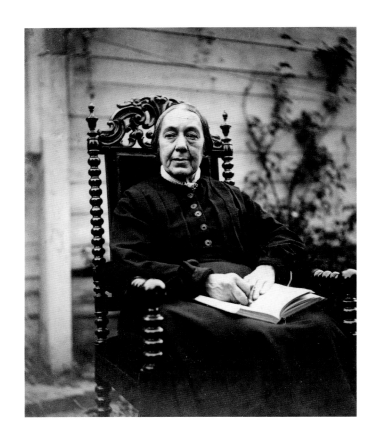

Plate 97. Thomas Eakins, *[Eliza Cowperthwait]*, 1880s.
Albumen print, 4¼ x 3⁹⁄₁₆ inches.
The J. Paul Getty Museum, Los Angeles (86.XM.756.3).

Plate 98. Thomas Eakins, *[Eliza Cowperthwait]*, 1880s.
Albumen print, 4⁷⁄₁₆ x 3½ inches.
Private Collection.

Plate 99. Circle of Thomas Eakins (attributed to Susan Hannah Macdowell), *[Susan Hannah Macdowell]*, early 1880s.
Cyanotype, 3⅜ x 2¾ inches.
Bryn Mawr College Library, Pennsylvania. Seymour Adelman Collection (Special Collections SA 27).

Plate 100. Thomas Eakins, *[Susan Hannah Macdowell]*, 1880s.
Albumen print, 4³⁄₁₆ x 3¹⁄₁₆ inches.
Collection of Daniel W. Dietrich II.

Plate 101. Circle of Thomas Eakins (attributed to Elizabeth Macdowell),
[Hannah Trimble Gardner Macdowell (Mrs. William H. Macdowell)], 1880s.
Platinum print, 6⅜ x 6 inches.
Hirshhorn Museum and Sculpture Garden, Smithsonian Institution, Washington, D.C.
Transferred from Hirshhorn Museum and Sculpture Garden Archives, 1983 (83.13).

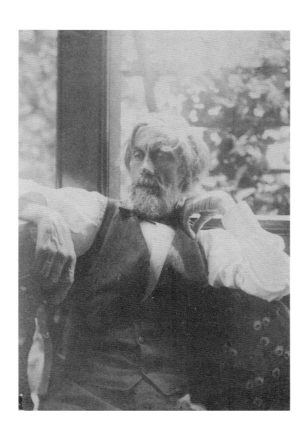

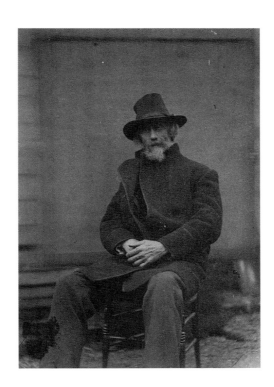

Plate 102. Thomas Eakins, *[William H. Macdowell]*, 1880s.
Albumen print, 3¹⁵⁄₁₆ x 2¾ inches.
The J. Paul Getty Museum, Los Angeles (84.XM.155.7).

Plate 103. Thomas Eakins, *[William H. Macdowell]*, 1880s.
Platinum print, 3⁹⁄₁₆ x 2½ inches.
Amon Carter Museum, Fort Worth, Texas (P1981.90).

Plate 104. Attributed to Thomas Eakins, *[Cat]*, 1880s.
Platinum print, 4¾ x 2⅝ inches.
Hirshhorn Museum and Sculpture Garden, Smithsonian Institution, Washington, D.C.
Transferred from Hirshhorn Museum and Sculpture Garden Archives, 1983 (83.66).

Plate 105. Thomas Eakins, *[Setter]*, 1880s.
Platinum print, 2⁹⁄₁₆ x 6⁵⁄₁₆ inches.
Pennsylvania Academy of the Fine Arts, Philadelphia. Charles Bregler's Thomas Eakins Collection,
purchased with the partial support of the Pew Memorial Trust (1985.68.2.271).

Plate 106. Thomas Eakins, *[Beech Tree at Avondale, Pennsylvania]*, early 1880s.
Albumen print, 8½ x 6⁹⁄₁₆ inches.
The J. Paul Getty Museum, Los Angeles (84.XM.201.19).

Plate 107. Thomas Eakins, *[Susan Macdowell and Crowell Children at Avondale, Pennsylvania]*, 1883.
Printing-out paper print, 3¹¹⁄₁₆ x 4⅝ inches.
Pennsylvania Academy of the Fine Arts, Philadelphia. Charles Bregler's Thomas Eakins Collection,
purchased with the partial support of the Pew Memorial Trust (1985.68.2.325).

Plate 108. Thomas Eakins, *[Crowell Family at Avondale, Pennsylvania]*, 1883.
Albumen print, 3½ x 4⁷⁄₁₆ inches.
The Metropolitan Museum of Art, New York. Gift of Robert D. English, 1985 (85.1027.43).

Plate 109. Thomas Eakins, *[Crowell Family at Avondale, Pennsylvania]*, 1883.
Albumen print, 3⁷⁄₁₆ x 4⅜ inches.
The Metropolitan Museum of Art, New York. Gift of Joseph R. Lasser and Ruth P. Lasser, 1985 (85.1027.42).

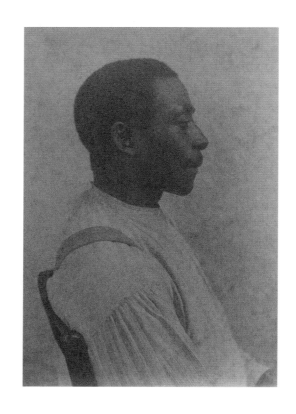

Plate 110. Thomas Eakins, *[Black Man]*, 1880s.
Printing-out paper print, 3¹³⁄₁₆ x 2¹¹⁄₁₆ inches.
Gilman Paper Company (82.774).

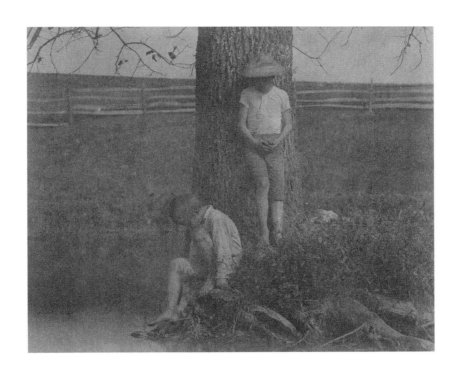

Plate 111. Thomas Eakins, *[Crowell Children at Avondale, Pennsylvania]*, 1885–90.
Platinum print, 3½ x 4⅜ inches.
Collection of John J. Medveckis.

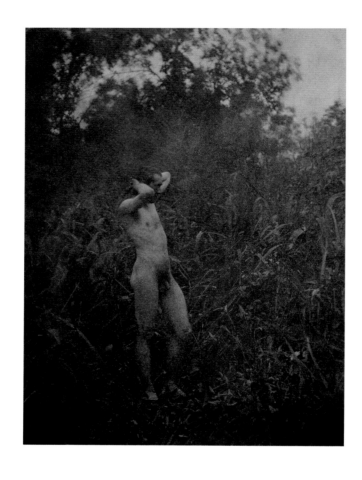

Plate 112. Circle of Thomas Eakins, *[Thomas Eakins, Nude]*, c. 1883.
Platinum print, 4⁵⁄₁₆ x 3⅜ inches (1985.68.2.464).
Pennsylvania Academy of the Fine Arts, Philadelphia. Charles Bregler's Thomas Eakins Collection,
purchased with the partial support of the Pew Memorial Trust.
See also list of Works Not Illustrated

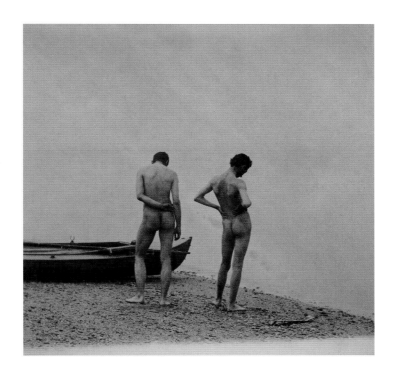

Plate 113. Circle of Thomas Eakins (attributed to Thomas Pollock Anshutz),
[Thomas Eakins and John Laurie Wallace, Nude], c. 1883.
Albumen print, 3½ x 4 inches (1985.68.2.454).
Pennsylvania Academy of the Fine Arts, Philadelphia. Charles Bregler's Thomas Eakins Collection,
purchased with the partial support of the Pew Memorial Trust.
See also list of Works Not Illustrated

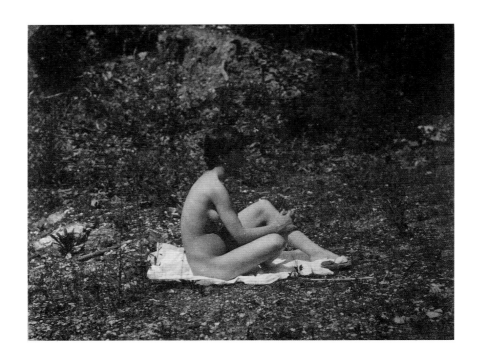

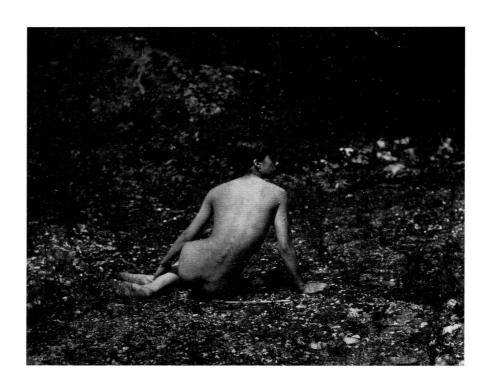

Plate 114. Thomas Eakins, *[Susan Macdowell, Nude]*, c. 1883.
Platinum print, 3⅜ x 4⅜ inches (1985.68.2.541).
Plate 115. Thomas Eakins, *[Susan Macdowell, Nude]*, c. 1883.
Cyanotype, 3½ x 4⁷⁄₁₆ inches (1985.68.2.544).
Pennsylvania Academy of the Fine Arts, Philadelphia. Charles Bregler's Thomas Eakins Collection,
purchased with the partial support of the Pew Memorial Trust.

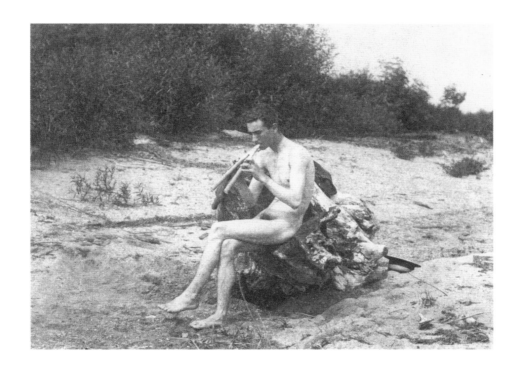

Plate 116. Thomas Eakins, *[John Laurie Wallace, Nude, Playing Pipes]*, c. 1883.
Platinum print, 3¼ x 4⅞ inches.
Philadelphia Museum of Art. Bequest of Mark Lutz (1969-194-25).

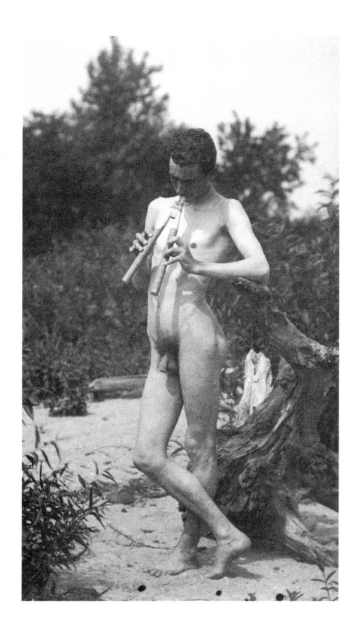

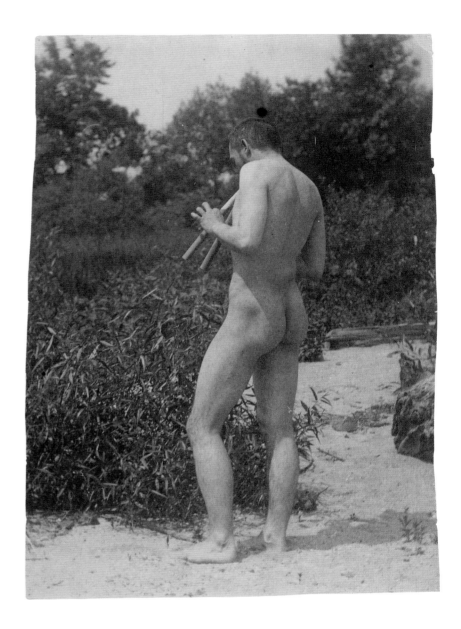

Plate 117. Thomas Eakins, *[John Laurie Wallace, Nude, Playing Pipes]*, c. 1883.
Platinum print, 6½ x 3¾ inches.
Hirshhorn Museum and Sculpture Garden, Smithsonian Institution, Washington, D.C.
Transferred from Hirshhorn Museum and Sculpture Garden Archives, 1983 (83.24).
See also list of Works Not Illustrated

Plate 118. Circle of Thomas Eakins, *[Thomas Eakins, Nude, Playing Pipes]*, c. 1883.
Platinum print, 8¹⁵⁄₁₆ x 6⁹⁄₁₆ inches.
The Metropolitan Museum of Art, New York. David Hunter McAlpin Fund, 1943 (43.87.22).

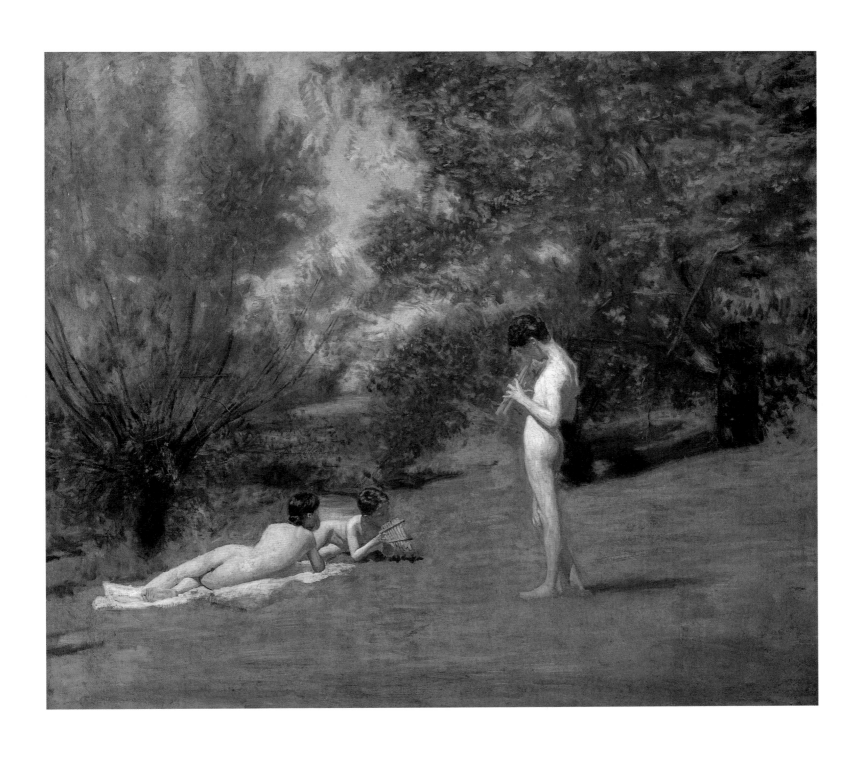

Plate 119. Thomas Eakins, *Arcadia*, c. 1883.
Oil on canvas, 38⅝ x 45 inches.
The Metropolitan Museum of Art, New York. Bequest of Miss Adelaide Milton de Groot (1876–1967), 1967.

Plate 120. Thomas Eakins, *Pastoral*, 1883–84.
Plaster with transparent brown patina, 11¾ x 24 x 2³⁄₁₆ inches.
Philadelphia Museum of Art. Purchased with the J. Stogdell Stokes Fund, 1975.

Plate 121. Thomas Eakins, *Professionals at Rehearsal*, 1883.
Oil on canvas, 16 x 12 inches.
Philadelphia Museum of Art. The John D. McIlhenny Collection, 1943.

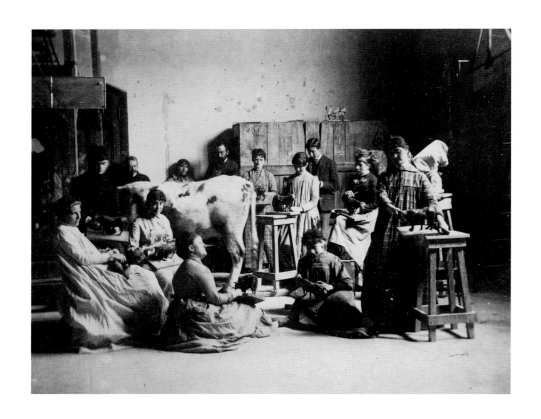

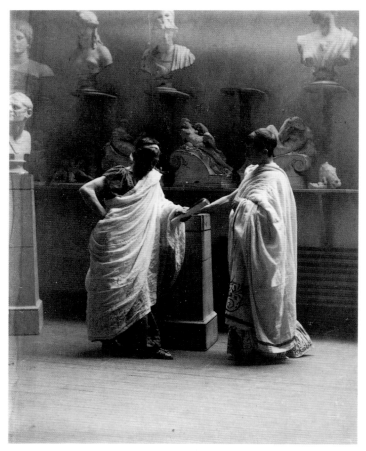

Plate 122. Circle of Thomas Eakins, *[Women's Modeling Class at the Pennsylvania Academy of the Fine Arts]*, c. 1882.
Albumen print, 3¹¹⁄₁₆ x 4¹⁵⁄₁₆ inches (1985.68.2.801).
Pennsylvania Academy of the Fine Arts, Philadelphia. Charles Bregler's Thomas Eakins Collection, purchased with the partial support of the Pew Memorial Trust.

Plate 123. Circle of Thomas Eakins, *[Two Male Students in Classical Costume at the
Pennsylvania Academy of the Fine Arts]*, c. 1883.
Albumen print, 5⅛ x 4⅛ inches.
The J. Paul Getty Museum, Los Angeles (85.XP.34.16).

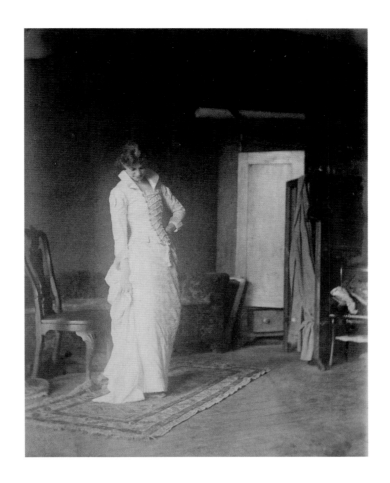

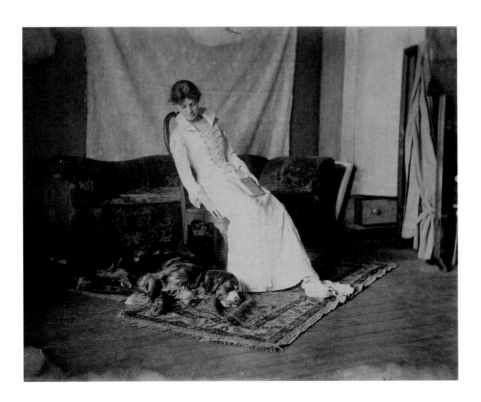

Plate 124. Thomas Eakins, *[Woman in a Laced-Bodice Dress in Eakins's Studio]*, c. 1883.
Albumen print, 4½ x 3⅝ inches (1985.68.2.264). *See also list of Works Not Illustrated*
Plate 125. Thomas Eakins, *[Woman in a Laced-Bodice Dress, with Setter, in Eakins's Studio]*, c. 1883.
Albumen print, 3⁹⁄₁₆ x 4½ inches (1985.68.2.265).
Pennsylvania Academy of the Fine Arts, Philadelphia. Charles Bregler's Thomas Eakins Collection,
purchased with the partial support of the Pew Memorial Trust.

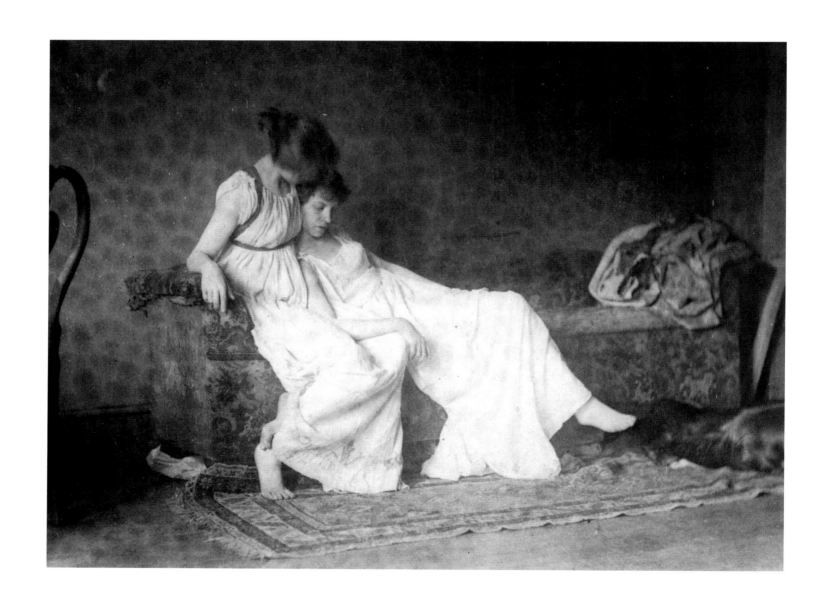

Plate 126. Thomas Eakins, *[Two Women in Classical Costume in Eakins's Studio]*, c. 1883.
Platinum print, 6⅜ x 8¹³⁄₁₆ inches.
Pennsylvania Academy of the Fine Arts, Philadelphia. Charles Bregler's Thomas Eakins Collection,
purchased with the partial support of the Pew Memorial Trust (1985.68.2.663).
See also list of Works Not Illustrated

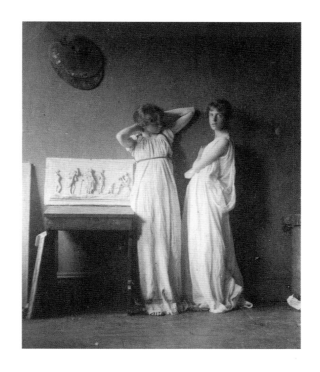

Plate 127. Thomas Eakins, *[Two Female Students in Classical Costume in Eakins's Studio]*, c. 1883.
Platinum print, 3½ x 2⅞ inches.
The J. Paul Getty Museum, Los Angeles (84.XM.155.2).
See also list of Works Not Illustrated

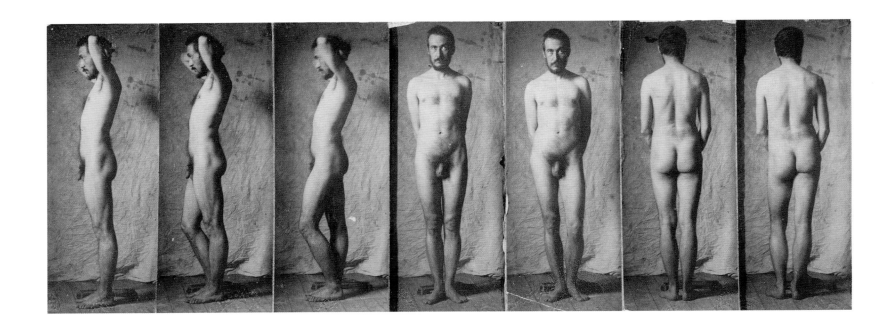

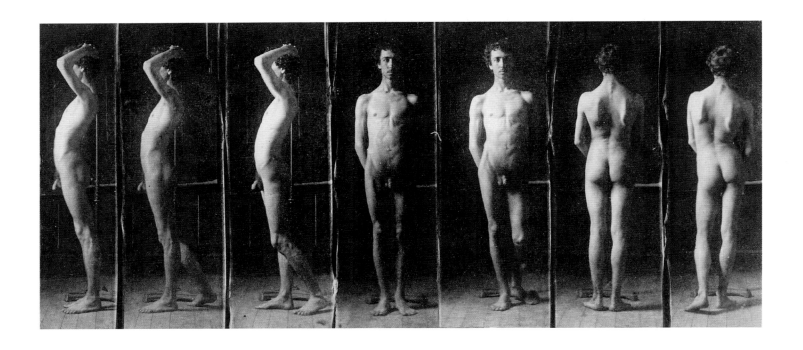

Plate 128. Circle of Thomas Eakins, *[Naked Series: Thomas Eakins]*, c. 1883.
Seven albumen prints, mounted on card, 3⅟₁₆ x 8⅜ inches (1984-89-3).
Plate 129. Circle of Thomas Eakins, *[Naked Series: John Laurie Wallace]*, c. 1883.
Seven albumen prints, mounted on card, 3³⁄₁₆ x 7⅝ inches (1984-89-1).
Philadelphia Museum of Art. Purchased with the SmithKline Beckman (now SmithKline Beecham) Fund
for the Ars Medica Collection, 1984.

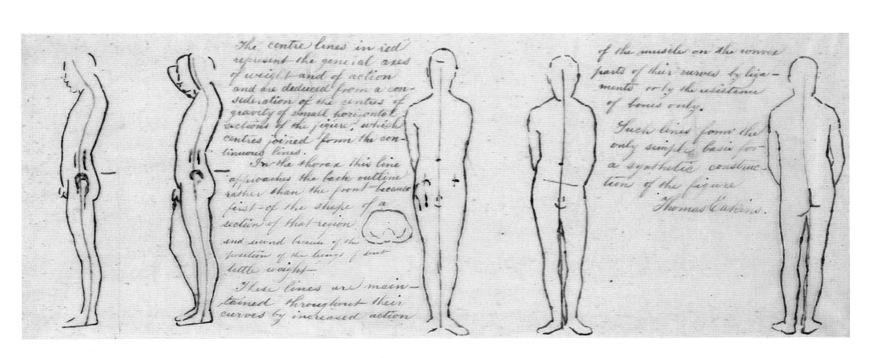

Plate 130. Thomas Eakins, *[Comparative Analysis of Anatomical Photographs]*, c. 1883.
Ink and graphite on paper, 3¹³⁄₁₆ x 2⅜ inches (1984-89-7).
Plate 131. Thomas Eakins, *[Comparative Analysis of Anatomical Photographs]*, c. 1883.
Ink and graphite on paper, 3⁵⁄₁₆ x 8½ inches (1984-89-8).
Philadelphia Museum of Art. Purchased with the SmithKline Beckman (now SmithKline Beecham) Fund
for the Ars Medica Collection, 1984.

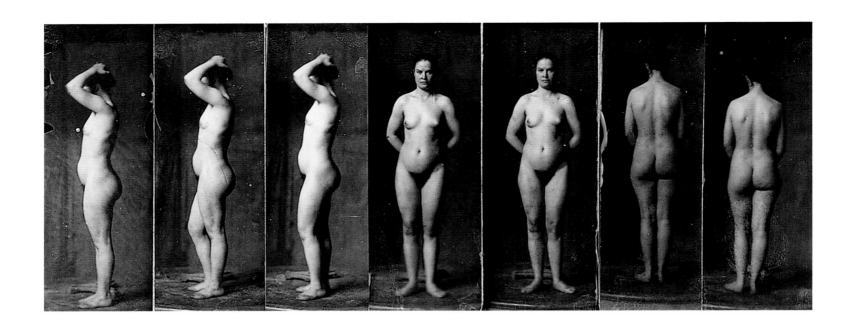

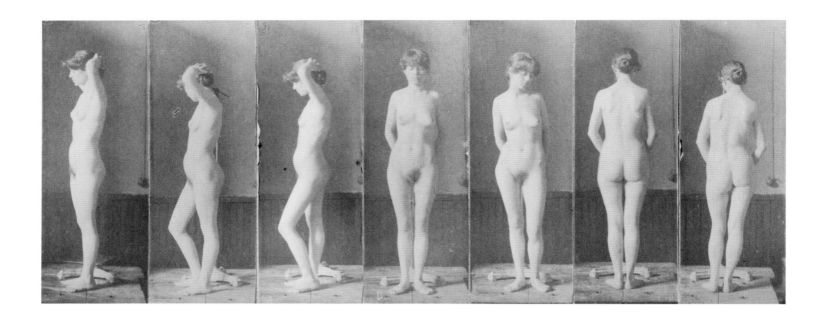

Plate 132. Circle of Thomas Eakins, *[Naked Series: Female Model]*, c. 1883.
Seven albumen prints, mounted on card, 3¹⁄₁₆ x 8¹³⁄₁₆ inches.
The J. Paul Getty Museum, Los Angeles (84.XM.254.13).

Plate 133. Circle of Thomas Eakins, *[Naked Series: Female Model]*, c. 1883.
Seven albumen prints, mounted on card, 3 x 7⅝ inches.
Philadelphia Museum of Art. Purchased with the SmithKline Beckman (now SmithKline Beecham) Fund
for the Ars Medica Collection, 1984 (1984-89-4).

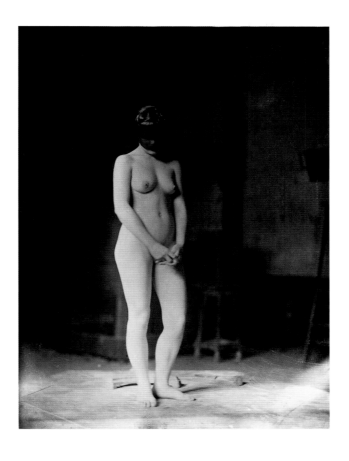

Plate 134. Circle of Thomas Eakins, *[Female Nude with a Mask at the Pennsylvania Academy of the Fine Arts]*, c. 1883.
Gelatin silver print, 4³⁄₁₆ x 3⅞ inches.
Pennsylvania Academy of the Fine Arts, Philadelphia. Charles Bregler's Thomas Eakins Collection,
purchased with the partial support of the Pew Memorial Trust (1985.68.2.394).

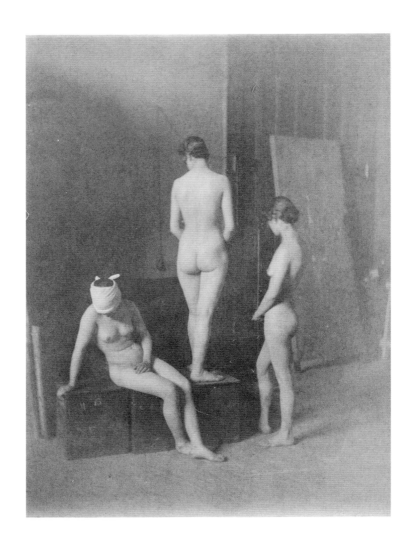

Plate 135. Circle of Thomas Eakins, *[Three Female Models, Nude, at the Pennsylvania Academy of the Fine Arts]*, c. 1883.
Albumen print, 5 x 3⅝ inches.
The Detroit Institute of Arts. Founders Society Purchase, Robert H. Tannahill Foundation Fund (F77.104).

Plate 136. Circle of Thomas Eakins, *[Thomas Eakins Carrying a Nude Woman at the*
Pennsylvania Academy of the Fine Arts], 1883–85.
Digital inkjet print from original gelatin dry-plate negative, 4 x 5 inches.
Pennsylvania Academy of the Fine Arts, Philadelphia. Charles Bregler's Thomas Eakins Collection,
purchased with the partial support of the Pew Memorial Trust (1985.68.2.848).

Plate 137. Circle of Thomas Eakins?, *[Female Nude]*, probably 1883–85.
Platinum print, 4�5⁄16 x 6 inches.
The Metropolitan Museum of Art, New York. David Hunter McAlpin Fund, 1943 (43.87.26).

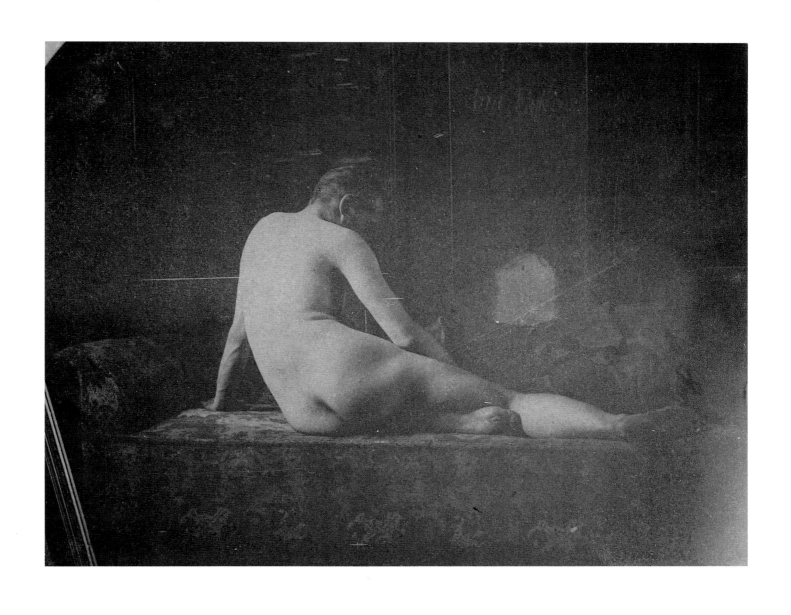

Plate 138. Circle of Thomas Eakins, *[Thomas Eakins, Nude]*, 1883–85.
Platinum print, 5⅜ x 7¼ inches.
Pennsylvania Academy of the Fine Arts, Philadelphia. Charles Bregler's Thomas Eakins Collection,
purchased with the partial support of the Pew Memorial Trust (1985.68.2.425).

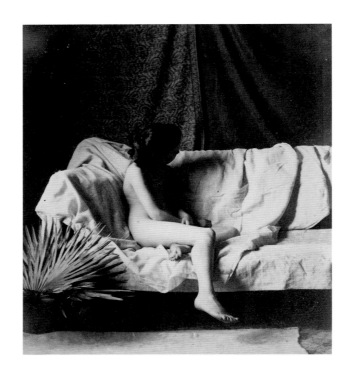

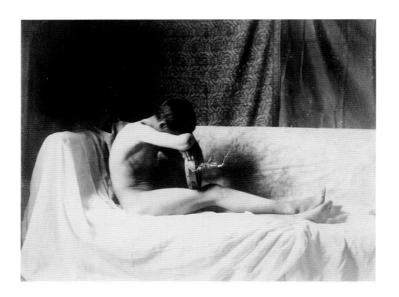

Plate 139. Circle of Thomas Eakins, *[Young Girl, Nude]*, 1883–85.
Albumen print, 3½ x 3¼ inches.
Pennsylvania Academy of the Fine Arts, Philadelphia. Charles Bregler's Thomas Eakins Collection,
purchased with the partial support of the Pew Memorial Trust (1985.68.2.519).

Plate 140. Circle of Thomas Eakins, *[Young Boy, Nude]*, 1883–85.
Albumen print, 2¹³⁄₁₆ x 3⅞ inches.
Philadelphia Museum of Art. Purchased with funds contributed by
the Daniel W. Dietrich Foundation, the J. J. Medveckis Foundation,
and Harvey S. Shipley Miller and J. Randall Plummer (1999.138.16).

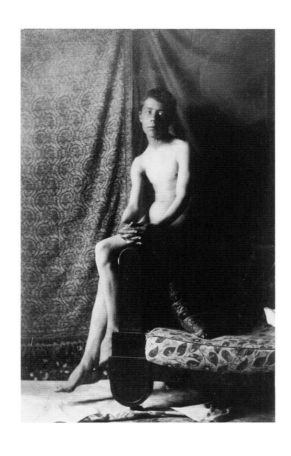

Plate 141. Circle of Thomas Eakins, *[Young Boy, Nude]*, 1883–85.
Albumen print, 4¹⁄₁₆ x 2⅝ inches.
Philadelphia Museum of Art. Purchased with funds contributed by the Daniel W. Dietrich Foundation,
the J. J. Medveckis Foundation, and Harvey S. Shipley Miller and J. Randall Plummer (1999-138-14).

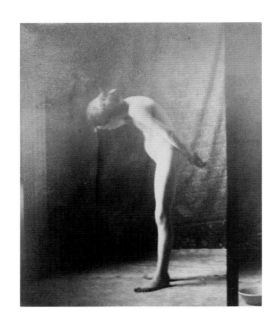

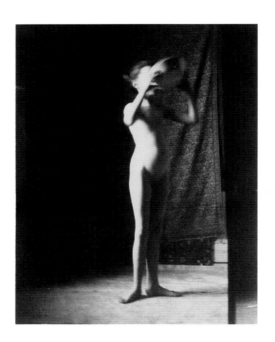

Plate 142. Circle of Thomas Eakins, *[Young Girl, Nude]*, 1883–85.
Albumen print, 2¾ x 2⅜ inches (1999-138-9).
Plate 143. Circle of Thomas Eakins, *[Young Girl, Nude]*, 1883–85.
Albumen print, 3 x 2⅜ inches (1999-138-10).
Philadelphia Museum of Art. Purchased with funds contributed by the Daniel W. Dietrich Foundation,
the J. J. Medveckis Foundation, and Harvey S. Shipley Miller and J. Randall Plummer.

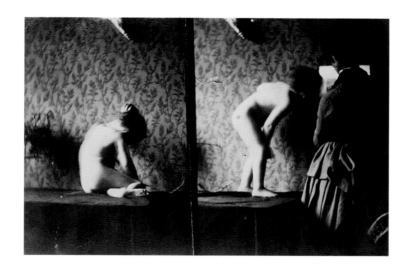

Plate 144. Circle of Thomas Eakins, *[Young Child, Nude, and Chaperone]*, 1883–85.
Albumen print, 2½ x 3¾ inches.
Philadelphia Museum of Art. Purchased with funds contributed by the Daniel W. Dietrich Foundation,
the J. J. Medveckis Foundation, and Harvey S. Shipley Miller and J. Randall Plummer (1999-138-11).

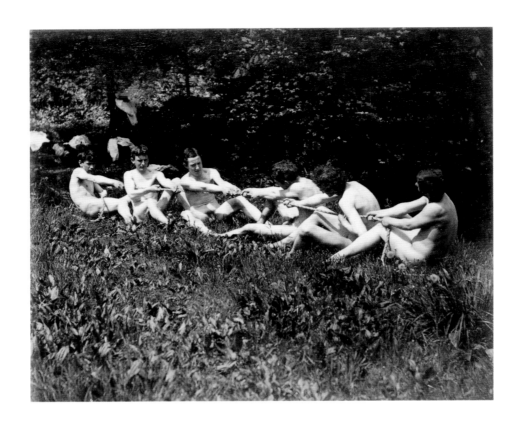

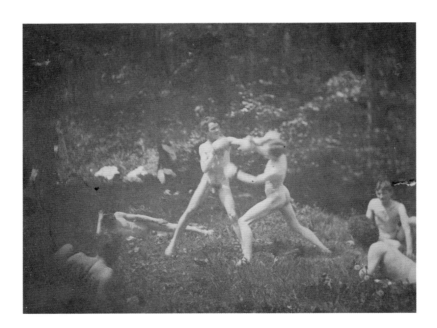

Plate 145. Thomas Eakins, *[Male Nudes in a Seated Tug-of-War]*, 1884.
Albumen print, 3¾ x 4¾ inches.
The Detroit Institute of Arts. Founders Society Purchase, Robert H. Tannahill Foundation Fund (F77.106)

Plate 146. Thomas Eakins, *[Male Nudes Boxing]*, 1884.
Albumen print, 3¹⁄₁₆ x 4⅛ inches.
Pennsylvania Academy of the Fine Arts, Philadelphia. Charles Bregler's Thomas Eakins Collection,
purchased with the partial support of the Pew Memorial Trust (1985.68.2.481).

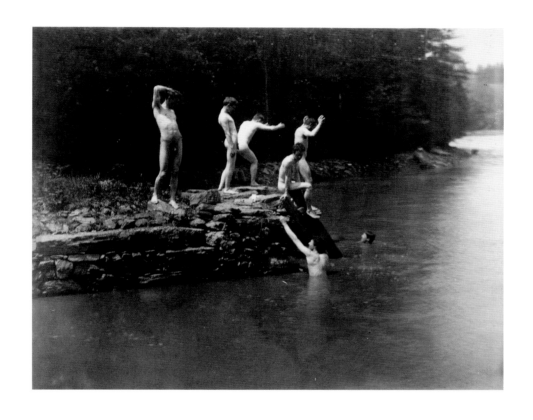

Plate 147. Circle of Thomas Eakins, *[Male Nudes at the Site of "Swimming"]*, 1884.
Albumen print, 3¹¹⁄₁₆ x 4¹³⁄₁₆ inches.
The J. Paul Getty Museum, Los Angeles (84.XM.811.1).

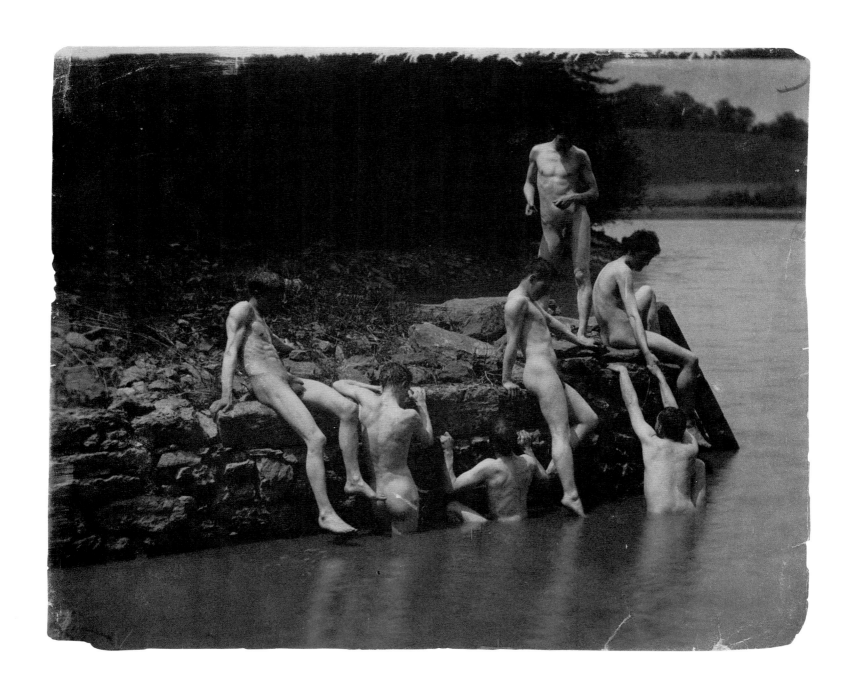

Plate 148. Circle of Thomas Eakins, *[Thomas Eakins and Male Nudes at the Site of "Swimming"]*, 1884.
Platinum print, 8¹⁵⁄₁₆ x 11¹⁄₁₆ inches.
Pennsylvania Academy of the Fine Arts, Philadelphia. Charles Bregler's Thomas Eakins Collection,
purchased with the partial support of the Pew Memorial Trust (1985.68.2.480).
See also list of Works Not Illustrated

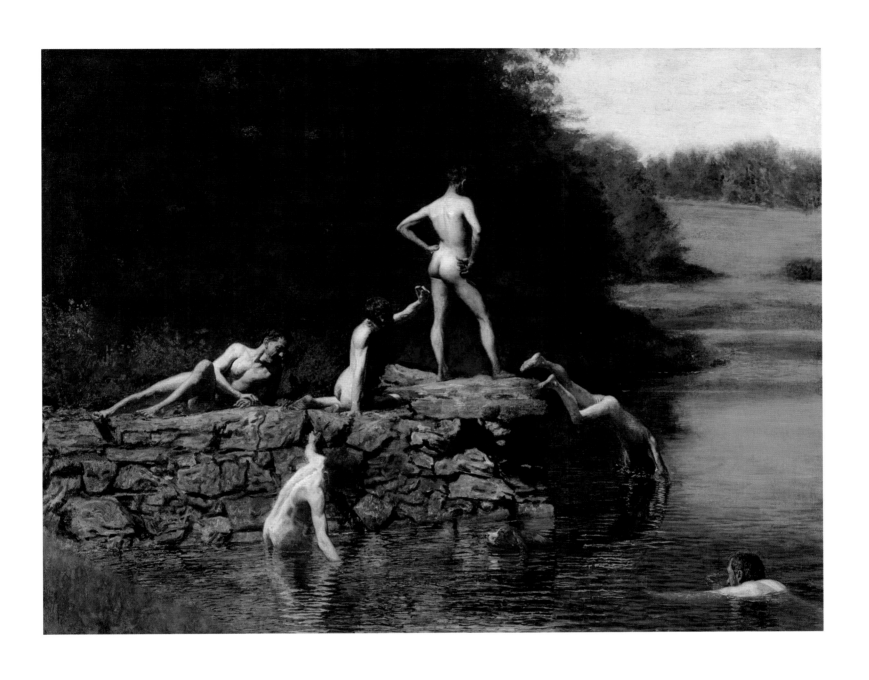

Plate 149. Thomas Eakins, *Swimming*, 1884–85.
Oil on canvas, 27⅜ x 36⅜ inches.

Amon Carter Museum, Fort Worth, Texas. Purchased by the Friends of Art, Fort Worth Art Association, 1925; acquired by the Amon Carter Museum, 1990, from the Modern Art Museum of Fort Worth through grants and donations from the Amon G. Carter Foundation, the Sid W. Richardson Foundation, the Anne Burnett and Charles Tandy Foundation, Capital Cities/ABC Foundation, *Fort Worth Star-Telegram*, The R. D. and Joan Dale Hubbard Foundation, and the people of Fort Worth.

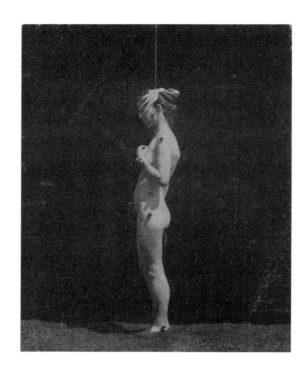

Plate 150. Thomas Eakins, *[Female Nude at the University of Pennsylvania]*, 1884–85.
Platinum print, 2⅞ x 2⅜ inches.
Hirshhorn Museum and Sculpture Garden, Smithsonian Institution, Washington, D.C.
Transferred from Hirshhorn Museum and Sculpture Garden Archives, 1983 (83.43).

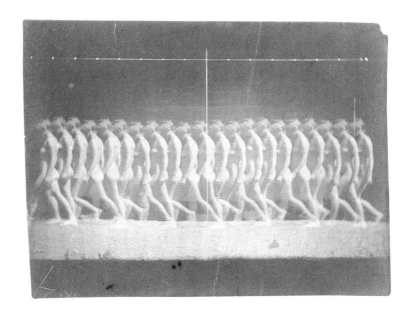

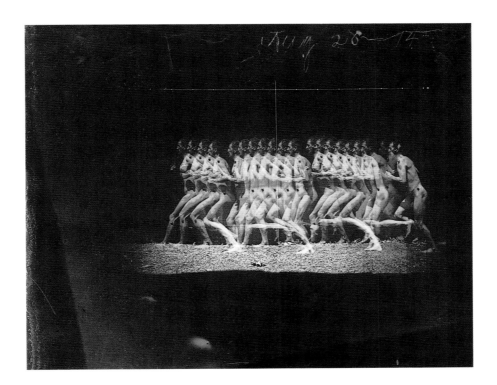

Plate 151. Thomas Eakins, *[Motion Study: Female Nude Walking]*, 1885.
Albumen print, 2⅞ x 3⅝ inches.
Hirshhorn Museum and Sculpture Garden, Smithsonian Institution, Washington, D.C.
Transferred from Hirshhorn Museum and Sculpture Garden Archives, 1983 (83.42).

Plate 152. Thomas Eakins, *[Motion Study: Male Nude Running]*, 1885.
Digital inkjet print from original gelatin dry-plate negative, 4 x 5 inches.
Pennsylvania Academy of the Fine Arts, Philadelphia. Charles Bregler's Thomas Eakins Collection,
purchased with the partial support of the Pew Memorial Trust (1985.68.2.994).

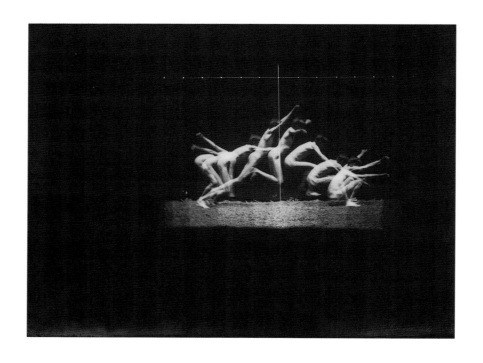

Plate 153. Thomas Eakins, *[Motion Study: "History of a Jump"]*, 1885.
Digital inkjet print from original gelatin dry-plate negative, 4 x 5 inches.
Pennsylvania Academy of the Fine Arts, Philadelphia. Charles Bregler's Thomas Eakins Collection,
purchased with the partial support of the Pew Memorial Trust (1985.68.2.985).

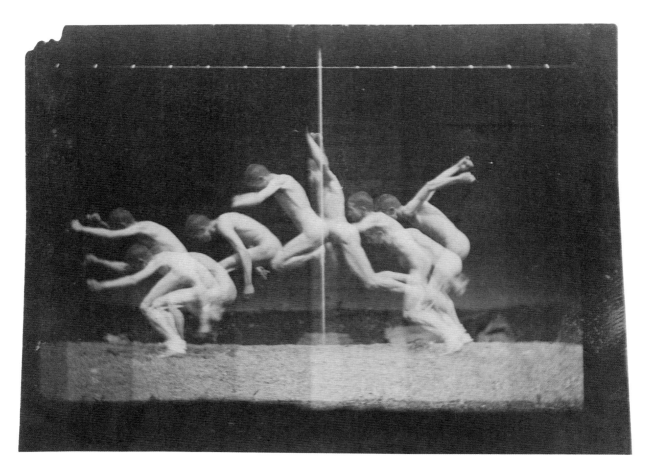

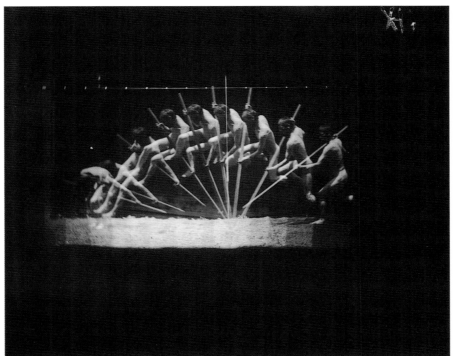

Plate 154. Thomas Eakins, *[Motion Study: Male Nude Leaping]*, 1885.
Albumen print, 2½ x 3⁹⁄₁₆ inches.
Hirshhorn Museum and Sculpture Garden, Smithsonian Institution, Washington, D.C.
Transferred from Hirshhorn Museum and Sculpture Garden Archives, 1983 (83.60).

Plate 155. Thomas Eakins, *[Motion Study: George Reynolds, Nude, Pole-Vaulting]*, 1885.
Digital inkjet print from original gelatin dry-plate negative, 4 x 5 inches.
Pennsylvania Academy of the Fine Arts, Philadelphia. Charles Bregler's Thomas Eakins Collection,
purchased with the partial support of the Pew Memorial Trust (1985.68.2.996).

Plate 156. Thomas Eakins, *[Differential-Action Study]*, 1885.
Platinum print, 1¾ x 1⁹⁄₁₆ inches.
Pennsylvania Academy of the Fine Arts, Philadelphia. Charles Bregler's Thomas Eakins Collection,
purchased with the partial support of the Pew Memorial Trust (1985.68.2.406).
See also list of Works Not Illustrated

Plate 157. Thomas Eakins, *[Differential-Action Study]*, 1885.
Platinum print, 1¾ x 1⁵⁄₁₆ inches.
Pennsylvania Academy of the Fine Arts, Philadelphia. Charles Bregler's Thomas Eakins Collection,
purchased with the partial support of the Pew Memorial Trust (1985.68.2.408).

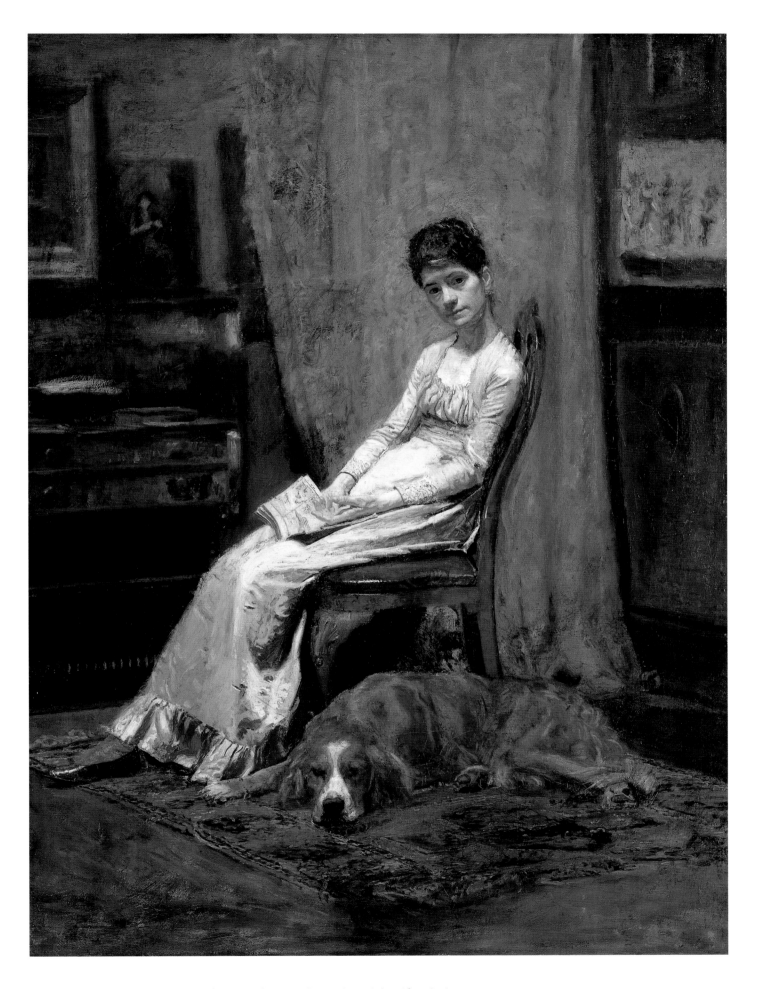

Plate 158. Thomas Eakins, *The Artist's Wife and His Setter Dog*, 1884–89.
Oil on canvas, 30 x 23 inches.
The Metropolitan Museum of Art, New York. Fletcher Fund, 1923.

Plate 159. Thomas Eakins, *[Woman on Horseback at the B-T Ranch]*, 1887.
Digital inkjet print from original gelatin dry-plate negative, 4 x 5 inches (1985.68.2.1075).
Plate 160. Thomas Eakins, *[Hogs and Chickens at the B-T Ranch]*, 1887.
Digital inkjet print from original gelatin dry-plate negative, 4 x 5 inches (1985.68.2.1070).
Pennsylvania Academy of the Fine Arts, Philadelphia. Charles Bregler's Thomas Eakins Collection,
purchased with the partial support of the Pew Memorial Trust.

Plate 161. Thomas Eakins, *[Cowboy and Dog at the B-T Ranch]*, 1887.
Albumen print, 3⁷⁄₁₆ x 4⁷⁄₁₆ inches.
The J. Paul Getty Museum, Los Angeles (84.XM.155.33).

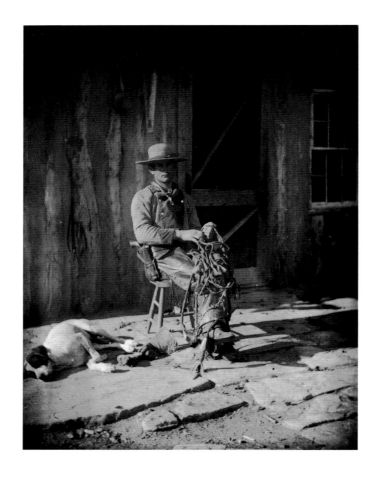

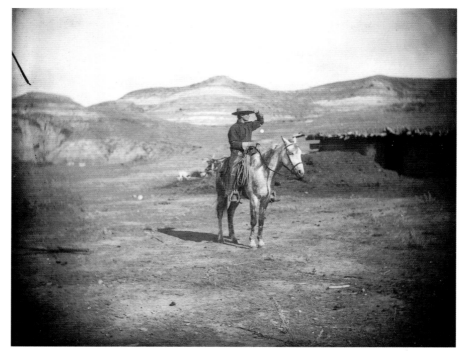

Plate 162. Thomas Eakins, *[Cowboy Sitting at the B-T Ranch]*, 1887.
Digital inkjet print from original gelatin dry-plate negative, 5 x 4 inches (1985.68.2.1074).
Plate 163. Thomas Eakins, *[Cowboy on Horseback in the Dakota Territory]*, 1887.
Digital inkjet print from original gelatin dry-plate negative, 4 x 5 inches (1985.68.2.1078).
Pennsylvania Academy of the Fine Arts, Philadelphia. Charles Bregler's Thomas Eakins Collection,
purchased with the partial support of the Pew Memorial Trust.

Plate 164. Thomas Eakins, *Cowboys in the Bad Lands*, 1888.
Oil on canvas, 32¼ x 45 inches.
Private Collection.

Plate 165. Thomas Eakins, *Portrait of Walt Whitman*, 1887–88.
Oil on canvas, 30⅛ x 24¼ inches.
Pennsylvania Academy of the Fine Arts, Philadelphia. General Fund.

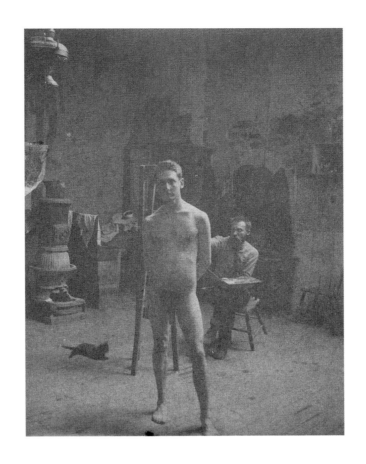

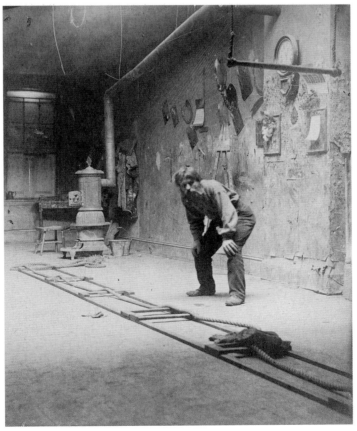

Plate 166. Circle of Thomas Eakins, *[John Wright, Nude, Posing for George Reynolds*
at the Art Students' League of Philadelphia], c. 1889.
Cyanotype, 4½ x 3⁹⁄₁₆ inches (1985.68.2.427).
Plate 167. Thomas Eakins, *[Franklin Schenck at the Art Students' League of Philadelphia]*, c. 1890.
Albumen print, 4¹¹⁄₁₆ x 3⅞ inches (1985.68.2.196).
Pennsylvania Academy of the Fine Arts, Philadelphia. Charles Bregler's Thomas Eakins
Collection, purchased with the partial support of the Pew Memorial Trust.

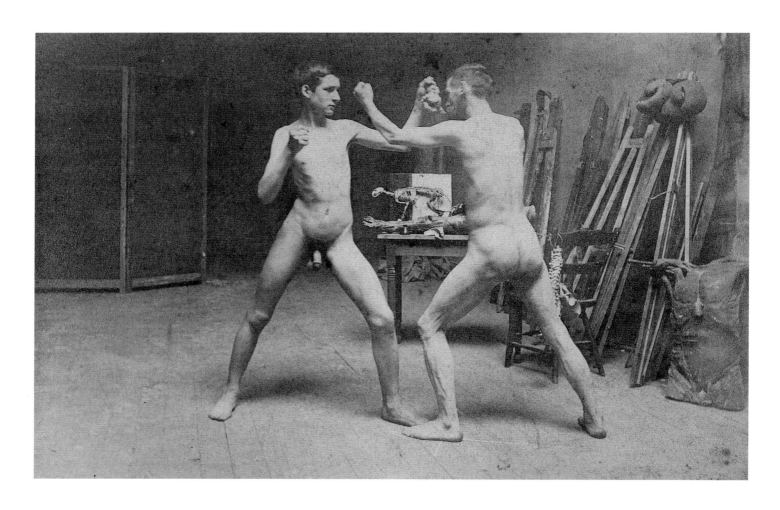

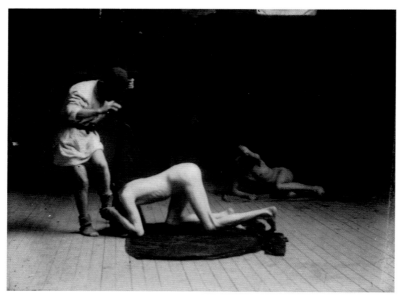

Plate 168. Circle of Thomas Eakins, *[Male Students Posing at the Art Students' League of Philadelphia]*, 1886.
Twenty albumen prints and one gelatin silver print, mounted in an album, each approximately 4½ x 7½ inches.
Sterling and Francine Clark Art Institute, Williamstown, Massachusetts.

Plate 169. Circle of Thomas Eakins (attributed to Edward W. Boulton),
[Male Students Posing at the Art Students' League of Philadelphia], c. 1890.
Digital inkjet print from original gelatin dry-plate negative, 3⅛ x 4⅛/₁₆ inches.
Philadelphia Museum of Art. Purchased with funds given by Seymour Adelman (1981-37-7).

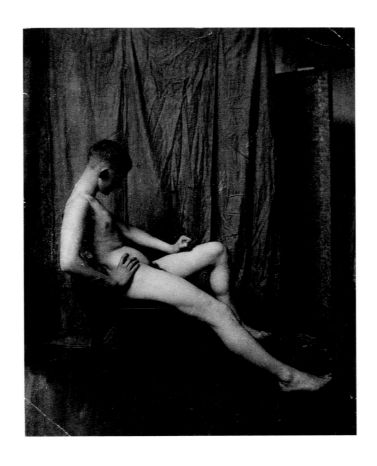

Plate 170. Thomas Eakins, *[Male Nude, Possibly Bill Duckett, at the Art Students' League of Philadelphia]*, c. 1889.
Platinum print, 4¼ x 3⁷⁄₁₆ inches.
Pennsylvania Academy of the Fine Arts, Philadelphia. Charles Bregler's Thomas Eakins Collection,
purchased with the partial support of the Pew Memorial Trust (1985.68.2.418).
See also list of Works Not Illustrated

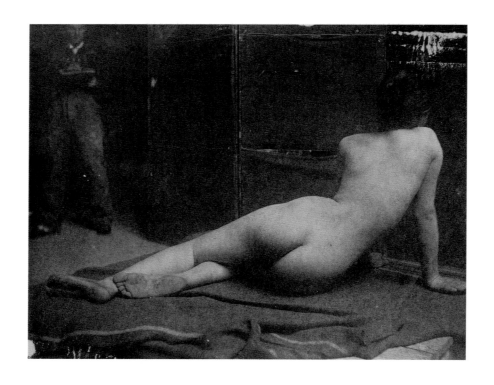

Plate 171. Thomas Eakins, *[Female Nude at the Art Students' League of Philadelphia]*, c. 1889.
Platinum print, 3⅞ x 5¹⁄₁₆ inches.
Pennsylvania Academy of the Fine Arts, Philadelphia. Charles Bregler's Thomas Eakins Collection,
purchased with the partial support of the Pew Memorial Trust (1985.68.2.501).
See also list of Works Not Illustrated

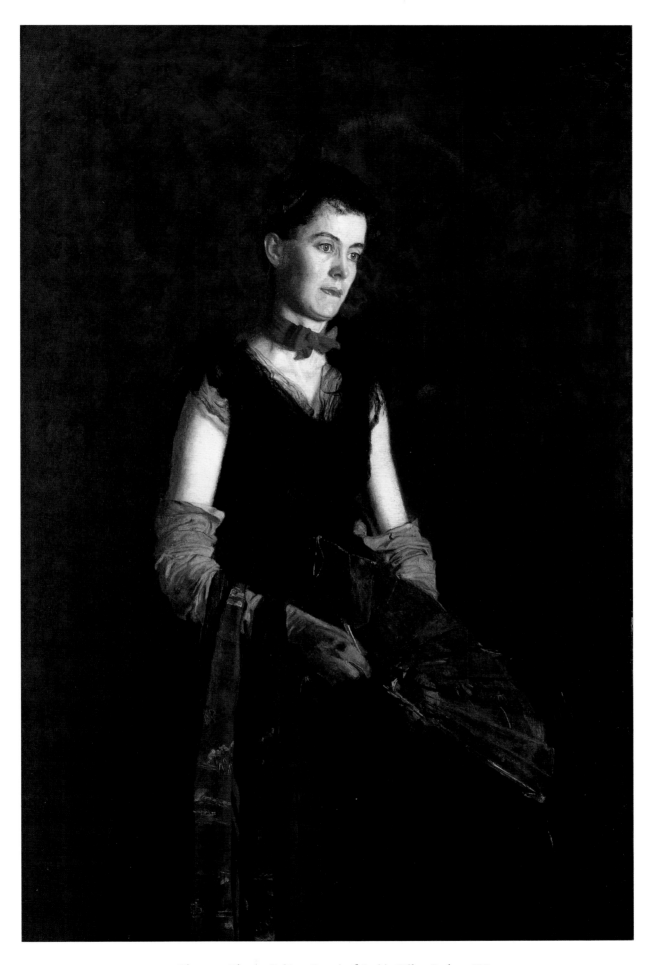

Plate 172. Thomas Eakins, *Portrait of Letitia Wilson Jordan*, 1888.
Oil on canvas, 60 x 40 inches.
Brooklyn Museum of Art, New York. Dick S. Ramsay Fund.

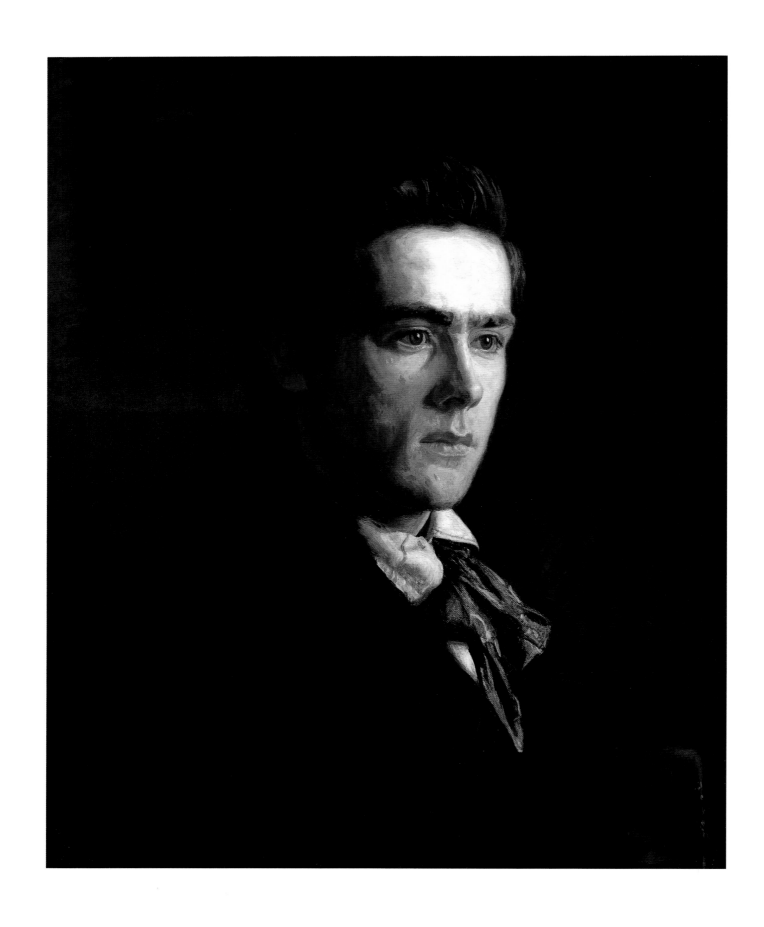

Plate 173. Thomas Eakins, *Portrait of Samuel Murray*, 1889.
Oil on canvas, 24 x 20 inches.
Mitchell Museum at Cedarhurst, Mount Vernon, Illinois.

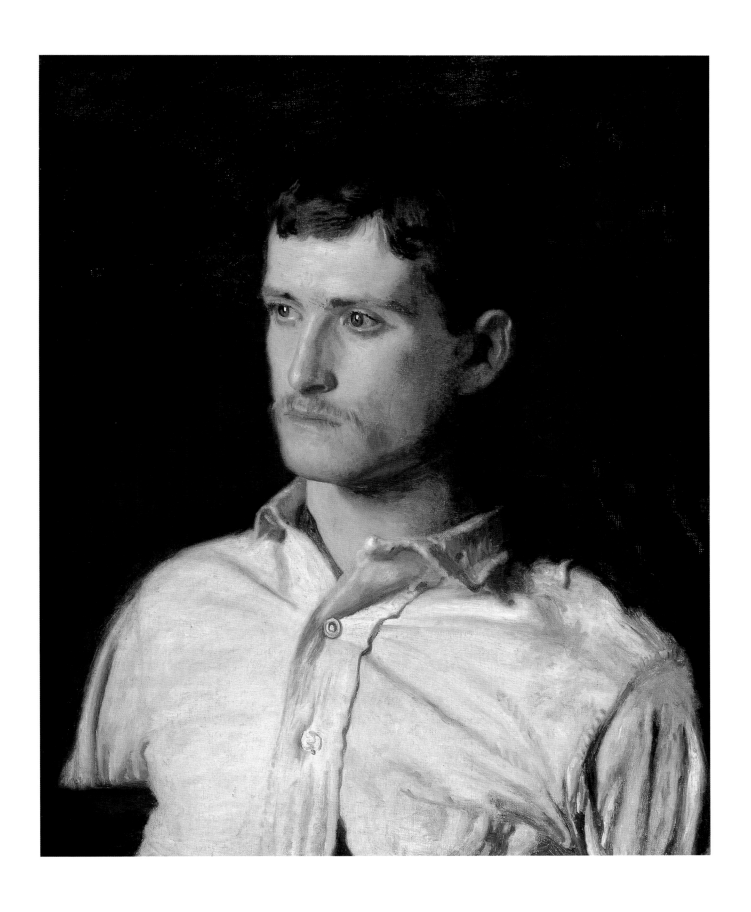

Plate 174. Thomas Eakins, *Portrait of Douglass Morgan Hall*, c. 1889.
Oil on canvas, 24 x 20 inches.
Philadelphia Museum of Art. Gift of Mrs. William E. Studdiford, 1975.

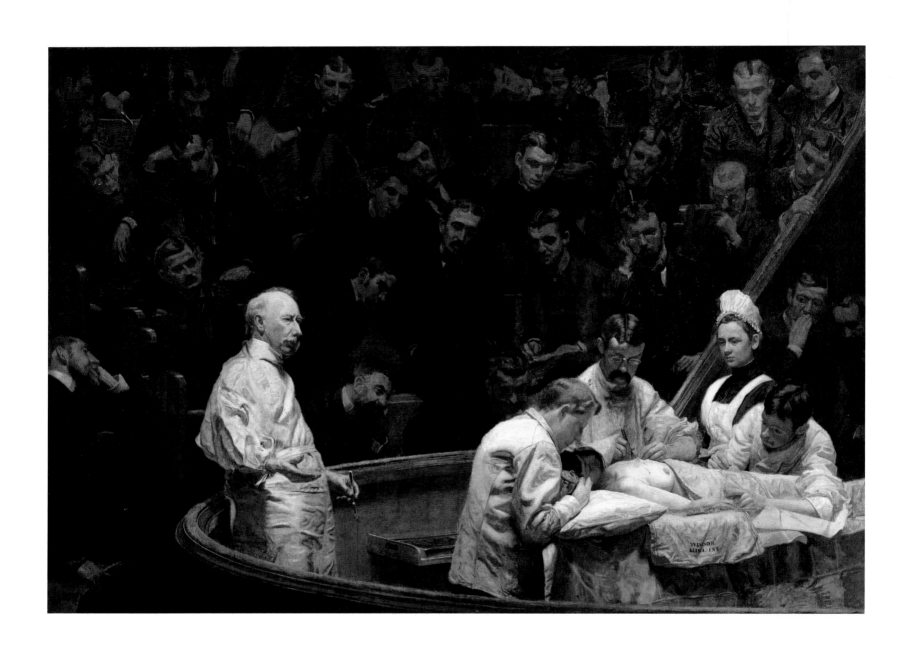

Plate 175. Thomas Eakins, *The Agnew Clinic*, 1889.
Oil on canvas, 84⅜ x 118⅛ inches.
University of Pennsylvania, Philadelphia.

Eakins's Vision of the Past and the Building of a Reputation

MARC SIMPSON

From 1877 to 1883 Thomas Eakins exhibited paintings, watercolors, and reliefs that portrayed worlds far removed from daily life in postbellum Philadelphia. Initially these imagined views appear anomalous in the career of a painter whose teachings and pronouncements, no less than his well-documented interest in perspective, anatomy, and motion photography, proclaim physical reality and its accurate visual transcription as crucial in the creation of solid, or "big," work.[1] Accordingly, most art historians have placed contemporary portraiture at the core of Eakins's artistic enterprise, marginalizing his explorations of bygone times as little more than curious interludes.[2] Yet a tally of the works he put on exhibition during these years belies this. Of one hundred and eight-four titles, forty-eight showed contemporary interiors and twenty-four outdoor working scenes, forty-six were sporting pictures, and fifteen were portraits—while fully fifty portrayed characters in historical costume.[3] This high number indicates that Eakins considered his visions of the past integral to his professional advancement; they merit a more concerted consideration than they have thus far been accorded.

Eakins began exhibiting professionally in 1871 and then, after a two-year hiatus, continuously from 1874 onward. Through late 1877 he showed sporting scenes and genre pictures of men in interiors as well as large, innovative male portraits.[4] In December 1877, at a show of watercolors at the Pennsylvania Academy of the Fine Arts, Eakins broke this pattern. While four of the six sheets he had on exhibit were already familiar to viewers,[5] two—*Fifty Years Ago (Young Girl Meditating)* (fig. 77) and *Seventy Years Ago* (fig. 78)—were

Fig. 77. Thomas Eakins, *Fifty Years Ago (Young Girl Meditating)*, 1877. Watercolor and gouache on paper, 9⁹⁄₁₆ x 6⅛". The Metropolitan Museum of Art, New York. Fletcher Fund, 1925 (pl. 43).

Fig. 78. Thomas Eakins, *Seventy Years Ago*, 1877. Watercolor on paper, 15⅝ x 11". The Art Museum, Princeton University, New Jersey. Gift of Mrs. Frank Jewett Mather, Jr. (pl. 42).

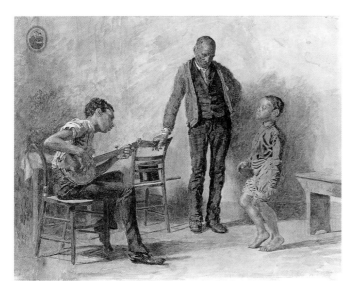

Fig. 79. Thomas Eakins, *The Dancing Lesson (Negro Boy Dancing)*, 1878. Watercolor on paper, 18¹⁄₁₆ x 22⁵⁄₁₆". The Metropolitan Museum of Art, New York. Fletcher Fund, 1925 (pl. 45).

Fig. 80. Edwin Austin Abbey, *Mrs. G. H. Gilbert as "Mrs. Candour" in the "School for Scandal,"* 1878. From [Brander Matthews], "Actors and Actresses of New York," *Scribner's Monthly*, vol. 17, no. 6 (April 1879), p. 776.

not only new to exhibition-goers but announced a wholly fresh subject for the painter: women in old-fashioned dress.

We do not know what prompted Eakins to show these imaginative feminine subjects redolent of America's past. Certainly pictures of elaborately dressed women were a modish component of the American art market.[6] Moreover, the American centenary celebrations of 1876, especially the world's fair in Philadelphia, had made the old up-to-date: "The patterns used in the manufacture of furniture a century ago are those now in vogue among the most fashionable people."[7] Throughout the decade, American artists and tastemakers looked to the Anglo-American past for inspiration, sparking a full-blown Colonial Revival.[8] At the least Eakins could anticipate that his two watercolors of women in old-fashioned dress would find a receptive audience; he was not disappointed.

Fifty Years Ago—an evocation of the 1820s—shows a young woman standing in a greenish gold gown with high waist and puffed sleeves, her awkwardly large hands clasped before her.[9] The sheen of her gown demonstrates Eakins's close observation of light and its reflections, a more modest, but still impressive, effect related to those in his rowing scenes. But he left off the detailing midway, as if wary of focusing too closely on the fabric. Instead, he drew attention to the woman's minutely stippled face through the red color of her hair ribbon and the pronounced texture of her necklace.

The props that surround her and define the space are likewise purposeful. The tilt-top table was a popular Anglo-American form throughout the later eighteenth century. Its plain feet and simply turned balustrade, which Eakins merely suggested, are consonant with Philadelphia examples that would have been accessible in area homes throughout the

nineteenth century.[10] Geraniums, too, were popular in Philadelphia around 1800.[11] One of the plants shoots up blooms of the same brilliancy as the girl's hair ribbon, as Eakins was adhering to a fashionable conceit associating the charms of flowers with those of young women.[12] Together the figure, props, and title evoke a generalized feminine presence in an American, mid-Atlantic past.[13]

Seventy Years Ago is nearly three times as large as its companion and accordingly more detailed.[14] Its gray and silvery hues delineate an elderly woman, seated and knitting in a well-suggested room. The title announces that the work's fictive date is about 1807, but only the sitter's high-waisted gray gown and white lace headdress attest to this; the room's furnishings either predate the costume or are too generic to serve as chronological markers.[15] Other than the knitter's face and hands the most detailed element of the watercolor is her chair. To judge from its shell ear, fluted stile, carved knee, and ball-and-claw foot, the artist intended to represent a Chippendale-style chair made in Philadelphia in the later eighteenth century.[16] Eakins borrowed such a chair from his friend Dr. S. Weir Mitchell.[17] Through its carefully registered presence, *Seventy Years Ago* evokes a distinctly Philadelphian past, while the composition as a whole conveys an elegant domesticity.

The watercolors' titles suggest a past time, but in a complex fashion, with the use of the word "ago" imposing a sense of process, of both now and then, on the spectator. This verbal complexity is matched by the works themselves, which elude easy characterization. They do not feel like then-fashionable costume pieces—what Eakins's friend Earl Shinn called "the millinery of art"—lacking as they do both the overriding concern with textures and stuffs as well as the self-aware glance

out of the picture that accompanies many such works.[18] Neither are they near-archaeological renderings striving to convince the viewer that both setting and person belong to a distant past.[19] Eakins instead cast his models, each marked by character rather than beauty, into an atmospheric space with only a few specific details. This visual formula mimics single-figure historical works by Jean-Louis-Ernest Meissonier and his American followers such as Walter Gay and Ignaz Gaugengigl but blunts their jewel-like precision with the more homey, generalizing approach to materials and things found in contemporary genre scenes by Thomas Waterman Wood and Eastman Johnson.

The critics received Eakins's first publicly shown historical works with enthusiasm. William J. Clark, Jr., critic for the *Daily Evening Telegraph* in Philadelphia, wrote that among American figure subjects there were "none that will at all compare" with them. *Fifty Years Ago* was "notable for its brilliant qualities," while *Seventy Years Ago*, praised for both its subject and technique, was "one of the most refined pieces of work that Mr. Eakins has yet turned out."[20]

Shinn, writing for the *Philadelphia Evening Bulletin*, began his review with notice of the works by Mariano Fortuny, José Villegas, Eduardo Zamacoïs, Meissonier, and other Europeans—several of them showing one or two figures "richly dressed." He praised especially a Fortuny watercolor as affording "glimpses of the careful method that underlies the artist's seemingly careless style."[21] This notion of seeming carelessness helps to explain the bold touches and gaucheries that Eakins let stand in his watercolors—such as the unblended, undescriptive crash of strokes in the background of *Fifty Years Ago*. He, like Fortuny (whom he had admired since his years in Paris[22]), wove the impression of spontaneous brushwork over and around a carefully realized figure. Shinn recognized Eakins's Continental ambition, including discussion of Eakins in the same introductory paragraph otherwise devoted to the Europeans. In both *Fifty Years Ago* ("a young girl in old-fashioned dress, standing by an old-fashioned table and with some old-fashioned flowers in pots indicated near her") and *Seventy Years Ago* ("a delightful old lady knitting, a spinning wheel dimly showing in the background"), "drawing, composition and light and shade are truly excellent, showing fine natural qualities on the part of the artist, supplemented by the soundest training."

By February 1878 the two watercolors, along with the even newer *Dancing Lesson (Negro Boy Dancing)* (fig. 79), were in New York for the Eleventh Annual Exhibition of the American Water Color Society.[23] Eakins's grouping of the old-fashioned works and *The Dancing Lesson* is telling, for while the latter is carefully cast in the present—through the clothes worn by the

figures and, especially, the representation of President Lincoln reading to his son on the back wall—the association emphasizes the watercolor's implicit nostalgia, a sentiment here evoked by race and class rather than chronology.[24] The critics were appreciative of all three sheets, one citing them as among "the most remarkable figures in the collection" and, after praising *The Dancing Lesson*, commenting that *Seventy Years Ago* especially proved that "delicacy does not of necessity mean weakness. Here is a work whose texture, tone, shadows, folds, and sentiment, are all well rendered."[25] Perhaps the highest accolade came, however, when *The Daily Graphic* included Eakins's work in its two-page pictorial spread on the exhibition.[26]

In addition to the critics, visitors to the exhibition were favorably impressed by *Seventy Years Ago*. One, R. D. Worsham, acquired the sheet from the show for the relatively high price of one hundred and thirty-five dollars—one of only two watercolors sold by the painter during the 1870s.[27] Another was the artist Edwin Austin Abbey, whose watercolor in the exhibition, *Rose in October* (a work not now known), was mentioned several times in close proximity to Eakins's.[28] When Abbey drew *Mrs. G. H. Gilbert as "Mrs. Candour" in the "School for Scandal"* in 1878 (fig. 80), he tied the basic pose and approach of its historicizing, pseudo-eighteenth-century subject closely to *Seventy Years Ago*.[29]

Eakins's first history painting, as opposed to historical genre painting—a scene, that is, with identifiable characters at significant moments rather than an anonymous evocation of times past—was also on view early in 1878. *William Rush Carving His Allegorical Figure of the Schuylkill River* (fig. 81)

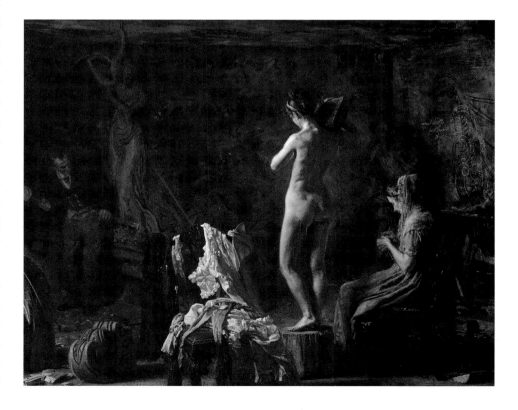

Fig. 81. Thomas Eakins, *William Rush Carving His Allegorical Figure of the Schuylkill River*, 1876–77. Oil on canvas, 20⅛ x 26⅛". Philadelphia Museum of Art. Gift of Mrs. Thomas Eakins and Miss Mary Adeline Williams, 1929 (pl. 41).

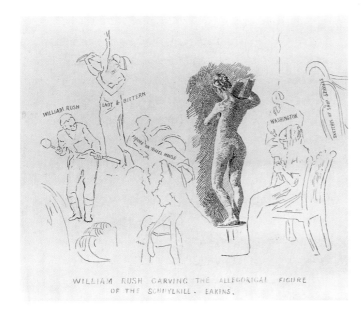

Fig. 82. Thomas Eakins, *Drawing after William Rush Carving His Allegorical Figure of the Schuylkill River*, 1881. Ink on paper-board, 9¾ x 12". Hirshhorn Museum and Sculpture Garden, Smithsonian Institution, Washington, D.C. Gift of Joseph H. Hirshhorn, 1966.

WILLIAM RUSH CARVING THE ALLEGORICAL FIGURE OF THE SCHUYLKILL. EAKINS.

has long been recognized as a milestone in Eakins's career.[30] The scene reveals the crowded workshop of the Philadelphia sculptor in the summer of 1809, with Rush at work on his wooden statue *Water Nymph and Bittern*, which would soon be installed as a fountain in front of the city's Centre Square water-pumping station. Eakins fixed on the subject for at least two reasons. First, he admired Rush's works and wished to draw attention to the sculptor's career; he wrote that *Water Nymph and Bittern* was "one of the earliest and best of American statues."[31] Second, the tradition that a young woman of good family, Louisa Vanuxem, had posed for Rush provided a respectable American precedent for the practice of making art from the close study of the living human form without fear of impropriety.

Eakins's research and preparations for the work were extensive. He visited the area of Rush's studio, spoke with old-time Philadelphians who remembered it, went to see Rush's statues and sketched them in various mediums, and examined early nineteenth-century artworks for hints concerning physiognomy and appropriate costumes. He also made numerous compositional studies. Doubtless some of this research followed from Eakins's sense of how the investigation of history ought to be done: he subscribed to the evidentiary materialism advocated by Hippolyte Taine as well as to the example of his teacher Jean-Léon Gérôme, whose precise historicizing or orientalizing works grew from a careful assembly of notes and props. "A subject is an opportunity to read, to teach oneself," wrote the French artist. "The painter is like a historian, he ought to speak the truth."[32]

One clear indication of Eakins's ambition that *William Rush* be considered a history painting was his preparation of both a keyed drawing (fig. 82) and several extended explanations of the work for its exhibition over the years. In one he

wrote of his efforts to find a patriotism-tinged, culturally enriching truth:

> The shop of William Rush was on Front Street just below Callowhill and I found several very old people who still remembered it and described it. The scrolls and the drawings on the wall are from sketches in an original sketch book of William Rush preserved by an apprentice and left to another ship carver.
>
> The figure of Washington seen in the background is in Independence Hall. Rush was a personal friend of Washington, and served in the Revolution.[33]

Yet in these preparations, Eakins was not simply striving for an accurate re-creation of a summer's day on Front Street in 1809, since in several ways he willfully departed from reality. First, as many scholars have pointed out, Eakins likely imposed the model's nudity on the situation—Miss Vanuxem probably never posed naked and would certainly not have had to do so for this stage of the carving: the sculptor works on the ankle of his nearly complete, fully draped statue. But the necessity and the absolute morality of studying from the nude lay at the heart of Eakins's art philosophy, so Rush was shown doing so—one of the few times that Eakins had the occasion to depict the female nude for the public.[34] Eakins, as well, introduced anachronisms into his canvas by including works from Rush's entire career, such as the *George Washington* of 1814 and the *Allegory of the Waterworks* from 1825.[35] These emendations to the historical record suited Eakins's thematic purpose, which revolved around the conjunction of academic practice, local artistic tradition, and unimpeachable historic association.

After its debut at the Boston Art Club, in early March 1878, *William Rush* joined another oil by Eakins, *In Grandmother's Time* (then called *Spinning*), and a reproduction after *The Gross Clinic* at the First Exhibition of the Society of American Artists in New York. The venue is worthy of note. This was the first exhibition of a group formed the previous year in rebellion against the National Academy of Design and its exhibition policies, which favored older, generally American-trained artists. (The Academy had at least twice, in 1875 and 1876, rejected Eakins's submissions.[36]) The Society, by contrast, focused on younger artists often trained in Europe. Clarence Cook summarized the widely perceived intent and, to a more limited degree, effect of the new group: "This exhibition means revolution. Here, in this modest room, Art in America... sets off in earnest to climb the heights. Here at last is painting, for painting's sake; study, for youth's delight in study."[37]

At the inaugural exhibition, Eakins's *William Rush*, which he priced at six hundred dollars, was one of the more expensive objects on display; of those of the one hundred and twenty-

four listed items that were for sale, only ten bore higher prices.[38] Moreover, his was one of only three works to have an explanatory text in the catalogue.[39] With the work, Eakins—displaying all of his hard-won skills and academic mastery, and by choosing to be one of the few in the show to deal with an old-time American subject—clearly aspired to the high status of history painting.

Most of the critics, however, missed the point.[40] The nude, seen from the back, became a lightning rod for opinions regarding the painting's beauty and propriety. It "would be improved by the wiping out of the female model," observed one; another declared the figure, "though certainly real enough, very ungraceful."[41] Nudity was very much an issue in art in America. A full four columns of the *American Art Journal* were devoted to the subject in May 1878—a suggestive coincidence given the controversy prompted by Eakins's painting. It concluded: "The modern costume, and Christianity, have made the nude, as a truly successful department of every-day art, ever an impossibility."[42]

One of the few writers to understand Eakins's efforts at history painting—and to appreciate the professionalism involved in its production—was Shinn, who had studied at the Ecole des Beaux-Arts in Paris during the same years as Eakins. He closed his review, which emphasized Europe's role in training the Society's artists, by observing that the "apparatus of hiring properties, arranging incidents, and employing models, by which conscientious works of art are elaborated," had apparently been used for only two works made in this country, Eakins's painting and Howard Roberts's sculpture *Lot's Wife*. "Both of these," he found, "though not above discussion in regard to the selection of subject, were thoroughly studied and artistically satisfactory."[43]

Clark, after weighing in with a summary of the work, the responses it had generated, and his own unqualified praise, concluded his long review with a passage that must have stirred Eakins's sense of achievement: "The best comment on this picture was that made by a leading landscape artist of the old school, and who, being of the old school, certainly had no prejudices in favor of works of this kind. This was that he had not believed there was a man outside of Paris, certainly not one in America, who could do painting of the human figure like this."[44] At least part of the point, no matter the resulting controversy, had been made publicly and in the press: Eakins could paint the human figure better than any of his compatriots.[45]

The other Eakins painting in the exhibition was *In Grandmother's Time* (fig. 83), depicting an elderly woman in a silvery silk gown, gauzy fichu, and lace cap with a satin ribbon, seated at a spinning wheel.[46] Many similarities exist between this work and the watercolor *Seventy Years Ago*.[47] The model is the same, as is much of her costume, although in the oil the gown's sleeves are pushed up and the waist cinched; the spinning wheel and rag rug are also featured in both. Even the titles share the double consciousness of portrayed versus observed time. The locution of *In Grandmother's Time*—the title is printed in Eakins's ornate hand on the back of the canvas—is in fact even more perplexing. The costume and activity fit the era just after the turn of the century, when Eakins's grandmothers were young women.[48] But if the painting depicts a scene from that time, then the older woman is not the "grandmother" of the 1870s viewer. Is this intended to be the great-(or great-great-) grandmother of the one who, in 1876, says "in grandmother's time"? Or is the scene meant to be contemporary with 1876, as the date inscribed on the side of the spinning wheel might indicate? That would explain the mid-nineteenth-century toys ranged on the floor around the woman,[49] as well as the mid-nineteenth-century upholstered armchair just discernible behind the spindle. In this reading, the spinner is the grandmother, surrounded by evidence of her grandchildren in 1876. But then how to explain her fancy dress and the archaic activity, spinning being a nearly lost art by this time?[50] Eakins intentionally mystified the painting's fiction, blurring the line between historical re-creation and contemporary observation, forcing the viewer mentally to straddle the span of seven or eight decades.

Fig. 83. Thomas Eakins, *In Grandmother's Time*, 1876. Oil on canvas, 16 x 12". Smith College Museum of Art, Northampton, Massachusetts. Purchased 1879.

Fig. 84. William Henry Lippincott, *Childish Thoughts*, 1895. Oil on canvas, 32¼ x 45¾". Pennsylvania Academy of the Fine Arts, Philadelphia. Gift of Mary H. Rice.

Fig. 85. Thomas Eakins, *The Chess Players*, 1876. Oil on wood, 11¾ x 16¾". The Metropolitan Museum of Art, New York. Gift of the artist, 1881 (pl. 19).

It is this purposeful indeterminacy of genre, time, and even objects portrayed—this latter the result of his highly selective focus and pervading darkness—that lends Eakins's scenes their vitality, while more resolutely clear re-creations of earlier times by such artists as Frank Millet, Alfred Fredericks, Seymour Guy, or William Henry Lippincott (fig. 84) now appear as obvious costume pieces. Eakins, rather than trying to re-create a vanished time through the accumulation of details, instead brought to his work precisely the same priorities he would have if depicting a scene of his own day—firm figural construction and solid placement in space—and then let the imagination of the viewer provide as much of a chronological envelope as necessary.[51] By focusing the viewer's attention, Eakins achieved an effect parallel to that he valued in the paintings of Gérôme

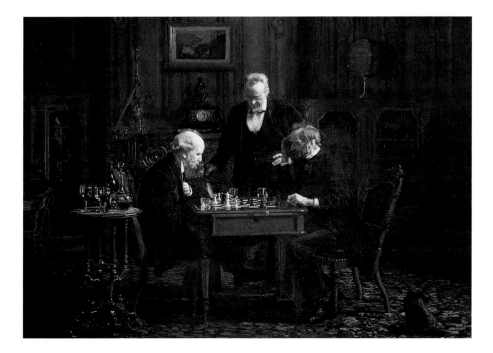

over those of "sweet little Meissonier" years earlier: humanity taking precedence over the surfaces of things.[52]

In its sentiment, subject, and handling, the work evokes much the same quiet emotion as William Dean Howells's often-quoted passage describing the Old Colony House at the Centennial Exhibition:

There are many actual relics of the Pilgrim days, all of which the crowd examined with the keenest interest; there was among other things the writing-desk of John Alden, and at the corner of the deep and wide fire-place sat Priscilla spinning—or some young lady in a quaint, old-fashioned dress, who served the same purpose. I thought nothing could be better than this, till a lovely old Quakeress, who had stood by, peering critically at the work through her glasses, asked the fair spinster to let her take the wheel. She sat down beside it, caught some strands of tow from the spindle, and with her long-unwonted fingers tried to splice the broken thread; but she got the thread entangled on the iron points of the card, and there was a breathless interval in which we all hung silent about her, fearing for her success. In another moment the thread was set free and spliced, the good old dame bowed herself to her work, and the wheel went round with a swift triumphant burr, while the crowd heaved a sigh of relief. That was altogether the prettiest thing I saw at the Centennial.[53]

When, later in the spring of 1878, Eakins chose to exhibit *In Grandmother's Time* at the Society of American Artists, he demonstrated his belief that the work showed both his skill with the realistically portrayed figure—evidence of his French training—and a modern or at least youthful sensibility. Where does this modernity, at least as seen by Eakins and his contemporaries, lie? Perhaps the answer can be discerned in the contrast with the work that he showed later that spring at the more tradition-oriented National Academy of Design: a detailed oil on panel from 1876 called *The Chess Players* (fig. 85). Amid a series of similarities—small size, dark tonality, depiction of an interior space—some important distinctions between the two works emerge. Foremost is the much greater extent and clarity of the background in *The Chess Players*, for which Eakins established a fully developed perspective plan that reveals space in an ordered, rational fashion.[54] He then filled this space with carefully detailed objects possessing haptic qualities as convincing as those in many seventeenth-century Dutch genre scenes. Also important is the fact that the three figures in the scene are engaged communally, creating a masculine tale of calculation and appraisal set in a readable, middle-class interior of the day.[55]

By contrast, *In Grandmother's Time* seems to draw the viewer away from narrative and toward contemplation of the artist's skill as a creator of a beautiful thing: "painting," as

Cook noted, "for painting's sake."[56] Throughout the later nineteenth century, artists found that portrayals of women, often surrounded by differently textured materials, provided a receptive showcase for technique. We see this in a raft of paintings—principally by such fashionable European painters as Fortuny, Giovanni Boldini, Raymondo de Madrazo, Zamacoïs, Alfred Stevens, and their followers—that were avidly praised and collected by Americans in the 1870s and 1880s. Even such modernist icons as James McNeill Whistler's *Symphony in White, No. 1 (The White Girl)* of 1862 (National Gallery of Art, Washington, D.C.) subscribe to these concerns.[57] It was this same combination of femininity, chronological and class distance, and technique that established the popularity of the most noted painting of the Society's exhibition: William Merritt Chase's *Ready for the Ride, 1795* (fig. 86).

Eakins evidently believed that *In Grandmother's Time* well represented his talents, for he sent it to at least four more exhibitions. In the end, his confidence was rewarded. In May 1879 the newly founded Smith College Museum of Art acquired the painting, the first of only three works by Eakins that would be purchased by a museum in his lifetime.[58] Together with the earlier sale of *Seventy Years Ago*, the commercial potential of the fancy-dress theme must have been evident to the artist, since he encouraged several of his most talented female students to make similar old-fashioned works.[59]

Eakins treated spinning many times over these years. Few other subjects—especially among those activities that neither he, his family, nor his friends practiced—lured him so concertedly. This fascination came, in part, from other art. Spinning was the foreground subject of Velázquez's *The Fable of Arachne (The Spinners)* (fig. 34), a painting that impressed the young artist as "the finest piece of painting I have ever seen" when he visited Madrid in December 1869.[60] In nineteenth-century America, moreover, spinning had come to symbolize the nation's idealized past.[61] This was especially true after the publication in 1858 of Longfellow's "Courtship of Miles Standish" with its climactic spinning scene—with which Eakins was probably familiar, since he had professed in 1867 that Longfellow "has written most beautiful poetry himself far better than any Englishman of today can even Tennyson."[62]

> So as she sat at her wheel one afternoon in the Autumn
> Alden, who opposite sat, and was watching her dexterous
> fingers,
> As if the thread she was spinning were that of his life and his
> fortune,
> After a pause in their talk, thus spake to the sound of the
> spindle.
> "Truly, Priscilla," he said, "when I see you spinning and
> spinning,
> Never idle a moment, but thrifty and thoughtful of others,

Fig. 86. William Merritt Chase, *Ready for the Ride, 1795*, 1877. Oil on canvas, 54 x 34". Union League Club, New York.

Fig. 87. John Rogers, *Why Don't You Speak for Yourself, John? (Courtship of Miles Standish)*, 1885. Bronze, 21¾ x 16¼". The New-York Historical Society.

Fig. 88. Henry Ossawa Tanner, *Spinning by Firelight—The Boyhood of George Washington Gray*, 1894. Oil on canvas, 44¼ x 66¼". Yale University Art Gallery, New Haven. Leonard C. Hanna, Jr., B.A. 1913, Fund.

> Suddenly you are transformed, are visibly changed in a
> moment;
> You are no longer Priscilla, but Bertha the Beautiful
> Spinner."[63]

From the sculptor John Rogers (fig. 87) to painters as diverse as Edwin D. White, Enoch Wood Perry, Edward Lamson Henry, Frank Millet, Stacy Tolman, Henry Ossawa Tanner (fig. 88), and Thomas Wilmer Dewing, numerous artists participated in the amalgamation of nostalgia, aestheticism, and patriotism as embodied in the spinning wheel.

The coincidence of the Philadelphia Centennial Exhibition and Eakins's choice to begin his own explorations of the past, with spinning as a tangible link, is suggestive. But although Eakins visited the fair at least seventeen times, he, unlike Howells, did not document any specific interest in the Old Colony House.[64] At the fair's art exhibition, however, which he surely did visit, he would have seen such Colonial-Revival or nostalgia-inducing works as George Henry Boughton's *Pilgrims Going to Church* (1867, The New-York Historical Society)[65] or Eastman Johnson's *Old Stage Coach*—the run-down vehicle in it is called *Mayflower* (1871, Milwaukee Art Museum).[66] The popularity of such works with both the public and the awards jury would have alerted him to a culture-wide interest in the American past. He also would have noted the prevalence and importance of history and historical genre painting among his contemporaries in France, England, Spain, Italy, and elsewhere.[67]

Eakins's personal susceptibility to the Colonial Revival, however, was apparently limited. He did not panel his studio in planks from Pilgrim homes, as did Frank Millet, nor retreat

to old homes or picturesque villages, like Childe Hassam. He did not follow J. Alden Weir's lead and paint studio still lifes with spinning wheels as props (c. 1878, Yale University Art Gallery, New Haven), nor form a noteworthy collection of antiques comparable to that of Edward Lamson Henry. Rather than gathering old things for the pleasure of their forms or historical associations and then contriving works inspired by them, Eakins seems to have acquired or borrowed only those props necessary for his own tightly focused projects, otherwise living very much in his own day. All the themes that lie deep within the Colonial Revival's antimodernist impulse—a glorification of handicrafts over modern technologies, of rural over urban existences, of simple rather than competitive relationships—are far distant from the way Eakins lived and practiced his art.[68]

The lure of spinning for Eakins, more than Colonial-Revival inspiration, reveals an interest in the tool itself—its treadle and rotating wheel, for instance, relating to his youthful mechanical drawings and ever-growing concern with the depiction of motion (culminating in his *May Morning in the Park* and motion-photography studies). The quiet, steady process of transformation from raw fiber to useful thread must also have appealed to this grandson of a weaver and son of a calligrapher (the latter, after all, spins out ink in threads of meaning). He would also likely have been sympathetic to the skill that spinning required; as with his other early works—be

Fig. 89. Thomas Eakins, *The Spinner (A Sketch)*, 1878. Oil on canvas, 30³⁄₁₆ x 25³⁄₁₆". Worcester Art Museum, Massachusetts.

they of rowers, hunters, or musicians—Eakins admired the trained adept's coordination of mind, body, and equipment.[69]

In December 1878 a new oil on a spinning theme debuted to the public at the Social Art Club in Philadelphia. Joining the often-seen pair of watercolors of *Fifty Years Ago* and *The Dancing Lesson*, *The Spinner (A Sketch)* (fig. 89) shows Nannie Williams, one of Eakins's favorite models—she had posed for a figure in *William Rush*—with the same props and seen from the same point of view as the older woman in *In Grandmother's Time*.[70] The painting's status as a sketch is clear: the handling of the paint is bold, with no portion of the figure worked up to even a rough finish; the lower region of the dress is only cursorily sketched in; and the canvas bears visible squared-off lines for transfer.[71] That Eakins chose this work for exhibition, of all the figure or genre studies then in hand, indicates his concern that viewers associate him with old-fashioned themes. Further, it both served to remind Philadelphians of related works seen over the past year and promised that new paintings along similar lines were on the way.

It was a promise that for several years went unfulfilled. *The Courtship* (fig. 90), for which *The Spinner* was a large-scale study, would have been among Eakins's most anecdotal and, if those parts of it that are now finished are any indication, most beautifully worked paintings. It would also have been the most literary and ambitious of Eakins's old-fashioned genre scenes. In any event, Eakins neither completed nor exhibited the whole composition.[72] Instead, he continued in 1879 and 1880 to show already familiar sporting and old-fashioned works, along with a few older portraits. His only new exhibition pieces were the now lost watercolor *A Quiet Moment*, which apparently featured an older woman in contemporary dress sewing, and *A May Morning in the Park (The Fairman Rogers Four-in-Hand)* (pl. 51)—both expansions of the type of work for which he was known.[73]

In 1881, however, Eakins showed seven new pictures: four depicted contemporary life, while three (two watercolors and an oil) portrayed women from seemingly bygone times.[74] Together with the familiar *Fifty Years Ago* and *William Rush*, these three accounted for more than one-third of Eakins's public appearances in 1881. Each was ready for exhibition by late January.

Spinning (fig. 91), signed and dated 1881, was at the American Water Color Society in New York, offered for sale at one hundred dollars. In hues of brown and gray, it shows Margaret Eakins in the most nearly frontal of any of the spinning scenes, and thus the closest to being a formal homage to Velázquez's *Spinners*. An oil study (fig. 92) records the painter's efforts to position Margaret in relation to the wheel and the hank of unspun flax to the right.[75] In the watercolor, Eakins used the

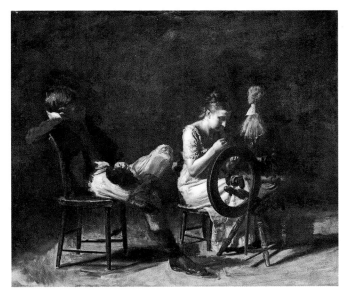

Fig. 90. Thomas Eakins, *The Courtship*, c. 1878. Oil on canvas, 20 x 24". Fine Arts Museums of San Francisco. Museum purchase by exchange: gift of Mrs. Herbert Fleishhacker, M. H. de Young, John McLaughlin, J. S. Morgan and Sons, and Miss Keith Wakeman.

final configuration of the spinning wheel, as well as the prominent floorboards not only to establish space but also to focus attention on the spinner's downturned face and busy hands. Everything contributes to this emphasis—the framing cupboard and open door, no less than Margaret's smocklike dress that, apparently tied and pinned into place, evokes a generalized past and provides no distracting details.[76] It is the work of spinning, and the mental and physical energy necessary to do it—the "quiet concentration and simplicity" noted by one reviewer[77]—that is crucial.

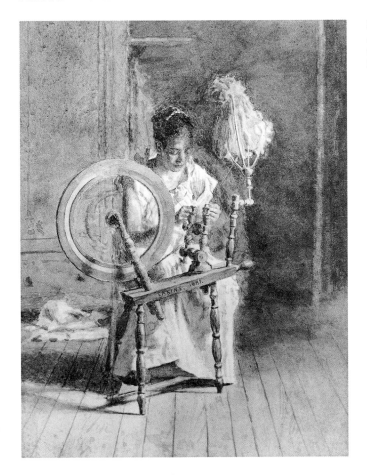

Fig. 91. Thomas Eakins, *Spinning*, 1881. Watercolor on paper, 15⅝ x 10⅝". Private Collection (pl. 91).

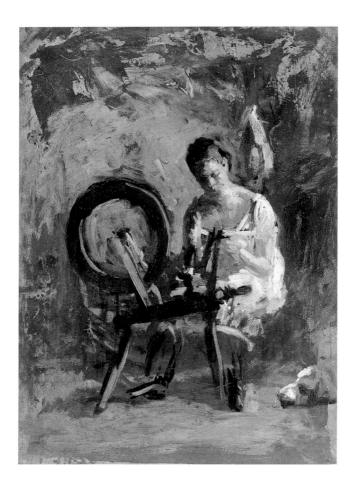

Fig. 92. Thomas Eakins, *Spinning: Study*, c. 1881. Oil on panel, 14⅛ x 10⅜". Charles Bregler's Thomas Eakins Collection, Pennsylvania Academy of the Fine Arts, Philadelphia. Purchased with the partial support of the Pew Memorial Trust and the Henry S. McNeil Fund.

A second watercolor of the same sitter, also signed and dated 1881, was at the Boston Art Club by the end of January; it was offered for sale at one hundred dollars. *Homespun* (fig. 93) shows the spinner from the back, her hands and face all but hidden from view. A large open cupboard behind her, filled with crockery of various shapes and colors, closes off more than half the background; the remainder of the space is dark, stippled shadow. In many ways it seems the opposite of *Spinning*, not a glorification of a specific activity, which is blocked from view, but instead an evocation of a quiet, simple place—perhaps a kitchen—filled with useful things.

The third new work, also seen in January at the Boston Art Club, was the small oil—about the same size as *Homespun*—called *A Study* (later known as *Retrospection*) (fig. 94). It is a simple composition: a young woman, wearing an elegantly suggested high-waisted gown, sits in a Chippendale-style chair.[78] She rests her hands on her lap, her head nodding downward slightly, her face in shadow. Stillness and near-tangible nostalgia pervade the panel.

In spite of its modest scale and quietness, *A Study* attracted much attention. The writer for the *Daily Evening Transcript* in Boston declared that "two brilliant little single figure subjects" by Gaugengigl and Eakins disputed for the title of "gem of the

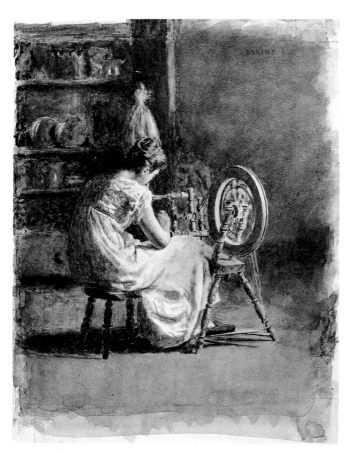

Fig. 93. Thomas Eakins, *Homespun*, 1881. Watercolor on paper, 13⅞ x 10¾". The Metropolitan Museum of Art, New York. Fletcher Fund, 1925 (pl. 90).

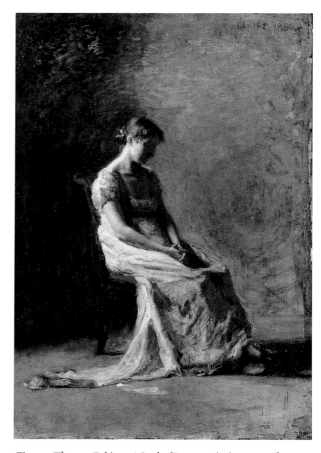

Fig. 94. Thomas Eakins, *A Study (Retrospection)*, 1880. Oil on panel, 14½ x 10⅛". Yale University Art Gallery, New Haven. Bequest of Stephen Carleton Clark, B.A. 1903.

exhibition," then declared in favor of the "solid and real, yet soft and tender 'presence' of the figure in Mr. Eakins's study," calling it "an extraordinary bit of painting for these days" and the "highest point of achievement in the exhibition."[79] The pseudonymous Greta felt likewise and contrasted it to the dash of William Merritt Chase. Citing the "sumptuous, boldly modulated color, glowing from hangings, stuffs, bric-à-brac, and various spoils of the Orient" in Chase's *Interior of the Studio* (1880, Saint Louis Art Museum), which had been given the exhibition's "place of honor," Greta continued: "But the gem of the show is a little study of a female figure—simply a girl seated, clad in satin, with bare bosom and arms. The light plays around arms, bosom, and head with just such clinging tenderness and sweetness of effect as it might around the sweet and tender actuality of such a presence." The critic concluded: "Fortunate would that eminent young master be could he often produce a thing in equal degree combining truth and charm, sentiment and reality, delicate beauty of color in depth of subtle shadow."[80]

When *A Study* was shown at the National Academy of Design, it again won singular praise: "For workmanship alone, no picture is more interesting or shows greater ability," wrote one critic; "a little study of a girl, beautifully treated for effects of light," opined another.[81] Acclamation was not, of course, universal. Shinn, Eakins's usual defender and advocate, here delivered a negative blow that, coming at the end of his article, carried all the more force—closing with what would become the quintessential critical response of the painter's career:

> Regret, however, is plainly justifiable in the case of Mr. Eakins's "study" of a model in a low-neck white dress, whom he has painted with such precision of fidelity as to have seemingly begrudged her the slight and evanescent beauty she might have disclosed to less searching eyes. It is a characteristic picture; nothing here is more powerful, more admirable in a dozen ways—or more irritating.[82]

Never again did Eakins attempt such an evocative, atmospheric figure work.[83] It would be more than a decade before such Americans as Thomas Dewing would treat the seated female model with comparable enigmatic delicacy abstracted from all but the most ethereal of settings.

In 1882 Eakins was at the top of his professional form, his teaching career well established, his research activities under way, and his art widely recognized. For his exhibition works—a larger number than ever before—he gathered a few scenes of outdoor recreation from the past decade (his baseball watercolor and paintings of the Biglin brothers rowing), a larger group of works that expanded the industrial fishing theme, *William Rush Carving His Allegorical Figure of the Schuylkill River,* a newly completed portrait of his father at work (*The*

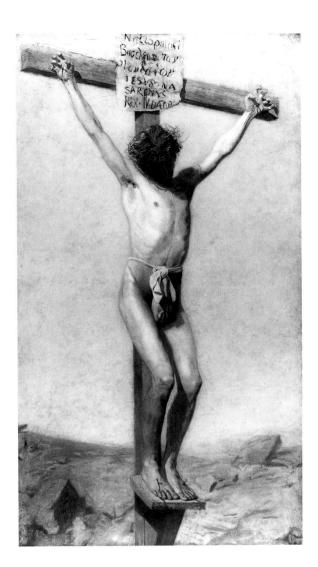

Fig. 95. Thomas Eakins, *The Crucifixion,* 1880. Oil on canvas, 96 x 54". Philadelphia Museum of Art. Gift of Mrs. Thomas Eakins and Miss Mary Adeline Williams, 1929 (pl. 54).

Writing Master), along with the spinning watercolors and *A Study.* The selection demonstrates versatility and breadth of subject, with recent works, most no more than a year old, dominating. Of these, one work shown for the first time in 1882, however, stands apart: the large-scale *Crucifixion* (fig. 95)—not merely Eakins's second history painting but an ambitious assay into one of the central themes of Christian art.

Eakins was not a religious man. His early letters reveal a virulent anticlericalism, and later in life, in spite of friendships with several of Philadelphia's most distinguished Catholic clergymen, the painter remained aloof from traditional religious observances.[84] Scholars have hypothesized that he turned to the subject largely for the opportunity of painting a nude in natural light. The uncompromising realism of the tortured body—most pathetic in the tension of the nailed and bleeding hands—has also been associated with his anatomical studies.[85]

But underlying these academic reasons for the subject's appearance in Eakins's oeuvre must be the artist's extreme ambition, witnessed not only by the subject's tradition but also by its immense size. Eakins here challenged comparison with the greatest old masters, as well as with many of his contemporaries, notably his own Parisian teacher Léon Bonnat (fig. 28).[86]

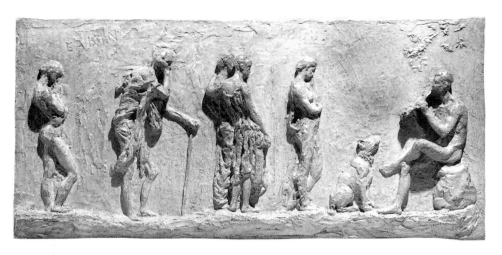

Fig. 96. Thomas Eakins, *Pastoral*, 1883–84. Plaster with transparent brown patina, 11¾ x 24 x 2³⁄₁₆". Philadelphia Museum of Art. Purchased with the J. Stogdell Stokes Fund, 1975 (pl. 120).

American and British precedents of large-scale religious works, many with a prominently displayed male nude, abounded. Some were historical and continuously accessible to Eakins, such as Washington Allston's *The Dead Man Restored to Life by Touching the Bones of the Prophet Elisha* (1811–14) at the Pennsylvania Academy. Others were more recent and controversial: a version of William Holman Hunt's *Shadow of Death* (1870–73, Leeds City Art Gallery), a proto-crucifixion full of pre-Raphaelite detail, had been seen in Boston late in 1879, during which time it created a ruckus in the press.[87] Major efforts by such of his contemporaries as Frank Moss and Charles Sprague Pearce, too, were frequently commented on as part of the Academy's annual exhibitions.[88] More relevant to the development of his own reputation was the work of another ambitious Gérôme-trained American figure painter, J. Alden Weir. Weir, returned from Paris only in 1877, was a founder and an officer of the Society of American Artists, his works there being among those most extensively noted by critics. In the Society's spring exhibition of 1880, he showed his sole religious canvas, the large-scale *Good Samaritan* (1880, St. Paul's Episcopal Church, Windham, Conn.).

In whatever manner these served as catalysts, in the summer of 1880 Eakins painted his *Crucifixion*. He chose not to show it until the Society's Supplementary Exhibition in the spring of 1882, when it proved controversial. Most critics, on first seeing it, had difficulty assessing it as anything other than an anatomical study. Its lack of "reverential light" and its uniform focus on all the details of the body prompted the writer for the New York *Art Journal* to conclude that "the ideal which everyone holds is degraded, and we realize that, in an age tending so strongly toward realism, there are subjects which should be left untouched."[89]

While negative reviews dominated, a few writers, including the prescient Mariana Griswold van Rensselaer, sounded a different note; she called it "most prominent" among the pictures of "capital importance," concluding:

It is extremely difficult to put into words the impression made by such a picture, so strong, so repulsive in some ways, yet so deeply pathetic, partly by reason, perhaps, of that very repulsiveness. I can only speak for myself, when I say that after seeing a hundred crucifixions from modern hands this one seemed to me not only a quite original but also a most impressive and haunted work.[90]

Eakins was clearly proud of the painting, exhibiting *The Crucifixion* frequently in later years and writing in 1908, "I think the picture one of my very best."[91]

In 1883 the objects Eakins showed in various exhibitions included already-seen figural works of women in both old-fashioned and contemporary dress, and of men indoors and out. The new works, however, even more than in previous years, signaled a departure for him. While each showed a scene from the distant past, of greater note was their medium: relief sculpture, a wholly new art form for Eakins to put before the public. Although many painters of the era practiced sculpture, few showed it in prominent exhibitions—notable exceptions being Frederic Leighton (then president of the British Royal Academy of Arts), Eakins's master Gérôme, and (so different from Gérôme and so uncannily similar in his interests to Eakins) Edgar Degas.[92] The profound anatomical knowledge underlying these men's art, honed and rigorously refined, must have allowed such polytechnical confidence. Eakins, the

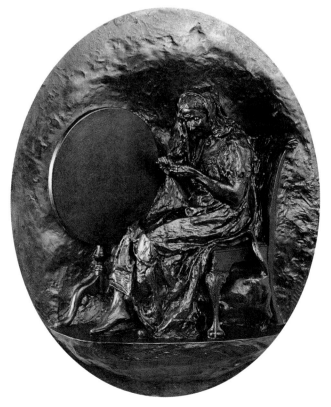

Fig. 97. Thomas Eakins, *Knitting*, 1882–83. Sand-cast bronze, 18⁷⁄₁₆ x 14¾ x 3½". Philadelphia Museum of Art. Gift of Charlene Sussel in memory of her husband, Eugene Sussel, 1992 (pl. 93).

most prominent academician in America, apparently felt qualified to undertake a similar virtuosic display.

Thus in October, at the Second Annual Exhibition of Sketches and Studies at the American Art Association (New York), he exhibited *Sketch in Plaster (Pastoral)*, the relief now known as *Pastoral* (fig. 96)—an elegiac scene of music-making in ancient Greece enlivened by a processional format. Among all of Eakins's known exhibited works, *Pastoral* is his sole effort in the then-popular classical mode. The historic references of the other two reliefs shown later that month in Philadelphia were more familiar. In their theme and basic format, *Knitting* and *Spinning* (figs. 97, 98) related directly to *Homespun* and *Seventy Years Ago*. When Eakins exhibited them at the Pennsylvania Academy, each bore the subtitle *Panel in High Relief, for open fireplace, In plaster*, revealing their origins as architectural commissions. Clark, in the *Daily Evening Telegraph*, appreciated them unreservedly:

> These pieces were prepared with a view to being cast in bronze [actually, carved in stone] as accessories to an elaborate piece of interior decoration—the artist's intention being to convey an idea of domesticity. This idea has been very beautifully carried out in both instances, while the workmanship on both panels is exquisite. Mr. Eakins is easily the first of American artists, in certain very important particulars, and these beautiful bas-reliefs ought to do much to advance his reputation with a general public which has been rather slow in showing its appreciation of his great merits, for they ought to be—what perhaps some of his paintings have not been—easily and entirely comprehensible to the least instructed understanding. The making of these pieces will be a happy augury if it means that there is a prospect of a really great artist like Thomas Eakins being in the future called upon by the architects who are engaged in constructions of importance to aid them in their labors.[93]

After this happy acclamation, Eakins sent the reliefs to the Society of American Artists for its spring exhibition in 1884. They were rejected. Eakins was genuinely shocked and wrote in protest to sculptor and jury member Augustus Saint-Gaudens. The sculptor professed innocence: "I write simply to say that I am in no way responsible for the rejection of your charming little reliefs. I was astonished that they were not received when I saw them after their rejection—I resigned from the jury two months ago."[94] Within the week Saint-Gaudens wrote again: "I think I have already written you how great an injustice I think has been done by the rejection of your little reliefs. I do not see how there could have been a moment's hesitation about them."[95] This was cold comfort for Eakins, who did not again attempt a domestic decorative commission. Barring the commission in 1892 for the bas-reliefs of the Trenton Battle Monument, these were his last historical works for public view (pls. 199, 200).[96]

Thomas Eakins was a profoundly ambitious and directed man; the whole course of his art and life reveals this. In the years around 1880, one of his goals was to be recognized as the most accomplished and versatile American figural artist of his generation. The way was slow, as his friend Shinn admitted in late 1882, writing in response to an exhibition that included *The Crucifixion* and the two spinning watercolors of 1881:

> This artist's works have won the heartiest appreciation of a select few, who have the culture necessary for the proper understanding of qualities such as no other artist on this side of the Atlantic possesses, but he assuredly is not popular with the crowd. Whether or no he would be able to win praises—and halfpence—where they are now denied, were he to make some concessions to the popular weakness for the more superficial aspect of beauty may be considered an open question which is likely to remain open, for the artist either cannot or will not concede anything.[97]

Eakins indeed made no concessions, producing instead a series of newly conceived works that stood apart from those of his colleagues by dint of their seriousness, their sincerity, and their method.[98] Among these, through his repeated and consistent decision to place them before the public, Eakins gave his historically themed works—colonial, classical, or religious—pride of place.

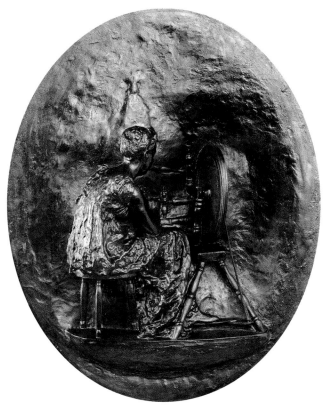

Fig. 98. Thomas Eakins, *Spinning*, 1882–83. Sand-cast bronze, 18¼ x 14¹¹⁄₁₆ x 2¹¹⁄₁₆". Philadelphia Museum of Art. Gift of Charlene Sussel in memory of her husband, Eugene Sussel, 1992 (pl. 92).

Photographs and the Making of Paintings

MARK TUCKER AND NICA GUTMAN

FROM ITS EMERGENCE, photography shaped the standards and expectations of artists, critics, and the public as to what paintings could and should be. Among painters who responded most directly to the challenges and potential of photographic vision in the period of Eakins's training and activity as an artist were those working in highly representational academic styles. One of the foremost attractions for such painters, including Eakins, was photography's capacity to reconcile immediacy and perfect accuracy, to "preserve records of transient and beautiful effects, of difficult poses, and of unusual combinations of line."[1] Photography also held the potential to assist with or even substitute for a fundamental practice in academic painting—drawing.[2] Even to those who criticized photographic qualities in painting, the usefulness of photography for gathering and studying subject matter was undeniable, "plac[ing] at the artist's disposal a vast amount of information about detail . . . quite unattainable with the pencil."[3] These advantages were of central relevance to painters in the French academic realist and naturalist milieus

to which Eakins was drawn and in which he trained in the late 1860s.[4] Further, for naturalist painters, whose work was committed to the dispassionate and objective treatment of contemporary subjects, the modernity that photographic vision conferred on a painting was valued both for its suggestion of contemporaneity and as a release from stale academic formulas. As the pursuit of photographic "scientific" literalism (and the direct appropriation of photographic images) in naturalist painting of the 1870s attests, Paris, toward the end of the previous decade, had been a center of mounting interest in linking the visual qualities and practical advantages of photography to painting. Eakins was there and surely regarded the prospect with interest.

Artists training in Paris in the late 1860s were quite aware of the use of photographs by established painters (including Eakins's teacher Jean-Léon Gérôme and also, apparently, Léon Bonnat).[5] They were no doubt also debating the possible and proper relationship between photography and painting, for set against the appeal of photography's aesthetic qualities

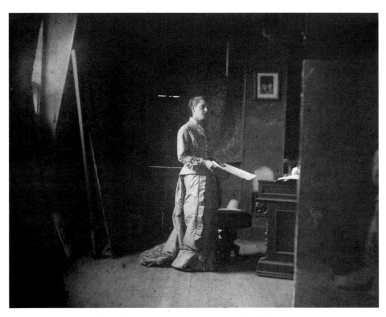

Fig. 99. Thomas Eakins, *[Margaret Harrison Posing for "Singing a Pathetic Song"]*, 1881. Digital inkjet print from original gelatin dry-plate negative, 4 x 5". Pennsylvania Academy of the Fine Arts, Philadelphia. Charles Bregler's Thomas Eakins Collection, purchased with the partial support of the Pew Memorial Trust (pl. 62). The partly completed painting (pl. 63) is visible at right.

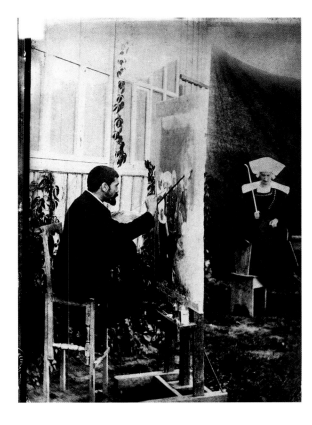

Fig. 100. Photograph of P.A.J. Dagnan-Bouveret working at Ormoy from a model on *The Pardon in Britanny*, 1886 (The Metropolitan Museum of Art, New York). Archives Departementales de la Haute-Saône, Vesoul, France.

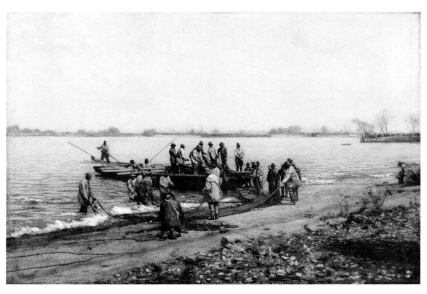

Fig. 101. Thomas Eakins, *[Shad Fishermen Setting the Net at Gloucester, New Jersey]*, 1881. Digital inkjet print from original gelatin dry-plate negative, 4 x 5". Pennsylvania Academy of the Fine Arts, Philadelphia. Charles Bregler's Thomas Eakins Collection, purchased with the partial support of the Pew Memorial Trust (pl. 71).

Fig. 102. Thomas Eakins, *Shad Fishing at Gloucester on the Delaware River*, 1881. Oil on canvas, 12 x 18¼". Ball State University Museum of Art, Muncie, Indiana. Elisabeth Ball Collection, partial gift and promised gift of the George and Frances Ball Foundation (pl. 72).

and practical applications were deeply rooted prejudices concerning the relationship between artistic talent or genius and academic skill in observation, recollection, composition, and drawing.[6] A painter's dependence upon photographs could be viewed as weakness in or underdevelopment of these fundamentals. Thus, while the increasingly common use of photographs by painters was widely recognized, it was rarely condoned unreservedly.[7] Apprehensions about others' judgments concerning the artistic legitimacy of using photographs as direct sources for paintings led some artists to understate their involvement in the practice.[8] Others worked secretly. In some cases artists even contrived to suggest that photographs were not of primary importance, and had photographs made showing them set up to work from the live model on paintings now known to have been based at least in part on photography. Though the creation of highly realistic paintings from monochrome photographs would require direct study of the subject to assign accurate color, the apparent purpose of these self-conscious "artist-before-the-motif" photographs seems to have been to maintain appearances of a more traditional approach, to suggest that increasingly photographic-looking paintings were not photograph-dependent (figs. 99, 100).[9] The advantages and attraction of using photographs proved irresistible to many nineteenth-century painters, despite risk of stigma, and the reliance on photographs as substitutes for drawn or painted studies or as aids during painting became ever more commonplace.

Like many of his contemporaries, Eakins was discreet regarding the extent and methods of his use of photographic studies. One critic responding to Eakins's *Crucifixion* (pl. 54) hailed him as "the greatest draughtsman in America."[10] In the face of such praise, Eakins must have sensed the risk of discredit were it to become widely known that some of his paintings made use of photography for the accuracy of their drawing (including *The Crucifixion* itself; the model for the work recounted Eakins's having made photographs for it).[11] One critic expressed open disdain for the practice, in which he assumed Eakins took no part, contrasting the power of Eakins's paintings with that missing in the work of "mentally barren, from photograph working" artists.[12] In 1930 Eakins's widow Susan stated: "Eakins only used a photograph when impossible to get information in the way he preferred, painting from the living, moving model. He disliked working from a photograph, and absolutely refused to do so in a portrait."[13] She herself had appeared both in Eakins's photographs and in paintings made from them, but her denial that Eakins used photographs as an aid in making paintings testifies to her misgivings about public acceptance of the practice decades after the fact.[14]

Based on the few known direct-source photographs used by Eakins before those in the Charles Bregler Collection were brought to light in 1985, there would have been little reason to doubt Susan Eakins's insistence that her husband disliked using photographs. The survival in the Bregler material of a significant number of photographic sources for Eakins's paintings is a seeming miracle, considering the apparent desire among those close to him to prevent any such direct comparison with his paintings. These photographs prove Eakins's intensive

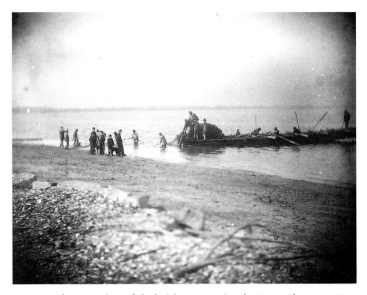

Fig. 103. Thomas Eakins, [*Shad Fishermen Setting the Net at Gloucester, New Jersey*], 1881. Digital inkjet print from original gelatin dry-plate negative, 4 x 5". Pennsylvania Academy of the Fine Arts, Philadelphia. Charles Bregler's Thomas Eakins Collection, purchased with the partial support of the Pew Memorial Trust (pl. 74).

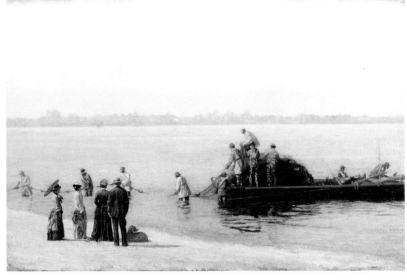

Fig. 104. Thomas Eakins, *Shad Fishing at Gloucester on the Delaware River*, 1881. Oil on canvas, 12⅛ x 18 ⅛". Philadelphia Museum of Art. Gift of Mrs. Thomas Eakins and Miss Mary Adeline Williams, 1929 (pl. 76).

involvement with photography was very much driven and guided by its potential application to the making of paintings. In fact, he used photographs as literal source images for paintings on a number of occasions; at the outset of the present study, however, the process linking photographs to finished paintings was unknown.

In technical examinations of Eakins's paintings based on extant photographic studies, we discovered working methods specific to his direct use of photographs. These same methods have also been identified in paintings for which source photographs are not known, leading us to conclude that Eakins's direct appropriation of photographic images was more widespread than previously believed. His work with photography is now one of the best documented and most ambitious instances of its use by a nineteenth-century painter as an extension of or substitute for traditional approaches to the creation and use of preparatory images.[15]

Eakins relied upon a number of different techniques and mediums to develop pictorial ideas. His preparatory work was often singularly thorough and complex, involving at times combinations of drawn, painted, or photographic studies of compositions, figures, or objects, as well as an occasional sculptural study. For the most part, the works produced for such preliminary study held little lasting interest for Eakins. The considerable effort that might be put toward preparatory work was justified by its end product: an image or set of images to be transferred to canvas or watercolor paper to provide a guide for the lay-in of paint. Eakins accomplished such transfer of drawn, painted, or photographic studies by a num-

ber of more or less traditional techniques investigated in previous technical studies.[16] We have identified two additional transfer techniques that relate exclusively to Eakins's use of photographs as source images for his paintings.

Eakins probably acquired his own camera in 1880,[17] and among the earliest paintings to utilize his photographic studies are the 1881–82 group of four oils and three watercolors related to shad fishing on the Delaware River at Gloucester, New Jersey. The techniques linking these photographs and paintings reveal an extraordinary vision and ingenuity and also provide a means for tracking the larger course of Eakins's use of photographs in painting.

Our study began with extremely close examinations of three oil paintings from this Gloucester group—two paintings of *Shad Fishing at Gloucester on the Delaware River* (pls. 72, 76) and *Mending the Net* (pl. 85)—using infrared reflectography (IRR), a technique often useful for capturing images of subsurface features of paintings, such as changes from one paint layer to the next or underdrawings that set out an entire composition or individual elements.[18] In the IRR images, pencil-drawn horizon lines (common in Eakins's paintings) were evident, but signs of his previously known transfer techniques were absent. Underdrawings were found, but not of a type previously seen in any Eakins work.

The underdrawings in these three paintings are faintly drawn in pencil and are direct transcriptions of major sections of photographic source images (figs. 101–4). The underdrawings show a consistent descriptive specificity, setting out detailed features from the photographs, such as the outlines of

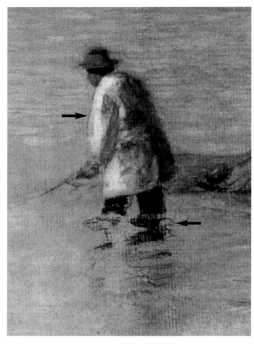

Fig. 105. Detail of figure from *[Shad Fishermen Setting the Net at Gloucester, New Jersey]* (fig. 103).

Fig. 106. Infrared reflectogram of figure from *Shad Fishing at Gloucester on the Delaware River*, Philadelphia Museum of Art (fig. 104). Arrows indicate pencil underdrawing of the figure and reflections in the water.

the foliage on the tree in *Mending the Net* or the light and dark patterns of reflections and foam in the water of the shad-fishing scenes (figs. 105, 106). The pencil underdrawing for the watercolor *Drawing the Seine* (pl. 87), a scene also set in Gloucester, is plainly visible to the naked eye and, like the underdrawing seen by IRR in the oils, is a detailed transcription of its source photograph, demarcating, for example, divisions between the lit and shaded areas of the figures, patches of grass and pebbles and debris in the foreground, and waves and foam in the water. The drawing for the watercolor records more detail than the

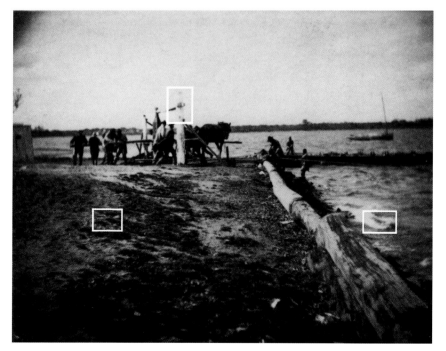

Fig. 107. Thomas Eakins, *[Shad Fishermen Hauling the Net with a Capstan at Gloucester, New Jersey]*, 1881–82. Albumen print, 3⅜ x 4⁵⁄₁₆". Collection of John J. Medveckis (pl. 86). The following details (figs. 108–10) of underdrawing in the watercolor *Drawing the Seine* (pl. 87) correspond to the marked locations.

Fig. 108. Detail of post (pl. 87). Arrows indicate pencil underdrawing.

Fig. 109. Detail of grassy bank from *Drawing the Seine* (pl. 87). Arrow indicates pencil underdrawing.

Fig. 110. Detail of breaking wave from *Drawing the Seine* (pl. 87). Arrow indicates pencil underdrawing.

underdrawings for the oils, reflecting the specific demands of the watercolor medium, the transparency of which required more accurate initial placement (figs. 107–10).

These underdrawings were not conventional drawings after the photographic images but direct tracings from them. Tracing from a photographic image onto an opaque watercolor sheet or primed canvas could have been accomplished by several methods.[19] The particular character of the drawings, however, made it clear that Eakins was doing something quite unexpected: he was projecting the photographic images onto his painting supports in order to make the underdrawings.[20] This practice, never before detected in Eakins's work, was hardly novel by the 1880s, or even by the time Eakins was

beginning to study art in the 1860s. Methods for producing enlarged photographic prints or tracings on canvas via projection were developing from at least the mid-1850s.[21] Eakins's tracing may have been accomplished easily using a magic lantern or similar device that would have been readily available.[22] In our own conservation work studying and restoring paintings, we have, on occasion, used photographic images projected onto paintings, and thus we recognized immediately the characteristics of tracing by this means. Even though a pencil line as faint as Eakins's in these underdrawings would have been visible in a dimly lit room as the projected image was being traced, the Gloucester underdrawings, for all their detail, exhibit a certain level of imprecision. This is partly

Fig. 111. Infrared reflectogram of figures from *Shad Fishing at Gloucester on the Delaware River*, Ball State University Museum of Art (fig. 102). Arrows indicate pencil underdrawing.

Fig. 112. Detail of figures from *Shad Fishing at Gloucester on the Delaware River*, Ball State University Museum of Art (fig. 102).

Fig. 113. Thomas Eakins, *[Tree and Capstan at Gloucester, New Jersey]*, 1881. Digital inkjet print from original gelatin dry-plate negative, 5 x 4". Pennsylvania Academy of the Fine Arts, Philadelphia. Charles Bregler's Thomas Eakins Collection, purchased with the partial support of the Pew Memorial Trust (pl. 83). Source photograph for the tree in *Mending the Net* (pl. 85); marked area corresponds to the projected and traced pencil underdrawing in figure 114.

Fig. 114. Infrared reflectogram of meandering pencil underdrawing for the tree from *Mending the Net* (pl. 85). The lack of distinction between outlines of forms and negative spaces within and around them is typical of tracings.

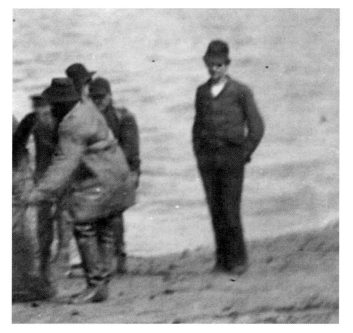

Fig. 115. Detail of figures from *[Shad Fishermen Setting the Net at Gloucester, New Jersey]* (fig. 101). Source photograph for *Shad Fishing at Gloucester on the Delaware River*, Ball State University Museum of Art (fig. 102).

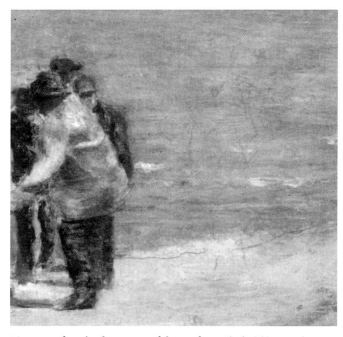

Fig. 116. Infrared reflectogram of figures from *Shad Fishing at Gloucester on the Delaware River*, Ball State University Museum of Art (fig. 102). The man standing at the right in figure 115 was one of two figures in the photograph omitted from the finished painting but traced sketchily in the underdrawing.

because Eakins's source images were often not in perfect focus, but also because he was tracing rapidly, anticipating that precise details could be added later during painting. The traced pencil lines frequently stray from or approximate the contours, not distinguishing between contours of solid forms and those of subordinate details (figs. 111, 112). Divisions drawn between areas of light and shade and outlines of forms and adjacent negative spaces are demarcated ambiguously (figs. 113, 114). The quality of the lines is typical of tracings: consistent in speed and weight, the lines are continuous across complicated forms and show negligible hesitation or emphasis throughout most of the image, no matter what is being drawn. All the Gloucester underdrawings we examined exhibit this detachment from descriptive conventions and traits of draftsmanship observed in Eakins's independent drawings.

Projection not only allowed efficient transfer of source photographic images onto his painting supports, but also simplified the process of combining elements from different photographs, an idea of much interest to Eakins. The complexity of the editing and the combinations of photographs for the Gloucester series varied. The simplest use of a photograph is the direct transcription of its unaltered content for the underdrawing, as seen in the watercolor *Drawing the Seine*. Eakins made significant compositional choices, however, in the two paintings of *Shad Fishing at Gloucester on the Delaware River*. Some figures in the source photographs were omitted from both finished paintings. They are present in the underdrawings but are traced sketchily, unlike those that would be executed in paint. Eakins indicated the position of the unused figures for possible reference, but their vagueness shows that he had already made editing decisions by the time the images were projected for transfer (figs. 115, 116).[23] In the underdrawing of the Philadelphia *Shad Fishing*, the cursory indication of figures at the left in the photograph shows that Eakins had determined they would not be included in the painting (fig. 117). In this case, however, he was planning to substitute something else in that area; in the finished painting a different figure group occupies the left foreground. This grouping was introduced into the scene from a second photograph and the dog from a third (figs. 118, 119).[24] The method of transferring the figure group and dog did not, however, fit the pattern used for transferring the overall photograph of the shad-fishing scene onto the canvas before painting; indeed, the left foreground figures were painted onto the surface of the already partly completed painting. The difference in approaches led us to look more closely for signs of other transfer techniques used by the artist.

In contrast to the highly detailed traced underdrawings for many parts of the Gloucester oils, the left foreground figure group in the Philadelphia *Shad Fishing* and all the figures in

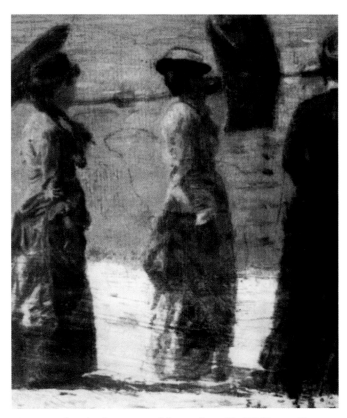

Fig. 117. Infrared reflectogram of figures from *Shad Fishing at Gloucester on the Delaware River*, Philadelphia Museum of Art (fig. 104). The underdrawn outline shows a dog seen in the main source photograph but omitted from the finished painting.

Mending the Net—among the most strikingly detailed and precisely painted in all of Eakins's work—show no evidence of underdrawing whatsoever, nor the use of any other transfer technique known to have been used by him. Eakins's standard for the sharply defined realism of these figures and their absolute fidelity to the photographs would have demanded the use of a precise guide. No drawing was detected by IRR, however, or by microscopic examination of small gaps between paint strokes or of translucent thin passages or blended soft contours, where underdrawing is sometimes visible in Eakins's paintings. What was noted, looking at the painting surface with a microscope at 15 to 30 times magnification, was a previously unnoticed type of auxiliary reference mark related to the transfer of source images: short, freehand horizontal and vertical lines, crosses, *T*s, or sections of contour, incised with a needlelike stylus into the paint at various stages *during* the painting of the figures. They occur at logical reference points for the construction of the figures: at extreme limits of the height or width of forms, junctions of external or internal contours, abrupt breaks in the direction of lines, and transitions between the lit and shaded sides of forms (figs. 120–24). It is not surprising that these marks eluded earlier studies; the size of most is well below the threshold of acute close vision, and Eakins himself would have needed to work with a magnifying

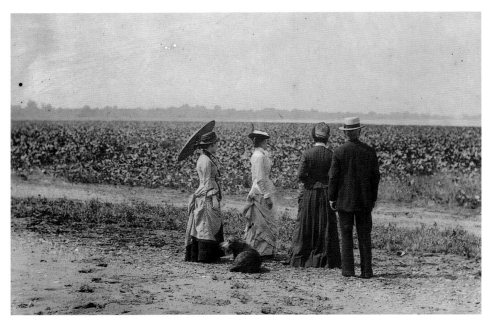

Fig. 118. Thomas Eakins, *[Eakins Family and Harry at Gloucester, New Jersey]*, 1881. Digital inkjet print from original gelatin dry-plate negative, 4 x 5". Pennsylvania Academy of the Fine Arts, Philadelphia. Charles Bregler's Thomas Eakins Collection, purchased with the partial support of the Pew Memorial Trust (pl. 75). Source photograph for foreground group in *Shad Fishing at Gloucester on the Delaware River*, Philadelphia Museum of Art (fig. 104).

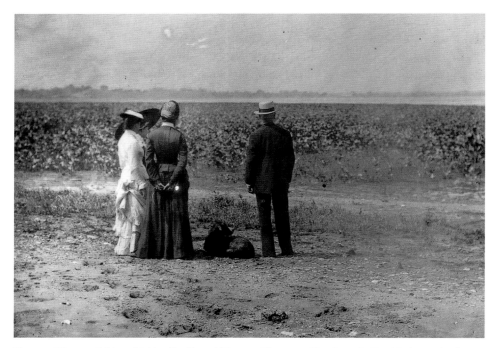

Fig. 119. Thomas Eakins, *[Eakins Family and Harry at Gloucester, New Jersey]*, 1881. Modern print from original gelatin dry-plate negative, 4 x 5". Pennsylvania Academy of the Fine Arts, Philadelphia. Charles Bregler's Thomas Eakins Collection, purchased with the partial support of the Pew Memorial Trust (1985.68.2.922). Source photograph for the dog to the right of lefthand foreground group in *Shad Fishing at Gloucester on the Delaware River*, Philadelphia Museum of Art (fig. 104).

glass or loupe of at least 10 times magnification to make use of them. They would have been undetectable even with a hand lens of the kind viewers interested in his technique might have used. Critics (and certainly other artists) were on the lookout for the secrets of the striking verisimilitude in paintings at the time; two of Eakins's works shown at the 1875 Paris Salon[25]

elicited the following wry remark from a French critic: "These two canvases [which M. Eakins has sent us from Philadelphia], each containing two hunters in a boat, resemble photographic prints covered with a light watercolor tint to such a degree that one asks oneself whether these are not specimens of a still secret industrial process, and that the inventor may have maliciously sent them to Paris to upset M. Detaille and frighten the *école française*."[26]

Unlike other transfer methods used to establish drawings on the canvas before painting, the incised marks were made at various stages during the buildup of paint. Eakins was obviously relying on repeated direct reference to the source image on the surface of the painting as he worked. As he had done for the traced underdrawings, Eakins was again projecting the source photographs onto the painting's surface. This had a truly revolutionary aspect: no actual drawing was ever made for the photographically accurate foreground group in the Philadelphia *Shad Fishing* and the single and grouped figures in *Mending the Net*. With this "virtual drawing" technique Eakins had severed the tie between preparatory drawing and perfection of complex, detailed form in paint.[27]

Associated with the incised reference marks are auxiliary baselines and verticals drawn with a pencil on the priming or incised lightly into the surface of areas worked up in paint before figures were introduced (fig. 125).[28] Although these lines had been noted in earlier studies, their purpose could only be speculated upon.[29] We now see that they were datums used to establish the placement and proper scaling of single or grouped figures from separate photographs to be combined in a single composition; they may have corresponded to lines drawn on lantern slides or reference photographic prints. Eakins first painted the setting for the figures, including the background against which they would be placed. In *Mending the Net*, for example, the landscape was partly finished, but not enough to hide completely the pencil datum lines on the priming that would be used as the figures were put in. In the Philadelphia *Shad Fishing*, the near riverbank and water were painted thickly and solidly before the left foreground group was superimposed; the datum lines in this case were scored lightly into the thick paint of the riverbank.[30] Working (as he had for the traced underdrawings) in a somewhat darkened studio, Eakins projected individual photographs of single figures or groups onto the paintings. He made his tiny marks, a few at a time, locating key reference points to paint a specific part of a figure. He then covered over the projector's lens and must have let in more daylight, to better judge colors being applied and to make it easier to see tones and details in the reference photographs. He projected the image repeatedly, as needed, to check the congruence of the painted image with the

Fig. 120. Incised horizontal mark at the tip of the parasol held by the left foreground figure in *Shad Fishing at Gloucester on the Delaware River*, Philadelphia Museum of Art (fig. 104).

Fig. 121. Detail of the left foreground group from *Shad Fishing at Gloucester on the Delaware River*, Philadelphia Museum of Art (fig. 104). Locations of incised lines in the paint are diagrammed in red. The blue line under the figures indicates where Eakins drew a very light pencil line across the still-soft paint surface during painting.

Fig. 122. Detail of hooks dangling from the basket carried by the far left figure in *Mending the Net* (pl. 85). Arrows indicate lines where a lower light-colored paint layer was revealed when Eakins incised the overlying dark paint of the basket to mark the locations of the hooks to be painted.

Fig. 123. Detail of far left figure from *Mending the Net* (pl. 85). Locations of incised lines in the paint are diagrammed in red. The concentration of marks made for a painted figure only 4⅜" in height shows Eakins's insistence on exactitude.

photograph and to make the next set of marks. As would be expected, he extensively marked complex forms like ears, hands, or drapery folds. He brought each part and then the whole figure to a fairly advanced state of completion before moving to the next. He made most of the marks in the lower layers of paint as the more basic forms and modeling were being established. Once the figures had been developed to a certain point, projection—and the corresponding incised marks—became less necessary for placing detail, which could be done accurately "freehand," working from the reference print only. The stop-and-start nature of the projection method would have posed no problem; on the contrary, this piecemeal

Fig. 124. Detail of figure group from *Mending the Net* (pl. 85). This group is derived from three separate photographs (pls. 81–83). Locations of incised lines in the paint are diagrammed in red. In the painting the taller child is 2¼" in height.

Fig. 125. Diagram of the locations of pencil datum lines beneath the paint in *Mending the Net* (pl. 85), as detected by infrared reflectography.

approach, whereby tasks were broken down and addressed in sequence, was consistent with Eakins's own inclinations and with his training under Gérôme.[31] The marks accumulated as Eakins worked on each figure, but they were also painted over as sections were completed. Since earlier marks were covered over, only a random selection of them remains visible, where subsequent paint buildup is not too thick or where they extend outside the figure outlines.[32]

The evidence of Eakins's projection of photographs for the Gloucester series, for which many exact photographs survive, can be applied to the investigation of Eakins's other paintings for which photographic sources are not known.[33] Three Gloucester oils and the watercolor *Drawing the Seine* are the only works examined thus far that exhibit clearly visible traced underdrawings. Two other watercolors (both in The Metropolitan Museum of Art) examined in connection with this study, *Taking Up the Net* (which has an exact surviving source photograph) and *Singing a Pathetic Song* (a watercolor after the painting [pl. 63], whose exact source does not survive within the known group of related photographic studies) have faint remnants of pencil drawing—very likely tracing—mostly erased by Eakins at some stage in painting.[34] Examination of additional oil paintings and watercolors by Eakins may reveal a wider use of traced underdrawings.[35]

The incised reference marks and auxiliary datum lines so specifically and distinctly related to Eakins's use of projected source photographs have been found in a number of other cases. Their presence in paintings for which source photographs are not known is positive evidence that photographs were nonetheless used. We have thus been able to detect Eakins's direct use of photographs in paintings from later and much earlier in his career than otherwise assumed. Confirmed use of painting from projection has been found in works as early as 1874 for which no photographs are known: for example, *Sailboats Racing on the Delaware* (pl. 10), the projected figures of which were superimposed on the nearly completed center and far right boats (fig. 126), and *Pushing for Rail* (pl. 11), in which figures were painted over the already well-established painting of the marsh setting. Two contemporaneous hunting pictures were seen at the 1875 Paris Salon and noted by the French critic cited above for their remarkable resemblance to tinted photographs. The critic's remark attributing the resemblance to "a still secret industrial process" was, as it turns out, not far from the truth. For the 1879–80 *A May Morning in the Park (The Fairman Rogers Four-in-Hand)* (pl. 51), a variety of preparatory and transfer techniques was used; most notably, the figure group riding on the coach exhibits incised marks and datums, indicating its origin in projected photographs (fig. 127).[36] Among paintings that date

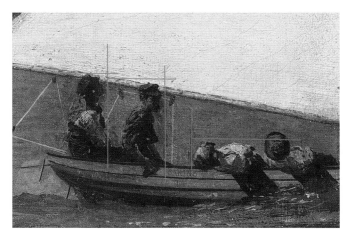

Fig. 126. Detail of figures in the far right sailboat from Thomas Eakins, *Sailboats Racing on the Delaware*, 1874. Oil on canvas. Philadelphia Museum of Art. Gift of Mrs. Thomas Eakins and Miss Mary Adeline Williams, 1929 (pl. 108). Locations of incised lines in the paint are diagrammed in red. The distance from the top of the leftmost figure's head to the gunwale of the boat is just one inch.

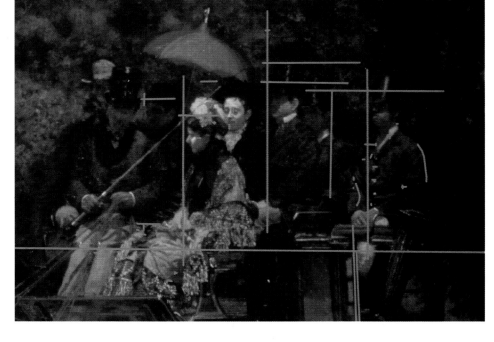

later than the 1881–82 Gloucester group, the three figures in *Arcadia* (pl. 119) and the figure in *An Arcadian* (Spanierman Gallery, New York) were painted from projected photographic images.[37] These two paintings were not completed; consequently the concentration of incised marks made in the priming and in paint layers was not covered over in finishing, and their number, complexity, and function remain more clearly visible (figs. 128, 129).

The use of photographs in the 1884–85 *Swimming* (pl. 149) has long been a subject of speculation, because none of the exact poses in the finished painting is recorded in surviving photographic studies. Directly matching photographs did once exist, however, as the figures exhibit incised marks and datums (figs. 130–33). The exception is the diver, who shows

no signs of projection marks, an absence that supports Susan Eakins's account that Eakins painted him from a small wax model.[38] Eakins's desire to conceal signs of his projection process is demonstrated in the swimming figure of the artist himself in the lower right of the painting: one of the incised marks extending into the water to the left of his eyelashes was carefully touched out at a later stage when Eakins deemed it to be too visible (figs. 134, 135).[39] *Swimming* shares with *A May Morning in the Park* the same hybrid process of preparatory work and execution. The landscape setting in *Swimming* was apparently derived, though not necessarily projected, from one of many photographs taken of the site (pls. 147, 148). The figures were projected and painted onto the partly completed landscape. The surface of the water, however, has the

Fig. 127. Detail of figures in carriage from Thomas Eakins, *A May Morning in the Park (The Fairman Rogers Four-in-Hand)*, 1879–80. Oil on canvas. Philadelphia Museum of Art. Gift of William Alexander Dick, 1930 (pl. 51). Locations of incised lines in the paint are diagrammed in red.

Fig. 128. Detail of pipes played by the reclining boy from Thomas Eakins, *Arcadia*, c. 1883. Oil on canvas. The Metropolitan Museum of Art, New York. Bequest of Miss Adelaide Milton de Groot (1876–1967), 1967 (pl. 119). Arrows indicate lines incised into the paint.

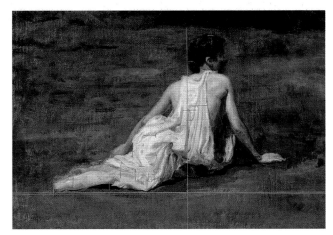

Fig. 129. Detail from Thomas Eakins, *An Arcadian*, c. 1883. Oil on canvas, 14 x 18". Spanierman Gallery, New York. Locations of incised lines in the paint are diagrammed in red. Long datum lines drawn in pencil are indicated in blue, incised ones in red.

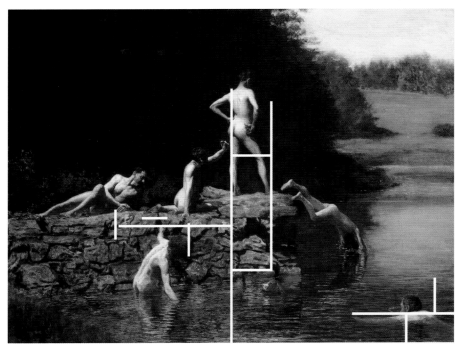

Fig. 130. Locations of incised and pencil-drawn datum lines in Thomas Eakins, *Swimming*, 1884–85. Oil on canvas, 27⁵⁄₁₆ x 36⁵⁄₁₆". Amon Carter Museum, Fort Worth, Texas (pl. 149).

Fig. 131. Detail of standing figure's right hand from *Swimming* (pl. 149). Locations of incised lines are diagrammed in red.

same schematic, "constructed" quality as that seen in the 1872 *Pair-Oared Shell* (pl. 4), suggesting that the reflective planes and recession in space of the wavelets may have been analyzed in separate perspective drawings. *Swimming* is the latest painting in Eakins's career on which we have seen marks indicating painting from projected photographs.[40]

If we consider as a group the paintings that exhibit projection reference marks, a pattern emerges. With a few possible exceptions, the technique has been used only for figures and, moreover, for figures of a small scale, ranging from sixteen inches for the standing figure in *Arcadia* to two-and-a-quarter inches for the central pair in *Pushing for Rail*. The size may have been determined by the need to keep the projector close to the picture—within arm's reach for Eakins—to facilitate the necessary repeated covering and uncovering of the lens as he worked. Again, our own experience with the use of pro-

Fig. 132. Photomicrograph of the paint surface of the standing figure's hand from *Swimming* (pl. 149), showing the intersecting horizontal and vertical incisions indicated in figure 131.

Fig. 133. Detail of reclining figure's head at left of *Swimming* (pl. 149). Locations of incised lines are diagrammed in red.

jected images as an aid to some restorations suggests this real constraint of the method. Where photographs are likely to have been used for larger images, such as *Singing a Pathetic Song* (pl. 63), *The Crucifixion* (pl. 54), or *The Meadows, Gloucester* (pl. 88), Eakins seems to have preferred traditional "squaring up" to transfer the image, drawing on the canvas from correspondingly squared photographs.[41]

Early in his career, by 1872 and possibly before, Eakins was using photographs in the preparation and execution of his paintings.[42] His general interest in synthesizing processes and images (photographic or not) is shown by the occasional occurrence of more than one technique for the study, layout, and transfer of whole compositions or of individual elements on a single canvas. Such occurrences also indicate another general inclination of the artist: to isolate problems at the outset and address each by the most apposite means.[43] Given his pragmatism in adopting and adapting imagery from various sources, it is not a straightforward matter to rule out the possibility that a painting was made, in whole or in part, by reference to photography. Even if the use of photographs was not as direct as in the Gloucester paintings, Eakins is known to have transferred photographic images to his painting supports by more traditional means such as squaring. The situation is complicated by the fact that Eakins seems to have ably combined photographic sources and techniques with more traditional approaches. The strongest indicator that a painting or parts of it did not rely on photographs is the existence of conventional drawn studies, which would have been superfluous if photographs were available. If preparatory drawings were made but do not survive, evidence specific to their transfer (such as pinpricking along contours) or the presence of other lines working out compositional or perspectival construction on the canvas itself argue against the use of source photographs for the specific pictorial elements involved.[44]

Photographs offered extraordinary advantages to painters interested in the pursuit of high verisimilitude, certainly, but also of new ideas driven by new processes. Such painters faced the fact that their creative use of photography would not be widely understood as rising to new challenges but rather as a way of circumventing conventional ones. An artist's use of raw information from photographs for rigorously analytical and artistically subtle ends is analogous to Eakins's application of his knowledge of anatomy or perspective (neither necessarily "artistic" in itself). The process was conceptually far removed from straightforward mechanical transcription. Eakins exercised specific choices both in making and editing source images. In some cases he omitted or substituted figures that were awkward formally or whose stare into his camera disrupted the sense of the artist's and viewer's passive observa-

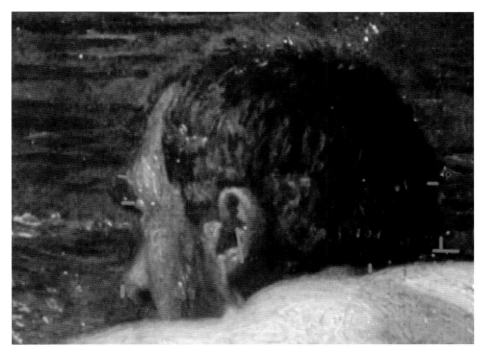

Fig. 134. Detail of Eakins's head at far right of *Swimming* (pl. 149). Locations of incised lines are diagrammed in red.

Fig. 135. Photomicrograph of the area around Eakins's eye from *Swimming* (pl. 149), showing the small stroke of gray paint he applied to touch out the horizontal incised line indicated by the arrows.

tion of the scene. In other cases he ambitiously integrated elements from two, three, four, or more source photographs, achieving a unity and plausibility, not to mention lyricism, that eluded most other artists who made the attempt. Raising the challenge to a higher level, Eakins combined photographs and traditional nonphotographic processes to realize strikingly photographic images that had never existed outside the painting. He also made artistic modifications in translating photographs

into paintings, occasionally altering contours in the interest of subtle emphasis and distinguishability of forms.[45] Although the direct use of photographs might ensure objective accuracy of forms, there was one vital element black-and-white photography could not provide for the painter: it could not describe colors, or even their correct relative values, because of the uneven sensitivity to colors of photographic plates of the period. Color still had to be studied, assigned to the image, and adjusted overall, and that fell squarely and fully within the realm of artistic sense and judgment.

Eakins's use of photographs in making his paintings was a deeply thoughtful undertaking driven by a personal, if not openly professed, belief in the full artistic validity of the process, and representing, lest there be any doubt, serious work. It is questionable, for example, whether the tedious process of making dozens of microscopic reference marks to paint a figure just a few inches in height was any sort of short-cut at all; it certainly gave a different quality of experience in the assembly, execution, and final appearance of an image, but probably saved little or no time. If it did not save time or effort, it did allow Eakins to do the job certifiably accurately—to his mind, therefore, perfectly—achieving effects of immediacy, transience, and specificity that made figures emblematic of their time, place, and circumstance. His success in this regard was appraised enthusiastically by his friend the critic Earl Shinn, who exclaimed after seeing *Mending the Net:* "The mere back view of a series of boatmen's pantaloons, whether of oil-cloth or of worn linsey-wolsey, broken into folds that explain a motion, or patched or stained with accidents that explain a toilsome life, are a positive revelation."[46]

In marked contrast to Susan Eakins's declaration that Eakins "disliked working from a photograph" for his paintings, present evidence of his creativity and enthusiasm for the processes he employed points to the fact that he reveled in working from, but more importantly *with*, photographs. As a conveyor of imagery, and as an artist's aid, photographs were the inevitable successor to objectifying devices with a long history in serious painting, such as Claude glasses and cameras obscura and lucida. Such devices helped artists isolate and analyze qualities of visual experience, countering the eye's too-willing accommodation to distortion or the tendency to overlook telling detail or grand design.[47] Eakins embraced photography as a modern extension of and an effective substitute for traditional means of visual characterization, analysis, and figuration and, as such, a tool that could both shape and serve the values of painting.

The Camera Artist

W. DOUGLASS PASCHALL

THOMAS EAKINS grew up with photography. He was born five years after Louis-Jacques-Mandé Daguerre's 1839 announcement of its invention, four years after Robert Cornelius opened Philadelphia's first commercial daguerreotype studio, and a bare month after the first installment of William Henry Fox Talbot's *The Pencil of Nature* introduced calotype photographs on paper to a general audience. Eakins was one of the first artists of whom a childhood photograph survives, affording us the very paradigm of Everyboy, little interested in providing a noble image for posterity (fig. 136).

Philadelphia in the 1840s was well positioned to embrace this new medium of representation, having evinced, at least from the earliest days of Charles Willson Peale's Philadelphia Museum, a particular fondness for pursuits that spanned the realms of science and art. The first to experiment with photography in the city were chemists, instrument makers, and opticians, joined in short order by a number of artists and engravers enthusiastic about the myriad new possibilities the medium opened up. Institutional support was immediate and substantial. As early as 1839 the venerable American Philosophical Society provided a forum to discuss locally produced daguerreotypes. That same year the Franklin Institute published a translation of Daguerre's process and, in 1840 and annually from 1843, exhibited American daguerreotypes and from 1849 paper photographs in the fine arts section of its Exhibitions of American Manufactures.[1] The Artists' Fund Society included a daguerreotype by New Yorker Alexander S. Wolcott in its fifth annual art exhibition in May 1840,[2] five months before the Franklin Institute's show; additional daguerreotypes were featured in their exhibitions in 1842 and 1843. The Pennsylvania Academy of the Fine Arts added its imprimatur: it hung the works of local photographers and Europeans Roger Fenton, the Bisson brothers, and Gustave Le Gray amid paintings, sculptures, and graphic work in its annual exhibitions throughout the 1850s.[3]

In late 1862, when the initial flurry of exhibitions subsided with the outbreak of the Civil War, the best local photographers, commercial and amateur, united to establish the Photographic Society of Philadelphia. The membership included

surgeons and chemists, engineers and inventors, attorneys and publishers, architects and artists, naturalists and teachers, whose wide-ranging interests propelled the camera to new uses and subjects and whose influence in the city's cultural and scientific institutions ensured those efforts would find respect and support.[4] In meetings and photographic outings, in public lantern-slide entertainments, and, from 1864, in the pages of its virtual house organ, the magazine *The Philadelphia Photographer*, members tested and debated new processes and equipment; they compared imagery submitted by colleagues around the world, urged greater artistry from commercial studios, and organized new venues to exhibit their works. When, years later, Eakins would take up the camera, it was largely in the

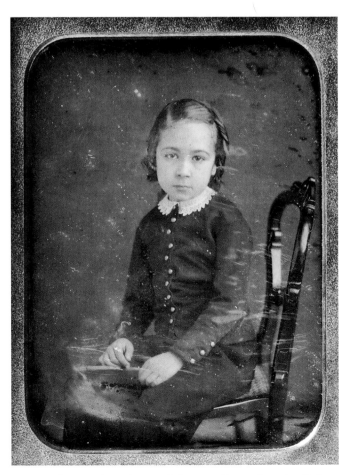

Fig. 136. Photographer unknown, *[Thomas Eakins at About Age Six]*, c. 1850. Quarter-plate daguerreotype, 3½ x 2⅝". Collection of Daniel W. Dietrich II.

239

Fig. 137. John Sartain, after a daguerreotype by Marcus Aurelius Root, *Robert T. Conrad, First Mayor of the Consolidated City of Philadelphia*, 1855. Mezzotint, 18⅜ x 14⅛". Philadelphia Museum of Art. Gift of Harriet Sartain, 1947.

society's meetings and exhibitions and in his casual conversations with its members that his own photographs and experiments would be measured.[5]

Growing up with interests in drawing and science, Eakins would have been keenly aware of the benefits photography offered to both fields of endeavor. Visiting the home of his childhood friend and classmate William Sartain, he could witness firsthand father John Sartain's and brothers Henry and Samuel Sartain's copying of daguerreotypes in their portrait engravings (fig. 137). John Sartain, Philadelphia's leading reproductive engraver, one-time magazine publisher, former president of the Artists' Fund Society, and a longtime director of the Pennsylvania Academy, was a figure whose activities held the aura of official sanction. The example he and his sons provided not only as artists openly using photographs but also as practicing amateur photographers must have been a potent one; John and Samuel Sartain were committed enough to join the Photographic Society of Philadelphia.[6]

Another potential role model in the early 1860s was Eakins's next-door neighbor Coleman Sellers, co-founder of the Amateur Photographic Exchange Club and the Photographic Society, a correspondent for photographic magazines in Britain and the United States, and the inventor of a kinematoscope to illustrate motion through photographs. An engineer by profession and a grandson of Charles Willson Peale, Sellers was a devotee whose predilections, like Eakins's, bridged disciplines. More

than the Sartains, Sellers could share news of other enthusiasts of the camera: in addition to professional colleagues, at least three relatives—his uncle Titian Ramsay Peale and cousins James Peale, Jr., and Howard Peale—were active photographers.[7]

Although the pursuit of photography at mid-century enjoyed public respect, even a certain cachet in its amateur incarnation, the use of photographs by artists as sources for works in more traditional mediums drew a welter of contradictory opinions. Evidence of the close rapport among photographers, painters, designers, and printmakers lay all about the aspiring painter as he embarked on his studies. Among the artists of Eakins's immediate acquaintance, Christian Schussele, a veteran of the Pennsylvania Academy, was known to have accompanied photographer Ridgway Glover on "rural rambles, gathering up studies for his canvas with the camera box, thus making photography a near and valuable friend."[8] And Thomas Moran, with whom Eakins was particularly close in the mid-1860s, often joined his brother John to photograph vistas in and around Philadelphia.[9] The situation was no different in Paris, where Eakins's mentor, Jean-Léon Gérôme, not only availed himself of this aid but freely advocated that students surround themselves with photographs and the paraphernalia of the subjects they would paint.[10]

Photography begged its use by artists. Indeed, it had in large part been invented for that purpose, as the prospectuses and announcements of Daguerre and Talbot attested.[11] Printmakers like the Sartains, illustrators for books and magazines, and painters of historical dioramas like the Philippoteaux family—producers, in short, of popular imagery—openly proclaimed their photographic sources as evidence of the veracity of their portraits and tableaux.[12] Painters aspiring to more rarefied circles in the fine arts, however, were generally more circumspect. As artists concentrated more and more on reproducing nature—a task at which photographs inherently were considered to excel—the very seat of originality, of creativity, of personal style was in question. When Peter Frederick Rothermel, for instance, another veteran at the Pennsylvania Academy and a friend of Eakins, was elected to the Photographic Society in its first months of existence in 1863, he declined the honor and the associations it might engender.[13]

This, then, was the context in which Eakins embarked on an artist's career upon his return to Philadelphia in 1870. For most of his early paintings, Eakins had little reason to master the intricacies of photography. At the time, the medium was dominated by the wet-plate collodion process, whose cumbersome equipment, slow exposure times, and constant need for clean water to keep plates moist before developing confined most photographers to their studios. The dark interiors of Eakins's Mount Vernon Street house or the mid-river vantage

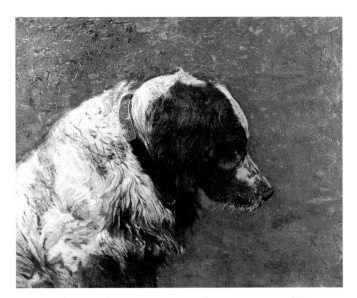

Fig. 138. Thomas Eakins, *Grouse*, 1872. Oil on canvas, 20 x 24⅛". Mint Museum of Art, Charlotte, North Carolina. The Harry and Mary Dalton Collection.

Fig. 139. Schreiber & Sons, *Photographs from Nature*, 1872. Frontispiece (detail) to *The Philadelphia Photographer*, vol. 10, no. 110 (February 1873). American Antiquarian Society, Worcester, Massachusetts.

points of his rowing paintings required more flexibility, and the artist relied on perspective drawings to organize his earliest compositions. It was on the Schuylkill River, however, that Eakins encountered the Schreiber brothers, fellow rowers and partners in a photographic studio specializing in animal studies. One brother, Henry, became a close friend, and it was almost certainly he who provided Eakins with first the photographs and then the means to use them as studies.

"I have made some genre portraits and some portraits of animals," Eakins wrote to Gérôme,[14] and it was for one of the latter, an 1872 painting of Henry Schreiber's dog Grouse that

the artist is first known to have copied a photograph (figs. 138, 139). Remnants of a grid incised into the paint indicate that Eakins squared the image for transfer, exploiting a traditional technique of enlarging from drawings to accommodate the latest and best technology of visual record-making. The same method of transfer was employed a year later when Eakins himself posed for another photograph, subsequently squared to match a grid he had added to a perspective drawing (private collection), from which to paint his own figure in *The Artist and His Father Hunting Reed Birds* (figs. 140, 141).[15] Between these two works, Eakins evidently resolved to take a more

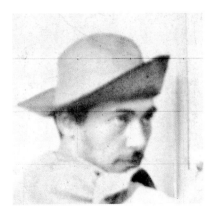

Fig. 140. Photographer unknown (possibly Henry Schreiber), *[Thomas Eakins in Hunting Garb]*, 1873. Albumen print, 2 x 2". Thomas Eakins Research Collection, Philadelphia Museum of Art. Gift of Mrs. Elizabeth M. Howarth, 1984.

Fig. 141. Thomas Eakins, *The Artist and His Father Hunting Reed Birds*, 1873–74. Oil on canvas, 17⅛ x 26½". Virginia Museum of Fine Arts, Richmond. Paul Mellon Collection.

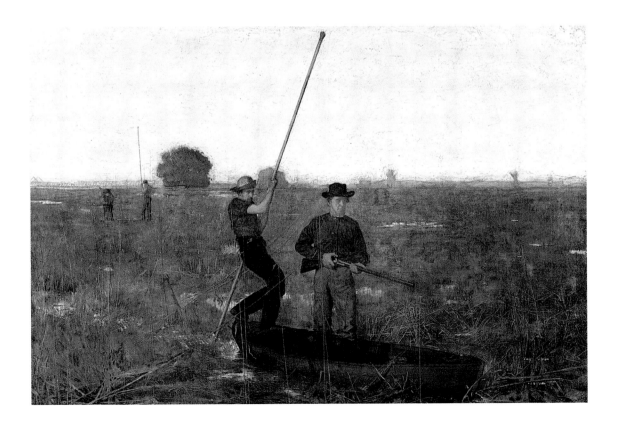

active role in shaping his sources. From a consumer of existing photographs—the limit of most painters' reach—he was becoming a choreographer of new ones, and by incremental steps over the ensuing decade, he would integrate photographs with increasing sophistication into his planning processes.

From his training at the Ecole des Beaux-Arts, Eakins had learned to see paintings as accretions, as collections of parts to be worked up in succession from sketches, memory, and life study.[16] The photographs Eakins used for *Grouse* and *The Artist and His Father* nestled easily into such a compartmentalized process and enabled him to appropriate subjects that could not maintain long poses. With featureless backgrounds, these photographs erased original contexts and accommodated the substitution of any other. They became the equivalent of study drawings, to be replicated and discarded. Confined at this early date to such a limited role, photography supplemented but did not appreciably challenge the academic methods Eakins had inherited.

By 1874 Eakins's confidence and ambitions were growing. He was submitting works to exhibitions, courting critics and dealers, and trying to establish a presence in the Paris Salon. He expanded his repertoire to attempt the populous compositions he had admired in Gérôme's work with two paintings of that year, *Sailboats Racing on the Delaware* (pl. 10) and *Pushing for Rail* (pl. 11). The placement of sportsmen in these flat landscapes could be laid out easily in rudimentary plans, but the distinctive poses of so many figures in constant motion defied simultaneous capture by any but photographic means. Though no photographs for these paintings are known to survive, evidence of their use remains in abbreviated tick marks that Eakins incised in the successive layers of his paint wherever figures were to appear.[17] The hunters and polers on their skiffs were probably recorded from the banks of the marsh, but the crews of the racing hikers, too distant from the shore and too swift to be caught in genuine competition, were almost certainly posed on land near the boathouses of Gloucester, New Jersey.[18] No grid being equal to the minute detail he sought in their representation, Eakins took advantage of photography's unique means of delivering images, and with a magic or catoptric lantern he projected those he had selected—from lantern slides, negatives, or prints—onto the canvases to indicate the positions and salient features of poses and costume.[19]

To the cognoscenti, such uses of photographs would have been accepted as a reasonable practice, even proof of diligent study, and Eakins was not the first to project photographs for transfer to canvas.[20] The broader audience for nineteenth-century art in the United States, however, was less sophisticated, less confident in their tastes, and all too likely to retreat to the safer refuge of the art of the past. Like most of his fellow artists, Eakins prudently concealed the evidence of his sources, and the marks he did not cover up were, to an unaided eye, invisible.[21] Many critics, if aware of the practice, as Eakins's friends Earl Shinn, William J. Clark, Jr., and Leslie W. Miller almost surely were, colluded in obscuring it, for they would attack only when they perceived it an offensive or jarring shortcut. The degree to which Eakins shaped nearly all the photographs he used—planning their content and vantage points to match his perspectives, manhandling the props, selecting (or assuming) the poses, and collaborating in their making—distinguished his efforts from the common run of studies. In his hands, photographs were less a convenience than a hard-won window on a modern subject matter that by its familiarity begged verification from the most objective witness at hand.

Following the flurry of experimentation in his hunting and sailing scenes, Eakins seems to have retreated temporarily from such direct recourse to photographs. The old-fashioned subjects and large portraits to which he turned in the mid-1870s called for fewer instantaneous effects, and the meager evidence we have that the camera was not banished entirely has come to us only in anecdotes. Alexander Stirling Calder, a Pennsylvania Academy student, recalled that Eakins "made some very fine photographs of Dr. Gross for his own use" in painting *The Gross Clinic* (pl. 16) in 1875—photographs that Calder and fellow pupil Charles Grafly borrowed when they competed on a monument to the surgeon.[22] Susan Eakins later shared with William Sartain the photographs of William Rush's sculptures her husband had gathered while working on *William Rush Carving His Allegorical Figure of the Schuylkill River* (pl. 41).[23] And John Laurie Wallace, the model for *The Crucifixion* (pl. 54), described the outing when Eakins erected a wooden cross in the New Jersey countryside, strapped Wallace to it, fitted a crown of thorns on his head, and photographed the result.[24] In none of these instances, though, was a photograph the single authority the artist employed, nor did any clearly replace a traditional step in the production of a painting. Dr. Gross grumblingly endured repeated sittings as Eakins labored on his canvas. Rush's sculptures were further studied in drawings and in small wax copies that could be rotated in different lights as their disposition in the painting demanded. And after their single outdoor session, Wallace posed in the studio for Eakins, who had set up the cross there for his model to revisit. For these projects, the camera and its products were merely tools like any other, a complement to the perspective drawings, costume sketches, sculptures, oil studies, and handwritten notes that contributed their respective parts to the paintings.

Nowhere were these increasingly hybrid sources more marked than in the preparations for *A May Morning in the Park*

(*The Fairman Rogers Four-in-Hand*) (pl. 51). This commissioned work was produced with the active collaboration of Eakins's patron Fairman Rogers, a prominent engineer, horseman, amateur photographer, trustee of the University of Pennsylvania, and chairman of the Committee on Instruction at the Pennsylvania Academy. By 1871 Rogers himself had attempted to make instantaneous photographs of horses in motion,[25] and he kept abreast of similar experiments by Etienne-Jules Marey in France and Eadweard Muybridge in California. When Muybridge circulated his first motion photographs of Leland Stanford's racehorses in 1878, Rogers and Eakins immediately tested the results by "reanimating" them in a zoetrope.[26] Finding the intervals between Muybridge's photographs to be inconsistent, Eakins traced the photographs to plot the trajectories of the horses' strides, redivided the whole into equal segments, and from his knowledge of equine anatomy reconstituted the appropriate poses for a successful turn.[27]

For his painting, Eakins measured the coach for a perspective drawing, made pencil and color oil sketches, and, very likely with Rogers's help, photographed the four-in-hand and its passengers. William Innes Homer has asserted that the horses' poses in the painting were based on four consecutive frames of Muybridge's sequence of the trotting Abe Edgington (fig. 142), but, if so, Eakins altered the positions of the hooves, perhaps to approximate his own trajectories or to match his and Rogers's photographs.[28] Eakins worked up the new poses in wax sculptures of the horses (pls. 47–50), which he could turn and rearrange to fit the chosen perspective. In the end, each component, supplementing and reinforcing the others, made its way to the final painting: the setting from oil sketches, the horses from the wax figures and additional oil sketches, the coach from the perspective drawing, and the passengers from color sketches and projected (and now lost) photographs.[29]

The length and complexity of Eakins's campaign to produce *A May Morning in the Park*, as much as Rogers's collaboration in its pursuit, distinguished this painting from the start. So, too, did Rogers's publication at its inception of an account of his and Eakins's manipulations of Muybridge's photographs. Appearing in *The Art Interchange*, a magazine of the applied arts and not a customary venue for this writer, the article pointedly reminded their American colleagues that a new regime, dedicated to enlisting the latest advances in the arts and sciences to the disciplines' mutual advantage, had taken hold in post-Centennial Philadelphia. Whereas *The Gross Clinic* had been Eakins's announcement of his arrival as an artist and *William Rush Carving His Allegorical Figure of the Schuylkill River*, a plea for study of the nude as the centerpiece of art education, *A May Morning* was a manifesto for a seriousness of purpose, the material exemplar to give notice of the rigorous

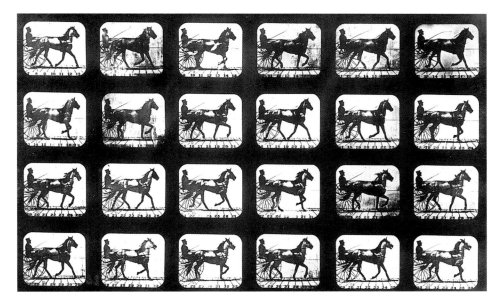

Fig. 142. Eadweard Muybridge, *"Abe Edgington" Trotting*, 1878–79. Photograph courtesy of William Innes Homer.

curriculum the two men were establishing at the Pennsylvania Academy at this time. In their view, art hereafter was to be a profession, assiduously studied and energetically prosecuted. Like any other profession—the medicine and science of Eakins's interests or the engineering of Rogers's experience—it would embrace technical innovations, enfolding them seamlessly and without hesitation into its time-tested traditions.

Over six months, Eakins exhibited *A May Morning* in Philadelphia, Boston, and New York. Knowing well its roots in Muybridge's famous images, critics understood that the painting was an experiment. Most agreed that Eakins brought to the task "the ablest dealing with the toughest problems of painting, of anatomical knowledge and accurate drawing."[30] Some acknowledged, in theory at least, the virtue of coaxing photography to the aid of painting. The practical result, though, was unconvincing. The "queer immobility of the camera's revelations" they sensed in the frozen gaits of the horses was incompatible with the forward motion indicated in the blurred spokes of the wheels (fig. 143).[31] The flaw, to most

Fig. 143. Thomas Eakins, Detail of *A May Morning in the Park (The Fairman Rogers Four-in-Hand)*, 1879–80. Oil on canvas. Philadelphia Museum of Art. Gift of William Alexander Dick, 1930 (pl. 51).

critics' minds, lay in the images chosen for the experiment and in Eakins's perceived captivity to them, for Muybridge's sequences, so little altered, lacked "just that amount of falsification which is needful to confer illusion."[32] This discrepancy, in fact, may have distracted reviewers from the one feature copied directly from projected photographs: the passengers on the four-in-hand, whose rendering earned consistent praise. In the end, while one commentator could concede *A May Morning* might be "the precursor possibly of success in a novel mode of search after exact truth," another lamented, "his scientific turn of mind is too obvious, and his pictorial problems too complicated. If somebody would only remind him that life is short, and that in this world one can lift only a corner of the curtain!"[33] The inconsistencies these critics singled out bore testimony that Eakins's aims strained his means, the technology of his sources, and his still-imperfect command of them. That technology, though, was changing, and by the summer of 1880, Eakins had purchased his own camera.[34]

"I have as photographic apparatus," he would write,

a camera 4 x 5, American Optical Co.; a Ross portrait tube marked No. 2 C d V. #23193, a view or landscape tube of long focus marked 8 x 5 S. A. doublet 17375, also by Ross of London, 14 double backs for dry plates; small trunk for carrying them, tripod, & accessories. Also a solar camera & accessories, and chemicals.[35]

It was a standard outfit of its day, designed for the amateur—inexpensive, durable, relatively lightweight and versatile—and readily available at any shop carrying photographic supplies.

Like most amateurs, Eakins first tested his proficiency with casual photographs of his family and friends in his backyard or on holiday at the shore (pls. 58, 60, 61).[36] These portraits of Margaret with her dog Harry (pls. 55, 56); his father, Benjamin; his aunt Eliza Cowperthwait; or his erstwhile teacher George W. Holmes self-consciously seated before a vine-covered plank fence (pls. 94, 95, 97, 98) are empathetically informal. The earliest were almost always made in diffuse outdoor light, where short exposures and soft shadows permitted him to concentrate on subtle distinctions in faces and expressions, shifts in posture or the repose of a hand. As testaments of his sitters' features and personalities, these photographs, like the artist's paintings, seldom stooped to flattery. Commercial portraits (fig. 144)—official portraits—might seek a summation of the sitter, an inhalation of propriety or seasoned, noble bearing, or the best approximation the photographer could capture in a fifteen-minute session. Eakins's subjects, however, most often his intimates or new acquaintances with whom he sensed an instinctive bond (fig. 145), were free to enjoy a casualness of dress, posture, and setting, a lack of pretense, sometimes an errant comfort more subtly expressive.[37]

In April 1881 Eakins made the first of several photographic visits to the shad-fishing grounds of Gloucester, New Jersey, where steadily declining catches threatened the livelihood of local watermen as well as the seasonal picnics that had for many years lured Philadelphians across the Delaware River. Eakins's project to memorialize the humble fishermen—"subjects which he has had in contemplation ever since his return to this country"—was reported by his knowing friend, the critic and Philadelphia Sketch Club president William J. Clark, Jr., who cited "studies" made at the site without noting that more than seventy of these were photographs.[38]

Though Eakins had used perspective drawings to lay out his rowing and hunting pictures, the monocular optics of the camera made its imagery a fluent substitute. From his first exploratory photographs of the fishermen with their nets, general views made with his wide-angle landscape lens, the artist selected two for the two paintings he would title *Shad Fishing at Gloucester on the Delaware River* (figs. 146, 147). On the unpainted canvas of the more straightforward of the pair (fig. 146), he projected its source photograph (pl. 71) and traced in pencil the outlines and internal details of the barge, oars, fishermen, and the principal reflections in the water. Oil sketches that Eakins had made at the site provided color notes to flesh out the monochromatic scheme of the camera study, and from another photograph of the same location (pl. 70), he transferred, freehand, minor changes in the background.[39]

The second version of *Shad Fishing*, now in the Philadelphia Museum of Art (fig. 147), began in the same manner, with the central section of a general view (pl. 74) projected onto the primed canvas and traced in pencil. Eakins cursorily outlined a spectator and a dog on the beach at the left, which he evidently intended to change from the start. In translating the image to paint, he adhered closely to the photograph for the fishermen's poses and the shadows that modeled their clothing. Individuals who had looked up at the camera were altered or replaced: two figures atop the piled nets were merged into one, and the head of another was turned to profile. From a variant photograph (pl. 73), Eakins substituted one figure on the boat and added another in the water to the left. The spectators in the original photograph, though, were poor representatives for their role: distracted, ill-configured, and scruffy in appearance, they formed an incoherent jumble obscuring the fishermen. In their place Eakins envisioned a smaller group whose static poses, urban attire, and judicious placement would more effectively differentiate them from the laborers. Returning to Gloucester, the artist posed his family on dry ground some distance from the shore. He took care to match the angle of the sun with that of his earlier views and made two photographs of the group at a distance approximating their position in the painting (pl. 75).

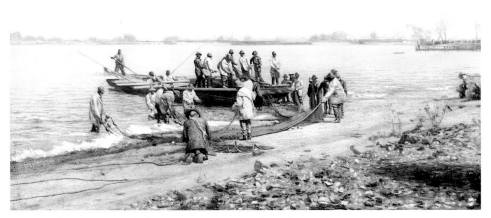

Fig. 146. Thomas Eakins, *Shad Fishing at Gloucester on the Delaware River*, 1881. Oil on canvas, 12 x 18¼". Ball State University Museum of Art, Muncie, Indiana. Elisabeth Ball Collection, partial gift and promised gift of the George and Frances Ball Foundation (pl. 72).

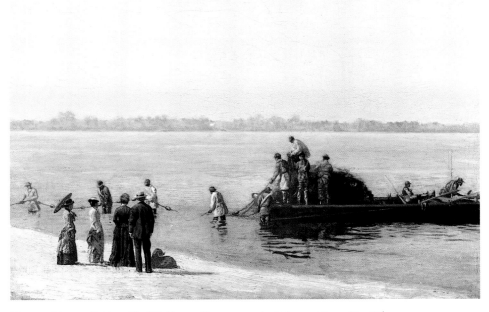

Fig. 147. Thomas Eakins, *Shad Fishing at Gloucester on the Delaware River*, 1881. Oil on canvas, 12⅛ x 18⅛". Philadelphia Museum of Art. Gift of Mrs. Thomas Eakins and Miss Mary Adeline Williams, 1929 (pl. 76).

On the half-finished painting surface, Eakins projected these images below the line of fishermen and incised their positions and salient details of dress and shadow to fill in the figures.[40]

Forgoing the compositional scaffold that a perspective drawing could provide, Eakins relied on other means to consolidate the space of his source photographs: the relative scale of his figures, a color scheme based on his plein-air oil sketches, and atmospheric effects of diminishing focus and saturation. "The character of depth," Eakins would remind his students, "is incompatible with that of sharpness."[41] Graduated sharpness, too, defined the meaning of his paintings and

pointed to differing intentions for the two canvases. The first was an attentive depiction of a local tradition, the counterpart to the Breton fisherfolk favored by European and expatriate American artists.[42] The principal subject of the Philadelphia painting, however, the feature most lavishly detailed, was not the fishermen—in one critic's opinion, "not particularly picturesque creatures at the best"[43]—but Eakins's own family. The exhibition-going public was expected to identify with the urbane group of onlookers, "respectful, surrogates for the painter and models for ourselves,"[44] and led by the family's gaze, appreciate the earnest labors of the fishermen.

Following closely upon *The Crucifixion* and *Singing a Pathetic Song* (pl. 63), the Gloucester series has been treated by most historians as a pleasant interlude of sunny landscapes in the march of more significant works in Eakins's career.[45] His increasing sophistication in developing his themes, testing his equipment and his skill as he proceeded, however, suggests greater ambitions. In fact, for all their accomplishment, both versions of *Shad Fishing* were but a dry run for the largest, most complex work of the Gloucester series, *Mending the Net* (pl. 85), and the pace of Eakins's production was, for so methodical and exacting an artist, extraordinary. From first study to final varnish, *William Rush Carving* had been the culmination of nearly two years of effort; *A May Morning in the Park*, the outcome of more than a year. *Mending the Net* and the works leading up to it occupied five months, squeezed between the spring and autumn semesters at the Pennsylvania Academy and interspersed with visits from critics, correspondence with magazines, and submissions to exhibitions in New York, Providence, Chicago, Cincinnati, and Saint Louis.[46] Eakins's working methods reflected this accelerated pace: gone were the perspectives and plans, the pencil sketches, the scribbled notes, and the sculptures that had marked his preparations for earlier paintings. Photographs, heretofore an adjunct to other mediums of study, supplanted all but his color oil sketches to provide both the imagery and the vehicle with which to construct his compositions. Even allowing for the expedience of lantern projections, the series progressed with a headlong rush quite in contrast with the stately calm of the subjects.

Mending the Net is one of Eakins's most narrative paintings, a characteristic often overlooked in the twentieth century, when anecdote and sentiment fell out of favor. It was also intended to stand on its own, without such explanatory text as accompanied *William Rush Carving*.[47] *Mending the Net* had to be readable, complete, and convincing for an audience accustomed to deciphering the meanings of genre subjects. The camera alone was capable of providing the "drawing" Eakins sought for so delicate an undertaking. While he might persuade family or friends to assume some poses, the Gloucester

watermen, sole possessors of their skills, had to represent themselves, and the variety of their interdependent, practiced actions could only be arrested in their normal course, free from the falsity interruption would have introduced. Only by that specificity, only with that credibility, could Eakins lead others to empathize with his subject.

If the two versions of *Shad Fishing* were developed from scenes Eakins found on the riverbank of Gloucester, to be "corrected" but not altered in essence from the general views he had made, the construction of *Mending the Net* evolved quite differently. No overall image of this subject survives among Eakins's known negatives and prints, and infrared reflectography shows that none was used. *Mending the Net* was compiled, instead, from a welter of details of figures and features of the site, photographed individually or in pairs. More than thirty such studies are preserved, and there is evidence within the painting that even more had been made. Eakins increasingly sought consistency in these studies: in the selection of lens; in the angle of the sun; and in the low position from which he photographed the tree and capstan on the horizon (pls. 83, 84), the fishermen on a flat expanse nearby (pls. 77, 78), and the children on a Philadelphia rooftop (pls. 81, 82). The lengths to which he would go can be seen in the eighteen negatives of geese (pls. 79, 80), photographed with a wide-angle lens (an illogical choice by any consideration other than the artist's desire to maintain the painting's perspective) that prompted a literal goose chase across the fields as the artist strove to place himself and his camera close to the nervous flock. In laying out the composition into which each piece would fall, Eakins clarified the broader topography of the site: the horizon line he ruled high on the primed canvas to admit a view to the river in the distance. Slightly above this he added placement lines for the figures, and from a projected image of the tree, he traced its limbs and leaves and the head of the adjacent capstan in a pliant pencil outline. After the whole had been underpainted, he projected one-by-one the images of the fishermen, the children, and the man reading a newspaper, and he made minute incisions in the paint to indicate where, and in what detail, he would work up each figure in turn.[48]

The planning and editing of his photographs and the painstaking effort Eakins expended to produce *Mending the Net* presupposed, as *Shad Fishing* perhaps did not, that he had a firm idea, before visiting the site, of what his composition was going to be. The viewer's attention is drawn to the top of the knoll and the line of figures arrayed there as if in a frieze. It is a line subtly but firmly divided into two contrasting halves. At the left, profiled against the sky under a warm midday sun, fishermen reknot their nets. In Eakins's time, no less than in our own, this would seem a humble task, like knitting or spinning,

or perhaps like painting itself, a practice of skillful craft stubbornly lingering into a mechanized age. To the right, beneath a lone tree, the fishermen's lunchtime refuge, an urban visitor in a natty boater, the only figure in shadow, reads a paper with news of his bustling mercantile, industrial, social world across the river. In counterpoint to his benign disinterest, two children (his, judging by their dress) approach the fishermen, setting down their toy sailboat to attempt a conversation. Their contact is clearly important—it has stilled their play—as if in this instant they might sense for the first time that the fishermen's quiet, steady devotion could signal an activity more significant than play.

Mending the Net conveys a simple, suggestive narrative. Though Eakins relied on modern means to create his composition, its theme is nostalgic. No general view of this scene was traced; none apparently could be made with the camera in 1881. Only vestiges of the subject could be found in Gloucester (the fishermen) or details be re-created (the father and children) to suit the artist's needs. Evidently it was not some general idea of Gloucester fishing scenes that Eakins had had in mind since his return from Europe—such could have been pursued anytime, for instance in 1874 when he painted *Sailboats Racing* only a few minutes' walk upriver—but a very specific subject, one that necessitated the artist's delay until he had the means at hand to recapitulate it. *Mending the Net* is not a glimpse of a contemporary encounter, but Eakins's reconstruction of a scene that must have transpired much earlier, at least by 1870, and presumably before he left for Paris in 1866. "I love sunlight," he had written then,

> & children & beautiful women & men their heads & hands & most everything I see & someday I expect to paint them as I see them and even paint some that I remember or imagine make up from old memories of love & light & warmth.[49]

Mending the Net represents just such a resonant memory, rendered not in an archaeological manner, with the finicky period detail so many European and American artists would bring to paintings of a classical or colonial past, but with all the emotional vividness and delicacy that defining personal moments retain over intervening years.[50]

The creative flurry that led to *Mending the Net*, the impetus as well as the culmination of this series, waned with its completion, and in his succeeding, more leisurely treatments of Gloucester subjects, Eakins retreated from that painting's necessarily elaborate constructs. Subsequent works sought their inspiration in the here and now of 1881–82, and simpler methods prevailed. In the past, Eakins's watercolors, the most popular and salable of his works, had customarily followed upon the finished oil paintings they reworked; the opaque pigments he could bring to canvases permitted him to resolve his compositions and tonal balance before copying them in more unforgiving transparent washes. The Gloucester photographs provided comparable ready-made studies (pls. 86, 87), and Eakins projected three to make an equal number of traced watercolors.[51] Shortly thereafter, for the only pure landscape the artist would ever attempt, *The Meadows, Gloucester* (pl. 88), the more traditional transfer technique of squaring was sufficient, and the cows he added to the scene later were painted freehand.[52]

Subsequent projects followed the conventions Eakins had established by the close of the Gloucester series. Paintings treating contemporary subjects that the artist could return to study either at the site or in studio poses were seldom photographed at all. Portraits fell into this category, and for these Eakins preferred to work from life. Elaborate interior settings might require perspective drawings, but with few exceptions he eschewed the aid of camera studies for all but commissions for posthumous likenesses. When a particularly sympathetic individual was asked to sit before both camera and easel, a span of months or years could separate Eakins's oil portraits from his photographs as he sought the expressive potential of each medium in independent, complementary works.

In the mid-1880s Eakins essayed new subjects, re-creating the idylls of ancient Greece in the Arcadian series (pls. 119, 120) and casting the bathers of *Swimming* (pl. 149) in the classic order of old master paintings.[53] Though photographs of Eakins's male students and friends and of fiancée Susan Macdowell (pls. 114–18) have long been known to have informed the painting *Arcadia*, the blizzard of transfer marks on that work and on its smaller variant, *An Arcadian* (Spanierman Gallery, New York), and the slightly less plentiful (because better covered in subsequent paint layers) array on *Swimming*, give ample evidence of just how numerous Eakins's source images may have been.[54] Practical considerations played the major role here, for any ambitious composition of nude figures in the landscape, and certainly one of so notional a theme as *Arcadia*'s, could only be realized in the studio. Discretion alone would have stayed his hand in works that united male and female nudes in one composition, and Eakins decorously segregated by gender the photographic sessions he undertook with models in the countryside.[55] If composite projections, then, could serve as the instrument to revive memories of Gloucester, they became as well the vehicle to explore subjects that resided solely in the cultural imagination or that were meant to kindle associations of a golden age in a contemporary bucolic re-creation.[56]

Enlargements of several of the photographs made for *Arcadia* and *Swimming*—though apparently not the images

that were actually used—made their way in the late 1880s to the walls of the Art Students' League of Philadelphia to hang amid other camera studies, plaster anatomical casts, and the artifacts of various subjects as a resource for Eakins's students (pl. 169). Were it not for the numbers of images so displayed, this would hardly merit mention, for photographs must long have been unheralded accessories in the studios of the Pennsylvania Academy and other established art schools. What was missing before, however, was a systematic exploration of the potential of the new medium, such as that proposed by one advocate, C. A. Shaw, in an article published just as Fairman Rogers was completing his first year on the board of directors of the Academy: "Let me suggest a use to which photographs might be put," he advised.

> Take this drawing from the nude figure which is so important, and so expensive to the student studying by himself. Suppose large photographs be had of these figures in definite series. They could be scattered all over the country. If there was a system in it the art culture of the nation would make rapid progress.... Nude figures, male and female, photographed in different positions, and with different lights, would be, I think, a most important addition if any art school would go so far as to ask for a scale divided thus:
> One of each temperament, and of these one of each sex;
> One of each age, from infancy to old age, at ten year's interval;
> One of different occupations;
> One of different positions of lighting,—front, back, left, right, low medium, and high-light; and,
> One of each position of the figure.
> This would easily foot up to several hundred thousand pictures, but a systemized list would embrace several facts in one picture. I think twenty-five would contain all the essential facts, and three hundred about all the studies worthy of preservation, except for scientific interest.[57]

Any suggestion in the 1870s that a profession having as tentative a hold on the public as contemporary artists enjoyed should, in turn, openly assimilate the products of a new, ostensibly mechanical contrivance would have been controversial. At the Academy, it was understandably not Sartain and Schussele, the successful veteran artists mindful of the rules even as they quietly stretched them, who would institutionalize a practice most of their colleagues preferred to obscure. It was their successors, Rogers and Eakins, comparative upstarts eager to explore and take advantage of scientific methods and new technologies, who would bring this innovation to the school.[58]

The impulse evinced by Eakins and Rogers to expand the role of photography in art education was enhanced by the timing of their ascendancy in the Academy. Eakins's curriculum encouraged exacting, comprehensive observation as a prerequisite to the making of art, a goal achievable only if its means

were accessible to the students. The advent of dry-plate negatives in 1879 opened photography to ready experimentation by all, and dozens of Eakins's students joined their teacher in responding to the challenge. In the classroom, in the private studio, or on excursions into the field, the use of the camera was not only welcomed, it was positively embraced. The apparent indifference of these artists to sign their photographs thwarts most attempts at attribution but is also consistent with the extent of their shared vision and aims. The power of Eakins's advocacy and aesthetic for photography was as strong as that he instilled in his students for painting, and the products of teacher and student form, together, a body of imagery that is diminished by division.

More than two hundred photographs or sequences made by Eakins or by students working under his guidance fall into the category of teaching imagery. Dozens more, for which family and friends were induced to pose, address similar concerns. Almost all of these images concentrate on the human figure, usually presented in a direct, unaffected, serious manner appropriate to their use. Many emphasize their earnest, utilitarian intent with disordered backgrounds and commonplace props. Photography in this context was, for Eakins, more a recordative medium than an expressive one; like the dissections undertaken at the Academy, it was a means to note an observable, verifiable, in some cases measurable, fact of the subject. Aesthetic considerations, never banished from an artist's mind, shaped each image in varying degrees, often most emphatically and self-consciously in the works of students less confident than their teacher (pl. 123). Never, though, in Eakins's hands did these overtures to convention interrupt the pragmatic purpose the photographs had as objects for empirical study.

The centerpiece of Eakins's curriculum, and the *sine qua non* of academic art education, was the study of the nude. Between the separate men's and women's life and clay modeling classes at the Pennsylvania Academy, more than sixty hours a week were devoted to working from the nude model, more initially than all the other classes combined and significantly more than was offered in any other art school in the world.[59] For so prominent a feature of the Academy's program, Eakins proposed a fundamental role for the camera, one that Rogers, writing for the Committee on Instruction, publicly endorsed: "A number of photographs of models used in the Life Classes, were made in cases in which the model was unusually good, or had any peculiarity of form or action which would be instructive, and a collection of these photographs will thus be gradually made for the use of the students."[60]

The Ecole des Beaux-Arts and its American counterparts traditionally had addressed that basis of representational art—the stance of the human figure—by assigning students the task

of making *académies*, or drawings of nude models in stock poses, turning or leaning on poles or suspended rings, that accentuated the action of their musculature under an envelope of skin. In the studios of the Pennsylvania Academy, Eakins abolished this exercise, arguing that students could better learn observation and descriptive dexterity from the immediate practice of painting. Their knowledge of the figure was enhanced through an expanded course in anatomy, augmented with dissections; that of volume and the balance of mass would come from the modeling classes. The other lesson of the *académies*, the canons of human proportion and movement, he assigned to the camera.[61]

The Naked Series, so designated after a reference in an account book,[62] was initiated by Eakins and pursued according to his design by students at the Academy by the early spring of 1883. In April of that year, C. Few Seiss wrote to a classmate:

> Tommy Anschutz [*sic*], Wallace & myself are now the "Academy photographers." Nearly every Thursday we photo. nude models for Eakins. Each one we take in *seven* different poses. When completed they are to be hung in the life class room. There [*sic*] object is to show how action of the same pose differs in different individuals. We have our dark room and photo. drugs in the room adjoining the dissecting room.[63]

Diversity in the models, also a hallmark of the Academy's life class, was stressed, not least by the particularity of the photographic record of them. In the series Eakins was replacing the tradition of idealized heroic (male) or decorative (female) figures, typically engraved in treatises on proportion, with an emphasis on the characteristic features that distinguished one actual, imperfect individual from another (pls. 128, 129, 132, 133, fig. 148). The series documented the proportions and posture of each figure in uniform poses that turned the model in place as the body's weight was shifted from one foot to the other. As if in a mechanical drawing, the photographs of each model were then mounted side by side in a rotational sequence to provide the student a permanent, concise summary of one individual and the means to compare any one with others displayed on different cards.

As the project continued, the subjects of the Naked Series were not confined to professional life-class models; Academy students were invited to stand before the camera as well, under Eakins's oft-stated conviction that anyone who sought an opportunity to work from the nude model should be willing in turn to pose nude for the benefit of his or her classmates when no professional models were available. To signal his own commitment, Eakins posed for at least four Naked Series sequences, and others featured his students John Laurie Wallace, Jesse Godley, and George Agnew Reid.

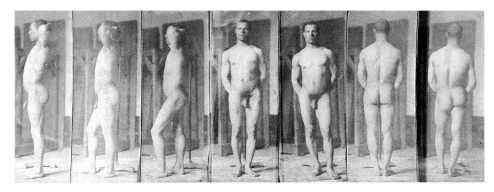

Fig. 148. Circle of Thomas Eakins, *[Naked Series: Male Model]*, c. 1883. Seven albumen prints, mounted on blue card, 3¹⁄₁₆ x 8⅜". Pennsylvania Academy of the Fine Arts, Philadelphia. Charles Bregler's Thomas Eakins Collection, purchased with the partial support of the Pew Memorial Trust (1985.68.2.347).

Should the photographs alone not be sufficient to convey the lesson of the Naked Series, drawings were traced from the prints (pls. 130, 131) to reiterate the artist's intention.[64] In the life and modeling classes, Eakins instructed his students to locate the model's center of gravity, a line roughly contiguous with the spine, and to develop the figure's volume and movement from that axis outward. On one drawing Eakins indicated this central axis over the outlines of his own figure and added the inscription:

> The centre lines in red represent the general axes of weight and of action and are deduced from a consideration of the centres of gravity of small horizontal sections of the figure, which centres joined form the continuous lines.
>
> In the thorax this line approaches the back outline rather than the front because first of the shape of a section of that region and second because of the position of the lungs of but little weight.
>
> These lines are maintained throughout their curves by increased action of the muscles on the convex parts of their curves by ligaments or by the resistance of bones only.
>
> Such lines form the only simple basis for a synthetic construction of the figure.
> Thomas Eakins.

On another sheet, he superimposed the axes of three models, taken from the leftmost image of sequences of Eakins and Wallace and a third of Jesse Godley (The J. Paul Getty Museum), to fulfill the series' comparative function.

More than thirty full or partial Naked Series sequences are known to have been made, but these almost certainly represent only a fraction of the total output. The investigations had continued for a year when Anshutz wrote Wallace: "The photographing of models takes place at intervals. But we have made no set as good as that hurried work of ours when we did the hypo deed."[65] Like the anatomy classes and dissections, the course on perspective drawing, and the preparations Eakins poured into each of his finished paintings, the Naked Series

Fig. 149. Unknown French photographer, *[Nude Study]*, c. 1855. Tinted stereoscopic daguerreotype, 6⁵⁄₁₆ x 8⅞". Bibliothèque Nationale de France, Paris. Georges Sirot Collection.

was exhaustive in its pursuit of a comprehensive understanding of its narrowly circumscribed subject.

At this time as well, Eakins and his students were making scores of photographs of nudes in less regimented poses. The official sanction the Committee on Instruction had lent to the enterprise afforded these artists a generous leeway in their approach to a subject little treated in American photography. The Academy photographers had an implicit license to produce imagery far more revealing, and hence more useful, than the half-clad males that James Wallace Black had photographed for the art students of Boston.[66] They could also forgo the elaborate staging that many European photographers of nude studies had thought necessary to create fully realized aesthetic objects for sale (fig. 149).

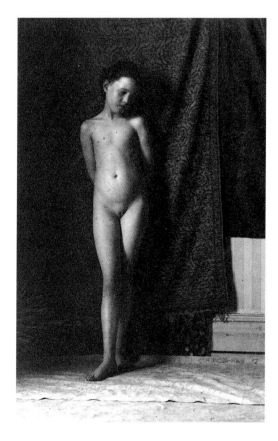

Fig. 150. Circle of Thomas Eakins, *[Nude Girl]*, 1883–85. Platinum print, 3⅝ x 2³⁄₁₆". Pennsylvania Academy of the Fine Arts, Philadelphia. Charles Bregler's Thomas Eakins Collection, purchased with the partial support of the Pew Memorial Trust (1985.68.2.554).

European precedents, nevertheless—for American ones were so few[67]—influenced many of these photographs. Rogers had specified "cases in which the model was unusually good," and in these studies the Academy artists dedicated themselves to the pursuit of beauty. This, again, would scarcely bear mention were it not a sensibility insufficiently associated with Eakins and a mission that many, including some artists, would hardly have conceded to the camera. No person willing to pose, it was thought, could embody both the form and the noble bearing to match the fiction a painter or sculptor could create. To Eakins, though, beauty lay not in a figure's conformity to a single Neoplatonic ideal, but in the varied refinements of nature's engineering. "If beauty resides in fitness to any extent," he asked one visitor,

> what can be more beautiful than this skeleton, or the perfection with which means and ends are reciprocally adapted to each other? . . . Even to refine upon natural beauty—to idealize—one must understand what it is that he is idealizing; otherwise his idealization—I don't like the word, by the way—becomes distortion, and distortion is ugliness.[68]

Sexuality, real or potential, was seldom concealed but accepted as a natural condition of the human figure. This alone could have provoked concern, especially when the subjects included minors (fig. 150): "It is a pity that American pruriency forbids, as a general thing, the photographing of little children nude or semi-nude, for some of the most artistically exquisite effects that human life has to offer are thus lost to the world."[69] Sessions with children required chaperones, who sometimes wandered into the frame of the photographs (pl. 144). Those with adult sitters were often attended by witnesses, students, or additional models visible in several of the images (pl. 171), who could attest to the propriety of the undertaking. For the rare and most incendiary instances entailing nude men and women together (pl. 136), it was Eakins, not his students, who posed, as he reserved for himself the likely task of explaining the lengths to which the project was going.[70]

The irony of the eventual reception these photographs received at the Academy was that their justification, like that for life study, was always cast in the highest moral terms, as the requisite tools and course of responsible professional education. One student wrote for many who "desire to study the entire nude figure, *not because it affords them pleasure to look at it*, but because it is the only true way to obtain the necessary experience to represent a *draped figure* in its movement and proportion."[71] The images themselves attested to that purpose. Their workmanlike settings, their haphazard props could only be the stuff of studies. In almost none could be found a hint of the luxurious trappings, the coquettish expressions, or the lewd poses of pornography. In this context, the coy body language

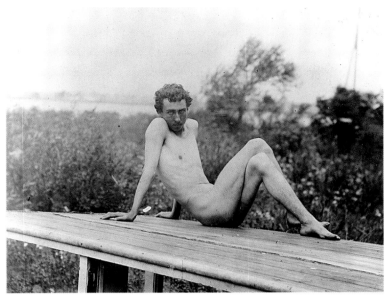

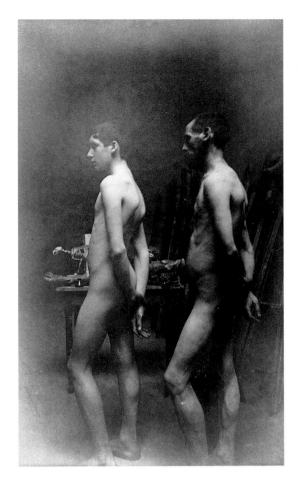

Fig. 151. Thomas Eakins, *[John Laurie Wallace, Nude]*, c. 1883. Modern print from original gelatin dry-plate negative. Pennsylvania Academy of the Fine Arts, Philadelphia. Charles Bregler's Thomas Eakins Collection, purchased with the partial support of the Pew Memorial Trust (1985.68.2.1018).

Fig. 152. Circle of Thomas Eakins, *[Male Students Posing at the Art Students' League of Philadelphia]*, 1886. Albumen print, 7⅝ x 4⁹⁄₁₆". Sterling and Francine Clark Art Institute, Williamstown, Massachusetts.

and confrontational gaze in a lone image of Wallace (fig. 151) jars the viewer most by the sitter's apparent and singular lapse.

Whether or not the photographs of nudes contributed significantly to Eakins's forced resignation from the Academy, his enemies, including a cadre of students who had willingly participated in the making of this imagery, turned it to his discredit. The sessions ended at the Academy but were enthusiastically revived at once by the students who seceded with Eakins to form the Art Students' League of Philadelphia. There the photography of nudes assumed an even greater ideological urgency as one of the most identifiable features distinguishing its curriculum from the Academy's.[72] An album of photographs made by the students in the league's first semester (pl. 168) reveals the breadth they sought for the project in this second incarnation: informal multifigure variations on the Naked Series poses (fig. 152), indoor action studies, and elaborate *tableaux vivants* of a narrative power never attempted at the Academy. As Eakins assumed direction of the league, his imagery joined and superseded theirs on the school's walls. Many of Eakins's most affecting images (pls. 170, 171) came about in this revival of the enterprise. As if in celebration, both teacher and students devoted several negatives to scenes of young artists sketching from nude models in the league rooms (pls. 166, 171)—the uncensored testament of their new school's methods and of a curriculum no longer under fire.

Between these two campaigns of the nude, in the hiatus of 1884–86, had come another project of long-standing appeal to Eakins. In February 1883, Eadweard Muybridge arrived in Philadelphia to deliver a series of illustrated lectures, two of them at the Pennsylvania Academy, detailing the progress of his motion studies.[73] If he expected to find there a sympathetic climate of inquiry, he could hardly have anticipated its extent or the conflicting agendas that would arise. Motion photography had preoccupied a generation of Philadelphians, from the reconstructed sequences of action in the stereographs Coleman Sellers had made for his kinematoscope in 1861, to Henry R. Heyl's and others' magic-lantern projections of "various objects and figures upon the screen [in] the most graceful and lifelike movements,"[74] to Fairman Rogers's experiments with instantaneous equine photography. Within months of Muybridge's lectures, three more Philadelphians, David Pepper, Jr., S. Fisher Corlies, and John Moran, would try their hand at instantaneous views of athletes or horses in action.[75] When local benefactors guaranteed funding, the University of Pennsylvania agreed in August 1883 to provide a venue for Muybridge to resume his project.[76] A commission of overseers, to which Eakins was named, was appointed in March 1884, and work commenced that summer.[77]

Of all the commissioners, Eakins took the most active interest in Muybridge's activities. Eakins alone had mastered

the skills to make comparable studies and, in December 1883— before he was named an overseer—he demonstrated an instantaneous shutter of his own invention to the Photographic Society of Philadelphia.[78] When Muybridge's shed was erected on the grounds of the university, he and Eakins worked side by side, each experimenting with his own variation on the wheel-shaped shutter mechanism that Marey had developed for similar investigations in France.

That summer saw few successes by either photographer. Eakins's use of a single Marey wheel resulted in fogged negatives. Muybridge's problems were more complex. When he reprised the solution that had served so well in California—a bank of cameras fired consecutively—the shutters were "too clumsy and slow."[79] However, the images that he was able to make with his Marey wheels were devoted to the commission's choice of a subject, the abnormal movements of patients with nervous diseases, in which he had little interest. As Anshutz reported,

> The university people are dissatisfied with the affair as he cannot give them the result they expected. Which was to photograph the walk of diseased people paralytics etc. so that by means of the zoopraxiscope...they could show their peculiarities to the medical student. This it seems however cannot be done even with the best known contrivances. So they would like to fire the whole concern but they have gone too far to back out.[80]

If Eakins's efforts in 1884 largely failed because of his insistence on reinventing for himself the means to accomplish them, Muybridge could only have seen his own efforts as suffering most from the meddling of the commissioners, including Eakins, in a process that had worked before. In the autumn the photographers parted ways.

As Muybridge's expenses soared, Eakins's allies on the commission quietly strove to keep the painter's parallel efforts going on a shoestring budget. Edward H. Coates, in his capacities as Academy director, chairman of the overseers, and also a guarantor, ensured that most of Eakins's costs were reimbursed. Two other commissioners, Professors William D. Marks and Harrison Allen, absorbed in the budgets of their departments the outlays for equipment and materials that could be put to uses they could justify for their teaching.[81] A second temporary shed, for Eakins's use, was built in the late autumn of 1884. His first experiments there brought favorable results, and the project moved forward in the following year.

While Muybridge concentrated on the row of cameras with which he would complete his well-known series, Eakins remained committed to improving a mechanism of counter-revolving Marey wheels that offered the advantage of a uniform perspective from a single camera. As slots cut in the rotating wheels repeatedly aligned before the plate, successive stages of the model's action were captured in a multiple exposure, a side elevation as it were, of the exercise, whose trajectories and increments of change could be accurately measured and mapped. Women walking (for anything more strenuous would have been indecorous) and men walking, running, jumping, and pole-vaulting were all photographed in this manner (pls. 151–55).

The different philosophies that Eakins and Muybridge brought to the project led the two to select their divergent means to carry it out. Although Muybridge, no doubt for the university's approval, proclaimed his motion studies to be intended as much for scientists as they were for artists, it was the latter audience and popular acclaim he sought above all else. One recent scholar, Marta Braun, has shown that Muybridge subtly edited his plates, eliminating infelicitous poses in several sequences and combining in others frames derived from multiple sessions, thus obliterating the objective value they might have had for understanding the attitudes of humans in motion.[82] Eakins, who enjoyed reading scientific and mathematical texts in his spare time, saw no conflict between the aims of science and those of art: both, in their highest forms, demanded rigorous observation and verification. It was in such a multidisciplinary spirit of inquiry that Eakins and his students dissected the leg of a horse, paring away one muscle after another, until it was determined the leg could stand and bear weight by the counterforces of its bones and tendons alone—an experiment they performed in front of the camera (pls. 156, 157).[83]

By the end of 1885, both Eakins and Muybridge had achieved successes. Muybridge's commitment to the venture he had initiated in California overcame the priorities of his Philadelphia overseers to produce results of which they (with lingering reservations) could be proud. From Eakins's ongoing work, one image, *History of a Jump* (pl. 153), was chosen for an international exhibition of photography organized in January 1886 by the Photographic Society and held at the Pennsylvania Academy. As Muybridge's investigation wound down, though, prior to its publication in *Animal Locomotion*, Eakins's was brought to a halt by his troubles at the Academy, barely a month after his photograph was shown there.

Despite Eakins's personal setback, the other commissioners of the Muybridge project intended to publish his motion studies. In September 1886 Coates inquired, "Will Mr. Eakins be ready with his treatise and the plates made? The latter are certainly of value in themselves."[84] Eakins was asked to provide a description of his apparatus and methods, a text eventually incorporated by Marks into his essay "The Mechanism of Instantaneous Photography," which followed the publication

of Muybridge's plates.[85] The survival today (in The Franklin Institute) of *History of a Jump* in an enlarged copy negative and glass positive—too large for standard projection—confirms that Eakins was preparing to reproduce the image in a collotype or photogravure. In *Animal Locomotion*, however, the image appeared only as a small wood-engraved illustration to the essay by Marks, who added, "It is to be regretted that Professor Eakins's admirable work is not yet sufficiently complete for publication as a whole."[86] In the face of slow sales of Muybridge's plates, any idea of a separate volume of Eakins's photographs gradually faded.

The exhibition of *History of a Jump*, though, was novel in 1886, when photographs of nudes were rarely shown in American institutions,[87] and both Eakins and the Photographic Society must have welcomed its submission for its technical accomplishment, as an example of what could be done by a resourceful investigator in instantaneous work. The exhibition was unusual, too, for Eakins, who had not to that point sought such recognition for his photographs.

The prominent role that Eakins assigned to photography in his teaching at the Pennsylvania Academy led many students to continue in the medium long after their schooling. Several were content to use it as a resource for their painting, but others found in photography "the inspiration that is to elevate it to a place among the fine arts"[88] and, as professionals or amateurs, adopted the camera alongside or in preference to careers as painters and illustrators (fig. 153). By the turn of the century, as the number of photography exhibitions grew, eleven of Eakins's former students, including his wife and sister-in-law, and a half-dozen friends and sitters entered their works in the Philadelphia Photographic Salons annually hosted by the Pennsylvania Academy.[89] Eakins's own works were absent.

Surprisingly, the only other known exhibition of Eakins's photographs in his lifetime, explicitly chosen for their aesthetic value, was of two images of *Bathers* that Alfred Stieglitz showed at the Camera Club of New York in 1899–1900.[90] The convergence of these two men, one the impresario of the newest trends in photography, the other a painter already beginning to acquire the cachet of an old master, reveals how extensive was the network that bound the nation's artists. Stieglitz must have heard much of Eakins from the critic Sadakichi Hartmann, who in 1895 had dedicated his *Conversations with Walt Whitman* to the painter and who owned Eakins's oil study for *Salutat*, a gift of the artist. Stieglitz also had connections in Philadelphia's photographic community, especially with Eakins's former student Eva Watson, who lent the two *Bathers* images for the exhibition and who soon (under her married name, Watson-Schütze) would join Stieglitz in founding the Photo-Secession. Such ties alone would not seem likely to explain entirely the honor

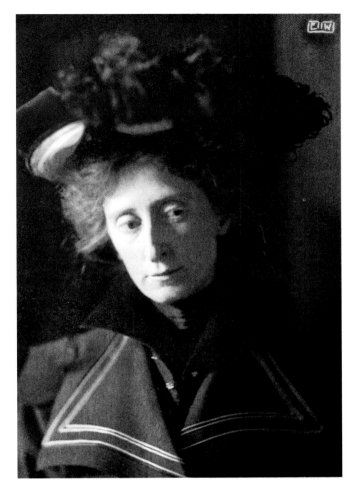

Fig. 153. Eva Watson, *[Jennie Dean Kershaw]*, 1890s. Platinum print, 6⁹⁄₁₆ x 4⅝". Bryn Mawr College Library, Pennsylvania. Seymour Adelman Collection (Special Collections SA 81).

Stieglitz gave to Eakins's photographs. This belated recognition (for the only images of bathers in Eakins's oeuvre had been made in the mid-1880s) came in the context of the Pictorialist movement that secured artistic status for photographs mimicking the moody atmosphere of paintings and etchings fashionable in the 1890s. Eakins's style, however, was rooted in the naturalistic tendencies of earlier decades, in a literal transcription of nature that was losing its appeal. For Stieglitz to have displayed these photographs for emulation suggests that he saw in them more than the vestige of an outmoded aesthetic.

Pictorialism at the turn of the century was an art of suggestion more than one of description, a style whose arbiters traced their sensibility to the broad graphic unity of British calotypes and the vaporous literary evocations of Julia Margaret Cameron (fig. 154). In the United States, the movement's beginnings could be discerned in the early 1880s, when amateurs of the camera, trained in and aspiring to vocations in the fine arts, enlisted photography to explore themes far removed from the normal course and observations of contemporary life. As their subject matter expanded to embrace symbol and allusion, the specificity of naturalism conflicted with the universality those

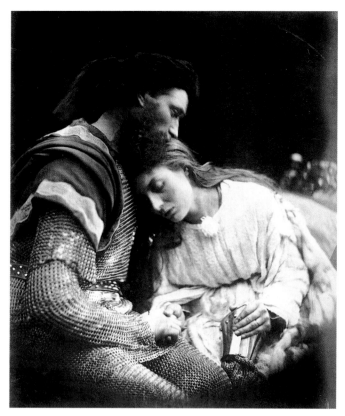

Fig. 154. Julia Margaret Cameron, *The Parting of Sir Lancelot and Queen Guinevere*, 1874. Albumen print, 13⅜₆ x 11⅛₆". The J. Paul Getty Museum, Los Angeles (84.XO.732.1.1.10).

Fig. 155. F. Holland Day, *The Marble Faun*, 1896. Platinum print, 6¼ x 4¾". The Royal Photographic Society, Bath, England. Acquired from Frederick H. Evans, 1937 (RPS 3561).

themes invited. The soft focus of Cameron's photographs that critics had grudgingly conceded an acceptable trade-off for expression when they were exhibited at the Centennial Exhibition in 1876 was soon advocated as an antidote to Pre-Raphaelite finickiness.[91] The asymmetry and simplification of Japanese art, another legacy of the Centennial, were appreciated for their grace and immediacy, as were the decorative color values in paintings by James McNeill Whistler, the American tonalists, and the French Impressionists. The hard contours of objects represented in albumen prints—an asset when photographs were judged for their sharpness—gave way to the gentle gradations of tone available in the platinum process. As such modifications de-emphasized the particulars of their subjects, the nude acquired an ideality and respectability it earlier enjoyed only in painting and sculpture (fig. 155).

In this shift in the visual culture of photography, not yet coalesced enough in the 1880s to have earned a name, Eakins was an incipient pioneer. For all his fixity to his own path, he was attentive to the aesthetic currents that were evident in exhibitions and the conversations of fellow artists and students. Eakins was one of the earliest to adopt platinum printing for the subtle continuity of its tones, analogous to the finishing glazes with which he consolidated the colors and textures of his paintings.[92] He moved his portrait subjects indoors

from the mid-1880s on, sacrificing detail for the richer relief of sitters' general features in the half-light of interiors (pls. 183, 202, 232). Above all, his determination to bend photography to the service of subjects not evident in nature—themes of history or memory, archetypes of the cultural imagination (pls. 117, 127, 148)—was an innovation taken up and extended by others, such as his students Eva Watson and Amelia Van Buren. Apparently, in 1899 they had not forgotten their debt and honored Eakins's work as a precursor of new directions.

These developments in his approach, however, marked the extent of Eakins's evolution as a photographer. The drift of the medium at century's end was crossing boundaries that he would not. Though he encouraged others to seek their own means of expression, in the exhibition at the Camera Club of New York he might not have welcomed the association of his photographs with the brushy prints of Robert Demachy or the etched fantasias of Frank Eugene. Eakins maintained, as did Stieglitz himself, a steadfast commitment to the "straight" aesthetic of unaltered representation of the subject that lay before the lens. It must have galled the artist three years earlier when his photograph of Walt Whitman was embellished with bold hatching for the frontispiece to John Burroughs's memoirs of the poet (fig. 156); when a similar image was used without adulteration in an edition of *Leaves of Grass*, Susan Eakins

Fig. 156. Thomas Eakins, *[Walt Whitman]*, 1891. Half-tone frontispiece to John Burroughs, *Whitman: A Study* (Boston and New York: Houghton Mifflin; Cambridge, Mass.: Riverside Press, 1896).

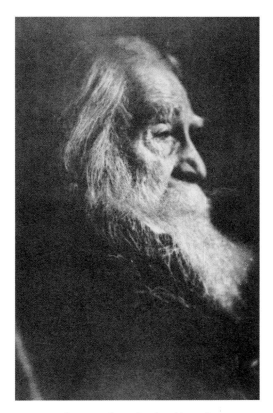

Fig. 157. Thomas Eakins, *[Walt Whitman]*, 1891. Photogravure in Walt Whitman, *Leaves of Grass* (Boston: Small, Maynard, 1898).

emphasized its preference by adding the inscription: "True— untouched" (fig. 157). The search for truth, the moral crux of art to Eakins's mind, admitted any investigation but not the substantive suppression of what was found. He could not countenance the Pictorialists' exaltation of the artist's touch, their emphatic crafting of the surface of their prints, over the figurative content that manipulation inevitably obscured.[93] The limits he set upon his photographs mirrored those he had established for his paintings.

To the end of his career, Eakins remained in many ways a fundamentally conservative artist. As new trends succeeded each other with redoubling speed, he chose to confine his scope to enlarging upon the themes and methods that he had staked out by the mid-1880s. Above all he stressed the importance of knowing the subject in its every aspect, of retuning the mind, eye, and hand to replace expectations received from the past with more attentive observations in the present. In that mission, science and art could share a common ground, and the medium of photography—authoritative servant to the one discipline, re-aspirant to the other—he took up as a potent instrument in the making and teaching of art. In little time it became a worthy destination in itself. Though he was fully aware that photography filtered reality no less than the intellect of the painter before his canvas, he retained a faith in the essential truthfulness of its record and in that record's value. To the end he found that the outward visage of the physical world, scrupulously studied and respectfully rendered, offered inexhaustible beauties, associations, and insights to an artist sensitive to its nuances. At the turn of the century, it was Eakins's teacher, Gérôme, who voiced the appreciation shared by many:

> The photograph . . . has compelled artists to divest them-
> selves of the old routine and to forget the old formulas. It
> has opened our eyes and forced us to gaze on that which we
> have never before seen, an important and inestimable service
> it has rendered to Art. Thanks to [the photograph], truth has
> finally emerged from its well. It will never go back again.[94]

The 1890s

MARC SIMPSON

D URING MOST of the 1890s, Thomas Eakins contin-
ued his scientific and artistic interests in the human
figure. Photographic figure studies—some taken in
his Chestnut Street studio (pls. 177–80) and others at the Crow-
ell farm in Avondale (pls. 195–97)—best document the com-
bined aesthetic, analytic, and utilitarian nature of his
explorations. His lecture "The Differential Action of Certain
Muscles Passing More Than One Joint," delivered before the
Academy of Natural Sciences in May 1894, likewise overtly
conjoined scientific discovery and artistic application.[1]

Some of this research was at the service of his teaching. He
taught at the Art Students' League of Philadelphia until 1893,
when declining enrollment forced its closure, and he lectured
on anatomy in New York at the schools of the National Acad-
emy of Design (through 1895) and the Women's Art School of
the Cooper Union (through 1897). He also undertook artistic
anatomy classes at the Art Students' League of Washington,
D.C., for two years and at the Drexel Institute in Philadelphia
in the spring of 1895.

His uncompromising presentation of nude male models to
female students at some of these venues, however, again cre-
ated difficulties for him. At the National Academy of Design
in 1894, his friend Edwin Blashfield, head of the education
committee, reported that "certain scholars have felt offended at
something in the matter or the manner of one of the lectures,"
tempering the notice by observing that the "council appreciat-
ing the sincerity of your point of view, and the enthusiasm
with which you treat your subject, is convinced that you will
willingly avoid hurting anyone's feelings, and will be consid-
erate of the point of view of any of your scholars if it differs
from yours."[2] Eakins responded: "I had no intention surely of
hurting the feelings of any one & do not see just where can
arise between me and my pupils, any serious or offensive diff-
erence of opinion in elemental descriptive anatomy."[3] After
the series of classes was complete, he was not rehired.

Eakins provoked greater public controversy when, while
delivering the third of twelve lectures to a mixed class at
Drexel, and having several times announced his intention to
do so, he removed a loincloth from a fifteen-year-old male
model. The series was promptly terminated, Eakins dismissed,

and the whole affair became fodder for newspaper accounts
and art-studio schadenfreude.[4] With the close of his formal
teaching career in 1897, Eakins's scientific-artistic activities,
including photography, wound down.

Early in the decade, while still actively teaching, Eakins
also explored a wholly new realm of professional art-making:
public sculpture. Sculpture had always been an adjunct of his
painting; as he said to his students, "if you do good modeling it
follows that you will do good painting."[5] Thus throughout his
career, he had made sculptures to assist such painting projects
as *William Rush Carving His Allegorical Figure of the Schuylkill
River*, *A May Morning in the Park (The Fairman Rogers Four-
in-Hand)*, and *Swimming* (pls. 41, 51, 149). He also undertook
bas-relief work both on private commission *(Spinning* and
Knitting) and for his own pleasure *(Pastoral)*. All of these
projects were of modest proportions. But now he began to
work on a monumental scale.

The transformation occurred through one of his friends,
the New York–based sculptor William R. O'Donovan (see
pl. 182),[6] who in 1891 received the commission for two life-
size bronze equestrian relief statues of Abraham Lincoln and
Ulysses S. Grant for the Soldiers' and Sailors' Memorial Arch
in Brooklyn. The arch, at the entrance to Prospect Park, was
designed by John Hemenway Duncan and decorated with alle-
gorical figures by Frederick MacMonnies. O'Donovan's goal,
it was later reported, "was to show in these two statues real men
on real horses." To this end he turned to Eakins, of whom the
reporter said: "There is probably no man in the country, cer-
tainly no artist, who has studied the anatomy of the horse so
profoundly as Eakins, or who possesses such intimate knowl-
edge of its every joint and muscle."[7]

Eakins and O'Donovan searched for individual horses to
serve as models, traveling to West Point, Newport, and Long
Branch, before settling on Eakins's own Billy, brought back
from the Dakotas, to serve as Lincoln's mount, and Clinker,
belonging to the railroad magnate (and brother of Mary Cas-
satt) A. J. Cassatt, for that of Grant. *Clinker* was finished in
April 1892 (see pl. 198) and shipped to O'Donovan's New
York studio; Eakins was "building up the Lincoln horse,"
Billy, in Avondale as late as August 1894.[8] Bronze casting

took place only in 1895, with the installation of the sculptures in December.

The decision to base the mounts on specific horses, realistically portrayed, did not strike a popular chord. Amid anticipation of the high-flown imagery of MacMonnies—his quadriga of idealized horseflesh topped the arch only in 1896—Eakins's figures seemed distinctly earthbound. A writer for the *Art Amateur* called *Clinker* "one of the ugliest beasts that we have seen in bronze, [who] trails his right foreleg like a tired donkey," while the legs of *Billy* were "notably weak."[9] *The Brooklyn Eagle* led an unsuccessful call for the removal of the figures and the withholding of payment ($17,500 for both men, including foundry costs; MacMonnies, by contrast, received $150,000 for his work).[10]

Meanwhile, in late 1892, while the Brooklyn work was still a promising project, the same team of Duncan, O'Donovan, and Eakins (later joined by the sculptor Charles H. Niehaus) received the commission for the Trenton Battle Monument, commemorating the Revolutionary War encounter fought at Christmastime 1776 in Trenton, New Jersey. Eakins undertook two of the monument's three narrative reliefs (Niehaus did the third): *The Continental Army Crossing the Delaware* and *The Opening of the Fight* (pls. 199, 200)—each nearly eight feet across.

General Washington's crossing of the Delaware had been immortalized by Emanuel Leutze, whose massive painting of 1850 and its several versions (the second canvas of 1851 is now at the Metropolitan Museum of Art, New York) had standardized a vision of the event, albeit one that was monumental and ahistorical. Eakins, predictably, chose instead to portray the events with accurately depicted Durham boats, cut at the edges of the scene to portray motion, and with the relatively inconspicuous Washington seated in a small rowboat, his famed profile a bit of calm amid the swirling actions and gesticulations of those around him. In *The Opening of the Fight*, Alexander Hamilton commands the first artillery shots of the battle, aiming his cannon down Trenton's likewise accurately depicted King Street at retreating Hessians.[11]

Both sculptures are in low relief, a form that Eakins found particularly intriguing. His scheme here, however, was far more ambitious than any of his earlier projects. In the 1880s Eakins had made compositions of one or a few figures in the half round and attached them to an abstract surface. In his Trenton works, by contrast, the relief is truly shallow, with limited projections throughout and no elements approaching freestanding status. Moreover, the illusion of what Eakins portrayed—all researched and approaching historical accuracy—has moved beyond the prototypical "simple processions of the Greeks." He has imagined instead deep spaces filled with landscape, architecture, crowds moving out of the picture space or back into depth, windblown garments, and even cannon smoke. These pictorial effects exceed the illusionism of nearly all his American contemporaries,[12] finding their rivals in the work of such Italian Renaissance masters as Ghiberti and, especially, Donatello.[13]

If, during the years around 1890, Eakins was discovering a new art form, he was also reconsidering his earlier achievements. Some of this came about as, in 1889, he set to work on *The Agnew Clinic* (pl. 175), a variation of his great if frequently maligned masterpiece, *The Gross Clinic* (pl. 16). These were also the years, 1889 to 1891, when, for the first time since 1875, he started to exhibit again in Paris, site of his early training and foundation of his academic art philosophy. For these Parisian venues—one international fair, the annual Salon, and one commercial gallery show—Eakins drew on works from more than a decade earlier.[14] Simultaneously another older work, the uniformly praised *Professionals at Rehearsal* (pl. 121), came once more into the public eye as the collection of its patron, Thomas B. Clarke, circulated in New York and Philadelphia in late 1891—the oldest by several years of Eakins's pictures on view in this country from 1888 to the end of 1892.

It would seem that with this last work in mind, and perhaps inspired by his renewed study of his Western pony for the Brooklyn memorial,[15] Eakins recalled his ambitions concerning cowboy pictures. Accordingly, he convinced his student and colleague Franklin Schenck (1855–1926) to don Western gear from the Dakotas and pose for him. Of the four works that resulted from this brief campaign of 1892—including what is probably his last known watercolor—the most ambitious is *Home Ranch* (pl. 191).[16] The small canvas shows Schenck dressed in fringed buckskin, armed with pistols, and playing a guitar.[17] Samuel Murray, fork in hand, sits in the background at a table, apparently arrested in his eating by the power of the cowboy's song. One critic, who described Schenck as "lustily carolling," called it "a romantic painting."[18] The appellation "romantic" is not one that Eakins often received, but the picture's dark tones, the exoticism of the model's garb, and its musical theme readily justify the claim. The similarity in format to Jean-Léon Gérôme's *Bashi-Bazouk Singing* (1859, Walters Art Museum, Baltimore)—of which Eakins owned a photograph[19]—furthers the canvas's undercurrent of romanticism.

Home Ranch was among the paintings Eakins chose to exhibit in 1893 at the World's Columbian Exposition in Chicago and its prelude in Philadelphia. One Philadelphia writer called this group of paintings—which included the two great clinic pictures, *The Crucifixion*, *The Writing Master (Portrait of Benjamin Eakins)*, the portraits of Professors Marks and Barker, and *Mending the Net*—"his strongest and most characteristic

work during twenty years." He continued, "It would be difficult to gather from the works of any man painting in this country pictures and portraits of equal originality and power."[20]

That the majority of the paintings Eakins selected to exhibit in Chicago were portraits testifies to the power the individualized depiction of another human being had come to hold over him. Portraits dominate Eakins's paintings of the 1890s. While arguments have been made that throughout his oeuvre "every figure he painted was a portrait, every scene or object a real one,"[21] in the 1890s such mediating elements as narrative, motion, and history dropped away, leaving the bald act of portrayal as the paintings' principal—often sole—focus.

Eakins had been tending in this direction since 1886. By 1891 at least one critic made public note of it: "Are we to have no more of Mr. Eakins' clever *genre* pictures? It is long since we have seen one from his hand, the skillfullest in dealing with such subjects of all our Americans."[22] But the simple roster of titles Eakins gave to the five works he showed at the Pennsylvania Academy of the Fine Arts in 1891—his first association with that institution since his forced resignation of 1886—underlines the purposeful nature of his decision: *Portrait of an Engineer, Portrait of an Artist, Portrait of a Lady* (pl. 172), *Portrait of a Poet* (pl. 165), and *Portrait of a Student* (pl. 173). The reiteration of the word *portrait* coupled with a generic role—although the name of the lender most often made the identity of the sitter clear—emphasized the intent.[23]

One significant shift resulting from Eakins's re-orientation from genre to portraiture is that of scale. Most often he was working at life size.[24] As his technique moved away from detailed miniaturism, he restricted the range of his figures' activity. Even more striking was his complete renunciation of outdoor light—the challenge that preoccupied his early years and, with the academicization of Impressionism in America, dominated the canvases of his contemporaries in the 1890s. It would be a mistake, however, to view these decisions as retreats. In his late forties and early fifties, Eakins focused on the individual seen in isolation and, for technical challenge, on the pictorial power achievable by pose, placement, and format. It was a return to basics.

Eakins's career as a portrait painter was typically distinctive. Most of his sitters were friends or acquaintances, and commissions were rare. More often, the painter would ask someone to pose, frequently offering the finished work in exchange for the sitter's time. Many would not accept the canvases; others did so only to hide or even destroy them.[25] Collectively the canvases form a remarkable body of work—a serious exploration of American character at the turn of the century, with hardly a trace of the glamour or predominant artiness common among such international stars as John Singer Sargent, William Merritt Chase, and James McNeill Whistler, or local talent such as Robert Vonnoh.

Phases of Eakins's method of construction can be seen in two of his unfinished portraits from the decade—a class of work whose number grew as the older Eakins, released from the drive for sales or reputation, worked up his canvases only to the extent that their challenges interested or were of use to him. William H. Macdowell, Eakins's father-in-law, sat for him many times over the years, in different costumes, moods, and positions; at least six paintings, a watercolor, and a number of photographs resulted.[26] Macdowell (c. 1816–1906), an engraver, had raised his children to be independent and free-thinking individuals, fascinated by the fine arts and skeptical of societal mores.[27] Eakins evidently harbored great fondness for the man whose views were so sympathetic to his own. Several of the Macdowell portraits are notably informal, with brush-strokes still prominent—none more so than the canvas of about 1891 (pl. 193), which served as a study for one of the last of Eakins's watercolors (an unfinished sheet now in the Baltimore Museum of Art).[28] Pose, orientation, and color all lend emphasis to the sitter's face and sinewy hand. Eakins's priorities in establishing the characterization are clear: eyes above all, the outline of the whole head only later created by dragging background color around the form. These elements in place, Eakins ceased further work on the canvas.

The *Portrait of Jennie Dean Kershaw* (pl. 210) from about 1897 is not a study but an incomplete project. Head and hands were worked up on a large canvas, while the contours of body and arms remain only directional slashes of paint. Even in this state the wide-eyed expression, in conjunction with the position of the hands, conveys a quizzical skepticism that is individualized and nearly palpable. Kershaw (1866–1952) was the actuary at the Philadelphia School of Design for Women (now Moore College of Art and Design), where she had earlier taught perspective. At the time of the portrait, she was engaged to fellow faculty member, and Eakins's close friend, Samuel Murray. Eakins painted her at least twice (the other canvas, also unfinished, is in the Baltimore Museum of Art). She also sat for photographic portraits by Eakins and Murray, several featuring a light-colored dress with flounces (pls. 208, 209) very different in character from the more somber dress of the painted portraits.

The smoothness of the finished portions of the canvas—so at odds with the visible brushwork that excited many artists and patrons of the era—is in keeping with Eakins's early precepts recorded in his so-called Spanish notebook, where he praised the work of Velázquez as having "no roughness at all to catch the light," claiming instead that it was "almost made to slide on."[29]

Art lovers in the 1890s had several opportunities to see collections of Eakins's most powerful works: the Retrospective Exhibition of the Society of American Artists in December 1892, for example, displayed nine canvases ranging in date from 1874 to 1892. In 1896 a similarly broad-ranging collection of pictures—twenty-nine canvases—was shown at Earles Galleries in Philadelphia; this was Eakins's only one-person exhibition during his lifetime.[30] But the group seen by the most people was undoubtedly the ten paintings at the art exhibition of the World's Columbian Exposition in Chicago from May through October 1893.[31]

Of those paintings, only three were from the 1890s—*Home Ranch*, *The Sculptor* (a now lost portrait of O'Donovan), and *Portrait of a Lady*. This last-named, now known as *Portrait of Amelia C. Van Buren* (pl. 190), is only the second portrait of a woman from outside his immediate family that Eakins chose to show to the public.[32] It debuted at the Philadelphia prelude to the Columbian Exposition and was then seen in Chicago, at neither place attracting a great deal of press attention.[33] It has since come to be considered one of Eakins's greatest works.

The subject of the painting is straightforward: a woman with a lean and unsmiling face, her gray-streaked hair pulled back, sits askew in the Jacobean-revival chair familiar from Eakins's portraits of the 1870s onward. Facing toward the light (reflections of studio windows gleam in her eyes), she leans her head on one hand while her other hand, holding a barely opened fan, rests in her lap. With these few elements, Eakins constructed a complex, animated picture. He devoted selective attention to the chair: the texture of the velvet on the armrests, the darkened knobs of the arms, the carved crest rail. Other parts, however, he only suggested, providing just enough information to convince the viewer of its integrity and feel, making it function as a secure—but not distracting—setting for the figure.

Van Buren's costume, too, provides both elusive evocation and solid information. Its layering and mix of solid and patterned fabrics alludes to eighteenth-century dress, but its precise structure is difficult to discern. The competing passages of smooth and jumbled fabric, abetted by the slight but pervasive angularity of all the forms—there are virtually no pure verticals or horizontals in the composition—energize the lower portion of the canvas. Van Buren is herself a study in torsion, twisting left and upward from knee to head like an overused spring, her near-fluid position completing the oblique approach of the chair.

The focal point of this complex, activated composition is Van Buren's head, which Eakins painted with nearly the same colors he used for her costume. But here there is no mystery as to structure—bone and cartilage determine form from within, and flesh responds to gravity and the pressure of head on hand. The broad forehead reveals the mind and its goings-on as the painting's principal preoccupation.

Van Buren (c. 1856–1942) was a student of Eakins at the Pennsylvania Academy of the Fine Arts in 1884 and 1885 and was reportedly "one of his most gifted pupils."[34] In late 1886 Eakins wrote about her:

> She is a lady of perhaps thirty years or more, and from Detroit[.] She came to the Academy some years ago to study figure painting by which art she hoped to support herself, her parents I believe being dead. I early recognized her as a very capable person. She had a temperament sensitive to color and form, was grave, earnest, thoughtful and industrious. She soon surpassed her fellows, and I marked her as one I ought to help in every way....
> She was taken sick that spring....
> The lady has been quite an invalid at home.[35]

Van Buren was apparently diagnosed as neurasthenic. She wrote in May 1886 to Susan Eakins: "I have at last discovered that the trouble with me is in my head it is exhausted by worry or something or other and I must just have patience until it is rested.... [S]o provoking to have nothing the matter with you and yet be everlastingly ill."[36] Susan Eakins wrote back in 1887, closing with the sentiment, "I hope you are well again and able to carry forward your studies as you wanted to."[37] Van Buren, however, took another path, away from painting to photography.[38] The attribution of several portrait photographs of her (pls. 186–89), often given to Eakins or his circle, remains uncertain. Using these photographs, several scholars have written of Eakins's tendency to "age" his sitters, portraying the painted figure as older and more careworn than reality justified. A stark photographic vision, however, such as that in the Bregler Collection (1985.68.2.702), which seems to show the gray-streaked hair and brooding expression of the painting, urges the question as to whether the more superficially attractive portraits may not be the more manipulated or arbitrary images.[39]

Van Buren apparently stayed at Mount Vernon Street whenever she visited Philadelphia.[40] It was during one of these visits, probably about 1891, that Eakins painted his portrait of her; Susan Eakins recorded one especially long stay extending from December 6, 1888, to August 12, 1889, that would have provided another opportunity.[41] Charles Bregler later wrote: "I recall with pleasure looking on for several hours one afternoon while he [Eakins] was painting in this room that beautiful portrait of Miss Van Buren.... No conversation took place, his attention being entirely concentrated on the painting."[42] The notion of silence reigning in the studio signals the difference between Eakins and such society painters as Chase

or Sargent, whose conversations and entertainments within the atelier were seen as key to maintaining a lively and engaging visage to portray on canvas. The sitter's reverie, rather than a reflection of the artist's engagement with the model, was to be the subject of Eakins's work.

Eakins had another life-size portrait of a woman from outside the family circle under way during the same time he was painting Van Buren: *The Concert Singer* (pl. 192), a portrayal of Weda Cook—and for at least some of the time during work on the canvas, the studio was not silent.[43] Cook (1867–1937), a professional mezzo-soprano, had made her debut at the Philadelphia Academy of Music at the age of sixteen. She came from Camden, New Jersey, where she knew the poet Walt Whitman, having set some of his words to music. She recounted that Whitman often asked her to sing an aria from Mendelssohn's *Elijah* to him: "I saw him many times, and he always asked me to sing 'O rest in the Lord.'"[44] Cook began posing for *The Concert Singer* in 1890; initially visiting Eakins's Chestnut Street studio as often as three or four times a week, she continued to stand for the painting sporadically through 1892. Each session began with Eakins asking her to sing "O rest in the Lord" for him, as Whitman had done, but with the painter watching her mouth and throat "as if through a microscope." The result was the first full-length standing female portrait of Eakins's career.

Eakins showed Cook in her professional guise singing on a barely suggested concert stage. Elements of the setting—footlights, palm frond, floral tribute (she perhaps sings an encore),[45] and, especially, the hand of a conductor—mark her space.[46] Yet it is difficult to account naturalistically for the implied orchestra pit and viewer's seat, or even the seemingly inconsistent point of view toward Cook herself.[47] It is almost as if Eakins intended the props to function emblematically rather than within a realistic space. They are in any event subservient to the singer, who triumphantly fills one of the lightest and brightest of Eakins's portraits. He depicts the gown with his usual combination of generalization and close focus: while bits of the beadwork are precisely rendered, the pattern of the floral brocade hovers between resolution and abstraction. These visual conundrums all serve to attract the eye but not hold it, allowing it finally to rest on Cook's strikingly pictured face.

There Eakins's "microscopic" examination combined with his anatomical studies allowed the precise rendition of a singer in action. So accurate was Eakins's portrayal of mouth and neck that some scholars have posited that she was forming the *e* sound in the word *rest*.[48] Eakins would probably have been pleased at the speculation, since he wanted the text to be recognized. As he later wrote: "I once painted a concert singer and on the chestnut frame I carved the opening bars of Mendelssohn's

'Rest in the Lord.' It was ornamental unobtrusive and to musicians I think it emphasized the expression of the face and pose of the figure."[49] To the viewer who reads music, the well-known melody rises from the frame, the English lyric unavoidably pulled in tandem. For those—singer and painter, certainly—who knew of Whitman's love of the song as sung by this particular woman, the spirit of the lamented poet, too, was doubtless invoked.

Sometime toward the end of his work on *The Concert Singer*, Cook refused to return to Eakins's studio.[50] The cause of the split was Eakins's desire to have Cook pose in the nude for him, which she steadfastly refused to do. He "kept after her," she reported to Goodrich, making his eyes "soft and appealing" and dropping into a Quaker "thee"—"gentleness combined with the persistence of a devil." One day he and Murray together persuaded her "down to my underclothes," but no further; here perhaps Cook refers to the "classical costume" photographs of her that are among Eakins's most self-consciously artful (including pls. 179, 180).[51]

The breach was healed by 1895 when she, her husband, and her cousin Maud all posed for individual portraits.[52] The head and bust of the latter (pl. 205) is one of Eakins's loveliest paintings. The sitter, dressed in flowing pink fabric that cascades down her shoulders to be gathered and pinned between her breasts, tilts her head away from the viewer. She looks off to the left, toward the light, which casts strong shadows revealing the structure of her face, yet falls diffusely on her skin to impart a subtle glow of youth and health. Maud Cook herself described the work in a letter of 1930: "As I was just a young girl my hair is done low in the neck and tied with a ribbon [not visible in the picture].... Mr. Eakins never gave [the painting] a name but said to himself it was like a 'big rose bud.'"[53] The verbal image—resonant and ripe with sensuality—seems apt.

Eakins's major work of 1895, however, was a full-length portrait of the famed, albeit controversial, anthropologist and ethnographer Frank Hamilton Cushing—a portrait as ambitious as any single-figure work he had yet undertaken (pl. 203).[54] Cushing (1857–1900), after only a year of college at Cornell University in 1875, joined the staff of the Smithsonian Institution; he was ultimately named curator of the Department of Ethnology in the Bureau of American Ethnology. In 1879 he began four and a half years of field work in New Mexico among the Zuni, most of the time as a participant in the life of the tribe. On his return, he began publishing scientific and popular texts revealing the pueblo's daily and spiritual life. One colleague later recalled: "His personal magnetism, his witchcraft of speech, his ardor, his wisdom in the unknowabilities, the undoubted romance of his life of research among 'wild Indians'...all were contagious.... Perhaps never was

another quite so curiously mixed between genuine scholarship and the arts of showmanship."[55] There was, however, a price to be paid; the rigors of his sojourn in New Mexico permanently damaged Cushing's health.

The anthropologist and Eakins met through Samuel Murray, who had been recommended to repair some of Cushing's Zuni pottery.[56] By July 1895, apparently friends, Eakins and Cushing were discussing a portrait. Eakins wrote:

> I hope sincerely you may be able on coming back to Philadelphia to prolong your stay beyond a few days.
>
> I think I could paint the whole picture in a couple of weeks if you would help me with the background and accessories, and in so helping me, I could teach you perspective.
>
> Could you not stay at our house while I paint you? Or whether I paint you or not.[57]

The painting was under way by late summer, when Cushing announced, "My friend, Thomas Eakins, the Scientist artist, of Philadelphia...is honoring me by painting my portrait."[58]

Together Cushing and Eakins, probably with Murray's assistance, transformed a corner of the Chestnut Street studio into a kiva (an excavated chamber) in which the Zuni enacted sacred ceremonies. Eakins reportedly built a fire on a brick base in the studio to replicate an appropriately smoky atmosphere.[59] Altar, weapons, and artifacts range throughout the space. The most exotic of the items depicted, however, was Cushing's costume, a romantic confabulation—half-Indian, half-Mexican vaquero—created and worn by Cushing while among the Zuni.[60] Silver, turquoise, and shell ornament the jewelry and buckskin belt and leggings, while the head-sash and embroidered shirt provide the painting's darkest color notes, setting off Cushing's pockmarked face, which Eakins ruthlessly transcribed with unblended touches of his brush.

A series of photographs taken during Cushing's pose reveals the passages where Eakins departed from visual reality (pls. 201, 202). There is, for instance, a light rectangle in one photograph that isolates Cushing's head; in the painting this has been submerged into the wall, with only a softly brushed, light-colored halo to help focus attention on the face. More obviously, Cushing had been a decade away from the Zuni and no longer wore his hair long or earrings in his pierced ears; Murray's sister recalled that she posed in Cushing's blouse "so Eakins could paint the dark hair about the shoulders."[61]

As is the case with so many of Eakins's later, life-size portraits, only one preparatory oil study now exists (Hirshhorn Museum and Sculpture Garden, Smithsonian Institution, Washington, D.C.), showing that Eakins made few variations as he transferred the subject to its larger format. In this case, the study's survival is especially fortuitous, since it bears a variant of the decorated frame—carved with glyphs of Cush-ing's Zuni name and honors, bound at sides and corners with rawhide thongs, and lost sometime in the twentieth century—that Cushing designed for the large work.[62]

Eakins reportedly submitted the finished work to the Pennsylvania Academy annual in December 1895. Although four other works were accepted, the portrait of Cushing was rejected. Eakins instead first showed it to the public in his one-person exhibition in May 1896 at Earles Galleries. Of the twenty-nine pictures on display there, the one of Cushing was by far the most noted. Riter Fitzgerald, whose portrait by Eakins (The Art Institute of Chicago) was one of those accepted at the Academy in 1895, wrote: "It is the fashion to say that Eakins is 'brutally frank,' that he has too high a regard for Art to idealize or etherealize his subjects. All of which translated into plain every day English means that he paints his subjects as he finds them imperfections, blemishes and all." He then became more specific:

> Probably the most notable example of the frankness of Mr. Eakins is the life-sized portrait of Lieutenant Cushing, the eminent archaeologist....
>
> Regarding the frankness with which the subject has been painted, it should be said, in justice to the artist, that it was the wish of Lieutenant Cushing to be so represented.
>
> This portrait makes one of two things very plain. Either Mr. Eakins is in advance of his time or he is very much misunderstood.[63]

Immediately after Cushing's death in 1900, Eakins and the Philadelphia archaeologist Stewart Culin—who had initially brought Cushing to Murray and whom Eakins painted about this time (the painting is lost)—sought to find an institutional home for the portrait, approaching both the Smithsonian Institution and the University of Pennsylvania. Eakins wrote:

> I have in my possession a full length life size portrait of Frank Hamilton Cushing which will cause me uneasiness until it finds a permanent resting place in some fire proof building.
>
> He is represented as in Zuñiland performing an incantation.
>
> An altar was built by Cushing in a corner of my studio, and all the proper details were assembled by him. Even the frame of the picture was designed by him, largely made and ornamented by him.
>
> Its lower piece contains his name (the picture of a plant), his office and his clan.
>
> I should be glad if the picture could be acquired by he Government Bureau or by the University of Pennsylvania.[64]

Eakins's language—the concern with the fireproof building and the specificity of sites where he hoped to place the work, relevant to Cushing's anthropological interests rather than in art settings—reveals his sense of the painting's historical

significance.[65] The men were, however, unsuccessful in finding a permanent home for the work. Nor did Eakins circulate it to the fairs and exhibitions at which he showed his largest and most important paintings in the last decades of his life.[66]

The year 1896 was a fertile one for Eakins's portraiture. Continuing to experiment with formats, he took advantage of the puffed sleeves and flounces of a young woman's gown to turn a portrait-format canvas sideways. Its horizontal orientation makes the resulting work, *Portrait of Lucy Lewis* (pl. 204), one of Eakins's most overtly decorative canvases. The artist characteristically presented Lewis from an oblique vantage point, her torso and gown-enhanced shoulders turned to the right. She, however, twists toward the viewer, then moves her eyes even farther to the left, creating a mood of gentle tension and alertness. Eakins furthered this spiraling sensation with a series of echoing or concatenating curves—flounce, neckline, necklace, round chin and lips, orb-like eyes, circular curls, hairline and contour—that contribute to the harmony of the canvas.

The critic Fitzgerald recognized the effective striving after beauty in the work when he saw it as part of Eakins's Earles Galleries exhibition:

A portrait of Miss Lucy Lewis, one of the teachers at the Girls' Normal School, is in the line which Mr. Eakins must cultivate if he wants to make a pecuniary as well as an artistic success.

There is a partial idealization of a very pretty subject, which could have been carried very much further with profit.[67]

Typically, Eakins ignored Fitzgerald's counsel, never again undertaking so aestheticizing a portrait—although other advanced painters, including Mary Cassatt, would independently explore the same unexpected use of the horizontal for a head-and-bust portrait to good effect.[68]

Beginning in 1894 and continuing until his death, Eakins began again to show at the annual exhibitions of the Pennsylvania Academy of the Fine Arts.[69] One of the principal factors in his willingness to associate with the institution that had caused him such trauma in 1886 was its secretary and managing director Harrison S. Morris (1856–1948), who worked hard, and in a variety of fashions, to bring Eakins back into the Academy's orbit. In his reminiscences he wrote:

When I began at the Academy, Eakins was in exile.... I had known him very well, and had felt the bold appeal of his vigorous painting; the attachment which his lovable nature had won from his students, and the force of his intellect.... I felt his value to the Academy. A city with Eakins living in it detached from its Fine Arts Academy was a Hamlet-less farce. You might as well try to run a wagon on three wheels. Everybody would ask where the fourth was. The fourth, as essential as the rest, was Eakins.... I set out to win him back.[70]

Morris's tactics—including hair-raising equestrianism while on a visit to Avondale—bore fruit.

In 1896, as Morris later remembered, Eakins "gave me so much a share of his regard, that before long he asked me to pose for my portrait, which I did."[71] In the resulting picture (pl. 207), Eakins once again set out to explore a format rare in his oeuvre, this time a three-quarter length in profile. The presentation proved apt for the vigorous young man, the stance emphasizing Morris's slender torso, the jutting elbow implying a contained dynamism, and the profile lending a visionary quality to the whole.[72] Such contemporaries of Eakins as Sargent and Giovanni Boldini would use the stance for both soldiers and aesthetes.[73]

The portrait proceeded slowly. Morris recounted: "I stood day after day while he patiently transcribed me—for his method stuck closely to the object; and I watched his large underlip, red and hanging; his rather lack-luster eyes, with listless lids; his overalls of blue, I think; and his woolen undershirt, the only upper garment.... I posed on my feet for so many hours that I was seized of an irruption on my weary legs and had to go to a doctor."[74] The artist evidently felt the mutual effort was worthwhile, for he included the portrait in his Earles Galleries exhibition in May 1896 (he also might well have wanted to publicize the fact that, a mere decade after his expulsion, he was painting an official of the Academy—an implied vindication). Morris, too, appreciated the work and wrote as much to Eakins, to judge from the artist's response:

Your very kind letter was duly received and gave me double pleasure, for it had been on my conscience that perhaps you might not be caring for my portrait, and yet had gone to the expense of a frame for it. Mrs. Eakins and I send our heartfelt wishes for a long and happy life to you both, and anticipate with pleasure a visit to your fireside.[75]

One of the most productive contacts between the two men, at least for Eakins's stature within Philadelphia, took place over the winter of 1896 and 1897, when Morris succeeded in acquiring Eakins's sole inclusion in the Academy's Sixty-sixth Annual—*The Cello Player* (pl. 206)—for that institution's permanent collection. Eakins wrote near the end of the exhibition: "The purchase of my *Cello Player* would be however a very simple transaction, as you have my price, and I would not think it at all fair to ask one price and take another."[76] Thus, for five hundred dollars Eakins sold his first work to a museum since 1879.

The Cello Player shows Rudolf Hennig (1845–1904), described in 1896 as "the distinguished violincello virtuoso," practicing in an undefined space, which is interrupted only by curiously falling shadows and Eakins's perspectively rendered signature. Thinly and vigorously brushed—so thin that the

transfer grid (the preparatory oil is at the Heckscher Museum, Huntington, New York) is still visible—the space of the picture seems almost filled with the "exquisite tone—a 'golden tone' one might almost call it" that characterized Hennig's playing.[77] The cellist is situated in the midst of this sonic aura, hemmed in by the contours of chair and cello. Although we know Hennig is meant to be moving—the horsehair of the bow flattens against the quivering D-string—Eakins makes him a still presence at the heart of the picture by occluding both his eyes and mouth, as well as by focusing on the near hand and foot. This forces the viewer away from Hennig's face, the usual locus of attention in a portrait, to concentrate instead on the emphasized bulk of the cello and the whole figure, which is enlivened by alternating crisp and softened contours.

The tepid critical response when it was first seen at the National Academy of Design in New York—"hardly more than an average specimen of the painter," wrote one reviewer—must have been balanced by Morris's keener appreciation of the work and its purchase for the Pennsylvania Academy.[78] Dividing the purchase price evenly with Hennig,[79] Eakins borrowed the painting from the Academy and sent it back to New York for the Society of American Artists exhibition the next year. Even the prestige of the lender failed to inspire critical enthusiasm. One of the painter's most ardent supporters, Sadakichi Hartmann, had written in April:

> Philadelphia can be proud of possessing Thomas Eakins. Among our mentally barren, from photograph working, and yet so blasé, sweet caramel artists, it is refreshing, like a whiff of the sea, to find at least one rugged, powerful personality like Thomas Eakins.[80]

Yet the very next month, on reviewing the Society's exhibition, he lumped *The Cello Player* together with works by two other artists at the end of his column, saying, "Of course, I should probably also say something about...Th. Eakins' 'Cello Player,'...but...sometimes the novelties of a new-comer seem more interesting than the mature work of well-known artists."[81]

Nonetheless, Eakins must have looked at 1896 and 1897 as a time of professional renewal: the one-person exhibition at Earles Galleries; the exhibition of *The Cello Player* in New York at both the National Academy of Design and the Society of American Artists, and its exhibition and sale in Philadelphia; an invitation to participate in the newly inaugurated Carnegie Annual Exhibitions in Pittsburgh in 1896; experimentation with new formats for portraits; and the return to Philadelphia of a former Academy student—Henry Ossawa Tanner—who had earned fame in Paris with an honorable mention in the Salon of 1896 and a third-class medal in 1897. Eakins celebrated Tanner's visit to the United States in 1897 with a portrait of his erstwhile pupil (pl. 212—although many sources date the work to 1902), one of a number of serious, individualizing portrayals of African Americans from Eakins's brush.[82] In the work, Tanner looks downward, his eyes framed but not revealed by his low-powered spectacles. The green light reflected from his bright-hued tie testifies to Eakins's close observation and sensitivity to color—a subtle but apt tribute to Tanner's own mastery of light effects, which dominated his canvases of the 1890s.

But the period also held trauma. Eakins's former student Lillian Hammitt—who was hospitalized as delusional in 1892—was arrested in the mid-1890s wandering the streets of Philadelphia in bathing costume and claiming to be Eakins's wife.[83] Even more traumatic was the suicide of his niece Ella—the child in *Baby at Play* (pl. 18)—who shot herself on July 2, 1897. Eakins was held by the Crowell family to be, at some level, responsible for his niece's madness, and a break with Will and Fanny Crowell—his childhood friend and sole surviving sister, both ardent defenders during the troubles of 1886—resulted. He was never again welcome at Avondale.[84]

Eakins responded to these events by throwing himself into an ambitious new project. By the third week of July 1897, he was in Seal Harbor, Maine, beginning work on a portrait of the renowned physicist Henry A. Rowland (1848–1901), the first professor to hold the chair in physics at the Johns Hopkins University in Baltimore and a leader in his field (pl. 211).[85] Rowland's principal accomplishments revolved around his finding physical constants—speeds, units, ratios—through better experiments and tools: theoretical inquiry furthered by pragmatic engineering. To make the diffraction grating that Eakins shows him holding, for example, Rowland designed a ruling machine that, working continuously over a period of six days, could inscribe the three miles of engraving (14,400 parallel lines) necessary for a five-inch, hand-held instrument.[86]

Twelve letters from Eakins to his wife, from Seal Harbor, detail the progress of his work; these are complemented by seven from Eakins to Rowland and another from Rowland to Eakins. These rare documents reveal that the portrait did not proceed particularly quickly, as various recreations presented themselves to distract both men—sailing most especially, augmented by bicycling, kite-flying, and social calls among the summer residents of the Seal Harbor colony.[87] One Saturday in July, Eakins reported that "Although I have had only about 3 hours or less of sitting from Rowland I have done a good sketch of a good characteristic pose [probably the study now in the Addison Gallery of American Art], the perspective all done, the big canvas stretched and the painting started on it. I think it will be every bit as good as the Hennig and I shall try to finish it without getting tired or stale."[88]

The comparisons that Eakins made here and elsewhere in the letters with *The Cello Player* are curious, since the finished state of the Rowland picture is very different in effect from that of Hennig, the stillness and the apparatus of the physicist's portrait seeming to have much more in common with the pictures of such scientists and doctors as John H. Brinton, Horatio Wood, or, especially, William D. Marks. The link perhaps had more to do with Eakins's hope that this, too, would prove to be an invigorating work, a spark to his career.

The diffraction grating that Rowland holds reveals the normal color spectrum—although it lightens curiously at both ends rather than deepening to infrared and ultraviolet. This rectangle, riveting in its prismatic brilliance, is the most chromatically rich passage of painting in all of Eakins's oeuvre— or that of nearly any other painter. The technical achievement of this prop, of choosing and blending and evenly applying his colors so as to make an even marginally convincing reproduction of the spectrum, is pyrotechnic.

Eakins, evidently missing his wife and family on Mount Vernon Street, wrote frequently, telling Susan of his work:

> I am going over the head again. You know I had finished it all in an hour & a half. It was pretty strong in a way but coarse. A head can hardly be gone over in that time. The work I did yesterday was I think pretty good. I cannot afford to miss the refinement of the man. We are getting on very well together.
>
> I will go over the forehead this morning. He dont want to look sunburnt for he says he is never that in Baltimore. Since I got in his hand and the spectrum he is greatly interested in the work and poses very well.[89]

With Rowland, whom he liked and respected, Eakins felt no compunction about acceding to requests concerning aspects of appearance—if Rowland did not want an overly reddened face, Rowland would not be painted with one, no matter the reality of how he looked at the moment.

Eakins continued to report to his wife on a regular basis: "Yesterday I got more clothes done[.] For the last few days Rowland has been interested in the portrait, ever since I finished one of his hands. Before that I am sure he didnt think my painting was going to amount to much. I am sure people dont see much in a loose sketch."[90] "Yesterday I went over the forehead. . . . Rowland sat a while for me in the afternoon and I finished the other hand not a great deal to be sure for you only see the tips of the fingers but it was that much nearer to home. To day I shall go over the chin and jaw. Next week I shall be home. . . . Rowland is at last greatly interested in the portrait. He sees how much it looks like him."[91] On August 9 he added, revealing an indulgent, casual attitude toward his distinguished sitter: "no painting at all to day but sailing instead for

Rowland couldnt pose if he tried. He is a big bad boy. . . . I have ordered the box made for my picture."[92]

By August 17, after almost a month away, Eakins was back in Philadelphia. He wrote to Rowland concerning details of how to ship the unfinished picture from Maine, and informed him that he would probably go to Baltimore "to study your engine" within the next day or two.[93] The picture must have arrived shortly thereafter, for Eakins wrote in early September:

> I worked all yesterday on your machine, and can now see its effect on the picture.
>
> I think I told you that instead of keeping the machine in shadow, I was going to let light in on it. I have done so and do not regret it. It spots the picture somewhat but I shall with other details spot the picture in other places, except behind the head, which will again simplify things in this way: The most prominent thing in the picture will be the head, whereas before it was the whole figure.

Eakins continued in the letter to give the first notice extant of the principal of those additional spots: the figure of Rowland's skilled machinist and laboratory assistant, Theodore Schneider:

> Schneider will now go particularly well in the background to continue the bright spots of the machine; and to the other side of the picture I shall put some shelves with bottles.
>
> So I trust the picture may gain in interest and not lose breadth.
>
> It will only take me a day to put in Schneider who will be out of focus entirely.[94]

The next month Eakins reported on the painting's progress, noting that he had "not done much to the picture. I have Schneider in now however & he has the effect in the composition that I had intended. He carries away the important machine from the important figure." As with *The Concert Singer*, Eakins was constructing a background with emblematic and pictorial concerns foremost, conveying greater meaning and visual power than a simply coherent interior would allow. Eakins asserted: "So far the picture has been growing better all the time."[95]

But the picture was far enough along that Eakins could also write, in the same letter:

> I sometimes think of the framing of it.
>
> My exhibition frames are mostly of plain chestnut gilded right upon the wood and showing the grain. Now it seems to me it would be fine to saw shallow some of the Fraunhofer lines which you were the first man to see, or the double scale of the Fraunhofer lines and the inch or centimetres. Would there be some simple & artistic way I wonder of suggesting the electric unit that I heard of your measuring so accurately.[96]

And indeed the frame became an essential element of the composition. Not only does it bear, as Eakins proudly stated, "lines

of the spectrum and with coefficients and mathematical formulae relating to light and electricity, all original with Professor Rowland and selected by himself,"[97] but it is also of immense size. In spite of its ornaments, the almost foot-wide flat boards establish a great deal of space around the work, dominating all else on any wall—as both Eakins and other artists knew. In 1904, when it was at the National Academy of Design, Eakins wrote to another painter, "Have you been to the Academy? I am wondering where they have hidden my Rowland whose frame they hate but I like."[98]

Eakins manifested his pride in the painting not only by the large size of his signature—it stretches halfway across the canvas—but by the venues in which he exhibited the work: the Pennsylvania Academy of the Fine Arts in January 1898, followed by showings in Chicago, Cincinnati, Pittsburgh, and, in 1904, New York. It met with a mixed response. At the Carnegie International in 1901, one writer declared it to be "painted in his most prosaic style, direct and literal, with scarce a particle of suggestion, and without the sobriety of color that distinguishes his strongest work."[99] Another, however, declaring it to be a "somewhat fanciful" portrait, said that it "justly elicits unstinted praise. Eakins's work…betrays the result of intimate acquaintance. The picture was painted as a souvenir of the artist to the widow of his friend. It was designed to be more than a mere portrait—to be symbolical of the subject's bent of mind and lifelong interests. The picture shows the scientist at work, and every detail is well calculated to enforce the artist's purpose."[100] In spite of the false attribution of memorial sentimentality, the second writer understood the larger symbolic or iconic purposes behind Eakins's carefully constructed painting.

The next year, for the first time since the 1870s, Eakins returned to the subject of sport. Three finished boxing paintings, along with one of wrestling (Columbus Museum of Art, Ohio) and the associated preparatory works that Eakins produced in 1898 and 1899, are as revolutionary in their subject matter as his earlier boating scenes. Such characters as the fighter "Turkey Point Billy Smith" and such sites as the interior of "The Arena"—at least in this guise[101]—were simply not pictured in the fine arts in the United States. The moral and legal questions concerning prize-fighting, its sanctioned violence, and the indulgence in gambling and alcohol that took place around it separated its adherents from the more genteel elements of the city.[102] Images of the sport proliferated in news and sporting sheets, but not within the halls of such temples of civility as the Pennsylvania Academy of the Fine Arts, in spite of the fact that the Academy and the Arena were literally within a stone's throw of one another. Once more, Eakins assayed the challenges of American contemporary life—his

life, for he was an avid boxing fan—and transformed it into the stuff of art.[103]

Taking the Count (pl. 213) was probably the first of Eakins's boxing paintings completed. It is a massive canvas, and in this shows a decided departure from his previous scenes of athletes. In even the largest of the earlier sporting pictures, such as *The Biglin Brothers Turning the Stake-Boat* (pl. 6), the figures are substantially reduced from life size. In *Taking the Count*, however, the principal figures are nearly as large as life—a scale in keeping with the majority of his significant portrait projects and, even more relevant, his one religious painting, *The Crucifixion* (pl. 54). Continuing the blurring of artistic boundaries that had characterized his works of the 1870s and 1880s—portraits that seconded as genre scenes, historical genre pictures that looked like studies—Eakins here elided sporting genre with portraiture and alluded to religious or mythological painting (through scale and solemnity). On a more autobiographical level, the decision to paint large-scale male nudes proclaimed Eakins's continuing status as the most knowledgeable anatomist among American artists.

Taking the Count puts the viewer into the ring with two boxers and a referee—even closer to the protagonists than the second at the far edge. The boxer to the left, Charley McKeever, has landed an effective punch and knocked down his opponent; the referee, Henry Walter Schlichter, counts toward "ten."[104] The audience is seated in three concentric tiers, with privilege inversely related to altitude; among the innermost circle is a recognizable image of Benjamin Eakins (in a light hat at the far left), although even the men in the top level, fogged in by tobacco smoke, are individualized.[105] The painter carefully centered the architectural supports of the Arena over the pelvises of the boxers.

The sheer size of the canvas demonstrates Eakins's ambitions for it. Yet it seems that Eakins never exhibited the work beyond its long-term loan to the Schuylkill Navy Athletic Club. In later life, though, he clearly valued it; in 1911 he made an inventory of possessions in which, along with his microscope, telescope, camera, and gun, he listed twelve paintings, among them "a large picture of boxing (Charley McKeever)."[106]

Further down the inventory list Eakins continued: "I have two pictures of boxing bouts with Billy Smith as principal." In these, *Between Rounds* and *Salutat*, the focus is away from the action in the ring—the punch and its immediate effect. They instead show seemingly tangential moments that emphasize a peculiarity of Eakins's boxing pictures: his imposition of thought and emotion onto even this most physical of circumstances.

Even in *Taking the Count*, the picture that is most directly about boxing's violence, McKeever holds back, watching, wondering whether his opponent will rise again and, if so,

what will be his next move. Meanwhile the crowd yells, trying to take a vicarious part in the match itself. Eakins portrayed none of the physical blows such as those that he and Eadweard Muybridge had photographed in the 1880s, nor any of the punishing fury that George Bellows would so effectively conjure in paint within the next decade.[107]

The more restrained *Between Rounds* (pl. 215) also shows the interior of the Arena; the same two theatrical posters hang from the far balcony (although at a different place in the structure). Eakins moved the point of view back from the ring to behind the roped stanchion, equivalent to where the policeman at the left stands.[108] This gives a clearer sense of the building, its structure, and its areas of activity. The pale body of a fighter gleams within the painting's brown, fuggy atmosphere—the still, quiet center, spatially and thematically, of the noisy scene.[109]

The fighter is Billy Smith—his name is at the bottom of the yellow placard. The evening, apparently April 22, 1898, is almost over.[110] That Smith would lose the fight that night to a boxer named Tim Callahan was of no moment to Eakins, although the painter hinted at that outcome by having most of the men in the Arena look away toward the other, out-of-our-view fighter.[111] In fact, the Callahan versus Smith bout was not the major event of the evening, as the big red letters "West" and "Wolcott" on the placard make clear.

In 1940 Smith wrote a letter about his posing for Eakins that helps explain this diffidence about victors and main attractions, and serves as a useful warning regarding the painting's powerful impression of being the transcription of a real event:

> You want to know something about Mr. Eakins, and the picture [referring to a profile study of Smith (Wichita Art Museum) that Smith had just sold]. First, as Mr. Eakins would say, when asked to speak of himself, My all is in my work. But, what I know. It was in 1898, when Mr. Eakins came to a Boxing Club, to get a modle [*sic*] for his first fight picture, titled, *Between rounds*. He choose me. I posed first for the picture you just sold.
> Then, for the Between Rounds, and next for the one titled Salutat.[112]

From this testimony it becomes clear that, as with the portrait of Dr. Gross or the Biglin brothers turning the stake, Eakins fabricated his scene. Inspired by his experience of the matches, he first sought a model. Not just any well-built man would do; it must be a practitioner. Taken to a boxing club, he met Smith, "a very clean little fellow."[113] He turned all his attention to the lean, one-hundred-and-fifteen-pound fighter, posing him in a stance to fit the already formed vision of the picture. Eakins then constructed the space and added the accoutrements—posters, placard, policeman, timekeeper, spectators ("Stay a while and I'll put you in the picture," he is reported as saying

to studio visitors while at work on the spectator galleries)—as design and opportunity dictated.[114] His "realism," as he wrote from Paris, "combines and combines."[115] He was not attempting to re-create a particular moment of April 22, but to make an effective picture.

In this goal he was strikingly successful. Goodrich was among the more eloquent observers of how carefully planned and "translucently and thinly" painted the canvas is, of how cannily Eakins was able to convey great depth and solid form through carefully handled tonal shifts.[116] He worked long and hard at the picture, which is probably the most complex interior scene of his career—again, a new, self-imposed challenge. Susan Eakins later recounted: "In 'Between Rounds' every person in [the] picture posed for him. The interior was the Hall used by the fighters. With perspective and color studies, no photographs, all the result of his untiring observation and study."[117] Eakins was able to sign and date the painting only in 1899. In November, Harrison Morris, soliciting for the upcoming exhibition at the Academy, wrote, "It is the new boxing picture in your studio I especially want."[118]

Morris got his wish. *Between Rounds*, along with two portraits, was part of the Annual at the Pennsylvania Academy in 1900, although it apparently had to be gathered from the New York Athletic Club rather than Eakins's studio.[119] Critical response, however, was unenthusiastic: "Feeding the now popular taste 'Between Rounds' is a realistic emanation at the hands of Thomas Eakins. You all know, however, that he can do better."[120]

Eakins's third boxing picture, *Salutat* (pl. 215), again featured Billy Smith, this time seen close up from the back as if exiting from the Arena's fighting area. He stops mid-stride, right arm raised, as a crowd of recognizable men cheer and applaud.[121] Smith has evidently prevailed in his fight. The original frame, now lost, bore a Latin inscription carved by the artist: DEXTRA VICTRICE CONCLAMANTES SALVTAT (With his right hand the victor salutes those acclaiming him).[122] The Latin not only tweaked an ironic note between elevated title and rowdy subject, but forcibly drew multilayered parallels between Eakins's work and the Roman gladiatorial scenes of Gérôme, such as *Ave Caesar, Morituri Te Salutant* (fig. 35), which Eakins had depicted as a photogravure in the background of *The Chess Players* (pl. 19). In the French work, stout gladiators, arranged to face the viewer, raise their arms to a porcine Caesar, brandishing shields and weapons at the start of their bouts; their predecessors, now dead or dying, are hooked and dragged from the amphitheater; fresh sand is spread over the pools of their blood. Neither Caesar nor those in attendance around him show any emotion at the human sacrifices past or looming. Eakins played consistently against this. Billy Smith's

lean but well-muscled body is seen from the back, the lone fighter at the end of his bout. He carries nothing, raising his bare arm in salute to the fervent applause of the crowd. There is no blood, there are no weapons. His seconds follow behind him, insouciant, bearing the mundane props of towel, bucket, and sponges.[123] Eakins pictorially contrasted Imperial Rome with democratic America, while, through the Latin title, establishing a relationship between them. Likewise, he made the association between French and American art, between his own painting and that of his master. He seems to have asserted baldly that here were the means for ready comparison.

Eakins took great pride in the painting. He sent it to the Annual of the Pennsylvania Academy in January 1899 as his sole exhibit. It was "a fine composition," wrote one critic, "in which that painter's fine knowledge of the human figures is shown to advantage."[124]

As if to present himself to Gérôme directly, he sent the painting along with *The Cello Player* to the Exposition Universelle of 1900 in Paris. Eakins won an honorable mention—foreign validation[125]—and *Salutat* was picked out for a full-page photogravure in one of the luxury volumes that summarized the art of the fair, which praised him reservedly:

> It is said that Gérôme pronounced Mr. Eakins to be one of the strongest of his pupils; it is probable that he never had one with a more scientific turn of mind. Generally the science is not too demonstrative; and there is evident a distinct effort to express as well the meaning, or the large aspect, of the incident. That these works are not lovely, is of not very much import.[126]

As an American critic had earlier observed of the picture, "always coarse, never beautiful, but often true."[127]

The final year of the decade held more personal losses for Eakins. On January 2, 1899, his Aunt Eliza Cowperthwait, who had lived in the Mount Vernon Street home since the 1860s, died. Perhaps this, coupled with his isolation from the Crowell family, prompted Eakins to use his art to study and reconsider the people closest to him, initiating a series of modestly scaled, probing, head-and-bust portraits apparently not intended for public presentation. They are among his greatest, most emotion-laden works.

Chief among them is the portrayal of his wife, Susan (pl. 216). In her diary entry of February 16, 1899, she wrote: "I try on rich stuffs to tempt Tom to paint."[128] While it is not clear that her effort at millinery seduction was the catalyst for this portrait, it is certain that in this close-focused, detailed look at his wife's face, Eakins made one of his most profound works. Eakins had painted Susan Macdowell Eakins several times in the 1880s, but never before had he dropped all props or narrative to concentrate so intently on the structure of her handsome head and straightforward expression. In one of the rare fully frontal approaches in his oeuvre, Eakins manipulated details of pose and costume to keep the canvas from becoming hierarchic or overtly composed. The sitter's quiet, stylish dress and softly gathered hair frame this much-watched face, in which each transient modulation—wrinkle, patch of rough skin, pinpoint depression—reveals underlying structure no less than specific identity. She simply stares back at the artist and viewer with the same cool intensity with which she is herself observed—an exchange of calm appraisals.

On February 26, Susan Eakins's diary reported that Eakins "begins portrait of Addie"; he was at work on this picture (pl. 217) through at least the middle of May.[129] Mary Adeline Williams (1853–1941) was a family friend of long standing and, through marriage, a distant relation.[130] In later years, she reminisced that Eakins "was like a big brother to me."[131]

The 1899 portrait shows Williams in a dark, pleated blouse (not dissimilar to the one worn by Susan Eakins for her portrait), finished by a cream-colored scarf wound around her throat and tied with a neat bow at the front. Eakins's scrutiny of his friend is typically unsparing; the portrait shows her with lines and creases at brow, mouth, and eyes. Susan Eakins later recounted that, while the portrait was under way, Williams was "rather worried," and this mood, emphasized by the length of her face and its extended philtrum and slight frown, has impressed itself on most commentators since.[132]

The day after he started the portrait of Addie, Susan Eakins noted in her diary, "Tom starts portrait of his father,"[133] probably referring to the work now in the Philadelphia Museum of Art—the only portrayal in oil of the man since *The Writing Master*—and as sober and detailed a record of a man's head as Eakins ever made. The timing was propitious, for at the end of the year, on December 30, Benjamin Eakins died. The elder Eakins had been an emotional, moral, and financial support for his son as well as a friend and companion throughout the decades.[134] The void left by his death must have been great.

According to Benjamin Eakins's will, his sizable estate was divided in thirds among his two surviving children, Thomas and Frances, and the children of Caroline Eakins Stephens. The painter was to keep the house on Mount Vernon Street, if he wanted, as part of his portion. Thus, at age fifty-six, Eakins became head of the household.

One of the decisions that the Eakinses made shortly after Benjamin Eakins's death was to invite Addie Williams to come and live with them. She did so, remaining in the house for nearly four decades. Sometime during the first year of her residence, Eakins painted a second portrait of her (pl. 218), which stands in marked contrast to the first—projecting a mood that Susan Eakins characterized as "more relaxed and more tender,"

following upon her becoming "a beloved companion in our house."[135] In this later work, Williams turns fully to the light, smooths her earlier worried brow and sagging flesh, adding sparkle to her eyes, color to her complexion, and gloss to her lips. Her mouth holds the slightest hint of a smile, and she tips her head away from the viewer, which further lends an optimistic tilt to her features. The canvas shape—narrower than Eakins's standard for this format—further focuses on the face and draws the viewer toward her.

Some commentators have attributed the shift between the two portraits of Addie Williams to the initiation of an affair between the sitter and the painter.[136] It might be relevant to note that the two extant photographs of Williams attributed to Eakins (Bregler Collection) reveal a similar dichotomy: in one she wears a white, frilled dress, looking upward into the light, smiling (pl. 219); in the second, which shows her in profile, she wears a dark suit, wide-striped blouse, high collar and bow, and, to the degree possible to see in profile, a more sober expression. Both photographs are thought to predate 1900.[137] It seems possible that, rather than registering an objective change in the sitter or his own relationship to her, Eakins perceived Williams's physiognomy as one that embodied contrasting emotional states and pictured it so.

As distinct as the expressions between the two paintings of Addie Williams are the clothes she wears in each. In the later work, she has replaced black pleats with an almost-girlish confection of coral-striped flounces, bows, and high velvet collar. In depicting this outfit, Eakins submerged his near-omnipresent concern with the body's carefully revealed form beneath energetic strokes of orange-red paint more at home on a canvas by an Italian Futurist than the sober American exemplar of the Brown Decades. Eakins revealed no seams or edges, no clear hints concerning the garment's construction beyond the direction of the bright lines (and these, in the lower left corner, amount to nonsensical clues), evincing powers of sartorial summation and verve comparable to that appearing in such so-called Impressionist works as J. Alden Weir's *Face Reflected in a Mirror* (1896, Rhode Island School of Design, Providence—a prizewinner at the Carnegie International in 1897)—and *The Gray Bodice* (1898, The Art Institute of Chicago) or Cecilia Beaux's *Self-Portrait No. 3* (1894, National Academy of Design, New York). In each of these, a blouse's striped material establishes a dynamic play between abstract pattern and detailed illusion. Eakins, at fifty-six, was still willing to learn and even exaggerate art-making's new tricks.

Eakins in the 1890s

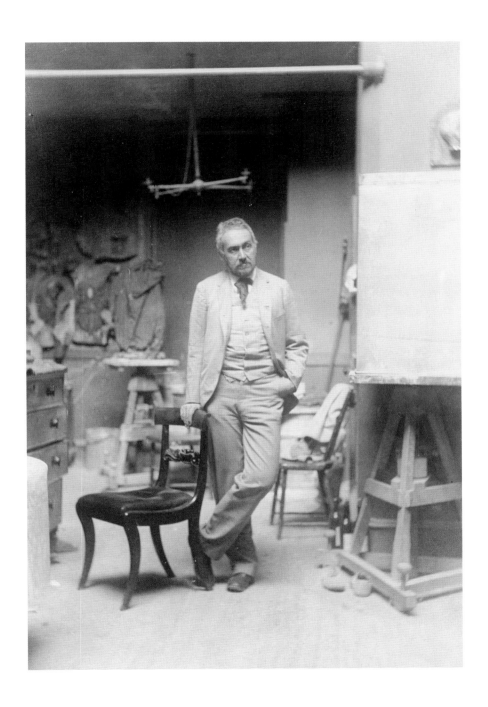

Plate 176. Circle of Thomas Eakins (attributed to Samuel Murray), *[Thomas Eakins in His Chestnut Street Studio]*, c. 1890.
Gelatin silver print, 6¹¹⁄₁₆ x 4¾ inches.
Philadelphia Museum of Art. The Lloyd Goodrich and Edith Havens Goodrich, Whitney Museum of American Art,
Record of Works by Thomas Eakins.

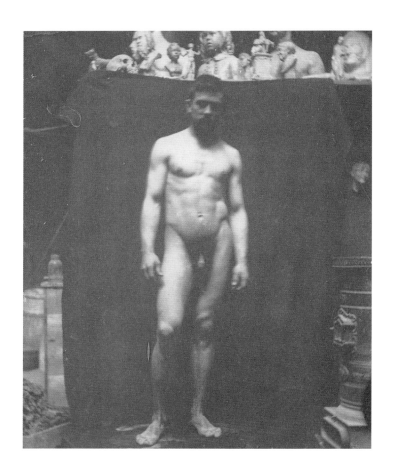

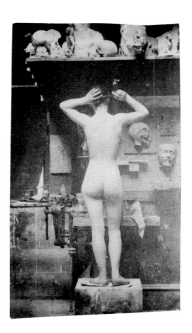

Plate 177. Thomas Eakins, *[Samuel Murray, Nude, in Eakins's Chestnut Street Studio]*, early 1890s.
Cyanotype, 4⅜ x 3¹¹⁄₁₆ inches.
Hirshhorn Museum and Sculpture Garden, Smithsonian Institution, Washington, D.C.
Transferred from Hirshhorn Museum and Sculpture Garden Archives, 1983 (83.108).

Plate 178. Thomas Eakins, *[Female Nude in Eakins's Chestnut Street Studio]*, 1890s.
Platinum print, 3³⁄₁₆ x 1⅞ inches.
Pennsylvania Academy of the Fine Arts, Philadelphia. Charles Bregler's Thomas Eakins Collection,
purchased with the partial support of the Pew Memorial Trust (1985.68.2.523).

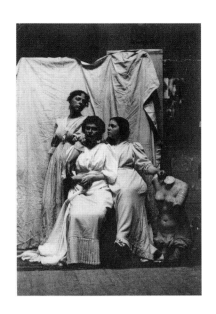

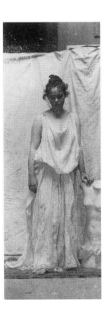

Plate 179. Thomas Eakins, *[Cook Cousins in Classical Costume in Eakins's Chestnut Street Studio]*, c. 1892.
Platinum print, 2¹⁵⁄₁₆ x 2¹⁄₁₆ inches.
The J. Paul Getty Museum, Los Angeles (84.XM.155.23)

Plate 180. Thomas Eakins, *[Weda Cook in Classical Costume in Eakins's Chestnut Street Studio]*, c. 1892.
Platinum print, 2¹³⁄₁₆ x 1 inch.
The J. Paul Getty Museum, Los Angeles (84.XM.155.6).

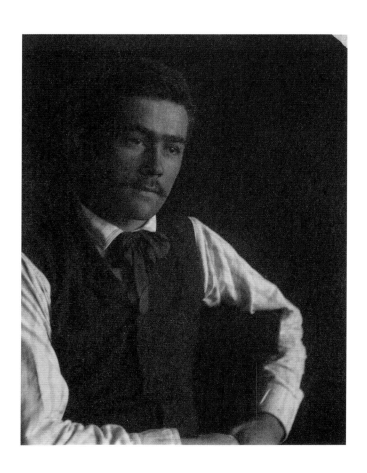

Plate 181. Thomas Eakins, *[Samuel Murray]*, 1891–92.
Platinum print, 4½ x 3½ inches.
Pennsylvania Academy of the Fine Arts, Philadelphia. Charles Bregler's Thomas Eakins Collection,
purchased with the partial support of the Pew Memorial Trust (1985.68.2.190).

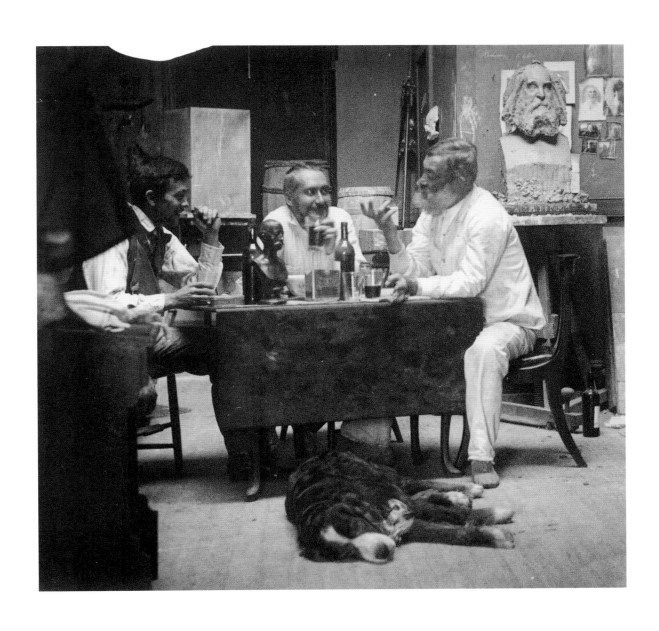

Plate 182. Circle of Thomas Eakins, *[Samuel Murray, Thomas Eakins, and William R. O'Donovan in Eakins's Chestnut Street Studio]*, 1891–92.
Platinum print, 6⅜ x 6¹⁵⁄₁₆ inches.
Collection of Daniel W. Dietrich II.

Plate 183. Thomas Eakins, *[Walt Whitman]*, 1891.
Platinum print, 3½ x 2¹⁵⁄₁₆ inches.
Private Collection.

Plate 184. Samuel Murray, *[Walt Whitman]*, 1891.
Platinum print, 3⅝ x 3 inches.
The Detroit Institute of Arts. Gift of Mr. and Mrs. Charles E. Feinberg (F78.105).

Plate 185. Samuel Murray, *[Mary Oakes Davis]*, 1891.
Platinum print, 3½ x 4½ inches.
Collection of Daniel W. Dietrich II.

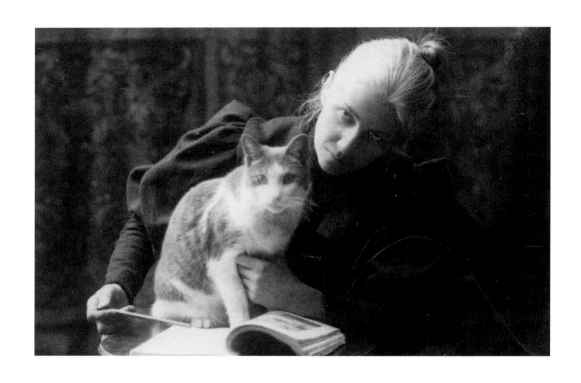

Plate 186. Attributed to Thomas Eakins, *[Amelia C. Van Buren with a Cat]*, probably late 1880s.
Platinum print, 3⅜ x 5⅜ inches.
Philadelphia Museum of Art. Gift of Seymour Adelman, 1968 (1968-203-2).

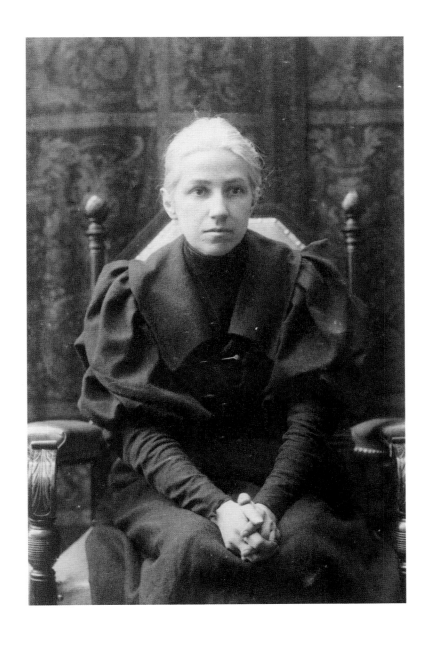

Plate 187. Attributed to Thomas Eakins, *[Amelia C. Van Buren]*, probably late 1880s.
Platinum print, 5¹⁵⁄₁₆ x 3¹⁵⁄₁₆ inches.
Collection of Daniel W. Dietrich II.

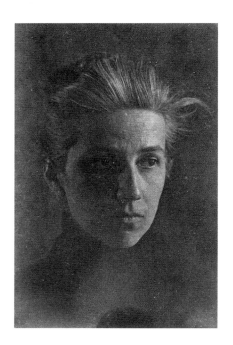

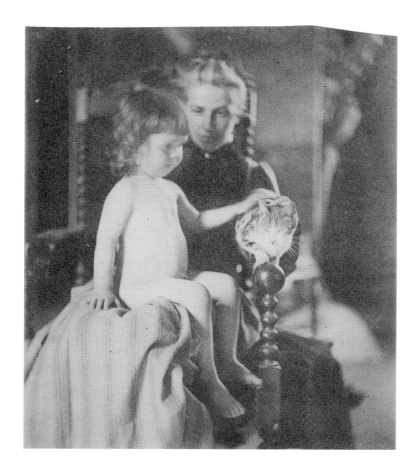

Plate 188. Thomas Eakins, *[Amelia C. Van Buren]*, 1890s.
Platinum print, 3⁵⁄₁₆ x 2¼ inches.
The J. Paul Getty Museum, Los Angeles (84.xm.155.15).

Plate 189. Circle of Thomas Eakins, *[Amelia C. Van Buren with a Nude Child and Cat]*, 1890s.
Platinum print, 4⅛ x 3⁹⁄₁₆ inches.
Bryn Mawr College Library, Pennsylvania. Seymour Adelman Collection (Special Collections SA 82).

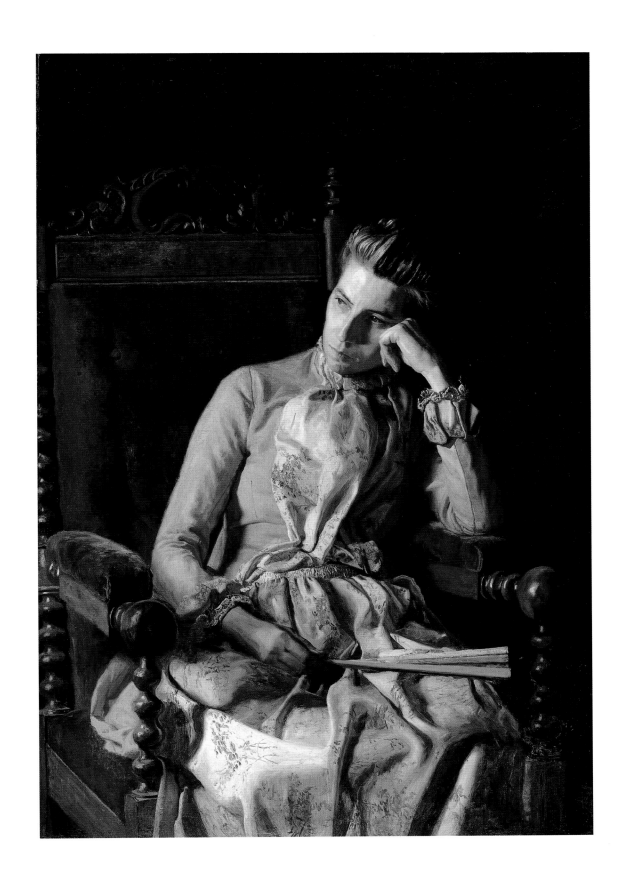

Plate 190. Thomas Eakins, *Portrait of Amelia C. Van Buren*, c. 1891.
Oil on canvas, 45 x 32 inches.
The Phillips Collection, Washington, D.C.

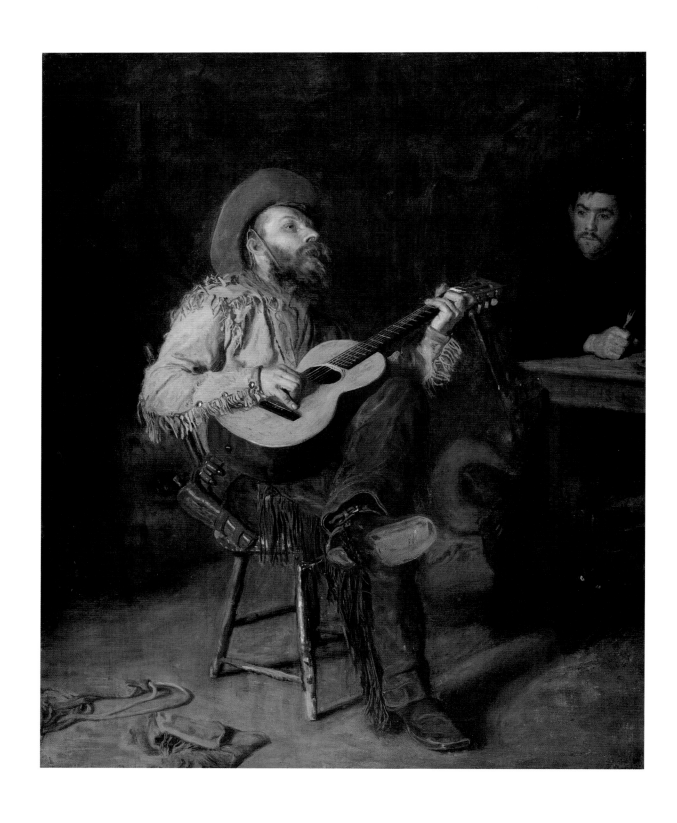

Plate 191. Thomas Eakins, *Home Ranch*, 1892.
Oil on canvas, 24 x 20 inches.
Philadelphia Museum of Art. Gift of Mrs. Thomas Eakins and Miss Mary Adeline Williams, 1929.

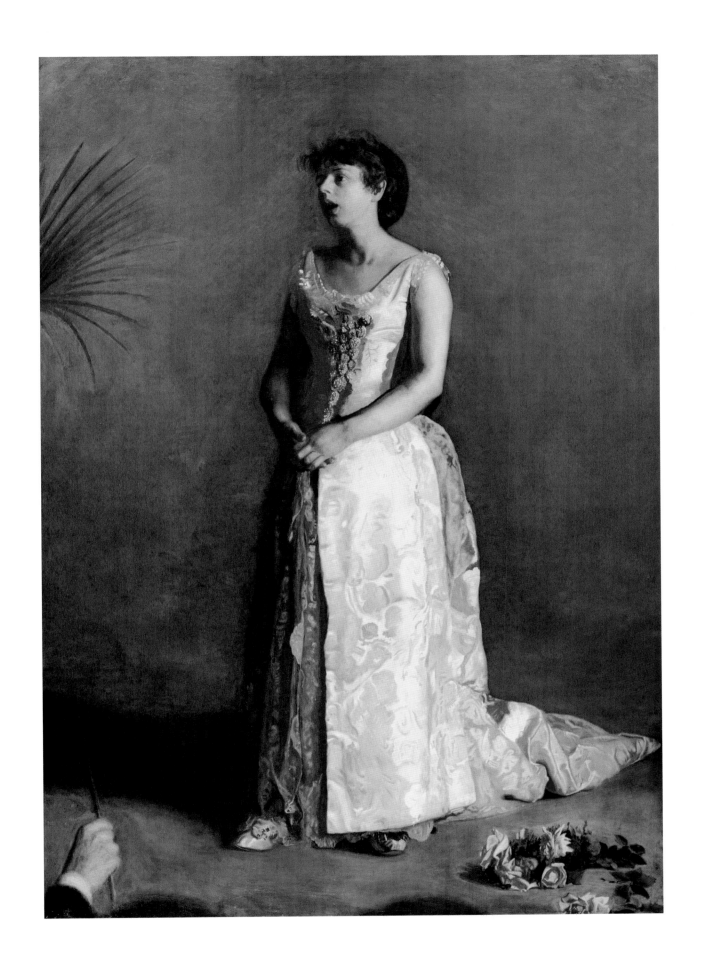

Plate 192. Thomas Eakins, *The Concert Singer*, 1890–92.
Oil on canvas, 75⅛ x 54¼ inches.
Philadelphia Museum of Art. Gift of Mrs. Thomas Eakins and Miss Mary Adeline Williams, 1929.

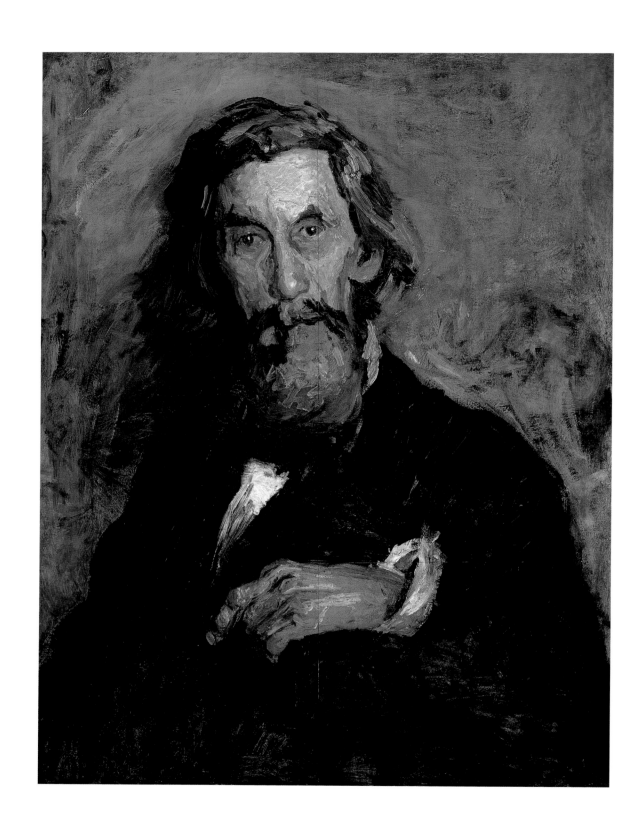

Plate 193. Thomas Eakins, *Portrait of William H. Macdowell*, c. 1891.
Oil on canvas, 28 x 22 inches.
Maier Museum of Art, Randolph-Macon Woman's College, Lynchburg, Virginia.

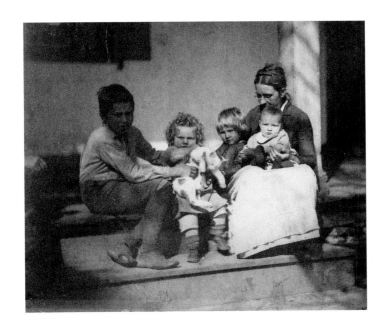

Plate 194. Thomas Eakins, *[Frances Crowell and Four of Her Children at Avondale, Pennsylvania]*, c. 1890.
Platinum print, 3 1/16 x 3 5/8 inches.
The Metropolitan Museum of Art, New York. Gift of Joseph R. Lasser and Ruth P. Lasser, 1985 (1985.1027.51).

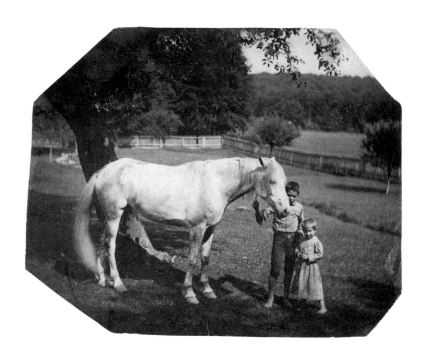

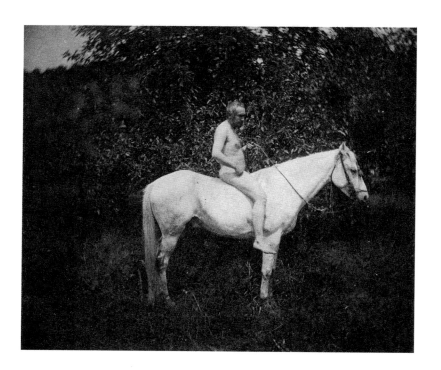

Plate 195. Thomas Eakins, *[Two Crowell Children and Billy at Avondale, Pennsylvania]*, c. 1891.
Platinum print, 3³⁄₁₆ x 3⅞ inches.
The Metropolitan Museum of Art, New York. Gift of Joseph R. Lasser and Ruth P. Lasser, 1985 (1985.1027.59).

Plate 196. Circle of Thomas Eakins (attributed to Samuel Murray), *[Thomas Eakins, Nude, on Billy]*, 1890–92.
Platinum print, 3½ x 4¼ inches.
Pennsylvania Academy of the Fine Arts, Philadelphia. Charles Bregler's Thomas Eakins Collection,
purchased with the partial support of the Pew Memorial Trust (1985.68.2.306).

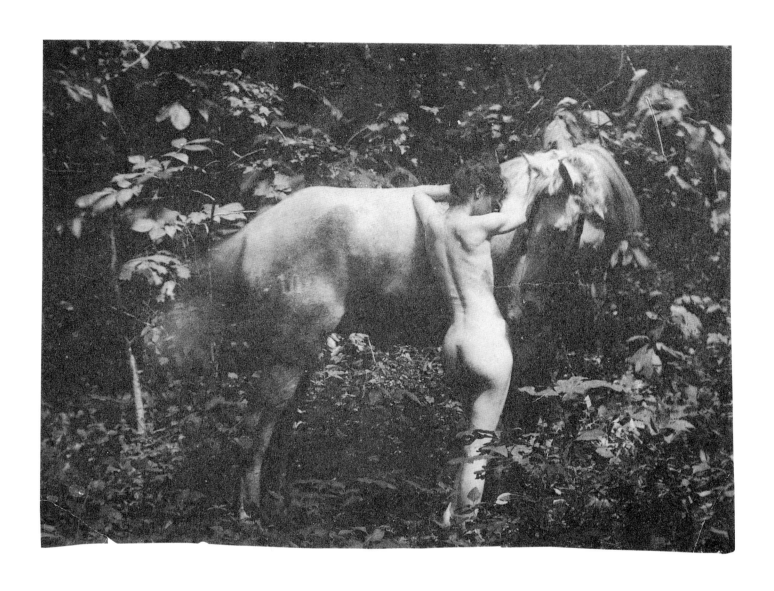

Plate 197. Thomas Eakins, *[Susan Macdowell Eakins, Nude, with Billy]*, 1890–92.
Platinum print, 5⁷⁄₁₆ x 7⁷⁄₁₆ inches.
Pennsylvania Academy of the Fine Arts, Philadelphia. Charles Bregler's Thomas Eakins Collection,
purchased with the partial support of the Pew Memorial Trust (1985.68.2.550).
See also list of Works Not Illustrated

Plate 198. Thomas Eakins or Samuel Murray, *[Plaster Model of Clinker for an Equestrian Relief of General Grant]*, 1892.
Platinum print, 3½ x 4⁷⁄₁₆ inches.
Bryn Mawr College Library, Pennsylvania. Seymour Adelman Collection (Special Collections SA 114).

Plate 199. Thomas Eakins, *The Continental Army Crossing the Delaware*, 1893 (cast 1969).
Bronze, 55 x 94⅛ x 3⅞ inches.
Plate 200. Thomas Eakins, *The Opening of the Fight*, 1893 (cast 1969).
Bronze, 54¾ x 93⅞ x 3¼ inches.
Hirshhorn Museum and Sculpture Garden, Smithsonian Institution, Washington, D.C.
Gift of the Joseph H. Hirshhorn Foundation, 1972.

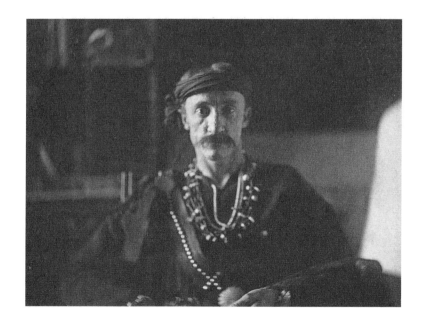

Plate 201. Thomas Eakins, *[Frank Hamilton Cushing in Zuni Costume]*, 1895.
Platinum print, 3½ x 2⅝ inches (83.85).
Plate 202. Thomas Eakins, *[Frank Hamilton Cushing in Zuni Costume]*, 1895.
Cyanotype, 3⅛ x 4¹/₁₆ inches (83.86).
Hirshhorn Museum and Sculpture Garden, Smithsonian Institution, Washington, D.C.
Transferred from Hirshhorn Museum and Sculpture Garden Archives, 1983.

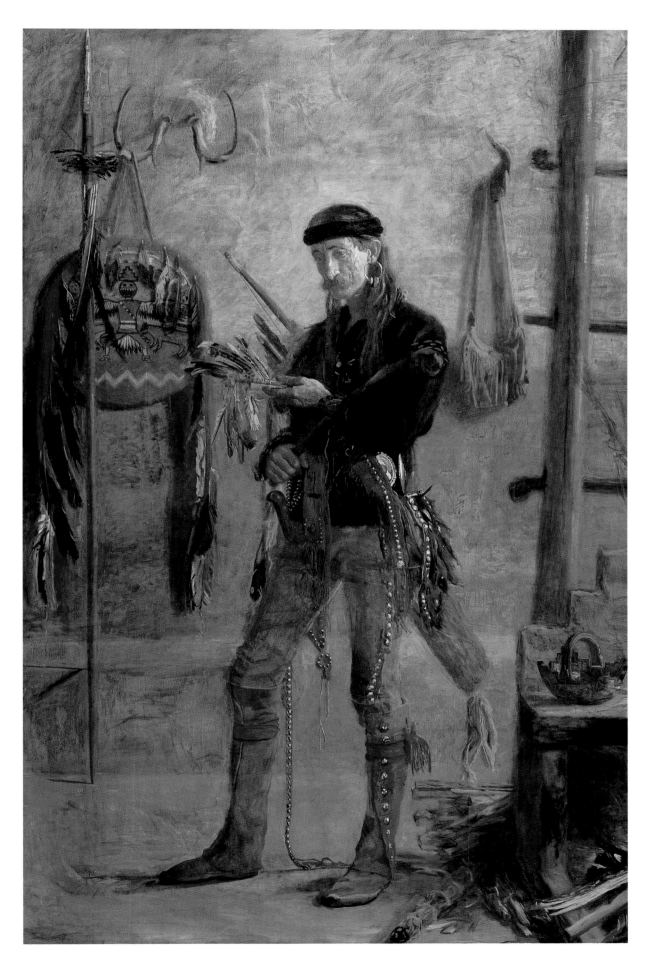

Plate 203. Thomas Eakins, *Portrait of Frank Hamilton Cushing*, 1895.
Oil on canvas, 90 x 60 inches.
Gilcrease Museum, Tulsa, Oklahoma.

Plate 204. Thomas Eakins, *Portrait of Lucy Lewis*, 1896.
Oil on canvas, 22 x 27⅛ inches.
Private Collection.

Plate 205. Thomas Eakins, *Portrait of Maud Cook*, 1895.
Oil on canvas, 24 x 20 inches.
Yale University Art Gallery, New Haven, Connecticut. Bequest of Stephen Carlton Clark, B.A. 1903, 1961.

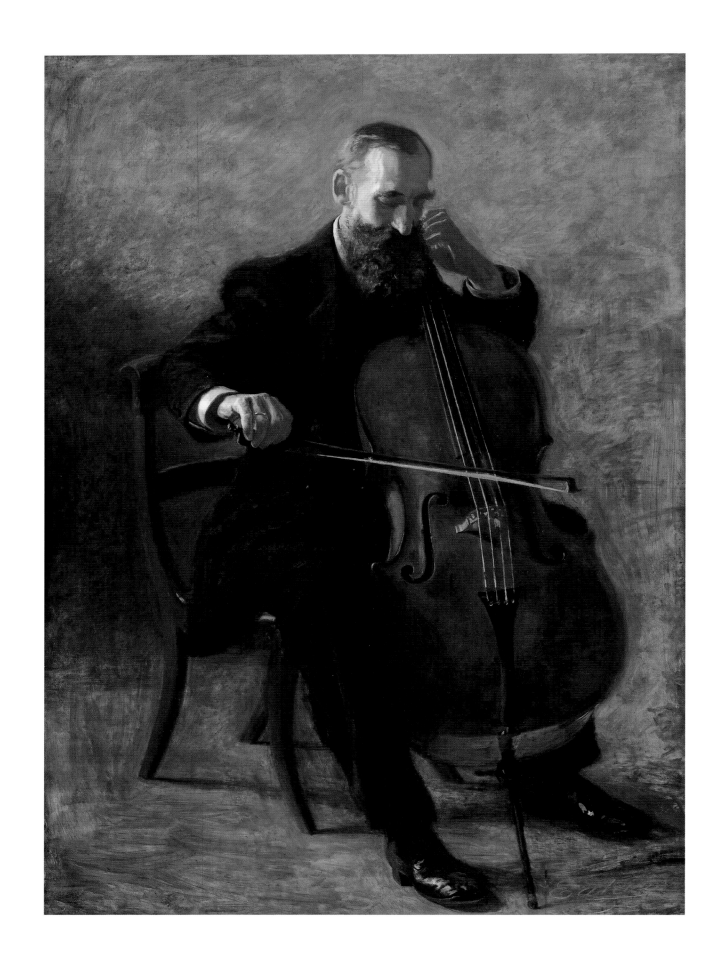

Plate 206. Thomas Eakins, *The Cello Player*, 1896.
Oil on canvas, 64¼ x 48⅛ inches.
Pennsylvania Academy of the Fine Arts, Philadelphia. Joseph E. Temple Fund.

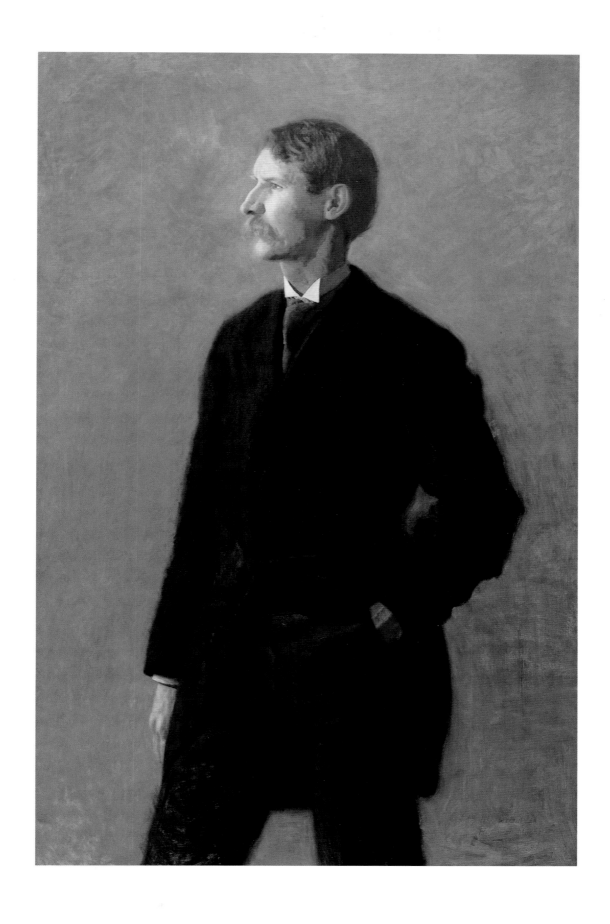

Plate 207. Thomas Eakins, *Portrait of Harrison S. Morris*, 1896.
Oil on canvas, 54 x 36 inches.

Pennsylvania Academy of the Fine Arts, Philadelphia. Partial gift of Harrison Morris Wright; partial purchase with funds provided by the Henry S. McNeil Fund, the Estate of John W. Merriam, the Samuel M. V. Hamilton Memorial Fund, the Women's Committee of the Pennsylvania Academy of the Fine Arts, Donald R. Caldwell, Jonathan L. Cohen, Dr. and Mrs. John A. Herring, William T. Justice and Mary Anne Dutt Justice, Charles E. Mather III and Mary MacGregor Mather, Robert W. Quinn, Herbert S. Riband, Jr. and Leah R. Riband, Mr. and Mrs. Joshua C. Thompson, and thirty-six anonymous subscribers.

Plate 208. Thomas Eakins or Samuel Murray, *[Jennie Dean Kershaw]*, c. 1897.
Platinum print, 3¾ x 3⁹⁄₁₆ inches.
Collection of Harvey S. Shipley Miller and J. Randall Plummer.

Plate 209. Thomas Eakins or Samuel Murray, *[Jennie Dean Kershaw]*, c. 1897.
Platinum print, 4⅛ x 3⅜ inches.
The J. Paul Getty Museum, Los Angeles (84.XM.155.17).

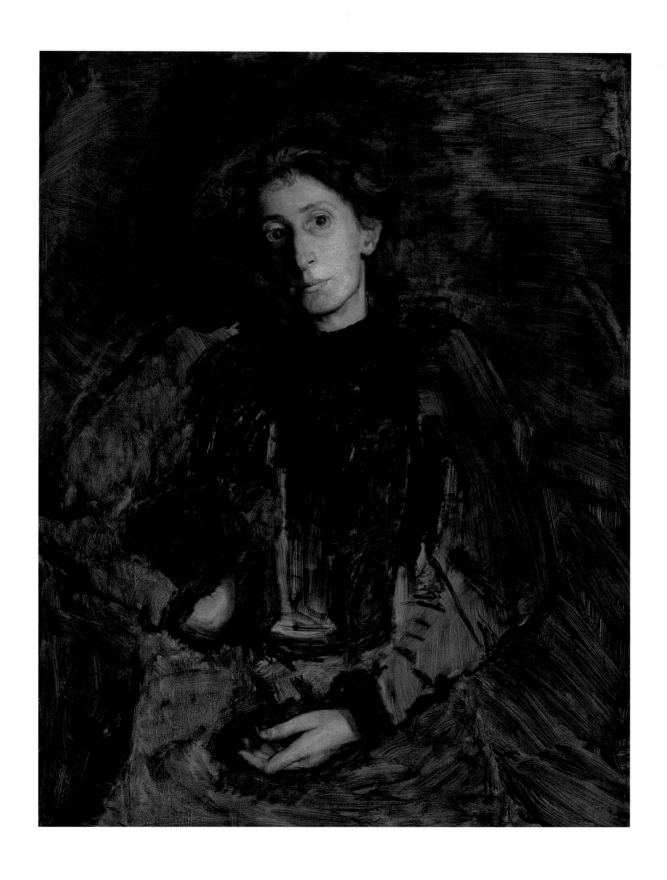

Plate 210. Thomas Eakins, *Portrait of Jennie Dean Kershaw*, c. 1897.
Oil on canvas, 40¼ x 30 inches.
Sheldon Memorial Art Gallery, University of Nebraska, Lincoln. F. M. Hall Collection.

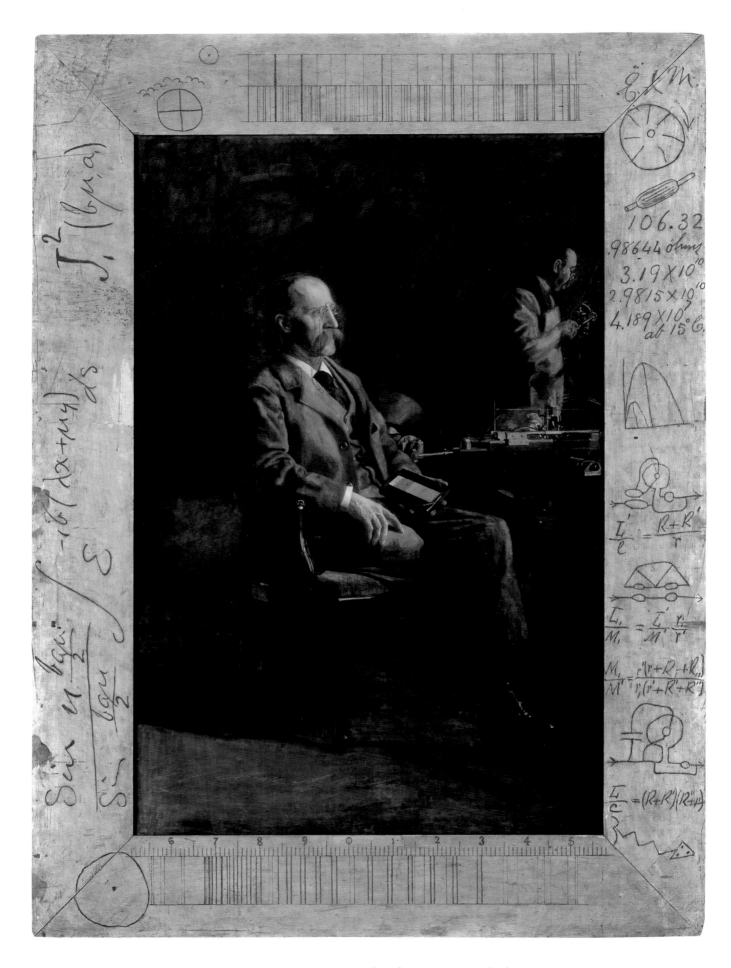

Plate 211. Thomas Eakins, *Portrait of Professor Henry A. Rowland*, 1897.
Oil on canvas, 80¼ x 54 inches.
Addison Gallery of American Art, Phillips Academy, Andover, Massachusetts. Gift of Stephen C. Clark, Esq.

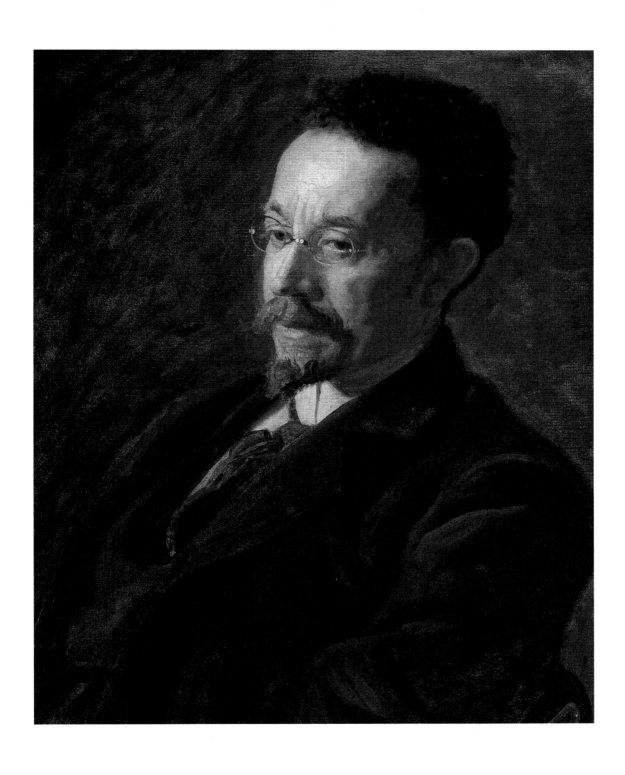

Plate 212. Thomas Eakins, *Portrait of Henry Ossawa Tanner*, c. 1897.
Oil on canvas, 24$\frac{1}{16}$ x 20$\frac{1}{4}$ inches.
The Hyde Collection Art Museum, Glens Falls, New York.

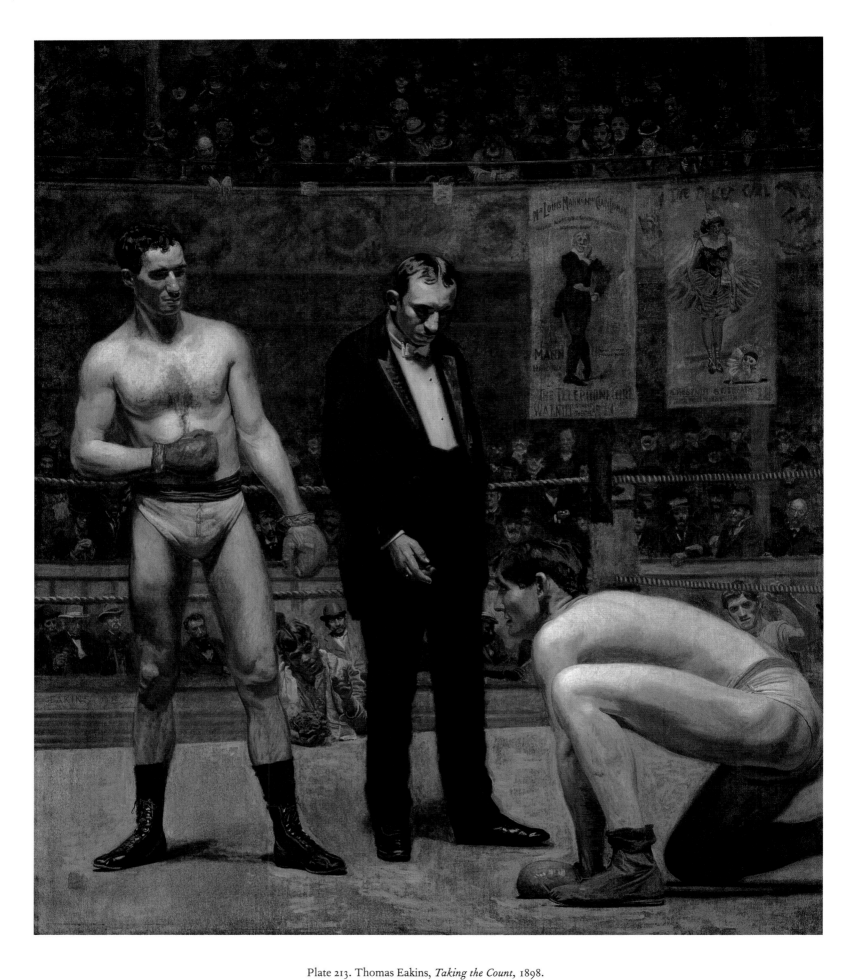

Plate 213. Thomas Eakins, *Taking the Count*, 1898.
Oil on canvas, 96¹⁵⁄₁₆ x 84⅝₁₆ inches.
Yale University Art Gallery, New Haven, Connecticut. Whitney Collection of Sporting Art,
given in memory of Harry Payne Whitney, B.A. 1894, and Francis Payne Whitney, B.A. 1898, by Francis P. Garvan, B.A 1897, M.A. (Hon.) 1922, June 2, 1932.

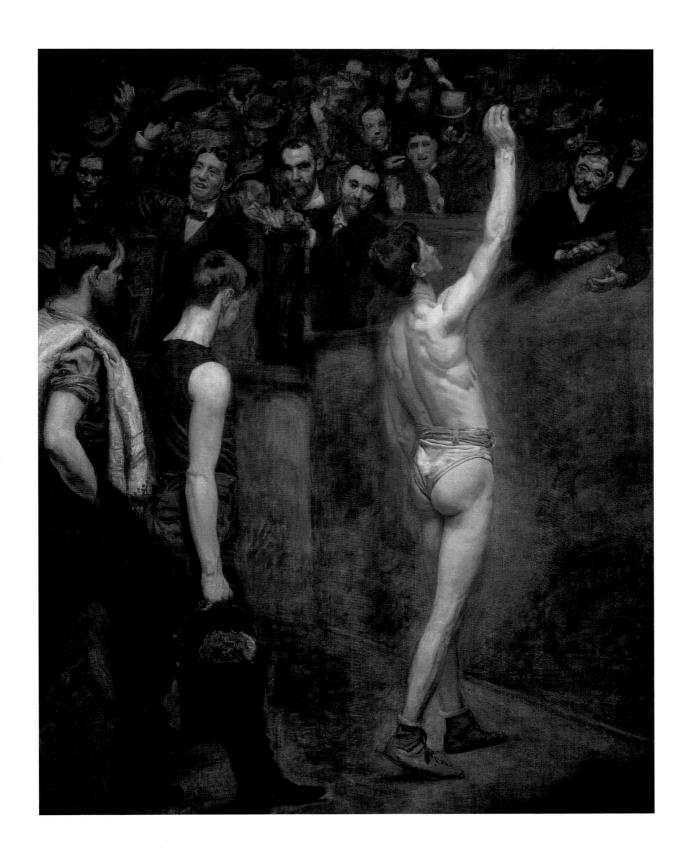

Plate 214. Thomas Eakins, *Salutat*, 1898.
Oil on canvas, 50 x 40 inches.
Addison Gallery of American Art, Phillips Academy, Andover, Massachusetts.

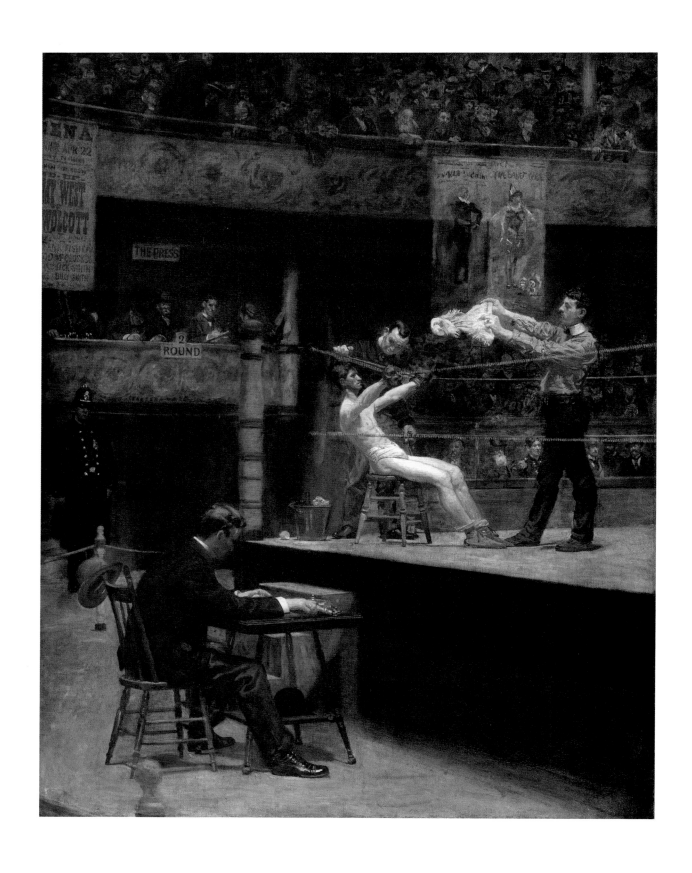

Plate 215. Thomas Eakins, *Between Rounds,* 1898–99.
Oil on canvas, 50⅛ x 39⅞ inches.
Philadelphia Museum of Art. Gift of Mrs. Thomas Eakins and Miss Mary Adeline Williams, 1929.

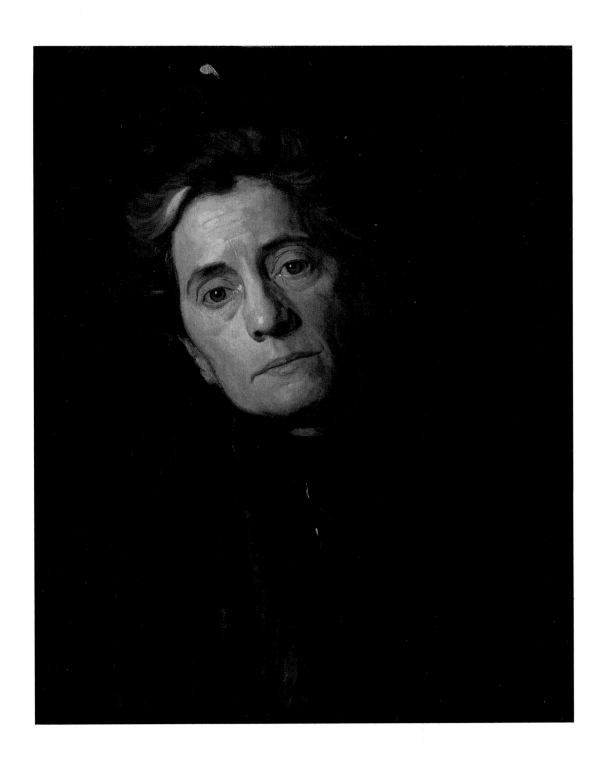

Plate 216. Thomas Eakins, *Portrait of Susan Macdowell Eakins (Mrs. Thomas Eakins)*, c. 1899.
Oil on canvas, 20⅛ x 16⅛ inches.
Hirshhorn Museum and Sculpture Garden, Smithsonian Institution, Washington, D.C.
Gift of Joseph H. Hirshhorn, 1966.

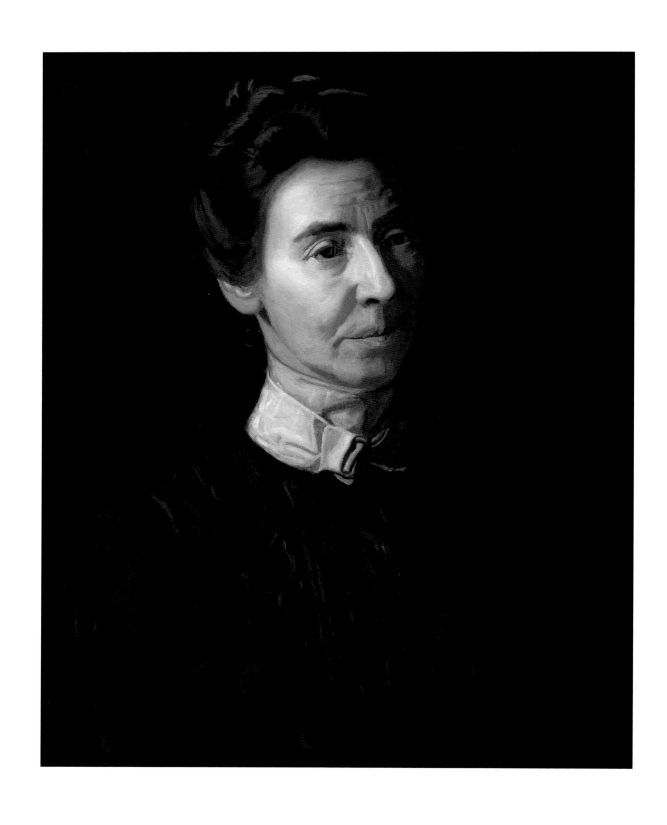

Plate 217. Thomas Eakins, *Portrait of Mary Adeline Williams,* 1899.
Oil on canvas, 24 x 20 1/16 inches.
The Art Institute of Chicago. Friends of American Art Collection.

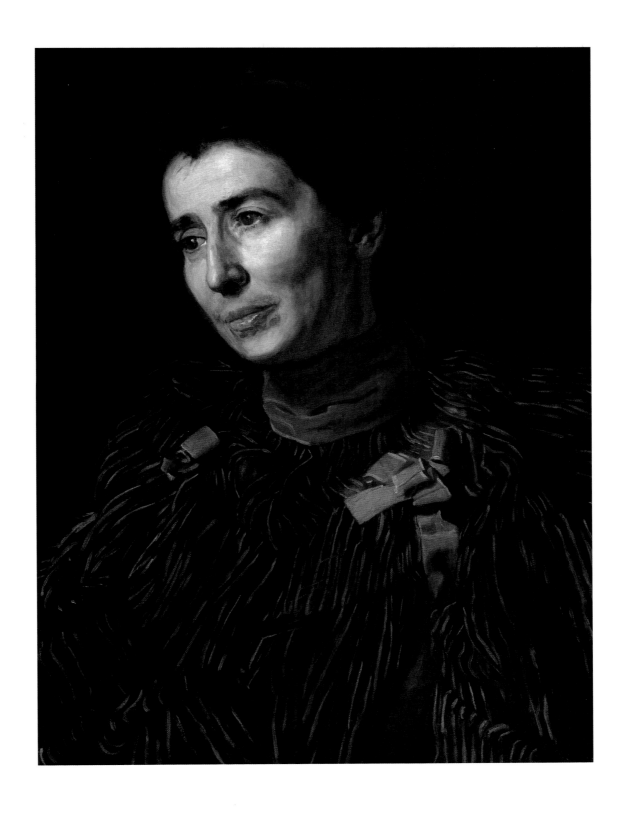

Plate 218. Thomas Eakins, *Portrait of Mary Adeline Williams*, c. 1900.
Oil on canvas, 24⅛ x 18⅛ inches.
Philadelphia Museum of Art. Gift of Mrs. Thomas Eakins and Miss Mary Adeline Williams, 1929.

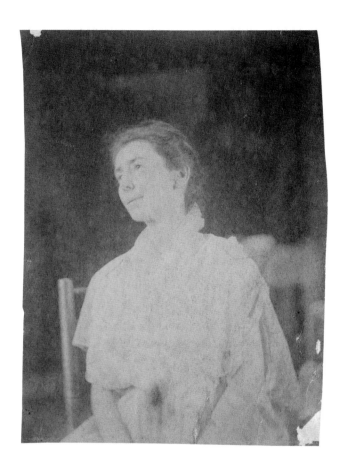

Plate 219. Thomas Eakins, *[Mary Adeline Williams]*, c. 1899.
Albumen print, 4⅝ x 3¼ inches.
Pennsylvania Academy of the Fine Arts, Philadelphia. Charles Bregler's Thomas Eakins Collection,
purchased with the partial support of the Pew Memorial Trust (1985.68.2.107).

Portraits of Teachers and Thinkers

KATHLEEN A. FOSTER

FORCED TO RESIGN from the Pennsylvania Academy in 1886, Thomas Eakins withdrew into a small circle of friends, relations, and devoted students for almost two years, struggling to put scandal to rest and painting little. In the first year of his retreat, he completed and dated only two pictures: portraits of George F. Barker (Mitchell Museum at Cedarhurst, Mount Vernon, Ill.) and William D. Marks (fig. 157), professors at the University of Pennsylvania. These paintings document his only arena of support in that year outside the circle of his closest friends, and they indicate the direction of his rehabilitation and artistic triumph after 1886. To Eakins, Barker and Marks represented an alternate "academy" where he remained welcome, a comforting realm of science and scholarship, of machines and measurements, of collaborative research and teaching that paralleled his own inclinations as an artist. Recording their accomplishments, he recovered his own sense of worth; meeting their expertise with his own, he painted their portraits to define a personal academy of arts and sciences and his place within it.[1]

A disciplined and inquiring student, Eakins had been drawn to both art and science as a boy, and he pursued various academic interests to the end of his life. An art critic who met Eakins in 1881 noted that he was "more like an inventor working out curious and interesting problems for himself than like an average artist," and another characterized him as "a scientific mind that has made the mistake of taking up art," wondering "whether any better career could have offered itself than the present one of successful instruction."[2] Indeed, at least one other career may have occurred to him, for he had studied anatomy at Jefferson Medical College with such zeal in the 1860s that it was rumored he considered becoming a surgeon.[3] He maintained his contacts there and, after returning from study in Paris, painted portraits of the school's famous professors Drs. Samuel Gross (pl. 16) and John H. Brinton (fig. 158) in the mid-1870s. This connection endured in Eakins's teaching and painting; at the time of his death, the portrait on his easel depicted Jefferson's celebrated anatomist Dr. Edward Anthony Spitzka (Hirshhorn Museum and Sculpture Garden, Washington, D.C.).

From anatomy, Eakins branched out to study human and animal locomotion, optics, and photography. By the 1880s Eakins began to experiment with cameras; he demonstrated his improved "instantaneous" equipment to the members of the Photographic Society of Philadelphia in 1883. Such work won him a place on the nine-member commission directing the motion photography of Eadweard Muybridge at the University of Pennsylvania in 1884–85. From this project grew three public presentations of his own scientific work: a lecture in 1885 on the zoetrope; a collaborative essay published in 1888 describing the timing apparatus that he and his colleague Professor William Marks produced to improve Muybridge's system; and a paper delivered before Philadelphia's Academy of Natural Sciences in 1894 and published later that year outlining research that combined his knowledge of anatomy gained

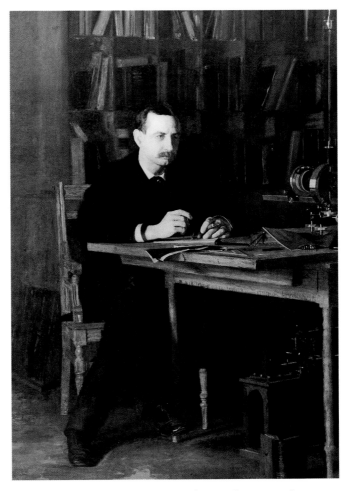

Fig. 157. Thomas Eakins, *Portrait of Professor William D. Marks*, 1886. Oil on canvas, 76⅜ x 54⅛". Washington University Gallery of Art, Saint Louis. University Purchase, Yeatman Fund, 1936.

Fig. 158. Thomas Eakins, *Portrait of Dr. John H. Brinton*, 1876. Oil on canvas, 81 x 60". The National Museum of Health and Medicine of the Armed Forces Institute of Pathology, Washington, D.C. (pl. 17).

from dissection with his motion studies of horses.[4] These scientific pursuits, from tinkering with lenses to studying equine anatomy, were driven by his desire to understand "how things work," tangential to an artist's concern with "how things look" or how to depict them. One of his first friends from the University of Pennsylvania, the engineer Fairman Rogers, commissioned from Eakins *A May Morning in the Park (The Fairman Rogers Four-in-Hand)* (pl. 51) to document, among other things, their shared enthusiasm for anatomy, horses, cameras, and the scientific study of motion.

After his departure from the Academy, colleagues from the Muybridge commission remained friendly. William Marks was among the group that Susan Eakins called "Tom's Sunday Club," mostly scientists and musicians from the University of Pennsylvania, united by an amateur interest in painting, who met at one another's houses beginning in 1886.[5] In the 1890s a similar group gathered at the home of engineer James Mapes Dodge in Germantown; following an afternoon spent with the Jesuits at Saint Charles Borromeo Seminary, Eakins would bicycle over to the Dodges to enjoy an evening of stories, songs, and conversation.[6] Disdainful of artists' societies, academies, and clubs, Eakins was happy in these informal, self-determined circles.[7]

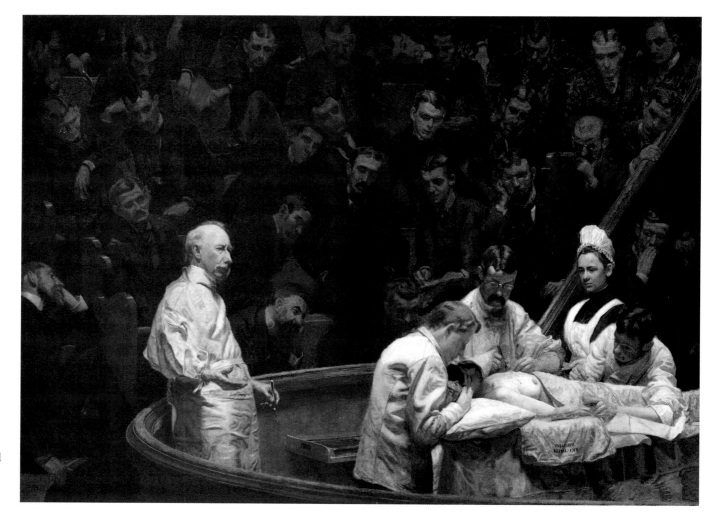

Fig. 159. Thomas Eakins, *The Agnew Clinic*, 1889. Oil on canvas, 84⅜ x 118⅛". University of Pennsylvania, Philadelphia (pl. 175).

With no official or institutional support, Eakins ventured into the territory of his "Sunday Club" to build a place for himself in Philadelphia's wider academy of professionals and intellectuals. This network of friends and colleagues outside of the art community inspired him to return to portraiture, which immediately eclipsed his earlier, more academic figure, genre, and landscape work. In the spring of 1886, in the throes of scandal, he sought out his two closest collaborators and friends on the Muybridge commission—Marks, the professor of engineering, and Barker, a professor of physics—and invited them to sit for their portraits. He painted them both life size, on large canvases, with Marks seen at full length, seated at a table with the timing mechanism that he and Eakins had developed for taking motion photographs.[8] They were the first large portraits Eakins had painted in a decade, reflecting—to Eakins if to no one else—his own proud relationship to their joint scientific achievement. Both pictures trade on the intimacy shared between painter and sitter; Barker looks directly and candidly into the artist's eyes, while Marks seems relaxed and preoccupied, the cigar in his left hand forgotten, the calipers in his right hand absently measuring the surface of a strip of card. His gesture, like the machine gleaming on the table next to him, recapitulates the importance of precise measurement to the creation and interpretation of motion photography. Portrait presences in their own right, the machines represent the shared art and understanding of painter and sitter.

Three years later, students at the University of Pennsylvania commissioned Eakins to depict their venerated professor Dr. D. Hayes Agnew (fig. 159) and drew him back into the circles of physicians and surgeons he had known and painted in the 1870s. Later, he would seek out other doctors and scientists, most from the University of Pennsylvania, painting their portraits for the stimulation of their company as well as to capture his sense of their importance. "We get on famously together, our tastes being similar," he noted in 1897 of Henry A. Rowland, a physicist from Johns Hopkins University (fig. 160). "There is no one in the world who holds a higher position in science than Rowland and it is very good to be able to associate with such people." For Eakins, the "goodness" of this experience resided in the understanding gained. He prepared a perspective drawing of the extremely refined measuring device that Rowland had invented and was pleased to tell his friend that he had "got an understanding of it. The directness and simplicity of that engine has affected me and I shall be a better mechanic and a better artist."[9]

Eakins's desire to study and learn from his sitters defines the special character of his portraits, few of which were commissioned. Largely chosen by the artist, his subjects reflect Eakins's affections and interests, his family and friends, the

Fig. 160. Thomas Eakins, *Portrait of Professor Henry A. Rowland*, 1897. Oil on canvas, 80¼ x 54". Addison Gallery of American Art, Phillips Academy, Andover, Massachusetts. Gift of Stephen C. Clark, Esq. (pl. 211).

Fig. 161. Thomas Eakins, *Portrait of Susan Macdowell Eakins (Mrs. Thomas Eakins)*, c. 1899. Oil on canvas, 20⅛ x 16⅛". Hirshhorn Museum and Sculpture Garden, Smithsonian Institution, Washington, D.C. Gift of Joseph H. Hirshhorn, 1966 (pl. 216).

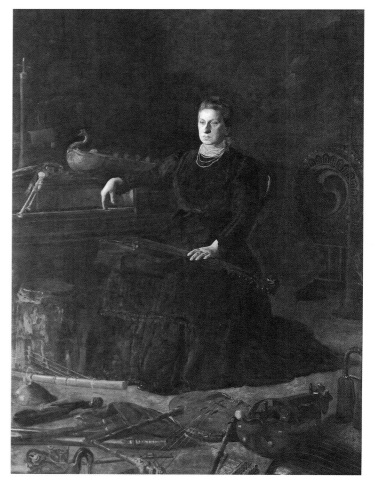

Fig. 162. Thomas Eakins, *Elizabeth at the Piano*, 1875. Oil on canvas, 72⅛ x 48³⁄₁₆". Addison Gallery of American Art, Phillips Academy, Andover, Massachusetts. Gift of an anonymous donor (pl. 13).

Fig. 163. Thomas Eakins, *Antiquated Music (Portrait of Sarah Sagehorn Frishmuth)*, 1900. Oil on canvas, 97 x 72". Philadelphia Museum of Art. Gift of Mrs. Thomas Eakins and Miss Mary Adeline Williams, 1929 (pl. 224).

people he found pictorially or intellectually inspiring, and those who were patient enough to endure lengthy sittings. His artistic values emerge from the visual qualities in these portraits—an intense, often unflattering realism, somber color, and strong contrast of dark and light. His cultural values are also expressed: his love of music and science, his respect for achievement in many fields.

Although size does not always denote merit or meaning—as Eakins's intense portrait of his wife (fig. 161) demonstrates alongside certain of his large but hollow commissioned works—the effort, expense, and ambition of a life-size, full-length image signals special emphasis. Eakins usually painted portraits on canvases 24 by 20 inches or smaller, showing just the head and shoulders at life scale. Out of 247 of his known portraits, slightly less than thirty percent are half-length or larger. Half of this group—or about fifteen percent of his total—might be termed "grand" in scale, showing the subject full length, at life size. Twenty-four of these figures are shown seated, like Marks and Rowland. Excluding Drs. Gross and Agnew, who appear on monumental canvases but are actually shown at three-quarter length, only thirteen people are shown

from head to toe, standing—about five percent of Eakins's finished portraits.

Eakins's "grand" portrait gallery was launched in the 1870s, early in his career, with several full-length seated images in the 1870s of his fiancée Kathrin Crowell, her sister Elizabeth at the piano (fig. 162), Archbishop James F. Wood, and two doctors from Jefferson Medical College (Brinton and Benjamin H. Rand), as well as the epic *Gross Clinic*. These large portraits ceased after 1877 until a new series, embracing four-fifths of the total, opened with the Marks and Barker paintings of 1886. His new portrait mission did not gain momentum until *The Agnew Clinic* (fig. 159), which was the first of eight large-format portraits made between 1889 and 1891. Preoccupied by work on the Brooklyn Memorial Arch and perhaps depressed by the dissolution of the Art Students' League of Philadelphia, where he taught after leaving the Academy, his production slowed in the early 1890s. He painted nine more portraits during his last three full years of teaching, from 1894 to 1896. The slump of activity during the dreary scandals of 1896–97 was broken by the Rowland portrait. His interest in large canvases continued to climb, peaking in 1902–5, when six or eight were produced

each year. Energized by the recognition received in this period, including several medals at international exhibitions and election to the National Academy of Design, he also recommenced ambitious, full-length figure paintings of male athletes and female nudes. His overall output declined after 1907, as he began to lose his eyesight and his health, but his very last canvas, begun in 1913, envisioned a full-length, standing portrait of the anatomist and brain surgeon Dr. Spitzka.[10]

Why did Eakins give a few sitters such grand treatment? Perhaps some were inherently picturesque, inspiring "a worthy and beautiful composition picture," like Mrs. Joseph W. Drexel surrounded by her collection of fans, Mrs. William D. Frishmuth and her musical instruments (fig. 163), Weda Cook in concert (pl. 192), or Monsignor James P. Turner officiating at Mass. As he argued in a letter to Mrs. Drexel, the truthful record of appearances enhanced visual merit with "historic value": Drexel's taste and generosity as a donor to the University of Pennsylvania's museum, or Cook's artistry as a singer, or Turner's eminence as vicar general. Both accuracy and historical significance were necessary, he noted, to create a picture worthy to send to an exhibition or to "enhance my reputation."[11] Indeed, many of these large portraits became showpieces for Eakins, who repeatedly exhibited his favorite subjects—Leslie W. Miller, Louis N. Kenton, Weda Cook— and won medals with them.

Eakins chose these sitters and their presentation carefully. Standing back to compass the entire figure, Eakins knew that these larger portraits gained in grandeur what they lost in intimacy, so it is not surprising that most of these sitters are either people of inherent dignity or distant acquaintances. After the early portraits of his fiancée and her sister, none of the full-length portraits are of Eakins's immediate family or dearest friends, who were more likely to receive closer scrutiny in a smaller format. Women also appear in smaller numbers in the larger portraits—only Weda Cook and Sophia Royce Williams (*The Black Fan*, Philadelphia Museum of Art) appear among the standing, full-length views, and just fifteen among the rest of the half-length or larger views.[12] Eighty percent of the full-length portraits are men, usually achievers in professions Eakins personally respected, and in which women were rare: medical doctors (Brinton, Gross, Agnew, Wood, Holland, Forbes, Thomson), scientists and social scientists (Marks, Barker, Rand, Rowland, Cushing, Culin), church authorities (Wood, Fedigan, Loughlin, Martinelli, Henry, Elder, Waldron, Falconio, Turner), musicians (Hennig), a writer (Fitzgerald), an architect (Borie), and three artists (Miller, Beckwith, and Hamilton).

To define their identities, Eakins often showed these people surrounded by attributes or in the context of work: Rowland

with the diffraction grating he invented, Frank Hamilton Cushing (fig. 164) with his Zuni material culture, and the great benefactors of the University of Pennsylvania Museum— Mrs. Drexel, Mrs. Frishmuth, and Stewart Culin—surrounded by artifacts from their collections. In his careful depiction of their machines and musical instruments, Eakins demonstrated his "understanding" of his subjects as well as his own professional skills.

This matching of accomplishments becomes more assertive in the large portraits, in which Eakins displayed respect for his sitters and a deep sense of equality and fraternity, covertly vested in his own art and craft. Eakins's identity is embedded in each of these paintings; as Oscar Wilde remarked, "every portrait that is painted with feeling is a portrait of the artist."[13] With care, he individualized each portrait: few of the large ones are exactly the same size, and each has a pose and a perspective setup (horizon line, viewing distance) as unique as a fingerprint.[14] Such refinements abide invisibly in the pictures until they are compared with one another, when the conceptual activity uniting Eakins and his sitters becomes clear. "Strain your brain more than your eye,"[15] he told his students, reminding them of the intellectual and imaginative "work" that Western artists since Michelan-

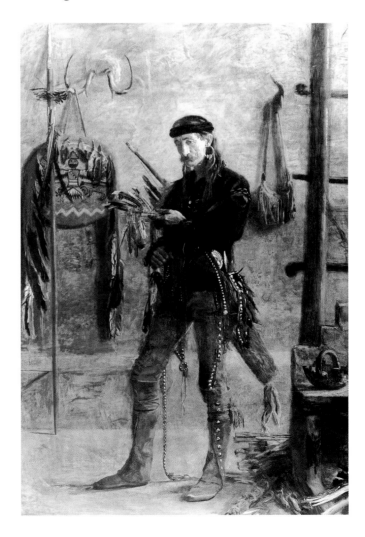

Fig. 164. Thomas Eakins, *Portrait of Frank Hamilton Cushing*, 1895. Oil on canvas, 90 x 60". Gilcrease Museum, Tulsa, Oklahoma (pl. 203).

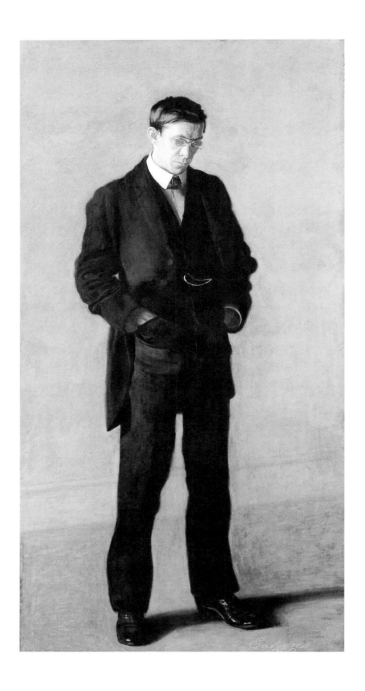

Fig. 165. Thomas Eakins, *The Thinker (Portrait of Louis N. Kenton)*, 1900. Oil on canvas, 82 x 42". The Metropolitan Museum of Art, New York. John Stewart Kennedy Fund, 1917 (pl. 220).

Fig. 166. Amelia C. Van Buren and Eva Watson, *[Louis N. Kenton?]*, 1894–96. Platinum print, 5¹⁵⁄₁₆ x 4³⁄₁₆". Pennsylvania Academy of the Fine Arts, Philadelphia. Charles Bregler's Thomas Eakins Collection, purchased with the partial support of the Pew Memorial Trust (1985.68.2.197).

gelo have identified as the basis for their claims to higher status. Premeditation set the artist apart from the manual worker and on a level with other professionals who likewise depended on "brain work." The best in such fields followed careful thinking and humane feeling with excellence in craft, defined as disciplined method and hand skill, equally germane to painting, or surgery, or making music, or building scientific instruments. And so he could write to Dr. Jacob Da Costa, professor at Jefferson, "I presume my position in art is not second to your own in medicine."[16] The application of his own thought, feeling, and expertise to the creation of a fine portrait was thus a gift, a tribute, and—for his most accomplished sitters, in his most ambitious paintings—an assertion of kindred values.

Thinking and feeling, followed by action, characterized the painter's work and, for Eakins, the work of his most in-teresting sitters. "I am very curious to watch Rowland's ways of thinking and doing things," he wrote after several days with the noted physicist at his summer home in Maine.[17] The campaign to capture these "ways" motivated some of his finest portraits. The work of the mind preoccupies most of his grand sitters, and Eakins portrayed them with the properties and products of thinking—books, inventions—or a deliberately contemplative look. Identified as "an Eakinsish expression" as early as 1882, when he was characterized as America's "master" of portraying "mere thinking without the aid of gesture or attitude,"[18] this look appears most famously on the faces of Amelia C. Van Buren (pl. 190) and Henry Ossawa Tanner (pl. 212), and down the entire length of Louis N. Kenton (fig. 165). These are, in Eakins's terms, the "higher class[,] the thinking people & feeling ones who always want to see everything [and] to know more"—the people most like himself.[19]

Full of "mere thinking," the portrait of Louis N. Kenton of 1900 is the barest of Eakins's full-length portraits and depicts the least famous sitter, known mostly for his brief and stormy marriage to Susan Eakins's sister, Elizabeth Macdowell.[20] Among Eakins's scholars and thinkers, he may be the lone representative of the working class. The son of a Philadelphia flour and grain salesman, Louis Kenton was born into a family of shoemakers, clerks, and motormen. His first appearance in the Philadelphia city directories in 1888 did not mention his occupation, but he evidently aspired to white-collar status, for the next year he was listed as a bookkeeper. The following two years the entry noted Kenton as simply a "clerk," but after 1891 his occupation was not given.[21] His studious inclinations, as well as his presence in Eakins's circle, are suggested in a portrait photograph (fig. 166) of about 1894–96 by Eva Watson and Amelia C. Van Buren, Eakins's students, who posed Kenton contemplating a large book.[22]

Kenton's vague identity forms the basis for the ultimate naturalist challenge: a picture without narrative, setting, distinctive costume or properties, dramatic "gesture or attitude," yet richly signifying the character of modern life and art. His relaxed posture, thoughtful expression, and baggy dress suit must convey all we can know about his world. Set squarely in the center of the picture, hands thrust in pockets, he takes an informal, unself-conscious stance, well calculated for a long pose. The earliest admirers of this painting described his appearance—and the picture—as awkward and ugly. This contrived unpretentiousness, so characteristic of Eakins, engages—and then deflates—the elegant conventions of aristocratic portraiture and establishes Kenton as contemporary, urban, middle-class, mature (thirty-one), and preoccupied. The painting's common title, *The Thinker*, adopted after Eakins's death, expresses Kenton's generic quality as modern, intellectual Everyman, following the pattern of many other titles from the large-format portraits: *The Archaeologist, The Cello Player, The Vicar General*.[23] Repeated the many times he exhibited this work, Eakins's original title underlines the importance of Kenton's individuality, notwithstanding the ambiguity of his identity. Kenton is defiantly specific, vaguely— maybe even distastefully—familiar. An unknown, he is thrust forward by Eakins, made representative, important, artistic.

Eakins, manifested subliminally in this picture, presents himself as both artist and master of "mere thinking." His presence emerges in his emphatic signature and, more subtly, in his choice to mute the identity of the figure and empty out the space, which draws unusual attention to the formal qualities of the picture. Generally self-effacing in his work, Eakins makes his own presence unusually palpable. His devices, such as the dark silhouette against a bright, tawny background, invoke

Velázquez. The flat contour and broad modeling in Kenton's clothing, in contrast to the delicate, three-dimensional effects of his head and shoes, also showcase the painter's art and the simultaneity of materiality and illusion set up by this portrait. As Kenton's gaze turns inward, his physical presence flattens, suggesting that his body is not important to the work at hand, and that his location, in some private, internal world, is fundamentally inaccessible to sight. As a visualization of the activity of thinking, Kenton is both particular and abstract, "real" and ephemeral. He is also an autobiographical summary of Eakins's artistic credo: modern, middle-class American life layered over the grand European tradition, the conceptual underpinning the observed.

Most of the sitters for Eakins's large-format portraits were thinkers, like Kenton, and the majority were academics. Many were practicing professionals who became teachers in their specialties, usually at the University of Pennsylvania or Jefferson Medical College. Some were deans, principals, or presidents, depicted in their official role: George W. Fetter, at his desk at the Girls' Normal School; Dr. James W. Holland, reciting the "Dean's Roll Call"; the Very Reverend John J. Fedigan, gesturing to plans for Villanova College. Like Fedigan, most of the sitters in Eakins's series of monumental clerical portraits were educators as well as priests and administrators. Others appear in the act of teaching—Drs. Gross, Agnew, and Forbes in their medical amphitheaters, or Leslie W. Miller (fig. 167) at Philadelphia's School of Industrial Art.[24]

The predominance of teachers on his list of grand portraits expresses Eakins's lifetime commitment to this work. Subtly, the whole series suggests self-portraiture: his identification with his father, captured in *The Writing Master* (pl. 96), his respect for earned authority, and his own wish for knowledge and control.[25] More obviously, the emphasis after 1897, when he ceased all teaching, records vicarious participation in a role denied to him but still desired. Perpetually both student and teacher himself, he understood the mutual satisfaction gained by the transfer of knowledge between willing parties. "It is always a pleasure to teach what you know to those who want to learn," he had written in 1874.[26] Teaching pressed "thinking" and "doing" into communication, making active, either by language or physical demonstration, the knowledge and experience held in mind and body. Eakins preferred to teach silently, by example, like his master Jean-Léon Gérôme, using his own art, his behavior, or a few blunt strokes across a student's sketch to make his point. But he was also an effective lecturer, able to make intimidating "laws" of perspective accessible and memorable, as attested in the plain prose of his drawing manual. The challenge of lecturing lay in the integration of speech and demonstration that made knowledge "real." Like the balance

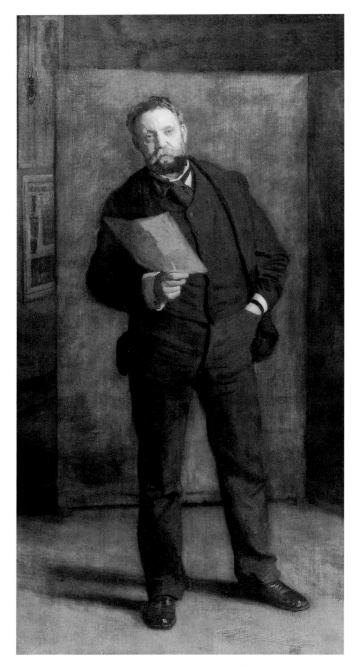

Fig. 167. Thomas Eakins, *Portrait of Leslie W. Miller*, 1901. Oil on
burlap canvas, 88 x 44". Philadelphia Museum of Art. Gift in memory
of Edgar Viguers Seeler by Martha Page Laughlin Seeler, 1932 (pl. 225).

of the scientific and the visual in his painting, Eakins sought to
combine the conceptual and the material in his lectures, or-
chestrating a live model, a flexible skeleton, a cadaver, a black-
board, lantern slides, and modeling clay to pack "muscle" onto
bone. As in rowing or surgery, there was an "art" to teaching
that Eakins understood well.

A master teacher cast in his own mold, such as Leslie W.
Miller, naturally won Eakins's respect. As in *The Thinker*,
Eakins's portrait of Miller defines a part of the artist's own
identity. Just four years younger than Eakins, Miller was the art
teacher that Eakins might have been if, back in 1862, he had
won the job he applied for, as drawing master at Central High
School. Miller trained at the school of the Museum of Fine Arts

in Boston and the Massachusetts Normal Art School, an insti-
tution organized to teach industrial drawing and its future
instructors. In 1880 he came to Philadelphia to head the city's
new industrial art school based on the collections formed at the
Centennial Exhibition, patterned after the South Kensington
Museum and School in London. By 1882 enrollment was about
half that of the Pennsylvania Academy: seventy-nine students,
all taught by Miller and an assistant, with the help of Dr. W. W.
Keen who lectured on artistic anatomy to Miller's students as
well as those of Eakins. An intellectual with diverse interests in
photography and archaeology, Miller mixed with the faculty at
the University of Pennsylvania and several learned societies
and art clubs in Philadelphia and later served as the secretary
of the Fairmount Park Art Association. Rather than exhibiting
his own work, he became an art critic and author of articles on
art education.[27]

Colleagues at complementary institutions, the two men
were not always the best of friends, perhaps because of the
subtle hierarchy between the "fine" and "applied" arts, or
because Miller revealed a streak of truth telling as blunt as
Eakins's. In 1882 Miller's review of the first Philadelphia
watercolor exhibition paid tribute to Eakins as "a man who has
made so many friends by the seriousness of his purpose and
singular faithfulness to his own ideals," but criticized his
"hard, photographic" watercolors of the shad fisheries as
"depressingly commonplace." "In their labored feebleness of
execution, as well as their singularly inartistic conception, one
wonders what relation they can possibly bear to art."[28] Eakins
must have been annoyed by such an exposé of his methods,
and he probably was not pleased when Miller published a man-
ual on *The Essentials of Perspective* in 1887, just as Eakins was
completing his own manual on the subject.[29]

But by 1901, Eakins clearly saw Miller as an ally on com-
mon and increasingly old-fashioned ground. By this time their
status had reversed: twenty years earlier, every art student in
Philadelphia would have known Thomas Eakins, but when he
came to Miller's school to work on the portrait, none of the
students—including the young Charles Sheeler—recognized
him. Now the teacher and "principal" that Eakins had once
been, Miller stands in the life-class studio with a folding screen
behind him, much like those used in the studios at the Acad-
emy and the Art Students' League. Behind the screen, we catch
a glimpse of two colored charts that, as Sheeler remembered,
"we knew only too well." Evidently illustrating Egyptian
architectural ornament, these charts may also refer to Miller's
archaeological enthusiasms. This spatial environment, simply
stated but more complex than in the other standing portraits,
gives a nod to their shared affection for perspective, antiquity,
and the ambience of the atelier.[30]

Miller is dressed for a school day in clothes less formal than Kenton's and—according to Miller—unsuitable for an official public appearance. "When he painted my portrait he not only wanted me to wear some old clothes but insisted that I go and don a little old sack coat—hardly more than a blouse—that he remembered seeing me in, in my bicycle days, which I certainly never would have worn facing an audience." Eakins's insistence reveals his famous preference for used, familiar clothing that expressed both the body and the taste of the wearer. His stage management of the portrait also suggests his preconception of Miller's image and the informal character of the implied audience, not to mention the superimposition of his own taste: an enthusiastic biker himself, and famous for his "casual" dress, Eakins surely addressed his own students in this style.[31]

Miller stuffs his left hand informally in his pocket, like Kenton, and shifts his weight to his right leg, lifting a sheet of paper as if preparing to address his class. The vitality in this pose comes from its asymmetry: although ostensibly centered on the canvas, Miller leans to the left of the center line that invisibly organizes all of Eakins's paintings. This line drops from the edge of Miller's ear to the tip of his index finger, grazing his right pant leg as it descends the canvas. All the highlights in the painting, save for the buried right wrist and cuff, rock to the left, as if Miller is moving to catch our attention as we scan the picture from left to right. For Eakins, ever sensitive to the "general axes of weight and action" in the human figure, this shift suggests movement and a sense of alertness and life; as Carol Troyen has noted, Miller is the active pendant to the stable, introverted *Thinker*.[32]

The horizon line of the painting is high, indicating that Eakins stood to paint his friend, who was close to his own height. His natural eye level, as usual in these standing portraits, was artificially lowered, to increase the authority of his sitter.[33] At about sixty inches from the floor, his vantage centered on Miller's chin, as if anticipating his voice. Serious, unpretentious, authoritative, Miller is one of those "living thinking acting men, whose faces tell their life long story"; he embodies the union of artist, scholar, and teacher that Eakins

also represented.[34] Unlike all the other subjects in Eakins's full-length portraits, he meets our gaze directly. Face to face with Miller, we stand in Eakins's shoes and look into a mirror.

The following year Eakins would paint himself in the same raking pose (pl. 229), commemorating his election to the National Academy of Design. At last gathered into an official academy of artists, Eakins appears almost reproachful in this self-portrait, which he submitted as part of the membership requirement. The tightened format enhances the intimacy and vulnerability of his expression, whereas Miller, by comparison, seems more composed and less accessible. But both show a quality of thoughtfulness and engagement that would appear only one more time, in the 1907 portrait of Dr. William Thomson, another doctor and teacher who met the painter's eye with a vaguely melancholy camaraderie.[35]

Thomson was Eakins's last finished, full-length portrait. After 1909 Eakins lost his health and his eyesight. He painted little after 1910, although he continued to plan the induction of new members into his personal academy. In 1911 he announced to John W. Beatty, director of fine arts at the Carnegie Institute, that "ever since I painted the Rowland portrait, I have intended to try [to] paint as a pendant one of John A. Brashear." Rowland's innovations would not have been possible without Brashear's engineering, he explained, "and their joint work is the beginning of a new astronomy originating at the Johns Hopkins and the Carnegie." Asking Beatty to introduce the idea to Brashear in Pittsburgh, Eakins admitted that "the subject appeals to me more strongly than that of a military hero." Beatty was glad to help, and within the next year Eakins wrote directly to Brashear, enclosing a photograph of his portrait of their mutual friend, Rowland. He complimented Brashear's "beautiful" scientific instruments, seen in the company of professors George Barker, Fairman Rogers, and Rowland. None of these men was still living, but the fellowship of portrait sitters endured. Confirming his own place within this circle of scientists, thinkers, and teachers, Eakins invited Brashear into their company. "Although I have never met you, you still seem like an old friend to me," he wrote. "Some day I want to paint your portrait."[36]

The 1900s

MARC SIMPSON

WITH THE NEW CENTURY, Eakins's professional career orbited ever more tightly around the house on Mount Vernon Street. By September 1900, he and Samuel Murray had given up the studio on Chestnut Street—the elder man writing late in the month that "alterations required the tearing down" of the building where he had worked from 1884 onward.[1] Along with this easy and versatile masculine environment, Eakins lost the steady companionship of Murray, who moved his own studio elsewhere, although the two men remained on close social and professional terms.[2] In May 1901 Eakins had the attic at the front of his Mount Vernon Street residence converted into a studio.[3] No longer did he have to leave home to carry on his more ambitious, more public work.

The emotional environment in which he labored, too, underwent a change in these years around the turn of the century. In spite of a paucity of critical voices actively promoting his vision, the sheer steadiness of Eakins's decades-long quest to center his art on the accurate portrayal of the human figure had won him a position in the art world.[4] In 1899 he was elected to the artists' jury of the Carnegie Institute in Pittsburgh, where he served again in 1900, 1901, 1903, and 1905. In the summer of 1900, he initially declined the invitation to serve on the jury for the Pennsylvania Academy's upcoming annual exhibition, although at Harrison Morris's urging he reconsidered, ultimately taking an active part for the shows of 1901, 1903, 1906, and 1909.[5] Medals and honors accrued to him. Some he accepted with iconoclastic nonchalance—"I think you've got a heap of impudence to give me a medal," he remarked on receiving the Pennsylvania Academy's Temple Gold Medal in 1904, before cycling off to redeem its value in gold from the United States Mint.[6] Some, such as membership in the National Institute of Arts and Letters, he simply declined.[7]

Other tributes, however, he welcomed. His designation as associate-elect of the National Academy of Design in March 1902, for example, prompted a sequence of quick, reciprocal responses. On Eakins's part, he presented the self-portrait required for validation of the election in under two months' time—speedy work for him, especially given that he had, according to National Academy rules, a year in which to submit

it. It was immediately accepted by the National Academy, which accordingly named him an associate on May 5. Within a fortnight, at its annual meeting on May 14, the members elevated him to full academician status. No other artist in the history of the institution had previously been elected both associate and academician in the same year.[8] The alacrity of these actions testifies to Eakins's pride at his initial election and at least hints at a belief on the part of the National Academy membership that their recognition was preposterously tardy.

The National Academy's dilatoriness had the positive effect of encouraging Eakins to undertake his self-portrait (pl. 229) while he was at the height of his powers. The artist earlier had painted himself into several of his sporting and clinic pictures but, somewhat surprisingly, had not undertaken a classic self-portrait. He now did so, on a canvas larger than his standard for head-and-shoulder portrayals—the size of thirty by twenty-five inches was mandated by the Academy.[9] Eakins's straight view out from the picture is rare among his sitters. Here—as was the case with the comparably formatted portrait of his wife (pl. 216) of three years earlier—Eakins took advantage of the direct stare to emphasize the liquid reflection of the eyes, lending an emotional charge to the portrayal.[10] This edge of reality compels closer examination of the painting's surface, which reveals Eakins's detailed examination and depiction of his flesh, defined, as Darrel Sewell has written, "by small, exactly placed, shaped strokes of rather liquid paint." Sewell concluded: "Beautiful technique is not usually considered an important component of Eakins's art, but the thinly painted, even surface of the self-portrait is an unmatched demonstration of his absolute control of the medium."[11] Eakins reveled in the idiosyncrasies of his physical self—mussed hair, scruffy beard, ill-trimmed mustache—not bowing to idealization or even a gentle neatening in any form.

The seriousness of the painting enterprise was a continual theme in his art and his teaching. "Strain your brain more than your eye,"[12] he would repeat, during an age when the seemingly rapid transcription of quick perceptions became the dominant mode of progressive artists. He valued neither the art teaching nor most of the progressive art being done in his day. In 1906 he wrote, "Nearly all the schools are bad here and

abroad," continuing to say of the Pennsylvania Academy in particular, "I am not connected with the Penna. Acad. & my advice would be contrary to nearly all teaching there."[13] In 1914, after he had ceased painting because of ill health, he gave an interview on various art matters. The text closes:

> On the point of the new impressionistic, futurist and cubist movements in art, Mr. Eakins laughed these away. "They are all nonsense," he said, "and no serious student should occupy his time with them. He who would succeed must work along the beaten path first and then gradually, as he progresses, try to add something new but sane, some thing which arises out of the new realities of life and not out of the hysterical imaginations of pathological temperament."[14]

Asked by the principal of the Corcoran School of Art in 1906 to offer advice to young artists, he responded with his firmest credo: "you must be a student of Nature always."[15]

Eakins began the century with a work that proved immensely important for his reputation, one of his strongest and purest paintings: *The Thinker (Portrait of Louis N. Kenton)* (pl. 220). The picture shows a man in a dark suit with his hands shoved into his pockets, seemingly unaware of being painted and making no effort to project the virtues often mimed by those presenting themselves to posterity. He stands before a pale, radiant—thus, for Eakins, unusual—background, in which space is suggested with the slightest of means: a tonal shift between wall and floor, a line of baseboard, a falling shadow.[16] The work's austere use of few elements and colors to create a complex and powerful image recalls Spanish portraits of the seventeenth century—especially those of Velázquez—which Eakins had admired as "so good so strong so reasonable so free from every affectation" during his trip to Spain thirty years earlier.[17]

There are passages of eye-catching detail throughout the picture: the man's flowered tie, shirt buttons, watch chain, pince-nez, and polished shoes. But it is Kenton's pink face, possessing a delicacy all the more vulnerable for being set off by the sharp edge of the unshadowed shirt collar, that commands attention. The selective specificity becomes all the more striking owing to Eakins's purposeful softening of other contours, especially the potentially crisp, decorative outline of the suit, which has been blurred to create a sense of palpable air within the painting.

The suit reveals its folds and bulges through Eakins's virtuosic mastery of tonalities, which plays shades of black against one another to convey the form beneath the clothing. In a sense, this is the painting's most expressive element, for it is here that Eakins's manipulation of the viewer's response—the sense of vulnerability first heralded by the shockingly pink flesh—becomes clear. The clothes are too large by far for the man: the

vest's buttons meander; the pants are baggy; the jacket's bunched sleeves, already covering the gaping shirt cuffs, wait to engulf his hands.[18] The effect is of a boy dressed up in his father's clothes. But, of course, the careworn, ruminative face forbids any reading of this as an image of fruitful potential; instead it seems to be a picture of a man who is not quite ready for the place he pretends to and who is fully aware of the situation.

Kenton (1869–1947) had married Susan Eakins's sister Elizabeth ("Lid" or "Liddie") on May 31, 1899, when he was in his mid-thirties and she in her early forties. The picture was perhaps a marriage portrait, for Eakins had given it to his sister-in-law by 1901.[19] The sitter's occupation is unknown, as are his interests and talents. The marriage was an unhappy one.[20]

Whatever familial difficulties the *Portrait of Louis N. Kenton* may have testified to, Eakins clearly understood the work's power. He exhibited it repeatedly throughout his lifetime, at important world's fairs and museum inaugural exhibitions as well as more regular annual shows, beginning at the Carnegie Institute's Annual Exhibition of 1900–1901, followed immediately by the Pennsylvania Academy's Annual of 1901 and the Pan-American Exposition in Buffalo.

When the painting was at the Pennsylvania Academy, the writer from *The Philadelphia Press*, noting that the installation seemed to propose a pairing of the work with John Singer Sargent's portrait of Ian Hamilton (1898, Tate Gallery, London), called it a painting "of unusual excellence...one of the best works that has ever come from Mr. Eakins' studio, and vital with a new forcefulness."[21] Other reviewers sought to associate it with the portrayal of Halsey Ives, also on view, by the dashing Swedish painter Anders Zorn (1894, The Saint Louis Art Museum), citing a shared "directness, vigor and simplicity" that "command at once one's admiration and respect."[22] The standard interpretation of the painting was best put in prose by Charles Caffin in 1904. He wrote of Eakins's realism as unmitigated and "sometimes...too dryly prosaic." He continued:

> But in one instance, at least, that of the "Portrait of Mr. Louis Kenton," the very crudity of the realism is in the highest degree impressive....The subject, indeed, has been surprised as he is pacing the floor, deep in some mental abstraction; he seems utterly unaware of the painter's presence, and the latter has forgotten himself in his absorption in the subject.
>
> As a result, the truth of the representation is so extraordinarily convincing, that one loses sight of the ugliness of the picture and becomes fascinated by the revelation of life and character.[23]

Since so little has been known of Kenton, the brooding, contemplative nature that the painting suggests has come to be taken as representing both the individual and the generic modern, introspective man.[24] The nature of his relations with his

wife, however, unsettles the impression of a meditative personality, lending an almost ironic quality to the title given the canvas by Susan Eakins—*The Thinker*.[25]

In the same year he was painting Kenton, Eakins had another large canvas under way of a contrasting portrait subject: instead of a lean youngish man standing against a bright, nearly empty backdrop, the portrait of Mrs. William D. Frishmuth (pl. 224) shows an older woman seated in a darkened room amid musical instruments.[26] The canvas—one of Eakins's largest—portrays Sarah Sagehorn Frishmuth (1842–1926), wife of a tobacco manufacturer and an inveterate collector of "Colonial Relics" and musical instruments. Eakins showed her expression as impassive, uninvolved with either the artist, the viewer, or her immediate setting. Simply on the basis of tonality, her flesh attracts attention, abetted by detail and the light blue scarf wrapped around her neck, which matches the color of her staring eyes.

Before her, in disarray, are instruments from around the world. She holds a viola d'amore across her lap, while the ivory chanter and drone of a set of bagpipes rest against the keyboard of an eighteenth-century piano. Even though Frishmuth presses down one of the piano's keys, her gesture is not purposeful or related to the actual playing of an instrument. Possession, rather than music making, lies at the thematic core of this canvas.

The theme of ownership animates several of Eakins's most ambitious canvases at the turn of the century. The celebration of collecting—prolific, purposeful, scientific accumulation—prompted at least in part the portraits of Frishmuth; Stewart Culin, an ethnographer and an anthropologist (the painting is lost); and Mrs. Joseph W. Drexel, a collector of fans (the unfinished, trimmed canvas is in the Hirshhorn Museum and Sculpture Garden, Smithsonian Institution, Washington, D.C.).[27] Civic generosity, too, unites the works; each sitter was an important lender or donor to the University of Pennsylvania's Free Museum of Science and Art (usually called, and later officially named, the University Museum)—the trio forming a chapter in Eakins's chronicle of important Philadelphians, which Elizabeth Johns has done so much to elaborate.[28]

Eakins must have also hoped for institutional patronage. Given the corporate repositories of his two clinic paintings—and the developing custom of memorializing significant museum donors by placing their portraits amid their collections, Eakins probably thought that, through either purchase or gift, he would be able to place these examples of his work in one of the city's major cultural resources. Indeed, after showing it several times in 1901—as *Antiquated Music*, a particularly poignant play on words for the collecting of silenced antique instruments—Eakins wrote to Culin, a curator as well as a donor and lender to the University Museum: "I should be delighted to have Mrs. Frishmuth's portrait in the Museum, so I beg you to put it there."[29]

Eakins withdrew *Antiquated Music* from the University Museum late in 1904 to exhibit it in Pittsburgh.[30] For inclusion at the National Academy of Design annual in late 1906 he sought to do the same. The administrators of the museum—Culin had by this time left to go to the Brooklyn Museum—warned that if Eakins withdrew it, they would not welcome it back. It was thus separated from the Frishmuth collection; portions of that collection itself have since been dispersed. With these actions, the loss of the Culin portrait, and the incompletion of the Drexel work, Eakins's grand plan for representation at the University of Pennsylvania's museum was thwarted.

In February 1901 Eakins was seeking to build ties with another Philadelphia institution: the School of Industrial Art. First he sent a set of perspective drawings (now lost) related to *Antiquated Music* to the school. His description of them reveals that, in spite of his years of experience, he took no liberties with the rendering of physical space:

> The first sketch and general perspective drawing are for convenience made one sixth the size of the picture, that is they are to be viewed at one sixth the distance from the eye of the finished picture.... To save time in calculating proportions I have in some cases used a table of logarithms.[31]

The principal, Leslie Miller, himself a writer on perspective, responded: "Replying to yours of February 1st, I thank you very much for the gift of the set of perspective drawings you made in connection with the Frishmuth portrait. I shall take pleasure in showing them to such students as are likely to understand and appreciate the lessons which they embody."[32] At the end of the month, Eakins wrote to Miller with another gift offer: the unfinished portrait of Elizabeth Duane Gillespie, who had devoted "her energy and wise benevolence" in support of the school.[33]

The gift was accepted, but the transaction proved to be a complicated one: Miller sought to have Gillespie sit further so that Eakins could finish the portrait; Gillespie revealed a continuing animus toward the artist.[34] Miller straddled the two camps, bearing Gillespie's annoyance while continuing to honor Eakins's gift.

The two men did not always walk in such accord. Miller (1848–1931) had come to Philadelphia in 1880 from Massachusetts. His published report back to his friends and colleagues there was filled with skeptical irony concerning Eakins's teaching methods and scientific fascinations.[35] His art criticism, published in *The American Architect and Building News* and *The American* in the early 1880s, almost always voiced exasperation with Eakins's work, pointedly expressed in a passage concerning the Gloucester watercolors that complained of "their labored

feebleness of execution, as well as their singularly inartistic conception," and questioned "what relation they can possibly bear to art."[36] He challenged Eakins's position as teacher at the Academy and, when Eakins was dismissed in 1886, deplored the foundation of the Art Students' League of Philadelphia and called for an end to Eakins's pedagogical regime as an experiment failed.[37]

Only in 1895, when interviewed concerning Eakins's swift dismissal from Drexel, did Miller go into print in his favor—and even then the reference was equivocal. Miller allowed, in words that Eakins must have appreciated, that the nude was absolutely necessary for the art student, "just the same as a medical student. However," he continued, distancing himself from Eakins, "I am bound to say that the best opinions in America and Europe are that it is inadvisable to use an entirely nude model in a mixed class....The use of an entirely nude model before a mixed class would undoubtedly have a tendency to kill the finer instincts and destroy the better element even in an artist." But he carried on:

> Mr. Eakins I have known for a number of years and in him I recognize a man who in my opinion has no superior in the knowledge of anatomy. He is in the fullest sense, however, an enthusiast on the subject of the nude in art, but in following out this line of study I believe he has the purest and noblest purposes. He is, in my opinion, free from any thought of indecency and is advocating what I think he sincerely believes is the study of the higher art. His difficulty has been that his enthusiasm on the subject has carried him away.[38]

Eakins did not readily forget those who spoke against him. These words of 1895 must have gone a long way toward allowing him to approach Miller with his gifts of 1901 for the School of Industrial Art.

But he had already come much further. Sometime, probably in the fall of 1900, Eakins had asked to paint Miller's portrait (pl. 225). As a leading figure in the institutional art life of the city for twenty years—in addition to his employment, Miller was a founder of the Art Club of Philadelphia and an officer of the Fairmount Park Art Association—he was a logical figure to add to the pantheon of prominent Philadelphians whom Eakins sought to immortalize.[39] More pragmatically, Eakins might well have thought that the portrait of the principal of the School of Industrial Art would eventually find a home there, amid generations of art students and designers.

Whatever the motives, Eakins set to work on the project, doing most of the work at the school. One of the pupils, Charles Sheeler, later recounted:

> One day a stocky little man, gray-haired and gray-bearded, passed through our workroom. His trousers were tucked into short leather boots and fitted so snugly as to make the

braces over his dark sweater superfluous....A few days later he returned and passed to the life-class room, just beyond where we were working.

They watched through knotholes in a partition:

> The stocky little man was beginning a portrait of the principal of the school, Leslie Miller, and before long the plan of the picture was indicated....As the artist's work continued we witnessed the progress of a perspective drawing which was made on paper and then transferred to the canvas, to account for charts of ornament receding into the background—those charts which we knew only too well. This careful procedure led us to the conclusion that the man, whoever he was, couldn't be a great artist, for we had learned somewhere that the great artists painted only by inspiration, a process akin to magic.
>
> Several months were thus consumed; then came a day, as we discovered through the convenient knotholes, when another perspective drawing was made and transferred to the canvas, on the floor and to one side. The letters spelled Eakins. The name was not familiar to us.[40]

In addition to the perspective drawings for select passages of the painting (that for the signature is in the Hirshhorn Museum and Sculpture Garden, Washington, D.C.; the others are lost), Eakins also made a small oil sketch on cardboard, squared for transfer, of the whole composition (Philadelphia Museum of Art).

The finished work portrays Miller looking straight out at the viewer, although his body is turned slightly askew and is held with a dynamic, curving contrapposto whose naturalness lends it a visual grace. Solidly, comfortably planted, Miller's distribution of weight reveals a springy center line that, accounting for the pressures of gravity and the torsions of anatomy, animates the figure, exemplifying Eakins's counsel to his students: "Get life into the middle line. If you get life into that the rest will be easy to put on."[41] A folding screen provides an accoutrement of the life-class room (a model could disrobe and perhaps rest there out of view of the class) as well as framing Miller from the knees upward. To the left, two of Sheeler's familiar charts of ornament—Egyptian at the top and Greek on the bottom—give evidence of the ornamental design emphasis of the school's curriculum.

The color of the whole, muted browns and grays, is Whistlerian in its subtlety. The use of the background screen, too, is a focusing trick that Eakins would have seen when James McNeill Whistler's *Princess from the Land of Porcelain* (1864, Freer Gallery of Art, Smithsonian Institution, Washington, D.C.) was exhibited at the Pennsylvania Academy annual in the winter of 1893–94. The very canvas on which the work is painted—a burlap fabric coarser than Eakins's usual support—was associated with the Anglo-American.[42] Eakins had mixed views on Whistler's art: "I think it a very cowardly way

to paint," he is reported as saying.[43] Nonetheless, one of the very few times he portrayed another painter's work in his own pictures was in *Music* (1904, Albright-Knox Art Gallery, Buffalo, New York), which includes a reduced version of Whistler's *Arrangement in Black: Portrait of Señor Pablo de Sarasate* (1884, Carnegie Museum of Art, Pittsburgh). *Portrait of Leslie W. Miller*, rather than an homage to Whistler, seems a clever twist on the aesthetic predilections of the sitter, who inclined to an art-for-art's-sake sensibility—a Whistlerian portrayal fleshed out with Eakinsish solidity.[44]

Miller wrote about the painting several times in later years:

The primitive, even shabby frame represents Eakins' taste rather than mine as do the old nondescript clothes in which the subject is garbed which he begged me to rescue from the slop-chest and put on for the occasion, and personally I should be very glad to have the frame at least spruced up a bit.

Ever since I found out how much of a picture he was going to make of it, I have been haunted by a mild regret that I didn't insist on his painting me,—if he painted me at all,—in habiliments that would at least have been more like those which I would have worn when appearing in any such character as that in which he has done me the honor to portray me, but, as is evident through out all his work, he had a passion for the ultra informal which sometimes carried him so far as to lead him to prefer the unfit to the fit if it were only old, and worn and familiar enough.

But all that is part of the Eakins hallmark and of course it cannot be spared. He was one of the great ones and I value the picture very highly.[45]

The portrait of Miller became one of Eakins's best known and most widely respected works. Even while it was still on the easel, it drew a notice in the press:

Mr. Eakins is engaged upon a full-length portrait of Mr. Leslie Miller, principal of the School of Industrial Art and secretary of the Art Club.... The attitude is slightly suggestive of the portrait of Louis Kenton, now at the Academy of the Fine Arts, but is in no way a following after it, as Mr. Eakins never poses his models, but watches for a natural attitude. The likeness is excellent, and from present prospects the picture promises to be one of the most successful of Mr. Eakins' recent productions.[46]

A week later, a photograph of the finished work appeared in *The Philadelphia Press*, announcing the display of the work on the school premises and accompanied by the notice that "Friends of Mr. Miller say the likeness is true and the atmosphere real."[47]

This publicity led up to the two-person exhibition that Eakins and Murray shared at the Faculty Club at the University of Pennsylvania, which opened on February 16. Eakins had more than twenty works on display (no catalogue or complete listing is now known). His friend the critic Riter Fitzgerald trumpeted the exhibition, eulogizing Eakins and praising the Miller portrait. His column read, in part:

I desire to remind the Art patrons of Philadelphia that our city possesses the leading painter of male portraits in America.

I refer to Thomas Eakins.

He is a remarkable painter, and I am glad to say that he is at present painting better than ever.

His full length portrait of Louis Kenton is full of character; the attitude is capital.

But I prefer the full length that Eakins has just finished of Leslie W. Miller, principal of the School of Industrial Art.

It is a particularly fine portrait in an unaffected attitude that is far better than the stereotyped pose portrait-painters generally give to their subjects....

It is a strong likeness....

Eakins is an unusually modest man, with one of the kindest natures, and belongs to that class of painters who never attempt to advance themselves in anything but their Art.

In this he has steadily advanced, and if he were in New York instead of Philadelphia, he would be recognized at once as the leading portrait painter of America.[48]

The *Portrait of Leslie W. Miller*, which Eakins gave to the sitter but borrowed back frequently, was soon on the exhibition circuit. At the National Academy of Design in 1905, it was awarded the Thomas R. Proctor Prize of two hundred dollars for the best portrait.[49] In 1907, at the annual exhibition of the Carnegie Institute, it won a second-class medal along with an award of one thousand dollars, as well as the criticism that it was "long on psychology, short on colour."[50]

In addition to doctors, scientists, collectors, and art teachers, Eakins also painted, especially in the early years of the twentieth century, Catholic priests. The strident anticlericalism of his letters from Europe had abated. Under the guidance of the Catholic-born Murray, who was receiving sculpture commissions from the Church, Eakins began to visit the Saint Charles Borromeo Seminary, bicycling with Murray on Sunday mornings the six miles to Overbrook, sometimes staying for meals and services.[51] Eakins clearly felt ties to the institution there, since he lent to the seminary his *Crucifixion* (pl. 54)—one of the works he remained proudest of throughout his lifetime.

Of his fourteen catalogued portraits of clergymen, nine were done in 1902 and 1903. While most of these were painted in Philadelphia, two—*Portrait of Sebastiano Cardinal Martinelli* (pl. 226) and *Portrait of Archbishop William Henry Elder* (pl. 227)—caused Eakins to travel to Washington, D.C., and Cincinnati, respectively, to do the work.

Sebastiano Cardinal Martinelli (1848–1918) was the second apostolic delegate to the United States from 1896 to 1902. In February 1902 Eakins painted him in the cardinal's residence

in Washington.[52] The painting's background evokes a richly paneled room and parquet floor whose warm tones and discreet patterns—along with an oriental rug, crucially turned at an angle to the picture plane—provide a carefully plotted setting (at least three perspective drawings, one in the Bregler Collection and two in the Joslyn Art Museum, Omaha, Nebr., are extant). A heraldic escutcheon with the cardinal's timbre floats in the top left corner.[53]

Martinelli is dressed in the black robes of the Order of the Hermits of Saint Augustine, holding his cardinal's biretta—further touches of red at sash, collar, and skullcap signal his high rank within the Roman Catholic Church. Apparently a small man (well under five feet tall) and in his mid-fifties at the time of the painting, Martinelli shows a thick mane of dark hair, lean features, and a firm, resolute expression. His steady look into the light seems that of a visionary leader, the physiognomy, pose, and lighting yielding much the same effect as in Eakins's earlier portrait of Harrison S. Morris (pl. 207).

Martinelli, who had been created cardinal and titular archbishop of Ephesus in 1901, would soon be returning to Rome. Eakins gave the completed portrait not to him but to the Catholic University of America in Washington—an institution that he evidently hoped would appreciate the entwined artistic and historical importance of his painting.[54] Eakins borrowed the painting frequently for exhibition, choosing to show it more often than any other of his clerical portraits. When at the Pennsylvania Academy in 1903 (along with portraits of three other priests, a bloc showing Eakins's concerted attention to the group), one critic praised its "quiet poise" and judged it as "one of the commanding features of the exhibition."[55] Another, testifying to the success with which Eakins cloaked his calculations, wrote:

> There is no trickery about this portrait, nor has the artist paid much attention to composition, but painted his subject in the most direct manner possible.... His sharp, intelligent face is painted with force and directness and the whole canvas is an artistic document of great value.[56]

Eakins considered it a specimen of his "best work"; many others tended to agree.[57]

In addition to artistic value, however, Eakins also wanted the portrait to have local, American historical value, so on the back he inscribed, in Latin and full capital letters, the name of the sitter, the office he held, and the years he held it: "EFFIGIES SEBASTIANI S R E CARDINALIS MARTINELLI QVI ANNOS VI IN STAT FOED AB MDCCCXVI AD MCMII DELEGATI APOSTOLICI OFFICIO FVNTVS//THOS. EAKINS PHILADELPHIEN A.D. MCMII PINXIT."[58] Perhaps this was seen as the start of a series. Three years later he painted the next apostolic delegate, Archbishop Diomede Falconio, although the painting remained unfinished and in

Eakins's studio (National Gallery of Art, Washington, D.C.).[59]

In winter 1903 Eakins traveled to Ohio to paint the portrait of William Henry Elder, archbishop of Cincinnati (1819–1904). Elder had been born in Baltimore, schooled in Maryland, and then sent in 1842 to the College of Propaganda, Rome, where he was ordained in 1846. In 1857 he was consecrated bishop of Natchez. Two episodes in his tenure were especially noteworthy: his refusal in 1864 to follow the orders of the federal post commandant to use a certain form of prayer for the president of the United States, which Elder judged to infringe on his religious freedom and for which he was tried and convicted (the decision of the military court was overturned), and the courage and charity he manifested during a yellow fever epidemic in 1878. In 1880 Elder moved to Cincinnati, first as coadjutor and then in 1883 as archbishop, in which role he stabilized and invigorated the diocese.[60]

The work was a good-will commission from Cincinnati's Coadjutor Archbishop Henry Moeller, through the good offices of Eakins's friend from the Overbrook seminary the Reverend (later Monsignor) James P. Turner—Eakins had painted the latter in 1900, and would do so again in 1906 (Saint Charles Borromeo Seminary, Overbrook, Pa., and The Nelson-Atkins Museum of Art, Kansas City, Mo., respectively). Moeller wrote to Turner in November 1903:

> You must pardon me for not answering sooner your letter of September 21st. I would like to get a good portrait of the Archbishop [Elder], and as you so highly recommend Mr. Eakins I will be pleased if you request him to paint one for me.
>
> His Grace has had portraits painted of Bishop Fenwick and Archbishop Purcell, but he is too modest to have one made of himself. He however promised me that he would submit to the necessary sittings for his picture.
>
> I will gladly pay Mr. Eakins travelling expenses. He could stay with me while he is engaged in doing the work.
>
> If these terms are satisfactory, please let me know when he will be here.[61]

Eakins wasted no time. On November 25 he took the train for Cincinnati to begin work on the project.[62]

By December 15 he was able to write to a New York friend: "I have just finished in Cincinnati a full length, life sized portrait of the venerable Archbishop Elder which I did in one week."[63] Contrary to the Martinelli canvas, here Eakins chose to turn the sitter more to the front, trimming the setting back to the point where the figure of the archbishop and the edges of the canvas are nearly coterminous. The closer, more frontal approach—taken in conjunction with the informal pose, simpler setting (no elegant paneling or floating coat of arms), and Eakins's obvious delight in Elder's aged face and sinewy, knobby hands—emphasizes the individual man over the powerful

position he holds.[64] Eakins bragged of his achievement: "I think it one of my best. Harrison Morris solicited it for our Academy."[65]

The canvas's showing in 1904 at the Pennsylvania Academy's annual was a great success. The art journalists praised it as "true to nature," "quite extraordinary in its cold, deliberate analysis of a human personality," and as "an exceedingly forceful piece of work [that] shows Eakins at his best."[66] Even more signally, the jury at the Pennsylvania Academy awarded it the Temple Gold Medal—the exhibition's highest honor and Eakins's first from the Academy. The competition was fierce.[67] It was all the more noteworthy, then, that Eakins, with what one newspaper reported as "universal approval," received the prize. "This medal stands for a long and brilliant series of paintings shown at the Academy, but it may be doubted if it has ever been given for a more solid and substantial piece of painting than Mr. Eakins' portrait." The text continued:

> Artists differ in the emotions which they excite. Mr. Eakins has never been one of those who aroused a special enthusiasm. His high qualities are those of balance, solid drawing, indefatigable attention to the precise quality of the subject before him and amazing capacity for handling his entire problem without losing sight of any of the component factors. It is easy to astonish. It is not difficult to move. It is always possible by forcing for a current view of the many issues which go to make up the round of painting to attract public attention and to arouse public enthusiasm, but under all temptations to do some one of these things, to paint solidly, clearly, and to see things as they are, to refuse to paint them except as they are seen, and inflexibly to adhere to those high canons which those who know the history of art are aware last, is to paint a picture such as received the honor of the Temple Medal at this exhibition.[68]

The writer's enthusiasm revolved around the notion of realism—the portrayal of the real man. But Eakins's painting is art, a construction that draws from earlier art as well as from the vision before him. With chronological distance, scholars have demonstrated Eakins's reliance in this painting on works by such earlier artists as Velázquez and Bonnat—both of whom Eakins admired.[69] Given the artist's general practice of showing his more successful works in numerous exhibitions, it is curious that the *Portrait of Archbishop William Elder* was not seen again in public during Eakins's lifetime. Perhaps with Elder's death in October 1904, the archdiocese of Cincinnati was wary of lending it.

One of the elements that sets Eakins's portraits of cardinals and bishops apart from his other portraits of men is the distinctive traditional garb—flowing drapery and light, sometimes bright, color accents. To a degree, Eakins had practiced for the painting of Elder's purple with a large-scale painting finished earlier in 1903—*An Actress (Portrait of Suzanne Santje)* (pl. 231). The Eakinses liked the theater.[70] In March 1901 Eakins reportedly saw Richard Mansfield's production of *Beau Brummel* at the Walnut Street Theatre; he was especially taken with the actress playing the role of Mrs. St. Aubyn—a character described as "passée but still beautiful . . . a very handsome woman of about thirty, beautifully dressed, and showing in every look and motion the woman accustomed to homage and command."[71] Sometime between then and 1903, when he dated the painting, Eakins persuaded that actress—Philadelphian Suzanne Santje (née Keyser; 1873–1947)—to sit for him.[72]

Educated at the University of Pennsylvania, Santje had studied music in Berlin and drama in Paris—"where I had almost forgotten my native tongue," she later said—before returning to the United States, "to try to take my native land by storm. . . . Home I came with my father, and it was highly gratifying to read in the Philadelphia papers the story of my foreign conquest."[73] She toured with the Augustin Daly Company until 1898, when she joined Mansfield; she was a principal of the Coburn-Santje Stock Company, headquartered in Roanoke, Virginia, before she brought her acting career to a close in 1905.

Eakins showed Santje not on stage, but during a private moment sitting in an elaborate room. Some of the furnishings can be identified. The pot on top of the mantel and the carpet seem to be the same as in *Singing a Pathetic Song* (pl. 63); the Jacobean-revival chair—the top knobs of its near arm support dissolving into the high color of Santje's dress—is identical to that Eakins had used often in the previous thirty years. These imply that the work was done in the artist's studio on Mount Vernon Street. Yet the portrait on the back wall, too large and hanging too low for convention, relates to Santje, not Eakins; it is a portrait of her father, a lawyer and leader in Philadelphia's preservationist movement.[74] The architecture, too, seems more baronial than the Eakinses' house. It is a character-revealing rather than realistic assemblage of things.[75] The apparently fictive portrait of her father testifies to Santje's heritage and place in Philadelphia society; the letter, addressed to "Miss Suzanne Santje Roanoke Va." identifies the site of her professional base; the book—evidently a script of Alexandre Dumas the younger's *Camille* (*La Dame aux Camélias*, 1852)—provides both a prop and, perhaps, an explanation for her mood.[76]

Eakins had initially labeled the script's cover *Hamlet*,[77] but replaced it with *Camille*, the romantic drama whose glittering heroine, the courtesan Marguerite Gautier, epitomizes the free-spirited—thus, in much of the era's fiction, doomed—woman of the nineteenth century. As Eakins portrayed her, Santje seems to reflect on Gautier's complex amalgam of traits,

simultaneously the most worldly yet most self-sacrificing of characters. He hinted at this paradox by the contrast between Santje's enervated form and her dress.

Santje wears an elaborate fuschia-colored tea gown—redolent of artistry, poetry, and fantasy—with a neo-medieval upright collar to frame her face.[78] Gauze flows over the whole expanse of the *robe d'intérieur,* as well as joining the split sleeves that leave the arms exposed. The combination of fabrics begs to be set in gentle motion, its various layers rustling, the gauze billowing in response to movement. But Santje lies inert, her body twisted; she seems to want to look further toward the light, but cannot muster the energy.[79] In spite of her ruddy complexion and luxuriant hair, Santje is momentarily drained of all vitality.[80]

To be fair, the condition of the painting exaggerates the contrast between Santje and her gown, with the dress's present uncompromised magenta unsettling the tonal integrity of the painting.[81] Perhaps the grayed lilac-salmon color still visible on the gusseted flounce provides a hint of Eakins's intention concerning it. Unfortunately, no early critics testified about the dress's effect. They did not ignore it; they never had a chance to see it. Eakins did not exhibit *An Actress* in his lifetime.

Eakins's decision to paint Santje might well have been prompted by his fascination with her particular character, as Samuel Murray testified.[82] But many of his famous colleagues—near contemporaries like Sargent and Chase as well as such younger portraitists as Irving Wiles—were also painting life-size portraits of actors and performers at the turn of the century. Sargent's *Ada Rehan* (1895, The Metropolitan Museum of Art, New York), for example, had been a significant presence in various American exhibitions, including at the Pennsylvania Academy in 1895–96, where it was, "of course, head and shoulders over" the other portraits.[83] Likewise, Wiles's *Miss Julia Marlowe* (1901, National Gallery of Art, Washington, D.C.), showing the actress wearing a flowing gown with a gauzy overlayer, was an immense success at the National Academy of Design in 1902 and the Pennsylvania Academy the next year.[84] Eakins—who saw both Rehan and Marlowe on stage—must have considered how his portrayal of Santje would join with these others in the public mind. Given the scale and complexity of the work, the likelihood of its being finished (the carefully plotted signature was generally among the last elements Eakins added to a canvas),[85] and his access to the work throughout his lifetime, his decision to seclude *An Actress* introduces a further puzzle concerning this singular work and its place in Eakins's oeuvre.

After 1900 Eakins continued to paint portraits of friends, family, and colleagues. *Portrait of William B. Kurtz* (pl. 228) shows the stockbroker and amateur athlete standing nearly square to

the canvas and looking directly out at the viewer.[86] Here Eakins returned to the format of his critically acclaimed portrait of George F. Barker from 1886, although shifts in color and fashion lend Kurtz's image a cool, metallic modernity absolutely distinct from Barker's stolid nineteenth-century appearance.

Kurtz wears a loose gray suit, jamming his hands into the jacket's short pockets. Although Eakins was careful to suggest the informality of the suit, he spent little time, aside from the play of light on the jacket buttons, in detailing it. While the shirt was of greater concern, especially the flesh-framing cuffs and collar, it has only a minimally articulated front opening. Instead, Eakins devoted his energy to the firm face and veined hands. Kurtz's cool, appraising stare dominates the canvas, the highlights in the eyes of both the lit and shadowed sides of his face compelling attention. Light reflecting off his full lower lip and flesh lends him a sleek glossiness, which is complemented by the silvery helmet of hair and glistening central curl. Perhaps the effort to counteract the general shininess of Kurtz's complexion is one reason that Eakins asked him to go unshaven for a day before his poses.[87] The painting belonged to Kurtz, although whether it was a gift or a commission is unclear; it was apparently not exhibited in the artist's lifetime.

William Innes Homer has sensibly associated the general informality of many of Eakins's portraits, citing the Kurtz portrait in particular, as a reflection of a secular Quakerism pervasive in the artist's home circle.[88] Eakins was not, however, averse to assaying works of near-opposite effect. One, the *Portrait of Frank B. A. Linton* (pl. 233), dates from 1904. Eakins both photographed (pl. 232) and painted his friend and former student (1871–1943), who had studied at the Art Students' League of Philadelphia before journeying to Paris in the 1890s to work with, among others, Jean-Léon Gérôme and Léon Bonnat.[89] Linton's bald pate, bushy but neatly trimmed beard, and full, waxed mustache all contribute to the image of a dapper, worldly sophisticate—an impression enlarged by his pince-nez and elegant white-tie ensemble. An atypical, nearly effulgent background lends a further note of glamour to the image, as does the smallness of his head relative to the expanse of the canvas—another unusual feature of this work amid the many canvases of this size from Eakins's later years.

Eakins painted a number of musicians in 1904, including the violinist Hedda van den Beemt and the pianists Edith Mahon and Samuel Myers, who was Linton's close friend and studio-mate. These, as well as Linton's own musical interests (according to Margaret McHenry, "Samuel Myers and Frank Linton used to give musicales on Saturday afternoons," which Eakins attended for years and at which he "would sit in a corner and sob like a child"[90]), perhaps explain why Linton projects more the air of a performer than a painter.

The last portrait Eakins painted of a close family member was also the culmination of a series of works showing his father-in-law, William H. Macdowell (pl. 237). Done when Macdowell was in his mid-eighties, the painting shows a cool, fearless stare encased in increasingly fragile flesh and bone. Eakins effectively captured Macdowell's thick hair, jutting eyebrows, and full beard, all luxuriant but slightly unruly and independent. He wears a topcoat over his suit, implying activity and his ability to be out in the world. Eakins did not emphasize these things, but the light falling on the buttons, the hair sticking out to the right, all contribute to the impression of continuing vitality caged within the sitter.

This dynamism is complicated, however, by the area of greatest detail within the painting: the shadowed side of the face reveals particularly the intensity of Eakins's scrutiny, where the melting flesh reveals the hollows of the cheek and the fine, soft wrinkles of the skin beneath the eye. The several painted portraits and many photographs of Macdowell, the hours the two men spent together over the previous quarter century, all seem summarized in this lovingly observed statement that joins with Eakins's late portrait of Susan, his self-portrait, and a very few other works to make emotion as palpable as physiological structure and in so doing to limn the dimensions of the human soul.

Eakins's growing reputation during the early years of the twentieth century yielded some pragmatic benefits. Commissions for at least ten paintings came to him between 1902 and 1905, three of them for large works of substantial men of business: *Portrait of Robert C. Ogden* (1904, Hirshhorn Museum and Sculpture Garden, Washington, D.C.), *Portrait of John B. Gest* (1905, The Museum of Fine Arts, Houston), and *Portrait of Asbury W. Lee* (pl. 235). Two of these commissions ended badly, with Ogden and Eakins arguing over price before Ogden simply put the painting into storage, and with Lee returning his work to Eakins after making a token payment.[91] Taken together, these—along with the later portraits of the businessmen Richard Wood, Edward S. Buckley, and Edward A. Schmidt, which also met with unhappy client responses—must have occupied a considerable amount of time and energy. Yet even today, they often fail to generate enthusiasm.

Lee was the foremost businessman of the small town of Clearfield, Pennsylvania, and reportedly "one of the richest men in this part of the State"—the town's bank, trust company, lumber company, water company, telephone company, and power company were his affairs.[92] He nonetheless had time enough to join the Art Club of Philadelphia, which is probably where he met Eakins and commissioned the portrait. Arranging sittings was not easy. Lee wrote early in 1905: "I am sorry that I have been unable to give you a sitting. Am now going South and will return by your City in March, when I hope to be able to give you some time."[93] By mid-September the portrait was painted, shipped, examined, and rejected. Lee again wrote: "You will receive the Painting back from Washington addressed Mary E. Lee, 1729 Mt. V. I may make a suggestion when I am down soon. While not accepted by me I send you a cheque for $200. anyway. In a general way, my daughter liked it."[94]

While the minimal check and the scant consolation of the daughter's opinion may have helped Eakins in this particular case, Lee's rejection—and the general unhappiness of his plutocrat sitters—points out a real problem that faced portraitists at the turn of the century: the distinction between a portrait and a picture, a work of art and a mere likeness. The balance between individual portrayal, the artist's response to a given personality, and the formal elements of the painting was in flux. Eakins felt pressure to shift between these various weightings, as witnessed by two exchanges he had with sitters—one happy and one not. The first was a discussion with Walter Copeland Bryant, as reported by Mrs. Bryant. The painter

> thought Mr. B. too youthful looking and said in 50 years nobody would know only the portrait. . . . Mr. Eakins asked Mr. Bryant if he could take all the liberty he wanted to do a fine piece of work as a work of art rather than a likeness. . . . He was pleased with it and said if people criticized it one must have a photograph if a likeness was wanted.[95]

When the discussion took place retrospectively, the results were likely to be less happy. The portrait of Edward A. Schmidt prompted a considerable correspondence. Schmidt's agent wrote to the artist, after the painting had been seen and hung prominently at public exhibition:

> This confirms what I have always been willing to concede, and that is, whatever criticism may be made of the picture as a portrait, it certainly as a work of art occupies a high rank. Unfortunately the expression of Mr. Schmidt's countenance as shown in your portrait, is so different from his usual one, that many of his friends who have seen the picture, have passed adverse criticisms upon the likeness; and you must concede that after all, it is intended as a portrait and not as evidence of art only.[96]

Somehow, in his portrait of Asbury Lee, as in the portrait of Schmidt, Eakins failed to balance the competing elements of likeness and art to the sitter's satisfaction.[97]

Many painters of the nineteenth and twentieth centuries shared Eakins's dilemma concerning the role of painted portraits. In institutions across the country—museum storerooms, universities, hospitals, banks, clubs, chambers of commerce—hang bevies of portraits showing, principally, men in dark suits. Almost no one pays attention to them. Even

those by famous artists—Eastman Johnson, John Singer Sargent, William Merritt Chase—remain largely undisturbed by the attention of critics and scholars. We do not yet have the right questions to ask of these works, so they remain mute and unexamined.[98]

In 1908, when Eakins was in his mid-sixties, his work took a decidedly nostalgic turn. One of his larger portraits featured a young student from the School of Industrial Design—Helen Montanverde Parker (1885–1975), whom Eakins had met at a musical afternoon in Frank Linton's studio—and a gown that belonged to her great-grandmother. The result was a painting now called *The Old-Fashioned Dress* (pl. 240).

The sitting process was arduous. Parker's mother—herself a professional silhouette artist—wrote that Eakins "put on it a world of work," estimating that her daughter "posed about thirty-five times; two and three hours at a time."[99] The younger Parker remembered trying and failing to cajole him into making her "just a little pretty"; he responded, "You're very beautiful. You're very beautiful," while studying the bones in her neck and making her "really small and dainty nose more and more bulbous."[100] She wrote in 1969: "Thomas Eakins was not interested in my face—(I have always felt a sense of being decapitated) but he was fascinated by my clavicles and the dress. . . . I read the other day that we only know one percent of what was happening to us in our youth. I truly look as if I did not rate that high. I was born in 1885—should have known enough to wear a little intelligent expression." She nicknamed this portrayal "my 'Ugly Duckling' portrait."[101]

Even with all the time with the model, the painting is unevenly finished. Parker's face, hands, and the upper part of the chair all seem to be reasonably detailed, but her neck, arms, and the lower regions of the dress lack their expected resolution (the transfer grid is in some places still visible).[102] One area of the canvas that Eakins did lavish attention on is the collar and high-waisted belt of what Parker's mother described as "my grandmother's old white silk and pearls," with its filigree and seed-pearl ornament.[103] Not only Eakins, but Susan Eakins and Addie Williams—a professional seamstress—were reported to be fascinated by it, taking the opportunity when it was left in the studio between sittings to "pore over it, examining every stitch."[104]

Eakins was sufficiently proud of the work to exhibit it at the Pennsylvania Academy annual in 1910 as *Portrait of a Lady*. At the exhibition opening, the model, "in rich dark yellow satin, topaz jewels, and hair ornaments" and looking "lovely," according to her mother, felt wholly undone by her appearance within the work. Looking back nearly sixty years, Parker emphasized her dismay: "I *cried* the first time I saw it at the Academy."[105]

Eakins's other nostalgia-laden project of 1908 was even more profound. For the first time in a decade, he turned away from portraiture, assaying a historical subject: William Rush carving his allegorical figure of the Schuylkill River. His version of thirty years before (pl. 41) had been a controversial exhibition subject, but Eakins remained proud of the painting, including it in his one-person exhibition at Earles Galleries in 1896 and in the show he shared with Murray at the Faculty Club in 1901.

In the meantime, the subject had taken on resonance. William Rush, in large part owing to Eakins's efforts, had migrated from the status of virtually unknown craftsman into the realm of respected American sculptors, his life and achievement fully inscribed in the written records of the field.[106] More trenchantly, the idea of the study of the nude serving as the basis for all art had brought Eakins to repeated points of personal and professional crisis. His return to the theme at the height of his maturity provided a *summa* that is nearly novelistic in its plotting.

The most complete of these later variations of the theme (pl. 238) closely relates to its predecessor while simultaneously witnessing distinct changes.[107] Although the principal characters and many of the accessories are still present in the workshop—sculptor, model, chaperone, three of Rush's figural works, a ship's scroll, and woodworking tools ranged across the back wall—they have been shuffled around and considerably enlarged. In keeping with Eakins's general trend of working at a larger scale as he grew older, he now put the scene on a canvas three by four feet and pulled the figures closer to the picture plane, so that the nude fills nearly the whole height of the painting. The formally dressed chaperone in a Chippendale chair of the earlier work is replaced by an African-American woman, who sits on a more humble green-painted country chair, turned to face the viewer. She has switched sides with the sculptor, who is now on the far right, dressed in working clothes, his rolled-up sleeves revealing thick, gnarled forearms and massive hands. Light from the left falls full on the model, her flesh the painting's brightest and most dominant element—there is no still life of clothing in the foreground to distract from her body. Strong shadows carve out the depressions of spine, shoulder blades, and buttocks, the whole testifying to Eakins's continued mastery of artistic anatomy. He prepared for each of these principal figures, as well as the whole composition, with a range of oil studies.[108]

While Eakins in 1908 still bowed to historical detail—the sculptor's short pants and buckled shoes—he eschewed the preciosity of the earlier work. More centrally, in 1877, Eakins had been concerned to show Rush as a gentleman, working in

fine clothes, his studio able to accommodate two high-style Chippendale chairs. In 1908, however, the artist and the workshop both are without pretension. The model, too, accompanied by the knitting chaperone as a sign of moral rectitude, is without any witness to her class and wealth. Simple humanity is emphasized.

Eakins had the work done by mid-March 1908, when he wrote to John Beatty, the head of the Carnegie Institute, that he was going to send it and a portrait head of Monsignor Turner (1901, Saint Charles Borromeo Seminary, Overbrook, Pa.) to the Carnegie's late April exhibition. Eakins was intent on showing the work, as witnessed by his sending off a long description of Rush's career and the scene's cultural context, in longhand, and authorizing Beatty to "use your judgment as to putting it in the catalogue in whole or in part or in suppressing it all."[109] The next week he wrote to Pittsburgh that he had found a frame "that suited the Rush picture."[110] So he must have been sorely disappointed when the painting was refused. He apparently did not try to exhibit it elsewhere during his lifetime.[111]

He did, however, continue to explore the theme. The finest of the variants—the one with the richest import in the simplest form—is *William Rush and His Model* (pl. 239).[112] Again on a large, three-by-four-foot canvas, Eakins pared down the characters portrayed and the materials shown. The space is an amorphous void, with the exception of a ship's scroll that looms up from the foreground—covering part of the sculptor and amalgamating the man with his work—and two blocks of wood on which the model steps. With these few elements, the painter evoked a world of meaning, creating a proud, poignant summation of his long career. Characteristically, while springing from inherited traditions—the much-admired Gérôme, who had died in 1904, did multiple versions of sculptors working from the nude model—the painting also broke new ground.

This is most obvious in the figure of the woman. Eakins lavished care and refinements on the form, a virtuosic combination of complex foreshortenings and motion studies. The lower portion of her body seems derived from one of the Muybridge studies in human locomotion—the very type and stance following closely upon the photographic model.[113] But Eakins exceeded what the photograph shows, for with color and choice he could portray her with greater weight and vigor than the photograph of the 1880s could manage. Her spatulate feet truly lift from and land on wooden blocks. She connects with their surfaces and rests her weight on them, exemplifying at this late date Eakins's continuing belief in the precepts he had articulated to his students: "Get the foot well planted on the floor."[114]

But Eakins was exploring and expanding the range of his art, as well, with this figure. Aside from sketches, this is the only frontal, full-length, female nude in his painted oeuvre—a curious gap in a professional life so criticized for its improprieties as regards the naked body. Moreover, he portrayed the model without bowing to any conventional modesties, including even her pubic hair. He simply presented the whole, natural woman, taking delight both in the fullness and gravity-bound nature of her swellings and concavities, as well as in his ability to portray them so convincingly.

The figure of the artist, too, is charged with meaning. Unlike any of his earlier representations of Rush, here Eakins turns the sculptor's face from the viewer, hiding a recognizable physiognomy. Numerous commentators have noted, however, that in this burly, stocky form, there is a signal echo of Eakins's own self.[115] Eakins did not often subscribe to allegory. But it is difficult to resist the call to see this as an autobiographical statement of his lifetime's work: the dedicated craftsman, using his skill and his tools to assist the figure of Art down to earth.

Eakins continued to paint portraits after 1908, although with less frequency, until his health began to fail. The causes of his physical decline remain conjectural.[116] In spite of his decreased activity and remove from fashion, critics and historians of American art found that they had to include him in their reviews and surveys, often in a starring role.[117] In 1914, for example, in the wake of the much-noted exhibition and sale of his portrait of Dr. Agnew (1889, Yale University Art Gallery, New Haven)—a study for the larger clinic painting—he was interviewed by a writer for *The Philadelphia Press*, who began the article: "In a large, commodious, old-fashioned house at 1729 Mt. Vernon Street lives Thomas Eakins, dean of American painters. Mr. Eakins is considered to be the foremost living American painter."[118] Two years later, at the National Academy of Design spring annual, a pair of much earlier works drew attention: *Portrait of J. Harry Lewis* (1876, Philadelphia Museum of Art) and *The Spinner* (1878, Worcester Art Museum, Mass.). The latter, "a slight work by a thoughtful painter," was one of the three best works on view, according to the writer for *The Sun*, who continued: "It is a pity Mr. Eakins's ability does not receive wider recognition. With so many of our academicians becoming enfeebled by age it is a pleasure to encounter one whose style acquires increased dignity with the years."[119] Through perseverance and longevity Eakins had become one of America's old masters.

The end came on June 25, 1916, after years of increasing debility. Susan Eakins recorded the event in her diary:

Sun. June 25, 1916 Tom is dead.
Mon. June 26, 1916 My poor Tom away forever from the
 house this day.[120]

Obituaries included such phrases as "one of the most notable figures in the American art world," and a memorial exhibition was readily organized at the Metropolitan Museum of Art in New York; it took longer and more persistent persuasion for a comparable tribute in Philadelphia.[121] But one senses that Eakins would neither have minded continuing neglect nor gloried in posthumous celebration. "I believe my life is all in my work," he had written.[122] And over the half-century of his active art life, in this regard, he had lived fully and well.

Eakins in the 1900s

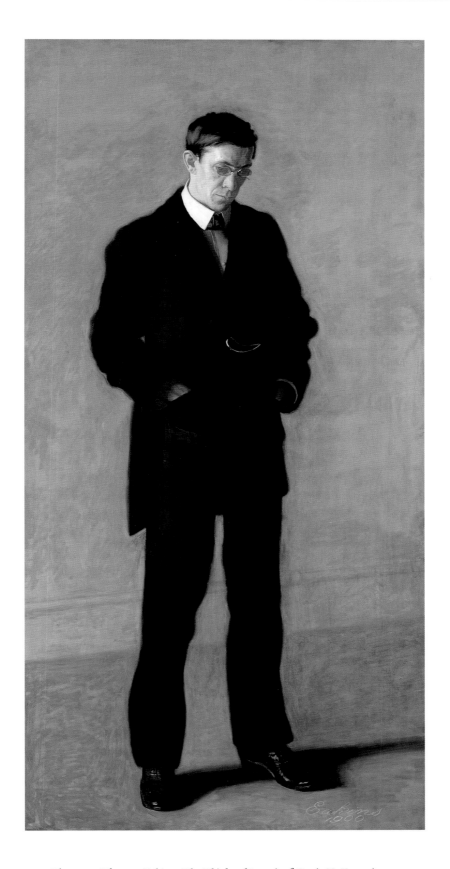

Plate 220. Thomas Eakins, *The Thinker (Portrait of Louis N. Kenton)*, 1900.
Oil on canvas, 82 x 42 inches.
The Metropolitan Museum of Art, New York. John Stewart Kennedy Fund, 1917.

Plate 221. Attributed to Thomas Eakins, *[Susan Macdowell Eakins with a Monkey and Two Cats]*, probably 1895–1900.
Platinum print, 3¾ x 4¹¹⁄₁₆ inches.
Pennsylvania Academy of the Fine Arts, Philadelphia. Charles Bregler's Thomas Eakins Collection,
purchased with the partial support of the Pew Memorial Trust (1985.68.2.282).

Plate 222. Circle of Thomas Eakins, *[Thomas Eakins Mounting a Bicycle]*, 1890s or 1900s.
Platinum print, 2¹⁵⁄₁₆ x 2⁹⁄₁₆ inches.
Bryn Mawr College Library, Pennsylvania. Seymour Adelman Collection (Special Collections SA 16).

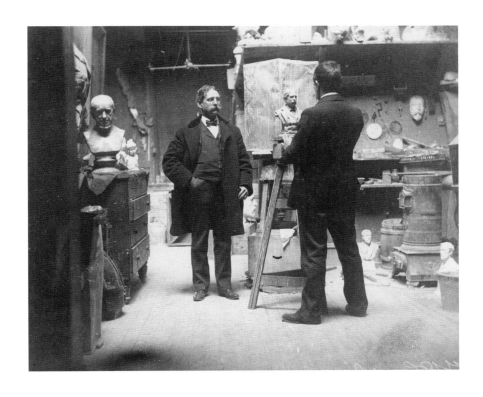

Plate 223. Attributed to Thomas Eakins, *[Samuel Murray Sculpting a Bust of Frank J. St. John in the Chestnut Street Studio]*, 1900.
Gelatin silver print, 3⅝ x 4½ inches.
Collection of Daniel W. Dietrich II.

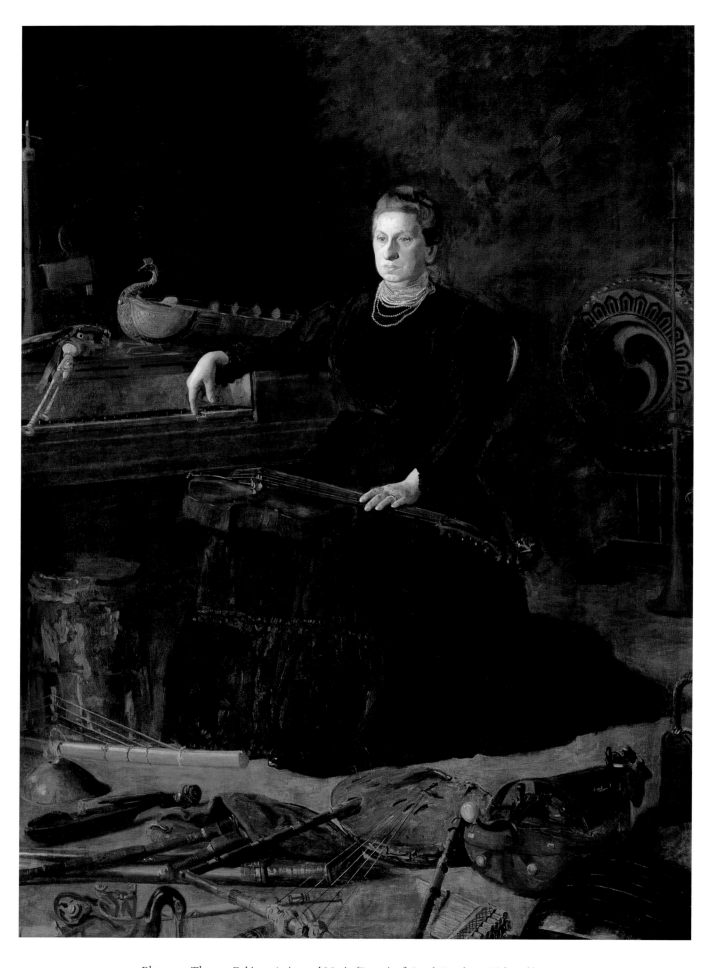

Plate 224. Thomas Eakins, *Antiquated Music (Portrait of Sarah Sagehorn Frishmuth)*, 1900.
Oil on canvas, 97 x 72 inches.
Philadelphia Museum of Art. Gift of Mrs. Thomas Eakins and Miss Mary Adeline Williams, 1929.

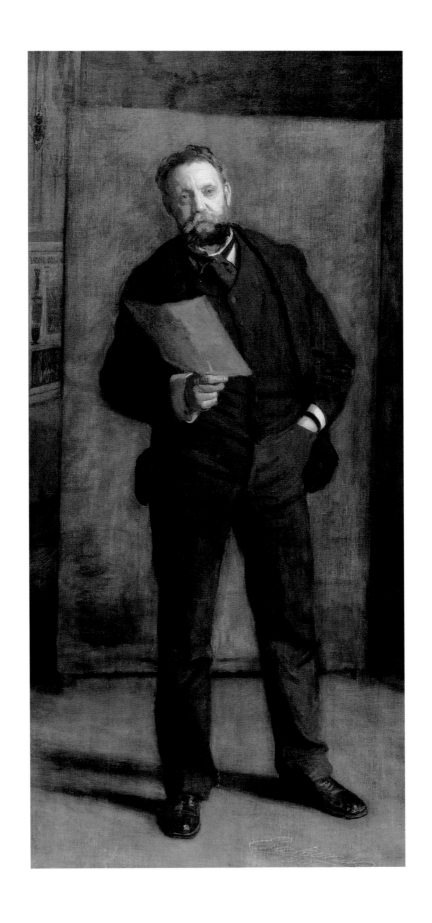

Plate 225. Thomas Eakins, *Portrait of Leslie W. Miller*, 1901.
Oil on burlap canvas, 88 x 44 inches.
Philadelphia Museum of Art. Gift in memory of Edgar Viguers Seeler by Martha Page Laughlin Seeler, 1932.

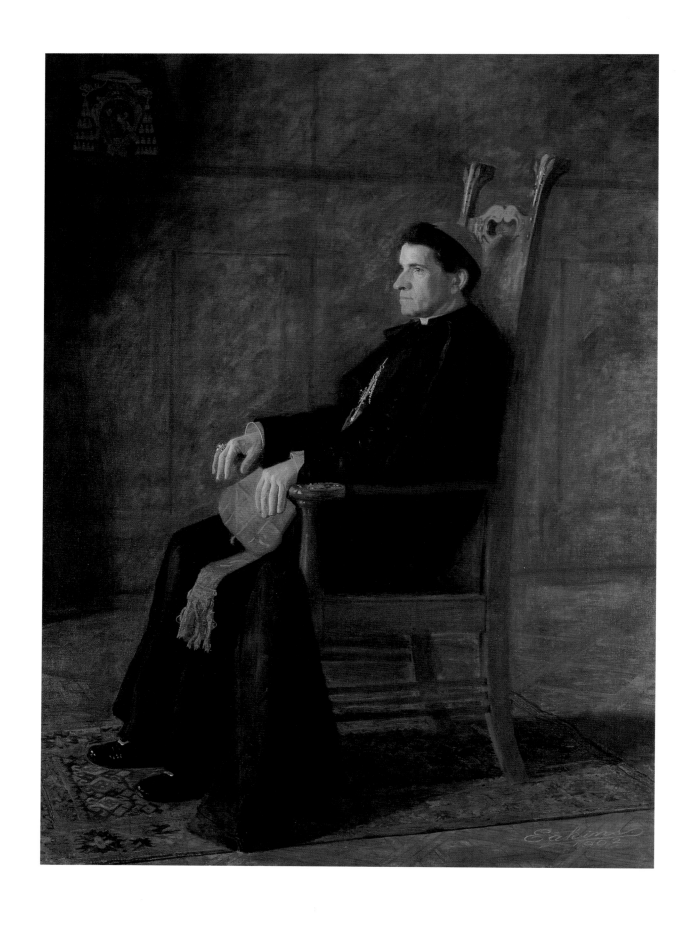

Plate 226. Thomas Eakins, *Portrait of Sebastiano Cardinal Martinelli*, 1902.
Oil on canvas, 78⅜ x 60 inches.
The Armand Hammer Collection, UCLA Hammer Museum, Los Angeles.

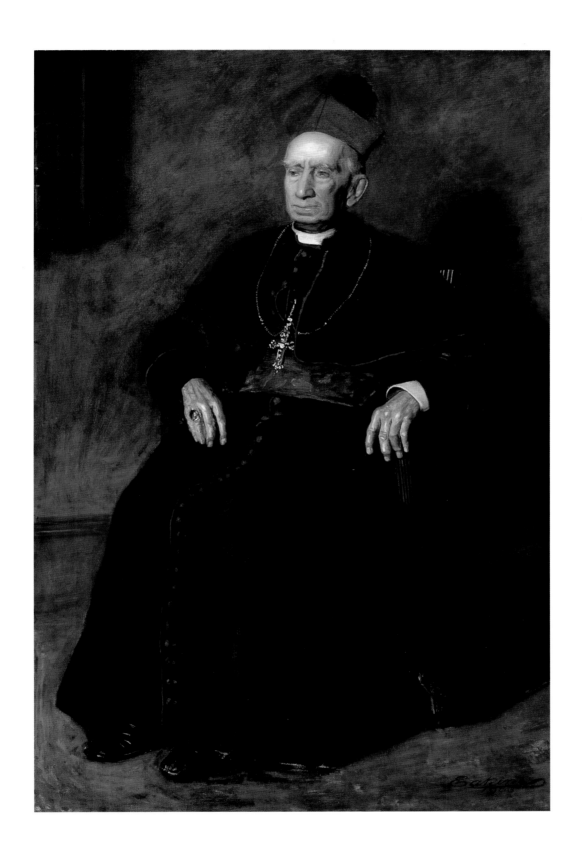

Plate 227. Thomas Eakins, *Portrait of Archbishop William Henry Elder*, 1903.
Oil on canvas, 66⅛ x 41⅛ inches.
Cincinnati Art Museum. Louis Belmont family in memory of William F. Halstrick, Bequest of Farny R. Wurlitzer,
Edward Foote Hinkle Collection, and Bequest of Frieda Hauck, by exchange.

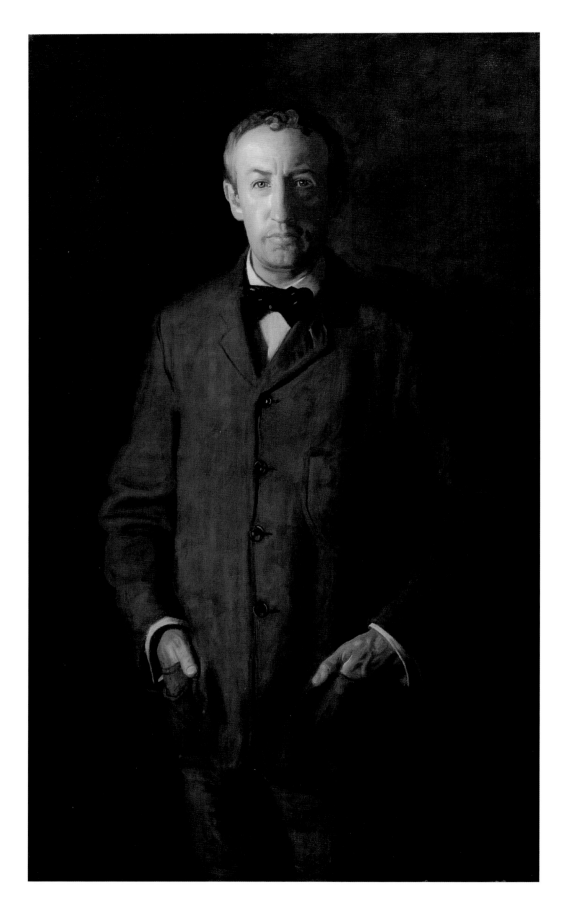

Plate 228. Thomas Eakins, *Portrait of William B. Kurtz*, 1903.
Oil on canvas, 52 x 32 inches.
Collection of Daniel W. Dietrich II.

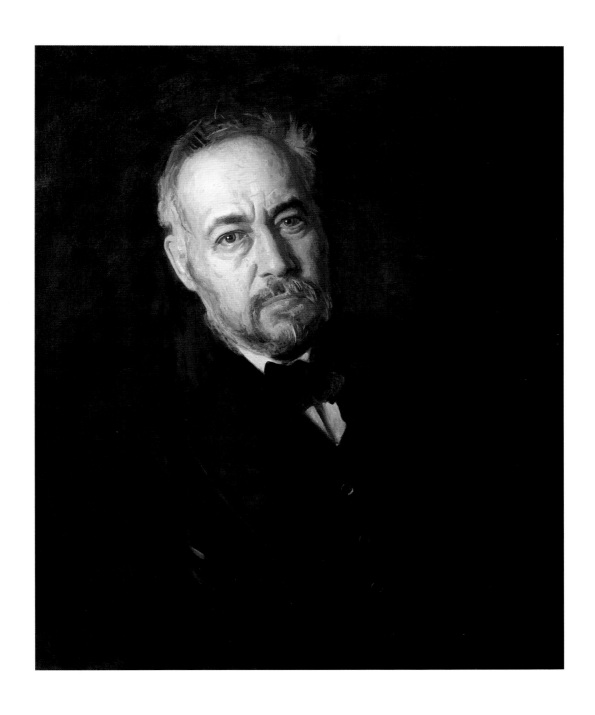

Plate 229. Thomas Eakins, *Self-Portrait*, 1902.
Oil on canvas, 30 x 25 inches.
National Academy of Design, New York.

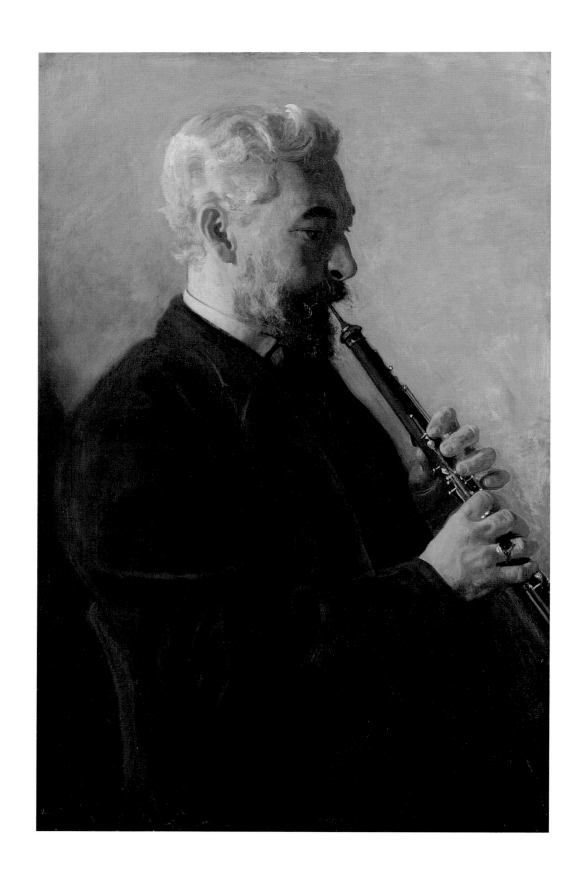

Plate 230. Thomas Eakins, *The Oboe Player (Portrait of Dr. Benjamin Sharp)*, 1903.
Oil on canvas, 36⅛ x 24⅛ inches.
Philadelphia Museum of Art. Gift of Mrs. Benjamin Sharp, 1946.

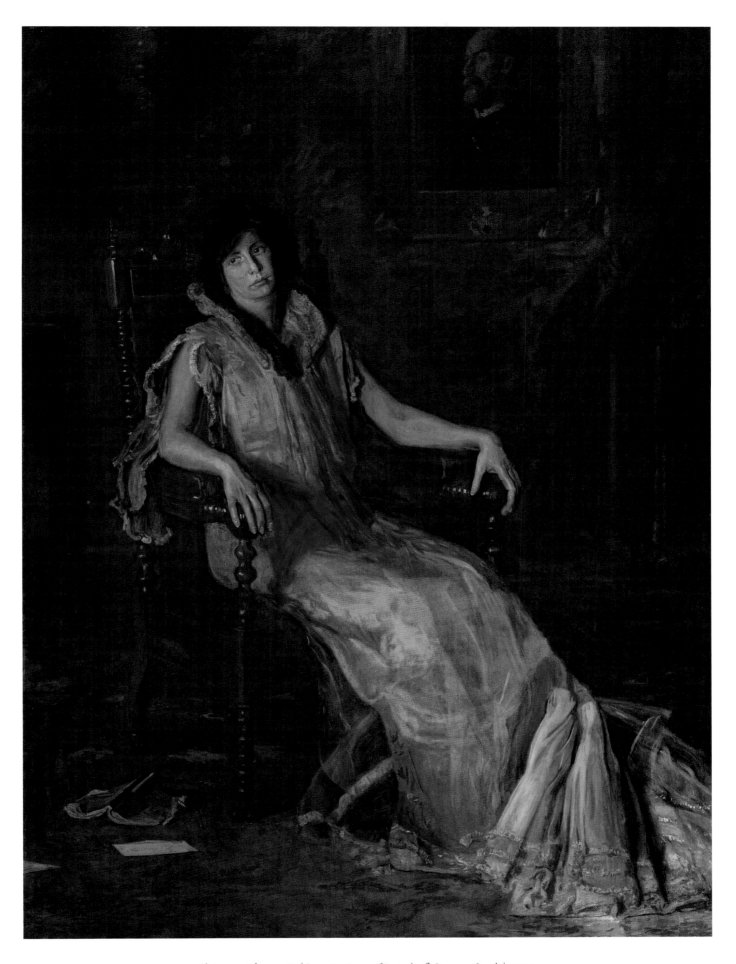

Plate 231. Thomas Eakins, *An Actress (Portrait of Suzanne Santje)*, 1903.
Oil on canvas, 79¾ x 59⅞ inches.
Philadelphia Museum of Art. Gift of Mrs. Thomas Eakins and Miss Mary Adeline Williams, 1929.

Plate 232. Thomas Eakins, *[Frank B. A. Linton]*, c. 1904.
Printing-out paper print, 3¾ x 3½ inches.
Hirshhorn Museum and Sculpture Garden, Smithsonian Institution, Washington, D.C.
Transferred from Hirshhorn Museum and Sculpture Garden Archives, 1983 (83.101).

Plate 233. Thomas Eakins, *Portrait of Frank B. A. Linton*, 1904.
Oil on canvas, 24 x 20¼ inches.
Hirshhorn Museum and Sculpture Garden, Smithsonian Institution, Washington, D.C.
Gift of Joseph H. Hirshhorn, 1966.

Plate 234. Chappel Studios, Philadelphia, *[Thomas Eakins at About Age Sixty]*, c. 1904.
Gelatin silver print, 6½ x 4¾ inches.
Collection of Daniel W. Dietrich II.

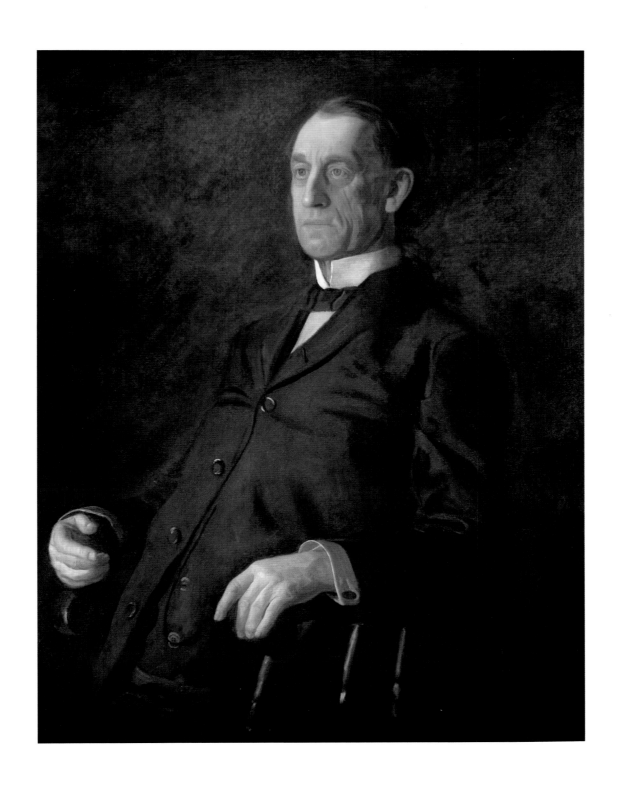

Plate 235. Thomas Eakins, *Portrait of Asbury W. Lee*, 1905.
Oil on canvas, 40 x 32 inches.
Reynolda House, Museum of American Art, Winston-Salem, North Carolina.
Gift of Nancy Susan Reynolds and Barbara B. Millhouse, and Acquisitions Fund.

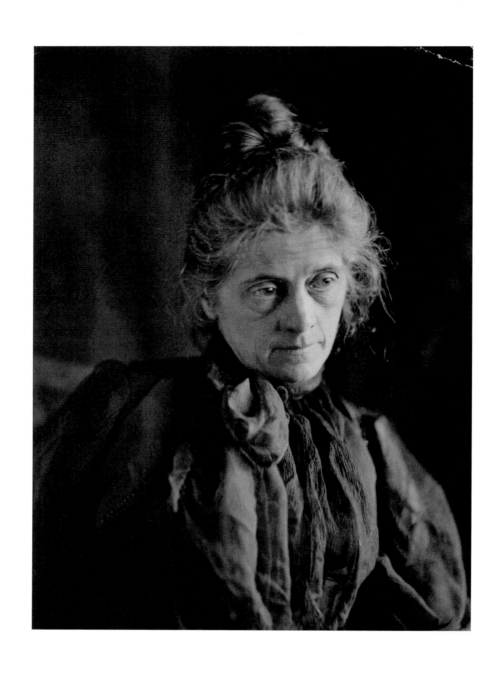

Plate 236. Thomas Eakins, *[Susan Macdowell Eakins]*, 1900s.
Platinum print, 6⅛ x 4⁹⁄₁₆ inches.
Bryn Mawr College Library, Pennsylvania. Seymour Adelman Collection (Special Collections SA 30).

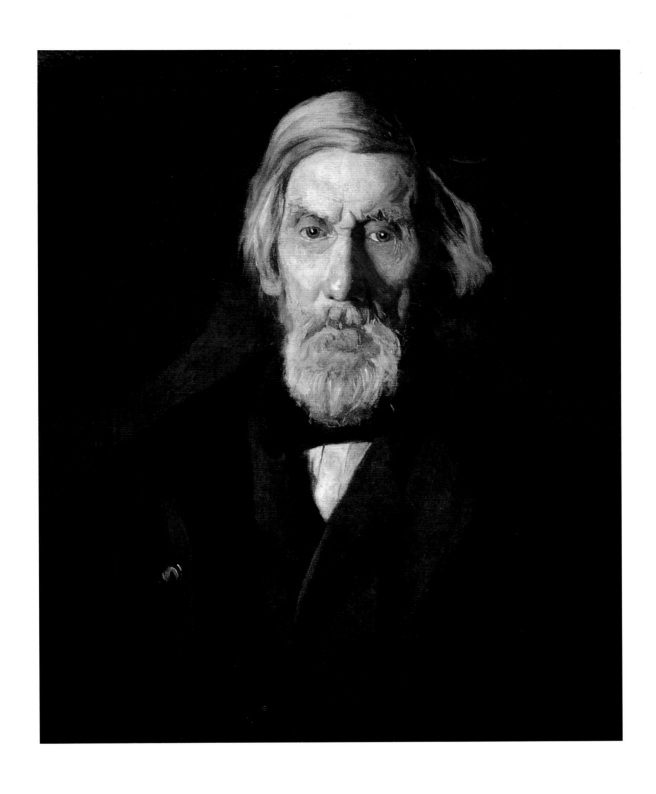

Plate 237. Thomas Eakins, *Portrait of William H. Macdowell*, c. 1904.
Oil on canvas, 24 x 20 inches.
Memorial Art Gallery of the University of Rochester, New York. Marion Stratton Gould Fund.

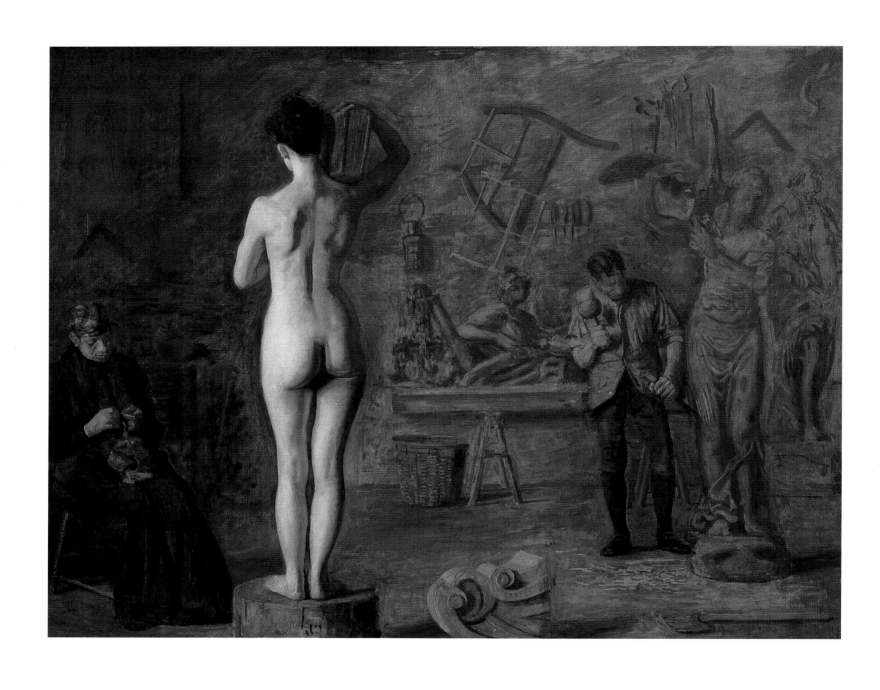

Plate 238. Thomas Eakins, *William Rush Carving His Allegorical Figure of the Schuylkill River*, 1908.
Oil on canvas, 36⁷⁄₁₆ x 48⁷⁄₁₆ inches.
Brooklyn Museum of Art, New York. Dick S. Ramsay Fund.

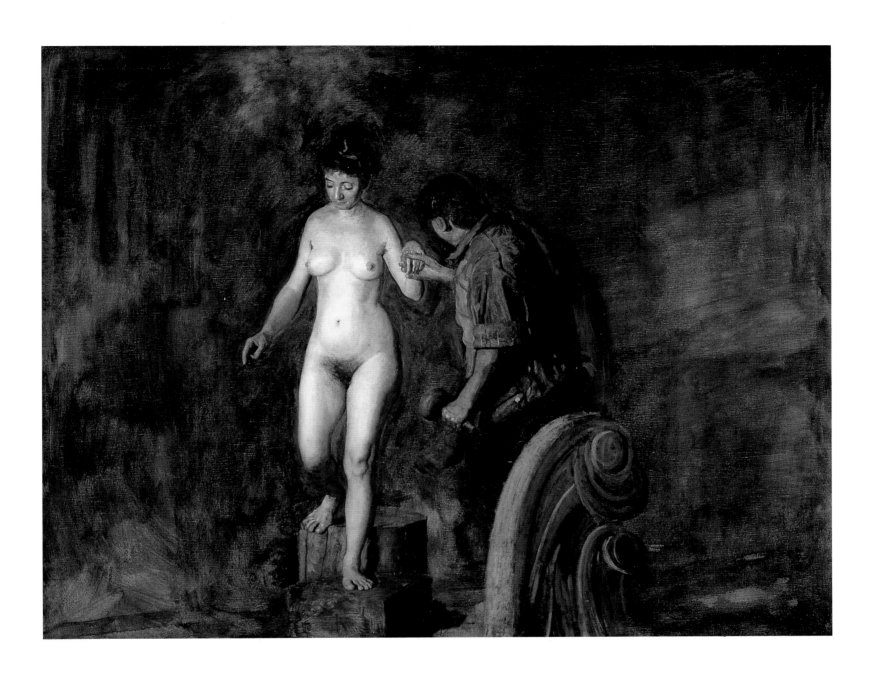

Plate 239. Thomas Eakins, *William Rush and His Model*, c. 1908.
Oil on canvas, 35¼ x 47¼ inches.
Honolulu Academy of Arts. Gift of the Friends of the Academy, 1947.

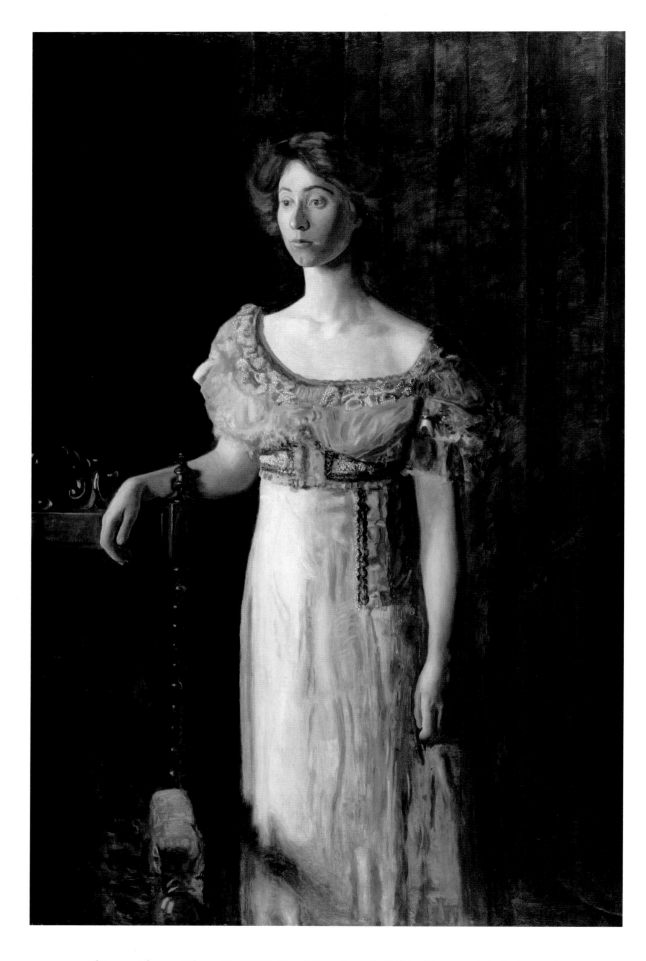

Plate 240. Thomas Eakins, *The Old-Fashioned Dress (Portrait of Helen Montanverde Parker)*, c. 1908.
Oil on canvas, 60⅛ x 40³⁄₁₆ inches.
Philadelphia Museum of Art. Gift of Mrs. Thomas Eakins and Miss Mary Adeline Williams, 1929.

Plate 241. Photographer unknown, *[Thomas Eakins in the Mount Vernon Street Studio]*, c. 1909.
Gelatin silver print, 4¾ x 7¹⁵⁄₁₆ inches.
Bryn Mawr College Library, Pennsylvania. Seymour Adelman Collection (Special Collections SA 22).

Plate 242. Circle of Thomas Eakins (attributed to Samuel Murray), *[Four Cats]*, 1910–14.
Platinum print, 2³⁄₁₆ x 5⅜ inches.
The Metropolitan Museum of Art, New York. Gift of Joan and Martin E. Messinger, 1985 (1985.1027.17).

Plate 243. Circle of Thomas Eakins (attributed to Samuel Murray), *[Thomas Eakins and Susan Macdowell Eakins with a Dog]*, 1910–14.
Gelatin silver print, 5½ x 3½ inches.
Collection of Daniel W. Dietrich II.

The Pursuit of "True Tones"

MARK TUCKER AND NICA GUTMAN

RESPONDING TO a request for biographical information in 1893, Thomas Eakins condensed his ancestry, artistic training, and career as a teacher, painter, and sculptor into a modest six sentences. He then concluded—as if by way of an explanation for his reserve—with the designation of his art as the sole source for everything he wished known and remembered about himself, saying, "For the public, I believe my life is all in my work."[1] As the material representation of his identity and legacy, Eakins's art bears a significant shortcoming: it *is* material and therefore subject to inevitable change. Visual changes in Eakins's paintings have resulted from the aging of their materials and also from interventions after Eakins's lifetime, such as cleanings that inadvertently altered the surfaces of some works. These changes affect the accuracy and completeness with which the paintings represent Eakins's artistic inclinations, ideas, and abilities. In trying to know Eakins better as an artist of his own time, our challenge is to gauge those changes and seek their possible implications, and our best path in that endeavor is a closer consideration both of the condition of the works themselves and of the personal and period sensibilities from which they arose. How we see Eakins reflected in his art depends critically on our knowing how his paintings would have looked as *he* knew them. Our particular concern here is the original final effect Eakins strove to achieve and the role of color in that effect. Painting techniques and evidence of specific patterns of physical and visual alterations in a broad sampling of his works show us that precise control of color in Eakins's paintings was closer to the core of his artistic concerns than the present appearance of many paintings conveys.

Eakins's approach to color was never set forth in any public expression of his views as a mature artist, in contrast to the principles and practices voiced explicitly in his teaching of perspective, anatomy, direct modeling with the brush, or other facets of painting. Though some incidental and general comments are recorded in connection with Eakins's teaching, light, color, and perception—galvanizing issues of late nineteenth-century painting—do not appear to have been emphasized as they were in the instruction offered by so many other artists.[2] Eakins's only known significant writing on color is from his student years and early career, and while his language is at times speculative or fragmentary, in these early writings Eakins's preferences and resolve with regard to color are unmistakable. As we look at his writing and its correlation with technical and visual characteristics of his paintings, it is evident that through four decades of artistic activity, the final effect of Eakins's paintings remained nearly always within the bounds of a vision that surfaced and crystallized early in his career. From the moment he realized that the challenge of color had to be met, he remained seriously engaged, at some points preoccupied, with analyzing its behavior and controlling its effects.

Much about Eakins's process for creating paintings bespeaks his capacity to be decisive in conceptualization and visualization. Surviving drawings and studies for his paintings and the accounts of those who knew him suggest that Eakins was able to work directly from an initial pictorial idea to a final composition.[3] The preparatory work leading up to the full realization of a picture, although frequently complex, involving various combinations of drawings, sculpted models, photographs, and painted sketches or studies, was nevertheless an efficient sorting and investigation of ideas, each step addressed directly and decisively.[4] By contrast, in our examinations of paintings spanning Eakins's career, we have been struck by the fact that his realization of those ideas in paint often followed an indirect course of successive approximations toward a harmonious arrangement and ordering of color. As a student abroad and early in his career in Philadelphia, Eakins expressed frustration over the basic challenges of color, for example, writing of one of his first paintings: "If all the work I have put on my picture could have been straight work I could have had a hundred pictures at least, but I had to change & bother, paint in & out. Picture making is new to me, there is the sun & gay colors & a hundred things you never see in a studio light & ever so many botherations that no one out of the trade could ever guess at."[5]

Such uncertainty persisted and is consistent with our observation that his paintings, especially throughout the 1870s and into the 1880s, often seem like multilayered workbooks in the study and control of color relationships and overall brightness,

Fig. 168. Detail of the left side of the sky in *The Pair-Oared Shell*, 1872 (pl. 4). The dull green, less textured areas indicated are the initial painting of the sky, revealed where some of Eakins's subsequent repainting of the sky flaked away at an early date.

Fig. 169. Detail near the upper edge of the sky in *Mending the Net*, 1881 (pl. 85). The bright blue earlier version of the sky can be seen beneath Eakins's later gray repainting of the sky.

or key. In many paintings broad areas of color such as skies have passed through earlier stages, sometimes tonally or texturally unrelated to the final surface (figs. 168, 169). Later paintings exhibit an assured dedication to a limited palette and, for the most part, simpler layering, but whether Eakins's final surface was the result of many superimposed paint layers or few, rarely in his finished paintings was it achieved solely by direct mixing, application, and wet blending of color. His preference for indirect painting—the development of modeling by the layering of glazes and scumbles over a strong and solid underpainting—is well known. For Eakins, however, indirect painting was not only a way of achieving modeling, it was also a means for adjusting relativities of color from one element to the next or across entire paintings.[6] It is not uncommon to find very light-toned underpainting, sometimes of unexpectedly brilliant color, the brightness of which was then attenuated

with glazes or scumbles or sometimes neutralized with layers of darker or more subdued opaque color (figs. 170, 171). Even final color choices are often found to be further muted with thin surface layers of black, brown, or gray neutral tone, which traverse edges of forms or color areas, reducing the brightness of broad passages or even of the painting overall (fig. 172).[7] The layers that Eakins applied to adjust the final surface tone of his paintings range from what appear to be no more than sparsely pigmented varnish to more conventionally pigmented transparent brown or black glazes to thin translucent scumbles (figs. 173–76).[8] The occurrence of final toning films can be traced from paintings as early as the 1869–70 *Scene in a Cathedral (Study)* (fig. 177), in which brighter colors are muted with a blackish glaze, through works in every decade of Eakins's career (fig. 178).[9] Progressive color adjustment throughout the painting process, in particular the lowering of

Fig. 170. The bookcase in *Kathrin* (1872, Yale University Art Gallery) was underpainted in a brilliant orange that now shows through the overlying opaque brown paint.

Fig. 171. Eakins reworked the *Sketch of Max Schmitt in a Single Scull* (1871–74, Philadelphia Museum of Art) to tone down various parts. This detail shows that the initial orange color of the scull was modified with a heavy brown glaze.

Fig. 172. The area to the left of the broken line in this section of water from *The Pair-Oared Shell*, 1872 (pl. 4), shows a more intact portion of the original umber-toned glaze that originally covered the entire surface of the river. To the right, patches of the pale gray underpainting were uncovered when the glaze was broken through in the first cleaning of the painting. This damage is visible in a 1917 photograph.

color intensity and key, is a consistent and characteristic feature of Eakins's technique.

That Eakins's paintings were noticeably and intentionally subdued in contrast and color and low in key is borne out by accounts of those who knew their early appearance firsthand. For example, in 1886 Hillborn T. Cresson, the president of the Art Students' League of Philadelphia, justified Eakins's approach by pointing out that *"color* should be rendered with as much truth as the palette will permit... *and for this reason, like Gerome's color,* [Eakins's] is *keyed low* in his pictures."[10] Eakins's student Charles Bregler said of his paintings, "While some are in a very low key this is what he desired to do and did so from choice."[11] Elizabeth L. Burton, an artist whose family lived next door to the Eakinses and who had posed for her portrait in 1906, later wrote, "When it was in process of painting I go[t] the impression it was too dark for my complexion, but

Fig. 173. A thick area of sparsely pigmented original varnish on the surface of *Shad Fishing at Gloucester on the Delaware River*, 1881 (pl. 72). Such varnish, which contains studio detritus such as the occasional wood or textile fiber and flecks of gold leaf or brush hair, is found on a number of paintings.

Fig. 174. A photomicrograph of a glaze containing black pigment particles that was applied to tone down the brilliant vermilion of the carriage in *Study for the "Fairman Rogers Four-in Hand,"* 1879 (Philadelphia Museum of Art).

Fig. 175. In *Rail Shooting on the Delaware [Will Shuster and Blackman Going Shooting for Rail]*, 1876 (Yale University Art Gallery), the color of the marsh vegetation was modified with a broadly worked brown glaze, visible in this detail where it passes over a small yellow flower.

Fig. 176. A broadly applied blackish brown glaze covers the bright green underpainting in this detail from the grassy hillside of *Mending the Net*, 1881 (pl. 85).

Fig. 177. Photomicrograph of an overall blackish glaze accumulated in the hollows of brushwork in passages of flesh and red drapery in *Scene in a Cathedral (Study)*, 1869–70 (Hirshhorn Museum and Sculpture Garden, Smithsonian Institution, Washington, D.C.).

Fig. 178. Detail of blackish glaze resting in the hollows of the brilliant yellow and red of the banner in *Between Rounds*, 1898–99 (pl. 215), painted about thirty years after *Scene in a Cathedral*.

now I see how wonderfully like me it is as I then was."[12] In 1934 Susan Eakins, who perhaps best understood the effect Eakins strove to achieve, was deeply upset by the excessive contrast in a photograph that she claimed misrepresented *Elizabeth at the Piano* (pl. 13), saying that it "in no way presents a true discription [*sic*] of the delicacy and quiet true tones of the picture."[13] Further, she insisted that the painting, which had been in her care from the 1880s until 1928, "has not darkened" and that in a correct photographic rendering of the painting, "no matter how soft or dark in tone it may appear, the tones are true."[14]

The restrained palette and low key indicated by such descriptions reflect Eakins's personal inclinations, period academic values, the example of painters he admired, and familiarity with current scientific studies in physiological optics.[15] Whatever the combination of sources and influences, his leanings were perfectly aligned with established and evolving critical tastes for high verisimilitude and "correctness" of representation of form and effects of light and for the effects of low-toned painting in general. From both points of view, subdued color and low key in Eakins's paintings were completely amenable to sympathetic assessment in terms of standards widely held and commonly understood among critics of the day.[16] Eakins's tendency was also consistent with an inclination among cognoscenti to equate coloristic restraint with a cultivated, artistic taste and high coloring with popular taste. The 1886 Cresson letter cited above, linking the low key of Eakins's color to the pursuit of truthful representation, states that "color of this kind will be better understood by artists because study of nature has taught them *her proper tones and values*. The public generally prefer light, bright colored pictures where *truth* is sacrificed in a great measure to effect."[17]

Eakins's letters and notes from the very earliest part of his career, up to about 1874, discuss aspects of light and color. In

the Spanish notebook, kept by Eakins as he traveled in Spain in 1869–70 and in the first years after his return to Philadelphia, he concerned himself with a number of points that remain pertinent to the technique and appearance of his painting through the decades. The notebook reveals Eakins's thinking through crucial years of transition from student to autonomous painter and makes practical, though often tentative, observations on points of craft and technique and on the management and qualities of color.

The entries made in Spain record a moment of revelation. He wrote to his father that he had finally seen painting that completely fulfills the true potential of the art—"big painting."[18] Eakins responded rapturously to the paintings of seventeenth-century Spanish masters, particularly Velázquez and Ribera, whose work "stands out like nature itself."[19] For Eakins, the excellence of their works was based very much in technique. In their works and in those of other old masters and contemporary painters, Eakins sought, and found, affirmation of his belief in the superior potential of indirect painting, both for modeling of light and shade and for refinement of color relationships.[20] Layered painting, he wrote, "is certainly the manner of Bonnat and Fortuny, [where] my own instincts have always carried me."[21] Indeed, the stage-by-stage process of indirect painting had an instinctual appeal for Eakins, who attributed his progress to "discoveries that have permitted me to divide my energies and work methods" and resolved to "ever divide things up so as ... to get as strong a start as possible."[22]

Eakins singled out the paintings of Delacroix as the antithesis of his own procedural inclinations: "Delacroix's color instinct pushed him involuntarily to seek the tones throughout his painting at the same time ... and his paintings are abominable.... He didn't have any process and it was the shadows and purely mechanical difficulties that always de-

feated him and defeated him perfectly."[23] To Eakins's way of thinking, Delacroix failed by working intuitively and apparently spontaneously, not adhering to any recognizable "process" of sequential stages to which rational goals are assigned.[24] Eakins, by contrast, envisioned his own painting process as a sequential approach to the mutual reinforcement of two expressive modes. Indirect, layered painting, he asserted, is "the only [way], in my opinion, that can give delicacy and strength at the same time."[25] He resolved to establish *strength* in his work by first painting solidly, quickly, and always putting in "as much light as possible at the beginning," thus establishing high key and emphatic contrasts at the outset. The objective of all subsequent layers and adjustments would then be to temper and counterpoise that strength with *delicacy*—ever finer gradations of modeling and contrasts, leading to an ultimate goal of refined total effect.[26]

Consistent with the conventions of mainstream academic aesthetics to which Eakins was exposed in his formative years as a painter, control and refinement of effect depended critically upon the disposition, ordering, and gradation of light and dark within a painting. It was commonplace to consider color as two separate but interrelated components—values (the lightness or darkness of a color) and hues (a color's attribute of blueness, redness, greenness, and so forth).[27] By academic standards and pedagogy, values were consistently characterized as more fundamental to representation than hues, as well as more constant and amenable to rational control. For many authorities and to many tastes, values held the equal or greater aesthetic appeal:

> It is in fact the correct observation of values that constitutes the true skill of the artist, and, given that each person sees the visual world differently, it is on this that personality and originality are based. It is of small importance, in comparison, whether the artist is a born colourist or has little colour sense: provided he sees values correctly he is a painter, and may be a great painter.[28]

One critic, speaking of the broad influence of Corot, the oft-cited master of the study of values, went so far as to claim that in painting, "the profound and accurate study of values—the knowledge how to keep tone perfect and yet keep color complete and true—is the greatest technical achievement of modern times."[29] The centrality of the handling of values to both superior representation and individual expression in painting was commonly acknowledged and becoming ever more strongly established in academic instruction and critical discourse when Eakins was a student in Paris in the late 1860s. The primacy of value over hue in the French school of that time was remarked upon by one Paris-trained American painter: "Positive colors were tabooed....The only thing about which

the authorities seemed to agree, was the suppression of all bright color."[30]

Describing in 1879 his own approach to the teaching of painting from the model, Eakins alluded conventionally to the priority of value over hue: "Every detail of color [will be] auxiliary to the main system of light and shade."[31] Judging from the technique and final appearance of his paintings and from the large proportion of his known analytical writing on color devoted to the subject, an artist's critical discrimination and disposition of values was clearly for Eakins a point on which a picture's power, illusionistic credibility, and delicacy of effect all turned.[32]

Artists who wished to represent nature objectively knew that the absolute tonal range of most subjects was beyond that of oil paints.[33] They therefore sought ways to most effectively suggest in their paintings the range that might be observed in the subject itself. Writing about a painting of a toreador and a priest by Pierre-François-Eugène Giraud *(Death of a Toreador,* Musée d'Orsay, Paris), Eakins noted admiringly that the care taken not to depict a brightly colored object in full sunlight allowed the artist "to extend his scale a great deal."[34] Of course, endpoints of the scale available to the painter are fixed by the absolute values of black and white pigment under a given illumination, so any apparent "extension" is more a question of compressing a wide scale of values within a median value range or shifting the median toward one of those endpoints. As we look at Eakins's paintings we see that he most commonly adjusted paintings to arrive at a median value that was quite dark. Under his particular system, light passages were lowered in value to the range more customarily occupied by half-lights or the even lower midtones, a shift that gave "headroom" for the sparingly disposed highest end of the

Fig. 179. Glittering, concentrated highlights on the water of the low-toned painting *The Pair-Oared Shell*, 1872 (pl. 4).

Fig. 180. The overall extremely low key of *Ships and Sailboats on the Delaware*, 1874 (Philadelphia Museum of Art), the middle painting, is evident in this 1944 installation photograph. The painting depicts, in Eakins's own words, "a still August morning 11 o'clock."

value scale, so that his most concentrated highlights (or any other point of color emphasis) could be set proportionally very high above the picture's overall key (fig. 179).[35] This was Eakins's preferred way of managing the tonal scale of paint to achieve a specific analogous relation to nature's scale. The visual effect might be compared to that of the subject viewed through a gray glass or in a dark-tinted mirror.[36] The same number of value gradations is represented, and in their proper ratios of brightness as seen in the subject itself, but compressed into a narrower range, shifted toward the dark end of the scale, with the exception of the highest highlights.[37] In many cases the resulting overall key in Eakins's paintings was certainly toward the darker end of academic realism's range, perhaps not unusually so for his interior subjects, but for outdoor scenes that were supposed to depict effects of sunlight, the overall key can be radically low (fig. 180).[38]

In the Spanish notebooks, Eakins did not fully arrive at a comprehensive or even unified simple system for the handling of color, but it is clear that a primary goal of striving for such a system was the artist's control over the refinement and relativities of color values. Eakins's absorption in the importance and difficulty of meeting this goal is evident in his worry over a problem beyond his control—the effect of various intensities and colors of light that would eventually illuminate a painting when it was hung. No matter how sensitive an artist might be in the discrimination of values or hues, or how knowledgeable and skilled in the application of a technical or theoretical system revealing that sensitivity, the final ordering of colors in a painting could appear sound and true only under very limited circumstances of lighting. Eakins speculated in passing about possible compensations to minimize the effect of different *colors* of illumination[39] and considered also that varying *intensities* of light on paintings bring forth different, sometimes undesirable, qualities of color. Noting in general the destructive result of

too much light on a picture's overall coloring, he cited as an example: "Observe the picture of Max, which is spoiled by a strong light,"[40] probably referring to *The Champion Single Sculls (Max Schmitt in a Single Scull)* (pl. 1). Aversion to overstrong illumination and its negation of illusion and effect in paintings was universal.[41] On *A May Morning in the Park (The Fairman Rogers Four-in-Hand)* (pl. 51), there is evidence of Eakins's response to higher than expected light where it was being exhibited; the painting's overall key was adjusted by a final, extremely thin black coating that does not extend onto the narrow margin covered by the frame along all four edges, obviously having been added after the painting was in its frame and on the wall (fig. 181).[42]

The problems posed by variations in illumination on paintings were much on Eakins's mind at least as late as 1874, when he drafted a letter asking the advice of his former teacher Jean-Léon Gérôme.[43] It is remarkable that Eakins, who by that time had produced a number of ambitious and apparently assured works, and who within a year would be at work on the monumental paragon of American nineteenth-century painting, *The Gross Clinic* (pl. 16), offered a dismayed analysis—no longer that of a student, but of a practicing artist—of basic difficulties he continued to struggle with in his painting.

In the draft he first set out the problem he encountered when changing intensity of illumination on a painting causes undesirable alterations in its value relationships:[44]

If I have 3 principal tones. A, B, C.
The first is a place where the sun shines directly. A.
The second is a place where the sun does not shine, but it receives light from the sky and illuminated things. B.
The third is a hole where one sees no light. C.

Fig. 181. Detail of right edge of *A May Morning in the Park (The Fairman Rogers Four-in-Hand)*, 1879–80 (pl. 51).

If I set these three tones correctly [painting] in a strong light and then carry my study into a weak light B darkens and grows closer to C and makes a blackish and disagree-able effect.

On the contrary, if I set my three tones [painting] in a weak light from my memory of the effect I saw in sunlight, and if I carry that study into stronger daylight, B draws too close to A and my effect appears weak.

Between these limits, where does one settle?[45]

Here Eakins isolated shifts in the middle range of values as problematic, asking how a painter might minimize untoward effects brought out by different levels of illumination on a painting. Having asked the question, he then answered it himself, apparently in afterthought, concluding there is probably nothing that properly could or should be done as a compromise, that the only solution is consistency between the light of the studio and that of the place of exhibition: "One ought to know the place where a picture will be shown before it is begun."[46] After considering shifts in value relationships, he discussed parallel difficulties with a painting's hues ("color" by his term) when altered by both color and intensity of illumination: "In color, same thing. If I had a blue sky and yellow clouds, the clouds a little more luminous than the sky, and if I had painted it in a warm light, when I carry my study where it will be illuminated by reflected light from a blue sky, immediately these same clouds become darker than the sky instead of being more luminous."[47]

Although at first this seems concerned with a shift in hues, Eakins was describing the darkening of a color viewed under light of a complementary color; again, the complaint is a shift in relative values. He continued: "Even the impact of an entirely white light mixes up my colors. A day growing very dim illuminates blue enormously long after having ceased to illuminate yellow and red."[48]

Eakins was noting the phenomenon of the red-blue shift, also known as the Purkinje effect.[49] Eakins painted his reds and blues (and all other colors, for that matter) to look correct to his eye under diffuse daylight that was dimmer and cooler in tone than the artificial light under which his paintings are now most usually viewed. Present-day artificial light is one of several factors that contributes significantly to an appearance of stridency in some of Eakins's reds and the low saturation of some of his blues, as, for example, in many of his skies.

Describing in the next passage the effect of the earlier considered value shifts resulting from changes in light intensity combined with color changes under lights of complementary color, Eakins observed: "I painted my two pictures in a very strong light and a warm enough one, in a reflected light that shone on the houses. A feeble light then darkened my colors, but a blue light destroyed them."

Again, he put forth his own reasonable solution: "I might have been more sensible to have taken a middle road, to have chosen to work on a day neither strong nor weak, with a light completely white."

Finally, out of hope that the means to an acceptable constancy of color might still lie in some codifiable practice as yet unknown to him, Eakins asked: "What is the practice of the best painters? Is there a conventional solution?"[50]

The questions are left open, for if Eakins included the contents of these draft pages in the letter he sent, Gérôme's return letter did not include any advice in response. Having reasoned through the problems, Eakins essentially found his own way, painting for the viewing conditions he preferred and considered as "standard"—the diffuse white daylight of a nineteenth-century picture gallery or domestic interior.[51]

Eakins's fundamental belief that successful effect depended both on the accuracy of the artist's perception of tones and on adequate consideration of the role of viewing conditions is still apparent in an 1884 letter to his student Harry Barnitz. In it Eakins invoked a traditional academic precept for landscape painting: "As for sunlight studies...the whole of the tones must be transposed into another key as you would say in your music, transposed so that what you do for out of doors will look like out of doors only when in doors in the gallery or house light."[52] Eakins's own outdoor studies are generalized notations of the colors of a site or objects in sunlight. In preparing for painting his rowing subjects in the early 1870s, for example, Eakins made a small model of a shell and rowers and "put them out into the sunlight on the roof and painted them, and tried to get the true tones."[53]

The subdued, veiled-looking aspect of the majority of Eakins's paintings was the product and measure of a specific, cultivated sensitivity to color.[54] That sensitivity, based on Eakins's personal inclinations and aptitudes, also embraced certain academic standards, in particular the importance of the artist's discriminating perception and disposition of color values to a painting's unified effect. The arrangement and gradations of light and dark throughout a painting came to be understood in the last half of the nineteenth century as inextricably associated with individuality of an artist's perception and effect:

Artists' manuals tell us that modeling is the art of grading tints from the lightest to the darkest so as to express physical relief.... But that is not all it does, and its further consequences are of the greatest importance in painting.... It must, above all, express the intimate appearance of objects, their essential or accidental being...the links which join and harmonize them.... In landscape it conveys the roughness, smoothness, solidity and fluidity of elements, the shimmering of light and the mystery of atmosphere. It adapts itself

to the feelings of every artist, or rather it is the chief carrier of his feelings.[55]

The individuality of Eakins's vision of color and the handling of values, and the layered, indirect painting technique that served his vision would have unforeseeable consequences for some of his paintings. With the fading of the critical currency of academic realism toward the end of the nineteenth century, by the time Eakins's paintings first began to be cleaned, in the period just following his death in 1916, certain rarefied tastes and theoretical criteria he had addressed in paintings created twenty, thirty, forty, or more years earlier were all but forgotten.[56] Certainly, the appreciation that sophisticated earlier viewers would have brought to the subtler and more intimate attainments of his work appears to have given way to a more general sense of its stylistic character. That character seems increasingly to have been viewed and valued above all as the frank, lucid, and penetrating exposition of subject, achieved through maximum clarity and power of form. The objective directness of "uncompromising" realism must have suggested to some an equal directness of execution. Certain qualities that did not contribute to these later ideas superimposed upon his work, though of prime concern to Eakins himself, often passed unrecognized. Foremost among these were the low key and "dark," "soft," "true" tones pointed out by Susan Eakins and others as fundamental to Eakins's intent.

As paintings were cleaned in subsequent years, despite the efforts of Susan Eakins and others to protect Eakins's work,

Fig. 182. Photomicrograph of a surviving final highlight resting on top of a fragment of a once-continuous surface layer on *Swimming*, 1884–85 (pl. 149).

the absence of specific knowledge of his desired effect and of the painting techniques by which it was achieved led to frequent misinterpretation. The primary aim of many earlier cleanings was not the preservation of finely wrought tonal relationships, but merely the exposing of a lighter paint surface and brighter touches and passages of color.[57] Susan Eakins's ongoing concern for the state of those pictures that were not in her direct care is clearly expressed in a letter of 1937: "I confess I fear always the so-called, expert restorer, if the effort is not understood irreparable damage may be done by the effort to lighten the colors, which destroy the tones."[58]

Fig. 183. Detail of *Sailboats Racing on the Delaware*, 1874 (pl. 10), showing blackish brown glaze remaining in horizontal furrows of the brushwork of the sail.

Fig. 184. Detail of *Portrait of William H. Macdowell*, c. 1890 (Yale University Art Gallery), showing remnants of black glaze in recesses of the paint surface of the white collar.

Fig. 185. Photomicrograph of the sky in *Shad Fishing at Gloucester on the Delaware River*, 1881 (pl. 72). The warmer-toned upper paint layer (with black particles) has been eroded by solvents, revealing underlying blue paint.

Susan Eakins had already seen that some of Eakins's intentionally subdued paintings had been mistakenly assumed to have been originally lighter and brighter and therefore had been cleaned excessively in the belief that their surfaces had become obscured by accumulated grime and darkened picture varnish. The consequent assumption that removal of what was wrongly thought to be only a dulling surface coating would make the pictures "truer" (or at least more superficially agreeable) according to a prevailing vision of how they *ought* to look was the reason many paintings were first cleaned as they were.

To the naked eye, Eakins's uppermost layers of neutral tone and glazes that modified color or key would have been indistinguishable from darkened picture varnish and accumulated grime.[59] An artist with Eakins's formal training and regard for craft would have known to plan for the inevitability of the periodic removal of grimy or discolored picture varnish, making sure the final layer of a painting could withstand the usual measures for the removal and replacement of aged soft resin picture varnish applied after the painting was adequately dry.[60] In early cleanings of Eakins's paintings, however, restorers' removal of only the more soluble uppermost picture varnish from the painting would not have brought about the increase in brightness or clarity of color that might have been expected.[61] If a further, more aggressive effort was made to reveal what was believed to be Eakins's still-obscured intended color by removing his intentionally dark surface layers, underlying glazes and upper paint layers were also likely to be disturbed, exposing in places the lighter or brighter colors he had used in the earlier foundational stages of painting.[62] In some paintings Eakins had placed delicate touches of highlight on top of glazes or general toning layers (fig. 182); such highlights were, of course, vulnerable to loss in attempts to remove

the darker layers on which they rested. Often cleaning continued in the hope of uncovering consistently purer color and achieving stronger contrasts by removal of areas of more subdued surface tones only where it most showed, in the lights and more intense colors. Through the decades, attempts to reveal what were believed to be the "true" colors of Eakins were taken up time and again, and with each campaign, the visual and material connection with the original surface and effect of paintings became more tenuous.

Even when cleanings went well beyond the removal of picture varnish and broadly disrupted Eakins's surface tone and upper paint layers, evidence of the original layering and final surface usually remains.[63] Within and around lighter passages of modeling and any areas of stronger color where cleaning efforts were concentrated, patches and residues of once-continuous surface layers can still usually be found in more protected recesses of the paint surface (figs. 183, 184). Where remnants of Eakins's darker surface layers are only bare traces, or are very widely scattered, evidence of their original presence can be seen in the effect their removal had on the underlying paint, which, under magnification, can show wear, erosion, or undercutting of layers (fig. 185).[64]

Archival photographs documenting the appearance of paintings before various cleanings are especially helpful in interpreting the physical evidence of changes that have occurred through the decades. The best cases, though rare, are photographs known to have been taken before paintings were ever cleaned. Defects in the tonal rendering of the early photographs call for caution in interpretation, but their comparison to the present state of paintings can give a comprehensive and direct idea of the effects of cleaning (figs. 186, 187). In addition to distortion of color relationships and overall key, some cleanings have had an unsettling influence on effects of paint texture and handling. Residues of once-continuous dark layers remaining only in the recesses of more textured paint surfaces give a falsely heightened sense of agitation or assertiveness that can overpower originally convincing modeling (fig. 188).[65] Such exaggeration of textural effect has a further consequence in pictures that have both highly finished, smooth-surfaced passages and painterly, assertively textured brush and palette-knife work. In such paintings the visual prominence of the more textured passages after cleaning gives them a counter-illusionistic materiality that is too strongly at odds with the refinement of representation in other passages.

It is important to acknowledge that a degree of change occurs through aging alone. Claims as to the stability and permanence of Eakins's painting materials were made by Charles Bregler and others who knew the artist directly.[66] Recent detailed technical studies of Eakins's materials have confirmed

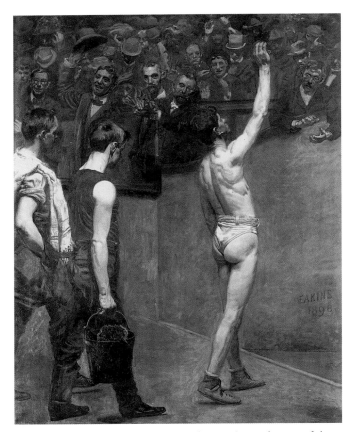

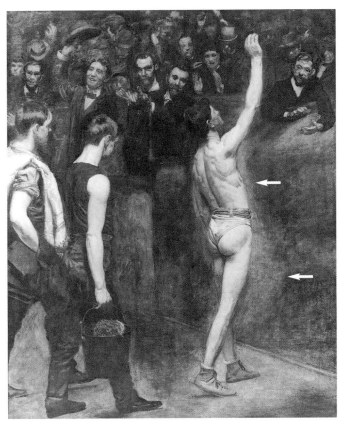

Fig. 186. Photograph of *Salutat*, 1898 (pl. 214) taken at the time of the 1899 Pennsylvania Academy of the Fine Arts 68th Annual Exhibition. Archives, Pennsylvania Academy of the Fine Arts, Philadelphia.

Fig. 187. Changes caused by disruption of upper paint layers in early cleanings are visible in comparison with figure 186. The arrows show the halo around the figure of the fighter caused by a cleaning that removed dark surface tone from the adjacent background. Addison Gallery of American Art.

his use of traditional, stable pigments and mediums, and, owing to sound craftsmanship, defects due to technique are rare in his work.[67] The fading of some pigments has been noted, and some colors have deepened in tone while others have changed little, an inevitable consequence of the aging of traditional oil paints.[68] Also, the mediums of any transparent or translucent layers of the paint structure have become darker and warmer in tone. Such visual changes in original materials are irreversible and are now accepted as inherent to the work. The effect of the aging of Eakins's materials on the appearance of his paintings, considered singly or collectively, is difficult to quantify, but in relative terms, compared with the consequences of well-meaning but inadequately informed cleanings, aging is by far the lesser factor in changes to color relationships and key throughout his work.

Our observations, supported by those of other conservators who have studied and worked with Eakins paintings through the years, indicate general trends in alterations traceable to efforts made in early cleanings. Early attempts to brighten and "clarify" Eakins's paintings, notably where original effects depended on successive downward color adjustments and overall subdued final tone, were common. The removal of moderating upper paint layers from lights and

brighter colors gives them a false emphasis that clearly conflicts with what we know of Eakins's original tonal scales. Light areas rendered inappropriately more so by removal of overlying tone may also exhibit false or more abrupt modeling transitions (figs. 189, 190), heightened contrasts, and area-to-area incongruities of key. Hues can show an unintended in-

Fig. 188. The vertical dark features in this passage of water in *The Pair-Oared Shell*, 1872 (pl. 4), are residues of a glaze layer remaining in hollows related to the texture of the canvas weave. The strong vertical pattern conflicts with the horizontal arrangement of paint strokes that creates the illusion of the receding plane of the river.

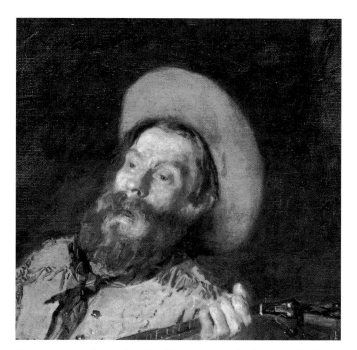

Fig. 189. Detail of an undated archival photograph of *Cowboy Singing*, about 1892 (Philadelphia Museum of Art). Conservation files, Philadelphia Museum of Art.

Fig. 190. Detail of the same area of the painting in figure 189, photographed April 2000, Conservation files, Philadelphia Museum of Art. The false light areas of modeling above the brow were created by a restorer's selective removal of the paint's dark surface tone.

tensity or even an implausible stridency (fig. 191). This is not to say that all of Eakins's purer colors were retiring. It is hard to imagine, for example, that the brilliant fuchsia of the dress of *An Actress (Portrait of Suzanne Santje)* (pl. 231), though it appeared more coherently modeled and evenly lower in tone before a past cleaning, ever rested completely easily with her

Fig. 191. Detail of foreground of *Mending the Net*, 1881 (pl. 85). The bright green underpainting at the left was exposed when overlying dark glazes and scumbles were removed.

dark complexion and deep umber surroundings. Cases of more aggressive attempts to lighten paintings may exhibit not just alteration of color by area or overall key but quite visible disruptions of modeling and spatial representation and loss of delicate detail that can produce a false appearance of lack or inconsistency of finish (figs. 192–94).

Such obvious damage is the exception. In most cases, only close technical examination allows us to gauge how much or even whether a given painting is altered in ways that cause it to be dominated now by certain qualities of color or surface that were originally better harmonized or counterpoised to suit Eakins's own judgment. Even when technical examination reveals that paintings have undergone significant changes in specific areas or in overall aspect, they may nonetheless retain a completely satisfying representational plausibility and expressive power, owing to sound composition and solid, descriptive modeling. As rightly impressed as we may be by the fundamental visual and intellectual strength and affective richness of Eakins's work, it is important to bear in mind that some paintings now present more of the substantial and apparently self-sufficient *basis* of the effect Eakins sought, not the finished effect itself. It can be said that he was more discriminating in his pursuit of tonal subtlety and unity and more concerned

Fig. 192. Detail of 1917 photograph of *Sailboats Racing on the Delaware*, 1874 (pl. 10). The Metropolitan Museum of Art, New York.

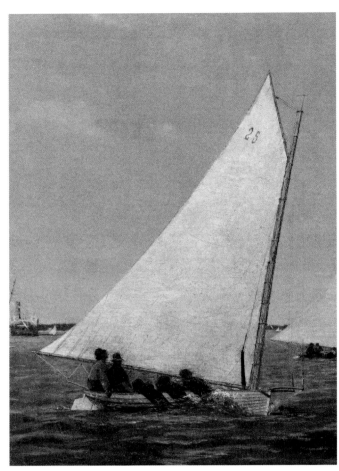

Fig. 193. Detail of the same area of the painting photographed October 2000. As early as 1944, photographs show that details of rigging visible in the 1917 photograph had been inadvertently removed in an attempt to lighten the tone of the sail.

with refinement of handling and finish than the present state of many of his paintings might lead us to believe.

Our study grew out of initial direct observations of altered surfaces on a number of Eakins's paintings, leading us to consider the extent of such alterations throughout his work and, ultimately, the ways they might interfere with perceptions of Eakins's abilities or motives in disposing color and tone. At the outset we were aware that difficulties with the condition of Eakins's paintings had been noted often, and our sense that such observations were widespread and had a long history was reinforced at every turn as we read condition reports from various eras and discussed with a number of conservators their experiences with Eakins's paintings. The reports and verbal accounts have presented a uniform view of the complexity of Eakins's surfaces, of patterns of alterations of the kind we have described, and of the confusing present state of many pictures relative to their original appearance. Despite the consistency of the observations of individuals through the years, the general influence of the *condition* of Eakins's works on past and present understanding of his artistic aims had not been broadly considered in a historical context. Continued close study of the paint-

ings themselves—not only as products of a combination of specific artistic and material concerns but also as products of a history of interpretations and interventions—still affords some of the best possibilities for enrichment of our understanding of distinctive qualities of his artistic identity and achievement.[69]

Fig. 194. Detail of distant riverbank in *Shad Fishing at Gloucester on the Delaware River*, 1881 (pl. 72). The far riverbank's appearance of rapid, thin paint handling that utilizes the canvas weave to suggest distant detail is actually the result of abrasion that has exposed points of the white priming in an area originally as solidly finished as the rest of the painting.

Despite Eakins's idealistic assertion that his paintings would speak fully for him, some of the qualities and ideas he considered enduring and self-evident have proved to be less so than he could have imagined. The paintings leave no doubt of the strength of his artistic voice. The challenge and responsibility are now ours to better understand that voice's nuances and inflections, as well as its ability to whisper a thing nonetheless significant—that quality of delicacy Eakins held was the necessary counterpart to strength in his vision of "big painting," consummate and timeless art.

The celebrated portrait painter Cecilia Beaux had studied and worked in Philadelphia throughout the period of Eakins's power and influence as a teacher. She was registered as a student at the Pennsylvania Academy of the Fine Arts in the late 1870s, and though it seems she never studied with Eakins directly, she recalled having learned much from "his vividly impressed students."[70] Beaux knew Eakins's work as a contemporary artist well, and her insightful words of tribute evoke images of an artist whose vision was unwavering in its deference to the essential:

> Force was never squandered or lacking, and emanated from his canvases with an almost physical stimulation, which, coming from nearly colorless and dusky painting, seemed strange to those whose idea (just at that moment) was that color-vitality must be served up straight from the tube (that is, from the factory). As color is the child of light, Eakins's deep scrutiny took light first and with it, of course, shadow. He never undertook to reveal form without these elements, even out-of-doors. The essential and broad meanings which he sought were clothed with light, not brilliantly, but half hidden in the moted atmosphere of the quiet workroom... the dusky daylight of the studio was glamour enough for him.[71]

Eakins in the Twentieth Century

CAROL TROYEN

I can conceive of few happier careers than that of Eakins. He was no fashionable painter avid of admiration. He went his steady way toward his goal and he attained it if ever man did. He had the happiness of achieving what he sought to do with brush and clay; he drew around him the companions he liked, whose ideals were his own; he lived a domestic life of tranquil comfort and intellectual interchange; he was respected and admired as an artist, though more beyond than in his own city; and he saw his faithful pupils rise and go forth to fame, to positions at home and abroad of enviable rank. He did what he liked, and what he liked was best worth doing in all our list of endeavor, for he was a great artist and he enriched our national possessions with masterpieces.[1]

HARRISON MORRIS'S EULOGY for Thomas Eakins is astonishing to contemporary ears. As managing director of the Pennsylvania Academy of the Fine Arts from the 1890s, Morris had labored to attract Eakins back to that institution after scandals over the use of nude models in the classroom had scuttled the artist's teaching career. In 1894 Eakins sent him his own summary of his life's work: "My honors are misunderstanding, persecution and neglect, enhanced because unsought."[2] That statement, uttered after a decade of few professional achievements, and even fewer accolades, has become the foundation of our understanding of Eakins's life and career.

The impression of Eakins as a pariah, but also as an artist with unshakable commitment to descriptive honesty, to principle, and to the pursuit of his own vision, while born of words uttered in the Gilded Age, by the time of the Depression had become firmly fixed. Although in the last decades of his career Eakins was reasonably well known, the notion of his neglect by the art establishment and his heroic indifference to that neglect became the defining feature of his posthumous reputation. Eakins had come to be seen, almost inalterably, as a realist, a loner, and a rugged American hero. The culminating events of Eakins's twentieth-century career—the Pennsylvania (now Philadelphia) Museum of Art's acceptance in 1929–30 of more than seventy works from Susan Eakins's collection and the publication of Lloyd Goodrich's monograph three years later—enshrined a mythic Thomas Eakins whose homespun

virtues at last came into alignment with the cultural values of the time.

By the early 1890s, Eakins was already recovering from the career and personal setbacks of the mid-1880s and would soon regain his place as a prominent figure in the art world. He was invited to lecture at prestigious art schools in New York, Philadelphia, and Washington, D.C.[3] Beginning in 1891, he resumed his regular submissions to the annual exhibitions at the Pennsylvania Academy and displayed his work at a number of local venues, including the Art Club of Philadelphia and, in 1896, at Earles Galleries.[4] In February 1901 his work was featured, along with that of his favorite student, the sculptor Samuel Murray, in a large exhibition at the Faculty Club at the University of Pennsylvania. That show provided viewers with a survey of Eakins's work from the rowing pictures of

Fig. 195. Thomas Eakins, *Portrait of William Merritt Chase*, c. 1899. Oil on canvas, 23⅞ x 20". Hirshhorn Museum and Sculpture Garden, Smithsonian Institution, Washington, D.C. Gift of Joseph H. Hirshhorn, 1966.

the 1870s to such recent portraits as *William Merritt Chase* (fig. 195) and *The Dean's Roll Call* (Museum of Fine Arts, Boston). Press accounts were enthusiastic; Eakins was declared "one of the foremost figures in the art of Philadelphia" and "an artist of national repute, and a man of great originality and independence."[5]

Outside of Philadelphia, Eakins's work was also attracting considerable attention. Ten of his paintings were shown at the World's Columbian Exposition in Chicago in 1893—among Americans only William Merritt Chase, Winslow Homer, George Inness, and Robert Vonnoh showed so many—and he was awarded a bronze medal for *Mending the Net* (pl. 85). At other world's fairs, he was similarly honored, winning commendations at the Exposition Universelle in Paris in 1900, the Pan-American Exposition in Buffalo in 1901, and the Louisiana Purchase Exposition in Saint Louis in 1904. He also began to show regularly at the contemporary art exhibitions at the Carnegie Institute in Pittsburgh and the Corcoran Gallery of Art in Washington, D.C., and in 1902 he was elected to the National Academy of Design.[6]

Eakins's income also improved after the turn of the century. Many of the citations received at those exhibitions were accompanied by cash prizes, including one thousand dollars (equivalent to about fifteen thousand dollars today) presented at the 1907 annual exhibition of the Carnegie Institute for *Portrait of Leslie W. Miller* (pl. 225). In the last two decades of Eakins's life, a number of his works entered museum collections, most as gifts but two as purchases.[7] Although his income from sales remained relatively meager, Eakins was receiving more commissions than before, from physicians as earlier, but also from the local business community, from which he had previously received little patronage.[8] Even more significant than this increase in support was Eakins's self-assurance. By this time, Eakins apparently felt free to paint what he liked and to present his work to those who admired it.

Eakins enjoyed a pleasant social life in his late years, and maintained satisfying relationships with local artists and others, such as William Merritt Chase, who were nationally known. He was a generous and supportive colleague, commending Joseph DeCamp in 1913 for his portrait of Frank Duveneck and writing Sergeant Kendall in 1905 that his painting was "the best thing in all the exhibition."[9] In turn, his fellow artists frequently expressed delight at his portraits of them and their pleasure at receiving them as gifts.[10]

Equally rewarding was his association with a group of local scholars, doctors, scientists, journalists, and, beginning about 1900, Catholic prelates from Saint Charles Borromeo Seminary in nearby Overbrook. He painted portraits of many of them, "because," according to Susan Eakins, "[they were] worthy to

be remembered;"[11] they formed, in the aggregate, a kind of "gallery of eminent Philadelphians."[12] The portraits—and the majority of Eakins's works after the turn of the century were portraits—tended to be of a standard size (24 by 20 inches) and format. They had plain backgrounds and were dark in tone. Many of these works have been called formulaic and routine,[13] but others—such as the portraits of painter Henry Ossawa Tanner (pl. 212) and of William H. Macdowell (pl. 237), Eakins's father-in-law—are sensitive, compassionate likenesses. Although Eakins's powers declined after his sixtieth birthday, some of his greatest paintings, including *The Thinker (Portrait of Louis N. Kenton)* (pl. 220) and *Portrait of Edith Mahon* (1904, Smith College Museum of Art, Northampton, Mass.), were painted in the twentieth century.

By the mid-1890s, Thomas Eakins had come to be regarded as an elder statesman in the art world. For the rest of his life he would be sought after to judge local and national exhibitions and was much admired for his fairness and discernment.[14] When the popular Philadelphia painters Thomas Hovenden and Peter Rothermel died within a day of each other in 1895, it was Eakins to whom the press turned for comment. Not surprisingly, his remarks were complimentary, if laconic: "The lives of both are told in their work."[15] In 1906 the principal of the Corcoran School of Art asked him for a statement to guide aspiring painters;[16] in 1914 Eakins was interviewed on the state of art in America.[17] That same year, the *Philadelphia Inquirer* dubbed him "the Dean of American Painters."[18]

Meanwhile, his reputation among national art writers was growing. His realism served to focus the debate between those whose ideals of high art were based on decorous subjects and elegant surfaces and those who believed in art exhibiting "strong, frank, and decided ways of expressing something American."[19] In his review of the 1901 Pan-American Exposition, critic Charles Caffin was disturbed by the absence of "any superficial qualities of beauty" in Eakins's pictures.[20] But by 1907, Caffin had come to see Eakins's directness as a virtue. As Impressionism and other late nineteenth-century styles began to appear over-aestheticized, Eakins's objectivity was perceived as leading to images of great power. His dedication to the "big picture" was considered a welcome alternative to the exhausted subject matter of the Impressionists, for whom every little creek or stand of trees was deemed worthy of attention. For Caffin, Eakins possessed "the qualities of manhood and mentality that are not too conspicuous in American painting."[21] Modernist critic Sadakichi Hartmann went even further: "Our American art is so effeminate at present that it would do no harm to have it inoculated with just some of that brutality [of *The Gross Clinic*]. Among our mentally barren, from photograph working, and yet so blasé, sweet-caramel

artists, it is as refreshing as a whiff of the sea, to meet with such a rugged, powerful personality. Eakins, like Whitman, sees beauty in everything. He does not always succeed in expressing it, but all his pictures impress one by their dignity and unbridled masculine power."[22] This correlation between Eakins's Americanness and his manliness would be heralded after his death as a key component of his character.

The most dramatic illustration of Eakins's increasing prominence after the turn of the century was the reception of his *Study for the Agnew Clinic* (fig. 196) at the 1914 Pennsylvania Academy annual. The painting was deemed the "sensation" of the show, crowds flocked to see it, and the Academy was urged "not [to] allow this canvas to leave the institution."[23] Soon after the exhibition opened, however, the collector Albert C. Barnes bought the painting for four thousand dollars. Barnes was encouraged by Robert Henri, whose note of congratulations asserted that Barnes's acquisition was "more significant than the purchase of a hundred old masters."[24] Barnes, in turn, crowed to Eakins that the study of Agnew had been called "the greatest portrait ever painted in America if not the greatest picture ever painted by an American."[25] The excitement surrounding the picture so elevated Eakins's stature that the press began advocating the creation of an Eakins gallery in Philadelphia: "A room devoted to the works of Thomas Eakins should have a place in any new museum which the city of his birth may erect."[26]

This would not happen in the painter's lifetime. By the time of his Academy triumph in early 1914, Eakins had been in poor health for several years. While he continued to receive tributes and to sell an occasional picture, he had been able to paint almost nothing, and required his wife's assistance with his last works.[27] Eakins died on June 25, 1916, at the age of seventy-one.

At his death, Eakins was lionized as a portraitist, a teacher, and, as a jurist and medal winner, a distinguished member of the art establishment. Obituaries described him as "one of the most notable figures in the American art world" and as a painter "who left a marked impression on the cultural history of the community."[28] By the early 1930s, however, Eakins's image had changed. He had become an outsider, a martyr, a "lonely pioneer," and, as described by Lewis Mumford in *The Brown Decades,* one of a very few "authentic talents" who could contribute to the future of American art.[29] At the outset of the Depression, this new Eakins set the style for an artist's life in America. The traits typically associated with him— manliness, Americanness, obstinate but noble independence, "uncompromising" realism, and above all, persistence in the face of "misunderstanding, persecution and neglect"—became central to the modern American artist's persona. This is not to say, of course, that Eakins was made into something he was

Fig. 196. Thomas Eakins, *Study for the Agnew Clinic,* 1889. Oil on canvas, 49 x 31½". Yale University Art Gallery, New Haven. Bequest of Stephen Carlton Clark, B.A. 1903.

not.[30] Rather, beginning shortly after Eakins's death, and through the 1920s, his partisans began to emphasize those specific aspects of his character and art above all others. The manly, American, martyred Eakins resounded particularly with the cultural spirit of the late 1920s and early 1930s. By the onset of the Depression, Thomas Eakins had been mythologized into a kind of homely saint.

The Eakins legend was fostered by a circle of former students (such as Samuel Murray and, later, Charles Bregler) and by a dedicated group of curators and art writers (including Bryson Burroughs, Henry McBride, Mumford, and Goodrich), most of whom had begun their careers as painters or teachers of art. At the center was Susan Eakins, the artist's widow. Although characterized as "unsophisticated...in the art world,"[31] Susan Eakins proved remarkably effective in managing the inventory of pictures left at her husband's death. That inventory, which filled much of the Mount Vernon Street house, was assessed at $2,860 on his death; Eakins's estate was valued at about $33,805 (or roughly half a million dollars now).

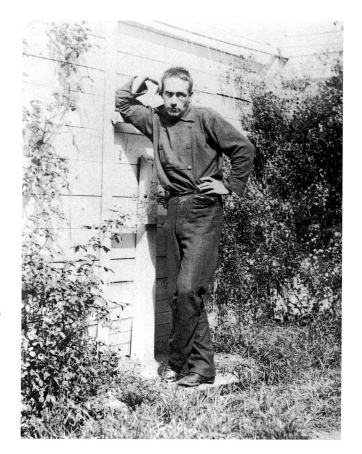

Fig. 197. Circle of Thomas Eakins (attributed to Susan Hannah Macdowell), *[Thomas Eakins at About Age Thirty-Five]*, 1880. Albumen print, 4½ x 3¼". Bryn Mawr College Library, Pennsylvania. Seymour Adelman Collection (pl. 52).

For Susan Eakins, everything about her husband was sacred: "She treasured *everything* that came from Eakins' hand."[33] She saved all the pictures, sketches, scraps, and writings left in the studio and thoughtfully reviewed and modified statements about her husband.[34] And while she was determined to place major paintings in significant collections, she also intended to "gather together all of Mr. Eakins's small pictures, to form a collection with some of his larger canvases, hoping...that I may be able to so place them that they will always be accessible and useful to serious students."[35]

How Susan Eakins saw Thomas (or how she hoped posterity would see him) is suggested by her correspondence and by the few photographs of him, of the many in her possession, she released for public scrutiny. What seems to have been her favorite photograph (fig. 197) was taken about 1880, at the height of his career as a painter and teacher at the Pennsylvania Academy and at the beginning of their courtship.[36] The image shows a youthful Thomas Eakins, leaning against a fence in the sunny, somewhat overgrown yard of 1729 Mount Vernon Street. His expression is intense and his pose, while a vague echo of classical types, is nonetheless awkward enough to appear unstudied. His scuffed shoes, baggy pants, and workingman's shirt are the antithesis of fashionable gentleman's attire sported by many artists of his day. In this photograph he appears both ordinary and larger than life, linked to a distinguished cultural tradition and to everyday experience. It is an image that is improbably affecting.

In her correspondence, Susan consistently portrayed Eakins as resolute and worthy. Writing to the art critic Henry McBride, she underscored the importance of Eakins's participation in an academic tradition and his debt to his teacher Jean-Léon Gérôme, his commitment to "studying from the naked model," and above

Fig. 198. *Thomas Eakins Memorial Exhibition at the Metropolitan Museum of Art, New York, November 5– December 3, 1917.* The Metropolitan Museum of Art, New York.

Financially secure, she was free from the pressures that had impelled another notable artist's widow of the day, Alice Chase, to burden the 1917 memorial exhibition of her husband's works with inferior, unsold pictures and to flood the market with his paintings and studio contents, with disastrous consequences for Chase's reputation and the cash value of his work.[32] In contrast, Susan Eakins proceeded cautiously and for the next twenty years, until her death in 1938, she would exercise careful control over the distribution of Eakins's pictures.

all, his determination and integrity: "[He was] unwilling to do clever or smart work or deceive himself by dash."[37]

In November 1917, after respectful consultation with Susan Eakins, the Metropolitan Museum of Art opened a memorial exhibition (fig. 198) organized by Bryson Burroughs, a Paris-trained academic artist and, from 1907 to 1934, the curator of paintings.[38] Burroughs was first approached by Eakins in 1910, when the painter, hoping to enhance his presence at the museum, offered to sell his *Crucifixion* (pl. 54).[39] Burroughs declined. In 1916, however, painter J. Alden Weir persuaded him to buy *Pushing for Rail* (pl. 11) then on display at the Pennsylvania Academy's annual exhibition; from that point, Burroughs became one of Eakins's most dedicated supporters. His enthusiasm was reinforced when Henry McBride singled out Eakins's *Portrait of J. Harry Lewis* (fig. 199) from the otherwise lackluster fare at the National Academy of Design's annual show.[40] Burroughs and McBride, whose long-standing friendship had been based on their mutual sympathy for modern styles, worked together to promote Eakins. Both had visited Susan Eakins in the summer of 1917. Burroughs chose sixty works for the memorial exhibition, largely from her collection, and McBride wrote glowingly about the show in *The Sun* (New York).

Only after considerable pressure from Eakins's Philadelphia supporters did the Pennsylvania Academy follow suit. One advocate, *Philadelphia Inquirer* critic Helen Henderson, took the city to task for its neglect of the artist. Her review of the Metropolitan's show began, "This is the Philadelphian whom Philadelphians have never thought it worth while to honor." Another *Inquirer* story featured the headline "Metropolitan Museum of New York Administers Reproof to Philadelphia by Fine Exhibition of Eakins Works." Henderson took her cause to Academy president John Frederick Lewis: "I hope you know that the initiative with regard to this splendid showing of the master's works came entirely from the management of the Metropolitan Museum. . . . You have allowed New York to show you what should have been our immediate impulse."[41] Such efforts finally shamed the Academy into presenting a memorial show. Organized by curator Gilbert S. Parker, it opened in December 1917 and included 139 works—more than twice as many as the Metropolitan's—most lent by Susan Eakins.

Both memorial exhibitions presented comprehensive surveys of Eakins's career (though the clinic pictures were not part of the Academy's show, and neither exhibition included sculpture, drawings, or photographs). The catalogues were well illustrated, and the commentaries—the Academy's by Parker and the Metropolitan's by Burroughs, with appreciations by Harrison Morris and Philadelphia portraitist John McLure Hamilton published in the Metropolitan's *Bulletin*—

Fig. 199. Thomas Eakins, *Portrait of J. Harry Lewis*, 1876. Oil on canvas, 23⅝ x 19¾". Philadelphia Museum of Art. Gift of Mrs. Thomas Eakins and Miss Mary Adeline Williams, 1929.

established the key themes for future writings about Eakins. These eulogies credited Eakins with masculinity, sobriety, and reluctance to charm. They praised his sophisticated technique and his seriousness as well as his tenacity. As Parker asserted, "Eakins did what he felt and believed to be right even though the whole world were against him."[42] All considered him "the greatest of all modern realists." Burroughs's essay was the most sensitive to the nineteenth-century European antecedents of Eakins's realism,[43] and Hamilton's was the most compassionate: "[the memorial exhibition provides] the recognition and admiration which the master was denied in his lifetime. Thomas Eakins died without receiving his just reward."[44]

Among the several commentaries on the memorial exhibitions, none proved as perceptive as those of Henry McBride. In *The Sun* he championed equally the quality of Eakins's art and the nobility of his character. McBride, who had begun his career as an art teacher, was particularly sensitive to the strength of Eakins's technique, his scientific bent, and his "impassioned" painting. McBride proclaimed *The Gross Clinic* a masterpiece ("a picture for modern times, a modern picture"). He underscored Eakins's distaste for self-promotion ("he was a modest man, without guile") and commented affectionately on the awkwardness in the pictures, which he took as a mark of Eakins's sincerity and humanity.

Fig. 200. Thomas Eakins, *Portrait of General E. Burd Grubb*, c. 1898.
Oil on canvas, 30 x 22". Yale University Art Gallery, New Haven.
Gift of estate of Felicia Meyer Marsh.

not a Rembrandt, but he is almost as serious.... He is the most
serious painter America has yet produced." Noting that (like
Rembrandt, like Cézanne) Eakins made "no concessions to
any admirer" but remained fiercely committed to the pursuit of
"the solemn mystery of life," McBride held him up as a stan-
dard of artistic achievement and integrity, an exemplar for
painters attempting to make their way in the art world.[47]

The Brummer Gallery show was one of several that were
part of Susan Eakins's efforts to promote her husband follow-
ing the memorial exhibitions. In 1919 she enlisted Clarence
Cranmer, a Philadelphia sportswriter who had been Eakins's
friend and occasional model,[48] to act as her agent. Over the
next dozen years, Cranmer sold at least sixteen works to major
museums across the country—working sometimes directly
and sometimes through New York dealers—and also sold
important pictures to such distinguished collectors as Thomas
Cochran, Francis P. Garvan, and Stephen C. Clark.[49] During
this period Susan Eakins and Cranmer sent works from her
collection to exhibitions sponsored by the Whitney Studio
Club (the show traveled to four European cities in 1920–21
before being shown in New York), the Minneapolis Institute of
Arts (1923), the Buffalo Fine Arts Academy (1925), three West
Coast museums (Portland, San Francisco, and Los Angeles,
1927), and (with works by J. Alden Weir and Albert Pinkham
Ryder) the Cleveland Museum of Art (1928). Selections from

For McBride the modernist, this awkwardness was the key to
Eakins's appeal. He confessed that his favorite pictures were not
the iconic images such as *The Thinker* ("successes for the pub-
lic") but those he dubbed "successes for artists." In paintings
such as the portraits of General E. Burd Grubb (fig. 200), Sophia
Royce Williams *(The Black Fan)* (c. 1891, Philadelphia Museum
of Art), and Monsignor Diomede Falconio (1905, National
Gallery of Art, Washington, D.C.)—works that were sketchy,
unfinished, or seemingly clumsy—he found evidence of both
artistic struggle and of triumph, evidence, in other words, of
modernity. In the drive for clarity and the intense dedication to
art making, McBride associated Eakins with Cézanne, the most
esteemed of modern artists. "Like Cézanne, Eakins often got
most when he thought he had least succeeded."[45]

McBride returned to this theme in a review of a small exhi-
bition of Eakins's works held at Brummer Gallery late in
1925.[46] McBride compared Eakins to Rembrandt, who "was
not considered so very good by his contemporaries" but who
had been accorded mythic status by posterity. Portraits such as
J. Harry Lewis and *Study of Samuel D. Gross* (fig. 201),
McBride predicted, "some day will hold their own comfortably
in any European collection of masterpieces. Thomas Eakins is

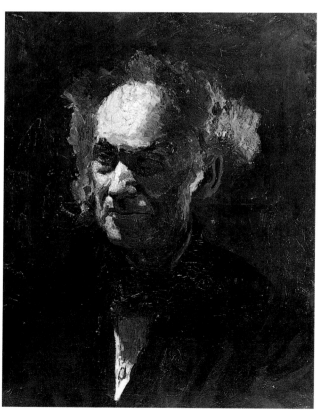

Fig. 201. Thomas Eakins, *Study of Samuel D. Gross*, 1875.
Oil on canvas, 24 x 18¼". Worcester Art Museum, Massachusetts.

the collection made up New York gallery shows at Ferargil (a joint exhibition with works by George Bellows in 1921), Babcock (1930–31), and Milch (1933).

It is significant that none of these shows was held in Philadelphia. After the memorial exhibition, the Academy returned to its usual menu of impressionist landscapes and society portraits;[50] local galleries, for the most part, followed suit. A small group of sporting pictures seems to have been displayed at the Penn Athletic Club in 1926;[51] that same year, a number of Eakinses were shown at the Sesquicentennial International Exposition. Otherwise, nothing by the artist was on view in Philadelphia for almost a decade following the memorial exhibition. Nor were any works by Eakins bought by local institutions after the Academy purchased the *Portrait of Walt Whitman* (pl. 165) in 1917. Despite the warm critical response to the Academy's memorial show, the official Philadelphia art community remained reluctant to embrace Eakins.

Artists and critics in the city nonetheless continued to lobby for recognition for him. In 1919 Robert Henri began to promote the creation of a gallery dedicated to Eakins. "It would be a fine thing for Philadelphia, for America, for all of us and future generations if an Eakins gallery were to be established in Philadelphia."[52] Susan Eakins herself had toyed with the idea of housing a memorial gallery in her home, but the most vigorous campaign was mounted by painter Mary Butler, a Pennsylvania Academy graduate. Beginning about 1926, Butler spearheaded a drive to purchase Susan Eakins's collection for Philadelphia. Her cause won the support of several members of the local art community and the enthusiastic endorsement of Dorothy Grafly, art critic for Philadelphia's *Public Ledger* and daughter of former Eakins student Charles Grafly. In February 1926, Grafly published a long article urging Philadelphia to create an Eakins gallery, bolstering her arguments with comments from Robert Henri.[53] Although this campaign was not immediately successful, it laid the groundwork for the Pennsylvania Museum's acquisition of Susan Eakins's collection a few years later.

Butler's and Henri's efforts were part of a pattern of artists' support for Eakins that developed through the 1920s, especially among figure painters. Henri was one of the most vocal defenders of Eakins's cause. He had admired Eakins since his student days at the Pennsylvania Academy, and thereafter would repeatedly promote him to his followers—"[he has] seen the way before him and has dared to follow it"[54]—spawning a whole generation of Eakins enthusiasts. In 1917 Henri wrote a letter to the artists enrolled at the Art Students' League of New York, urging them to attend the memorial exhibition. In the letter he proclaimed Eakins "the greatest portrait painter America has produced."[55]

In truth, it was less the style of the work than the style of the man that inspired Henri. While he and his followers carried on both Eakins's dedication to figurative subjects and the essential humanism of his work, their exuberant pursuit of urban types from all classes and ethnic backgrounds, their vigorous technique, and their delight in painting *au premier coup* (fig. 202) were worlds away from Eakins's melancholy images of middle-class Philadelphians, his meticulous preparation, and his fidelity to academic methods. But Henri, himself a legendary teacher, respected Eakins's dedication to his teaching and the loyalty of his students. Furthermore, Henri carefully nurtured his public image as a rebel, a crusader for progressive vision in the face of an unfriendly art world. For him, Eakins's stubborn refusal to modify his academic curriculum served as a model of integrity and as a precedent for his own iconoclasm.[56]

Eakins's unpretentious lifestyle was undoubtedly an additional source of inspiration. In an era when many successful artists affected the style of gentlemen and maintained well-appointed studios, Eakins was notorious for working on commissioned portraits in rough shirts and informal clothing. His studio at 1330 Chestnut Street (fig. 203)—cluttered with remnants of old projects and mismatched furniture—was decidedly ungenteel. Several photographs from the early 1890s (pl. 182) emphasize masculine camaraderie and present the studio as what Eakins himself had characterized as a workshop, not an

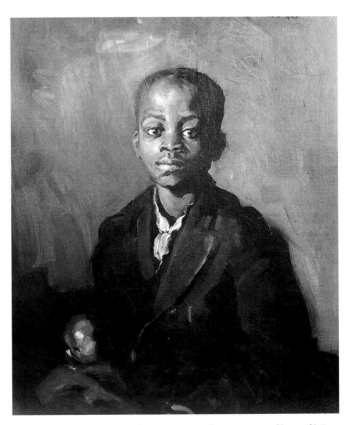

Fig. 202. Robert Henri, *Willie Gee*, 1904. Oil on canvas, 32³⁄₁₆ x 26³⁄₁₆". Newark Art Museum, New Jersey. Anonymous gift, 1925.

atelier.[57] Henri's studio of the same era, located four blocks up Chestnut Street at 1717 (fig. 204), was similarly inelegant, lacking material display or comfort. An arena for serious art making and manly fellowship, it, too, proclaimed its occupant as both a maverick and a genuine working artist.[58]

Henri and his followers, of course, garnered far more attention in the early years of the twentieth century than had Eakins. The press saw their work as possessing "virility without loss of tenderness, a manly strength that worships beauty, and art that is...a true echo of the significant American life about them."[59] Such attributes would be attached to Eakins's work as well.[60] Despite the fact that he endeavored all his life to work within the academic system while they sought to make their way by conspicuously seeming to oppose it, Eakins became a beacon for Henri and his followers. And at the same time, Henri's fame—and his advocacy—contributed to the older painter's increasingly mythic stature.

Among the next generation of artists, Reginald Marsh was perhaps Eakins's most dedicated promoter. His support was more material than Henri's and was based on a personal identification with a man he never met. As a young artist, he had been surrounded by Eakins enthusiasts. He studied at New York's Art Students' League under Kenneth Hayes Miller, a figure painter who greatly admired Eakins. In 1923 Marsh married Betty Burroughs, daughter of Bryson Burroughs and sister of Alan, who published articles on Eakins that same year. Marsh's active interest in Eakins can be traced to the late 1920s, when he himself was painting dark, probing portraits; he further paralleled Eakins in his commitment to academic tech-

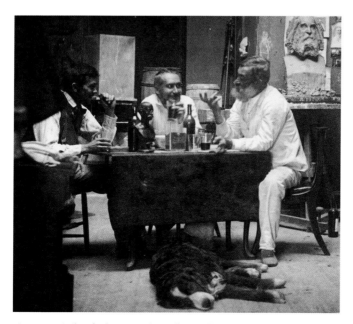

Fig. 203. Circle of Thomas Eakins, [*Samuel Murray, Thomas Eakins, and William R. O'Donovan in Eakins's Chestnut Street Studio*], 1891–92. Platinum print, 6⅜ x 6¹⁵⁄₁₆". Collection of Daniel W. Dietrich II (pl. 182).

nique and his dedication to the study of anatomy. And as a painter whose "realism was too uncompromising for most private collectors,"[61] Marsh surely found solace in the career of a masterful painter who was increasingly characterized as plagued by setbacks and public indifference.

In the fall of 1928 Marsh called on Susan Eakins and arranged through Cranmer to purchase two paintings—*General E. Burd Grubb* and *Monsignor Diomede Falconio*—for forty-three hundred dollars.[62] Shortly thereafter he approached her about publishing "an illustrated discourse" on her husband's work. As the defender of "a man who did not care to be written about," Susan expressed reservations about Marsh's proposal: "I believe...the Eakins pictures will never be popular, and for this reason, I think, your project may not repay you for the time and expense, that must be given to it." She nonetheless agreed to meet Marsh's closest friend, Lloyd Goodrich, a painter turned art historian who was to write the book. With her cooperation and the financial backing of Marsh and, later, the Whitney Museum, Goodrich published his ambitious monograph *Thomas Eakins: His Life and Work* in 1933.[63]

Although widely regarded as a landmark of scholarship and as the text that established Eakins's position in the pantheon of American artists, Goodrich's book disappointed Susan Eakins. She privately suggested that Goodrich was hampered by his lack of personal knowledge of her husband and that a key ingredient of Goodrich's portrait of Eakins—the notion of the artist as an "uncompromising" realist, as an "innocent" eye "little influenced by others"—disregarded Eakins's roots in the French academic tradition. "Mr. Goodrich published a most useful volume on Eakins, but how much he may have profited by his research I cannot say, when a man cannot understand the greatness of Gérôme I cannot think he understands Eakins."[64] Nonetheless, Goodrich's Eakins—an original American talent whose art was based on direct observation and whose "virtues [were] too austere ever to be popular"—would dominate interpretations of the artist and his work for more than half a century.[65]

As Susan Eakins undertook her first conversations with Marsh and Goodrich about the monograph, she was also completing negotiations with Fiske Kimball, then director of the Pennsylvania Museum of Art, about the disposition of her collection. After a three-year courtship, in November 1929, Kimball persuaded her to donate to the museum a significant portion of her holdings—some seventy paintings, reliefs, oil sketches, wax models, and charcoal drawings—to form the core of the new Eakins Memorial Gallery. The selection was designed to illustrate both Eakins's mastery as a painter and sculptor and his working methods. For Susan Eakins, the establishment of a permanent public display of Eakins's work

Fig. 204. Robert Henri's studio at 1717 Chestnut Street. John Sloan Archives, Delaware Art Museum, Wilmington.

in Philadelphia secured his immortality;[66] for Kimball, who during his nearly thirty-year tenure would transform the museum from a collection based on the decorative arts to an encyclopedic institution, the acquisition was "a definite step toward the inauguration of an American art collection" at the museum.[67] The Eakins gift doubled the museum's holdings of American paintings, building on strong examples of works by Homer, John Singer Sargent, Chase, Inness, and Mary Cassatt, and gave the collection new distinction. It also made the museum the nation's principal repository for Eakins's work and, at long last, marked Philadelphia's official acknowledgment of the artist as "a decided force in forming the traditions of the American school of painting."[68]

The museum's securing of the Eakins collection came at the end of a decade (no doubt reflecting the resurgence of isolationist sentiment following World War I) that had seen an energetic revival of interest in American art. Both publications and cultural institutions from the era emphasized native achievements. In 1922 *The Magazine Antiques* was founded to promote appreciation for American art of the past. The next year, critic Forbes Watson took over *The Arts* and molded it into the country's most adventurous art journal, one that took recent American art as a special cause, proclaiming it was "not afraid to enjoy American work just because it was American."[69] Over the next ten years, *The Arts* would publish six articles and numerous comments and editorials about Eakins. The Metropolitan Museum opened its American Wing in 1924. Soon thereafter, several museums—notably, the Whitney Museum and the Addison Gallery of American Art—were founded to show American art exclusively; both these institutions made particular efforts to acquire works by Eakins.[70] By this time, even the cosmopolitan tastemaker Alfred Stieglitz had dropped Europeans from his roster in order to concentrate on native

talents. And although the Museum of Modern Art, which opened to the public in November 1929, made its international aspirations clear from the beginning, its mission included the presentation of "a very fine collection of the immediate ancestors, American and European, of the modern movement" so that students, artists, and visitors would see not just examples of foreign trends, but "*our own* accomplishment in painting and sculpture."[71]

In this environment, Eakins's Americanness would become his salient trait. Few accounts of Eakins from this era fail to mention his Anglo-Saxon heritage. His work was deemed admirable for recording "the intellectual travail of our old American stock."[72] His "embodying the character of his country and generation" placed him with Ralph Waldo Emerson, Walt Whitman, and Mark Twain in the pantheon of American artists; his *Thinker* was called "a type as purely American as Abraham Lincoln."[73] And although critics continued to invoke Velázquez and Rembrandt in their discussions of Eakins, and to characterize him as one of America's old masters,[74] his roots in French academic art could now readily be dismissed. Even artist and critic Walter Pach, who had spent many years abroad, chose to minimize Eakins's debt to his French masters and characterize him as "a grand provincial": "Despite some years of study in Europe, he was American to the core."[75]

When the Philadelphia Museum first displayed its new Eakins collection early in 1930, art in the United States was undergoing a decided shift. Many of the styles that had held sway in recent decades—Impressionism, various modes of abstraction and expressionism—were also seen as tainted with foreign influence. Realism, identified as a "constant strain in our American painting," was emerging as a contemporary style.[76]

An indication of this trend was the exhibition the Museum of Modern Art opened in May 1930: *Sixth Loan Exhibition, Winslow Homer, Albert P. Ryder, Thomas Eakins*. Of the three painters, two were defined as objective realists and one as a visionary, but all were presented as self-sufficient, unaffected by external (that is, foreign) influences, and unsusceptible to the mercurial demands of fashion. Homer, Ryder, and Eakins were promoted not only as historically significant but also as particularly meaningful for contemporary artists.[77] According to the museum's director, Alfred H. Barr, Jr., the show reflected "a new regard for the values of objective observation ... [for the] direct, accurate, even meticulous study of actual appearances." Homer and Eakins were seen as harbingers; for the new generation of artists they "may well be of far greater importance than Gauguin and Van Gogh, Picasso and Matisse."[78]

If realism was the new American style, then Eakins was one of its noblest practitioners.[79] Art writers repeatedly called his realism "sober" and "uncompromising" and praised the

scientific spirit of investigation behind it, uncorrupted by sentiment or glamour.[80] And at the same time Forbes Watson credited his work with a near-messianic spirituality: "when the pursuit of reality is carried on with the relentless intensity of Eakins, it becomes a kind of mysticism."[81]

The notion that realism was not just a modern style but somehow a heroic one with the capacity to improve the world circulated widely in the Depression era. In the month of the stock market crash, Goodrich wrote, "We need the example of Eakins's art today... his full-blooded power of extracting art from the elements of his own experience, his courage to paint life in any of its aspects, his firm roots in reality."[82] Eakins's "grim, hard-working generation," his physicians and scientists with "lines of worry" on their faces, his women with "gauche, self-conscious" expressions would resonate with the anxiety and despair of many Americans in the Depression years.[83] The melancholy truthfulness of Eakins's portraits was echoed by the somber tones, deep shadows, and resigned expressions found in much realist painting and photography of the period (by, among others, Marsh, Edward Hopper, Raphael Soyer, Walker Evans, and Dorothea Lange) as well as in many films, novels, and even advertising of the thirties. At the same time, Eakins's sincerity was seen as ennobling his subjects, giving them life. An artistic era dedicated to belief in the "sacredness of the everyday fact"[84] found much to honor in Thomas Eakins, realist.

The Depression era also saw a renewed emphasis on the "manliness" of both Eakins's art and his character. Writing in 1931, Mumford described Eakins's work in terms of its "firm, tough prose," its "salty directness" and "absence of pretense and sham."[85] During this period, the rowing and boxing pictures were particularly sought after, and critics drew attention to Eakins's own athleticism. They described him as an "ardent sportsman"[86] and emphasized his commanding appearance. Pach portrayed him as a type worthy of Hemingway: "His head was massive, his eyes clear and determined, his bronzed skin was that of a man who had faced rough weather, and his strong jaw was only half hidden under his sparse, iron-gray beard."[87]

For such admirers, even Eakins's maverick behavior came to be viewed as a mark of his strong moral code. His trading in for cash the gold medal awarded him by the Pennsylvania Academy in 1904 was depicted not as sulky behavior of a bitter man but as the noble gesture of an artist refusing to be corrupted by social pretension or ambition, who worked for himself alone.[88] His ungentlemanly style of dressing, which the patrician art critic Mariana van Rensselaer found so uncouth in the 1880s, became a token of his opposition to foreign effeteness and a symbol of America's hardworking approach to art. "His overalls of blue and his woolen undershirt," wrote Harrison Morris in 1930, were "the American equivalent of the velveteen of my Lord Leighton or of Carolus Duran."[89] In an era marked by distress, self-doubt, a sense of powerlessness, and disillusionment with authority, the rugged, independent individual held special appeal. As Goodrich wrote, "The main strands of his character were strength, courage, and integrity; and it was these that made it possible for him to look ugliness and pain in the face and record them truthfully."[90]

This same larger-than-life profile was shared by many heroes of the Depression era, real and fictional. Figures diverse as Charles Lindbergh and Dashiell Hammett's Sam Spade provided an antidote to America's growing anxiety about its future. Characterized as plain, hardworking, ordinary yet courageous men, they triumphed over adversity, pursued their goals despite doubters, naysayers, and forces of opposition, and worked outside convention to arrive at enduring truths. To Mumford, Goodrich, Watson, and others, Eakins came from the same mold. His honesty was unimpeachable ("He painted what he saw with... terrible candor").[91] His dedication to his work regardless of recognition or remuneration was noble ("His life was [a] marvelous... example of fidelity to painting").[92] And his art, while factual, was redemptive ("He made it face the rough and brutal and ugly facts of our civilization, determined that its values should grow out of these things").[93] Eakins restored a model of truth and value to American art. To the degree that a painter could be a hero, by the early 1930s, Eakins had become one.

Eakins as a Writer

WILLIAM INNES HOMER

WHEN WE THINK OF Thomas Eakins, visual images rather than written statements spring to mind. Though indeed best known as a painter, Eakins was a prolific writer, especially of letters. Those he wrote from Paris as an art student from 1866 to 1869 are a treasure-house of information, revealing much about his training, his growth as an artist, and his opinions of France and the French. He continued this practice while in Spain, in 1869–70, and recorded trenchant observations in a pocket notebook that serves as a rare compendium of his opinions on art and artists.

After Eakins returned to Philadelphia in 1870, he had no further need for regular correspondence. In his later letters, he mentioned his goals and aspirations only occasionally, but not in any large measure. We look in vain for comprehensive explanations of his thinking while he painted such masterpieces as *The Gross Clinic* (pl. 16); none has been discovered. He did, however, offer clues about his mental processes in regard to certain other works, and we must be grateful for these brief accounts.

When it came to theorizing on topics that related to his art and teaching, Eakins did not hold back. He wrote treatises on perspective and related subjects, anatomy (now lost), motion photography, and the variations in the musculature of a horse pulling a cart. The last two were published; the first two were not. Each of these topics, in its own way, possesses a scientific cast, and Eakins himself must be seen as compulsively rational, a modern-day Leonardo da Vinci, practicing art while fathoming and explaining its underlying principles. Eakins's act of writing on these matters demonstrated his committed theoretical mind and his need to share his insights with others.

LETTERS FROM PARIS, MADRID, AND SEVILLE (1866–70)

While abroad for nearly four years, Eakins wrote his family and friends long, detailed letters with full accounts of his daily life and artistic development. Perhaps his father had asked this of him, just as he had required him to write home once a week; or possibly Eakins found his new experiences so compelling that

he felt a need to capture everything in words. Whatever the reason, his letters from Europe are revealing documents: they bear witness to the growth of a highly intelligent, artistically talented individual, and they often indicate the roots of his later thinking about art and aesthetics. Furthermore, Eakins's letters offer us a rare and intimate view of his values and prejudices. Some of his opinions would change as he matured, but most remained permanently at the core of his being.

We must wonder whether Eakins thought his letters would be cherished by posterity—or even published. Although punctuated by personal opinions of little interest to a wider audience, the letters include lively accounts of life in Paris seen through the eyes of an American art student. Perhaps these writings should be viewed as a glorified diary, designed to be read by his family and friends, but also to be enjoyed by future generations.

Like his first independent paintings of the 1870s, Eakins's early letters are filled with narrative detail. His descriptions go on for page after page, often without focus or emphasis. These impressions are particularly fresh, often bordering on wonderment, because they come from an American who was experiencing the pleasures of Europe, and especially Paris, for the first time. During that period Paris was teeming with activity; Napoleon III was emperor and brought the trappings of regal splendor to the office. The French nation was at the height of its power, and many of its citizens enjoyed unparalleled prosperity. Paris presented Eakins with an astonishing panoply of cultural experiences.

Although fond of narrative detail, Eakins was more than an objective reporter; in fact, he was opinionated and colored his remarks with strong prejudices. About Christianity, he wrote: "Of all religions the christian is the most intolerant & inconsistent & no one without living here can know what a frightful war it wages against everything that is good."[1] One of his guiding principles was to measure people in ethical and moral terms. The "great man" became his model:

It has been my good fortune to have spoken personally with some of the greatest men in the world known in Europe & America alike. Dr. Dunglison, Pancoast, Gérôme and through my associations to know very close the habits of

377

others. Jacques, Couture, Troyon, Gounod, Robert-Fleury & others, without exception they are the simplest hearted and mannered people in the world. They can frolic, some can be intemperate in a hundred things or get drunk or what not, but impossible is it to be great & waste time on imposition.[2]

By contrast, he denigrated small-minded individuals who did not measure up. He referred to minor French officials as "a hateful set of little vermin, uneducated except in low cunning, who having all their lives perverted what little minds they had, have not left one manly sentiment."[3] This negative portrayal stemmed from Eakins's struggle to gain admission to the Ecole des Beaux-Arts, wrangling with the official government bureaucracy. Eakins recounted his adventures in detailed letters to his family, which show him to be a forceful and determined individual who would not accept "no" for an answer. In a letter to his father, he explained: "On looking back at my month's work, I have certainly to regret that to get what I wanted I had sometimes to descend to petty deceptions but the end has justified the means."[4]

Eakins generally upheld high moral standards. For example, his letters contained stern messages to his sisters. He continually warned them of duplicitous behavior on the part of friends and acquaintances and, by the same token, praised those who exemplified upright ethical conduct. Eakins urged his sisters toward ever higher goals and better performance, offering specific as well as general advice. He would cheer his sister Fanny's efforts to play the piano, but also chastised her for making mistakes in spelling.[5]

Eakins's letters provide an invaluable record of his early growth as an artist. He came to Paris as a naive Philadelphian with almost no knowledge of European painting and sculpture. During his first weeks in the city, Eakins looked at the paintings in the Louvre, writing to his sister, "I never in my life saw such nice funny old pictures."[6] Soon, however, he had educated himself in the fine points of art, both old and new, with his attention focused on the work of his teacher, Jean-Léon Gérôme. Eakins expressed his profound appreciation for Gérôme's manner of painting, finding him to be a master of human character. Gérôme was thoroughly attached to the academic tradition, but his style inclined toward realism and his subjects were often taken from contemporary life. Even his historical scenes, Eakins observed, seemed real. His student letters, however, gradually reveal his growing skepticism about Gérôme's virtues as an artist and as a teacher. The young American began to study color and light on his own and would often cut class to work out compositions in the privacy of his studio. At this point, Eakins's letters tell us, the French painter Thomas Couture became one of his heroes. Although Couture had won the respect of the academic establishment on the basis of historical "machines" like *Romans of the Decadence* (1847, Musée d'Orsay, Paris), he was also quite able to represent the everyday world in a broadly brushed, tonal manner, stressing the effects of natural light. It was this side of Couture that appealed to Eakins, a taste reinforced by his reading of the French painter's *Méthode et entretiens d'atelier* (*Conversations on Art Methods*, 1867), which he found "curious and very interesting."[7] Eakins's effusive praise of Couture's painting is worth quoting: "What a grand talent. He is the Phidias of painting & drawing. Who that has ever looked in a girl's eyes or run his fingers through her soft hair or smoothed her cheek with his hand or kissed her lips or their corners that plexus of all that is beautiful in modelling but must love Couture for having shown us nature again & beauty on canvass."[8]

His letters bear witness to his steady movement away from Gérôme's cold, icy surfaces and hard outlines toward a more painterly style, a manner exemplified most powerfully by the seventeenth-century Spanish artists Jusepe de Ribera and Velázquez and by the Dutch master Rembrandt. It is perhaps no accident that Eakins chose to study briefly under Léon Bonnat, himself an admirer of the Spanish painters.

In short, Eakins adopted the stance of a realist. In a long letter to his father, he explained his position in a series of simple analogies:

> The big artist does not sit down monkey like & copy a coal scuttle or an ugly old woman like some Dutch painters have done nor a dungpile, but he keeps a sharp eye on Nature & steals her tools. He learns what she does with light the big tool & then color then form and appropriates them to his own use. Then he's got a canoe of his own smaller than Nature's but big enough for every purpose except to paint the midday sun which is not beautiful at all. . . . With this canoe he can sail parallel to Nature's sailing. He will soon be sailing only where he wants to selecting nice little coves & shady shores or storms to his own liking, but if ever he thinks he can sail another fashion from Nature or make a better shaped boat he'll capsize or stick in the mud & nobody will buy his pictures or sail with him in his old tub.

After elaborating on this idea, Eakins went on to attack teachers—no doubt referring to certain professors at the Ecole des Beaux-Arts—who "read Greek poetry for inspiration & talk classic & give out classic subjects & make a fellow draw antique." Eakins condemned not only the imitation of classic art but all imitations: nature was the court of last appeal. He wrote:

> In a big picture you can see what o'clock it is afternoon or morning if its hot or cold winter or summer & what kind of people are there & what they are doing & why they are doing it. The sentiments run beyond words. If a man makes a hot day he makes it like a hot day he once saw or is seeing if a sweet face a face he once saw or which he imagines from

old memories or parts of memories & his knowledge & he combines & combines never creates but at the very first combination no man & less of all himself could ever disentangle the feelings that animated him just then & refer each one to its right place.[9]

Whatever the reason for Eakins's conversion to realism, he became deeply convinced of the value of representing actual and concrete things. He also believed in cultivating in his person the traits of honesty, simplicity, and directness, with the understanding that these virtues would have a beneficial effect on the production of art. His heroes were artists who presented their experiences without idealization, and his enemies were those who offered a superficial and contrived view of the world. He explained to his father that he hated the fashionable Salon painters, who "make naked women, standing sitting lying down flying dancing doing nothing which they call Phrynes, Venuses, nymphs, hermaphrodites, houris & Greek proper names.... It would be a godsend to see a fine man model painted in a studio with the bare walls, alongside of the smiling smirking goddesses of waxy complexion amidst the delicious arsenic green trees and gentle wax flowers & purling streams a running melodious up and down the hills especially up."[10] To Eakins, this kind of painting represented the worst the French tradition had to offer.

It should come as no surprise that Eakins chose Spain, not France, as the place where he would embark on a career as an independent painter. His letters make it clear that Spain was a catalyst for his growing belief in the honest portrayal of real things, persons, and events. The museums of Madrid and Seville offered an array of Spanish paintings that he greatly admired; but even more, the intense sunlight of the country threw the natural world into sharp relief. Moreover, any number of picturesque everyday subjects—gypsies, dancers, bullfighters, and circus people—attracted his eye. A company of dancers became the theme of his first major painting, *A Street Scene in Seville* (fig. 32).

THE SPANISH NOTEBOOK

Eakins's trip to Spain gave rise to an important piece of writing, his so-called Spanish notebook. The only surviving document of its kind from Eakins's hand, the notebook comprises a random collection of observations about painting—his own and that of earlier and contemporary masters. Most of his positive remarks were inspired by pictures by Velázquez, Ribera, and Rembrandt, but he also offered praise, especially in technical matters, to Couture, Bonnat, Henri-Alexandre-Georges Regnault, Mariano Fortuny, and Pierre-François-Eugène Giraud. The Spanish notebook is where Eakins uttered his

famous remark, "I must resolve never to paint in the manner of my master," referring to Gérôme. He gave mixed reviews to Anthony van Dyck and Francisco Goya and condemned Eugène Delacroix, writing that his drawing was "impossible."[11]

Most of this document is concerned with technical observations, both on his own painting and on that of others. Eakins used the notebook, in part, as a "reminder" of how to paint. He cautioned himself to "divide up my energies and my work methods" when starting a picture, "to achieve my broad effect from the very beginning," and to add color once the form (drawing) had been established.[12] He also made notes about how to draw, occasionally introducing anatomical observations. And he gave much attention to the way the appearance of a painting was altered by the type of illumination.

The Spanish notebook was probably not intended for anyone's eyes but Eakins's. The disorganized observations on art and technique no doubt helped the artist clarify his thinking and reminded him of paths that he might take in his own creative work. More concerned with "how to" than with ideas or expression, the notebook forecasts the largely technical tone of Eakins's future writing on art.

LETTERS AFTER 1870

When Eakins returned to Philadelphia in 1870, his correspondence greatly diminished. He would no longer be separated from his family and friends for any length of time, and thus his reason for writing largely evaporated. Some revealing letters do exist, but they are not numerous, and in them he did not philosophize much about the making of art. He did speak of his work from time to time, but without enthusiasm or excitement. Only when he was defending his own morality, justifying his behavior, or preserving his reputation at the time of his expulsion from the Pennsylvania Academy of the Fine Arts and the Philadelphia Sketch Club in 1886 do we find real passion in his letters.

Eakins's letters of the early and mid-1870s, mainly to his friend Earl Shinn, the critic, reveal the writer's frustrations as an independent artist. He told Shinn of his optimistic goal of selling his work and making a name for himself, especially in New York. However, it soon became clear that the American public was not ready for Eakins. In response to the refusal of one of his paintings to a New York exhibition, he proudly wrote to Shinn: "It is a much better figure picture than any one in N.Y. can paint." He went on to say: "I conclude that those who judged it are incapable of judging or jealous of my work, or that there was no judgment at all on merit, the works being hung up in the order received or by lottery."[13] At this point, a note of frustration creeps into the letters, and we

Fig. 205. Thomas Eakins, *Spinning*, 1882–83. Sand-cast bronze, 18¼ x 14¹¹⁄₁₆ x 2¹¹⁄₁₆". Philadelphia Museum of Art. Gift of Charlene Sussel in memory of her husband, Eugene Sussel, 1992 (pl. 92).

sense that his faith in his ability to earn a living by painting was wavering.

He also voiced frustration about other matters. A fair number of the letters reflect his tense relations with clients. He used an argumentative tone in his correspondence with James P. Scott, a wealthy Philadelphian, who had commissioned two sculptured reliefs, *Spinning* and *Knitting* (figs. 205, 206) as chimneypieces for his townhouse. When Scott saw the finished plasters, he was not satisfied. He also thought they were too expensive. Eakins responded:

> Your remark to me that the price seemed high for a thing you might not even use, requires of me an explanation. Mr. Chandler [the architect] told me last summer that there was a great need for fine sculpture in this country now, that taste here had much improved, that architecture was very advanced, that gentlemen were building here such houses as had never been built before. I told him that good sculpture was much more expensive than pretty good sculpture, but he said that the expense was nothing to the rich men, if they got what they wanted, and the worth of their money. He wished me to undertake myself the ornamentation of the chimney piece and easily induced me, for the work was much to my taste. We settled that the price might be 3 or 4 hundred dollars for a figure.

I have taken great pains to do my work well. I did not stint myself in the use of models, or of anything that might improve it.

Eakins went on to explain how much the models had cost him and then continued in an offended tone:

> My interest in my work does not terminate with the receipt of my bill. Thus, I have heard with dismay that a stone cutter had offered to finish those panels each in a week's time.
>
> I have been twenty years studying the naked figure, modelling, painting, drawing, dissecting, teaching.
>
> How can any stone cutter unacquainted with the nude, follow my lines, especially, covered as they are, not obscured, by the light draperies? How could the life be retained?[14]

Maintaining his defensive position, Eakins wrote to Scott again:

> Although you were at first surprised at the cost of modelling, I do not think you imagined I had overcharged you after I had shown you the time consumed and expense I had put myself to upon the little things, but I do not agree with you that a less finished work would do almost as well.[15]

In the end, the two reliefs remained with Eakins, and they were never mounted in Scott's house. In the course of the negotiations, the artist showed himself, characteristically, to be stubborn and self-righteous.

Fig. 206. Thomas Eakins, *Knitting*, 1882–83. Sand-cast bronze, 18⁷⁄₁₆ x 14¾ x 3½". Philadelphia Museum of Art. Gift of Charlene Sussel in memory of her husband, Eugene Sussel, 1992 (pl. 93).

The same tone, though more intense, permeated his correspondence with one of his portrait subjects, Dr. Jacob Mendez Da Costa. The subject of a commissioned portrait (fig. 207), Da Costa apparently was displeased with its negative public perception and must have asked Eakins to "correct" the work. Eakins replied:

It is I believe to your interest and to mine that the painting does remain in its present condition.

Any attempt on my part to get from mean sources what I may have failed to get from the best would be disastrous, and I do not consider the picture a failure at all, or I should not have parted with it or consented to exhibit it.

As to your friends, I have known some of them whom I esteem greatly to give most injudicious art advice and to admire what was ignorant, ill constructed, vulgar and bad; and as to the concurrent testimony of the newspapers, which I have not seen, I wonder at your mentioning them after our many conversations regarding them.

I presume my position in art is not second to your own in medicine, and I can hardly imagine myself writing to you a letter like this: Dear Doctor, The concurrent testimony of the newspapers and of friends is that your treatment of my case has not been one of your successes. I therefore suggest that you treat me a while with Mrs. Brown's Metaphysical Discovery.[16]

Not all of Eakins's letters contained sarcasm. Much of his later correspondence dealt with routine business, mostly the exhibition and shipping of his work. But there were times when he was away from home and felt compelled to write letters that are more revealing—principally to his wife, Susan Macdowell Eakins, whom he had married in 1884. Most notable among these are the ones he sent from the North Dakota Territory, where he retreated in 1887 for a rest cure after being forced to resign from the Academy. This correspondence is full of graphic descriptions of cowboy life in the Bad Lands, in which he actively participated. Typical are the following excerpts from a letter describing preparations for a roundup:

We started to the Ranche then Wednesday evening intending to travel all night, but a thunder storm threatening we put in at Green River at Pryor's ranch. Next day we started about 7 o'clock, it having rained furiously in the night & wet some of our things.

We saw antelopes on the hills and I got a shot at one 400 yards off. I had to ask Tripp [one of his hosts] how far he was off. He said fix your sights for 400 yards....

I intended to ride a little each day to get accustomed to it, but that afternoon a couple of cowboys stopped with a string of horses going to the round up. They wanted dinner & would push on then unless the Tripps were ready to go. Tripp concluded to send his men the next day so Walkup remained over. We were to get off the next day very early, but Tripp's horses wandered off far from home & it was

Fig. 207. Thomas Eakins, *Portrait of Dr. Jacob Mendez Da Costa*, 1893. Oil on canvas, 42 x 34". Pennsylvania Hospital Historic Collections, Philadelphia.

10½ o'clock by the time they were found & corralled & picked out and saddled & packed. Then we started towards Medora where the round up was to be.

Two cowboys went ahead, then the ponies biting & kicking each other all the time. Then the rest of us behind that is two more cowboys & myself. One was Tripps son. The horses are unshod & I never saw anything more sure-footed. You would laugh to see them scampering & jumping & sliding & climbing about & jumping over the gullies & water courses.[17]

Eakins went on at length in this kind of descriptive narrative. It is clear from these letters that he was indeed captivated by primitive life in the West—a powerful antidote to his rejection by a large sector of the Philadelphia art world. In the Dakota Territory, nevertheless, he continued to think about art. His letters relate not only his daily activities but also his plans for painting and photographing cowboy subjects, providing rare clues about his creative process.

Similar insights can be found in his letters to his wife from Seal Harbor, Maine, where, in 1897, he went to paint a portrait of the noted Johns Hopkins physicist Dr. Henry A. Rowland (fig. 208). Eakins wrote of first establishing a perspective framework for the picture, then creating a broad oil sketch for it. Next came the full-sized canvas: "I got my canvas all covered

yesterday, and had another sitting yesterday making about four hours in all."[18] He finished the head in an hour and a half, though he worked later on the forehead, chin, and jaw. All of his stay, however, was not given over to the serious matter of painting. In his spare time he went sailing with Rowland and taught him to fly a kite and ride a bicycle. Eakins remarked:

> There was no wind in the afternoon so Rowland practiced the bicycle. He was immensely delighted to find that he could get on easily as well as off and rode up & down the road a long time. After that we went to the carpenter shop to make sticks for the kite. He whittled and I planed and we soon had good sticks and while I smoothed off some of my painting he got the sticks all tied together and after supper we sewed on the muslin.[19]

Eakins traveled to Baltimore to make a careful perspective drawing of the "engine" (ruling machine) that appears in the painting and, back in Philadelphia where the picture had been shipped for further refinement, spent a day painting the apparatus. Eakins also paid close attention to portraying Rowland's assistant, Theodore Schneider. He wrote: "Schneider will now go particularly well in the background to continue the bright

Fig. 208. Thomas Eakins, *Portrait of Professor Henry A. Rowland*, 1897. Oil on canvas, 80¼ x 54". Addison Gallery of American Art, Phillips Academy, Andover, Massachusetts. Gift of Stephen C. Clark, Esq. (pl. 211).

spots of the machine; and to the other side of the picture I shall put some shelves with bottles. So I trust the picture may gain in interest and not lose breadth."[20]

Eakins rarely wrote so specifically about his aims and procedures in making a painting. True, he referred now and then to a particular pictorial problem and how he would solve it, but, for the most part, he did not articulate his own creative beliefs in his letters. An exception is the advice to students he outlined in a letter to a Washington, D.C., art teacher, Edmund Clarence Messer, on July 3, 1906. Here, Eakins provided a concise account of his tenets:

> I would recommend clay and paint only as the tools to work with.... Frequent the life schools and reproduce from memory what you do there at home.
> Make pictures from the very start, and you will feel what you need as you go along.
> As a picture is a synthesis of many factors used to build it, never waste time in copying.
> It is disastrous.
> Learn the laws of perspective and if you are going to be a figure painter, do some dissecting.
> Show your work from time to time to those who paint better than yourself, but don't follow any advice blindly. You must do your own thinking....
> I think a couple of years of school work would be probably enough but taper off school work into picture painting, in the beginning more school work afterwards more painting, but you must be a student of Nature always.[21]

TREATISES AND THEORIES

With the exception of these remarks to Messer, Eakins did not expound upon his theories in his letters in any consistent way, but he did turn to the writing of systematic treatises. We are fortunate in having from the artist's hand an unpublished text, in two versions, that focuses mainly on perspective but branches out into mechanical and isometric drawing, reflections in water, shadows, the laws of sculptured relief, and motion photography.[22] In the longer version, the various sections are identified as "chapters," suggesting that he had planned to publish the manuscript; the Charles Bregler collection at the Pennsylvania Academy of the Fine Arts includes a number of finished illustrations by Eakins that fit this text. With the exception of the photography section, however, there is no record of any part of this work ever being published intact.

It must be assumed that the manuscript was intended for a willing student because the reader, or listener, is addressed as "you." The tone of the writing, moreover, is pedagogical, leading the reader step by step through the maze of perspective and similar complex subjects. As one might expect from Eakins, the tone is logical and pragmatic. "Theory" takes sec-

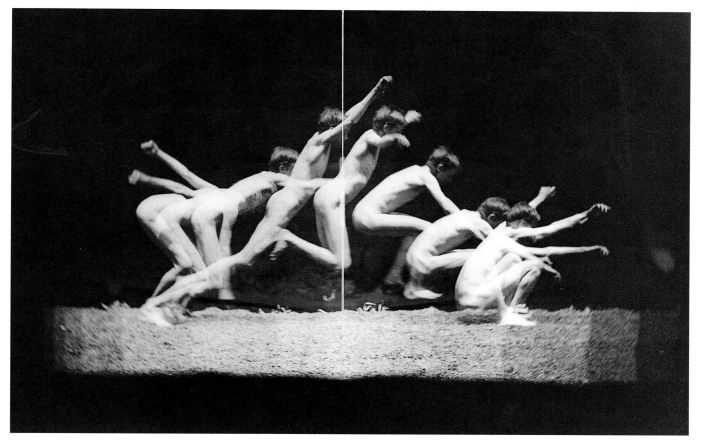

Fig. 209. Thomas Eakins, *[Motion Study: "History of a Jump"]*, 1885. Digital inkjet print from original gelatin dry-plate negative, 4 x 5". Pennsylvania Academy of the Fine Arts, Philadelphia. Charles Bregler's Thomas Eakins Collection, purchased with the partial support of the Pew Memorial Trust (pl. 153).

ond place to practical examples explained with concrete visual illustrations. Only in his discussion of refraction does his writing become highly mathematical, a direction that no doubt would have lost some of his public. Even so, Eakins maintained a consistent logical methodology in his writing, undoubtedly hoping that the absolute clarity of his presentation would explain any subject.

Following the section on "sculptured relief" is an untitled essay on the construction of a camera that Eakins designed and used for action photography. Unlike the rest of the manuscript, this essay, slightly shortened and revised, was published in 1888 as a scientific report—part of the book *Animal Locomotion. The Muybridge Work at the University of Pennsylvania*—under the name of William Dennis Marks, a University of Pennsylvania engineer. Although Marks acknowledged Eakins as the originator of these ideas, he did not directly credit his friend as their author. But Eakins's words are clearly recognizable from the manuscript.

This text represents the culmination of Eakins's experimental work—a primitive yet sophisticated method of photographing humans and animals in motion. He shared this interest with the English photographer Eadweard Muybridge and the French physiologist Etienne-Jules Marey, and in 1884–85 the work of all three men intersected at the University of Pennsylvania. Muybridge had been invited to study "animal locomotion" at the university, and there he lined up twenty-

four cameras and made sequential exposures as the subject ran by. He also employed Marey's method of using a single camera equipped with one or two perforated discs rotating before the lens to capture the varied stages of motion on one plate. Eakins helped Muybridge conduct these experiments and then created his own enclosure at the university to see if he could improve on the others' results. His camera and the images made with it were successful, and Eakins's text gives a full explanation of what he had accomplished. Marks tersely summarized Eakins's achievement. Writing about a photograph Eakins took of a jumping figure (fig. 209), he observed: "The reproduction of a boy jumping horizontally... which Professor Eakins has photographed on a single plate by means of his adaptation of the Marey wheel, is of exceedingly great interest, because, in this picture, each impression occurred at exact intervals. The velocity of motion can be determined, by measurement of the spaces separating the successive figures, with very great precision, as also the relative motion of the various members of the body."[23]

Eakins's photographic work, like his investigations of anatomy and perspective, represented another tool that would augment his understanding of the human figure. However, once he had satisfied his curiosity about human locomotion and had solved the technical problems that confronted him, he abandoned serial photography; there is no evidence that he pursued it after 1886.

Eakins did publish once again on a scientific theme, in this case a subject from anatomy and physiology. In the course of his studies he became fascinated with the action of a horse's leg as it pulled a cart. Contemporary textbooks classified muscles as "flexors and extensors" and pointed out that they worked and rested alternately, but Eakins found something different. When he observed the leg muscle of the horse straining to start a cart rolling, he found that both the flexors and extensors were contracting at the same time. He confirmed his observation by experiment and photographed the result. After calling the discovery to the attention of one of his scientific friends, he was invited to deliver two lectures on the subject at Philadelphia's Academy of Natural Sciences and to publish his findings in their *Proceedings*. His article, "The Differential Action of Certain Muscles Passing More Than One Joint," appeared in 1894.[24]

There is some speculation as to whether Eakins planned to publish his ideas on anatomy. He is said to have written a treatise on the subject, but only scattered fragments have been found. The Bregler Collection contains many of his anatomical drawings, and some may have been intended as illustrations, but they may have been only sketches and notes on dissections done for his own edification. As his widow told Lloyd Goodrich, "He [Eakins] wrote very much about anatomy but I do not think it was prepared for publishing, it was more to get a knowledge himself."[25]

Eakins's writings help us understand his art, his theories, and his personality. Especially relevant are his student letters from Paris and Spain. The later correspondence, while not as richly detailed, still offers us a window into his aspirations and struggles as a mature artist. We learn that he was in conflict with his clients, his former students, and the Academy where he worked. We also discover that Eakins was a realist in his prose; there is little in the way of deep poetic expression or nuance. His letters are often "scientific," not only in the interests he reveals, but also in his mode of expression.

As a writer, Eakins was most at home in the composition of theoretical treatises, expressing what truly interested him without literary pretensions. His prose in this kind of writing is factual, sharing the spare, utilitarian traits of the worldly things he admired—yachts, "flowers, axe handles, the tools of workmen, but above all the living animal forms."[26]

To ask more from Eakins's writing would be unfair. He was an artist-scientist, a product of late nineteenth-century Positivism, the system of philosophy based on natural phenomena or factual properties verified by the methods of empirical sciences. He shows us the limitations of that position, but he also reflects its confident, self-assured view of the material world.

Notes

"Thomas Eakins and American Art," pp. xi–xxii

DARREL SEWELL

1. M[ariana] G[riswold] van Rensselaer, "The Philadelphia Exhibition.—II," *The American Architect and Building News*, vol. 8, no. 261 (December 25, 1880), p. 303; quoted in Linda Jones Docherty, "A Search for Identity: American Art Criticism and the Concept of the 'Native School,' 1876–1893" (Ph.D. diss., University of North Carolina at Chapel Hill, 1985), p. 171.
2. Mariana Griswold van Rensselaer to S. R. Koehler, June 12, 1881, S. R. Koehler Papers, Archives of American Art, Smithsonian Institution, Washington, D.C. (hereafter Archives of American Art).
3. M[ariana] G[riswold] van Rensselaer, "William Merritt Chase," *The American Art Review*, vol. 2, pt. 1, nos. 3–4 (January–February 1881), pp. 91–98, 135–42.
4. Sarah Burns, *Inventing the Modern Artist: Art and Culture in Gilded Age America* (New Haven and London: Yale University Press, 1996), p. 21.
5. Annette Blaugrund, *The Tenth Street Studio Building: Artist-Entrepreneurs from the Hudson River School to the American Impressionists* (Southampton, N.Y.: The Parrish Art Museum, 1997), p. 107.
6. Lloyd Goodrich, *Thomas Eakins*, 2 vols. (Cambridge, Mass.: Harvard University Press for the National Gallery of Art, 1982), vol. 2, p. 8.
7. Burns 1996, pp. 23, 50–52, 58.
8. Russell F. Weigley, ed., *Philadelphia: A 300-Year History* (New York and London: W. W. Norton for The Barra Foundation, 1982), p. 363.
9. Benjamin Henry Latrobe, "Anniversary Oration to the Society of Artists," quoted in Beatrice B. Garvan, *Federal Philadelphia, 1785–1825: The Athens of the Western World* (Philadelphia: Philadelphia Museum of Art, 1987), p. 39.
10. Joseph Sill, diary, entry for March 8, 1844, Historical Society of Pennsylvania; quoted in Neil Harris, *The Artist in American Society: The Formative Years, 1790–1860* (New York: George Braziller, 1966), p. 265.
11. Elizabeth M. Geffen, "Industrial Development and Social Crisis, 1841–1854," in Weigley 1982, p. 308.
12. Harris 1966, pp. 112–13.
13. Katharine Martinez, "A Portrait of the Sartain Family and Their Home," in *Philadelphia's Cultural Landscape: The Sartain Family Legacy*, ed. Katharine Martinez and Page Talbott (Philadelphia: Temple University Press for The Barra Foundation, 2000), pp. 1–24.
14. Harris 1966, p. 275.
15. Kathleen A. Foster, *Thomas Eakins Rediscovered: Charles Bregler's Thomas Eakins Collection at the Pennsylvania Academy of the Fine Arts* (New Haven: Yale University Press for the Pennsylvania Academy of the Fine Arts, 1997), pp. 24–31.
16. Thomas Eakins to Benjamin Eakins, March 12, 1867, The Lloyd Goodrich and Edith Havens Goodrich, Whitney Museum of American Art, Record of Works by Thomas Eakins, Philadelphia Museum of Art.
17. Frances Eakins to Caroline Cowperthwait Eakins, July 7, 1868, Thomas Eakins Research Collection, Philadelphia Museum of Art.
18. [Earl Shinn], "Art-Study at the Imperial School in Paris," *The Nation*, vol. 8, no. 198 (April 15, 1869), p. 294; quoted in Elizabeth LaMotte Cates Milroy, "Thomas Eakins' Artistic Training, 1860–1870" (Ph.D. diss., University of Pennsylvania, 1986), p. 2.
19. Eakins to Caroline Cowperthwait Eakins, October 1, 1866, Pennsylvania Academy of the Fine Arts, Philadelphia, Charles Bregler's Thomas Eakins Collection, purchased with the partial support of the Pew Memorial Trust (hereafter Bregler Collection).

20. [Earl Shinn], "Art-Study at the Imperial School in Paris," *The Nation*, vol. 8, no. 198 (April 15, 1869), p. 294; quoted in Milroy 1986, p. 2.
21. Carrie Rebora Barratt, "Mapping the Venues: New York City Art Exhibitions," in *Art and the Empire City: New York, 1825–1861*, ed. Catherine Hoover Voorsanger and John K. Howat (New Haven and London: Yale University Press for the Metropolitan Museum of Art, 2000), p. 64.
22. Eakins to Benjamin and Frances Eakins, February 1868, Bregler Collection.
23. Eakins to Caroline Cowperthwait Eakins, April 14, 1869, Archives of American Art.
24. Goodrich 1982, vol. 2, p. 32.
25. Eakins to Benjamin Eakins, March 6, 1868, Bregler Collection.
26. Milroy 1986, pp. 228–35.
27. Eakins to Margaret Eakins and Max Schmitt, April 12, 1867, Bregler Collection.
28. Quoted in Linda Bantel, foreword to *Paris 1889: American Artists at the Universal Exposition*, ed. Annette Blaugrund (New York: Harry N. Abrams for the Pennsylvania Academy of the Fine Arts, 1989), p. 7.
29. Carol Troyen, "Innocents Abroad: American Painters at the 1867 Exposition Universelle, Paris," *The American Art Journal*, vol. 16, no. 4 (Autumn 1984), p. 4.
30. Ibid., p. 9.
31. Ibid., p. 4.
32. James Jackson Jarves, *Art Thoughts: The Experiences and Observations of an American Amateur in Europe* (New York: Hurd and Houghton, 1869), pp. 297–99; quoted in Troyen 1984, p. 14.
33. Troyen 1984, p. 8.
34. Mariana Griswold van Rensselaer, *Book of American Figure Painters* (1886; reprint, New York and London: Garland Publishing, 1977), unpaginated.
35. Jennifer A. Martin Bienenstock, "The Formation and Early Years of the Society of American Artists: 1877–1884" (Ph.D. diss., City University of New York, 1983), pp. 10–72.
36. M[ariana] G[riswold] van Rensselaer, "American Etchers," *The Century Magazine*, n.s., vol. 3 (February 1883), p. 488; quoted in Lois Dinnerstein, "Opulence and Ocular Delight, Splendor and Squalor: Critical Writings in Art and Architecture by Mariana Griswold van Rensselaer" (Ph.D. diss., The City University of New York, 1979), p. 56.
37. Burns 1996, p. 2.
38. Mariana Griswold van Rensselaer to S. R. Koehler, June 12, 1881, S. R. Koehler Papers, Archives of American Art.
39. Mariana Griswold van Rensselaer, "Society of American Artists—II," *The Independent*, May 19, 1887, p. 618; quoted in Dinnerstein 1979, pp. 277–78.
40. M[ariana] G[riswold] van Rensselaer, "The New York Art Season," *The Atlantic Monthly*, vol. 48, no. 286 (August 1881), pp. 198–99.
41. Mariana Griswold van Rensselaer, "Society of American Artists—II," *The Independent*, May 19, 1887, p. 618; quoted in Dinnerstein 1979, p. 278.
42. Annette Blaugrund, "Behind the Scenes: The Organization of the American Paintings," in Blaugrund 1989, p. 14.
43. H. Barbara Weinberg, "Cosmopolitan Attitudes: The Coming of Age of American Art," in Blaugrund 1989, p. 36.
44. Henry James, "John S. Sargent," *Harper's Magazine* (October 1887); quoted in Weinberg in Blaugrund 1989, p. 33.
45. David M. Lubin, "Modern Psychological Selfhood in the Art of Thomas Eakins," in *Inventing the Psychological: Toward a Cultural History of*

Emotional Life in America, ed. Joel Pfister and Nancy Schnog (New Haven and London: Yale University Press, 1997), p. 135.

46. Elizabeth Johns, *Thomas Eakins: The Heroism of Modern Life* (Princeton: Princeton University Press, 1983), p. 152.

47. Burns 1996, pp. 187–217.

48. John B. Cauldwell, "Report of the Department of Fine Arts," in *Report of the Commissioner-General for the United States to the International Universal Exposition, Paris, 1900* (Washington, D.C.: Government Printing Office, 1901), vol. 2, pp. 513–14; quoted in Diane P. Fischer, "Constructing the 'American School' of 1900'," in *Paris 1900: The "American School" at the Universal Exposition*, ed. Diane P. Fischer (New Brunswick, N.J., and London: Rutgers University Press for the Montclair Art Museum, 1999), p. 1.

49. Fischer in Fischer 1999, p. 5.

50. Ibid., p. 47.

51. Ibid., p. 61.

52. N. N. [Elizabeth Robins Pennell], "The Paris Exposition—V, The American Section," *The Nation*, vol. 71 (August 2, 1900), p. 89; quoted in Fischer in Fischer 1999, p. 62.

53. Walter Pach, quoted in Sylvan Schendler, *Eakins* (Boston and Toronto: Little, Brown, 1967), p. 180.

54. Walter Pach, *Queer Thing, Painting: Forty Years in the World of Art* (New York and London: Harper & Brothers, 1938), p. 64.

"Eakins's Early Years," pp. 1–11

AMY B. WERBEL

1. Little is known about Caroline Cowperthwait, but the occupations of Cowperthwait men were recorded in directories of the day: Her father was a shoemaker, and among her uncles were Emmor, an upholsterer, and Thomas, a publisher and mapmaker (J. Eliot Woodbridge, *Cowperthwaite: Seven Generations from Hugh Born in 1648* [Princeton, N.J.: privately printed, 1983], p. 21).

2. Gordon Hendricks, *The Life and Work of Thomas Eakins* (New York: Grossman, 1974), p. 4.

3. Bruce Laurie, *Artisans into Workers: Labor in Nineteenth-Century America* (New York: Hill and Wang, 1989), p. 17.

4. John Jenkins, *The Art of Writing, Book I* (Cambridge, Mass., 1813), p. xii.

5. For example, in 1850 he was awarded the contract to produce diplomas for the University of Pennsylvania Medical College (Elizabeth La-Motte Cates Milroy, "Thomas Eakins' Artistic Training, 1860–1870" [Ph.D. diss., University of Pennsylvania, 1986], p. 35).

6. Milroy 1986, p. 37.

7. Kathleen A. Foster, *Thomas Eakins Rediscovered: Charles Bregler's Thomas Eakins Collection at the Pennsylvania Academy of the Fine Arts* (New Haven and London: Yale University Press for the Pennsylvania Academy of the Fine Arts, 1997), p. 12.

8. Foster has written that "Eakins had drawn closest to the center of taste when his images were most nostalgic and descriptive, as in *Study of Negroes* or *Seventy Years Ago*" (Kathleen A. Foster, "Makers of the American Watercolor Movement: 1860–1890" [Ph.D. diss., Yale University, 1982], p. 360).

9. Michael Fried has noted that the mobility between art and craft in early to mid-nineteenth century Philadelphia was codified and celebrated in Eakins's painting of William Rush, in which attributes of both sculptor and ship carver "call attention precisely to the *continuity* between [the] vocations...the picture presents Eakins's training and practice as a writing master as directly relevant to—as inextricably bound up with—his work as a painter" (Fried, *Realism, Writing, Disfiguration: On Thomas Eakins and Stephen Crane* [Chicago: University of Chicago Press, 1987], p. 20).

10. Frances Eakins to Eakins, February 25, 1868, Pennsylvania Academy of the Fine Arts, Philadelphia, Charles Bregler's Thomas Eakins Collection, purchased with the partial support of the Pew Memorial Trust (hereafter Bregler Collection); Foster (1997, p. 9) added: "Samples of

Mr. Eakins' own work emerge from this collection to illustrate his character...several illustrate the stream of graduation diplomas and marriage certificates that made every June a crisis in the Eakins household."

11. This map may have been drawn following the text of Rembrandt Peale's drawing manual, *Graphics: A Manual of Drawing and Writing* (Philadelphia: J. Whetham, 1838). Peale boasted that, using his system, he had taught a small boy to draw a map of Europe in fifteen minutes. See Peter C. Marzio, *The Art Crusade: An Analysis of American Drawing Manuals, 1820–1860* (Washington, D.C.: Smithsonian Institution Press, 1976), p. 21.

12. "Thirty-Ninth Annual Report of the Controllers of the Public Schools, of the First School District of Pennsylvania, Comprising the City of Philadelphia, for the Year Ending July 16th, 1857" (Philadelphia: Board of Controllers, 1858), p. 140.

13. George J. Becker, *Becker's Ornamental Penmanship: A Series of Analytical and Finished Alphabets* (Philadelphia: U. Hunt & Son, 1854), p. 2.

14. John Jenkins, *Jenkins' System of Writing, Designed for Private Families, Schools, and Academies, Book II* (New Haven, 1811); quoted in Ray Nash, *American Writing Masters and Copybooks: History and Bibliography through Colonial Times* (Boston: The Colonial Society of Massachusetts, 1959), pp. 57–58.

15. Jenkins 1813, p. xxi.

16. Quoted in Nash 1959, p. 58.

17. Peale 1838, pp. 6, 8.

18. Rembrandt Peale credited Johann Pestalozzi with the idea that drawing would assist the child in acquiring mathematical skills in *Graphics: A Manual of Drawing and Writing* (Philadelphia, 1838), p. 7: "The experience of the persevering PESTALOZZI, and his associates, in Switzerland, having shown the advantage of teaching the elements of drawing previous to writing, they invented an alphabet of drawing." For a review of Pestalozzi's influence in the United States, see Will S. Monroe, *History of the Pestalozzian Movement in the United States* (1907; reprint, New York: Arno Press, 1969), and Johann Pestalozzi, *Letters on Early Education* (London: Sherwood, Gilbert, and Piper, 1827).

19. Becker 1854, p. 3.

20. These drawings are in the Bregler Collection. The finished portrait of Monsignor Turner is in the collection of the Nelson-Atkins Museum of Art, Kansas City, Missouri.

21. For more on Eakins's perspective system, see Amy B. Werbel, "Perspective in the Life and Art of Thomas Eakins" (Ph.D. diss., Yale University, 1996).

22. Fried 1987, p. 35. A further connection is that Benjamin signed *The Lord's Prayer* "B. Eakins Scripxit." Thomas followed his father in using Latin to sign works such as *The Crucifixion*, where Eakins's signature, on the reverse of the canvas lining, reads: "CHRISTI EFFIGIEM EAKINS PHIL [...] PHIENSIS PINXIT MDCCCLXXX." See Theodor Siegl, *The Thomas Eakins Collection* (Philadelphia: Philadelphia Museum of Art, 1978), p. 89.

23. See Fried 1987, pp. 39–40.

24. Goodrich wrote: "It is said that [Benjamin] told his son before they parted: 'You learn to paint as best you can, Tom; you'll never have to earn your own living'" (Lloyd Goodrich, *Thomas Eakins*, 2 vols. [Cambridge, Mass.: Harvard University Press for the National Gallery of Art, 1982], vol. 1, p. 15).

25. John Hart, principal during Eakins's tenure at the school, used this phrase to describe its place in the city's public school system. See Franklin Spencer Edmonds, *History of the Central High School of Philadelphia* (Philadelphia: J. B. Lippincott, 1902), p. 27.

26. David F. Labaree, *The Making of an American High School: The Credentials Market and the Central High School of Philadelphia, 1838–1939* (New Haven and London: Yale University Press, 1988), p. 27.

27. Edmonds 1902, p. 169.

28. Bache served as Central High School's first principal from 1839 to 1842. See Alexander Dallas Bache, "Report to the Controllers of the Public Schools on the Reorganization of the Central High School of Philadelphia" (Philadelphia: Board of Controllers, 1839).

29. This trip resulted in Bache's publication of a massive tome titled *Report on Education in Europe to the Trustees of the Girard College for Orphans* (Philadelphia: Lydia R. Bailey, 1839). See Merle M. Odgers, *Alexander Dallas Bache, Scientist and Educator, 1806–1867* (Philadelphia: University of Pennsylvania Press, 1947), p. 99.

30. Rush, in particular, saw a link between utility and science in education. As an early proponent of public schools, Rush "urged a genuinely useful education, pointedly addressed to the improvement of the human condition" (Lawrence A. Cremin, *American Education: The National Experience, 1783–1876* [New York: Harper and Row, 1980], p. 3).

31. "Thirty-Ninth Annual Report of the Board of Controllers of the Public Schools of the First District of Pennsylvania, Comprising the City of Philadelphia, for the Year Ending December 31, 1857" (Philadelphia: Board of Controllers, 1858), p. 137.

32. Nicholas H. Maguire, "Report of the Principal of the Central High School for the 42d and 43d Terms," 1860, in "[Thirty-Ninth through Forty-Third] Annual Reports of the Board of Controllers of the Public Schools of the First District of Pennsylvania..." (Philadelphia: Board of Controllers, 1858–60), p. 128.

33. "[Thirty-Ninth through Forty-Third] Annual Reports of the Board of Controllers of the Public Schools of the First District of Pennsylvania..." (Philadelphia: Board of Controllers, 1858–60).

34. Changes in the curriculum were occasionally made to accommodate the job market. For example, in 1860, principal Nicholas Maguire replaced phonography with bookkeeping "to afford an education from which the student may derive an immediate applicate advantage, or which may form the basis for a more elaborate and finished, yet useful structure" (Nicholas H. Maguire, "Report of the Principal of the Central High School for the 42d and 43d Terms," 1860, in "[Thirty-Ninth through Forty-Third] Annual Reports of the Board of Controllers of the Public Schools of the First District of Pennsylvania..." [Philadelphia: Board of Controllers, 1858–60], pp. 130–31).

35. Central High School was able to attract outstanding faculty because of the school's high wages and prestige. "Paid four times as much as the average Philadelphia schoolteacher, these were men of power and privilege who were meritocratically selected from the city's grammar-school masters" (Labaree 1988, pp. 4–5).

36. William Vogdes, *An Elementary Treatise on Mensuration and Practical Geometry; Together with Numerous Problems of Practical Importance in Mechanics* (Philadelphia: E.C. & J. Biddle, 1852), p. 3.

37. John Gummere, *An Elementary Treatise on Astronomy*, 6th ed. rev. by E. Otis Kendall, 1851 (Philadelphia: E. C. & J. Biddle, 1860).

38. Labaree 1988, p. 18.

39. "Annual Report" (1846) as quoted in Labaree 1988, pp. 18–19.

40. Frederick Schober's student notebook of 1859 recorded the substance of a "Lecture on Delirium Tremens" given by E. W. Vogdes: "*Delerium Tremens*. There is no form of evil so universal as the partaking of alcoholic drinks. Alcohol leads to insanity." Professor Vogdes's lectures on the dangers of alcohol, which discussed mental and physical decline, extended for several weeks (Archives of Central High School, Philadelphia).

41. Minute Book Number 2, 1854–72, unpaginated, Archives of Central High School, Philadelphia.

42. Ibid.

43. See Amy B. Werbel, "Art and Science in the Work of Thomas Eakins: The Case of *Spinning* and *Knitting*," *American Art*, vol. 12, no. 3 (Autumn 1998), pp. 31–45.

44. Peale taught at Central from 1840 to 1844, when his assistant, George Becker, took over the post. MacNeill, who had graduated from Central in 1848, replaced Becker in 1853 (Elizabeth Johns, "Drawing Instruction at Central High School and Its Impact on Thomas Eakins," *Winterthur Portfolio*, vol. 15, no. 2 [Summer 1980], p. 143).

45. Johns 1980, p. 143.

46. Ibid., p. 144. Kathleen Foster (1997, pp. 19–20) correlated Eakins's student drawings with the subjects of each semester.

47. A. Cornu, *A Course of Linear Drawing, Applied to the Drawing of Machinery*, trans. Alexander D. Bache (Philadelphia: A. S. Barnes, 1842), p. 3.

48. Cornu 1842, p. 5.

49. Ibid., p. 6.

50. Ibid., p. 3.

51. Foster 1997, p. 372.

52. Johns 1980, p. 144.

53. For a description of this examination, and its results, see Johns 1980, pp. 144–46.

54. Elizabeth Johns, *Thomas Eakins: The Heroism of Modern Life* (Princeton: Princeton University Press, 1985), p. 11.

55. Eakins's admission tickets to anatomy lectures at Jefferson Medical College and antique and life classes at the Pennsylvania Academy of the Fine Arts, Philadelphia, 1862, are now in the collection of the Hirshhorn Museum and Sculpture Garden; see Phyllis D. Rosenzweig, *The Thomas Eakins Collection of the Hirshhorn Museum and Sculpture Garden* (Washington, D.C.: Smithsonian Institution Press, 1977), cat. nos. 7a, b.

56. Although Susan Eakins recalled that her husband did not study with Rothermel or Schussele, thirty-four figure studies by Rothermel were found in Eakins's studio some years after his death. See Foster 1997, pp. 29–30.

57. Some scholars have judged this drawing to be so fine in its handling of mass and modeling that it must date from later in Eakins's career. Also see Foster 1997, p. 26.

58. Werbel 1998, p. 36.

59. Milroy 1986, p. 63.

"Studies in Paris and Spain," pp. 13–26

H. BARBARA WEINBERG

1. See Gerald M. Ackerman, "Thomas Eakins and His Parisian Masters Gérôme and Bonnat," *Gazette des Beaux-Arts*, series 6, vol. 73 (April 1969), pp. 237–56; and, for example, Kathleen A. Foster, "Philadelphia and Paris: Thomas Eakins and the Beaux-Arts" (M.A. thesis, Yale University, 1972); Elizabeth LaMotte Cates Milroy, "Thomas Eakins's Artistic Training, 1860–1870" (Ph.D. diss., University of Pennsylvania, 1986); H. Barbara Weinberg, *The American Pupils of Jean-Léon Gérôme* (Fort Worth, Tex.: Amon Carter Museum, 1984), pp. 35–47; and H. Barbara Weinberg, *The Lure of Paris: Nineteenth-Century American Painters and Their French Teachers* (New York: Abbeville Press, 1991), pp. 8–9, 93–104; Kathleen A. Foster, "Writing About Eakins," in Kathleen A. Foster and Cheryl Leibold, *Writing About Eakins: The Manuscripts in Charles Bregler's Thomas Eakins Collection* (Philadelphia: University of Pennsylvania Press for the Pennsylvania Academy of the Fine Arts, 1989), pp. 39–64; Kathleen A. Foster, *Thomas Eakins Rediscovered: Charles Bregler's Thomas Eakins Collection at the Pennsylvania Academy of the Fine Arts* (New Haven and London: Yale University Press for the Pennsylvania Academy of the Fine Arts, 1997), pp. 32–48.

2. About 2,200 American painters born by 1880 are reported to have studied under particular French teachers or in Parisian art schools, according to information compiled by the author. For the phenomenon in general, see Weinberg 1991.

3. See Milroy 1986, pp. 53–54, 81–83; Ronald J. Onorato, "The Pennsylvania Academy of the Fine Arts and the Development of an Academic Curriculum in the Nineteenth Century" (Ph.D. diss., Brown University, 1977), pp. 45–65.

4. Wylie studied in Paris with sculptor Antoine-Louis Barye and possibly with the history painter Joseph-Nicolas Robert-Fleury, director of the Ecole from 1863 to 1865; he was also acquainted with Gérôme. Five of the eleven Americans who enrolled in the Ecole's ateliers in the 1860s had first studied at the Pennsylvania Academy: Eakins, Harry Humphrey Moore, Earl Shinn (enrolled under Gérôme in October and November 1866); Augustus George Heaton (enrolled under Alexandre Cabanel in 1864); and Howard Helmick (enrolled under Cabanel in 1867) (*Registre d'inscription des élèves dans les ateliers de peinture, sculpture, architecture et gravure. 1863–1875*, Archives de l'Ecole Nationale Supérieure des Beaux-Arts, Archives Nationales, Paris, series AJ52, no. 246). For a register of American students in the ateliers of the Ecole, see H. Barbara Weinberg, "Nineteenth-Century American Painters at the Ecole des Beaux-Arts," *American Art Journal*, vol. 13, no. 4 (Autumn 1981), pp. 76–84.

5. Lloyd Goodrich, *Thomas Eakins*, 2 vols. (Cambridge, Mass.: Harvard University Press for the National Gallery of Art, 1982), vol. 1, p. 17.

6. Eakins to Caroline Cowperthwait Eakins, October 6, 1866, Pennsylvania Academy of the Fine Arts, Philadelphia, Charles Bregler's Thomas Eakins Collection, purchased with the partial support of the Pew Memorial Trust (hereafter Bregler Collection).

7. Eakins to Benjamin Eakins, October 13 and 26, 1866, Bregler Collection.

8. Eakins to Benjamin Eakins, October 27, 1866, Bregler Collection. Foster (1997, p. 32) has noted: "Eakins likely stated a preference, which Lenoir accommodated, predicting Gérôme's liberal reception of such an applicant."

9. For the structure of the Ecole des Beaux-Arts and curriculum reforms of 1863, see Weinberg 1991, pp. 13–22.

10. *Registre d'inscription des élèves dans les ateliers de peinture, sculpture, architecture et gravure. 1863–1875*, Archives de l'Ecole Nationale Supérieure des Beaux-Arts, Archives Nationales, Paris, series AJ52, no. 246, indicates Wilmarth's inscription in Gérôme's atelier, but gives no specific dates before May 28, 1866.

11. Ibid.

12. Eakins to [John] Sartain, October 29, 1866, Archives, Pennsylvania Academy of the Fine Arts, Philadelphia. In this letter, Eakins gave his new address in Paris.

13. Eakins to Frances Eakins, October 30, 1866, Bregler Collection.

14. Eakins to Benjamin Eakins, November 11, 1866, The Lloyd Goodrich and Edith Havens Goodrich, Whitney Museum of American Art, Record of Works by Thomas Eakins, Philadelphia Museum of Art (hereafter Goodrich Papers).

15. The standard source on Gérôme is Gerald M. Ackerman, *The Life and Work of Jean-Léon Gérôme, with a Catalogue Raisonné* (New York: Sotheby's, 1986). For a revised edition, see Gerald M. Ackerman, *Jean-Léon Gérôme, monographie revisé, catalogue raisonné mis à jour* (Courbevoie and Paris: ACR, 2000).

16. For Gérôme's wish to use *Cock Fight* as an exercise, see Fanny Field Hering, *Gérôme: The Life and Works of Jean Léon Gérôme* (New York: Cassell, 1892), p. 51. Hering's is one of two lavish illustrated monographs on Gérôme published by writers from Philadelphia, as noted by Foster 1997, pp. 32–33. The other was Edward Strahan [Earl Shinn], ed., *Gérôme: A Collection of the Works of J. L. Gérôme in One Hundred Photogravures*, 2 vols. (New York: Samuel L. Hall, 1881–83).

17. Eugene Benson, "Jean-Léon Gérôme," *The Galaxy*, vol. 1 (August 1, 1866), p. 682. Another useful American appraisal is Lucy H. Hooper, "Léon Gérôme," *The Art Journal* (New York), vol. 3 (1877), pp. 26–28. For the marketing of Gérôme, see Hélène Lafont-Couturier et al., *Gérôme & Goupil: Art and Enterprise* (Paris: Réunion des Musées Nationaux, 2000).

18. See Edward Strahan [Earl Shinn], *The Art Treasures of America*, 3 vols. (1879–[82]; reprint, New York: Garland, 1977). Foster 1972, appendix, listed Gérôme's works in American collections prior to 1888. Ackerman 1986 has given additional data on American holdings.

19. Foster 1997, p. 238 n. 8, has indicated that "a dozen paintings by Gérôme were in circulation in the United States before 1866." She cited information from William H. Gerdts and James L. Yarnall, *Index to American Art Exhibition Catalogues from the Beginning through the 1876 Centennial Year* (Boston: G. K. Hall, 1986), vol. 2, pp. 1399–1401.

20. Ackerman (1969, pp. 235–36) noted the likely attraction of *Egyptian Recruits Crossing the Desert*. Milroy (1986, pp. 116–17) posited the influence of Benson's article. Foster (1997, pp. 33–34) has noted: "By the time Eakins arrived at his door in 1866, Gérôme was already a member of the Institut and the Legion of Honor, *hors concours* at the Salon, and entering his fourth year as professor at the Ecole.... At the age of forty-two Gérôme was at the peak of his powers and beginning his greatest decade of critical and popular success."

21. Eakins to Benjamin Eakins, January 16, 1867, Bregler Collection.

22. Eakins to Benjamin Eakins, March 12, 1867, Goodrich Papers.

23. Gérôme himself noted his ignorance of English in his preface to Hering 1892, p. v. Bridgman stated that Gérôme was unusually indulgent of his pupils' halting French, in "Gérôme Among His Pupils," clipping from an unidentified newspaper, dated January 24, 1904, bound into New York Public Library copy of F[rederick] A[rthur] Bridgman, "Working Under Great Masters, II: Gérôme, the Painter," *Youth's Companion*, vol. 68 (June 21, 1894), p. 290. For Gérôme as a teacher of Americans, see Weinberg 1991, pp. 83–129.

24. Jean-Léon Gérôme to Eakins, February 22, 1877; translated by Louis Husson, Bregler Collection.

25. Milroy 1986, pp. 232–43, noted Taine's curriculum and his possible impact on Eakins.

26. The most successful independent school was the Académie Julian, founded in 1868 to prepare students for admission to the Ecole but competitive with the government school by the early 1870s. See Weinberg 1991, pp. 221–62, for Julian's history and effect on American students. The *concours des places* at the Ecole usually began with tests in anatomy and perspective and in ornamental design or world history. A student's combined scores on the preliminary tests determined one's vantage point in the studio for the execution of a drawing from the antique or from life in two six-hour sessions *en loges*—three-walled stalls that prevented communication among students.

27. For a register of American matriculants in the Ecole, see Weinberg 1981, pp. 72–75.

28. Eakins to Benjamin Eakins, March 12, 1867, Goodrich Papers.

29. *Procès-verbaux originaux des jugements des concours des sections de peinture et de sculpture*, Archives de l'Ecole Nationale Supérieure des Beaux-Arts, Archives Nationales, Paris, 1864–74, series AJ52, no. 77. The next American to matriculate after Moore was Charles Edward Dubois (1847–1885), a student of Gleyre's, who was admitted on March 19, 1872. The Ecole's records indicate in ranked order only those who succeeded in the *concours des places* and not all those who entered.

30. Eakins to Benjamin Eakins, March 21, 1867, Bregler Collection.

31. Eakins to [his parents], ["two weeks later"], quoted in Goodrich 1982, vol. 1, p. 23.

32. Eakins to Benjamin Eakins, May 31, 1867, Goodrich Papers.

33. Eakins to Benjamin Eakins, August 2, 1867, Bregler Collection.

34. For an excellent account of the 1867 American display and its effect on American art and taste, see Carol Troyen, "Innocents Abroad: American Painters at the 1867 Exposition Universelle, Paris," *The American Art Journal*, vol. 16, no. 4 (Autumn 1984), pp. 2–29.

35. Eakins to Benjamin Eakins, September 20, [1867], Bregler Collection.

36. Eakins to [unknown correspondent], September 21, [1867], Bregler Collection.

37. Eakins to Benjamin Eakins, December 30, [1867]–January 3, 1868, Bregler Collection.

38. Eakins to Benjamin Eakins, January 17, 1868, Goodrich Papers.

39. *Registre d'inscription des élèves dans les ateliers de peinture, sculpture, architecture et gravure. 1863–1875*, Archives de l'Ecole Nationale Supérieure des Beaux-Arts, Archives Nationales, Paris, series AJ52, no. 246.

40. Eakins to Benjamin Eakins, March 6, 1868, Bregler Collection.

41. Foster 1997, pp. 38–40. An excellent account of Dumont's atelier appears in Allen Stuart Weller, *Lorado in Paris: The Letters of Lorado Taft, 1880–1885* (Urbana: University of Illinois Press, 1985), especially chap. 6.

42. Eakins to Benjamin Eakins, March 17, 1868, Bregler Collection.

43. See *Explication des ouvrages de peinture, sculpture, architecture, gravure et lithographie des artistes vivants, exposés au Palais des Champs-Elysées le 1er mai 1868* (Paris: Ch. de Mourgues frères, 1868). Bacon was inscribed in Cabanel's atelier in October 1864 as his second American pupil, after Heaton.

44. Eakins to Benjamin Eakins and Caroline Eakins, May 9, 1868, Collection of Daniel W. Dietrich II (hereafter Dietrich Collection).

45. *Explication des ouvrages de peinture, sculpture, architecture, gravure et lithographie des artistes vivants, exposés au Palais des Champs-Elysées le 1er mai 1869* (Paris: Ch. de Mourgues frères, 1869).

46. Eakins to Caroline Cowperthwait Eakins and Caroline Eakins, April 14, [1869], Archives of American Art, Smithsonian Institution, Washington, D.C. (hereafter Archives of American Art).

47. Frances Eakins diary (copy by Gordon Hendricks of the original), Gordon Hendricks research files on American artists, 1950–77, Archives of American Art, summarized in William Innes Homer, *Thomas Eakins: His Life and Art* (New York: Abbeville Press, 1992), pp. 39–40.

48. Frances Eakins to Caroline Cowperthwait Eakins, July 7, 1868, Archives of American Art.

49. Eakins to Benjamin Eakins, September 8, 1868, Goodrich Papers.

50. Eakins to Benjamin Eakins, October 29, 1868, Bregler Collection.

51. Eakins to Frances Eakins, "April Fool's day [April 1]," 1869, Archives of American Art.

52. Eakins to Benjamin Eakins, June 24, 1869, Bregler Collection.

53. Eakins's principal link with Bonnat was Sartain. In March 1869, Sartain had accompanied Eakins when he returned to Europe after a three-month visit home at Christmas and had enrolled in Yvon's private class before transferring to Bonnat's in June. Foster (1997, p. 240 n. 2) has indicated that Eakins's Spanish notebook (Bregler Collection) includes references to his studies with Bonnat in entries made on July 26 and August 12: "mois a l'atelier Bonnat 25.00" and "Bienvenue 10.00," referring to the month's tuition, paid in advance, and the collation paid for by new students.

54. Eakins linked Couture with "the greatest men in the world" (Eakins to unknown correspondent, October 15, 1867, Goodrich Papers). He read Couture's *Méthode et entretiens d'atelier* (*Conversations on Art Methods*, 1867) "as soon as it came out," called it "curious and very interesting," and had bought a copy for William Sartain (Eakins to Benjamin Eakins, Monday night, February 1868, Bregler Collection). He also lamented Couture's absence from the 1868 Salon (Eakins to Benjamin Eakins and Caroline Eakins, May 9, 1868, Dietrich Collection).

55. For biographical information on Bonnat, see Anne Clark James, "Joseph-Florentin-Léon Bonnat," in Gabriel P. Weisberg, *The Realist Tradition: French Painting and Drawing, 1830–1900* (Cleveland, Ohio: Cleveland Museum of Art, 1980), pp. 271–73; Léonce Bénédite, "Léon Bonnat (1833–1922)," *Gazette des Beaux-Arts*, 5th series, vol. 7 (1923), pp. 1–15; and Barclay Day, "L'Atelier Bonnat," *Magazine of Art*, vol. 5 (1882), p. 138.

56. Léon Bonnat, "Velázquez," *Gazette des Beaux-Arts*, 3rd series, vol. 19 (1898), p. 177, quoted Bonnat as saying: "J'ai été élévé dans le culte de Velázquez" ("I was raised in the cult of Velázquez").

57. Bonnat's success would permit him to assemble an important collection of old master paintings and drawings, to bequeath some of them to the Louvre, and to house others in the Musée Bonnat, which he founded in Bayonne.

58. See Strahan 1879–82, vol. 3, p. 132.

59. J. Alden Weir to Robert W. Weir, postmarked February 21, 1874, quoted in Dorothy Weir Young, *The Life and Letters of J. Alden Weir* (1960; reprint, New York: Kennedy Graphics, DaCapo Press, 1971), pp. 30–31.

60. For complaints, see Roger Ballu, "Les Peintures de M. Bonnat au Palais de Justice," *L'Art*, vol. 4 (1876), pp. 123–24.

61. [Augustus George Heaton], "Léon Bonnat," *The Nutshell*, vol. 8 (January–March 1923), p. 5, referring to the portrait completed in 1883 of Levi Morton, banker, minister to France, and later (1889–93), vice president of the United States.

62. Mentioned in Alice Meynell, "Our Living Artists: Léon Bonnat," *Magazine of Art*, vol. 4 (1881), p. 242.

63. Edwin H. Blashfield indicated that between 1867 and 1870, "Sartain and about six other Americans were in the class with me" (Blashfield in an interview with DeWitt McClellan Lockman, July 1927, Lockman Papers, New-York Historical Society; microfilm, Archives of American Art). Blashfield, who studied again with Bonnat in 1874–80, referred to a studio "filled with thirty or forty young men…American[s] predominating." See Grace Whitworth, "The Work and Workshop of Edwin Howland Blashfield," *Fine Arts Journal*, vol. 23 (November 1910), p. 288. In the Lockman interview, Blashfield noted: "He spoke good English which helped his American pupils, but in his later years he declared that he had fallen away." For general information on Bonnat and his American students, see Weinberg 1991, pp. 155–86. Bonnat closed his private teaching studio in 1883, when he was invited, along with seven colleagues, to oversee the restructured late-afternoon drawing course in the Ecole. In 1888 Bonnat became the *chef d'atelier* of one of the school's three painting studios and in 1905 was named director.

64. Edwin Blashfield, "Léon Bonnat," in John C. Van Dyke, ed., *Modern French Masters* (1896; reprint, New York: Garland, 1976), pp. 48–49, and Blashfield in the Lockman interview.

65. Blashfield, in the Lockman interview, described Bonnat's crowded, dirty, overheated studio, located at 13, rue de Laval, around the corner from the rue Pigalle in Montmartre, at the time he enrolled in 1867.

66. Blashfield, in Van Dyke 1896, p. 48, noted: "Here was an atelier of a different kind, where you simply knocked at the door and walked in."

In the Lockman interview, Blashfield recalled: "Bonnat put me straight at life, I never made a drawing from a cast at any time whatever in my student days."

67. "American Painters—William Sartain," *The Art Journal* (New York), n.s., vol. 6 (June 1880), p. 162.

68. Eakins to Benjamin Eakins, September 8, 1869, Goodrich Papers. See also Day 1882, pp. 139–40.

69. Quoted in Herbert F. Sherwood, ed., *H. Siddons Mowbray, Mural Painter, 1858–1928* (Stamford, Conn.: Privately printed, 1928), p. 20.

70. Eakins to Caroline Cowperthwait Eakins, August 30, 1869, Bregler Collection.

71. Eakins to Benjamin Eakins, September 8, 1869, Goodrich Papers.

72. Eakins to Benjamin Eakins, November 5, 1869, Bregler Collection.

73. Eakins to Benjamin Eakins, [Autumn 1869], Goodrich Papers.

74. Milroy 1986, pp. 275–85, has provided an excellent summary of Spain's attraction for realist painters.

75. The author acknowledges with gratitude information provided by Deborah Roldán, Research Associate, Department of European Paintings, The Metropolitan Museum of Art, New York, on Spanish paintings in France during the late nineteenth century.

76. For Gérôme's admiration of Velázquez, see Ackerman 1986, p. 92, citing Théophile Poilpot, who traveled with Gérôme through Spain in 1873 and whose recollections were recorded in Charles Moreau-Vauthier, *Gérôme: Peintre et sculpteur* (Paris: Hachette, 1906), p. 269.

77. Milroy 1986, pp. 274–75, 282–83, citing Foster 1972.

78. Eakins to Benjamin Eakins, December 2, 1869, Bregler Collection. For American painters in Spain, including Eakins, see M. Elizabeth Boone, "Vistas de España: American Views of Art and Life in Spain, 1860–1898" (Ph.D. diss., City University of New York, 1996).

79. Eakins to Benjamin Eakins, March 29, 1870, Goodrich Papers. The following letters from Seville (all Goodrich Papers) also recount Eakins's difficulties with *A Street Scene in Seville*: Eakins to Benjamin Eakins, January 26, 1870; Eakins to [unknown correspondent], March 14, 1870; Eakins to [unknown correspondent], April 28, 1870. His Spanish notebook (Bregler Collection) contains a comment about the painting.

The Spanish notebook is one of three surviving pocket notebooks or sketchbooks that Eakins kept in Europe. He began using this notebook in late 1868 to record his accounts and added other notes to it during his visit to Spain and after his return to Philadelphia. A sketchbook, also in the Bregler Collection, contains studies made in Seville. Another notebook, in the Philadelphia Museum of Art, contains accounts and addresses from 1867–68.

80. Eakins's appreciation of Rembrandt reflected the taste of his Parisian teachers. For Gérôme's remark that, "As a master painter, [Rembrandt] would be my ideal," see letter of September 7, 1899, to Adolph Rosenberg, De Coursey Collection, quoted in Ackerman 1986, p. 161. Gérôme's *Rembrandt Etching a Plate in His Atelier* was apparently his first historical image of an artist at work in his studio. Bonnat had begun his collection in 1865 with one of Rembrandt's drawings, a gift from a neighbor (Weisberg 1980, p. 273 n. 19). Bonnat was said to have remarked: "To me Rembrandt was not a man but a god" (quoted in Heaton 1923, p. 5). Eakins responded with *The Gross Clinic* (pl. 16) to Rembrandt's *Anatomy Lesson of Dr. Nicolaas Tulp* (1632, Mauritshuis, The Hague).

81. Spanish notebook, Bregler Collection.

82. Eakins to Benjamin Eakins, [Autumn 1869], Goodrich Papers.

83. Goodrich 1982, vol. 1, p. 186, referring to interviews with Eakins's students.

84. Eakins to [Edward Hornor] Coates, February 15, 1886, Bregler Collection.

85. Susan Eakins, "Notes on Thomas Eakins," Bregler Collection; quoted in Foster 1997, p. 32.

86. F. de Lagenevais, "Salon de 1875," *Revue des Deux Mondes*, vol. 9, no. 3 (June 15, 1875), p. 927; quoted in Darrel Sewell, *Thomas Eakins: Artist of Philadelphia* (Philadelphia: Philadelphia Museum of Art, 1982), p. 25. The two paintings were selected by Gérôme from Goupil's stock when the canvases that Eakins shipped from Philadelphia failed to arrive in time. See Goodrich 1982, vol. 1, pp. 118–19; Ackerman 1986, p. 169; and the following letters: Eakins to [Earl] Shinn, April 2, 1874, Richard T. Cadbury Papers, Friends Historical Library, Swarthmore College (hereafter Cadbury Papers); Eakins to Jean-Léon Gérôme,

draft, [c. April 1874], Bregler Collection; Eakins to Earl [Shinn], April 13, 1875, Cadbury Papers.

87. See note 16, above.

88. Eakins to Frances Eakins, "April Fool's day [April 1]," 1869, Archives of American Art.

89. Foster (1997, p. 32, and p. 237 n. 3) indicated that Eakins purchased photogravures of Gérôme's *Ave Caesar* and *The Two Augurs* (1861, location unknown) in Paris. She speculated that the print of *Ave Caesar* shown in the family parlor was either in place or was an invented homage by Eakins; the print of the *Two Augurs* hung in Eakins's studio through the early 1880s. Foster also noted Eakins's ownership of other reproductions of Gérôme's works.

90. Eakins to [Earl] Shinn, January 30 [1875], Cadbury Papers.

91. For example, Gérôme portrayed *Rembrandt Etching a Plate in His Atelier* (1860), and Bonnat showed *Ribera Drawing at the Gate of the Ara Coeli in Rome* (1867); both canvases, now unlocated, appeared at the 1867 Exposition Universelle.

92. Eakins to Earl Shinn, April 2, 1874, Cadbury Papers. Eakins noted: "Bonnat a dit qu'il est à New York mais je ne me souviens plus du nom du monsieur."

93. Eakins to Earl Shinn, January 30 [1875], Cadbury Papers.

94. See Elizabeth Milroy, "'Consummatum est...': A Reassessment of Thomas Eakins's *Crucifixion* of 1880," *The Art Bulletin*, vol. 71, no. 2 (June 1989), pp. 269–84.

95. William H. Gerdts, "Thomas Eakins and the Episcopal Portrait: Archbishop William Henry Elder," *Arts Magazine*, vol. 53, no. 9 (May 1979), p. 157.

96. Eakins noted his preference for the practice in his Spanish notebook, Bregler Collection.

"The 1870s," pp. 27–40

MARC SIMPSON

1. At the end of the decade, Earl Shinn, his companion from Jean-Léon Gérôme's studio, drew a pointed connection between Eakins and his French masters: "Professor Eakins, so far as he is an artist, proceeds from the exact photographic realism of Gérôme, modified by the robust realism of Bonnat, who paints his figures so solid that you seem to see all around them. He, too, plays with languages. He has opinions on the various readings of Dante, and makes pastime of mathematics" ("Fine Arts. Exhibition by the Society of American Artists," *The Nation*, vol. 28, no. 716 [March 20, 1879], p. 207).

Eakins's attempts to shape public recognition took the form of exhibitions and their attendant critical responses, the patronage of select leaders largely within Philadelphia's scientific and medical communities, and discourse concerning his teaching. During the decade he started two record books in which—along with a listing of his principal works, their exhibition venues, and their prices—he recorded the names and addresses of artists, publishers, wood engravers, exhibition societies and their agents, and others necessary in the pragmatics of becoming known (now in the Philadelphia Museum of Art and Pennsylvania Academy of the Fine Arts, Philadelphia, Charles Bregler's Thomas Eakins Collection, purchased with the partial support of the Pew Memorial Trust; hereafter Bregler Collection).

2. These are not hard and fast divisions. Many of the individuals portrayed in the interior and sporting scenes are recognizable or, at least in the latter case, identified in the title. Among the portraits is at least one that shows action and narrative intent. The permeability of artistic boundaries is a key element of Eakins's work in the 1870s and early 1880s.

3. Eakins to Emily Sartain, November 16, 1866, Pennsylvania Academy of the Fine Arts, Philadelphia.

4. The Eakins family lived only a few blocks from the river, and it seems that all of the family rowed. Eakins began reminiscing about the sport even while he was on the way to Paris. From the ship, reporting his

recovery from seasickness, he noted that a series of good dreams presaged his recovery: among them, "...then, I had been rowing with Max and I was drinking some cool beer at Popp's at Fairmount" (October 1, 1866, Eakins to Caroline Cowperthwait Eakins, Bregler Collection). Within the week, he wrote: "Have you been out on the river? It must be very beautiful now with the red and yellow leaves of the trees" (October 6, 1866, Eakins to Caroline Cowperthwait Eakins, Bregler Collection). Two days later: "I hope you have been boating. Our Schuylkill is so beautiful at this season. I hope Poppy goes out regularly with Max. I should be sorry if he should lose his taste for rowing" (October 8, 1866, Eakins to Caroline Cowperthwait Eakins, Bregler Collection). The cultural context of rowing, along with Eakins's rowing pictures themselves, have been most fully presented in Elizabeth Johns, *Thomas Eakins: The Heroism of Modern Life* (Princeton: Princeton University Press, 1983), pp. 19–45; and Helen A. Cooper et al., *Thomas Eakins: The Rowing Pictures* (New Haven: Yale University Art Gallery, 1996).

5. Eakins to Frances Eakins, July 8, 1869, Archives of American Art, Smithsonian Institution, Washington, D.C. (hereafter Archives of American Art).

6. The work was exhibited along with a now unknown and otherwise unrecorded portrait lent by M. H. Messchert.

7. "The Fine Arts: The Third Art Reception at the Union League. III," *Philadelphia Evening Bulletin*, April 28, 1871.

8. The water has its way with reflections as well, carefully and seemingly completely showing the effects of boats and rowers, but responding only capriciously with the reflections that would be cast by the bridges. Eakins's water harbors strange power. Michael Leja has thoughtfully explored the disjunctions of time and optics in *The Champion Single Sculls*, among other works, in a lecture called "Eakins' Icons," delivered at the Sterling and Francine Clark Art Institute, Williamstown, Massachusetts, September 6, 2000.

9. Eakins was, in the words of Johns, "perhaps the earliest artist in Philadelphia—and...certainly the first American artist of his capability—to paint portraits of scullers at work" (Johns 1983, p. 4).

10. Charles Bregler noted: "On one occasion when mentioning it was my intention to paint a certain subject, he exclaimed: 'That has never been painted before.' It flashed through my mind that here in this brief sentence was revealed to me a glimpse of that which he had been doing during his whole life, painting things that had never been painted before" (Charles Bregler, "Thomas Eakins as a Teacher: Second Article," *The Arts*, vol. 18 [October 1931], p. 38).

11. The most detailed study of this group of works is in Cooper 1996.

12. *The Philadelphia Press*, May 21, 1872; quoted in Cooper 1996, p. 39.

13. Edward Strahan [Earl Shinn], "The Pennsylvania Academy Exhibition," *The Art Amateur*, vol. 4, no. 6 (May 1881), pp. 114–15.

14. Theodor Siegl, entries 336a and b and 337 in *Philadelphia: Three Centuries of American Art* (Philadelphia: Philadelphia Museum of Art, 1976), pp. 391–94. For a revelatory discussion of Eakins's use of perspective for emotional and pictorial effect, see Kathleen A. Foster, *Thomas Eakins Rediscovered: Charles Bregler's Thomas Eakins Collection at the Pennsylvania Academy of the Fine Arts* (New Haven and London: Yale University Press for the Pennsylvania Academy of the Fine Arts, 1997), pp. 62–65, 125–27.

15. Eakins to Benjamin Eakins, March 6, 1868, Bregler Collection.

16. Eakins, Miscellaneous Notes, Philadelphia Museum of Art typescript, p. 68; quoted in Foster 1997, p. 346, and, with variations, in Cooper 1996, p. 44.

17. "Fine Arts: Exhibition of the National Academy of Design.—II," *The Nation*, vol. 28, no. 725 (May 22, 1879), p. 359. It is curious that, trusting to the truth of Eakins's depiction, the critic could not consider that dusk rather than daylight was being depicted.

18. "Budding Academicians. American Genre Pictures.... 'The Oarsmen' of Thomas Eakins," *The New York Times*, April 20, 1879, p. 10.

19. "The Fine Arts: The Spring Exhibition at the Academy—Second Notice," *The Philadelphia Evening Telegraph*, April 6, 1881, p. 5. The writer for *The American Art Review*, perhaps influenced by other, later works recently seen in exhibition, condemned it as a "scientific statement of form and light, rather than as an embodiment of movement and color" (S. R. Koehler, "The Exhibitions: Pennsylvania Academy

of the Fine Arts, Fifty-second Annual Exhibition," *The American Art Review*, vol. 2, pt. 2 [1880–81], p. 122).

20. *Turf, Field and Farm*, May 24, 1872, p. 335. This and other accounts are quoted extensively in Cooper 1996, p. 48.

21. Eakins to Benjamin Eakins, March 6, 1868, Bregler Collection.

22. S. R. Koehler, "The Exhibitions: III.—Second Annual Exhibition of the Philadelphia Society of Artists," *The American Art Review*, vol. 2, pt. 1, no. 3 (January 1881), p. 110. Koehler applied this comment to both *The Biglin Brothers Turning the Stake* and *A May Morning in the Park*, then elaborated his dislike of the latter.

23. Mariana Griswold van Rensselaer, "The Philadelphia Exhibition.—II," *The American Architect and Building News*, vol. 8, no. 261 (December 25, 1880), p. 303. The line drawing is credited to Dora Wheeler. The critic was also taken with the unusual color of the work: "Another singular point, perhaps, is the way in which very strong blues give the color-note of the canvas. They are found in the large flag and the headdresses, and are continued in the water. They are neither the pale and faded nor the very dark blues to which artists usually resort for safety when they needs must undertake the color. They are deep and brilliant, and most uncompromising. They have been criticized by many in my hearing, but merely, it seemed to me, in deference to the conventional theory about blues in general. If we imagine the picture with its blues changed to the more usual reds, for instance, we find that it looses [*sic*] at once much of its singular force and charm."

24. The fullest, most accessible discussion of Eakins's work in watercolor is Foster 1997, pp. 81–97. Donelson F. Hoopes, *Eakins Watercolors* (1971; reprint, New York: Watson-Guptill, 1985) contains commentaries and good color reproductions of many of Eakins's extant works in the medium.

25. These include *The Pair-Oared Race—John and Barney Biglin Turning the Stake* (location unknown), apparently a copy of the oil painting; *The Sculler* (location unknown); *John Biglin in a Single Scull* (probably the work now in the Yale University Art Gallery, New Haven); and *Harry Young, of Moyamensing, and Sam Helhower, "The Pusher," Going Rail Shooting* (Wichita Art Museum, Kansas).

26. "Water-Color Paintings. Some of the Pictures Now on Exhibition at the Academy of Design," *The Daily Graphic* (New York), February 7, 1874, p. 663.

27. "Fine Arts: The Water Color Exhibition," *New York Daily Tribune*, February 14, 1874, p. 7.

28. For a discussion of the project, see Cooper 1996, pp. 54–64; and Kathleen A. Foster in *Thomas Eakins (1844–1916) and the Heart of American Life*, ed. John Wilmerding (London: National Portrait Gallery, 1993), pp. 71–73.

29. Gérôme to Eakins, September 18, 1874; quoted in the original French and translated in Lloyd Goodrich, *Thomas Eakins*, 2 vols. (Cambridge, Mass.: Harvard University Press for the National Gallery of Art, 1982), vol. 1, p. 116.

30. Noted in "City Intelligence. Close of the Water-Color Exhibition," *The Evening Post* (New York), March 2, 1874, p. 4.

31. Eakins, Philadelphia Museum of Art typescript; quoted in Foster 1997, p. 132. It is probably not coincidence that by 1880 James C. Wignall, a Philadelphia boatbuilder from whom Eakins apparently borrowed plans, owned the watercolor (see Foster 1997, pp. 131–34).

32. Gérôme to Eakins, September 18, 1874; quoted in the original French and translated in Goodrich 1982, vol. 1, p. 116. A second oil, *Sailing* (Philadelphia Museum of Art), on a larger scale and with a horizontal format, was perhaps started in 1875 in response to Gérôme's criticism of the smaller oil (Theodor Siegl, *The Thomas Eakins Collection* [Philadelphia: Philadelphia Museum of Art, 1978], p. 63).

33. Eakins to Gérôme, c. March 1874, letter draft, Bregler Collection.

34. *Pushing for Rail* appears, however, only to have been shown at Goupil's galleries (Foster 1997, p. 263 n. 16). The figure to the left in *Pushing for Rail* and both figures in *Rail Shooting on the Delaware* (1876, Yale University Art Gallery, New Haven)—two African-American pushers and one white shooter—provided the basis for illustrations that Eakins, along with Joseph Pennell and Henry Poore, provided for an article on the theme that appeared in *Scribner's Monthly*, in July 1881, which was one of Eakins's few forays into the lucrative field of commercial periodical illustration (Maurice F. Egan, "A Day in the Ma'sh,"

Scribner's Monthly, vol. 22, no. 3 [July 1881], pp. 343–52). For a discussion of Eakins as illustrator, see Ellwood C. Parry III and Maria Chamberlin-Hellman, "Thomas Eakins as an Illustrator, 1878–1881," *American Art Journal*, vol. 5, no. 1 (May 1973), pp. 20–45.

35. Eakins to Frances Eakins, Good Friday 1868, Archives of American Art.

36. The concurrent cluster of works—two oils and a watercolor—variously called *Drifting*, *No Wind—Race Boats Drifting*, and *Waiting for a Breeze* (oils of 1874, Philadelphia Museum of Art and Wadsworth Atheneum, Hartford, Conn.; watercolor of 1875, private collection) demonstrates Eakins's equal appreciation of a more static moment. It is this group of works that grew from the race Eakins witnessed and wrote about on August 19: "Monday I went down to Gloucester with Hen Schreiber] to make a study of splatterdocks [a yellow waterlily] in Little Timber Creek & when we were done we got up to Gloucester in time to see the largest race ever seen on the Delaware & which I had forgotten all about. I think there must have been upwards two hundred sail boats" (Eakins to Kathrin Crowell, August 19, 1874, Bregler Collection).

37. Identified in Foster 1997, p. 371.

38. Charles Bregler, "Thomas Eakins as a Teacher," *The Arts*, vol. 17, no. 6 (March 1931), p. 383.

39. Eakins to Earl Shinn, April 13, 1875, Richard T. Cadbury Papers, Friends Historical Library, Swarthmore College, Pa. (hereafter Cadbury Papers).

40. Homer had begun working on the theme probably while in Gloucester, Massachusetts, in 1873, likely then finishing a watercolor (*Sailing the Catboat*, private collection), and, in 1874, the oil *The Flirt* (Collection of Mrs. Paul Mellon).

41. Eakins to Shinn, January 30, 1875, Cadbury Papers. Eakins never apparently made the oil, although Foster (1997, pp. 66–67) identifies a drawing now in the Hirshhorn Museum and Sculpture Garden as an advanced stage in the planning for such a work.

42. The sheet was also shown in Cincinnati, Boston, Chicago, Saint Louis, Brooklyn, Providence, Detroit, and Toronto. For details, see Elizabeth Milroy, *Guide to the Thomas Eakins Research Collection with a Lifetime Exhibition Record and Bibliography*, ed. W. Douglass Paschall (Philadelphia: Philadelphia Museum of Art, 1996), pp. 19–25.

43. "The International Exhibition. . . . Our Great Show," *Philadelphia Evening Bulletin*, July 18, 1876, p. 2.

44. Ibid.; "The Fine Arts. The Water-Color Exhibition—Concluding Notice," *The New York Times*, February 14, 1875, p. 5.

45. "Culture and Progress: Eighth Exhibition of the Water-Color Society," *Scribner's Monthly*, vol. 9, no. 6 (April 1875), p. 764. Homer and Eakins were often paired in these years. The next year, Eakins's absence from the ninth exhibition of the watercolorists prompted one critic to note: "Mr. Eakins, whose studies of American sports seemed to complete what Mr. Homer aimed at, is regretfully missed this year" ("Fine Arts. Ninth Exhibition of the Water-Color Society," *The Nation*, vol. 22, no. 555 [February 17, 1876], p. 120).

46. Earl Shinn, "Fine Arts: The Water-Color Society's Exhibition.—II," *The Nation*, vol. 20, no. 503 (February 18, 1875), p. 120.

47. Eakins wrote to Earl Shinn, January 30, 1875, outlining his proposal for convincing the collector A. T. Stewart to allow him to see Gérôme's *Pollice Verso* (Cadbury Papers).

48. Johns 1983, pp. 115–21 and 188–89.

49. In the Eakins family, the piano and practice upon it were items of comment even from faraway Paris: in the spring of 1867, Eakins congratulated his eldest sister Frances (Fanny) on the "possession of the new piano," inquired as to her repertoire, and even sought to arrange—in part—her social life around it (see, for one example, Eakins to Frances Eakins, March 21, 1867, Bregler Collection). See also Martin A. Berger in Wilmerding 1993, p. 64.

50. Rebecca Fussell to her daughter, April 2, 1871 (Pennsylvania Academy of the Fine Arts, Philadelphia); quoted in Goodrich 1982, vol. 1, p. 76.

51. Yale University Art Gallery. For a discussion of the work, see Jules David Prown in Wilmerding 1993, p. 66.

52. Then they acquired the farm in Avondale that would become a home-away-from-home for the painter (William Innes Homer, *Eakins at Avondale and Thomas Eakins: A Personal Collection* [Chadds Ford, Pa.: Brandywine River Museum, 1980], p. 9).

53. Margaret McHenry, *Thomas Eakins, Who Painted* (Oreland, Pa.: privately printed, 1946), p. 29. The same source reports, "She was younger than Kathryn [*sic*]. . . . Rumor had it that she was the one Eakins loved but never won."

54. Martin Peterson, *San Diego Fine Arts Gallery Report* (1971); cited by Julia M. Einspruch in Wilmerding 1993, p. 86. The Philadelphia Musical Academy was at 1328 Spruce Street.

55. "In this picture especially the wall looks like rough mortar calcimined, and the occasional flashes of brilliancy which start out of his canvases are so sudden as to convey the impression of unreality" (S.G.W. Benjamin, "The Exhibitions: IV.—Society of American Artists," *The American Art Review*, vol. 1, no. 6 [April 1880], p. 261).

56. In New York, at the Society of American Artists in 1887, he showed *The Artist's Wife and His Setter Dog*—the depiction of his wife (pl. 158).

57. "Our Great Show. . . . A Stroll through the Art Gallery. The Carriage Annex and Belgian Showing," *Philadelphia Evening Bulletin*, May 17, 1876, p. 1; William J. Clark, Jr., "The Centennial. The Art Department: American Section—Eakins," *The Philadelphia Evening Telegraph*, June 16, 1876, p. 2.

58. S.G.W. Benjamin, "The Exhibitions: IV.—Society of American Artists," *The American Art Review*, vol. 1, no. 6 (April 1880), p. 261.

59. "Society of American Artists. Opening of the Third Annual Exhibition This Afternoon," *The Evening Post* (New York), March 15, 1880, p. 4; E[arl] S[hinn], "Fine Arts: The Society of American Artists.—Modern American Tendency," *The Nation*, vol. 30, no. 770 (April 1, 1880), p. 258.

60. E[arl] S[hinn], "Fine Arts: The Society of American Artists.—Modern American Tendency," *The Nation*, vol. 30, no. 770 (April 1, 1880), p. 258.

61. Eakins to Earl Shinn, Good Friday [March 26], 1875, Cadbury Papers.

62. Johns 1983, pp. 46–81. Eakins was familiar with the teaching at Jefferson in several ways: his father engrossed diplomas for the school from 1846 to 1878; the young artist attended anatomy classes there for the semester beginning in October 1864; and he again enrolled in a course on visceral and surgical anatomy at the college, probably for the spring semester of 1874. See the discussion of the two extant admission cards in Julie S. Berkowitz, *"Adorn the Halls": History of the Art Collection at Thomas Jefferson University* (Philadelphia: Thomas Jefferson University, 1999), pp. 124–28.

63. Depictions from the seventeenth century onward of anatomy lessons (that is, portrayals with corpses) and operations on battlefields provided a context for depictions of medical training and procedure (cited by Johns 1983, pp. 70–75).

64. Berkowitz 1999, pp. 24–26. See Ellwood C. Parry III, "Thomas Eakins and *The Gross Clinic*," *Jefferson Medical College Alumni Bulletin*, vol. 16 (Summer 1967), pp. 3–6; and Parry, "*The Gross Clinic* as Anatomy Lesson and Memorial Portrait," *The Art Quarterly*, vol. 32, no. 4 (1969), pp. 373–75.

65. Eakins to Earl Shinn, April 13, 1875, Cadbury Papers.

66. For a thorough identification of the assisting doctors, see Berkowitz 1999, pp. 168–70.

67. Foster (1997, pp. 108–9) discussed a photograph in the Bregler Collection, which has been ruled as if for transfer and which appears, in reverse, on the artist's Exhibitor's Pass to the Centennial, as close to the artist's source for the self-portrait. The only one of the auditors who has been identified is the figure with his hand on his chin, in the second tier above the entryway: Robert C. V. Meyers—a friend of Eakins and not, so far as is known, a student at Jefferson. The painted study for Meyers (Dietrich Collection) is one of three extant for *The Gross Clinic*. One of the most sustained inquiries into the meanings of the painting has been carried out by Michael Fried, for whom the artist's pen or pencil is crucial and parallel to Gross's scalpel (*Realism, Writing, Disfiguration: On Thomas Eakins and Stephen Crane* [Chicago and London: University of Chicago Press, 1987]). It might be noted that, in addition to the figures engaged in writing or writing-related activities noted by Fried, it appears that the student seated in the third tier directly above Gross is also writing or drawing.

68. Berkowitz 1999, p. 175.

69. Neither the patient nor the woman is identified. It seems likely, given that public operations were most often the fate of the working poor, that the youth is a charity case (Berkowitz 1999, p. 175). The woman, identified by some contemporary critics who were friends of Eakins as his mother, is distinguished by the somberness of her dress, veil, wedding ring, and boniness of her wrist.

70. Johns 1983, pp. 68–70, 75. The procedure removes a segment of bone diseased due to osteomyelitis.

71. Eakins was so concerned with the tonal relationships within the work, and so convinced of the painting's importance, that in late 1875 or early 1876 he made a detailed replica of it in india ink and watercolor (Metropolitan Museum of Art, New York). He undertook this laborious transcription so that an accurate collotype—a photomechanical process print—could be made without the tonal distortions that photographs of the era would have introduced: "My drawing was made with the intention of coming out right in a photograph," he wrote (Eakins to S. R. Koehler, July 13, 1881, quoted in Foster 1997, p. 109). He was proud of the resulting print and displayed it frequently over the next decade, sometimes in conjunction with the painting itself, and in later life gave signed copies to close friends and associates. He submitted the drawing itself, at least according to newspaper accounts, to the tenth annual exhibition of the American Society of Painters in Water Colors in 1877 ("Painters in Water-Colors," *The Evening Post* [New York], January 20, 1877, p. 3).

72. James D. McCabe, *The Illustrated History of the Centennial Exhibition, Held in Commemoration of the One Hundredth Anniversary of American Independence* (Philadelphia, Chicago, and Saint Louis: National Publishing, c. 1876), p. 651.

73. "The Fine Arts: Eakins' Portrait of Dr. Gross," *The Philadelphia Evening Telegraph*, April 28, 1876, p. 4.

74. "The Centennial. The Art Department: American Section—Eakins," *The Philadelphia Evening Telegraph*, June 16, 1876, p. 2.

75. For the appreciation of *The Gross Clinic* at Jefferson Medical College, see Berkowitz 1999, pp. 188–93. The price paid for the canvas, on which Eakins had labored for the better part of a year—his only other known oil dating from 1875 is *Elizabeth at the Piano*—was precisely the same as the more senior portraitist Samuel Bell Waugh had earlier received for his head-and-bust portrait of Gross (1874, Jefferson Medical College, Thomas Jefferson University, Philadelphia). See Samuel Bell Waugh's record book of works, Waugh Family Papers, Archives of American Art, Smithsonian Institution, Washington, D.C.

76. "Fine Arts: The Society of American Artists," *The Daily Graphic* (New York), March 8, 1879, p. 58. At the end of the month, reviewing the exhibition of the National Academy of Design without mention of Eakins's two works on view—*Portrait of Dr. John Brinton* or *A Pair-Oared Shell*—the same writer noted that "the present display contains no figure painting that compares with Mr. Eakins's 'Clinic' at the Kurtz Gallery in intellectual power and serious thought" ("The Academy Exhibition. A Creditable Display of the Work of American Artists," *The Daily Graphic* [New York], March 29, 1879, p. 207).

77. "The Society of American Artists. Second Annual Exhibition—Varnishing-Day," *New York Daily Tribune*, March 8, 1879, p. 5.

78. "The Society of American Artists. Second Annual Exhibition," *New York Daily Tribune*, March 22, 1879, p. 5.

79. See, for example, "Fine Arts: . . . The Society of American Artists and the Philadelphia Exhibition," *The New York Herald*, May 6, 1879, p. 10.

80. Robert Wilson Torchia, "The *Chess Players* by Thomas Eakins," *Winterthur Portfolio*, vol. 26, no. 4 (Winter 1991), pp. 267–76.

81. The artist carefully plotted the positions of these objects, and the space itself, by means of perspective drawings, one of which is still extant (The Metropolitan Museum of Art, New York).

82. Susan Eakins, reported by Lloyd Goodrich, Goodrich Papers.

83. Edward Strahan [Earl Shinn], "The Art Gallery: . . . The Metropolitan Museum of Art," *The Art Amateur*, vol. 2, no. 6 (May 1880), p. 116.

84. "An Extraordinary Picture Collection," *The Art Amateur*, vol. 5, no. 2 (July 1881), p. 24.

85. Eakins to Benjamin Eakins, October 29, 1868, Bregler Collection.

86. Jules David Prown, "Thomas Eakins's *Baby at Play*," *Studies in the History of Art*, vol. 18 (1985), pp. 121–27; Nicolai Cikovsky, Jr., in *American Paintings of the Nineteenth Century: Part I*, ed. Franklin Kelly (Washington, D.C.: National Gallery of Art, 1996), pp. 162–67.

87. The quotation is from Michael Fried in Wilmerding 1993, p. 83.

88. Eakins wrote to Kathrin Crowell in an undated letter, probably of August 1876: "I saw Dr. Brinton to day. He sits for me tomorrow." On August 19 he reported: "Dr. Brinton has been gone for a week past to Newport and wont be back till the 3d Sept." (Eakins to Kathrin Crowell, undated and August 19, 1876, Bregler Collection).

89. Berkowitz 1999, pp. 100–102. One of Brinton's cousins was Major General George B. McClellan. Brinton's military experiences led him to contribute the article on gunshot wounds to the three-volume *Surgical History of the War of the Rebellion* (1870–77) and, while working in Washington, D.C., for the surgeon general and the Army of the Potomac, to create and serve as first director of the United States Army Medical Museum.

90. D.C.M., "Spring Exhibition at the Philadelphia Academy of Arts," *The Art Journal* (New York), vol. 3 (June 1877), p. 190.

91. "The Academy Exhibition," *The Art Journal* (New York), vol. 5 (May 1879), p. 158. The critic noted: "It is cause for regret that this able artist does not adopt a less smoky scheme of colors."

92. See Jane E. Myers, "Eakins and the 1704 Brinton House," in Homer 1980, pp. 30–31.

93. See Foster 1997, p. 449.

94. Quoted in Goodrich 1982, vol. 1, p. 146.

95. A sixth figure, of the nude model, was recorded by Goodrich in 1930 but is not now known.

96. "Fine Arts: The Lessons of a Late Exhibition," *The Nation*, vol. 26, no. 667 (April 11, 1878), p. 251.

97. Susan Eakins to William Sartain, July 5, mid-July, September 15, 1917, Historical Society of Pennsylvania, Philadelphia.

98. Gordon Hendricks, *The Life and Work of Thomas Eakins* (New York: Grossman Publishers, 1974), pp. 112–14; Phyllis D. Rosenzweig, *The Thomas Eakins Collection of the Hirshhorn Museum and Sculpture Garden* (Washington, D.C.: Smithsonian Institution Press, 1977), pp. 63–75.

99. Johns 1983, pp. 91–96.

100. "If belles have such faults as these to hide, we counsel them to hide them" (Clarence Cook, "A New Art Departure. Association of American Artists. First Annual Exhibition—Art for Its Own Sake," *New York Daily Tribune*, March 9, 1878, p. 6). A year later, one critic marveled at Eakins's "considerable talent for making a naturally attractive subject disagreeable,—like his woodeny Philadelphia belle of last year" ("The Two New York Exhibitions," *The Atlantic Monthly*, vol. 43, no. 260 [June 1879], p. 782). Two years later, in 1881, the writer for *Harper's Weekly* could still recall that the William Rush "was the subject of considerable dispute.... Then, however, it was an aggravation amongst aggravations, while in the present Philadelphia collection it appears to fall into place naturally with its surroundings, and instead of commanding consideration at all hazards, it has to be sought for" ("The Philadelphia Art Exhibition," *Harper's Weekly*, vol. 25, no. 1303 [December 10, 1881], p. 827).

101. "The American Artists: New Paintings in the Exhibition—Duveneck and Twachtman—Philadelphians Who Exhibit," *The New York Times*, March 28, 1878, p. 4.

102. Mariana Griswold van Rensselaer, "Picture Exhibitions in Philadelphia.—II," *The American Architect and Building News*, vol. 10, no. 314 (December 31, 1881), p. 311.

103. Linda Nochlin, *Realism* (Baltimore: Penguin, 1971), pp. 36–37.

104. Elizabeth Johns has demonstrated that "the 'tradition' that William Rush worked from the nude was Thomas Eakins's invention, and the 'tradition' that William Rush had caused a scandal by doing so was the invention of the Philadelphia community in the late nineteenth century after Thomas Eakins caused—in his insistence on working and teaching from the nude—a scandal" (Johns 1983, p. 111).

105. "Fine Arts. The Pennsylvania Academy," *The Nation*, vol. 22, no. 566 (May 4, 1876), p. 298.

106. Eakins had earlier had a hand in the arrangements of the building: "for the largest life-class room, the lighting was not projected until after taking advice from the professor of the Sketch-Club life-class, Mr. Eakins. The arrangements are, therefore, practicable as well as enormous in scale" ("Fine Arts. The Pennsylvania Academy," *The Nation*, vol. 22, no. 566 [May 4, 1876], p. 297).

107. Eakins to the Committee on Instruction, January 8, 1876 [1877], Archives, Pennsylvania Academy of the Fine Arts, Philadelphia.

108. Although by 1879 there seems to have been progress: "These models are both male and female and not less than a score of people make a living by posing before the classes. The female model is not easy to obtain, at least such ones as present good studies of the human form divine. They are paid seventy-five cents an hour, and pose three hours at a time, with five minutes' rest in every thirty minutes. Most of them conceal their identity, and come to the Academy closely veiled and appear before the classes with a mask over their faces, and one or two that have been coming for several years are not known except as models, even to the actuary of the Academy. Formerly the price paid an hour was $1.50, but now 75 cents is the highest figure paid, unless in an exceptional case, when a woman of fine figure presents herself and holds out for a larger sum.

The men are paid fifty cents an hour, and are easily obtained; in fact, the applications are largely in excess of the number accepted" ("Academy of Fine Arts: Annual Meeting of Stockholders," *The Times* [Philadelphia], February 4, 1879, p. 4).

109. "Fine Arts: The Lessons of a Late Exhibition," *The Nation*, vol. 26, no. 667 (April 11, 1878), p. 251.

110. "The Fine Arts: The Water-Color Exhibition," *Daily Evening Telegraph* (Philadelphia), December 3, 1877, p. 15. (Described as "in every way admirable.... One of the most refined pieces of work that Mr. Eakins has yet turned out.")

111. Alan C. Braddock, "Eakins, Race and Ethnographic Ambivalence," *Winterthur Portfolio*, vol. 33, nos. 2–3 (Summer–Autumn 1998), pp. 135–61.

112. C[larence] C[ook], "The Water-Color Society Exhibition at the Academy," *New York Daily Tribune*, February 9, 1878, p. 5.

113. "Fine Arts. The Water-Color Society," *The Independent*, February 14, 1878, p. 7.

114. "Fine Arts: Eleventh Exhibition of the Water-Color Society. II," *The Nation*, vol. 26, no. 661 (February 28, 1878), pp. 156–57.

115. Ibid., p. 157.

116. For a discussion of this phenomenon, which was present in the 1860s, see Marc Simpson, *Winslow Homer: Paintings of the Civil War* (San Francisco: The Fine Arts Museums of San Francisco, 1988), pp. 47–63.

117. A posture somewhat at odds with the position he was to advocate in his later writings on the art of coaching: "The coachman should sit straight and square to the front" (*A Manual of Coaching* [Philadelphia: Lippincott's, 1899], p. 305; quoted in Gordon Hendricks, "A May Morning in the Park," *Philadelphia Museum of Art Bulletin*, vol. 60, no. 285 (Spring 1965), p. 56. I would like to thank Aysha Haider, Williams College, for sharing her thoughts on this work with me.

118. Perspective drawing, Bregler Collection; Foster 1997, p. 401.

119. Foster 1997, pp. 158–59. The canvas thus functions in a fashion parallel to Eakins's re-creation of the Biglin brothers' pair-oared race earlier in the decade.

120. Rogers 1899, p. 429; quoted in Foster 1997, p. 159. Rogers included a black-and-white reproduction of *A May Morning in the Park*—photographed from a grisaille made specially for the purpose by Eakins, probably in November 1898 (The Saint Louis Art Museum)—in his text.

121. "Six cards of automatic electro-photographs, by Merrybridge [Muybridge], of San Francisco, representing the horse in motion, presented by Fairman Rogers" ("Academy of Fine Arts: Annual Meeting of Stockholders," *The Times* [Philadelphia], February 4, 1879, p. 4).

122. Eakins probably to Fairman Rogers, undated drafts of letters; Bregler Collection; Foster 1997, p. 151.

123. This was difficult, as Eakins made clear in a letter written not earlier than April: "Dear Muybridge, I pray you to dispense with your lines back of the horse in future experiments. I am very glad you are going to draw out the trajectories of the different parts of the horse in motion.... Do you not find that in your old way the perspective [is] very troublesome? The lines being further off than the horse a calculation was necessary to establish the size of your measure. The horses being a little nearer or a little farther off from the reflecting screen deranged and complicated the calculation each time" (quoted in Hendricks 1965, pp. 51–52).

124. Fairman Rogers, "The Zoötrope," *The Art Interchange*, vol. 3, no. 1 (July 9, 1879), p. 2.

125. See Foster 1997, pp. 151–62, 321–30, 398–401, 438–39.

126. Quoted in Hendricks 1965, pp. 50–51.

127. Fairman Rogers, "The Zoötrope," *The Art Interchange*, vol. 3, no. 1 (July 9, 1879), p. 6.

128. William Innes Homer with the assistance of John Talbot, "Eakins, Muybridge and the Motion Picture Process," *The Art Quarterly*, vol. 26, no. 2 (Summer 1963), pp. 194–216; Foster 1997, p. 268 n. 14.

129. Susan Eakins later asserted "TE staid with Rogers [in Newport] and did most of the painting there" ("Notes on TE," 1931; quoted in Foster 1997, p. 268 n. 16).

130. "The Fine Arts: The Second Annual Exhibition of the Philadelphia Society of Artists—A Superb Collection of American Paintings," *Philadelphia Evening Bulletin*, October 28, 1880, p. 6.

131. "The Academy: Stray Moments Among the Pictures Now on Exhibition," *The North American* (Philadelphia), November 19, 1880, p. 1.

132. Mariana Griswold van Rensselaer, "The Philadelphia Exhibition,—II," *The American Architect and Building News*, vol. 8, no. 261 (December 25, 1880), p. 303.

133. S.G.W. Benjamin, "Present Tendencies of American Art," *Harper's New Monthly Magazine*, vol. 58, no. 346 (March 1879), p. 495. The artists' biographies were organized by city: Boston, New York, and Philadelphia. In the last, the smallest section by far, only Eakins, Emily Sartain, and Mary Cassatt were listed.

"Images of Fairmount Park in Philadelphia," pp. 77–94

ELIZABETH MILROY

1. Edward Strahan [Earl Shinn], ed., *A Century After: Picturesque Glimpses of Philadelphia and Pennsylvania* (Philadelphia: Allen, Lane & Scott and J. W. Lauderbach, 1875), p. 125.

2. *Catalogue of the Third Art Reception of the Union League of Philadelphia* (Philadelphia: Henry Ashmead, 1871); see also Maxwell Whiteman, *Paintings and Sculpture at The Union League of Philadelphia* (Philadelphia: The Union League, 1978), pp. 5–6.

3. Elizabeth Johns, *Thomas Eakins: The Heroism of Modern Life* (Princeton: Princeton University Press, 1983), pp. 19–45; and Helen A. Cooper et al., *Thomas Eakins: The Rowing Pictures* (New Haven: Yale University Press, 1996), pp. 27–36.

4. Kathleen Foster was first to recognize that the structure was Eaglesfield, demolished later in the 1870s, and not Sweetbriar, located farther upriver, as previous scholars had assumed (Kathleen A. Foster, *Thomas Eakins Rediscovered: Charles Bregler's Thomas Eakins Collection at the Pennsylvania Academy of the Fine Arts* [New Haven: Yale University Press for the Pennsylvania Academy of the Fine Arts, 1997]), p. 296.

5. Johns 1983, pp. 33–35.

6. Henry James, *The American Scene* (1907; reprint, Bloomington: Indiana University Press, 1968), p. 282.

7. See Sam Bass Warner, Jr., *The Private City: Philadelphia in Three Periods of Its Growth* (Philadelphia: University of Pennsylvania Press, 1968); and Russell F. Weigley, ed., *Philadelphia, A 300-Year History* (New York and London: W. W. Norton for The Barra Foundation, 1982).

8. M. Christine Boyer, *Dreaming the Rational City: The Myth of American City Planning* (Cambridge, Mass.: MIT Press, 1983), p. 9.

9. Eakins to Frances Eakins, November 13, 1867, Archives of American Art, Smithsonian Institution, Washington, D.C.

10. "An Act Appropriating Ground for Public Purposes in the City of Philadelphia," in *Acts of Assembly Relating to Fairmount Park* (Philadelphia: King and Baird, 1869), p. 4.

11. See Elizabeth Milroy, "Assembling Fairmount Park," in *Philadelphia's Cultural Landscape: The Sartain Family Legacy*, ed. Katharine Martinez and Page Talbott (Philadelphia: Temple University Press for The Barra Foundation, 2000), pp. 72–86.

12. Frederick Law Olmsted and Calvert Vaux to the chairman of the Committee on Plans of the Park Commission of Philadelphia, December 4, 1867, Minutes of the Fairmount Park Commission, January 4, 1868, Department of Records, Philadelphia City Archives.

13. *Third Annual Report of the Commissioners of Fairmount Park* (Philadelphia: King and Baird, 1871), p. 5.

14. See Jane Mork Gibson, "The Fairmount Waterworks," *Philadelphia Museum of Art Bulletin*, vol. 84, nos. 360–361 (Summer 1988), pp. 5–40.

15. Jeffrey P. Roberts, "Railroads and the Downtown: Philadelphia, 1830–1900," in *The Divided Metropolis: Social and Spatial Dimensions of Philadelphia, 1800–1975*, ed. William W. Cutler III and Howard Gillette, Jr. (Westport, Conn.: Greenwood Press, 1980), pp. 27–55.

16. Milroy in Martinez and Talbott 2000, pp. 73–75.

17. The Consolidation Act directed the City Council "to obtain by dedication or purchase, within the limits of [Philadelphia], an adequate number of squares or other areas of ground, convenient of access to all its inhabitants, and lay out and maintain such squares and areas of ground as open public places, for the health and enjoyment of the people forever" (*A Further Supplement to…An Act to Incorporate the City of Philadelphia* [Philadelphia: Crissy and Markley, 1855], p. 37).

18. J. C. Sidney and A. Adams, *Description of Plan for the Improvement of Fairmount Park* (Philadelphia: Merrihew and Thompson, 1859).

19. Spring Garden east of Broad Street was incorporated as an independent township in 1813; in 1827 Penn township land west of Broad Street was added to incorporate the districts of Bush Hill and Franklinville (or Vinyard) west to the Schuylkill, thereby doubling the size of the township.

20. *Pennsylvania Inquirer and National Gazette* (now *The Philadelphia Inquirer*), July 28, 1857. On Spring Garden's diversity, see George E. Thomas, "Architectural Patronage and Social Stratification in Philadelphia between 1840 and 1920," in Cutler and Gillette 1980, pp. 85–124.

21. See David Schuyler, *The New Urban Landscape: The Redefinition of City Form in Nineteenth-Century America* (Baltimore: Johns Hopkins University Press, 1986), pp. 59–100.

22. A. J. Downing, "A Talk About Public Parks and Gardens," *The Horticulturist*, vol. 3, no. 4 (October 1848), p. 156.

23. A. J. Downing, "The New-York Park," *The Horticulturist*, vol. 6, no. 8 (August 1851), pp. 347–48.

24. See Roy Rosenzweig and Elizabeth Blackmar, *The Park and the People: A History of Central Park* (Ithaca, N.Y.: Cornell University Press, 1992).

25. [William Saunders], "The Lemon Hill Park," *Pennsylvania Inquirer and National Gazette* (now *The Philadelphia Inquirer*), February 25, 1857.

26. In 1865 the Belmont Oil Company started operation on the west side of the river just north of the Columbia Bridge; nearby were the Elkins Oil Works at Sweetbriar. Farther upriver, the Powers & Weightman chemical plant extended from the Falls Bridge north, almost to the mouth of the Wissahickon.

27. *Speech of the Hon. James Miller on the Bill Authorizing the Purchase of Grounds on the West Side of the Schuylkill…for a Public Park* (Philadelphia: J. A. Wagenseller, 1865), p. 3.

28. Minutes of the Fairmount Park Commission, December 4, 1867, Department of Records, Philadelphia City Archives.

29. Quoted in Newton Crane, "Fairmount Park," *Scribner's Monthly*, vol. 1, no. 3 (January 1871), p. 237.

30. Eakins to Emily Sartain, November 16, 1866, Archives, Pennsylvania Academy of the Fine Arts, Philadelphia.

31. "A Supplement to an Act Entitled 'An Act Appropriating Ground for Public Purposes, in the City of Philadelphia'" in *Acts of Assembly Relating to Fairmount Park* (Philadelphia: King and Baird, 1869), p. 9.

32. George H. Boker, *Eighth Annual Report of the Board of Directors of the Union League* (Philadelphia: Henry Ashmead, 1870), p. 12.

33. Paintings exhibited at the first reception included *View in the Park* by Isaac Williams; *Devil's Pool, Wissahickon* and *Riverside in the Park* (also shown at the second reception) by Thomas Fennimore; *Old Mill, Wissahickon* by Russell Smith; George Holmes's *Landscape on the Schuylkill;* and two views in Laurel Hill by Thomas Moran. W. E. Winner showed *View from George's Hill* at the second reception. Park views at the third reception included W. W. Boyle's *Nutting in the Woods;* Isaac Williams's *Park View from Lansdowne Terrace;* as well as Eakins's and Moran's canvases.

34. For Holmes's involvement in Eakins's early career, see Foster 1997, pp. 14–16.

35. *Fourth Annual Report of the Commissioners of Fairmount Park* (Philadelphia: King and Baird, 1872), p. 13.

36. *The Builder: An Illustrated Weekly Magazine*, vol. 27 (June 5, 1869), p. 437; quoted in Christopher Prendergast, *Paris and the Nineteenth Century* (Oxford: Blackwell, 1992), p. 9. See also David Pinkney, *Napoleon III and the Rebuilding of Paris* (Princeton: Princeton University Press, 1958).

37. See Martin A. Berger, "Painting Victorian Manhood," in Cooper 1996, pp. 102–23.

38. *Turf, Field and Farm*, May 24, 1872, p. 335; cited in Cooper 1996, pp. 44–48.

39. Strahan 1875, pp. 41, 44.

40. Strahan 1875, p. 48.

41. Secretary's notes, October 3 and 17, 1878, Philadelphia Sketch Club.

42. George Fenner, *Justice vs. Extraordinary Generosity* (Philadelphia, 1870), p. 7.

43. Thomas Cochran, "Fairmount Park: A Necessity for the Health and Recreation of the Present and Future Population of the City," *The Philadelphia Evening Telegraph*, September 16, 1872.

44. Newton Crane, "Fairmount Park," *Scribner's Monthly*, vol. 1, no. 3 (January 1871), p. 231.

45. Strahan 1875, pp. 39–40.

46. Harrison to Fairmount Park Commission, January 9, 1871; reprinted in *Third Annual Report of the Commissioners of Fairmount Park* (Philadelphia: King and Baird, 1871), pp. 79–80.

47. Penny Balkin Bach, *Public Art in Philadelphia* (Philadelphia: Temple University Press, 1992), pp. 41–57 and passim.

48. Olmsted and Vaux submitted a report on August, 15, 1871, but in January 1872, the commission voted to follow a less expensive plan devised by staff engineer Hermann Schwarzmann (Minutes of the Fairmount Park Commission, Department of Records, Philadelphia City Archives). See also Schuyler 1986, pp. 107–8.

49. See Elizabeth Milroy, "Avenue of Dreams: Politics and Display at Philadelphia's Great Central Sanitary Fair," in *Making and Remaking Pennsylvania's Civil War*, ed. William Blair and William Pencak (State College: Pennsylvania State University Press, 2001), pp. 53–59.

50. See Roger W. Moss, *Historic Houses of Philadelphia* (Philadelphia: University of Pennsylvania Press, 1998), pp. 59–107.

51. Strahan 1875, p. 24.

52. There is no up-to-date history of the Centennial: the most thorough accounts are contained in the many guidebooks published for the event and the official reports published afterward. See *International Exhibition, 1876: Official Catalogue*, rev. ed. (Philadelphia: John R. Nagle and Co., 1876); *The Masterpieces of the Centennial International Exhibition*, 3 vols. (Philadelphia: Gebbie and Barrie, 1876); and *U.S. Centennial Commission: International Exhibition, 1876; Reports and Awards*, 9 vols. (Washington, D.C., 1880). See also Dorothy Gondos Beers, "The Centennial City, 1865–1876," in Weigley 1982, pp. 459–70; John Maass, *The Glorious Enterprise: The Centennial Exhibition of 1876 and H. J. Schwarzmann, Architect-in-Chief* (Watkins Glen, N.Y.: American Life Foundation, 1973); and Robert W. Rydell, *All the World's a Fair: Visions of Empire at American International Expositions, 1876–1916* (Chicago: University of Chicago Press, 1984), pp. 9–37.

53. Bruno Giberti, "The Classified Landscape: Consumption, Commodity Order, and the 1876 Centennial Exhibition at Philadelphia" (Ph.D. diss., University of California, Berkeley, 1994), pp. 95–101 and passim. See also Maass 1973.

54. The numerical system of classifying exhibits devised for the Centennial was modeled after Philadelphia's street and house numbering system. See Giberti 1994, pp. 17–18.

55. John Brinckerhoff Jackson, *American Space: The Centennial Years, 1865–1876* (New York: W. W. Norton, 1972), p. 234.

56. International Exhibition Co., Philadelphia, *Official Bulletin of the International Exhibition*, no. 4 (Philadelphia, 1877); quoted in Giberti 1994, p. 177.

57. Burton Benedict, "The Anthropology of World's Fairs," in *The Anthropology of World's Fairs: San Francisco's Panama Pacific International Exposition of 1915* (Berkeley, Calif.: Scolar Press, 1983), p. 2; quoted in Giberti 1994, p. 176 n. 2. See also Tony Bennett, "The Exhibitionary Complex," *New Formations*, vol. 4 (Spring 1988), pp. 81–82.

58. See Steven Conn, *Museums and American Intellectual Life, 1876–1926* (Chicago: University of Chicago Press, 1998), pp. 195–205.

59. From a letter read at the September 11, 1875, meeting of the Fairmount Park Commission; a transcript is contained in appendix 74 of the Minutes of the Fairmount Park Commission, 1875, Department of Records, Philadelphia City Archives.

60. Pennsylvania Museum (now the Philadelphia Museum of Art), *Annual Report*, 1876, p. 9; quoted in Conn 1998, p. 203.

61. See Gilbert Chinard, "The American Philosophical Society and the Early History of Forestry in America," *Proceedings of the American Philosophical Society*, vol. 89, no. 2 (July 1945), pp. 444–88; and Henry Savage, Jr., and Elizabeth J. Savage, *André and François André Michaux* (Charlottesville: University Press of Virginia, 1986), pp. 355–61.

62. Richards's painting (no. 188), probably a work from the 1860s, was lent by George Whitney; Lewis's view (no. 164) was lent by the artist.

63. Communications from the three groups were read at commission meetings in March and April 1879. See Minutes of the Fairmount Park Commission, 1879, Department of Records, Philadelphia City Archives.

64. Peter B. Hales, *Silver Cities: The Photography of American Urbanization, 1839–1915* (Philadelphia: Temple University Press, 1984), p. 69.

65. Hales 1984, p. 100. In May 1875, Cremer presented the commission with 120 stereographs; Minutes of the Fairmount Park Commission, 1875, Department of Records, Philadelphia City Archives.

66. See Joni Louise Kinsey, *Thomas Moran and the Surveying of the American West* (Washington, D.C.: Smithsonian Institution Press, 1992), pp. 6–7, 58–67.

67. See Johns 1983, pp. 82–114; and Foster 1997, pp. 144–50, 378–91.

68. Gordon Hendricks proposed this location because the stone parapet in the painting resembles a surviving parapet in the park. If this is correct, the carriage would have been heading directly toward the former location of the Carriage Exhibit pavilion at the Centennial. See "A May Morning in the Park," *Philadelphia Museum of Art Bulletin*, vol. 60, no. 285 (Spring 1965), pp. 48–49. See also Foster 1997, pp. 51–62.

69. Foster 1997, pp. 151–52.

70. Ibid., p. 159.

71. Ibid., pp. 158–59.

72. For Rogers's biography, see Edgar F. Smith, "Biographical Memoir of Fairman Rogers, 1833–1900, Read Before the National Academy of Science, 22 November 1906," in *Addresses, Papers, etc. . . . of the National Academy of Science* (Philadelphia, 1906), pp. 92–107.

73. Foster 1997, p. 158.

74. See Robert V. Bruce, *1877: Year of Violence* (Chicago: Quadrangle Press, 1970), pp. 194–96, 232–33.

75. Minutes of the Fairmount Park Commission, May 13, 1882, Department of Records, Philadelphia City Archives.

76. See Fredric M. Miller and William H. Will, "City Parks Association," in *Invisible Philadelphia: Community through Voluntary Organizations*, ed. Jean Barth Toll and Mildred S. Gillam (Philadelphia: Atwater Kent Museum, 1995), pp. 851–53.

77. See David Brownlee, *Building the City Beautiful: The Benjamin Franklin Parkway and the Philadelphia Museum of Art* (Philadelphia: Philadelphia Museum of Art, 1989).

78. See Gibson 1988, pp. 38–39.

79. See David Brownlee, *Making a Modern Classic: The Architecture of the Philadelphia Museum of Art* (Philadelphia: Philadelphia Museum of Art, 1997).

"Eakins and the Academy," pp. 95–106

KATHLEEN A. FOSTER

1. "Eakins . . . was to be a single sculler all his life" (Elizabeth Johns, *Thomas Eakins: The Heroism of Modern Life* [Princeton: Princeton University Press, 1983], p. 43). Eakins's student Horatio W. Shaw described his teacher as "very peculiar in his ways" (to Susie Shaw, October 3–5, 1880, Wilfred B. Shaw Papers, Bentley Historical Library, University of Michigan, Ann Arbor).

2. Eakins to Harrison Morris, April 23, 1894, Archives, Pennsylvania Academy of the Fine Arts, Philadelphia; quoted in Lloyd Goodrich, *Thomas Eakins*, 2 vols. (Cambridge, Mass.: Harvard University Press for the National Gallery of Art, 1982), vol. 2, p. 160.

3. Eakins's debt to his Parisian teachers was first explored by Gerald Ackerman, "Thomas Eakins and His Parisian Masters Gérôme and Bonnat," *Gazette des Beaux-Arts*, vol. 73 (April 1969), pp. 235–56. More recently, John Hayes has looked to a wider context in "Thomas Eakins and His European Contemporaries," in *Thomas Eakins (1844–1916) and the Heart of American Life*, ed. John Wilmerding (London: National Portrait Gallery, 1993), pp. 36–49. In this same book, pp. 16–35, Wilmerding used many binary oppositions to present "The Tensions of Biography and Art in Thomas Eakins." See also H. Barbara Weinberg's essay, "Studies in Paris and Spain," in this volume.

4. Goodrich 1982, vol. 1, p. 8; on Eakins's childhood training, see pp. 1–8. His education at Central High School was analyzed by Elizabeth Johns in "Drawing Instruction at Central High School and Its Impact on Thomas Eakins," *Winterthur Portfolio*, vol. 15, no. 2 (Summer 1980), pp. 139–49; and Kathleen A. Foster, *Thomas Eakins Rediscovered: Charles Bregler's Thomas Eakins Collection at the Pennsylvania Academy of the Fine Arts* (New Haven: Yale University Press for the Pennsylvania Academy of the Fine Arts, 1997), pp. 9–23. See also Amy B. Werbel's essay, "Eakins's Early Years," in this volume.

5. Johns 1980; and Michael Fried, *Realism, Writing, Disfiguration: On Thomas Eakins and Stephen Crane* (Chicago: University of Chicago Press, 1987).

6. Barbara Novak, *American Painting of the Nineteenth Century: Realism, Idealism, and the American Experience* (New York: Praeger, 1969), pp. 191–210; Fried 1987; see also Foster 1997, pp. 51–80.

7. Charles Bregler, "Thomas Eakins as a Teacher," *The Arts*, vol. 17, no. 6 (March 1931), p. 384.

8. These drawings may record the onset of new life classes at the Academy in 1855–56, when both Rothermel and Schussele were involved with the curriculum; perhaps they document the first female model hired for these sessions, in 1856. See Edward J. Nygren, "Art Instruction in Philadelphia, 1795–1845" (M.A. thesis, University of Delaware, 1969), pp. 141–43.

9. Eakins to Benjamin Eakins, December 23, 1866, Pennsylvania Academy of the Fine Arts, Philadelphia, Charles Bregler's Thomas Eakins Collection, purchased with the partial support of the Pew Memorial Trust (hereafter Bregler Collection).

10. Eakins to Benjamin Eakins, October 26, 1866, Bregler Collection; published in full in Kathleen A. Foster and Cheryl Leibold, *Writing About Eakins: The Manuscripts in Charles Bregler's Thomas Eakins Collection* (Philadelphia: University of Pennsylvania Press for the Pennsylvania Academy of the Fine Arts, 1989), pp. 197–203.

11. Eakins to Benjamin Eakins, October 29, 1868, Bregler Collection; see Foster and Leibold 1989, pp. 208–9.

12. Eakins to Caroline Cowperthwait Eakins and Frances Eakins, April 1, 1869, Archives of American Art, Smithsonian Institution, Washington, D.C. Ackerman (1969) was the first to understand Eakins's debts to Gérôme's work. For other sources on the impact of Gérôme and Bonnat, see H. Barbara Weinberg's essay, "Studies in Paris and Spain," in this volume.

13. On the academic method, see Albert Boime, *The Academy and French Painting in the Nineteenth Century* (1971; reprint, New Haven: Yale University Press, 1986). On Gérôme's version of this practice, which—like Eakins's—relied on preconception followed by study from nature, see Gerald Ackerman, *The Life and Work of Jean-Léon Gérôme, with a Catalogue Raisonné* (London: Sotheby's, 1986), pp. 162–63; for a fuller comparison of Eakins and Gérôme, with quotations from Earl Shinn's reviews, see Foster 1997, pp. 32–37, 144–50.

14. See Elizabeth Milroy, *Guide to the Thomas Eakins Research Collection, with a Lifetime Exhibition Record and Bibliography*, ed. W. Douglass Paschall (Philadelphia: Philadelphia Museum of Art, 1996), pp. 19–20; on the works sent to Paris in 1874 and 1875, see Foster 1997, p. 263 n. 16.

15. Clara Erskine Clement Waters and Laurence Hutton, *Artists of the Nineteenth Century and Their Works* (Boston: Houghton Mifflin, 1879; rev. ed. 1907), p. xxxiv. See also Eakins to Earl Shinn, April 2, 1874,

Richard T. Cadbury Papers, Friends Historical Library, Swarthmore College, Pa.

16. Susan Eakins, "Notes on Thomas Eakins," undated, Bregler Collection.

17. On French and American reactions to Bonnat's painting, see Foster 1997, p. 45.

18. On the reception of *The Gross Clinic*, see Goodrich 1982, vol. 1, pp. 130–38; Johns 1983, pp. 46–81.

19. Jules Prown has argued that *Baby at Play* is a pendant to the teaching and learning themes of *The Gross Clinic*; see "Thomas Eakins' *Baby at Play*," *Studies in the History of Art*, vol. 18 (1985), pp. 121–27.

20. The quotation is from Earl Shinn, "Fine Arts: The Lessons of a Late Exhibition," *The Nation*, vol. 26, no. 667 (April 11, 1878), p. 251. From this same time is *The Chess Players* (pl. 19) which draws from Gérôme's *Arnauts Playing Chess* (also known as *The Draught Players*, 1859; The Wallace Collection, London) and *Ave Caesar, Morituri Te Salutant* (fig. 35). See Johns 1983, pp. 82–114; Foster 1997, pp. 144–50. David Sellin has noted that Eakins's interest in the theme of an artist working from life coincided with the reinstitution of the Academy's life class, begun in 1876 only after much foot-dragging by the directors. Eakins and William Sartain solicited letters from their teachers Gérôme and Bonnat to argue for the importance of these classes; see David Sellin, "The First Pose: Howard Roberts, Thomas Eakins, and A Century of Philadelphia Nudes," *Philadelphia Museum of Art Bulletin*, vol. 70, nos. 311–12 (Spring 1975), pp. 5–56.

21. On *A May Morning in the Park*, see Theodor Siegl, *The Thomas Eakins Collection* (Philadelphia: Philadelphia Museum of Art, 1978), pp. 73–81; on the coaching phenomenon, see Foster 1997, pp. 151–62.

22. On *The Crucifixion*, see Siegl 1978, pp. 88–90; and Elizabeth Milroy, "'Consummatum est': A Reassessment of Thomas Eakins' *Crucifixion* of 1880," *The Art Bulletin*, vol. 71, no. 2 (June 1989), pp. 269–84.

23. On *Swimming*, see Doreen Bolger and Sarah Cash, eds., *Thomas Eakins and the Swimming Picture* (Fort Worth, Tex.: Amon Carter Museum, 1996), particularly Elizabeth Johns on the idealized "Academy" enacted in this painting, pp. 66–79.

24. Brownell's interview offers the best contemporary account of Eakins's impact on the Academy; see "The Art Schools of Philadelphia," *Scribner's Monthly*, vol. 18, no. 5 (September 1879), pp. 737–50. Remarks cited here from pp. 747 and 745.

25. Brownell 1879, p. 742.

26. Brownell 1879, pp. 740–41. The full course of Eakins's transformation of the school is traced in Louise Lippincott, "Thomas Eakins and the Academy," in *In This Academy: The Pennsylvania Academy of the Fine Arts, 1805–1976* (Philadelphia: Pennsylvania Academy of the Fine Arts, 1976), pp. 166–74. See also Goodrich 1982, vol. 1, pp. 167–89; Ronald J. Onorato, "The Pennsylvania Academy of the Fine Arts and the Development of an Academic Curriculum in the Nineteenth Century" (Ph.D. diss., Brown University, 1977), pp. 104–55; Maria Chamberlin-Hellman, "Thomas Eakins as a Teacher" (Ph.D. diss., Columbia University, 1981); Elizabeth Johns, "Thomas Eakins and 'Pure Art' Education," *Archives of American Art Journal*, vol. 23, no. 3 (1983), pp. 2–5; and Foster 1997, pp. 225–31.

27. A complete description of the curriculum and its rationale was given by Fairman Rogers, chairman of the Committee on Instruction, in an article evidently written with Eakins's assistance: "The Schools of the Pennsylvania Academy of the Fine Arts," *The Penn Monthly*, vol. 12 (June 1881), pp. 453–62; reprinted by the Pennsylvania Academy of the Fine Arts as a school brochure in 1881. Cited here from p. 3. Eakins's undated draft (c. 1881) on "The Object of the School," containing many of the ideas in Rogers's article, is in the Archives, Pennsylvania Academy of the Fine Arts, Philadelphia.

28. Eakins's manuscript of the drawing manual is in the Philadelphia Museum of Art; see Siegl 1978, p. 109. Variant texts are also in the Bregler Collection, along with most of his original illustrations; see Foster 1997, pp. 331–52.

29. Eakins, "The Object of the School," Archives, Pennsylvania Academy of the Fine Arts, Philadelphia.

30. Fairman Rogers, "The Schools of the Pennsylvania Academy of the Fine Arts," *The Penn Monthly*, vol. 12 (June 1881); reprinted by the Pennsylvania Academy of the Fine Arts as a school brochure in 1881. Cited here from p. 1.

31. Eakins to Benjamin Eakins, [autumn 1869], The Lloyd Goodrich and Edith Havens Goodrich, Whitney Museum of American Art, Record of Works by Thomas Eakins, Philadelphia Museum of Art.

32. Pennsylvania Academy of the Fine Arts brochure, 1881, pp. 2, 5 (see note 27).

33. See Christine Jones Huber, The Pennsylvania Academy and Its Women, 1850 to 1920 (Philadelphia: Pennsylvania Academy of the Fine Arts, 1973), pp. 12–17.

34. Eakins, "The Object of the School," Archives, Pennsylvania Academy of the Fine Arts, Philadelphia; Pennsylvania Academy of the Fine Arts brochure, p. 1 (see note 27).

35. Eakins to the Committee on Instruction, January 8, 1876 [1877], Archives, Pennsylvania Academy of the Fine Arts, Philadelphia. Eakins complained about the coarse, "flabby" figures of the models then in use, who were usually lower-class women or prostitutes.

36. "R.S." to James L. Claghorn, April 11, 1882, Archives, Pennsylvania Academy of the Fine Arts, Philadelphia. The full text is published in Goodrich 1982, vol. 1, pp. 282–84.

37. On the Comstock movement, see Anne McCauley, "'The Most Beautiful of Nature's Works': Thomas Eakins's Photographic Nudes in their French and American Contexts," in Susan Danly and Cheryl Leibold, Eakins and the Photograph: Works by Thomas Eakins and His Circle in the Collection of the Pennsylvania Academy of the Fine Arts (Washington, D.C.: Smithsonian Institution Press for the Pennsylvania Academy of the Fine Arts, 1994), pp. 52–57. On the models in Swimming and the reception of the painting, see Bolger and Cash 1996, pp. 13–31, 49–60, 117–22.

38. See Goodrich 1982, vol. 1, pp. 282–91; Foster and Leibold 1989, pp. 69–90, 109.

39. Eakins to Edward H. Coates, February 15, 1886, Bregler Collection. Eakins's position is best understood from his sequence of letters to Coates, published in Foster and Leibold 1989, pp. 214–18.

40. Harrison Morris, Confessions in Art (New York: Sears, 1930), p. 31. Representing the opinion of the next generation, Morris would argue for Eakins's "innocence."

41. Goodrich 1982, vol. 2, p. 97.

42. On the scandals of the 1890s and Eakins's personality, see Foster and Leibold 1989, pp. 69, 78–79 , 93–122; Foster 1997, pp. 118, 259 n. 42.

43. Eakins to Charlotte Connard, March 2, 1887, Bregler Collection.

44. Eakins's one line of thanks to the committee assured them of "my appreciation of the motives which led to the establishment of the prize" (Goodrich 1982, vol. 2, p. 201). He meant that he remembered the establishment of the Temple Fund in 1880, which supported the award of a cash prize and medals beginning in 1883, and the purchase of contemporary art for the Academy. His own painting, The Cello Player, was acquired for the Academy by the Temple Fund in 1897, as relations between the artist and the Academy warmed. The prize devolved, however, into a medal worth only seventy-three dollars (when Eakins baldly cashed it after the ceremony).

45. On these miserable episodes of the 1890s, see "The 'Nude' at Drexel," "The Hammitt Case: 'A Most Unfortunate Lady,'" and "Ella Crowell's Suicide," in Foster and Leibold 1989, pp. 93–122. Siegl (1978, p. 44) noted that Eakins's last lectures (at the Cooper Union) were in 1897; Goodrich (1982, vol. 1, p. 308) dated these to 1898.

46. On Eakins's late honors, see Goodrich 1982, vol. 2, pp. 199–201.

47. On the late Rush paintings, see Johns 1983, pp. 82–114. On Gérôme's late paintings on the theme of the sculptor, see Ackerman 1969, pp. 246–47; and Ackerman 1986, pp. 308–33.

"The 1880s," pp. 107–20

MARC SIMPSON

1. "Art in Philadelphia. An Exhibition of Paintings by American Artists at the Pennsylvania Academy of Fine Arts," The New York World, November 21, 1881, p. 2. Much the same phrase was used a year later in "Fine Arts. The American Water-Color Society. Fifteenth Exhibition. II," The Independent, February 16, 1882, p. 8.

2. It was a source of personal pride, as well. In the contract between him and his father regarding rent, board, and privacy, written in 1883, Eakins was referred to as "painter and sculptor, Director of the schools of the Pennsylvania Academy of the Fine Arts"; Benjamin, the writing master, was characterized simply as "his father." See Phyllis D. Rosenzweig, The Thomas Eakins Collection of the Hirshhorn Museum and Sculpture Garden (Chicago: University of Chicago Press, 1977), pp. 114–15.

3. "The Fine Arts. The Academy Exhibition—Fifth Notice," Daily Evening Telegraph (Philadelphia), November 19, 1881, p. 12. Another phrased it less kindly: "Mr. Eakins is an artist who is apt to astonish and to irritate by his assertion of a very unique individuality" ("The Philadelphia Art Exhibition," Harper's Weekly, vol. 25, no. 1303 [December 10, 1881], p. 827).

4. Clarence Cook, "The Art Gallery: The Water-Color Society's Exhibition," The Art Amateur, vol. 6, no. 4 (March 1882), p. 74.

5. When in 1882 George Parsons Lathrop published an article about the city, Eakins was one of two living painters mentioned by name and, more remarkably, one of nine men—the others all social and financial leaders—to have his portrait reproduced. See "'A Clever Town Built by Quakers,'" Harper's New Monthly Magazine, vol. 64, no. 381 (February 1882), p. 336.

6. Even before his official advancement, Eakins had played a major role in the teaching program. His supervisor, Christian Schussele, had been in declining health for years. In January 1879, the Committee on Instruction at the Academy considered forcing Schussele's resignation. The minutes reported: "It apparently could not be accomplished without the loss of Mr. Eakins' services—he considering himself bound in honor to Professor Schussele, so that he could not continue his connection with the Academy, after Professor Schussele's resignation, if caused by any act of the Academy. The committee considered it a matter of vital importance to the schools to retain Mr. Eakins; and believed that he would be willing to serve for some [time] without compensation, if Professor Schussele should not be compelled to resign" (quoted in Lloyd Goodrich, Thomas Eakins, 2 vols. [Cambridge, Mass.: Harvard University Press for the National Gallery of Art, 1982], vol. 1, p. 172).

7. William C. Brownell, "The Art Schools of Philadelphia," Scribner's Monthly, vol. 18, no. 5 (September 1879), pp. 737–50.

8. Ibid., pp. 740–42.

9. Ibid., pp. 743–45.

10. Frank Waller, Report on Art Schools (New York: Art Students' League, 1879), p. 20. Waller continued: "This school, which I visited very lately, impressed me strongly with the genuineness of a real love for art, which I found in both teacher and student....The relation between Mr. Eakins and the students is most intimate and friendly, and arises partly from the fact that Mr. Eakins is but little, if any, older than some in the school, partly because he has been there several years, but mainly on account of his ability, and the unquestioned assistance they actually receive from him. The relation is more like family than that of master and scholars, and Mr. Eakins, in his association with the trustees and committee of instruction, has many opportunities to further the interest of the students not common in schools of this character" (p. 22).

11. Pennsylvania Academy of the Fine Arts, Circular of the Committee on Instruction, 1882–83 (Philadelphia: Pennsylvania Academy of the Fine Arts, 1882), p. 3.

12. Sigma [Earl Shinn], "A Philadelphia Art School," The Art Amateur, vol. 10, no. 2 (January 1884), p. 32. Indeed, he added: "on the death of Mr. Schuessele [sic], [Eakins] was placed in full charge of the school. The Pennsylvania Academy of the Fine Arts, as an educational institution, in fact as well as name, dates from this time" (p. 33).

13. William J. Clark, Jr., "The Fine Arts. The Academy Exhibition—Fifth Notice," Daily Evening Telegraph (Philadelphia), November 19, 1881, p. 12. Years later, when the Academy was facing a change in the regimen of teaching, Clark would write: "I have taken the greatest interest in all experiments that have been made in the way of securing for Philadelphia an art school in which the fundamentals at least would

be thoroughly taught. I hoped that the solution of the problem had been reached when a man whom I knew to be a scientific draftsman and to have great teaching promise was placed in charge of the classes. I think that . . . an excellent foundation has been made upon which it should be possible to build with success" (Clark to Edward H. Coates, February 22, 1886, Archives, Pennsylvania Academy of the Fine Arts, Philadelphia).

14. Horatio W. Shaw to Susie Shaw, October 3–5, 1880, Wilfred B. Shaw Papers, Bentley Historical Library, University of Michigan, Ann Arbor.

15. A readily accessible survey of Eakins's teaching is in Goodrich 1982, vol. 1, p. 188.

16. Kathleen A. Foster, *Thomas Eakins Rediscovered: Charles Bregler's Thomas Eakins Collection at the Pennsylvania Academy of the Fine Arts* (New Haven: Yale University Press for the Pennsylvania Academy of the Fine Arts, 1997), pp. 59–62, 331–51. The manuscripts of the lectures are now in the collection of the Philadelphia Museum of Art, with incomplete drafts at the Pennsylvania Academy of the Fine Arts, Philadelphia, Charles Bregler's Thomas Eakins Collection, purchased with the partial support of the Pew Memorial Trust (hereafter Bregler Collection).

17. "The Fine Arts," *Daily Evening Telegraph* (Philadelphia), October 17, 1881, p. 4. Mariana Griswold van Rensselaer noted earlier in 1881 that "His teaching occupies most of his time in the winter" (Van Rensselaer to S. R. Koehler, June 12, 1881, Koehler Papers, Archives of American Art, Smithsonian Institution, Washington, D.C. [hereafter Archives of American Art]; quoted in Goodrich 1982, vol. 1, p. 198).

18. The fullest discussions of the work have been Elizabeth Milroy, "'Consummatum est . . .': A Reassessment of Thomas Eakins's *Crucifixion* of 1880," *The Art Bulletin*, vol. 71, no. 2 (June 1989), pp. 269–84; and Lois Dinnerstein, "Thomas Eakins' *Crucifixion* as Perceived by Mariana Griswold van Rensselaer," *Arts Magazine*, vol. 53, no. 9 (May 1979), pp. 140–45.

19. Goodrich 1982, vol. 1, pp. 190–91. Eakins reportedly made photographs (none are now known); painted a small, extremely strong, contrast-full study of the head (1880, Hirshhorn Museum and Sculpture Garden, Smithsonian Institution, Washington, D.C.); and continued the campaign in his studio and, perhaps, on the roof of the Mount Vernon Street house.

20. Milroy (1989, pp. 271–73) has made highly reasonable comparisons to works by Velázquez, Rubens, and Delacroix.

21. As an American reviewer noted in 1883: "The Crucifixions of this year, not less numerous than usual, mark also with pregnant emphasis this characteristic of to-day's French art. Not one of them, vital point of the religious life of millions though the scene is, would awaken a single heavenward-aspiring thought, or even tender earthly emotion. . . . In all these pictures, the showy, colorful, and color-focusing blood is always scientifically arranged, and largely *en evidence*, while the anatomical and muscular expression of the mortal leaves no place for suggestion of the divine agony" ("The Contributors' Club," *The Atlantic Monthly*, vol. 52 [November 1883], p. 713; quoted in Milroy 1989, p. 277).

The well-known *Crucifixion* of Léon Bonnat (fig. 28), exhibited in the Salon of 1874, is exemplary of the type, having gained special notoriety through tales of its creation: the painter was said to have nailed a well-muscled cadaver to a cross to serve as his model. In 1882, William J. Clark, Jr., drew a direct comparison between the works by Eakins and Bonnat in "The Fine Arts: The Academy Exhibition—Third Notice," *Daily Evening Telegraph* (Philadelphia), November 1, 1882, p. 4.

22. S. R. Koehler, "The Exhibitions. III.—Second Annual Exhibition of the Philadelphia Society of Artists," *The American Art Review*, vol. 2, pt. 1, no. 3 (January 1881), p. 105. Frank Moss, Charles Sprague Pearce, Stephen Parker, and the more senior Edward H. May showed large religious canvases with the Philadelphia Society of Artists (held at the Pennsylvania Academy; they each had also shown these particular works in earlier Paris Salons); J. Alden Weir at the Society of American Artists in 1880; and the older Benjamin F. Reinhart at the National Academy of Design in 1879.

23. "Budding Academicians. American Genre Pictures," *The New York Times*, April 20, 1879, p. 10.

24. "Fine Arts. Exhibition Notes," *The Independent*, May 11, 1882, p. 99.

25. M[ariana] G[riswold] v[an] R[ensselaer], "Art Matters. The Fifth Annual Exhibition of the Society of American Artists, New York," *Lippincott's Magazine*, n.s., vol. 4 (July 1882), pp. 106–7.

26. "The Fine Arts: Review of the Fifty-third Annual Exhibition of the Pennsylvania Academy of the Fine Arts (Second Notice)," *Philadelphia Evening Bulletin*, November 13, 1882, p. 8. The review noted: "As regards the higher merits of technique, the rigid observance of correct anatomical measurements and requirements, and the remarkable analytical study of the physical manifestations of a crucified figure, the picture will always gain and hold the praise of those who are thoroughly conversant with the difficulty of painting and drawing, and who view the composition simply from that standpoint. To those who from deep sacred feelings invest the person of Christ with ideal characteristics and qualities, the manner in which Mr. Eakins has treated the subject can never seem anything else than offensively repulsive."

27. William J. Clark, Jr., "The Fine Arts: The Academy Exhibition—Third Notice," *Daily Evening Telegraph* (Philadelphia), November 1, 1882, p. 4.

28. Eakins to Frances Eakins, April 1, 1869, Archives of American Art. He had earlier written in the same vein, complaining about grammarians and their rules: "All this springs from such a fact as simple as the religion of Jesus Christ & see what men & grammarians have done for them both" (Eakins to Frances Eakins, June 19, 1867, Archives of American Art).

29. M[ariana] G[riswold] van Rensselaer, "Picture Exhibitions in Philadelphia.—II," *The American Architect and Building News*, vol. 10, no. 314 (December 31, 1881), p. 311. She concluded: "and in preaching it as he does with his clever and well-trained brush, persistently, variously, and in calm disregard of the question whether or not pecuniary gain and general popularity will immediately follow, Mr. Eakins nobly supplements his more direct teacher's work in the Philadelphia school."

30. See, for example, Dewing's *The Spinner* (1880, Brigham Young University Art Gallery Collection, Salt Lake City, Utah), which combines a mismatch of costume, props, and action.

31. "Art Notes: New York—The American Water-Color Society," *The Art Journal* (New York), n.s., vol. 7 (March 1881), p. 95; William J. Clark, Jr., "The Fine Arts: The Academy Exhibition—Third Notice," *Daily Evening Telegraph* (Philadelphia), November 1, 1882, p. 4; "The Academy Exhibition," *The Art Amateur*, vol. 4, no. 3 (February 1881), p. 47.

32. L[eslie] W. Miller, "Water-Color Exhibition at Philadelphia," *The American Architect and Building News*, vol. 11, no. 330 (April 22, 1882), p. 185.

33. Eakins's exhibition record notebook, Bregler Collection, pp. 43–44.

34. Eakins to James P. Scott, June 18, 1883; quoted in Goodrich 1982, vol. 1, p. 216.

35. The manuscript is now in the collection of the Philadelphia Museum of Art.

36. Eakins to James P. Scott, June 18, 1883; quoted in Goodrich 1982, vol. 1, p. 216.

37. Eakins to James P. Scott, June 18, 1883, transcript in the Lloyd Goodrich and Edith Havens Goodrich, Whitney Museum of American Art, Record of Works by Thomas Eakins, Philadelphia Museum of Art; quoted in Goodrich 1982, vol. 1, p. 216.

38. For a full account, see Goodrich 1982, vol. 1, pp. 213–19.

39. For more details and further exhibition history, see my essay, "Eakins's Visions of the Past and the Building of a Reputation," in this volume.

40. When the painting was shown in Philadelphia, one local writer noted that "the figures in this work are capital portraits" ("The Fine Arts. Fifty-third Annual Exhibition of the Pennsylvania Academy of the Fine Arts," *Philadelphia Evening Bulletin*, October 21, 1882, p. 6).

41. Rosenzweig 1977, pp. 93–94; Foster 1997, pp. 404–5.

42. Foster 1997, pp. 114–16.

43. Edward Strahan [Earl Shinn], "Exhibition of the Society of American Artists," *The Art Amateur*, vol. 4, no. 6 (May 1881), p. 117.

44. S.G.W. Benjamin, "The Exhibitions. VIII.—Society of American Artists. Fourth Annual Exhibition," *The American Art Review*, vol. 2, pt. 2, no. 2 (June 1881), pp. 72–73.

45. "Art Notes. New York.—American Art Gallery," *The Art Journal*, n.s., vol. 7 (May 1881), pp. 157–58.

46. M[ariana] G[riswold] van Rensselaer, "The New York Art Season," *The Atlantic Monthly*, vol. 48, no. 286 (August 1881), pp. 198–99.

47. "Some American Artists: Various Notable Pictures in the Exhibition," *The New York Times*, April 15, 1881, p. 5.

48. "The Fine Arts: Fifty-third Annual Exhibition of the Pennsylvania Academy of the Fine Arts," *Philadelphia Evening Bulletin*, October 21, 1882, p. 6; "The Fine Arts," *Philadelphia Evening Bulletin*, November 13, 1882, p. 8.

49. L[eslie] W. Miller, "Art in Philadelphia. The Fifty-Third Annual Exhibition at the Academy," *The American Architect and Building News*, vol. 12, no. 361 (November 25, 1882), p. 253.

50. A Philadelphia reviewer, seeing pictures of workingmen by both Anshutz and Eakins, wrote: "The qualities for which we chiefly honor [Eakins], are, however, better expressed in the work of his promising pupil, Mr. Aushutz [*sic*], which hangs near his own" ("The Fine Arts. The Philadelphia Exhibition at the Academy. Fourth Notice," *The Philadelphia Press*, December 9, 1881, p. 5).

51. "The Fine Arts," *Daily Evening Telegraph* (Philadelphia), October 17, 1881, p. 4.

52. Foster 1997, pp. 439–42.

53. For this group as a whole, as well as an intense discussion of Eakins and photography in these works, see Foster 1997, pp. 163–77.

54. See Mark Tucker and Nica Gutman's essay, "Photographs and the Making of Paintings," in this volume.

55. M[ariana] G[riswold] van Rensselaer, "Picture Exhibitions in Philadelphia.—II," *The American Architect and Building News*, vol. 10, no. 314 (December 31, 1881), p. 311; "The Fine Arts. The Philadelphia Exhibition at the Academy. Fourth Notice," *The Philadelphia Press*, December 9, 1881, p. 5. Van Rensselaer also commented on the work favorably in "Art Matters. Exhibitions of the Pennsylvania Academy of Fine Arts and the Philadelphia Society of Artists," *Lippincott's Magazine*, vol. 29, n.s., vol. 3 (January 1882), p. 104.

56. Edward Strahan [Earl Shinn], "The Art Gallery: The Philadelphia Society of Artists. Third Annual Exhibition," *The Art Amateur*, vol. 6, no. 2 (January 1882), p. 26.

57. "The Academy of Design," *The New York Times*, April 30, 1882, p. 3.

58. *Mending the Net* (private collection) and *Taking Up the Net* (The Metropolitan Museum of Art, New York).

59. L[eslie] W. Miller, "Water-Color Exhibition at Philadelphia," *The American Architect and Building News*, vol. 11, no. 330 (April 22, 1882), p. 185.

60. When the same two works had been seen in New York, they were reviewed favorably as "strong, artistic and individual" by Van Rensselaer, who also called them "two of the most capable things in the rooms, ... complete in their bold yet accurate modelling on so small a scale, and in their strong local flavor." See "Our Monthly Gossip: Art Matters. The Water-Color Exhibition in New York," *Lippincott's Magazine*, n.s., vol. 3 (April 1882), p. 418; and "Water-Colors in New York," *The American Architect and Building News*, vol. 11, no. 328 (April 8, 1882), p. 160.

61. M[ariana] G[riswold] van Rensselaer, "Picture Exhibitions in Philadelphia.—II," *The American Architect and Building News*, vol. 10, no. 314 (December 31, 1881), p. 311.

62. Edward Strahan [Earl Shinn], "Works of American Artists Abroad. The Second Philadelphia Exhibition," *The Art Amateur*, vol. 6, no. 1 (December 1881), p. 6. He concluded by comparing Eakins's work to a painting by Titian: "This view of the baggy side of a series of breeches really has more expression than Titian's series of bishops' backs in the Louvre."

63. "The Fine Arts. The Philadelphia Society Exhibition at the Academy. Third Notice," *The Philadelphia Press*, December 2, 1881, p. 5.

64. He continued: "The industry and endeavor to be true are readily acknowledged; but the art is that of the copper-plate, dry and unimaginative" ("The Academy of Design," *The New York Times*, March 30, 1882, p. 5). The writer in *The Art Journal* concurred: "Each figure is sharply individualized, and the interest of the work is in these separately. Taken as a whole, they do not fuse into the landscape nor satisfy in any way the requirements of a picture" ("Art Notes. New York—Academy of Design," *The Art Journal*, vol. 8 [June 1882], p. 190).

65. Harold [A Special Correspondent], "Art at the Metropolis," *The Philadelphia Press*, March 28, 1882, p. 5. Just over a week later, a staff writer covered the same exhibition and praised the work: "All told, there is nothing here in its line to match Thomas Eakin's [*sic*] 'Net Mending'" (T. W., "Art in New York," *The Philadelphia Press*, April 7, 1882, p. 2).

66. "World's Fair Medals to American Artists," *The Art Amateur*, vol. 29, no. 6 (November 1893), p. 163.

67. "The Fine Arts: Fifty-Fifth Annual Exhibition at the Academy," *The Philadelphia Inquirer*, October 30, 1884, p. 2.

68. Clarence Cook, "The Society of American Artists' Exhibition," *The Art Amateur*, vol. 8, no. 6 (May 1883), p. 124.

69. At least one of Eakins's knitting scenes, and one that he frequently exhibited, evidently portrayed a woman knitting in contemporary dress rather than historic costume—*A Quiet Moment* (location unknown).

70. Benjamin Eakins, among other positions, taught penmanship for fifty-one years at Friend's Central School and engrossed diplomas for Jefferson Medical College from 1846 to 1878. For the latter, see Julie S. Berkowitz, *"Adorn the Halls": The History of the Art Collection at Thomas Jefferson University* (Philadelphia: Thomas Jefferson University, 1999), p. 124.

71. Eakins to Bryson Burroughs, April 23, 1916, Archives, The Metropolitan Museum of Art, New York. When, in 1917, the museum did purchase the work, Susan Eakins wrote to convey her "happiness in the knowledge that the most treasured for all reasons, of the pictures—the portrait of my husband's father 'The Writing Master' has found a safe and honored position among the works of other painters, whom Eakins respected and admired" (Susan Eakins to Bryson Burroughs, December 21, 1917, Archives, Metropolitan Museum of Art, New York; quoted in Natalie Spassky, *American Paintings in the Metropolitan Museum of Art: A Catalogue of Works by Artists Born between 1816 and 1845* [New York: The Metropolitan Museum of Art, 1985], p. 605).

72. For Clarke, see H. Barbara Weinberg, "Thomas B. Clarke: Foremost Patron of American Art from 1872–1899," *The American Art Journal*, vol. 8, no. 1 (May 1976), pp. 52–83. Theodor Siegl, citing entries in Eakins's account book (Collection of Daniel W. Dietrich II, hereafter Dietrich Collection), indicated the commission as being for three hundred dollars (entry for April 5, 1884), minus the cost of the frame, which eventually amounted to thirty dollars. See Theodor Siegl, *The Thomas Eakins Collection* (Philadelphia: Philadelphia Museum of Art, 1978), p. 105.

73. Eakins exhibited the watercolor widely from 1876 through 1880, then again in his one-man exhibitions of 1901 and, probably, 1896.

74. Guitar players were a significant subject among advanced painters from the 1860s onward, with such artists as Edouard Manet and Edgar Degas responding to a fascination with things Spanish. Among American artists, J. Alden Weir, Dennis Miller Bunker, and, especially, John Singer Sargent—in his widely publicized *El Jaleo* (1880–82, Isabella Stewart Gardner Museum, Boston)—used the instrument as a major element in compositions from the 1880s. Eakins's decision to pair the guitar with the zither is curious. In spite of the Mediterranean look of the two men, the zither was known as an instrument popular in German-speaking regions of Europe, particularly Bavaria, Austria, and Switzerland. It was apt for his friend Max Schmitt to relax by playing the instrument in the watercolor of 1876. It was somewhat less likely to see it paired with the guitar and in the distinctly overlarge hands of the Spanish-masquerading Wallace.

75. "The Clarke Exhibition. First Notice," *The Studio*, vol. 2, no. 52 (December 29, 1883), p. 298; "The Fine Arts: Fifty-Fifth Annual Exhibition at the Academy," *The Philadelphia Inquirer*, October 30, 1884, p. 2; M[ariana] G[riswold] van Rensselaer, "Pictures of the Season in New York," *The American Architect and Building News*, vol. 15, no. 430 (March 22, 1884), pp. 136–37; "Art Gossip," *Art Age*, vol. 3, no. 27 (October 1885), p. 45.

76. Eakins had clearly matured since he had written to his father from Paris, "If I went to Greece to live there twenty years I could not paint a Greek subject for my head would be full of classics the nasty besmeared wooden hard gloomy tragic figures of the great French school of the last few centuries & Ingres & the Greek letters I learned at the High School with old Haverstick & my mud marks of the antique statues" (Eakins to Benjamin Eakins, March 6, 1868, Bregler Collection).

77. These have been most fully explicated in Foster 1997, pp. 179–83.

78. For a particularly winning account, see James W. Crowell, ed. by Betty Crowell, "Recollections of Life on the Crowell Farm," in *Eakins at Avondale and Thomas Eakins: A Personal Collection*, ed. William Innes Homer (Chadds Ford, Pa.: Brandywine River Museum, 1980), pp. 15–17.

79. Charles Bregler, "Thomas Eakins as a Teacher," *The Arts*, vol. 17, no. 6 (March 1931), p. 386.

80. "Laws of Sculptured Relief" lecture, insert between pp. 4–5, typescript in Thomas Eakins Research Collection, Philadelphia Museum of Art.

81. For Tanagra figurines in the Pennsylvania Academy's collection, see Foster 1997, pp. 184–85.

82. Siegl 1978, p. 107.

83. The work was the subject of a recent exhibition and accompanying catalogue that explored many of its elements and several of its contexts: Doreen Bolger and Sarah Cash, eds., *Thomas Eakins and the Swimming Picture* (Fort Worth, Tex.: Amon Carter Museum, 1996).

84. Rogers wrote to Eakins on November 9, 1883 (Bregler Collection): "I suppose that you will not be pleased when I tell you that I have resigned from the Board of Direction of the Penna. Academy of the Fine Arts. I have had for several years past altogether too many occupations and interests and I am determined to diminish their number and to have my time more at my own disposal.

"I leave the Academy with regret as I have many pleasant associations with my work there—not the least among them the hours spent with you."

85. The two most extensive, accessible considerations of the Naked Series are Ellwood C. Parry III, "Thomas Eakins's 'Naked Series' Reconsidered: Another Look at the Standing Nude Photographs Made for the Use of Eakins's Students," *The American Art Journal*, vol. 20, no. 2 (Spring 1988), pp. 53–77 (the quoted passage is on p. 72); and Anne McCauley, "'The Most Beautiful of Nature's Works': Thomas Eakins's Photographic Nudes in Their French and American Contexts," in Susan Danly and Cheryl Leibold, *Eakins and the Photograph: Works by Thomas Eakins and His Circle in the Collection of the Pennsylvania Academy of the Fine Arts* (Washington, D.C.: Smithsonian Institution Press for the Pennsylvania Academy of the Fine Arts, 1994), pp. 22–63.

86. Pennsylvania Academy of the Fine Arts, *Circular of the Committee on Instruction, 1882–83* (Philadelphia: Pennsylvania Academy of the Fine Arts, 1882), p. 3.

87. Writers over the years have proposed various identifications, but those put forward by Sarah Cash seem the most supportable; see "'Friendly and Unfriendly': The Swimmers of Dove Lake," in Bolger and Cash 1996, pp. 49–65.

88. The account book in the Dietrich Collection records that Eakins spent funds for travel to Dove Lake and photography by July 31, 1884, and then throughout the remainder of the year and into 1885.

89. Eakins was well into his tenure as Director of Schools, actively involved at the University of Pennsylvania with the world's leading experimenters in the recording of human and animal locomotion, confident in his artistic powers, and represented in his home institution's prestigious annual art exhibition by two portraits of students—one of them, Wallace, then himself a teacher predictive of an educational dynasty—and a successfully completed commission from his immediate supervisor.

90. "At the Private View. First Impressions of the Autumn Exhibition at the Academy of the Fine Arts," *The Times* (Philadelphia), October 29, 1885, p. 2.

91. Coates to Eakins, November 27, 1885, Bregler Collection.

92. L[eslie] W. M[iller], "Art. The Awards of Prizes at the Academy," *The American*, vol. 11, no. 274 (November 7, 1885), p. 45.

93. Edward Strahan [Earl Shinn], "The Art Gallery: The Philadelphia Society of Artists. Third Annual Exhibition," *The Art Amateur*, vol. 6, no. 2 (January 1882), p. 26.

94. "The Fine Arts. The Academy Exhibition—Fifth Notice," *Daily Evening Telegraph* (Philadelphia), November 19, 1881, p. 12.

95. L[eslie] W. Miller, "The Fifty-fourth Annual Exhibition at the Pennsylvania Academy," *The American Architect and Building News*, vol. 14, no. 417 (December 22, 1883), p. 293. See also his Dickensian complaint in "Letter from Philadelphia," *The Art Student*, vol. 1, no. 4 (December 1884), unpaginated. Miller would later write at length about his belief in the need for drawing as a foundation of art education, counter

96. When Eakins was elevated to being Director of Schools in 1882, it was in the midst of a reorganization that included the imposition of student tuition fees, in the hope of making the schools self-sufficient. He received a salary of twelve hundred dollars and the promise of doubling it "as soon and as rapidly as the income of the school will permit" (Board Minutes, Pennsylvania Academy of the Fine Arts, March 13, 1882; quoted in Goodrich 1982, vol. 1, p. 187). Eakins asked in 1885 for a salary increase to twenty-five hundred dollars, suggesting that "my promised salary was a large factor in my determination to remain in Philadelphia"—one of the few times he is on record as showing that he ever considered leaving his native city (Eakins to the Pennsylvania Academy of the Fine Arts, April 8, 1885; quoted in Goodrich 1982, vol. 1, p. 281). The administration, feeling the pressure of a continuing deficit of six thousand to seven thousand dollars a year and having embarked on a one-hundred-thousand-dollar endowment fund for the support of the school, declined the request. The endowment fund was announced widely, being reported so far afield as "Art and Artists," *Daily Evening Transcript* (Boston), May 11, 1885, p. 7.

97. "R. S." to James L. Claghorn, April 11, 1882, Archives, Pennsylvania Academy of the Fine Arts, Philadelphia; quoted in Goodrich 1982, vol. 1, pp. 282–84.

98. The community in general, led by such moral reformers as Joseph Leeds, voiced loud and successful campaigns during these years to condemn sensuous materials, including the fine arts. The work of Leeds and his spiritual mentor, Anthony Comstock, is summarized in McCauley in Danly and Leibold 1994, pp. 52–57.

99. Eakins to E. Mitchell, October 27, 1888; quoted in Goodrich 1982, vol. 1, p. 285.

100. Eakins to Emily Sartain, March 25, 1886, Archives, Pennsylvania Academy of the Fine Arts, Philadelphia.

101. Coates to Eakins, February 8, 1886, Bregler Collection.

102. Among the fuller accounts of Eakins's troubles at the Academy and the Philadelphia Sketch Club are David Sellin, *Thomas Eakins, Susan Macdowell Eakins, and Elizabeth Macdowell Kenton* (Roanoke, Va.: North Cross School, 1977), pp. 32–43; and Kathleen A. Foster and Cheryl Leibold, *Writing About Eakins: The Manuscripts in Charles Bregler's Thomas Eakins Collection* (Philadelphia: University of Pennsylvania Press for the Pennsylvania Academy of the Fine Arts, 1989), pp. 69–90.

103. Eakins to Coates, February 15, 1886, Bregler Collection.

104. "Professor Eakins Resigns. He Withdraws from the Life Class of the Academy of the Fine Arts," *Philadelphia Evening Bulletin*, February 15, 1886, p. 6.

105. *The Evening Item* took great pleasure, it seems, in announcing on its front page "The End of Eakins. The Eccentric Director of the Academy Life Class Retires" and going on to declare: "Professor Eakins has been given a lengthened trial, and has proved from the first a mistake. Very few of the scholars who graduated from the Academy have amounted to anything; those who have achieved reputation have attained it by abandoning the methods forced on them by Mr. Eakins and begun over again on a sensible plan.... Mr. Eakins cannot paint a good picture. His latest work, 'The Bathers,' which was in the December exhibition of the Academy, was more than usually bad.... We admire Mr. Eakins for one thing, and that is, his resignation from the Academy" (*The Evening Item* [Philadelphia], February 15, 1886, p. 1).

106. "Indignant Art Students. They Demand the Return of Mr. Thomas Eakins to the Academy of the Fine Arts," *Philadelphia Evening Bulletin*, February 16, 1886, p. 6.

107. "The Fiery Art Students. The Directors Will Refuse Their Request for Mr. Eakins' Return," *The North American* (Philadelphia), February 18, 1886, p. 1.

108. "Forming a Students' League. Artists Join Their Fortunes and Elect Professor Eakins Instructor," *The Philadelphia Press*, February 19, 1886, p. 2.

109. C., "Philadelphia Letter," *The Art Interchange*, vol. 16, no. 5 (February 27, 1886), p. 69.

110. C., "Philadelphia Letter," *The Art Interchange*, vol. 16, no. 13 (June 19, 1886), p. 195.

to Eakins's approach: L[eslie] W. M[iller], "Art, a Question of Methods," *The American*, vol. 12, no. 303 (May 29, 1886), p. 92.

111. Eakins to John Laurie Wallace, October 22, 1888, Bregler Collection.

112. He wrote to Coates: "It seems that Stephens had been bragging some time of his power over me, that he could put me out of the school and out of the city and out of any other school, and all this while living in my family & professing great friendship & admiration for me. I have been very blind.... It was a petty conspiracy in which there was more folly than malice weak ambitions and foolish hopes, and the actors in it are I think already coming to a sense of their shame. My conscience is clear, and my suffering is past" (Eakins to Coates, draft, c. March 10, 1886, Bregler Collection).

113. Eakins to Coates, September 11, 1886, Bregler Collection.

114. See Foster and Leibold 1989, pp. 156–59, 165–67, 172–79, and 214–39, for a survey of relevant materials in the Bregler Collection.

115. The campaign against Eakins evidently included questioning their status as husband and wife. He wrote to Arthur Frost: "I have desired for many months to lay before you evidence of the falsity of some outrageous slanders, and it was for this purpose *only* that I took the liberty of calling at your home some weeks ago. My reason for wishing to show you my marriage certificate, amongst other things, is that you as a well wisher may be in a position to say to any doubter or enquirer, if you feel like it, that you know there was nothing irregular in our marriage which was in the Quaker form and registered and published in the daily papers, it having been industriously rumored that Sue and I were unmarried" (June 8, 1887, Bregler Collection).

116. Eakins praised his wife's painting, calling her, according to Goodrich (1982, vol. 1, p. 223), the "best woman painter in America." In 1887, when he was out West, he wrote to her: "I only found one letter from you and that one a little doleful on account of your bad painting. All painting is bad but yours is very good compared with other people's" (Eakins to Susan Eakins, Wednesday morning [August or September, 1887], Bregler Collection).

117. The fullest consideration of the painting is Ellwood C. Parry III, "The Thomas Eakins Portrait of Sue and Harry; or, When Did the Artist Change His Mind?" *Arts Magazine*, vol. 53, no. 9 (May 1979), pp. 146–53; see also Goodrich 1982, vol. 1, pp. 224–27. I am grateful to Rachel Butt (Williams College, M.A. '01) for her insight during our joint exploration of this work.

118. Eakins to Frances Eakins, June 4, 1886, Bregler Collection.

119. The one painting with an identifiable figure of a woman sewing does not match any work by Eakins or Susan Eakins now known. Perhaps it is the lost *A Quiet Moment*, a watercolor said to be of a woman sewing, which Eakins showed often from 1879 through 1883.

120. Parry (1979, p. 152) noted the similarity in format of this portrayed work to Hiroshige's *Sohitsu Gafu* (1848), but added that "none of the sheets exactly match what Eakins painted so loosely, yet appreciatively, in his Philadelphia studio."

121. For examples of Chase's portraits of his young wife, see Ronald Pisano, *A Leading Spirit in American Art: William Merritt Chase, 1849–1916* (Seattle, Wash.: Henry Art Gallery, 1983). Chase later dismembered the Ayer portrait—the head is now in the collection of the Fine Arts Museums of San Francisco, the feet are in a private collection; the portrait of Dora Wheeler is in the Cleveland Museum of Art.

122. Charles de Kay, "Ninth Exhibition, Society of American Artists," *The Art Review*, vol. 1, no. 6 (April 1887), p. 11.

123. *Book of American Figure Painters* (Philadelphia: J. B. Lippincott, 1886), unpaginated. Eakins's account book (Dietrich Collection) for September 10, 1886, notes: "to Portrait of Sue & Harry from J. B. Lippincott for privilege of photographing 100 —."

124. Shakespeare and Eakins both are treating conjugal love although, given the picture's early history, a reference to familial love also seems warranted.

125. Parry 1979, pp. 149–50; Spassky 1985, pp. 613–16.

126. "Painters and Sculptors: Society of American Artists' Exhibition," *Art Age*, vol. 5, no. 47 (June 1887), p. 68. The reference to science is not immediately clear; the portrayal of subjects that had earlier prompted such criticism—motion and subjects that could be considered grisly or indecorous by some viewers of the day—is not an issue. The closest clue we have to the meaning is from another critic who disliked the work: "In his portrait of a lady, with a dog lying at her feet, he has followed various theories of painting in different parts of the work, a very good one in rendering the dog, an unfortunate one—of much consideration given to details and none to the general effect—when he came to the painting of the lady" ("Gallery and Studio: The Society of American Artists," *The Art Amateur*, vol. 17, no. 1 [June 1887], p. 5). Perhaps it is the science of perception that the critics were concerned with, wondering at Eakins's choice of which areas of the painting to show in a detailed fashion and which to soften. The dog is successful since, except for a few details of face and the pads of his hind legs, areas where precision and anecdotal interest coincide, the painter has only suggested the form and texture. The woman, on the other hand, has been fully detailed from top to toe—somewhat arbitrarily, since neither the book in her hands nor the carpet beneath her slipper share her appendages' intensity of focus.

127. "I had intended never to part with it & had it hidden away" (Susan Eakins to Bryson Burroughs, June 3, 1923, Archives, The Metropolitan Museum of Art, New York; quoted in Spassky 1985, p. 616).

128. The portrait of Barker was cut down sometime in the mid-twentieth century—the surviving half-figure is in the Mitchell Museum at Cedarhurst, Mount Vernon, Ill.; among those who praised it were the writers for *The Sun* (April 1, 1888), *The Critic* (April 7, 1888), *The New York Times* (April 8, 1888), *The Independent* (April 26, 1888—the loyal Mariana Griswold van Rensselaer), and *The Art Amateur* (May 1888), some among these being traditionally very chary in giving Eakins any praise at all. The portrait of Marks seated among his tools and instruments is in the collection of the Washington University Gallery of Art, Saint Louis, Mo.

129. Eakins to John Laurie Wallace, June 23, 1887, Wallace Collection, Joslyn Art Museum, Omaha, Nebr. The fullest studies of Eakins in the Dakota Territories are Cheryl Leibold, "Thomas Eakins in the Badlands," *Archives of American Art Journal*, vol. 28, no. 2 (1988), pp. 2–15; and Leibold and Kathleen A. Foster, "A Little Trip to the West," in Foster 1997, pp. 189–97.

130. For Mitchell and Eakins, see Norma Lifton, "Thomas Eakins and S. Weir Mitchell: Images and Cures in Nineteenth Century Philadelphia," in *Psychoanalytic Perspectives in Art*, ed. Mary Gedo, 3 vols. (Hillsdale, N.J.: Analytic Press, 1989), vol. 2, pp. 247–74. For Wood, Mitchell, and Eakins, see Elizabeth Johns, *Thomas Eakins: The Heroism of Modern Life* (Princeton: Princeton University Press, 1983), pp. 160–61. Leibold and Foster have noted several acquaintances or prominent men—J. L. Wallace, Arthur B. Frost, Walt Whitman, Frank Furness, and Owen Wister—whose recent journeys or contacts with the West may have further inspired Eakins to the journey; see Foster 1997, pp. 189–90.

131. Wood's son James had studied under Eakins; Eakins was to make portraits of both men as well as of James's brother, George, who spent the summer of 1887 with Eakins in the Dakotas. Wood's acquisition of a share in the ranch in 1886 is recorded in Nancy K. Anderson, "*Cowboys in the Badlands* and the Role of Avondale," in Homer 1980, p. 21.

132. H. C. Wood to Tripp, n.d. [c. June 1887], Bregler Collection. There are no known records of Eakins's entering himself under Wood's care. Likewise, when Eakins offered to pay his board at the ranch, the manager declined the fee, noting that Eakins's work around the place more than compensated.

133. The letters to Susan are transcribed in Leibold 1988, pp. 3–13.

134. Eakins to John Laurie Wallace, October 1887, Bregler Collection.

135. Horace Traubel, *With Walt Whitman in Camden*, vol. 4, *January 21–April 7, 1889* (Philadelphia: University of Pennsylvania Press, 1953), p. 135; quoted in Leibold 1988, p. 3.

136. Harrison Morris recounted going to Avondale to visit Eakins: "One sunshiny day—perhaps it was August or September—I went down there by train to be met by Eakins on my arrival at the station. My attire was of the usual style for a visit. I had a stiff hat, good clothes, with no idea of any rough travel. When I got off, there was Eakins on the back of a lean Western pony, leading a white one by the bridle.... He was dressed as a robust cowboy...and looked to me in his fringed leggings and sombrero hat like the attendant of a circus" (Harrison Morris, *Confessions in Art* [New York: Sears, 1930], p. 33).

137. Eakins to Susan Eakins, August 28, 1887, Bregler Collection.

138. Eakins to John Laurie Wallace, October 22, 1888, Bregler Collection.

139. Perhaps it was one of the works that the Society of American Artists rejected from their exhibitions from 1890 to 1892 (Foster 1997, p. 197).

In any event it was not seen, and the public made no motion toward wanting a "cowboy subject" from Eakins. He ultimately, in the early 1890s, gave the painting to architect John Hemenway Duncan, with whom he was working on the Soldiers' and Sailors' Memorial Arch for Prospect Park in Brooklyn; see Goodrich 1982, vol. 2, p. 27.

140. Leibold and Foster (in Foster 1997, pp. 195–96) have associated Eakins's Bad Lands project with the desert works of Gérôme and a shared fascination with Spanish bullfighting scenes.

141. The meeting and the beginning of Eakins's portrait of the poet must have taken place in the spring or early summer, since an article appeared in September—when Eakins was still in the Dakota Territory—reporting that, among other works portraying the poet, "Thomas Eakins has begun work on a portrait" (*North's Philadelphia Musical Journal*, vol. 2, no. 9 [September 1887], p. 7).

142. Weda Cook Addicks to Lloyd Goodrich, although she went on to add that Eakins held a view different from Whitman's adoration of the common man: "The average man is a nincompoop," he thought, admiring the exceptional individual and achiever; quoted in Goodrich 1982, vol. 2, p. 31.

143. Traubel diary, May 25, 1891, quoted in William Innes Homer, "New Light on Thomas Eakins and Walt Whitman in Camden," in *Walt Whitman and the Visual Arts*, ed. Geoffrey M. Sill and Roberta K. Tarbell (New Brunswick, N.J.: Rutgers University Press, 1992), p. 93; Traubel 1953, vol. 1, p. 284, quoted in Homer 1992, p. 89.

144. Traubel 1953, p. 155. The relationship between Eakins and Whitman has been written of in depth by Goodrich 1982, vol. 2, pp. 28–38; Johns 1983, pp. 144–69; and Henry B. Rule, "Walt Whitman and Thomas Eakins: Variations on Some Common Themes," *Texas Quarterly* (Winter 1974), pp. 7–57; and Homer 1992, pp. 85–98.

145. Quoted in John Wilmerding, ed., *Thomas Eakins (1844–1916) and the Heart of American Life* (London: National Portrait Gallery, 1993), p. 109.

146. Whitman wrote on November 19, 1887: "Mr. Eakins the portrait painter, of Phila:, is going to have a whack at me next week" (Whitman to Leonard M. Brown). On April 15 he wrote "It is about finished"; both passages quoted in Wilmerding 1993, p. 109. In between times, Susan Eakins recorded in her retrospective diary for January 9, 1888 (Bregler Collection): "Over to Camden with Tom stop at Walt Whitman to see the portrait Tom is painting of him, we have Harry good dog along with us." The current bold signature and date are apparently later additions; see Wilmerding 1993, p. 111 n. 11.

147. The most concentrated treatment of the late portraits as a group is Marisa Kayyem, "Thomas Eakins's Late-Format Portraits: Identity, Consciousness, and Typology in Turn-of-the-Century Portraiture" (Ph.D. diss., Columbia University, 1998).

148. Homer 1992, pp. 89–93.

149. Whitman to Sidney H. Morse, quoted in Horace L. Traubel, Richard Maurice Burke, and Thomas B. Harned, eds., *In re Walt Whitman: Edited by His Literary Executors* (Philadelphia: Published by the editors through David McKay, 1893 [G. S. Ferguson Co.]), p. 389.

150. May 10, 1888; quoted in Goodrich 1982, vol. 2, p. 34.

151. "The Academy's 61st Year. A Great Throng of Well-Known People in the Gallery at the Private View. Fine Paintings on Exhibit," *The Philadelphia Press*, January 29, 1891, p. 6.

152. Susan Eakins recorded the precise date in her retrospective diary, Bregler Collection.

153. Goodrich 1982, vol. 2, p. 67.

154. He received comparatively vast sums (reportedly three thousand to five thousand dollars for a single full-length portrait), the honor of a one-man exhibition in Boston, and plaudits in the press. For details, see Richard Ormond and Elaine Kilmurray, *John Singer Sargent: Complete Paintings*, vol. 1, *The Early Portraits* (New Haven: Yale University Press for the Paul Mellon Centre for Studies in British Art, 1998), pp. 195–217.

155. Mariana Griswold van Rensselaer, writing in *The Independent*, juxtaposed her favorable notice of Eakins's portrait of Barker with the Sargent painting ("Fine Arts. The Academy Exhibition. II," *The Independent*, April 26, 1888, p. 7), which might further have led to Eakins's notice of the work. The same was true of both Sargent's portraits—in the Society of American Artists and the National Academy of Design—and Eakins's portrait of Barker in the review "National

Academy of Design. Sixty-third Annual Exhibition. First Notice," *The Studio: Journal of the Fine Arts*, vol. 3, no. 6 (May 1888), pp. 88–89.

156. But as he considered how to put these elements on canvas, it seems that it was the reproduction of yet another painting by Sargent that provided an inspirational template—*Mrs. William Playfair* (Huntington Library, Art Collections, and Botanical Gardens, San Marino, Calif.). There are clear differences, of course—Sargent portrayed an older woman turned to the left and facing straight out of the picture. But the commonalities of three-quarter length portrait and the use of the open, foreshortened fan as the foremost prop of the scene seems telling. It, too, was an image that would have been readily available for Eakins. While the painting *Mrs. William Playfair* was not in the United States in 1888, it was the first illustration in an article devoted to Sargent in the March 1888 issue of *The Art Journal*, where it was called "as near to a Velasquez in the quality of its technique as the work of any man living" (R.A.M. Stevenson, "J. S. Sargent," *The Art Journal* [London], vol. 50 [March 1888], p. 69).

157. "'The Academy' Exhibition," *The Art Amateur*, vol. 24, no. 6 (May 1891), p. 145. She married the Connecticut clergyman Leonard Woolsey Bacon only after the painting of 1888 was completed (Siegl 1978, p. 120).

158. Murray was almost a member of the family at Mount Vernon Street—Eakins's companion on long bicycle trips, swimming excursions, and on jaunts through the city to sporting events and the theater. Lloyd Goodrich characterized the relationship as paternal: "Everything that we know about Eakins and his art, I believe, shows that his relation to Murray was that of father to son. In his youth he had expressed a desire for 'strong beautiful children.' Now he had a son who was a talented co-worker and companion" (Goodrich 1982, vol. 2, p. 110).

159. "D. Hayes Agnew M.D. Chirurgus Peritissimus. Scriptor et Doctor Clarissimus. Vir Veneratus et Carissimus. MDCCCLXXXIX"; quoted in Goodrich 1982, vol. 2, p. 45.

160. Susan Eakins to Dr. Horatio C. Wood, April 4, 1917, Bregler Collection.

161. The principal studies of *The Agnew Clinic*, aside from Goodrich (1982), are David Lubin, *Act of Portrayal: Eakins, Sargent, James* (New Haven and London: Yale University Press, 1985), pp. 27–82; essays by Patricia Hills, Margaret Supplee Smith, and others gathered in *Prospects* 11 (1987); and Bridget L. Goodbody, "'The present opprobrium of surgery': *The Agnew Clinic* and Nineteenth-Century Representations of Cancerous Female Breasts," *American Art*, vol. 8, no. 1 (Winter 1994), pp. 32–51.

162. Susan Eakins also reportedly painted the figure of Dr. Fred H. Milliken, who whispers into Eakins's ear; see Foster 1997, p. 246 n. 11. The knees along the top range of benches were posed for by Eakins's young friend from out West, George Wood; see Margaret McHenry, *Thomas Eakins, Who Painted* (Oreland, Pa.: privately printed, 1946), p. 83.

163. "The Unidentified Student in the Agnew Painting. Recognized as Dr. John D. Thomas of New Orleans," *Old Penn: Weekly Review of the University of Pennsylvania*, vol. 14, no. 5 (October 30, 1915), p. 171.

164. One recent scholar (Lubin 1985, p. 39) has called the background of the picture "a frolic for the eye through or across the multiformity of postures and positions."

165. McHenry 1946, p. 144.

166. Goodrich 1982, vol. 2, pp. 48–49.

167. Quoted in Goodrich 1982, vol. 2, pp. 48–49.

168. Eakins to the Society of American Artists; quoted in Goodrich 1982, vol. 2, pp. 50–51.

169. The painting was earlier shown at the Haseltine Galleries in Philadelphia, prompting little comment in the press. Privately, however, some found the subject was vulgar and whispered among themselves, "Eakins is a butcher." He is said to have responded, "with tears in his eyes," "They call me a butcher, and all I was trying to do was to picture the soul of a great surgeon" (Weda Cook Addicks, interview with Lloyd Goodrich, c. 1930, quoted in Goodrich 1982, vol. 2, p. 46).

170. Martin Church, "The Fine Arts. The Philadelphia Exhibit of Works for the World's Fair," *Daily Evening Transcript* (Boston), January 17, 1893, p. 6.

171. "Pennsylvania Art Exhibit. To Be Sent to the Columbian Exhibition," *Public Ledger* [Philadelphia], January 16, 1893, p. 6.

172. Montague Marks, "My Note Book," *The Art Amateur*, vol. 29, no. 2 (July 1893), p. 30.

"Eakins's Vision of the Past and the Building of a Reputation," pp. 211–23

MARC SIMPSON

I am extremely grateful to Darrel Sewell, W. Douglass Paschall, and other members of the American Art Department of the Philadelphia Museum of Art for their generous assistance in finding documentary materials for this essay. With exemplary generosity, William Innes Homer shared his transcriptions of Eakins's correspondence. Others who have provided welcome aid are David Brigham, Jane Glover, Patricia Junker, Laura Mills, and, especially, Fronia W. Simpson.

1. For Eakins's realism-inspired aphorisms and instructions, see Charles Bregler, "Thomas Eakins as a Teacher," *The Arts*, vol. 17, no. 6 (March 1931), pp. 379–86; and its continuation, "Thomas Eakins as a Teacher: Second Article," *The Arts*, vol. 18, no. 1 (October 1931), pp. 29–42.

2. In his pioneering study of 1933 Lloyd Goodrich declared: "Seldom has there been so consistent a realist as Eakins—whose art was such a direct outgrowth of reality.... Every figure he painted was a portrait, every scene or object a real one...the actual rather than the ideal" (*Thomas Eakins: His Life and Work* [New York: Whitney Museum of American Art, 1933], p. 143). In 1983 Elizabeth Johns echoed this sentiment as the basis of her rich evaluation of the artist: "From his earliest years, he painted almost nothing but portraits" *(Thomas Eakins: The Heroism of Modern Life* [Princeton: Princeton University Press, 1983], p. xix). The marginalization of the historical works is typified by the space allotted to them in Goodrich's magisterial *Thomas Eakins*, 2 vols. (Cambridge, Mass.: Harvard University Press for the National Gallery of Art, 1982), in which, barring the *William Rush* series, all the early American subject works "form a curious interlude in Eakins' evolution" and are discussed on one page (vol. 1, p. 158), while the Greek works, which again "form a curious interlude in Eakins' art" (vol. 1, p. 236), have but six, albeit rich and sympathetic, pages of text. Recent, significant exceptions to this dominant viewpoint can be found in Michael Fried, *Realism, Writing, Disfiguration: On Thomas Eakins and Stephen Crane* (Chicago and London: University of Chicago Press, 1987), p. 11; and Kathleen A. Foster, *Thomas Eakins Rediscovered: Charles Bregler's Thomas Eakins Collection at the Pennsylvania Academy of the Fine Arts* (New Haven and London: Yale University Press for the Pennsylvania Academy of the Fine Arts, 1997), pp. 91–92, 162, 394–95.

3. For this and all other statements concerning the artist's exhibition practices in this essay, I have relied on Elizabeth Milroy, *Guide to the Thomas Eakins Research Collection with a Lifetime Exhibition Record and Bibliography*, ed. W. Douglass Paschall (Philadelphia: Philadelphia Museum of Art, 1996), adding a showing of the ink drawing after *The Gross Clinic* (The Metropolitan Museum of Art, New York) to the American Society of Painters in Watercolor (1877—on the basis of a review titled "Painters in Water-Colors" in *The Evening Post* [New York], January 20, 1877, p. 3). Each entry is counted once; thus thirty-five of the forty-eight interior genre scenes represent his showings of only three works—*The Chess Players* (pl. 19), *The Dancing Lesson (Negro Boy Dancing)* (pl. 45), and *A Quiet Moment* (unlocated)—which were exhibited ten, fifteen, and ten times each, respectively, during these years. The categories of my count are both arbitrary and permeable.

4. The exception to his early pattern of exhibiting predominantly male images was *Portrait*, now known as *Elizabeth at the Piano* (pl. 13), first shown in the Centennial Exhibition of 1876. The only other woman to be featured in any of the paintings seen before December 1877 is the anonymous woman with her hands clenched before her face in *The Gross Clinic* (pl. 16).

5. *Negro Whistling Plover* (1874, The Brooklyn Museum of Art) had been seen in New York and Brooklyn in 1875, and in Philadelphia in 1876; *No Wind, Race-Boats Drifting* (1875, private collection) in New York in 1875; *The Zither Player* (1876, Art Institute of Chicago) in Philadelphia in 1876 and New York and Chicago earlier in 1877; *John Biglen* [*sic*] *(John Biglin in a Single Scull*, pl. 8), or at least a close version of it, had been in New York in 1874.

6. A paragraph by Earl Shinn on paintings in the collection of Philadelphian Henry C. Gibson provides an overview of the type: "We have

thus far reviewed painters who have been inventors and thinkers and creators. It is a question whether, as artists, they were any the better for it. There is Alfred Stevens, for an instance on the other side, who has never thought out a dramatic situation in his life. He dresses a model in certain colors, puts a vase near by on a table, and copies what he sees in a picture that is a chef d'oeuvre. Here is a plain woman in a velvet jacket edged with sable—harp, music, flowers, a rose at her foot—and it seems as if nothing could be finer: it is to be noticed, for instance, that the glitter of changeable silk is perfectly hit off in her skirt.... Again, for powerful painting that is mere model painting, go to Tissot for his 'Girl Reading.' Her only merit is, perhaps, that she is utterly well understood and seems to be alive. She is the girl in the next street, the girl you were introduced to last evening. She is decidedly ugly, with her bull-dog sallow face, and she is absorbing the *Figaro* newspaper in a gormandizing [*sic*], unlady-like manner. But she lives there where the painter has set her—lives to the tips of those long, intelligent fingers enclosing the lower part of her face like the basket-hilt of a sword. Or for something still less elevated, yet true to Nature, pass to the 'Girl Deciphering the Seal,' by Toulmouche. If you think a muddy skin and a bombazine dress cannot be coquettish, look at this grudging girl with some other girl's letter.... Or again, if the millinery of art may arrest us a little longer—it arrested Veronese and Titian, in their day, a good while—take a study of the different ways of painting white satin in the pictures here present by Baugniet and Florent Willems" ("Private Art-Collections of Philadelphia. II.—Mr. Henry C. Gibson's Gallery," *Lippincott's Magazine*, vol. 9, no. 5 [May 1872], pp. 574–75).

7. *Philadelphia Ledger & Transcript*, January 14, 1879. In painting, even Winslow Homer turned his hand to historicizing works—his shepherdesses of 1878—and even history painting, as in the now lost *Arrival of the French Ambassador in Madrid* and *The Old Cavalier*. See Margaret C. Conrads, *Winslow Homer and the Critics: Forging a National Art in the 1870s* (Princeton: Princeton University Press in association with the Nelson-Atkins Museum of Art, 2001), p. 108.

8. The fullest exploration of the Colonial Revival in American art in general is the compilation of essays in Alan Axelrod, ed., *The Colonial Revival in America* (New York: W. W. Norton for The Henry Francis du Pont Winterthur Museum, 1985). See also Rodris Roth, "The Colonial Revival and 'Centennial Furniture,'" *The Art Quarterly*, vol. 27, no. 1 (1964), pp. 57–81; William Bertolet Rhoads, "The Colonial Revival" (Ph.D. diss., Princeton University, 1974); Michael G. Kammen, *Mystic Chords of Memory: The Transformation of Tradition in American Culture* (New York: Alfred A. Knopf, 1991); William H. Truettner and Roger B. Stein, eds., *Picturing Old New England: Image and Memory* (Washington, D.C.: National Museum of American Art, Smithsonian Institution; New Haven: Yale University Press, 1999).

9. The model was identified by Goodrich as Annie King, perhaps a relative of Sally King, who would also model for the artist (The Lloyd Goodrich and Edith Havens Goodrich, Whitney Museum of American Art, Record of Works by Thomas Eakins, Philadelphia Museum of Art; hereafter Goodrich Papers).

10. Eakins himself suggested this when he earlier used the same table, more carefully detailed, as a simple bit of domestic apparatus in the clearly contemporary setting of *The Zither Player*. What seems to be the same table was again pressed into service when in 1883 he painted a variant of *The Zither Player* in oil: *Professionals at Rehearsal* (pl. 121). The table, now in the collection of Daniel W. Dietrich II, is described in detail in a series of illustrations Eakins planned for his drawing manual of c. 1881–87. See Foster 1997, pp. 337–39, cat. nos. 105–8; and Phyllis D. Rosenzweig, *The Thomas Eakins Collection of the Hirshhorn Museum and Sculpture Garden* (Washington, D.C.: Smithsonian Institution Press, 1977), p. 116, cat. no. 56.

Of the table type, Morrison H. Heckscher wrote: "Associated particularly with Philadelphia, the form was made there in great numbers, almost to the exclusion of the square type" (*American Furniture in the Metropolitan Museum of Art, II, Late Colonial Period: The Queen Anne and Chippendale Styles* [New York: The Metropolitan Museum of Art and Random House, 1985], p. 190).

11. For a detailed discussion of this flower in early America, see Ellen G. Miles, "Rubens Peale with a Geranium," in Robert Wilson Torchia et

al., *American Paintings of the Nineteenth Century, Part II* (Washington, D.C.: National Gallery of Art, 1998), pp. 51–52.

12. Winslow Homer, among many other American painters of the 1870s, used this formula, as in his *Morning Glories* (1873, private collection).

13. Foster (1997, p. 88) provides a description of two oil studies and the general procedure of Eakins's work on this watercolor.

14. Eakins set its initial price at the exhibition to reflect this greater importance, one hundred and fifty dollars versus one hundred and twenty for the smaller work. The model was identified by Goodrich as "Aunt Sally" King, a relative of the Crowell family, who posed for several works during the late 1870s and the early 1880s (Goodrich 1982, vol. 1, pp. 151, 158).

15. The title seems to be taken from an article based on an unnamed woman's diary concerned especially with the maintenance of textiles (Ethel C. Gale, "An American Lady's Occupations Seventy Years Ago," *Lippincott's Magazine*, vol. 15, no. 4 [April 1875], pp. 475–80).

16. Although the fall of her skirt disguises the fact, the model must be seated twisted and at an angle on the chair, much like the pose assumed in a photograph of c. 1885 showing a much younger model in the same or similar chair. See Susan Danly and Cheryl Leibold, *Eakins and the Photograph: Works by Thomas Eakins and His Circle in the Collection of the Pennsylvania Academy of the Fine Arts* (Washington, D.C.: Smithsonian Institution Press for the Pennsylvania Academy of the Fine Arts, 1994), p. 171, fig. 217. The chair (or one from its set) also appears two times from both the front and the back in *William Rush Carving His Allegorical Figure of the Schuylkill River* (pl. 41), the oil and watercolor versions of *Retrospection* (1880, Yale University Art Gallery, New Haven, and Philadelphia Museum of Art, respectively), and the relief *Knitting* (pl. 93).

17. Mitchell's original chair is reproduced in William Macpherson Horner, Jr., *Blue Book: Philadelphia Furniture, William Penn to George Washington* (Philadelphia, 1935), pl. 221. One of Mitchell's copies after the chair was sold at public auction in the art galleries of Wm. D. Morley, Inc., Philadelphia, May 28, 1942. Eakins expressed his gratitude in a letter of June 18, 1883: "I should like to give at some time, a gelatine cast of the knitting panel with your permission to my friend Dr. Weir Mitchell who lent me his old chair" (Eakins to James P. Scott, quoted in Goodrich 1982, vol. 1, p. 217).

18. "Private Art-Collections of Philadelphia. II.—Mr. Henry C. Gibson's Gallery," *Lippincott's Magazine*, vol. 9, no. 5 (May 1872), pp. 574–75.

19. Gérôme, Meissonier, Lawrence Alma-Tadema, and the Austrian Hans Makart exemplified the mode. As one writer for *Lippincott's* noted: "We have plenty of archaeological painters, who painfully restore antiquity for us, following accurate authorities and examples. The curiosity to know the past, which has created a literature of its own, the researches of travellers and of learned men, the excavations made in Greece, in Asia Minor, in Africa, at Pompeii, have led many artists to search for new effects in this direction" (L. Lejeune, "The Paris Exposition of 1878. III.—Fine Arts," *Lippincott's Magazine*, vol. 22, no. 5 [November 1878], p. 605).

20. "The Fine Arts: The Water-Color Exhibition," *Daily Evening Telegraph* (Philadelphia), December 3, 1877, p. 15.

21. "The Fine Arts: Exhibition of Water-color Drawings at the Academy of Fine Arts," *Philadelphia Evening Bulletin*, December 24, 1877, p. 2. The near-mocking repetition of "old-fashioned" in this passage is one of the few times that any of Eakins's works prompted the word's appearance in the public press.

22. Eakins, looking at Velázquez's paintings in Spain with admiration, noted to himself: "Besides, that is certainly the manner of Bonnat and Fortuny, it is there that my own instincts have always carried me" (Spanish notebook, Pennsylvania Academy of the Fine Arts, Philadelphia, Charles Bregler's Thomas Eakins Collection, purchased with the partial support of the Pew Memorial Trust [hereafter Bregler Collection], p. 31; typescript translation in Thomas Eakins Research Collection, Philadelphia Museum of Art [hereafter Eakins Research Collection]; original French quoted in Foster 1997, p. 241 n. 50). He is, further, reported to have commented that a painting by Fortuny was "the most beautiful thing I have ever seen" (Donelson F. Hoopes, *Eakins Watercolors* [New York: Watson-Guptill, 1971], p. 14).

23. For a fuller discussion of the works in this exhibition, see Kathleen A. Foster, "Makers of the American Watercolor Movement: 1860–1890" (Ph.D. diss., Yale University, 1982), pp. 229–33.

24. Eakins valued the watercolor highly, putting a price of three hundred and fifty dollars on it. Its nostalgia has been perceived by nearly all its recent commentators, including Foster (1997, p. 91); and Alan C. Braddock, "Eakins, Race, and Ethnographic Ambivalence," *Winterthur Portfolio*, vol. 33, nos. 2–3 (Summer–Autumn 1998), p. 148.

25. John Moran, "The American Water-Colour Society's Exhibition," *The Art Journal*, n.s., vol. 4 (March 1878), p. 92.

26. "The Eleventh Annual Exhibition of the American Water Color Society. Reproductions of Notable Pictures in the Collection from Autograph Sketches by the Painters and Photographs and Drawings Made in the Gallery by Our Artists," *The Daily Graphic* (New York), February 6, 1878, pp. 644–45. Two days earlier in its overview of the exhibition, *Seventy Years Ago* was described as "a very striking and strongly painted figure...remarkable for its harmony and character" ("The Water Color Exhibition. A Review of the Works To Be Seen at the National Academy of Design," *The Daily Graphic* [New York], February 4, 1878, p. 627).

27. The other watercolor was *The Sculler* (now lost)—probably showing John Biglin—which he had sold for eighty dollars in 1874 to C. T. Barney (see Foster 1997, p. 83). In March 1878, the month that the American Water Color Society exhibition closed, he sold the massive, multifigure oil of *The Gross Clinic* (pl. 16)—the labor of a year—for two hundred dollars (Goodrich 1982, vol. 1, p. 165).

28. Raymond Westbrook, "Open Letters from New York," *The Atlantic Monthly*, vol. 41, no. 246 (April 1878), p. 534; "Fine Arts. Eleventh Exhibition of the Water-color Society. II," *The Nation*, vol. 26, no. 661 (February 28, 1878), p. 156.

29. Illustrated in [Brander Matthews], "Actors and Actresses of New York," *Scribner's Monthly*, vol. 17, no. 6 (April 1879), p. 776. Abbey's drawing even assimilated the elegant quiet of Eakins's knitter, very different in tone from the "vivacious and virulent vixen" the author described as the actress's most common role.

Since *Fifty Years Ago* and *The Dancing Lesson* did not sell, Eakins circulated them for the next four years throughout the United States, often in tandem. He evidently believed that the two varieties of popular genre painting—one historical and one African American—effectively represented him and the breadth of his efforts. Later in 1878 the two sheets were in Philadelphia, in Boston (where they received a silver medal), and again in Philadelphia. In 1879, while *The Dancing Lesson* was in Louisville, *Fifty Years Ago*—bearing the title *Reminiscence*—was in Cincinnati. The two were sent to Chicago in the fall of 1880, to Saint Louis in 1881, and to New Orleans and Denver in 1882. The Boston award diploma is in the Bregler Collection (see Foster 1997, p. 451). The writer for the *Independent*, in reviewing the Boston show, stated: "What we would most like to possess in this room is Mr. Eakins's 'Fifty Years Ago.'...which is exquisite in conception and color" ("Fine Arts. The Water-Color Society. II," *The Independent*, February 21, 1878, p. 7).

30. Gordon Hendricks, "Eakins' *William Rush Carving His Allegorical Statue of the Schuylkill*," *Art Quarterly*, vol. 31, no. 4 (Winter 1968), pp. 382–404; Darrel Sewell, *Thomas Eakins: Artist of Philadelphia* (Philadelphia: Philadelphia Museum of Art, 1982), pp. 46–57; Goodrich 1982, vol. 1, pp. 145–57; Johns 1983, pp. 83–114; Darrel Sewell in John Wilmerding, ed., *Thomas Eakins (1844–1916) and the Heart of American Life* (London: National Portrait Gallery, 1993), pp. 90–93; Foster 1997, pp. 92, 144–50, 251 n. 64.

31. *Catalogue of the First Exhibition* (New York: Society of American Artists, 1878), p. 5.

32. Quoted in Foster 1997, p. 145. Eakins, in following the regimen of the Ecole des Beaux-Arts in the 1860s, would have attended Taine's lectures on aesthetics and the history of art along with courses on historical costume. See David Sellin, *Thomas Eakins, Susan Macdowell Eakins, and Elizabeth Macdowell Kenton* (Roanoke, Va.: North Cross School, 1977), p. 13.

33. Quoted in Johns 1983, pp. 104–5.

34. He had earlier written to his father from Paris: "I can conceive of few circumstances wherein I would have to make a woman naked" (Eakins to Benjamin Eakins, May 9, 1868, Bregler Collection). For a detailed discussion of the controversies during the mid-1870s that Eakins found swirling around himself regarding his advocacy of studying from the

nude, see David Sellin, "The First Pose: Howard Roberts, Thomas Eakins, and a Century of Philadelphia Nudes," *Philadelphia Museum of Art Bulletin*, vol. 70, nos. 311–312 (Spring 1975), pp. 5–56.

35. Sewell in Wilmerding 1993, pp. 91–92.

36. Foster 1997, pp. 82, 248 n. 4.

37. C[larence] C[ook], "A New Art Departure: Association of American Artists. First Annual Exhibition—Art for Its Own Sake," *New York Daily Tribune*, March 9, 1878, p. 5.

38. Eakins's price exceeded all but a few landscapes and genre scenes by Walter Shirlaw, the president of the Society, A. F. Bunner, John La Farge, R. Swain Gifford, and Samuel Colman. The bulk of the most highly valued works were those with historical subjects: *Lamentations over the First Born in Egypt* by Charles Sprague Pearce ($2,500), *Egyptian Fête, House of Ramses II* by Frederick Bridgman ($2,000), and Sarah Dodson's *The Pupils of Love* ($1,000) were the chief examples in painting, while the sculpture by fellow Philadelphian Howard Roberts, *Lot's Wife, Statuette in Marble* ($1,500), stood out not only as one of the few biblical subjects but as one of only two fully three-dimensional objects in the show. *Le Jour des Morts* by Will Low ($400) was apparently the least expensive of the history paintings.

39. The other two with texts were Low's *Le Jour des Morts* and Pearce's *Lamentations over the First Born in Egypt*. The one accompanying Eakins's work, the longest, reads in its entirety: "William Rush, ship carver, was called on to make a statue for a fountain at Central Square, on the completion of the first Water Works of Philadelphia. A celebrated belle consented to pose for him, and the wooden statue he made, now stands in Fairmount Park, one of the earliest and best of American statues" (*Catalogue of the First Exhibition* [New York: Society of American Artists, 1878], p. 5).

40. One of the few favorable New York reviews, apparently blind to its contrivance, called it "simple and honest and so far commendable" ("Fine Arts. The Rival Exhibitions," *The Independent*, March 14, 1878, p. 7). It was Charles De Kay, writing almost a decade later, who recognized the type of painting that Eakins was here attempting: "He has painted many portraits . . . and an historical painting of William Rush, the first Pennsylvanian who did anything in sculpture, carving in wood his ideal figure representing the River Schuylkill" ("Movements in American Painting. The Clarke Collection in New York," *The Magazine of Art*, vol. 10 [1887], p. 39).

41. "Secession in Art. The First Exhibition of the New Society of American Artists," *The Evening Post* (New York), March 19, 1878, p. 1; "Fine Arts. First Exhibition of the Society of American Artists—Varnishing Day—The Pictures," *The New York Herald*, March 5, 1878, p. 10. When the painting was seen in Philadelphia in 1881, at least one critic there saw beyond the sensationalism of the nude: "But the model is not the soul of the picture. After all, its principal charm lies in the air of earnest restraint that pervades the whole. The perfect absorption of the carver in his work, the simple dignity of the mother at her knitting, the delightful air which all, even the posing model, have of caring more for what they are doing than for displaying themselves while doing it" ("The Fine Arts. The Philadelphia Society Exhibition at the Academy. Third Notice," *The Philadelphia Press*, December 2, 1881, p. 5).

42. "The Nude in Art," *American Art Journal*, vol. 29, no. 2 (May 11, 1878), p. 20.

43. [Earl Shinn], "Fine Arts. The Lessons of a Late Exhibition," *The Nation*, vol. 26, no. 667 (April 11, 1878), p. 251.

44. W[illiam] J. C[lark], Jr., "American Art. A New Departure—The Exhibition of the Society of American Artists in New York," *Daily Evening Telegraph* (Philadelphia), March 13, 1878, p. 7.

45. Eakins continued showing the work throughout the century. His continuing interest in the theme, however, is best demonstrated later by the fact that in 1908 he returned to it, making a series of works, paring down and simplifying the presentation until, in the great final version now in Honolulu (pl. 239), he presented the model in motion (plucked from one of Muybridge's photographic studies; see Van Deren Coke, *The Painter and the Photograph: From Delacroix to Warhol*, rev. ed. [Albuquerque: University of New Mexico Press, 1972], pp. 162–65) and himself as Rush—a poignant linking of modernity and tradition, of historical re-creation and autobiography.

46. The most detailed and interesting work on *In Grandmother's Time* to date has been done by Amy Kurtz, first in an undergraduate Tryon Prize paper of April 1996, Smith College, Northampton, Mass. ("*In Grandmother's Time*, the Colonial Revival and Smith," Smith College Museum of Art files), then expanded in a lecture given at Smith College in October 1999.

47. *In Grandmother's Time* is signed and dated 1876 and thus represents probably the first completed of Eakins's historical works.

48. Eakins's maternal grandmother, Margaret Cowperthwait (the one grandparent whom Eakins knew and grew up around), was married in about 1795; his paternal grandmother was married in 1812.

49. Eakins's portrait of his niece Ella, *Baby at Play* (pl. 18), shows similar kinds of toys, but not these examples. A reviewer in 1879 called the toys in *In Grandmother's Time* "decidedly modern" in "The Smith College Paintings: Unequalled Collection by American Artists," *Springfield (Mass.) Republican*, excerpt appearing in the *Hampshire (Mass.) Gazette*, June 24, 1879; cited in Kurtz 1996, p. 7.

50. Domestic spinning wheels were basically obsolete by the 1830s. A hint of the spinning wheel's status as a relic of a lost time was clear in a notice of the sale of the Eliza Greatorex collection of "rare old bric-a-brac," which included "very old spinning wheels" ("Art Notes," *The Daily Graphic* [New York], February 11, 1878, p. 678). This general impression is confirmed by a work at the National Academy of Design exhibition later that spring—Gilbert Gaul's *A Rainy Day in the Garret*, which shows two children dressed up in old-fashioned, oversized clothes, a spinning wheel prominent to the right of the canvas (illustrated in *The Daily Graphic* [New York], April 2, 1878, p. 224).

51. Eakins was not alone in this usage. Enoch Wood Perry, too, in such works as *Mother and Child* (1881, Manoogian Collection) used darkness to lend weight to his antiquarian creations.

52. Eakins to Frances Eakins, April 1, 1869, Archives of American Art.

53. William Dean Howells, "A Sennight of the Centennial," *The Atlantic Monthly*, vol. 38, no. 225 (July 1876), pp. 100–101.

54. The surviving perspectival drawing is in the Metropolitan Museum of Art, New York.

55. The setting has frequently been identified as the parlor of the Eakins family home, but Susan Eakins asserted that it was not set there (reported by Lloyd Goodrich, Goodrich Papers). Robert Torchia has written in great detail about the painting, being able to assess the state of this particular game (augmenting the notion of narrative with specific study of the player's board positions and the body language of all three of the men) as well as the cultural status of chess in late-nineteenth-century America; see Robert Wilson Torchia, "*The Chess Players* by Thomas Eakins," *Winterthur Portfolio*, vol. 26, no. 4 (Winter 1991), pp. 267–76.

56. The prominence of technique over narrative in *In Grandmother's Time* prompted one writer to wonder about the appropriateness of exhibiting studies, or works marked as such, before the public: "the question arises why there should be this difference [of some works titled as studies and others, of comparable finish, not], and whether, in the case of the last-mentioned works [by Eaton, Eakins, and Volk], the unity of the impression would have been impaired by an increased elaboration of their parts. Certainly the public have not yet been educated up to a dislike of what is called finish, at least in figure paintings" ("Secession in Art. The First Exhibition of the New Society of American Artists," *The Evening Post* [New York], March 19, 1878, p. 1). The concern regarding finish was widespread: "Of late there has been not a little of amazing jargon in regard to and in behalf of uncompleted pictures," began an editorial in *Appleton's Journal* ("Editor's Table," vol. 5, no. 2 [August 1878], p. 185).

57. This is a painting that Eakins very likely saw when it was exhibited in the Paris Exposition Universelle of 1867. It was also reported on view in Baltimore in 1876 before a widely reviewed showing in New York in 1881. See Andrew McLaren Young et al., *The Paintings of James McNeill Whistler*, 2 vols. (New Haven and London: Yale University Press, 1980), vol. 1, pp. 17–18.

58. Smith College paid one hundred dollars, half what Eakins had asked at the Society's exhibition. The second work Eakins sold to a museum was *The Cello Player* (pl. 206), purchased by the Pennsylvania Academy of the Fine Arts eighteen years later in 1897. Only in 1916, just

months before his death, did he again sell to a museum, when The Metropolitan Museum of Art acquired *Pushing for Rail* (pl. 11).

59. Susan Hannah Macdowell—whom Eakins would marry in 1884, and whom he called "the best American woman painter" (Goodrich 1982, vol. 1, p. 223)—replicated the figure from *Seventy Years Ago* in her watercolor of 1879, *Chaperone* (private collection), and made a close variant of *In Grandmother's Time* in her small watercolor *Spinning* (c. 1878, private collection). She continued in the nostalgic vein with her *Old-Fashioned Dress* (1880), *Reflections* (1881; a close variant of Eakins's contemporary *Retrospection*—perhaps an instance of Eakins sharing a model and pose with his more promising students), and her Toppan Prize–winning painting of 1882, *The Old Clock on the Stairs* (formerly in the collection of Fairman Rogers). Alice Barber, one of the other leading female students of the Academy in the late 1870s and early 1880s, made a variant of Eakins's *Zither Player*, substituting for the men two young women in early nineteenth-century gowns (at the Schwarz Gallery, Philadelphia, in 1993).

60. Spanish notebook, Bregler Collection. Other artists over the centuries dealt with the subject, both as a sign of country labor—as in such paintings as Jean-François Millet's *The Spinner* (c. 1855, Sterling and Francine Clark Art Institute, Williamstown, Mass.) or William Morris Hunt's closely related *Girl Spinning* (c. 1853–55, private collection)—and its opposite, as with Gustave Courbet's *The Sleeping Spinner* (1853, Musée Fabre, Montpellier, France).

61. For a review of the iconography of the spinning wheel in nineteenth- and early twentieth-century America, see Christopher Monkhouse, "The Spinning Wheel as Artifact, Symbol, and Source of Design," in Kenneth L. Ames, ed., *Victorian Furniture: Essays from a Victorian Society Autumn Symposium* (Philadelphia: Victorian Society in America, 1982), pp. 154–72; Beverly Gordon, "Spinning Wheels, Samplers, and the Modern Priscilla: The Images and Paradoxes of Colonial Revival Needlework," *Winterthur Portfolio*, vol. 33, nos. 2–3 (Summer–Autumn 1998), esp. pp. 163–74.

62. Eakins to Frances Eakins, September 24, 1867, Archives of American Art. Eakins had begun, probably in 1874, a watercolor based on canto 5 of Longfellow's *Song of Hiawatha* but did not bring it to completion. It was destroyed during a restoration attempt in the 1940s, though the oil study is extant (see Goodrich 1982, vol. 1, p. 113; and Rosenzweig 1977, pp. 53–54).

63. Henry Wadsworth Longfellow, "The Courtship of Miles Standish," in *The Complete Poetical Works of Henry Wadsworth Longfellow* (Boston: Houghton, Mifflin, 1883), p. 164. Longfellow and his popular poem, first published in 1858, "not only succeeded in rescuing the wheel from years of neglect, but also transformed the spinning wheel from a symbol of female bondage into a relic shrouded in romance" (Monkhouse in Ames 1982, p. 157).

64. We know very little about Eakins's responses to the fair. For his fair pass, see Rosenzweig 1977, pp. 61–62. Gordon Hendricks has cited the dates when the ticket was used *(The Life and Work of Thomas Eakins* [New York: Grossman, 1974], pp. 96–97). The illustration of the New England Log-House in *Lippincott's Magazine* shows two women—one spinning and the other apparently knitting—outside the door of the building (vol. 18, no. 6 [December 1876], p. 661).

65. Eakins's friend and patron Fairman Rogers owned one of Boughton's most famous scenes, *The Return of the Mayflower*, described by Earl Shinn in "Private Art—Collections of Philadelphia. IX.—Professor Fairman Rogers's Gallery," *Lippincott's Magazine*, vol. 10, no. 5 (November 1872), p. 593.

66. Owned in the 1870s by the Philadelphian George Whitney; see Earl Shinn, "Private Art-Collections of Philadelphia. X.—Additional Galleries," *Lippincott's Magazine*, vol. 10, no. 6 (December 1872), p. 709.

67. Eakins's friend Earl Shinn, writing as Edward Strahan, focused on a number of these in his luxurious survey of the exhibition, *The Masterpieces of the Centennial International Exhibition: Vol. I, Fine Art* (Philadelphia: Gebbie & Barrie, 1876).

68. Kenneth L. Ames enumerates these factors in his introduction to Axelrod 1985, p. 11.

69. For spinning, this has been beautifully written of by Kurtz (1996, p. 4): "The lyrical rhythmic motion of the treadle wheel, synchronized with the sympathetic, bodily, act of lightly holding back the twist while drawing out, and then releasing, the fibers against the self-winding pull of the bobbin, establishes a synchrony of hand, foot, eye, and mind orchestrated to the slow steady beat of the treadle and the cadence of the humming bobbin. The woman's production of a fine even thread, like that of a pure tone, evokes, through her tranquil, absorbed attention, a kind of 'domestic music' that links *In Grandmother's Time* to Eakins' *Elizabeth Crowell at the Piano*...and to other depictions of his sisters' musical pursuits."

70. For an overview of Nannie Williams's career, see Goodrich 1982, vol. 1, pp. 148–51.

71. After Eakins showed the work at the Social Art Club, he next exhibited it in 1883 at the American Art Association's "Second Annual Exhibition of Sketches and Studies." After the turn of the century, in the last year of the painter's life, he again brought the work forward, showing it—titled this time only as *The Spinner*—in New York at the National Academy of Design, followed by venues in Detroit, Toledo, Chicago (after his death), and, in 1917, Indianapolis. A writer for *The Sun* thought it one of the three best works of the Academy show, calling it "a slight work by a thoughtful painter" and "such a work as a painter might do in preparation for a larger picture. It bears signs of haste in execution, but like most pictures by Mr. Eakins has the power of suggestion" ("National Academy Lacking in Thrills," *The Sun* [New York], March 19, 1916, p. 9). The fact of the work's acceptability for the National Academy of Design's annual exhibition testifies to the change that had taken place in the intervening thirty-odd years: the public had at last been "educated up to a dislike of what is called finish" ("Succession in Art," *New York Post*, March 19, 1878, p. 1).

72. For a particularly rich consideration of this project, see the entry on *The Spinner (A Sketch)* by Sally Mills in Wilmerding 1993, pp. 94–96. According to a son of its first owner, Eakins's friend Dr. Horatio Wood, Wood took it from the painter's easel for fear of its becoming overworked (Goodrich Papers). However, Susan Eakins recorded in her retrospective diary that Wood purchased the painting for fifty dollars on February 2, 1889 (Bregler Collection).

73. Goodrich speculated that the oil of a woman in dark contemporary clothes (now in the New Britain Museum of American Art, Conn.), served as a study for *A Quiet Moment* (Goodrich Papers). Eakins, by its frequent exhibition, accorded the watercolor great importance. *A May Morning in the Park* was an outdoor scene featuring equine anatomy and scientifically recorded motion, as well as the fashionable sport of coaching as practiced by one of Philadelphia's elite (Fairman Rogers, who was also Eakins's chief patron at the Pennsylvania Academy of the Fine Arts).

Both years witnessed a more modest exhibition program in terms of numbers of works shown and sites. This reduction probably reflects not only Eakins's increased teaching responsibilities at the Academy, with his parallel professional interest in photography and the codification of his perspective studies into an illustrated lecture series, but also the time required to cope with the deaths in 1879 of his fiancée Kathrin Crowell and his friend and supervisor at the Academy, Christian Schussele.

74. Two versions of *Shad Fishing at Gloucester on the Delaware River* (pls. 72, 76) and the related *Mending the Net* (pl. 85) represented fresh subject matter for Eakins—men working in the outdoors—while the elaborate *Singing a Pathetic Song* (pl. 63) was his largest contemporary genre scene to date.

The near crush of colonial themes at this time, by Eakins and others, might be gathered from Mariana Griswold van Rensselaer's closing praise for *Singing a Pathetic Song:* "All possible renderings of Italian peasants and colonial damsels and pretty models cannot equal in importance to our growing art one such strong and real and artistic work as this one" ("The New York Art Season," *The Atlantic Monthly*, vol. 48, no. 286 [August 1881], p. 199). This did not stop her, however, from later in the same article calling Douglas Volk's *Puritan Girl* "one of the most perfect of the year's pictures" (p. 200).

75. Discussed in Foster 1997, p. 437.

76. The gown is similar to those Eakins used in his photographs of women in pseudo-antique dress. See, for example, the photograph of the unidentified model seated with a banjo in front of the Worcester (Mass.) Museum of Art's *Spinner* (photograph c. 1883, The Metropolitan Museum of Art, New York; gift of Charles Bregler, 1944).

77. L[eslie] W. Miller, "Water-Color Exhibition at Philadelphia," *The American Architect and Building News*, vol. 11, no. 330 (April 22, 1882), p. 185.

78. The chair was borrowed from Dr. Mitchell, as with *Seventy Years Ago* and *William Rush*. Eakins recorded the work as *Study (Mrs. Perkins on Dr. M's chair)* in his record book when it was displayed at the Philadelphia Sketch Club in January 1882. Mrs. Perkins is otherwise unidentified. There are extant photographs attributed to Eakins apparently related to the painting; see Danly and Leibold 1994, p. 171, cat. nos. 217 and 218.

79. "Art Notes," *Daily Evening Transcript* (Boston), February 5, 1881, p. 6.

80. Greta, "Greta's Boston Letter. The Art Club's Exhibition—Holman Hunt Condemned by Harvard—The Follies of Art Pedantry—The St. Botolph Club," *The Art Amateur*, vol. 4, no. 4 (March 1881), p. 72.

81. "The Fine Arts: The Academy Exhibition," *The Critic*, March 26, 1881, p. 83; Mariana Griswold van Rensselaer, "The New York Art Season," *The Atlantic Monthly*, vol. 48, no. 286 (August 1881), p. 201.

82. "Fine Arts. Fifty-sixth Annual Exhibition of the National Academy of Design.—I," *The Nation*, vol. 32, no. 822 (March 31, 1881), p. 230. In 1882 Eakins sent the painting to the Philadelphia Sketch Club, to Providence, perhaps the Inter-State Industrial Exposition of Chicago (Eakins recorded it in his record book, but it is not listed in the catalogue), and then to the Pennsylvania Academy for the Fifty-third Annual Exhibition. The next year it traveled to Brooklyn and Detroit.

83. Eakins evidently began a watercolor copy of the oil, but left it unfinished (c. 1880, Philadelphia Museum of Art).

84. In the retrospective words of Cardinal Dougherty, archbishop of Philadelphia: "He told me he was a man who didn't believe in the divinity of Christ; whether or not he was an atheist I have not heard. He seemed to be an amiable character" (Denis Cardinal Dougherty to Shane Leslie, April 10, 1948, typescript in Goodrich Papers; quoted in Goodrich 1982, vol. 1, p. 187).

85. For an overview of what is known of the work's creation and reception, see Goodrich 1982, vol. 1, pp. 190–96.

86. In 1874 Bonnat exhibited at the Salon his strikingly realistic *Crucifixion* that used as a model a muscular cadaver nailed to a cross (fig. 28). The fullest treatment of Eakins's work and its European precedents is Elizabeth Milroy, "'Consummatum est...': A Reassessment of Thomas Eakins's *Crucifixion* of 1880," *Art Bulletin*, vol. 71, no. 2 (June 1989), pp. 269–84. Foster has written extensively on Bonnat's influence on Eakins in general as well as in this particular instance (1997, pp. 44–45). The first scholar to associate Eakins's *Crucifixion* with Bonnat's earlier work was Gerald Ackerman, "Thomas Eakins and His Parisian Masters Gérôme and Bonnat," *Gazette des Beaux-Arts*, series 6, vol. 73, no. 1203 (April 1969), pp. 235–56.

87. One American critic later recalled Hunt's painting as being "so execrable that not only every lover of art on approaching it had an almost irresistible impulse to put his foot through the canvas, but anybody who had a true respect for the subject was shocked and disgusted" (Greta, "Greta's Boston Letter. The Art Club's Exhibition—Holman Hunt Condemned by Harvard—The Follies of Art Pedantry—The St. Botolph Club," *The Art Amateur*, vol. 4, no. 4 [March 1881], p. 72). For the exhibition, held at the Williams & Everett Gallery, see Susan P. Casteras, *English Pre-Raphaelitism and Its Reception in America in the Nineteenth Century* (Rutherford, Madison, Teaneck, N.J.: Fairleigh Dickinson University Press, 1990), pp. 118–19.

88. See, for example, Edward Strahan [Earl Shinn], "Works of American Artists Abroad. The Second Philadelphia Exhibition," *The Art Amateur*, vol. 6, no. 1 (December 1881), p. 4.

89. The reviewer, in passing, noted that Hunt's *Shadow of the Cross* possessed this reverential light ("Art Notes...The Society of American Artists," *The Art Journal* [New York], vol. 8 [June 1882], p. 190).

90. M[ariana] G[riswold] van Rensselaer, "Society of American Artists, New York.—II," *The American Architect and Building News*, vol. 11, no. 334 (May 20, 1882), p. 231. A somewhat condensed, altered version appeared in "Art Matters. The Fifth Annual Exhibition of the Society of American Artists, New York," *Lippincott's Magazine*, n.s., vol. 4 (July 1882), pp. 106–7. For a detailed review of the work and this critic's response, see Lois Dinnerstein, "Thomas Eakins' 'Crucifixion'

as Perceived by Mariana Griswold van Rensselaer," *Arts Magazine*, vol. 53, no. 9 (May 1979), pp. 140–45.

91. Eakins to John W. Beatty, March 10, 1908, Carnegie Institute, Museum of Art records, Archives of American Art.

92. These three first showed major sculptures that won wide acclaim, or in Degas's case notoriety, in 1877, 1878, and 1881, respectively. All these works, in contrast to those by Eakins, were large and in the round. For a recent summary of Leighton's sculptural work, see Stephen Jones et al., *Frederic Leighton, 1830–1896* (London: Royal Academy of Arts, 1996), pp. 182–83. For Gérôme's, see Gerald M. Ackerman, *The Life and Work of Jean-Léon Gérôme, with a Catalogue Raisonné* (New York: Sotheby's, 1986), pp. 308–33, especially pp. 310–11. For Degas, see Richard Kendall et al., *Degas and The Little Dancer* (New Haven: Yale University Press for the Joslyn Art Museum, 1998).

93. [William C. Clark], "The Fine Arts. The Academy Exhibition—Third Notice," *Daily Evening Telegraph* (Philadelphia), November 7, 1883, p. 8.

94. Augustus Saint-Gaudens to Eakins, c. May 27, 1884, transcript in Goodrich Papers.

95. Augustus Saint-Gaudens to Eakins, June 2, 1884, transcript in Goodrich Papers. A note from Will Sartain elaborated on Saint-Gaudens's thoughts on the works: "St. Gaudens told how that there were things in your bas relief that he would have been proud to have modelled. He says you did things that no sculptor would have attempted and that the effort to do them marred the effect of the work very much. The excessive reality of the chair and the wheel for instance demanded an unattainable perfection in the figure" (May 29, 1884, transcript in Goodrich Papers).

Eakins eventually showed the reliefs in Brooklyn in February 1885—his sole New York–area showing for three years after this slight in early 1884. Only in 1887 did Eakins again exhibit at the Society of American Artists, when he sent three portraits and these same two reliefs. This time they were accepted.

96. Goodrich 1982, vol. 2, pp. 119–26.

97. Sigma [Earl Shinn], "Pennsylvania Academy Exhibition," *The Art Amateur*, vol. 8, no. 1 (December 1882), p. 8.

98. The exhibition records for 1884 and 1885 show a marked diminution in sheer numbers of works sent out, probably the result of his teaching responsibilities, an ever-greater involvement with photographic exercises, and the distractions of his marriage and move out of the family home in 1884. But even here the new works being shown continued to expand the repertoire of types in which Eakins could claim proficiency: the pure landscape of *The Meadows, Gloucester* (pl. 88) shown in 1884 and *Swimming* (pl. 149) in 1885.

"Photographs and the Making of Paintings," pp. 225–38

MARK TUCKER AND NICA GUTMAN

The authors wish to acknowledge their indebtedness to Kathleen A. Foster, whose scholarship contributed greatly to this essay. Her work with Charles Bregler's Thomas Eakins Collection at the Pennsylvania Academy of the Fine Arts was the impetus and touchstone for our research. We wish also to express our appreciation for the constant, lively exchange of ideas with W. Douglass Paschall that took place throughout the course of our research.

1. Letter to editor, signed "P.D.N.," *The Studio*, vol. 2, no. 44 (November 1883), pp. 197–98.

2. This last possibility would have held special appeal for Eakins, who seems to have regarded drawing as little more than a functional necessity. Kathleen A. Foster has convincingly established that Eakins was not committed to drawing as an independent artistic activity and that the relative scarcity of drawings is because of low production rather than selective survival. See Foster, *Thomas Eakins Rediscovered: Charles Bregler's Thomas Eakins Collection at the Pennsylvania Academy*

of the Fine Arts (New Haven and London: Yale University Press for the Pennsylvania Academy of the Fine Arts, 1997), pp. 51–71.

3. John M. Tracy, "Recollections of Parisian Art Schools," *The Studio*, vol. 2, no. 27 (July 1883), p. 7.

4. For an extended discussion of the role of photography in naturalist painting, see Gabriel P. Weisberg, *Beyond Impressionism: The Naturalist Impulse* (New York: Abrams, 1992). See also his articles: "P.A.J. Dagnan-Bouveret and The Illusion of Photographic Naturalism," *Arts Magazine*, vol. 56, no. 7 (March 1982), pp. 100–105; and "P.A.J. Dagnan-Bouveret, Jules Bastien-Lepage, and the Naturalist Instinct," *Arts Magazine*, vol. 56, no. 8 (April 1982), pp. 70–76.

5. One observer of the Parisian art scene in the 1860s noted, "Meissonier was quite the pioneer in the use of photography. Many of his pictures were almost entirely done from photographs. The celebrated *Retreat of Napoleon in 1814*, lately owned by Mr. Ruskin and sold for a fabulous price was one of these. The not less famous *Chess Players* is another. Pasini is another example of the skillful use of photography. But I need not give names. Pretty nearly all French painters do the same to a greater or less extent. I remember seeing in a shop window one day in autumn, a very beautiful photograph of a cow. In the following Salon I counted thirteen pictures in which that photograph had been used" (John M. Tracy, "Recollections of Parisian Art Schools," *The Studio*, vol. 2, no. 27 [July 1883], p. 7).

6. For example, in his *Lectures on Aesthetics* from the 1820s (first published 1835–38), Georg Friedrich Wilhelm Hegel wrote: "I will not enter more closely into the confusions which have prevailed respecting the conception of inspiration and genius, and which prevail even at the present day respecting the omnipotence of inspiration as such. We need only lay down as essential the view that, though the artist's talent and genius contains a natural element, yet it is essentially in need of cultivation by thought, and of reflection on the mode in which it produces, as well as of practice and skill in producing" (G.F.W. Hegel, *Introductory Lectures on Aesthetics*, trans. Bernard Bosanquet [London: Keegan Paul, 1886]; quoted in Charles Harrison, Paul Wood, and Jason Gaiger, eds., *Art in Theory, 1815–1900: An Anthology of Changing Ideas* [Oxford: Blackwell, 1998], p. 63).

7. An 1883 letter to *The Studio* indicates the ambivalence among artists and the public regarding the use of photographs: "It is doubtless a surer, and it is certainly a much easier way, to paint from…photographs than from nature itself," but "we are not after all as much artists as when we do our own drawing and stand simply in our own thoughts." The writer then proposed "full disclosure" of the use of photographs: "Granted (which we certainly question) that [working from photographs] is the true and best method of work, it should at least be fairly and honestly stated when thus done. Those artists who conscientiously and consistently refrain from such aid should let the fact be understood, since otherwise they place themselves at an immense disadvantage in exhibitions, where their own drawing and modelling is side by side with photographic work, not stated to be such" (Letter to editor, signed "P.D.N.," *The Studio*, vol. 2, no. 44 [November 1883], pp. 197–98).

8. Jean-Louis-Ernest Meissonier, who was profoundly interested in the revelations of photography (agreeing, for example, to paint Leland Stanford's portrait only after learning of Stanford's involvement in Eadweard Muybridge's motion studies, at which point he "recognised a collaborator!") and who was reputed to rely extensively on photographs for his paintings, is nevertheless quoted as having had only a passing interest in its artistic value: "I hear a great deal of talk about photography. But what would be the pleasure of practicing it? No pursuits are really amusing but those which present great difficulties. Don't you feel that you would lose all interest in an operation if your instrument could work of its own accord?" (quoted in Vallery C. O. Gréard, *Meissonier: His Life and His Art* [London: William Heinemann, 1897], pp. 77, 82).

9. See Weisberg 1992, pp. 38–40 for relevant images of Jules-Alexis Muenier; and Weisberg 1982, pp. 100–105.

10. [William J. Clark, Jr.], "The Fine Arts: The Academy Exhibition— Third Notice," *The Daily Evening Telegraph* (Philadelphia), November 1, 1882, p. 4.

11. Lloyd Goodrich, *Thomas Eakins*, 2 vols. (Cambridge, Mass.: Harvard University Press for the National Gallery of Art, 1982), vol. 1, p. 191.

12. Sadakichi Hartmann, *The Art News*, vol. 1, no. 2 (April 1897), p. 4.

13. Susan Eakins to Alfred R. Mitchell, October 26, 1930, Archives of American Art, Smithsonian Institution, Washington, D.C. (hereafter Archives of American Art).

14. "P.D.N." appealed to artists to admit openly their use of photographs: "We do not mean to assert that this use of photographs is made in an underhand or clandestine manner. We believe the fact to be no secret, nor do any of the artists who avail themselves of such aid deny it; the very denial or effort to keep it secret would in itself stamp it as illegitimate" (Letter to editor, signed "P.D.N.," *The Studio*, vol. 2, no. 44 [November 1883], pp. 197–98).

15. The secrecy surrounding any serious artist's use of photographs contravened the sharing, much less the standardization and teaching, of specific techniques.

16. Previous studies noted various techniques for the transfer of drawings or painted sketches to canvas. Pencil-drawn or incised center and horizon lines that fix the viewer's point of sight in relation to the limits of the picture plane were a basis of compositional layout advocated by Eakins in his teaching and are frequently found on his canvases, put on as a beginning step (see Eakins's drafts for his drawing manual, c. 1881–87, Thomas Eakins Research Collection, Philadelphia Museum of Art [hereafter Eakins Research Collection]; described in Foster 1997, pp. 59*ff.*, 331). Canvases were sometimes squared off with a grid of pencil lines to facilitate accurate copying of the image from a correspondingly squared drawing or painted sketch. See Mark Bockrath, "The Conservation of the Paintings," in Foster 1997, pp. 453–54; and Theodor Siegl, *The Thomas Eakins Collection* (Philadelphia: Philadelphia Museum of Art, 1978), p. 89. The transfer of preparatory drawings by placing them over the canvas and pricking though them to mark contours with closely spaced tiny holes in the priming has been noted in the early 1870s rowing pictures and in the 1879–80 *A May Morning in the Park*; see, respectively, Christina Currie, "Thomas Eakins Under the Microscope," in Helen A. Cooper et al., *Thomas Eakins: The Rowing Pictures* (New Haven: Yale University Press, 1996), pp. 91–96, and Siegl 1978, p. 81. Pinholes also occur singly at the ends or junctions of layout lines. Pencil-drawn or incised arcs and lines delimiting the size or edges of forms indicate that a source image was transferred using dividers and straightedge or that some elements may have been constructed directly on the priming prior to painting; see Currie in Cooper 1996, pp. 91–96, and Currie, "The Biglin Brothers Turning the Stake by Thomas Eakins: A Technical Study Reveals Surprising Techniques," talk delivered at the Annual Meeting of the American Institute for Conservation, Nashville, Tenn., 1994. Incised lengths of intersecting horizontal and vertical lines have been found associated with figures in *Swimming*; see Claire M. Barry, "*Swimming* by Thomas Eakins: Its Construction, Condition and Restoration," in *Thomas Eakins and the Swimming Picture*, ed. Doreen Bolger and Sarah Cash (Fort Worth, Tex.: Amon Carter Museum, 1996), pp. 100–101.

17. See W. Douglass Paschall's essay "The Camera Artist," in this volume.

18. Our study of underdrawings was carried out with a Hamamatsu C1000-03 infrared vidicon camera, with an N2606 tube. Reflectogram assemblies were made by Joseph Mikuliak using Photoshop 5.0.

19. One tracing method available at the time was the pantograph, a mechanical instrument that allows lines traced on a source image to be duplicated in variable scale on another surface. A few areas of the underdrawings in the Gloucester works were drawn more sketchily and freehand (but clearly in the same tracing session) and do not therefore look consistently mechanical enough to have been transferred with a pantograph. A more traditional tracing method for transfer onto opaque surfaces is a sort of "carbon paper" method, whereby the reverse of a drawing to be traced is blackened with pencil or charcoal. The sheet is then placed on a surface and the lines retraced, transferring the image. The sharp pencil lines seen in the Gloucester underdrawings, however, appear to have been made directly, as was the visible drawing for the *Drawing the Seine* watercolor.

20. The French painter Jules-Alexis Muenier's use of glass lantern slides in the late 1880s to project photographs onto intermediary drawings

on paper for subsequent transfer to canvas is discussed in Weisberg 1992, p. 34ff. Weisberg also noted the increasing proliferation, critical acknowledgment, and (in some circles) full validation of painters' direct use of photographs by the end of the century.

21. See Aaron Scharf, *Art and Photography* (London: Penguin, 1968), p. 33.

22. See W. Douglass Paschall's essay "The Camera Artist" in this volume for discussion of image-projection devices available at the time. These included not only the common magic lantern for projecting glass slides but also, as Paschall has found, the catoptric lantern for projecting photographic prints. Producing glass photographic positives for the magic lantern was simple and inexpensive; Charles Bregler's Thomas Eakins Collection at the Pennsylvania Academy of the Fine Arts, Philadelphia (purchased with the partial support of the Pew Memorial Trust; hereafter Bregler Collection) includes glass positives from Eakins's photographs, although none of these relate to paintings. Descriptions of the ways artists could use magic lanterns appeared in periodicals devoted to photography; the following, from 1875, is typical: "Another important application of this instrument is in making enlargements for life-size crayons or oil paintings.... Now, as an outline sketch is all that is required by most good artists, this can be made with the sciopticon [magic lantern] with very little trouble. All that is required to work from is a small negative of card or cabinet size. This is placed in the usual position, with the varnished side towards the condensers. The canvas or cartoon paper, on which the oil portrait or crayon is to be made, is then placed in an upright position, upon a frame or stretcher, at such distance as to give the proper enlargement, or this may be first placed in position, and the lantern adjusted to it. The impression is made by transmitted light. The artist, with a charcoal crayon, works on the side from the lantern, and makes a careful tracing of every line and feature in such a way as to best suit his purpose" ("Uses of the Sciopticon in Photography," *The Magic Lantern*, vol. 1, no. 9 [1875], p. 76). Interestingly, this writer proposed placing a large photographic print over a canvas and "sticking the outlines full of pinholes, and rubbing over with crayon to get an impression on the canvas" (ibid.).

23. A number of small foreground features seen in the source photograph for *Drawing the Seine* were traced in the underdrawing of the watercolor, but were not painted. Eakins left his options open in the tracing; he transcribed an excess of information from the photograph, then sorted and edited during painting.

24. In addition, the right-hand standing figure of the central group on the barge is substituted from yet another photograph, the one used for the watercolor *Taking Up the Net* (The Metropolitan Museum of Art, New York).

25. P.A.J. Dagnan-Bouveret, the naturalist painter and a former student with Eakins in Gérome's studio, had described *Pushing for Rail*, which he had seen in 1875 in Paris, to J. Alden Weir well enough so that when Weir later saw it he said: "The remarkable character of the figures made me realize it was the one he spoke of." Dagnan's special notice of the painting may indicate his recognition, suspicion, or even admiration of Eakins's use of photographs (quoted in Goodrich 1982, vol. 2, p. 271).

26. F. de Lagenevais, "Salon de 1875," *Revue des Deux Mondes*, vol. 9, no. 3 (June 15, 1875), p. 927; translated in Ellwood C. Parry III, "Thomas Eakins and the Everpresence of Photography," *Arts Magazine*, vol. 51, no. 10 (June 1977), p. 113.

27. Photography's gradual displacement of drawing was not universally regarded as a negative development, but rather, among painters concerned with strict accuracy of representation, as a welcome progression beyond inaccurate conventions of drawing. An account of one artist's experiences in Paris in the late 1860s—"during one of the great transition periods that mark the history of the French School...a change from the old to the new, whose importance seems to be imperfectly understood [in the United States]"—reflects such approval: "Little as some like to own it, [the influence of photography on the French School] has been very great; chiefly in the overthrow of conventional classic drawing. The old system of drawing, by which a man's stature must be eight times the length of his head, could not stand beside the absolute verity of the photograph" (J. M. Tracy, "Recollections of Parisian Art Schools," *The Studio*, vol. 2, nos. 27–30 [July 1883], pp. 1, 7).

28. In a number of cases, Eakins renewed datum lines that he had drawn in pencil at an earlier stage by incising them into the paint.

29. Former Philadelphia Museum of Art conservator Theodor Siegl had noted the pencil-drawn horizontal baseline in *Mending the Net* (Conservation files, Philadelphia Museum of Art); Claire M. Barry (in Bolger and Cash 1996, pp. 99–101) noted long incised horizontal and vertical lines in *Swimming*.

30. Eakins had obviously chosen the overall scene of the shad fishermen and decided what kind of figure group he wanted for the left foreground before he photographed that group separately. When he then took the study photographs, as Foster (1997, p. 165) pointed out, he set them along a patch of grass at an angle matching that of the receding shoreline in the main source photograph. When the image of the foreground figure group photograph (pl. 75) is projected onto the Philadelphia *Shad Fishing* painting, the edge of the road in the study photograph matches perfectly the angle and alignment of the shoreline relative to the same group in the finished painting.

31. Eakins's "fragmented approach" as described by Foster (1997, p. 27) is consistent with his piecemeal method of painting from projection. Eakins himself said, "When finishing, paint a small piece, then don't go and finish another beside it. If you do you lose your drawing. But finish a piece some distance from it and then keep working the two points. For example, if I were painting an arm, I would finish the elbow and then the wrist, then I would finish in between until the two ends meet" (Charles Bregler, "Thomas Eakins as a Teacher," *The Arts*, vol. 17, no. 6 [March 1931], p. 384). For Gérome's related working procedure, see Gerald Ackerman, *The Life and Work of Jean-Léon Gérôme, with a Catalogue Raisonné* (London: Sotheby's, 1986), p. 163.

32. It takes close looking and a practiced eye, even with a very high-quality stereomicroscope, to locate the marks. Eakins took care to make sure they were not apparent in the finished painting, touching out at the last those that remained too visible.

33. In some cases there is a curious pattern of survival of photographic images; while a number of related photographic studies might survive for a subject, its identical match often does not. The most likely explanation is that the exact source image was separated from the others for use and then lost or destroyed. *Mending the Net* is an example of a painting for which only some of the source photographs survive, though it is clear that photographs were used for all the figures.

34. The intact detailed pencil drawing on *Drawing the Seine* is unusually conspicuous. Another watercolor examined in this study that showed vestiges of drawing and erasure was *Whistling Plover* (Brooklyn Museum, New York), confirmed by conservator Antoinette Owen during our examination on April 11, 2001.

35. The detection of underdrawings in Eakins's oil paintings using IRR can be difficult, owing to the characteristic lightness of his contour lines, which are easily obscured by thicker buildups of paint or by paint mixtures containing pigments (particularly black) that mask the drawn lines. The IRR study of the Gloucester paintings required examination at very close range, in small sections at a time, in order to resolve the light graphite lines of the drawing.

36. See W. Douglass Paschall's essay "The Camera Artist," in this volume on the complex preparatory study, transfer, construction, and combination of the painting's various elements.

37. Photographs of Susan Eakins were used for both paintings. The landscapes were derived from Eakins's photographic landscape studies taken at Avondale in the early 1880s. No photograph of a draped figure survives among the group of photographic studies for *An Arcadian*. The incised marks throughout the drapery in the painting show, however, that it was painted from a photograph of a clothed figure, not from the nude that does survive in photographs (pl. 115).

38. "In *The Swimming Hole* Eakins modelled the diving figure in wax and painted from it" (Susan Eakins to Alfred R. Mitchell, October 26, 1930, Archives of American Art).

39. Despite the care taken to conceal the small marks made for painting from projected images, Eakins made little effort to hide auxiliary lines, marks, or grids related to more traditional methods of transferring or constructing images.

40. *Cowboys in the Bad Lands* (pl. 164) of 1888 is another painting for which photographic studies of both figures and landscape survive.

During our research it was not possible to examine the painting, though Foster (1997, p. 194) has noted that a transfer grid related to the one on the large Philadelphia study of the standing cowboy and his horse can be seen beneath the paint of the landscape.

41. It is less likely, but possible, that Eakins initially projected the photograph onto his canvas to establish the basic contours of the underdrawing and then used squaring only for reference for lay-in of modeling. The pencil drawings in these three paintings are not sufficiently visible with IRR to judge whether they were traced.

42. Eakins may have painted from a projected photograph as early as 1872. W. Douglass Paschall has discovered a photographic source for Eakins's painting of his friend Henry Schreiber's setter dog Grouse (fig. 138). The work exhibits some of the tiny incised marks associated with projection as well as squaring drawn before painting and renewed with incised lines in the paint during painting, which suggests Eakins's experimentation with a combined technique at an early point in his career.

43. As Eakins wrote in the Spanish notebook, kept at the very beginning of his career as a painter: "All the progress I have made so far has been the result of the discoveries that have permitted me to divide my energies and my work methods. Let us ever divide things up so as to get as strong a start as possible" (Bregler Collection; typescript translation from the original French in Eakins Research Collection).

44. Although Christina Currie (in Cooper 1996, pp. 91–96) investigated the use of pinpricking to transfer contours from drawings onto canvas in the rowing pictures, one source mentioned the technique in relation to transfer from photographic prints: "Uses of the Sciopticon in Photography," *The Magic Lantern*, vol. 1, no. 9 (1875), p. 76. In some cases, construction of the composition or pictorial space was worked out on the surface of the canvas itself. Red paint and red pencil marks, present along the edges of *Sailboats Racing on the Delaware* and *Between Rounds* (pl. 215) suggest end points of auxiliary construction lines. Painted red orthogonals can be detected beneath the paint in *Baby at Play* (pl. 18) and *Elizabeth Crowell with a Dog* (pl. 9).

45. See Foster (1997, pp. 167–69) on changes from the source photographs in *Mending the Net*. As Eakins translated the forms from photographs into paint, he made subtle adjustments of sharpness. Alterations were necessary to compensate for the excessive blurriness of some source photographs, but Eakins had additional concerns. He certainly considered the sharpness of forms relative to depth of field, often putting one principal plane in sharpest focus. But he was also interested in another specific effect of sharpness related to photographic vision; Eakins's softening of some edges clearly represents halation, the phenomenon seen in photographs when a point or field of bright illumination spreads beyond its proper boundary, causing edge blurring of strongly backlit dark forms. This effect appears in the figures in *Mending the Net*, whose lighter-than-background edges and interior details are sharp while their brightly backlit dark edges are softened. Eakins's interest in halation is also evident in the edge blurring of the strongly backlit bridge pier in *The Pair-Oared Shell*, a picture that has no apparent connection to a photographic source. He was also quite likely aware of the principle in physiological optics of irradiation or the perceived encroachment of light areas onto adjacent dark ones. Hermann von Helmholtz's *Treatise on Physiological Optics*, first published in German in 1856–57 and then in French in 1867, was the authoritative source on the subject during Eakins's lifetime. For irradiation, see the current English edition: *Helmholtz's Treatise on Physiological Optics*, ed. James P. C. Southall (1924–25; reprint, New York: Dover, 1962), vol. 2, part 2, pp. 186–93.

46. Edward Strahan [Earl Shinn], "Works of American Artists Abroad: The Second Philadelphia Exhibition," *The Art Amateur*, vol. 6, no. 1 (December 1881), p. 6.

47. Even accomplished painters recognized the need to check the eye's accommodation to weakness or error in the painted image. Léon Bonnat was said to have "carried a hand mirror to compare the portrait with the sitter and worked persistently until the aspect was similar" (H. Barbara Weinberg, *The Lure of Paris: Nineteenth-Century American Painters and Their French Teachers* [New York: Abbeville Press, 1991], p. 160). Edouard Manet, proud of having painted the head of the guitarist in the *Spanish Singer* "in one go," described his test of its veracity: "After working for two hours, I looked at it in my little black

mirror, and it was all right. I never added another stroke" (cited in Françoise Cachin and Charles S. Moffett, *Manet 1882–1883* [New York: Abrams, 1982], p. 64).

"The Camera Artist," pp. 239–55

W. DOUGLASS PASCHALL

This essay would have been impossible without the unstinting generosity of scores of individuals: curators and conservators, librarians and archivists, collectors, and the descendants of several of the persons discussed. Above all, I owe a debt to Cheryl Leibold, archivist of the Pennsylvania Academy of the Fine Arts, who never flinched under a barrage of inquiries and special requests. An especially rewarding collaborative investigation with Mark Tucker and Nica Gutman and discussions with Eric Greenleaf, Elizabeth Milroy, and Darrel Sewell gave the project its backbone. Dorothea Frankl and Max Paschall sustained it.

Thomas Eakins was reluctant to title his photographs; only three are known to have been named during his lifetime. The titles given to his photographs in recent decades often vary. For this exhibition, a neutral solution seemed the best course, and the titles that accompany photographs in this volume are descriptive, bracketed to indicate that choice.

1. These discussions, lectures, and exhibitions were reported in the *Proceedings of the American Philosophical Society* and the *Journal of the Franklin Institute*. For a summary of the daguerreotype's introduction in Philadelphia, see William F. Stapp, *Robert Cornelius: Portraits from the Dawn of Photography* (Washington, D.C.: Smithsonian Institution Press, 1983), pp. 25–44. The rise of photography in Philadelphia is summarized in Kenneth Finkel, *Nineteenth-Century Photography in Philadelphia: 250 Historic Prints from The Library Company of Philadelphia* (New York: Dover for the Library Company of Philadelphia, 1980), esp. pp. vii–xxviii.

2. Alexander Wolcott and John Johnson opened the nation's first commercial photographic studio in New York City in February or early March 1840, when they made this daguerreotype, an image of James Jay Mapes. Mapes, the editor of the New York-based *American Repertory of Arts, Sciences, and Manufactures* that in April published Wolcott's account of his progress, showed a group of their daguerreotype portraits before a meeting of the Franklin Institute later that month (*Journal of the Franklin Institute*, vol. 25 [May 1840], pp. 300–301) and lent one to the Artists' Fund Society's exhibition.

3. Cheryl Leibold provided a list of the photographs exhibited at the Pennsylvania Academy before 1870.

4. Officers of these institutions were among the founders of the Photographic Society, including Matthias W. Baldwin and James L. Claghorn of the Pennsylvania Academy's board of directors. Fairman Rogers, another of the society's initial members, became a director of the Academy in 1871, oversaw the construction of its new building, and chaired its Committee on Instruction from 1877 to 1883. In its first fifteen years, the Photographic Society would add four more past, active, or future Academy directors to its membership: Joseph W. Bates, Sr., in 1863, John Henry Towne in 1864, John Sartain in 1872, and Henry C. Gibson in 1876. Bates would serve as the Society's president for several years before he died in 1886. The membership register of the Photographic Society of Philadelphia is now in the Louis Walton Sipley Papers at the George Eastman House/International Museum of Photography and Film, Rochester, N. Y. (hereafter Sipley Papers).

5. Eakins never joined the Photographic Society, though he attended some of their meetings and celebrations, shared with them his innovations, and exhibited with the group in 1886. See Thomas Eakins to [Robert S. Redfield], November 22, 1883, Sipley Papers; Robert S. Redfield, "Society Gossip: Photographic Society of Philadelphia...," *The Philadelphia Photographer*, vol. 21, no. 241 (January 1884), p. 15; and "The Philadelphia Exhibition," part 2, *Anthony's Photographic Bulletin*, vol. 17, no. 4 (February 27, 1886), p. 117.

6. As corresponding secretary of the Pennsylvania Academy in the mid-1860s, John Sartain would provide the young Eakins with letters of introduction to enter the Ecole des Beaux-Arts. The elder Sartain's interest in photography surely dated to the early 1840s, when he was a close friend of James Jay Mapes (see William Sartain's retrospective diary, typescript, p. 38, Thomas Eakins Research Collection, Philadelphia Museum of Art; hereafter Eakins Research Collection). Sartain, an early member of the Artists' Fund Society, served as its president from 1844, the year after Mapes had been made an honorary amateur member of the association.

Considerably later, through the Sartains, Eakins met Mapes's grandson James Mapes Dodge, an engineer and amateur photographer and from 1885 to 1893 a member of the Photographic Society of Philadelphia (nominated by John Sartain). It was to Dodge's house in Germantown that Eakins and his student Samuel Murray would go bicycling after visiting Saint Charles Borromeo Seminary on weekends in the early 1900s.

Photographs by John, Henry, Samuel, and Paul Judd Sartain are preserved in the archives of the Moore College of Art and Design, Philadelphia, and at the George Eastman House/International Museum of Photography and Film, Rochester, N.Y. Correspondence between the Dodges and Sartains and photographs by James M. Dodge are held by his descendants and in the Dodge Family Papers, Rare Books and Special Collections, Princeton University Library.

7. On Sellers's activities during this period, see Robert Taft, *Photography and the American Scene: A Social History, 1839–1889* (1938; reprint, New York: Dover, 1964), pp. 215–22; and Robert Wall Eskind, "The Amateur Photographic Exchange Club (1861–1863): The Profits of Association" (M.A. thesis, University of Texas at Austin, 1982). Sellers would later serve as president of the Franklin Institute from 1870 to 1874 and as the first president of the board of trustees of the Pennsylvania Museum and School of Industrial Art, now the Philadelphia Museum of Art.

Titian Ramsay Peale joined the Amateur Photographic Exchange Club in June 1862 and was elected an honorary member of the Photographic Society in 1884, one year before his death. Howard Peale, a son of daguerreotypist James Peale, Jr., was a member of the Photographic Society from its inception. See the membership register of the Photographic Society of Philadelphia; and [Edward L. Wilson], "In Memoriam," *The Philadelphia Photographer*, vol. 1, no. 9 (September 1864), pp. 139–41.

8. [Edward L. Wilson], "Editor's Table," *The Philadelphia Photographer*, vol. 3, no. 28 (April 1866), p. 128.

9. For accounts of the Morans' activities, see Nancy K. Anderson et al., *Thomas Moran* (New Haven and London: Yale University Press for the National Gallery of Art, 1997); and Mary Caroline Panzer, "Romantic Origins of American Realism: Photography, Arts and Letters in Philadelphia, 1850–1875" (Ph.D. diss., Boston University, 1990). Eakins, in a letter from Paris to Frances and Benjamin Eakins, June 21, 1867 (Pennsylvania Academy of the Fine Arts, Philadelphia, Charles Bregler's Thomas Eakins Collection, purchased with the partial support of the Pew Memorial Trust; hereafter Bregler Collection), recounted his friendship with the Morans in Philadelphia: "I owe them a heavy debt of gratitude for their kindness to me as their house was to me everything but my own home at 1729."

John Moran at this time, too, photographed the home and family of portrait painter Samuel Bell Waugh, whose daughters Ida and Amy numbered among Eakins's closest female friends. One of these stereographs, showing a backlit pianist (The Library Company of Philadelphia, reproduced in Finkel 1980, p. 82), bears comparison with Eakins's 1875 painting *Elizabeth at the Piano* (pl. 13).

10. On Gérôme's use of photographs by Nadar, see Sylvie Aubenas, "Modèles de peintre, modèles de photographe," in Aubenas et al., *L'Art du nu au XIXᵉ siècle: Le photographe et son modèle* (Paris: Hazan for the Bibliothèque Nationale de France, 1997), pp. 46–49. I would like to thank Laurence des Cars for bringing this publication to my attention. On Gérôme's advice to his pupils, see the reminiscences by Edwin H. Blashfield, Eakins's fellow student in Paris, in "Open Letters," *The Century Magazine*, vol. 37, no. 4 (February 1889), p. 635.

That Eakins took his teacher's advice can be seen in his purchases of photographs in Europe, recorded in letters to Benjamin Eakins (November 11, 1866, and September 8, 1869, preserved in transcripts in the Lloyd Goodrich and Edith Havens Goodrich, Whitney Museum of American Art, Record of Works by Thomas Eakins, Philadelphia Museum of Art [hereafter Goodrich Papers]; and March 17, 1868, Bregler Collection) and to Caroline Cowperthwait Eakins (June 28, 1867, and August 30, 1869, Bregler Collection; and April 14, [1869], Archives of American Art, Smithsonian Institution, Washington, D.C.). His visit to sculptor-photographer Antoine-Samuel Adam-Salomon's studio is described in his letter to both parents, December 19, 1867 (collection of Daniel W. Dietrich II; hereafter Dietrich Collection). From another renowned photographer, Etienne Carjat, Eakins acquired carte-de-visite portraits of himself and of Gérôme (Philadelphia Museum of Art). Carjat's address and further purchases of photographs were recorded in the account book he kept in Paris (Philadelphia Museum of Art).

11. Daguerre, a diorama painter, claimed his invention would "give a new impulse to the arts, and far from damaging those who practise them, it will prove a great boon to them" ("Daguerreotype," 1838 broadside prospectus, quoted in Helmut and Alison Gernsheim, *L.J.M. Daguerre: The History of the Diorama and the Daguerreotype*, rev. ed. [New York: Dover, 1968], p. 81). Talbot, who began his researches leading to paper photography after he was dissatisfied with travel sketches he had made with a camera obscura, argued that talbotypes "will enable us to introduce into our pictures a multitude of minute details which add to the truth and reality of the representation, but which no artist would take the trouble to copy faithfully from nature" (*The Pencil of Nature* [1844–46: reprint, New York: Da Capo Press, 1969], commentary for plate 10).

12. When Henri-Félix-Emmanuel Philippoteaux's *Panorama of the Siege of Montretout* was exhibited in New York in 1882, the editors of *The Art Journal* proclaimed it "one of the sights of the city. The realistic effects are marvellous; and these have been aided by the introduction of actual trees, barrels, hot-beds, walls, and roofs apparently battered by shot and shell, a trickery which we readily pardon to panoramas. The scene is reproduced from photographs and the testimony of eyewitnesses, and is in this sense historical" ("Art Notes," *The Art Journal* [New York], n.s., vol. 8 [November 1882], pp. 350–51).

13. Records of the Photographic Society of Philadelphia, Sipley Papers. Eakins knew Rothermel "all my life, from my childhood up," and at the time of the Photographic Society election had just entered the Academy's life class, where the older artist was often available for informal critiques of students' drawings. See "Hovenden and Rothermel. Thomas Eakins Talks of the Two Great Artists Now Lying in Death...," *The Philadelphia Press*, August 17, 1895, p. 4.

14. "J'ai fait quelques portraits de genre et quelques portraits d'animaux"; from Eakins's draft of a letter to Jean-Léon Gérôme, probably March 1874, Bregler Collection.

15. Eakins's techniques and the evidence his paintings bear of his use of photographic sources are examined in the essay "Photographs and the Making of Paintings" by Mark Tucker and Nica Gutman, in this volume.

The perspective drawing for *The Artist and His Father Hunting Reed Birds* is the only surviving example in which a single figure in the composition was independently squared. By implication, it would thus appear that this was the only painting requiring a detailed perspective for which a photograph was transferred by this means. Speculations that Eakins might have used photographs for one or more rowing subjects (see Kathleen A. Foster, *Thomas Eakins Rediscovered: Charles Bregler's Thomas Eakins Collection at the Pennsylvania Academy of the Fine Arts* [New Haven: Yale University Press for the Pennsylvania Academy of the Fine Arts, 1997], p. 108) have not yet been borne out in examinations of these paintings and related drawings.

16. See Eakins's own comments in [William C. Brownell], "The Art Schools of Philadelphia," *Scribner's Monthly*, vol. 18, no. 5 (September 1879), p. 741.

17. For discussion, see Mark Tucker and Nica Gutman, "Photographs and the Making of Paintings," in this volume.

18. Eakins had chanced upon the largest drifting boat race (a very different competition and the subject of a series of the artist's paintings and watercolors) ever held on the Delaware River, in August 1874, when he accompanied Henry Schreiber to Gloucester to make studies of pond lilies in nearby Timber Creek (Eakins to Kathrin Crowell, August 19, 1874, Bregler Collection). It seems likely, too,

that Schreiber would have helped Eakins make the photographs he used that year for *Sailboats Racing*. Several years later, the artist would make his own photograph of similar boats, their sails billowing, on a beach at the New Jersey shore (pl. 68). Such photographs could only be made in a gentle breeze, to avoid tipping and damaging the lightweight boats. *Sailboats Racing* originally was conceived with choppy water in the foreground, as Mark Tucker and Nica Gutman have observed in x-radiographs of the painting. This would suggest a stiff wind that would have heeled the powerful hikers much farther from the picture plane. Eakins overpainted the foreground, diminishing the waves, perhaps to match the photographic studies of the boats.

19. Mark Tucker and Nica Gutman were the first to recognize that Eakins must have been projecting photographs for some of his paintings (communicated to this author in June 1999). See their essay "Photographs and the Making of Paintings" in this volume.

That Eakins had recourse to a magic lantern at some stage of his career may be inferred from the number of lantern slides made from his photographs (now in the Bregler Collection and the Metropolitan Museum of Art, New York). Such projectors, especially in inexpensive versions intended for parlor entertainment, were commonplace in Philadelphia from the 1860s. The enlarging lantern, a standard piece of equipment in many commercial photographic studios, enabled negatives of any size to be projected. Catoptric lanterns, or magic mirrors, permitted a user to project opaque items, such as prints, by reflection. George Sibbald, a Philadelphia merchant, patented a coal oil-illuminated catoptric lantern in 1864; "The Photographoscope Catoptric Lantern," *The Philadelphia Photographer*, vol. 1, no. 11 (November 1864), p. 170. Should none of these devices have been among the Eakinses' possessions, the means to project photographs may have come from Henry Schreiber, whose father, Franz George Schreiber, had been a pioneer in the use of lantern slides in the early 1850s.

20. To judge from published accounts of the time, a veritable industry had arisen among commercial photographers by the late 1860s to enlarge photographs by projection onto canvas, either to stand on their own or to be overpainted by artists with watercolor or oil pigments. See, among many other reports, "Solar Printing on Canvas," *The Philadelphia Photographer*, vol. 5, no. 54 (June 1868), pp. 190–91; and G. Wharton Simpson, "Practical Notes on Photographic Subjects," *The Philadelphia Photographer*, vol. 6, no. 67 (July 1869), pp. 242–43. By the mid-1870s, another Philadelphia magazine singled out artists' projections of photographs onto canvas as a selling point for magic lanterns; see "Uses of the Sciopticon in Photography," *The Magic Lantern*, vol. 1, no. 9 (May 1875), p. 76.

21. The enduring controversy over artists' use of photographs led Susan Eakins, in conversations with her husband's first biographer, Lloyd Goodrich, in the early 1930s, to deny all but the most unavoidable instances of Eakins's employment of such methods. Goodrich was permitted to see no more than a handful of the photographs in the Eakins home. See Lloyd Goodrich, *Thomas Eakins*, 2 vols. (Cambridge, Mass.: Harvard University Press for the National Gallery of Art, 1982), vol. 1, p. 244. On the other hand, Eakins's student and model John Laurie Wallace, in an interview with Goodrich (March 24, 1938, recorded in notes preserved in the Goodrich Papers), "spoke continually of Eakins' using photos." Goodrich dismissed this as a momentary aberration and barely acknowledged the practice in his subsequent writings on the artist's work.

22. Nanette Calder, ed., *Thoughts of A. Stirling Calder on Art and Life* (New York: privately printed, 1947), p. 6. Though Eakins owned these negatives in 1894, it is not known if he produced them unaided. Neither the negatives nor prints from them have been located.

23. Susan Eakins's letters to William Sartain (July 5, mid-July, and September 15, 1917, all in the Historical Society of Pennsylvania, Philadelphia) cite photographs of Rush's *Allegory of the Schuylkill River (Water Nymph and Bittern)*, his statue of George Washington, and figures decorating the doorways of the Fairmount Waterworks, such as *The Schuylkill Freed*. Eakins also sketched all three sculptures in pencil (pls. 25–31) and modeled small wax figures (pls. 33–37). See Elizabeth Johns, *Thomas Eakins: The Heroism of Modern Life* (Princeton: Princeton University Press, 1983), p. 90.

24. Lloyd Goodrich, notes from an interview with John Laurie Wallace, March 24, 1938, Goodrich Papers.

25. John C. Browne, "A Rapid Exposing Shutter," *The Philadelphia Photographer*, vol. 8, no. 90 (June 1871), pp. 162–63.

26. The zoetrope was a popular "philosophical toy," composed of a hollow, pierced drum mounted vertically on an axle. By affixing sequential images of a moving subject inside the drum, opposite evenly spaced openings cut in the cylinder wall, and spinning the device, a viewer looking through the openings could see the sequence reanimated as if in a movie. In using the zoetrope, Rogers and Eakins were consciously duplicating the similar practices of Marey and Muybridge. See E. J. Marey, *Animal Mechanism: A Treatise on Terrestrial and Aërial Locomotion* (New York: D. Appleton, 1874), pp. 137, 177–78; and Fairman Rogers, "The Zoötrope. Action of Animals in Motion—The Muybridge Photographs of Horses—The Instrument as a Factor in Art Studies," *The Art Interchange*, vol. 3, no. 1 (July 9, 1879), p. 2. Eakins probably knew only by report the zoetrope strips that anatomist Mathias Duval was making for Marey, as Duval began teaching at the Ecole des Beaux-Arts only after Eakins had returned to Philadelphia.

27. Rogers 1879, p. 2. In a further elaboration, Rogers planned to add a small hammer to the zoetrope to sound out the cadence of the horse's footfalls, in obvious homage to Marey's emphasis on the gaits' near-musical rhythm (Marey 1874, pp. 132 and 164).

28. William Innes Homer with the assistance of John Talbot, "Eakins, Muybridge and the Motion Picture Process," *The Art Quarterly*, vol. 26, no. 2 (Summer 1963), p. 204. An independent oil sketch (Philadelphia Museum of Art) that Eakins made in Newport in the summer of 1879, ultimately to be used as a study for a painted fan for Mrs. Rogers, more closely followed Muybridge's sequence. This squared sketch may have been copied from a photograph, as a later, similar study for *The Meadows, Gloucester* was. If so, even with Rogers's camera, Eakins could not match the rapidity of Muybridge's shutter speeds, and for the legs of the horses in the sketch, evidently from their brushwork a source of trouble for the artist, he turned to the clearest model.

Active, experimental curiosity aside, there was much to impel Rogers and Eakins to attempt their own photographs for *A May Morning in the Park*. Both men knew, even without Marey's prompting (Marey 1874, pp. 144, 155, and 161), that the paces of no two horses were exactly the same, and that a team harnessed to a heavy coach moved quite differently than a single trotter pulling a light sulky. It was only natural, given the specificity of every other detail of the painting, that Eakins should have sought to particularize his rendering of Rogers's favorite horses.

29. Eakins's methods in producing *A May Morning in the Park* have been discussed in detail in Foster 1997, pp. 151–62 and 398–401.

Eakins's dependence on so many types of studies, including photographs, inevitably brings to mind the composite imagery of such photographers as Henry Peach Robinson (whose 1869 manual *Pictorial Effect in Photography*, with a chapter on such methods, was the bible of amateurs), Oscar G. Rejlander, William Notman, and from 1872 the Schreiber brothers in Philadelphia. Robinson's work in particular was well known in Philadelphia, having been exhibited there at a convention of the National Photographic Association of the United States in 1871 and at the Centennial International Exhibition in 1876; more examples were published in *The Philadelphia Photographer* in August 1869, January 1871, and March 1874. On the Schreibers' emulation of Robinson's techniques, see R. J. Chute, "Pennsylvania Photographic Association," *The Philadelphia Photographer*, vol. 9, no. 101 (May 1872), pp. 142–43.

30. "Art Notes," *Daily Evening Transcript* (Boston), February 5, 1881, p. 6.

31. "The Academy. Stray Moments Among the Pictures Now on Exhibition," *The North American* (Philadelphia), November 19, 1880, p. 1.

32. Edward Strahan [Earl Shinn], "The Art Gallery: Exhibition of the Philadelphia Society of Artists," *The Art Amateur*, vol. 4, no. 1 (December 1880), p. 6.

33. *The North American* (Philadelphia), November 19, 1880, p. 1; and "Art as Decoration. Review of the Fourth Annual Exhibition of the Society of American Artists," *The Evening Post* (New York), April 2, 1881, p. 1.

34. Kathleen Foster (1997, p. 163) has dated Eakins's purchase of a camera as occurring "probably in the spring of 1881." A photograph of William J. Crowell and his daughter Ella (pl. 57), attributed to Eakins, nevertheless bears the date November 1880 and, to judge from the lush foliage behind the sitters, probably was made earlier that year. Frances Eakins Crowell's birthday was November 1, and the inscription may indicate that the print was a gift to her on that occasion. Three additional photographs at the Metropolitan Museum of Art (1985.1027.21–23), showing an infant Ella playing on a brick walk, are surely related to Eakins's painting *Baby at Play* (pl. 18) of 1876; if Eakins was their author, they are probably the earliest of the artist's surviving photographs, for which he may have used a borrowed camera.

35. Thomas Eakins, autograph journal, 1883–88, Dietrich Collection; typescript at the Philadelphia Museum of Art. Eakins's camera is preserved in the Hirshhorn Museum and Sculpture Garden, Smithsonian Institution, Washington, D.C.

36. Theodor Siegl divided Eakins's photographs into four categories: images commemorating personal events or friends, documents of scientific inquiry, studies related to artworks in other mediums, and self-consciously aesthetic photographs. The strength of his analysis has been borne out as more photographs have come to light in the intervening twenty years—effectively tripling Eakins's known output (Siegl, *The Thomas Eakins Collection* [Philadelphia: Philadelphia Museum of Art, 1978], pp. 91–92).

37. The same distinction has been noted by Ken Finkel and Dale Jensen in Finkel 1980, p. xi.

38. [William J. Clark, Jr.], "The Fine Arts: Artists and Art Doings," *The Daily Evening Telegraph* (Philadelphia), October 17, 1881, p. 4. In published art columns of this period, the term "studies" and its variants often served as a code for photographs, a reference innocuous enough to the general readership but fully grasped by the cognoscenti. In France, from the 1850s on, the nomenclature of the traditional arts—*Études d'après nature*—was similarly adopted by makers of photographic imagery for artists (Hélène Pinet, "De l'Étude d'après nature au nu esthétique," in Aubenas et al. 1997, p. 30). Clark's stress of Eakins's studies attested to the painstaking veracity the artist sought for his paintings, but it also may have signaled tactfully that the critic was aware of his methods.

Foster (1997, p. 270 n. 3) has enumerated the contents of the boxes, inscribed with dates and other data, in which most of Eakins's Gloucester negatives were found. These images, part of the Bregler Collection, are catalogued in Susan Danly and Cheryl Leibold, *Eakins and the Photograph: Works by Thomas Eakins and His Circle in the Collection of the Pennsylvania Academy of the Fine Arts* (Washington, D.C.: Smithsonian Institution Press for the Pennsylvania Academy of the Fine Arts, 1994), pp. 163, 212–13, and 215–19. Additional prints of the fishermen may be found in the Dietrich Collection; the Independence Seaport Museum, Philadelphia; and the Seymour Adelman Collection, Bryn Mawr College Library, Pa.

39. Indispensable to this discussion of Eakins's methods in making his Gloucester paintings have been the analyses of these works by Foster (1997, pp. 163–77).

40. As discussed by Mark Tucker and Nica Gutman in their essay "Photographs and the Making of Paintings" in this volume.

41. Thomas Eakins, "Focus of the Eye," from his drawing manual, c. 1881–87, Philadelphia Museum of Art; typescript, p. 63. Much has been made of Eakins's "camera vision." The selective focus perceived in paintings such as *Shad Fishing*, however, like the practice of composite imagery, was not only a feature of photography, but a long-standing mainstay of the education Eakins received in painting when he was a student at the Ecole des Beaux-Arts. In softening the contours of successive bands in this and other works, the artist was first and foremost obeying the rules of painting.

42. Among the Americans adopting such peasant themes in Europe were (to cite Philadelphians alone) Daniel Ridgway Knight, Robert Wylie, Helen Corson, Thomas Hovenden, William Henry Lippincott, and Cecilia Beaux. This trend is explored further in David Sellin, *Americans in Brittany and Normandy, 1860–1910* (Phoenix, Ariz.: Phoenix Art Museum, 1982). Photographers as well would take up similar subjects, as Alfred Stieglitz did in his images of the fisherwives of Katwyk in 1894.

43. "The Academy of Design. Why Members Refuse to Serve on the Hanging Committee . . . ," *The New York Times*, April 30, 1882, p. 3.

44. Foster 1997, p. 164.

45. The two volumes of Lloyd Goodrich's 1982 monograph on Eakins, for instance, devoted only eight paragraphs to the entire series.

46. The boxes that contained Eakins's Gloucester negatives of 1881 were dated April 21 and 23 and May 14 and 15 (Foster 1997, p. 270 n. 3). From the artist's holograph notebook recording the exhibitions he entered, now in the Bregler Collection, we know the first *Shad Fishing* painting was completed in June 1881, and the Philadelphia version must have immediately followed. *Mending the Net* was listed in the notebook as finished in September 1881. Mariana Griswold van Rensselaer visited Eakins in June 1881 and reported her impressions to S. R. Koehler, who was considering an article on Eakins for the *American Art Review*, of which he was editor (Van Rensselaer to Koehler, June 12 and 19, 1881, Koehler Papers, Archives of American Art). Clark's column implies that he, too, met with Eakins ([William J. Clark, Jr.], "The Fine Arts: Artists and Art Doings," *The Daily Evening Telegraph* [Philadelphia], October 17, 1881, p. 4). Eakins himself wrote to Koehler on July 3, 4, and 26 (Goodrich Papers, Dietrich Collection, and private collection, respectively). According to Susan Eakins's retrospective diary (entry for June 15, 1881, Bregler Collection), Eakins was simultaneously engaged in another project, photographing female Academy students in Empire dresses outdoors (pls. 64, 65).

47. The contrast between these two paintings was made explicit in *Mending the Net*'s first public showing, with *William Rush Carving*, in the Special Exhibition of Paintings by American Artists at Home and in Europe, held at the Pennsylvania Academy in November 1881. The catalogue illustrated both paintings, Eakins's only submissions, in line drawings, the *William Rush* centered amid the text it alone carried.

48. As discussed by Mark Tucker and Nica Gutman in their essay "Photographs and the Making of Paintings" in this volume.

49. Eakins to Benjamin Eakins, March 6, 1868, Bregler Collection.

50. Given the painting's theme and the potency of a memory held in abeyance so long, we must at least consider the possibility that *Mending the Net* could have been autobiographical, reprising an incident perhaps from Eakins's childhood, though neither the artist nor his family and friends ever voiced this distinction. Few other subjects would be so compelling for him, and even the choice of toy could be construed as a personal reference for an artist and family so attached to the water.

51. The other two watercolors are *Taking Up the Net* (The Metropolitan Museum of Art, New York), based on one of the photographs used for *Shad Fishing* (pl. 73), and *Mending the Net* (private collection), derived from a now-lost photograph.

52. Microscopic analysis by Tucker and Gutman has shown that Eakins, who was never happy with *The Meadows, Gloucester* when it simply reiterated the photograph on which it was based, added the cows on top of the fully dried paint of the landscape. Even in that complete state, the painting was only exhibited twice, in 1884 and 1885.

53. The Arcadian series has been discussed in depth in Marc Simpson, "Thomas Eakins and His Arcadian Works," *Smithsonian Studies in American Art*, vol. 1, no. 2 (Fall 1987), pp. 71–95. On *Swimming* and its preparatory studies, see Doreen Bolger and Sarah Cash, eds., *Thomas Eakins and the Swimming Picture* (Fort Worth, Tex.: Amon Carter Museum, 1996).

54. Photographs for *Arcadia* were exhibited by Gordon Hendricks in *Thomas Eakins: His Photographic Works*, held at the Pennsylvania Academy of the Fine Arts in 1969; see also Foster 1997, esp. pp. 178–88.

55. In the light of these measures, the thought that Eakins may have been naively oblivious to the social mores of his time (and that this could have contributed to his later troubles at the Pennsylvania Academy) must surely be discarded.

The surface of the finished *Pastoral* relief (pl. 120) retains faint vertical lines between its figures, showing that it paralleled the photographs in being conceived in separate panels that were lined up, merged, and cast as one.

56. Elizabeth Johns has found a parallel purpose of fantasy in the photographs themselves ("An Avowal of Artistic Community: Nudity and Fantasy in Thomas Eakins's Photographs," in Danly and Leibold 1994, p. 80).

57. C. A. Shaw, "On the Use of Photographs as Art Studies," *The Photographic World*, vol. 1, no. 12 (December 1871), p. 368.

58. For accounts of Eakins's curriculum, see Louise Lippincott, "Thomas Eakins and the Academy," in *In This Academy: The Pennsylvania Academy of the Fine Arts, 1805–1976* (Philadelphia: Pennsylvania Academy of the Fine Arts, 1976), pp. 162–87; Foster 1997, pp. 225–31; and Kathleen Foster's essay "Eakins and the Academy" in this volume.

59. This number, an aggregate of several classes serving the Academy's enrollment of more than 200 students, is based on the schedule published in Frank Waller, *Report on Art Schools* (New York: Art Students' League, 1879), p. 21. Individual experiences, of course, varied, with the beginning students encountering no live models at all in their classes drawing from antique statuary. Advanced students, however, the ones to whose education the Academy was dedicated, could expect at a minimum to have eighteen hours per week before the nude in a life class and two more in an anatomy class; if the student also participated in dissections, took a modeling class, or assisted the teacher in conducting a life class for other students, this number could double. The Academy's nearest competition in this regard, the Art Students' League of New York, offered fifty-one hours of life study per week for its 325 students in the 1880–81 season ("Art Notes," *The Art Journal* [New York], n.s., vol. 7 [May 1881], p. 158). By the 1885–86 season, the Pennsylvania Academy provided more than eighty-five hours of nude study in its life and modeling classes for 172 students (Pennsylvania Academy of the Fine Arts, *Circular of the Committee on Instruction, 1885–1886* [Philadelphia: Globe for the Pennsylvania Academy of the Fine Arts, 1885], p. 7; and *Seventy-Ninth Annual Report of the Pennsylvania Academy of the Fine Arts* [Philadelphia: Globe for the Pennsylvania Academy of the Fine Arts, 1886], p. 11). The Art Students' League of New York scheduled ninety-nine hours for its 423 students. On the other hand, the Art Students' League significantly outshone the Academy—by a ratio of well over four to one—in hours scheduled for painting, portrait, costume, and sketch classes working from the clothed model (Frank Waller, *First Report of the Art Students' League of New York* [New York: Art Students' League, 1886], pp. 7–11).

60. "Report of the Committee on Instruction," in Pennsylvania Academy of the Fine Arts, *Circular of the Committee on Instruction, 1883–1884 (With Report on the Season of 1882–1883)* (Philadelphia, 1883), p. 13.

61. For a parallel, though later, use of photographs in Europe to replace *académies*, see Aubenas et al. 1997; and Ulrich Pohlmann, "Another Nature; or, Arsenals of Memory: Photography as Study Aid, 1850–1900," in Dorothy Kosinski, *The Artist and the Camera: Degas to Picasso* (New Haven and London: Yale University Press for the Dallas Museum of Art, 1999), pp. 48–49.

62. The entry for May 31, 1883, in Eakins's 1883–88 account book (Dietrich Collection) reads: "For Miss Ahrens's bill for horse drawings $10 for platinum print for perspective lecture .30 & 2 pieces of glass 8 x 10 for mounting naked series."

63. C. Few Seiss to Horatio W. Shaw, April 8, 1883, Shaw Family Papers, Bentley Historical Library, University of Michigan, Ann Arbor.

64. One of these drawings, part of the Bregler Collection, is reproduced in Foster 1997, p. 305; another in the Hirshhorn Museum and Sculpture Garden is reproduced in Albert Boime, "American Culture and the Revival of the French Academic Tradition," *Arts Magazine*, vol. 56, no. 9 (May 1982), p. 95. Individual studies were also appended to at least two of the Naked Series sequences of photographs (Detroit Institute of Arts and private collection).

65. "Hypo deed" is a reference to a chemical used in developing photographs (Thomas Anshutz to John Laurie Wallace, April [mistranscribed as August] 7, 1884, typescript in the Eakins Research Collection).

66. [Edward L. Wilson], "Editor's Table," *The Philadelphia Photographer*, vol. 5, no. 55 (July 1868), p. 248.

67. Almost all of the photographs of nudes (other than those with a pornographic purpose) available to American artists in the 1880s came from Europe, where photographers had been practicing the genre since the early 1840s. See Sylvie Aubenas, "Le Nu académique existe-t-il en daguerréotype?," in Aubenas et al. 1997, p. 24. The estate sale of a contemporary of Eakins, the decorative artist Francis Lathrop, included approximately five hundred French and five hundred German "Photographic Nude Life Studies for Use of Sculptors and Painters"

(Anderson Art Galleries, New York, *Paintings and Studio Property of the Late Francis Lathrop of New York City*, April 4–6, 1911, lots 202 and 203).

68. [William C. Brownell], "The Art Schools of Philadelphia," *Scribner's Monthly*, vol. 18, no. 5 (September 1879), p. 745.

69. Charlotte Adams, "A Review of the Photographic Work in Phila. Phot.," *The Philadelphia Photographer*, vol. 20, no. 240 (December 1883), p. 391.

70. The propriety of photographing nudes for art study was a concern wherever it was pursued. For an incident at the Ecole des Beaux-Arts in Paris in 1893, see Catherine Mathon, "Le Corps modélisé," in Aubenas et al. 1997, pp. 155–56.

71. [Hillborn T. Cresson], "Eakins Defended. Mr. H. T. Cresson Answers Mr. Bement's Remarks in 'The Item' About the Artist. He Defends the Nude. What He Has to Say About the Art Students' League of Philadelphia," *The Evening Item* (Philadelphia), February 22, 1886, p. 1.

72. On Eakins's departure from the Academy, the dissections were reduced in emphasis, and drawing was restored in the life classes. In all other respects, however, the curriculum Eakins had established was maintained by his successor, Thomas Anshutz, into the next decade.

73. This lecture, presented also at the Franklin Institute, was published as "The Attitude of Animals in Motion" in the *Journal of the Franklin Institute*, vol. 115, no. 4 (April 1883), pp. 260–74. Original handwritten notes made by Eakins's assistant and future brother-in-law, Frank Stephens, at one of Muybridge's Academy lectures are preserved in a private collection.

74. Printed program for Heyl's performance at Philadelphia's Academy of Music on February 5, 1870, preserved in the University of Pennsylvania Archives. Sellers's kinematoscope (now in the collection of the Franklin Institute) and Heyl's "phasmatrope" entertainments are discussed in George E. Nitzsche, "Discovery and Evolution of the Moving Pictures," *Vision*, vol. 3, no. 2 (1917), pp. 21–23.

75. On Pepper's experiments, see Robert S. Redfield, "Society Gossip: The Photographic Society of Philadelphia...," *The Philadelphia Photographer*, vol. 21, no. 246 (June 1884), pp. 176–77; and "Exhibition of Lantern Slides by the Photographic Society of Philadelphia," *The Philadelphia Photographer*, vol. 22, no. 255 (March 1885), pp. 89–90. On those of Corlies, a close friend of Eakins's father-in-law, see Robert S. Redfield, "Society Gossip: Photographic Society of Philadelphia...," *The Philadelphia Photographer*, vol. 21, no. 251 (November 1884), p. 337. On Moran's, see Robert S. Redfield, "Society Gossip: The Photographic Society of Philadelphia...," *The Philadelphia Photographer*, vol. 22, no. 254 (February 1885), p. 49.

76. Minutes of the Board of Trustees, August 7, 1883, University of Pennsylvania Archives. Though Fairman Rogers, one of the university's trustees, was doubtless instrumental in persuading the institution to sponsor Muybridge's project (Muybridge named him in a letter to William Pepper, September 3, 1883, Pepper Papers, University of Pennsylvania Library), he was not present at the meeting that authorized it. Coleman Sellers, another trustee, was there, and William Pepper, the university's provost (and first cousin of David Pepper, Jr.), spearheaded the vote.

77. William Pepper, "Note," in University of Pennsylvania, *Animal Locomotion. The Muybridge Work at the University of Pennsylvania—The Method and the Result* (1888; reprint, New York: Arno Press, 1973), p. 6; and Thomas Anshutz to J. Laurie Wallace, April (mistranscribed as August) 7, 1884, June 18, 1884, August 1884, and August 25, 1884, typescripts in the Eakins Research Collection.

78. Robert S. Redfield, "Society Gossip: Photographic Society of Philadelphia...," *The Philadelphia Photographer*, vol. 21, no. 241 (January 1884), p. 15.

79. Thomas Anshutz to John Laurie Wallace, August 1884, typescript in the Eakins Research Collection.

80. Ibid.

81. Eakins's 1883–88 account book (Dietrich Collection) records reimbursements by Coates, the committee of guarantors, the Pennsylvania Academy, and Harrison Allen. See especially the entries for October 31 and December 31, 1884, for October 10 and November 30, 1885, and for January 31, February 26 and 28, and May 21, 1886. The chronograph that Marks designed to regulate Eakins's exposures was underwritten by the university's Towne Scientific School, whose students

used it at other times to measure variations in the stroke of steam engines. The James W. Queen & Company's invoice of October 25, [1884] and several letters disputing the cost are preserved in the University of Pennsylvania Archives.

82. Marta Braun, "Muybridge's Scientific Fictions," *Studies in Visual Communication*, vol. 10, no. 3 (Summer 1984), pp. 2–21.

83. Years later, Eakins's fellow commissioner Harrison Allen would be the editor of the artist's article discussing his findings, "The Differential Action of Certain Muscles Passing More Than One Joint," *Proceedings of the Academy of Natural Sciences of Philadelphia*, vol. 46 (1894), pp. 172–80.

84. Edward H. Coates to William Pepper, September 27, 1886, Pepper Papers, University of Pennsylvania Library.

85. University of Pennsylvania 1888, pp. 9–33. Eakins's manuscript is preserved in the Philadelphia Museum of Art.

86. William Dennis Marks, "The Mechanism of Instantaneous Photography," in University of Pennsylvania 1888, p. 14.

87. When William T. Brigham, the first president of the Boston Society of Amateur Photographers, had entered his own instantaneous photographs of nude athletes in that organization's annual exhibition at the Boston Art Club in 1884, one image, "an excellent (back) view of a well-built young man, standing on a rock, with hands raised, ready to dive," won top honors in the "Portrait (Full Figure)" class for lack of a more appropriate category. See Our Special Correspondent, "Exhibition of the Boston Society of Amateur Photographers," *The Philadelphia Photographer*, vol. 22, no. 253 (January 1885), p. 24; and N[ewton] M[ackintosh], "Exhibition of Amateur Photographers," *The Art Student*, vol. 1, no. 4 (December 1884), unpaginated. Of these two reviews only the latter, appearing in a publication of the students of the Museum of Fine Arts in Boston, explained that Brigham's entries were photographs of nudes, hailing the arrival of such subjects as "the greatest opportunity that now offers to the amateur."

88. N[ewton] M[ackintosh], December 1884, unpaginated.

89. The best discussions to date of the Philadelphia Photographic Salons are William Innes Homer et al., *Pictorial Photography in Philadelphia: The Pennsylvania Academy's Salons, 1898–1901* (Philadelphia: Pennsylvania Academy of the Fine Arts, 1984); and Mary Panzer, *Philadelphia Naturalistic Photography, 1865–1906* (New Haven: Yale University Art Gallery, 1982).

90. The Camera Club [of New York], "Loan Exhibition," December 20, 1899–January 5, 1900, nos. 82 and 83.

91. On the critical response to Cameron's photographs, see Edward L. Wilson, "Lancelot and Guinevere," *The Philadelphia Photographer*, vol. 14, no. 166 (October 1877), pp. 297–98, reprinting his remarks published in the *Harper's Weekly* of September 1, 1877. On the growing acceptance of soft focus, see W. J. Lee, "Society Gossip:... Rochester Photographic Association....," *The Philadelphia Photographer*, vol. 21, no. 245 (May 1884), p. 147.

92. The platinotype, invented by William Willis, Jr., in England in 1873, was first commercially available in North America in 1878. Photographers were generally slow to embrace the process, which was considered to produce unappealingly cold tones compared to those of albumen prints. Willis's partner, Alfred Clements, unable to secure a sufficient clientele in New York, moved their firm's American headquarters to Philadelphia in late 1881. See "Alfred Clements and His Work," *The Photographic Times*, vol. 27, no. 4 (October 1895), pp. 216–18. Eakins's choice at least by 1883 to print (or to have others print) many of his photographs in platinum was therefore quite early, for the process did not gain wide usage until the 1890s.

One of Clements's own landscape photographs was among those that Eva Watson lent to the Camera Club of New York in 1899–1900 (no. 90).

The toning layers that Eakins used in his paintings are discussed in "The Pursuit of 'True Tones'" by Mark Tucker and Nica Gutman, in this volume.

93. We are reminded in this that Susan Eakins printed many of her husband's negatives, that Frederick Von Rapp printed more, that Anshutz and Wallace had performed "the hypo deed." See Charles Bregler's notes on the prints that he donated to the Metropolitan Museum of Art; Susan Eakins's diary, entry for April 20, 1899, Bregler Collection;

and Anshutz to Wallace, April (mistranscribed as August) 7, 1884, typescript in the Eakins Research Collection.

94. "La photo [...] a forcé les artistes à se dépouiller de la vieille routine et oublier les vieilles formules. Elle nous a ouvert les yeux et forcé à regarder ce qu'auparavant nous n'avions jamais vu, service considérable et inappréciable qu'elle a rendu à l'Art. C'est grâce à elle que la vérité est enfin sortie de son puits. Elle n'y rentrera plus" (Jean-Léon Gérôme, preface to Emile Bayard, *Le Nu esthétique* [October 1906], quoted in Hélène Pinet, "De l'Étude d'après nature au nu esthétique," in Aubenas et al. 1997, p. 33 [author's translation]).

"The 1890s," pp. 257–69

MARC SIMPSON

1. Delivered in May; published later, after refinements undertaken with the aid of Doctors Nolan and Allen. See correspondence, Eakins to Edward J. Nolan (June 8, June 12, June 14, 1894) and to William J. Fox (June 29, 1894), The Academy of Natural Sciences, Philadelphia; and Thomas Eakins, "The Differential Action of Certain Muscles Passing More Than One Joint," *Proceedings of the Academy of Natural Sciences of Philadelphia*, vol. 46 (1894), pp. 172–80.

2. Edwin Blashfield to Eakins, December 19, 1894, The Lloyd Goodrich and Edith Havens Goodrich, Whitney Museum of American Art, Record of Works by Thomas Eakins, Philadelphia Museum of Art (hereafter Goodrich Papers).

3. Eakins to Edwin Blashfield, December 22, 1894, draft, transcript in the Thomas Eakins Research Collection, Philadelphia Museum of Art (hereafter Eakins Research Collection).

4. See, for example, "A Revolt at Drexel Institute," *The Times* (Philadelphia), March 14, 1895, p. 1; "Objected to the Nude," *The Sun* (New York), March 15, 1895, p. 1; "No 'Altogether' There," *The Philadelphia Press*, March 15, 1895, p. 14; "Eakins and His Model Must Go," *The Times* (Philadelphia), March 15, 1895, p. 1; "Eakins and His Models," *The Times* (Philadelphia), March 16, 1895, p. 4; "Varieties & Verities," *The Collector*, vol. 6, no. 1 (April 1, 1895), p. 175.

5. Charles Bregler, "Thomas Eakins as a Teacher," *The Arts*, vol. 17, no. 6 (March 1931), p. 385.

6. Eakins and O'Donovan, long-standing members of the Society of American Artists, probably knew one another best through their joint admiration of Walt Whitman. O'Donovan used Eakins's studio while at work on his portrait of the poet, which is in the background of pl. 182, while his bust of Winslow Homer, which Eakins owned, is on the table.

7. Cleveland Moffett, "Grant and Lincoln in Bronze," *McClure's Magazine*, vol. 5, no. 5 (October 1895), pp. 420–21.

8. Eakins to "Bunny" McCord, August 4, 1894, transcript in Eakins Research Collection.

9. "Public Sculptures in Brooklyn," *The Art Amateur*, vol. 34, no. 3 (February 1896), p. 60.

10. Lloyd Goodrich, *Thomas Eakins*, 2 vols. (Cambridge, Mass.: Harvard University Press for the National Gallery of Art, 1982), vol. 2, p. 119. The figures remained in situ and the sculptors were paid; as *The Art Amateur* critic recognized, their positions on the inside of the arch assured that "they will be little in view, and cannot interfere with the effect of statuary placed on the outside of the monument" ("Public Sculptures in Brooklyn," *The Art Amateur*, vol. 34, no. 3 [February 1896], p. 60).

11. The scenes are described in detail in *The Trenton Battle Monument Erected to Commemorate the Battle Fought in the Streets of Trenton, New Jersey, December 26, 1776* (Trenton, N.J.: J. L. Murphy, 1895), pp. 98–99.

12. Niehaus's historical panels for the doors of Trinity Church, New York (1892), provide a parallel pictorialism—although each scene is less than half the size of Eakins's panels.

13. The present versions were cast in 1969 from the original bronzes, which were deinstalled, cleaned, and moved to the New Jersey State Museum in Trenton.

14. The retrospective nature of Eakins's thoughts at this time is clear from the range of works he sent to Paris: the full-length portrait of Barker, the head-and-bust portrait of Reynolds (*The Veteran*, Yale University Art Gallery), and the watercolor of *The Dancing Lesson* for the Exposition Universelle; and *The Crucifixion*, *The Writing Master*, and *Mending the Net* for the Salon. For some reason, Eakins had no works accepted in the Salon of 1889; in that of 1890, only *The Writing Master* was shown (as *Le calligraphe*). At the Galeries Durand-Ruel in 1891, Eakins showed *Retrospection*, *The Artist's Wife and His Setter Dog*, and *The Veteran*.

15. Eakins would ultimately give his *Cowboys in the Bad Lands* (pl. 164) to the architect Duncan—another link associating his work for Brooklyn and Trenton with his visions of the West.

16. The four are the oil paintings *Home Ranch*, *Cowboy Singing* (Philadelphia Museum of Art), *Head of a Cowboy* (Mead Art Museum, Amherst College, Mass.), and the watercolor *Cowboy Singing* (The Metropolitan Museum of Art, New York).

17. Schenck was reportedly a gifted musician as well as an artist, model, and curator of the Art Students' League of Philadelphia. After the closing of the league, Schenck led a reclusive life on Long Island. In January 1894, responding to a letter that read "like a catalogue of a spring exhibition" instead of a "sincere letter telling me exactly of your affairs, health, and prospects," Eakins sent "Schenk" five dollars "to relieve any pressing want" (Eakins to Schenck, January 26, 1894, Charles Bregler's Thomas Eakins Collection at the Pennsylvania Academy of the Fine Arts, Philadelphia, purchased with the partial support of the Pew Memorial Trust; hereafter Bregler Collection). Schenck, writing to "Mr. Eakins" on the back of his letter, returned the money the day he received it (Schenck to Eakins, January 31, 1894, Bregler Collection).

18. "Pennsylvania Art Exhibit To Be Sent to the Columbian Exhibition," *Public Ledger* (Philadelphia), January 16, 1893, p. 6.

19. Gerald M. Ackerman, "Thomas Eakins and His Parisian Masters Gérôme and Bonnat," *Gazette des Beaux-arts*, vol. 73, no. 1203 (April 1969), pp. 243–44.

20. "Pennsylvania Fine Arts," *The Philadelphia Press*, January 15, 1893, p. 8.

21. Lloyd Goodrich phrased it succinctly and memorably as early as 1933 in *Thomas Eakins: His Life and Work* (New York: Whitney Museum of American Art, 1933), p. 143. More recently Elizabeth Johns has echoed the sentiment: "From his earliest years he painted almost nothing but portraits" (*Thomas Eakins: The Heroism of Modern Life* [Princeton: Princeton University Press, 1983], p. xix).

22. [Clarence Cook?], "National Academy of Design: Sixty-Sixth Annual Exhibition," *The Studio*, n.s., vol. 6, no. 19 (April 11, 1891), p. 185.

23. It is significant that, up to December 1887, if Eakins showed more than one work at a given venue, there was always at least one genre scene. Numerically, from 1871 to December 1887, Eakins showed genre scenes well over two hundred times, as opposed to just over thirty presentations of portraits (most of those being such genrelike works as *The Gross Clinic* or *The Writing Master*). From December 1887 to the time of his death, the ratio switches, with genre scenes—mostly old ones—seen roughly one-third as frequently as portraits.

24. There are a few exceptions, as in *Portrait of Emily Magill Cushing (Mrs. Frank Hamilton Cushing)* (1895, Philadelphia Museum of Art) and *Portrait of Frank Jay St. John* (1900, Fine Arts Museums of San Francisco), in which he returned to a radically smaller presentation of the figure.

25. Goodrich 1982, vol. 2, pp. 77–80.

26. Phyllis D. Rosenzweig, *The Thomas Eakins Collection of the Hirshhorn Museum and Sculpture Garden* (Washington, D.C.: Smithsonian Institution Press, 1977), p. 131 n. 2.

27. Goodrich 1982, vol. 1, p. 221.

28. Lines scored through the paint layers of the oil—most visible are one vertical line running just to the right of the sitter's left pupil and two horizontals just below his eye and above the top of his hand—assisted Eakins's transfer of the design.

29. Spanish notebook, Bregler Collection; typescript translation in Eakins Research Collection.

30. Evan H. Turner, "Thomas Eakins: The Earles' Galleries Exhibition of 1896," *Arts Magazine*, vol. 53, no. 9 (May 1979), pp. 100–107. The week-long exhibition, for which no catalogue or complete listing of works is known to exist, was reviewed in Philadelphia papers *The Evening Item* (May 12, 1896), p. 1; *The Philadelphia Record* (May 15, 1896), p. 12; *Daily Evening Telegraph* (May 16, 1896), p. 7; and *The Philadelphia Inquirer* (May 17, 1896), p. 21.

31. An eleventh work, *The Concert Singer* (pl. 192), was in the Pennsylvania State Building.

32. The often-seen portrait-genre work *Elizabeth at the Piano* (pl. 13) showed his brother-in-law's sister while *The Artist's Wife and His Setter Dog* (pl. 158) showed his wife. Only the portrait of Letitia Wilson Jordan (pl. 172) preceded the debut of Amelia Van Buren's likeness.

33. The leading critical voices that had promoted Eakins's work—writing the longest explications and defenses in the 1870s and 1880s—were largely stilled. Earl Shinn died in 1886 and William J. Clark, Jr., in 1889; Mariana Griswold van Rensselaer shifted her writing away from fine arts criticism; and even Leslie Miller, who wrote extensive, albeit often negative reviews, had reduced his critical writing in favor of his teaching and administrative career.

34. Charles Bregler, "Thomas Eakins as a Teacher: Second Article," *The Arts*, vol. 18, no. 1 (October 1931), p. 36.

35. Eakins to E. H. Coates, September 12, 1886, Bregler Collection. In this letter Eakins detailed the circumstances wherein, in his studio, he stripped for Van Buren in order to illustrate the answer, "as I could not have done by words only," to her question concerning the "movement of the pelvis in relation to the axis of movement of the whole body." "There was," he asserted, "not the slightest embarrassment or cause for embarrassment on her part or mine. When next year she arrived at the Philadelphia school, I was using a nude man, and I had her come around and model [i.e., sculpt] alongside of me that I might give her more particular advantages of which she profited for some weeks."

36. Amelia Van Buren to Susan Eakins, May 14, 1886, Bregler Collection.

37. Susan Eakins to Amelia Van Buren, July 9, 1887, Bregler Collection. Amelia Van Buren's health was the topic of a paper by Annette Stott, "Thomas Eakins' *Portrait of Amelia Van Buren*: New Woman or Neurasthenic," delivered before the College Art Association, February 15, 1997.

38. "It was from work in photogravures that I drifted into photographs.... [and the] determination to use photography solely as a medium through which to express artistic ideas. I am more interested in portraits than anything else and it certainly sounds conceited to say that I hope to make portraits to stand with Sargeant [*sic*] and Watts and the other masters" (Amelia Van Buren to Frances Benjamin Johnston, June 7, 1900, Johnston Collection, Library of Congress; partly quoted by Leigh Bullard Weisblat in Erika D. Passantino, ed., *The Eye of Duncan Phillips: A Collection in the Making* [Washington, D.C.: The Phillips Collection, in association with Yale University Press, 1999], p. 139). I am grateful to Anna Kamplain, Williams College M.A. '01, for bringing the fuller text to my attention and for her help in reconsidering the body of images depicting Van Buren. Van Buren eventually entered into a professional photographic partnership with Eva Watson, another former Eakins student, and exhibited in the Philadelphia Photographic Salons of 1898 to 1900 and at the Camera Club of New York. See Kathleen A. Foster, *Thomas Eakins Rediscovered: Charles Bregler's Thomas Eakins Collection at the Pennsylvania Academy of the Fine Arts* (New Haven and London: Yale University Press for the Pennsylvania Academy of the Fine Arts, 1997), p. 260.

39. The phenomenon of Eakins painting Van Buren as older than she appeared has been widely noted (see, as one instance, Johns 1983, p. 164 n. 36).

40. Margaret McHenry, *Thomas Eakins, Who Painted* (Oreland, Pa.: privately printed, 1946), p. 126.

41. Susan Eakins's retrospective diary, Bregler Collection.

42. Charles Bregler, "Thomas Eakins as a Teacher: Second Article," *The Arts*, vol. 18, no. 1 (October 1931), p. 36.

43. Johns 1983, pp. 130, 138–43.

44. Weda Cook Addicks, manuscript reminiscences; quoted in Goodrich 1982, vol. 2, p. 84. See Synnove Haughom, "Thomas Eakins' *The Concert Singer*," *Antiques Magazine*, vol. 108 (December 1975), pp. 1, 182–84.

45. Cook told Goodrich that the roses were provided by O'Donovan, "who fell in love with me, the old fool" (quoted in Goodrich 1982, vol. 2, p. 84).

46. The hand, which is nicely out of focus, forbidding any temptation to linger there, was modeled after that of Cook's vocal teacher and the conductor of the Germania Orchestra, Charles Schmitz. McHenry (1946, pp. 121–22) told how the hand was initially painted as if holding a brush rather than a musician's baton, prompting Eakins to find a professional to pose. In the oil study for the work (Philadelphia Museum of Art), only the hand was added—palm, roses, and prominent shadows were evidently later additions to the scheme.

47. See Paul Paret in John Wilmerding, ed., *Thomas Eakins (1844–1916) and the Heart of American Life* (Washington, D.C.: Smithsonian Institution Press, 1993), p. 118.

48. Theodor Siegl, *The Thomas Eakins Collection* (Philadelphia: Philadelphia Museum of Art, 1978), p. 128.

49. Eakins to Henry A. Rowland, October 4, 1897, transcript, Addison Gallery of American Art, Phillips Academy, Andover, Mass. (hereafter Addison Gallery of American Art). Elizabeth Johns (1983, pp. 141–43) has written about the popularity of Mendelssohn's work generally and in the Philadelphia region, and contributed to an analysis of why the music was so effective.

50. Reportedly the right slipper, the one that projects most from beneath her dress, was done without benefit of her foot being inside it; Eakins worried that it looked amiss. According to McHenry (1946, p. 121), he asked his student Frank Linton to study the painting, for "Eakins was a little in doubt about the foot, but Linton thought it fell in line." See also Siegl 1978, p. 128.

51. Goodrich 1982, vol. 2, p. 91. See also pp. 94–95.

52. Weda's head-and-bust portrait is in the Columbus Museum of Art; that of her husband, musician Stanley Addicks, whom she had married in 1894, in the Indianapolis Museum of Art.

53. Mrs. Robert C. Reid (née Maud Cook) to Goodrich, September 6, 1930; quoted in Goodrich 1982, vol. 2, p. 69.

54. For this painting, see William H. Truettner, "Dressing the Part: Thomas Eakins's Portrait of Frank Hamilton Cushing," *The American Art Journal*, vol. 17, no. 2 (Spring 1985), pp. 48–72. Other valuable accounts are in Rosenzweig 1977, pp. 153–56; and Judith Zilczer, "Eakins Letter Provides More Evidence on the Portrait of Frank Hamilton Cushing," *The American Art Journal*, vol. 14, no. 1 (Winter 1982), pp. 74–76.

55. Charles F. Lummis, "The White Indian," *The Land of Sunshine*, vol. 13 (June 1900), p. 11; quoted in Truettner 1985, p. 49.

56. McHenry 1946, p. 112.

57. Eakins to Cushing, July 14, 1895, Frank Hamilton Cushing Collection, Southwest Museum, Los Angeles.

58. Frank Hamilton Cushing, "The Arrow," *Proceedings of the American Association for the Advancement of Science*, nos. 30–34 (May 1896), p. 219; quoted in Truettner 1985, p. 57.

59. McHenry 1946, p. 112.

60. Truettner (1985, p. 48) was the first to recognize that the costume was Cushing's creation rather than traditional garb. The costume is now in the collection of the Brooklyn Museum of Art. Truettner reproduced a photograph of Cushing taken by John K. Hillers, c. 1880–81, showing a closely related costume (the leggings differ, and Cushing wears a more prominent necklace in the photograph).

61. McHenry 1946, p. 112.

62. At least Eakins ascribed the frame to Cushing, although it is not dissimilar in method to Eakins's earlier frame for *The Concert Singer*: "Even the frame of the picture was designed by him, largely made and ornamented by him." Eakins to W. J. McGee, April 17, 1900, Letters Received, 1899–1906, Bureau of American Ethnology, now in the National Anthropological Archives, Smithsonian Institution, Washington, D.C.; quoted in Zilczer 1982, p. 75.

63. "Thomas Eakins: Exhibition at Earle's Opens To-Day: The Portrait of Cushing: What Critics Say about the Artist's Frankness," *The Evening Item* (Philadelphia), May 12, 1896, p. 1.

64. Eakins to W. J. McGee, April 17, 1900, Letters Received, 1899–1906, Bureau of American Ethnology, now in the National Anthropological Archives, Smithsonian Institution, Washington, D.C.; quoted in Zilczer 1982, p. 75.

65. Eakins's project of creating a record of notable contemporaries has been most fully explored by Johns 1983 and Marisa Kayyem, "Thomas Eakins's Late-Format Portraits: Identity, Consciousness, and Typology in Turn-of-the-Century Portraiture" (Ph.D. diss., Columbia University, 1998).

66. Put on deposit at the University of Pennsylvania, it was transferred to the Brooklyn Museum when Culin went to work there. Only in 1928 did Brooklyn acquire the painting, but the work did not long remain, Brooklyn selling it in 1947 to the Gilcrease Museum, Tulsa, Okla.

67. "Thomas Eakins: Exhibition at Earle's Opens To-Day: The Portrait of Cushing: What Critics Say About the Artist's Frankness," *The Evening Item* (Philadelphia), May 12, 1896, p. 1.

68. See, for example, Cassatt's pastel *The Cup of Tea* (1897, Daniel J. Terra Collection) and Frank W. Benson's *Decorative Head* (1894, Museum of Fine Arts, Boston).

69. He had been prevailed upon to contribute in 1891, but the rejection of *The Agnew Clinic* did not encourage him to participate at the next two annuals.

70. Harrison S. Morris, *Confessions in Art* (New York: Sears, 1930), pp. 30–31.

71. Ibid., p. 31.

72. One of the few comparable works among Eakins's portraits is *The Young Man (Portrait of Kern Dodge)* (c. 1898–1902, Philadelphia Museum of Art).

73. Sargent's portrait of Sir Ian Hamilton (c. 1898, Tate Gallery, London) and Giovanni Boldini's of Count Robert de Montesquiou (1897, Musée d'Orsay, Paris) exemplify the type.

74. Morris 1930, p. 32.

75. Eakins to Harrison S. Morris, June 25, 1896, transcript, Eakins Research Collection.

76. Eakins to Harrison S. Morris, February 16, 1897, Archives, Pennsylvania Academy of the Fine Arts, Philadelphia.

77. *The Philadelphia Ledger*, May 8, 1896; quoted in Johns 1983, p. 124.

78. "The National Academy of Design," *The Art Amateur*, vol. 34, no. 6 (May 1896), p. 129.

79. Goodrich 1982, vol. 2, p. 86.

80. Sadakichi Hartmann, *The Art News*, vol. 1, no. 2 (April 1897), p. 4; quoted in Goodrich 1982, vol. 2, p. 166. Earlier, in 1895, Hartmann had dedicated his book *Conversations with Walt Whitman* (New York: E. P. Coby, 1895) to Eakins, "as an Admirer of Walt Whitman, in his own Native Independence, Simplicity and Force, without Crankiness and Subserviency."

81. "Nineteenth Exhibition of the Society of American Artists," *Art News*, vol. 1, no. 3 (May 1897), p. 4.

82. For a sensitive reading of the portrait in the context of American racial attitudes of the era, see Martin A. Berger in Wilmerding 1993, pp. 150–53. For a more involved discussion of Eakins's portrayals of African Americans, see Alan C. Braddock, "Eakins, Race, and Ethnographic Ambivalence," *Winterthur Portfolio*, vol. 33, nos. 2–3 (Summer–Autumn 1998), pp. 135–61.

83. Eakins's portrait of her (c. 1888, often called *Girl in a Big Hat)* is now in the Hirshhorn Museum and Sculpture Garden, Smithsonian Institution, Washington, D.C. The fullest discussion of the incidents are in Goodrich 1982, vol. 2, p. 97; and Kathleen A. Foster and Cheryl Leibold, *Writing About Eakins: The Manuscripts in Charles Bregler's Thomas Eakins Collection* (Philadelphia: University of Pennsylvania Press for the Pennsylvania Academy of the Fine Arts, 1989), pp. 95–104.

84. The fullest account of Ella Crowell's life is in Foster and Leibold 1989, pp. 105–22, much of which is based on Susan Eakins's memorandum of Ella's stay with the Eakinses from 1894, transcribed on pp. 290–98. See also Goodrich 1982, vol. 2, pp. 135–36.

85. The most interesting discussion of the painting in print is that of Bryan Wolf (in Wilmerding 1993, pp. 128–33), who considers the work as a *portrait d'apparat* and associates it and its development with great sensitivity to Eakins's culture and to the philosophy of William James and Charles Sanders Peirce, ultimately revealing the painting as a self-portrait, "a study in how representation may be put to the service of class definition and individual agency" (p. 132).

86. A. D. Moore, "Henry A. Rowland," *Scientific American*, February 1982, pp. 150–61.

87. "He wanted to go out sailing. So out we went & didnt get back till so late that by the time we had our lunch the sun was in the room and I hardly got any painting done at all. I hope there wont be any wind to

tempt him to day" (Eakins to Susan Eakins, Tuesday [July 1897], Bregler Collection).

88. Eakins to Susan Eakins, Saturday [July 1897], Bregler Collection. He wrote later in the letter of wanting to meet Murray in Boston on his way back to Philadelphia "and we will spend the day together and see the Sargent things"—evidently a reference to the north wall of Sargent Hall in the Boston Public Library. Since Murray and Eakins were working on their own set of prophets for the Witherspoon Building, the effort to see Sargent's prophets, among other themes of the old dispensation, was probably pointed.

89. Eakins to Susan Eakins, Friday [Summer 1897], Bregler Collection.

90. Eakins to Susan Eakins, Wednesday [Summer 1897], Bregler Collection.

91. Eakins to Susan Eakins, Saturday [Summer 1897], Bregler Collection.

92. Eakins to Susan Eakins, August 9, 1897, Bregler Collection.

93. Eakins to H. A. Rowland, August 17, 1897, Addison Gallery of American Art. Seeing the ruling machine was an epiphany for the artist: "The directness and simplicity of that engine has affected me and I shall be a better mechanic and a better artist" (Eakins to H. A. Rowland, August 28, 1897, Addison Gallery of American Art).

94. Eakins to H. A. Rowland, September 3, 1897, Addison Gallery of American Art. Rowland was happy to accommodate Eakins, although he did express some contrariness: "As to the portrait, write to Schneider whenever you want him and tell him that I say he can come." He goes on: "However, Mr. Gilman [the president of the Johns Hopkins University] has seen the portrait and likes it very much as it is. He thinks that it would be more natural to have me near a library table with books on it" (Rowland to Eakins, September 15, 1897, Goodrich Papers).

95. Eakins to H. A. Rowland, October 4, 1897, Addison Gallery of American Art.

96. Ibid.

97. Quoted in Goodrich 1982, vol. 2, p. 140.

98. Eakins to Frank W. Stokes, January 3, 1904, Hirshhorn Museum and Sculpture Garden, Smithsonian Institution, Washington, D.C.

99. Charles H. Caffin, "American Studio Notes. I. Sixth Annual International Exhibition at the Carnegie Institute, Pittsburg [*sic*], Pa.," *International Studio*, vol. 15, no. 57 (November 1901), p. xlii.

100. Austin S. Holland, "Pittsburgh's Sixth International Art Exhibition," *Brush and Pencil*, vol. 9, no. 3 (December 1901), pp. 139–40.

101. For a history of the Arena, which at other times in its existence served for the display of painted panoramas and for circuses, see Marjorie Alison Walter, "Fine Art and the Sweet Science: On Thomas Eakins, His Boxing Paintings, and Turn-of-the-Century Philadelphia" (Ph.D. diss., University of California, Berkeley, 1995), pp. 140–43. Walter's is the fullest exploration of these works, with a rich discussion of the individual paintings, the subject's place in Philadelphia society, and the physical locus of the sport and Eakins's own activities.

102. As the title of one recent compilation acknowledges, such reservations persist: Joyce Carol Oates and Daniel Halpern, eds., *Reading the Fights: The Best Writing About the Most Controversial Sport* (New York: Henry Holt, 1988).

103. Eakins wrote several times from Paris of recreational boxing and wrestling among the students at the Ecole des Beaux-Arts (see, for example, his letter of November 26, 1866, quoted in Goodrich 1982, vol. 1, p. 21). As for professional prize-fighting, Murray reported that Eakins went to the fights several times a week, becoming so engrossed in the excitement of the bouts that, as Goodrich stated, he "would go through the fighters' motions, twisting in his seat so that his neighbors protested." He had seen, reported sportswriter and friend Clarence Cranmer, "over 300 rounds of fighting, before he started this group of paintings" (quoted in Goodrich 1982, vol. 2, p. 144).

104. The downed boxer has been identified as Joe Mack by Goodrich, who relied on the testimony of Clarence Cranmer in 1930. According to Walter (1995, p. 37 n. 12), however, who assumed that Eakins was re-creating an actual fight that took place in April 1898, the man must be Jack Daly. In that match, McKeever did eventually prevail. Crucially, however, as regards the notion of reportage versus picture-making, newspaper accounts of the fight made no mention of a partial knockout; Eakins here, as elsewhere in his career, was creating his scene, not simply reproducing what he had seen. Walter (1995, pp. 38–39) exam-

ined the newspaper accounts and noted the disparity between the picture and the night's action; she nonetheless remained confident of discounting Cranmer's identification of the downed fighter as Joe Mack.

105. Walter (1985, pp. 174–75) posited that Samuel Murray, William Macdowell, and David Jordan can also be identified among the audience.

106. The page of manuscript, dated July 1, 1911, is reproduced in Foster and Leibold 1989, p. 186.

107. See, for example, Eakins's photographs of his students boxing (pl. 146), where gloves are in motion if not actually hitting the opponent (Bregler Collection); and Eadweard Muybridge, *Muybridge's Complete Human and Animal Locomotion: All 781 Plates from the 1887 "Animal Locomotion,"* 3 vols. (1887; reprint, New York: Dover, 1979), vol. 2, pls. 329–42 and especially pl. 336. For Bellows's boxing pictures, see E. A. Carmean, Jr., et al., *Bellows: The Boxing Pictures* (Washington, D.C.: National Gallery of Art, 1982).

108. Walter recorded how necessary policemen were on fight nights, citing newspaper accounts of a fight outside the ring on the night of April 22, 1898, that required the "most vigorous action on the part of Sergeant Hodgson and Patrolmen Searles and McKenna" to quell (*The Philadelphia Inquirer*, April 23, 1898, p. 4; quoted in Walter 1995, p. 200).

109. Clarence Cranmer reported that, on hearing complaints about the murky air when the painting was on view in 1917, "I felt like telling them that 5,000 men and boys had been smoking cigars, cigarettes, and pipes through a good many rounds" (quoted in Goodrich 1982, vol. 2, p. 149).

110. The placard represents a series of fights that took place on this date (Walter 1995, p. 146).

111. Newspaper reports of the bout are reproduced by Walter (1995, pp. 148–50).

112. Billy Smith to Walker Galleries, August 15, 1940, Archives of American Art, Smithsonian Institution, Washington, D.C. (hereafter Archives of American Art); quoted in Goodrich 1982, vol. 2, p. 145.

113. Goodrich quoted Samuel Murray, who later made a statuette of Smith. Smith also wrote about himself in his letter of 1940 to the Walker Galleries: "The purchaser of my painting may want to know a little about me? I boxed over 100 times made a living at it for ten years, in my time I fought two Feather weight champions Tommy Warren and Terry McGovern, and Harry Forbes of Chicago, who won the Bantam weight championship I think in 1901. I was known then as Turkey Point [a section of South Philadelphia] Billy Smith. I am now past 66 years of age." After his boxing career, Smith joined the Salvation Army, became a "fighting evangelist," and regularly visited Eakins through the painter's years of infirmity (Goodrich 1982, vol. 2, p. 145).

114. Goodrich 1982, vol. 2, p. 147. Along with the head of Billy Smith, Eakins prepared a separate oil study of his full figure, posed in the nude and without gloves (Philadelphia Museum of Art; see Siegl 1978, p. 147), and one of Cranmer (*The Timer*, private collection).

115. Eakins to Benjamin Eakins, March 6, 1868, Bregler Collection.

116. Goodrich 1982, vol. 2, p. 149.

117. Susan Eakins to Mrs. Lewis R. Dick, c. 1930; quoted in Foster and Leibold 1989, p. 300.

118. Harrison S. Morris to Eakins, November 8, 1899, Bregler Collection; quoted in Foster and Leibold 1989, p. 350.

119. Eakins to Harrison S. Morris, no date [c. January 1900]; cited in Foster and Leibold 1989, p. 350.

120. W. P. Lockington, "The Pennsylvania Academy's Annual Exhibition," *The Collector and Art Critic*, vol. 2, no. 7 (February 1, 1900), p. 121.

121. The men along the front row were identified by Susan Eakins: Louis Kenton, Clarence Cranmer (bow tie and waving hat), David Wilson Jordan, Louis Husson, Samuel Murray, and Benjamin Eakins (far right). See Susan Eakins to Charles Sawyer, January 23, 1934, Addison Gallery of American Art; cited in Walter 1995, p. 171.

122. Walter 1995, p. 90.

123. One of the principal changes between the finished work and its study (Carnegie Museum of Art, Pittsburgh) is the position of the seconds.

124. "Academy Exhibition. Sixty-Eighth Annual Show Opened on Saturday Evening," *Public Ledger* (Philadelphia), January 16, 1899, p. 10.

125. Eakins, though, did not attach much stock to awards and medals. He penciled on his certificate of award: "Diplomas from committees who did not know a good picture from a bad one" (quoted in Foster 1997, p. 451).

126. Victor Champier, André Saglio, and William Walton, *The Arts of the XIXth Century: Painting, Sculpture, Architecture, and Decorative Arts of All Races*, 2 vols. (Philadelphia: George Barrie & Son, 1901), vol. 1, pp. 49–50.

127. Mitscha, "Pennsylvania Academy of the Fine Arts Exhibition as Seen and Heard," *The Art Collector*, vol. 9, no. 7 (February 1, 1899), p. 102.

128. Bregler Collection.

129. Susan Eakins's diary for 1899 records sittings on February 26, March 26, April 9, 16, 23, 29, and 30, and May 14 (Bregler Collection).

130. In 1867 Eakins had written to his sister Fanny: "How did you like little Addie Williams? She is a pretty little girl & I guess just as good as she is pretty, or she belies her blood. We owe a great deal to her father & mother for their unvarying and disinterested kindness to us....Try to make her welcome whenever she comes to town" (Eakins to Frances Eakins, [May 1867?], Archives of American Art). He continued by noting that she was cousin to Bill Crowell—whom Fanny would eventually marry.

131. Mary Adeline Williams to Goodrich, reported in Goodrich 1982, vol. 2, p. 171.

132. Susan Eakins is quoted by Goodrich 1982, vol. 2, p. 174. For later commentators, see, for example, David Lubin in Wilmerding 1993, pp. 160–61.

133. Susan Eakins's diary, February 27, 1899, Bregler Collection.

134. The father's belief in the rightness and propriety of his son's stance in each of the several controversies that arose surrounding Eakins's teaching was unswerving; even faced with divisions within the family, he seems always to have sided with his son. From the painter's point of view, his father was a recurring presence in the photographs and genre paintings of the 1870s and 1880s, and, as late as June 1899, a sporting companion (Susan Eakins's diary for June 4, 1899, records Benjamin Eakins, Addie Williams, Eakins, and herself bicycling from Egg Harbor to Atlantic City; Bregler Collection).

135. Goodrich 1982, vol. 2, p. 174.

136. These speculations grew largely after Gordon Hendricks's 1974 book *The Life and Works of Thomas Eakins* (New York: Grossman, 1974). Goodrich (1982, vol. 2, p. 174) considered and dismissed them. More recently, David Lubin (in Wilmerding 1993, p. 161) has written convincingly of the limitations such a biographical reading imposes on the work.

137. Susan Danly and Cheryl Leibold dated both about 1899 in *Eakins and the Photograph: Works by Thomas Eakins and His Circle in the Collection of the Pennsylvania Academy of the Fine Arts* (Washington, D.C.: Smithsonian Institution Press for the Pennsylvania Academy of the Fine Arts, 1994), p. 146. McHenry (1946, p. 133) recorded that Williams's niece possessed an 1898 letter from Eakins requesting that she come spend the afternoon sewing with Susan Eakins, "for Eakins would like to get a photograph of her head."

"Portraits of Teachers and Thinkers," pp. 307–15

KATHLEEN A. FOSTER

1. Eakins's turn to portraiture after 1886 has been frequently studied; see Lloyd Goodrich, *Thomas Eakins*, 2 vols. (Cambridge, Mass.: Harvard University Press for the National Gallery of Art, 1982), vol. 2, pp. 52–98. Elizabeth Johns takes as her premise the priority of portraiture throughout Eakins's work and his lifetime construction of an oeuvre commemorating the heroes of modern life; see Johns, *Thomas Eakins: The Heroism of Modern Life* (Princeton: Princeton University Press, 1983), esp. p. 150. Portraiture is also the organizing principle of John Wilmerding, ed., *Thomas Eakins (1844–1916) and the Heart of American Life* (London: National Portrait Gallery, 1993). See also Wilmerding, "Thomas Eakins's Late Portraits," *Arts Magazine*, vol. 53, no. 9 (May 1979), pp. 108–12.

2. Mariana Griswold van Rensselaer, quoted in Goodrich 1982, vol. 1, p. 198; Edward Strahan [Earl Shinn], "The Pennsylvania Academy Exhibition," *The Art Amateur*, vol. 4, no. 6 (May 1881), p. 115.

3. Goodrich 1982, vol. 1, p. 13. On Eakins's anatomical studies, see Julie S. Berkowitz, "Thomas Eakins as a Scientist and His Relationship with Jefferson Medical College," in *"Adorn the Halls": The History of the Art Collection at Thomas Jefferson University* (Philadelphia: Thomas Jefferson University, 1999), pp. 123–28.

4. His lecture "The Zoetrope with Illustrations of the Movement of a Horse" was delivered at the Pennsylvania Academy of the Fine Arts in May 1885; that same month he also lectured before the Muybridge Commission on his "electrical apparatus" to improve the precision of Muybridge's cameras. Marks was credited as author of their essay, published in the commission's report by the University of Pennsylvania, *Animal Locomotion. The Muybridge Work at the University of Pennsylvania—The Method and the Result* (1888; reprint, New York: Arno Press, 1973). Eakins's paper, "The Differential Action of Certain Muscles Passing More Than One Joint," appeared in the *Proceedings of the Academy of Natural Sciences of Philadelphia*, vol. 46 (1894), pp. 172–80, with notes by one of his colleagues on the Muybridge Commission, the physiologist Dr. Harrison Allen. See Goodrich 1982, vol. 2, pp. 128–29, and discussion of the original drawings in Kathleen A. Foster, *Thomas Eakins Rediscovered: Charles Bregler's Thomas Eakins Collection at the Pennsylvania Academy of the Fine Arts* (New Haven and London: Yale University Press for the Pennsylvania Academy of the Fine Arts, 1997), pp. 325–27.

5. Susan Eakins noted in her diary that "Tom's Sunday Club was 1886." She listed the members as Marks, Harrison Allen, "Koenig," Hugh A. Clarke, and Robert Arthur, but did not mention how long the club continued to meet; retrospective diary, September 19, 1886, Pennsylvania Academy of the Fine Arts, Philadelphia, Charles Bregler's Thomas Eakins Collection, purchased with the partial support of the Pew Memorial Trust (hereafter Bregler Collection). Margaret McHenry described this as Eakins's "University of Penn Club," a group united both by an interest in painting and summer residences in Maine; see McHenry, *Thomas Eakins, Who Painted* (Oreland, Pa.: privately printed, 1946), p. 111; and Goodrich 1982, vol. 2, p. 5.

6. McHenry 1946, pp. 100, 114–16; Theodor Siegl, *The Thomas Eakins Collection* (Philadelphia: Philadelphia Museum of Art, 1978), p. 144.

7. Although he was not a regular member of either group, Eakins was expelled in 1886 from the Philadelphia Sketch Club and the Academy Art Club. See Kathleen A. Foster, "The Art Club Scandals," in Foster and Cheryl Leibold, *Writing About Eakins: The Manuscripts in Charles Bregler's Thomas Eakins Collection* (Philadelphia: University of Pennsylvania Press for the Pennsylvania Academy of the Fine Arts, 1989), pp. 79–90. He resigned from the Society of American Artists in 1892, insulted by the refusal of his work three years in a row, and he declined an invitation to join the Institute of Arts and Letters (later the American Academy of Arts and Letters) in 1908. See letters to the Society of American Artists of May 7, 1892 (quoted in Goodrich 1982, vol. 2, pp. 50–51), and to Hamilton Mabie of November 12, 1908 (American Academy of Arts and Letters, New York). Letters from Eakins to Stewart Culin suggest that they visited the Faculty Club at the University of Pennsylvania and the Oriental Club of Philadelphia; see February 22, 1901, and May 13, 1896 (both Archives, Brooklyn Museum of Art; transcripts in Thomas Eakins Research Collection, Philadelphia Museum of Art).

8. Both remained close friends. Eakins gave his portrait to Marks, and offered Barker's portrait to the university, but it was refused. Barker's portrait, now in the Mitchell Museum at Cedarhurst, Mount Vernon, Illinois, has been cut down from its original dimensions of 60 by 40 inches. See Lloyd Goodrich, *Thomas Eakins: His Life and Work* (New York: Whitney Museum of American Art, 1933), pp. 178–79; and Goodrich 1982, vol. 2, pp. 5, 56–57.

9. Eakins to Susan Eakins, "Saturday morning" [c. July 1897], Bregler Collection, and to Rowland, August 28, 1897, Addison Gallery of American Art, Phillips Academy, Andover, Mass.

10. The last standing full-length portrait was *Monsignor James P. Turner* of 1906 (Nelson-Atkins Museum of Art, Kansas City, Mo.); the last seated full-length image was *Dr. William Thomson* of 1907 (College of Physicians of Philadelphia), both discussed in Foster 1997, pp. 212–24. The portrait of Spitzka (Hirshhorn Museum and Sculpture Garden, Smithsonian Institution, Washington, D.C.), now cut down, was

planned for a canvas approximately the size of *Leslie W. Miller* and *Louis N. Kenton;* see Phyllis D. Rosenzweig, *The Thomas Eakins Collection of the Hirshhorn Museum and Sculpture Garden* (Washington, D.C.: Smithsonian Institution Press, 1977), pp. 211–12.

11. Eakins to Mrs. Joseph W. Drexel, describing his hopes for her unfinished portrait, November 22, 1900 (location unknown; transcript in the Lloyd Goodrich and Edith Havens Goodrich, Whitney Museum of American Art, Record of Works by Thomas Eakins, Philadelphia Museum of Art; hereafter Goodrich Papers). The portrait is now at the Hirshhorn Museum and Sculpture Garden.

12. Goodrich (1982, vol. 2, pp. 65–75) estimated that overall, Eakins's portraits depict men and women at a ratio of about three to two.

13. From *The Portrait of Dorian Gray,* quoted in Richard Ellmann, *Oscar Wilde* (New York: Vintage Books, 1988), p. 310.

14. On the construction of Eakins's portraits, see Foster 1997, pp. 198–224.

15. Charles Bregler, "Thomas Eakins as a Teacher," *The Arts,* vol. 17, no. 6 (March 1931), p. 383.

16. Eakins to Da Costa, January 9, 1893, typescript in Goodrich Papers.

17. To Susan Eakins, "Sun. eve" [c. August 1897], Bregler Collection. On the depiction of thinking and the element of self-portraiture in the Rowland image, see Brian J. Wolf in Wilmerding 1993, pp. 129–32.

18. Clarence Cook, "The Water-Color Society's Exhibition," *The Art Amateur,* vol. 6, no. 4 (March 1882), p. 74.

19. Eakins to Caroline Eakins and Fanny Eakins, April 1, 1869, Archives of American Art, Smithsonian Institution, Washington, D.C. (hereafter Archives of American Art).

20. Kenton married Elizabeth Macdowell (1858–1953) on May 31, 1899, and lived in the Macdowell family home at 2018 Race Street, not far from the Eakinses, until 1901, when the couple moved into their own home at 226 South 39th Street. Entries in Susan Eakins's diaries indicate that "Lid" occasionally took refuge with the Eakinses later, moving in permanently in 1910. Kenton left town about that time and refused to support his wife, although they remained married. As Carol Troyen has suggested, their estrangement may explain why Mrs. Eakins described him evasively in 1916 as "a friend of Mr. Eakins's," and why she evidently annotated the stretcher with the title, "Thinker," first used in the catalogue of the Metropolitan Museum of Art's memorial exhibition in 1916. See Susan Eakins's papers and Charles Bregler's notes from her diaries, Bregler Collection; Theodore E. Stebbins Jr., Carol Troyen, and Trevor J. Fairbrother, *A New World: Masterpieces of American Painting, 1760–1910* (Boston: Museum of Fine Arts, 1983), pp. 329–30. On this painting and its reception, see Natalie Spassky, *American Paintings in the Metropolitan Museum of Art: A Catalogue of Works by Artists Born between 1816 and 1845* (New York: The Metropolitan Museum of Art, 1985), pp. 622–26; and Barbara Weinberg in Wilmerding 1993, p. 148. Kenton's friendship with Eakins is suggested by two laconic postcards he sent to Eakins from Europe in 1905–1906, now in the Seymour Adelman Collection in the Bryn Mawr College Library, Pa.

21. Kenton's life dates are given as 1865–1947 in Spassky 1985, p. 622. A note in the curatorial files suggests that this should have been printed as 1869–1947. The source of this information or the location of Kenton's death is unknown. He was enumerated at the age of one in the 1870 census of Philadelphia, along with his father, Levi, and mother, Ella. His father disappeared from the city directories by 1880, and Kenton later was listed at the same address as Catherine Kenton, "widow of Levi," in 1889. Philadelphia city directories list him at five different addresses in South Philadelphia between 1888 and his marriage in 1899, including 1326 Jackson, where other Kentons resided as "shoemaker" and "motorman." In this period, several Kentons in the city were shoemakers. Helping me in my search, David Azzolina uncovered a Levi Kenton, known for a string of shoe stores from Tennessee to Georgia; perhaps Kenton also headed south after 1910. Thanks also to Jim Green, Akela Reason, and the staff of the Free Library of Philadelphia for their assistance with the city directories.

22. Bregler Collection. Kenton has been identified in this photograph on the basis of his resemblance to the sitter in Eakins's portrait. The photograph can be dated by the photographers' joint signature, used during the studio partnership of Van Buren and Watson from 1894 to 1896. My thanks to Cheryl Leibold for her assistance.

23. *The Archaeologist,* now lost, was a portrait of Stewart Culin (see Foster 1997, pp. 210–12); *The Cello Player* (pl. 206) of Rudolph Hennig; *The Vicar General* is an alternate title for *Portrait of Monsignor James P. Turner* (Nelson-Atkins Museum of Art, Kansas City, Mo.).

24. Apart from many doctors and clerics, other teachers among the large-format portraits include James MacAlister, president of Drexel University, and Mrs. Elizabeth Duane Gillespie; smaller portraits include the educators Emily Sartain, Florence Einstein, and Lucy L. W. Wilson.

25. These themes were explored by Michael Fried in *Realism, Writing, Disfiguration: On Thomas Eakins and Stephen Crane* (Chicago and London: University of Chicago Press, 1987).

26. Eakins to Earl Shinn, April 2, 1874, Richard T. Cadbury Papers, Friends Historical Library, Swarthmore College, Pa.

27. On Miller, see Arthur Nicholas Hosking, *The Artists Year Book* (Chicago: Art League Publishing, 1905), p. 132; S. R. Koehler, *United States Art Directory and Year-book,* vol. 2 (New York: Cassell, 1884), pp. 135–36; Siegl 1978, pp. 155–56. Goodrich (1982, vol. 2, pp. 182–86), described Miller's genial personality and the circumstances of Eakins's portrait.

28. "The Water-Color Exhibition at Philadelphia," *The American Architect and Building News,* vol. 11, no. 330 (April 22, 1882), p. 185, quoted at greater length in Foster 1997, p. 172. Miller also wrote harshly of Eakins's landscapes in "Art: The Awards of Prizes at the Academy," *The American,* vol. 11, no. 274 (November 7, 1885); clippings scrapbooks, Archives, Pennsylvania Academy of the Fine Arts, Philadelphia.

29. On Miller's treatise, *The Essentials of Perspective* (New York: Scribner's, 1887), see Foster 1997, p. 243 n. 14. Most of Eakins's illustrations for his manual are in the Bregler Collection. Several of the drawings are on paper watermarked 1887, indicating work on the manual after his departure from the Academy; see Foster 1997, pp. 331–32.

30. Sheeler, quoted in Goodrich 1982, vol. 2, p. 184.

31. Leslie W. Miller to Lloyd Goodrich, April 23, 1930, quoted in Goodrich 1982, vol. 2, p. 64. Miller's letter also recounted Eakins's insistence that Holland wear his old fishing shoes in *The Dean's Roll Call,* and his offense to Mrs. Gillespie, when he greeted her at his studio on a hot day wearing "an old pair of trousers and an *undershirt!*" (quoted in Goodrich 1982, vol. 2, p. 72).

32. On Eakins's use of the axes of weight and motion, see Foster 1997, pp. 304–5; Troyen in Stebbins et al. 1983, p. 329.

33. On the importance of the center line and the horizon line, coincident with the eye level of the artist, see Foster 1997, pp. 60–61, 206.

34. The quotation is from Eakins's admiring description of Gérôme's figure paintings; see Eakins to his mother and sister, Caroline Eakins and Frances Eakins, April 1, 1869, Archives of American Art.

35. On Eakins's *Self-Portrait,* see Wilmerding 1993, pp. 155–57, where Darrel Sewell has discussed the rareness of direct eye contact in Eakins's portraits and the "accusatory and sad" quality of this picture. On the Thomson portrait, see Foster 1997, pp. 220–24, 283 n. 55; and Julie S. Berkowitz, *The College of Physicians of Philadelphia Portrait Catalogue* (Philadelphia: College of Physicians, 1984), pp. 210–13.

36. Eakins to Beatty, June 9, 1911; Beatty to Eakins, June 14, 1911; both Carnegie Institute, Museum of Art records, Archives of American Art (thanks to Judith Throm for the discovery of this correspondence); Eakins to Brashear, draft or copy by Susan Eakins, not dated [c. 1912], Bregler Collection. Brashear responded with interest on May 9, 1912 (Bregler Collection).

"The 1900s," pp. 317–28

MARC SIMPSON

1. Eakins to John W. Beatty, September 25, 1900, Carnegie Institute, Museum of Art records, Archives of American Art, Smithsonian Institution, Washington, D.C. (hereafter Archives of American Art).

2. Only in 1904, according to a transcript of Susan Eakins's diary for February 29, did Murray finally move "all his things into his new studio,"

so apparently he kept some things at Mount Vernon Street for nearly three years after leaving the Chestnut Street studio (Pennsylvania Academy of the Fine Arts, Philadelphia, Charles Bregler's Thomas Eakins Collection, purchased with the partial support of the Pew Memorial Trust; hereafter Bregler Collection).

3. Work began, according to Susan Eakins's retrospective diary, on May 29, 1901 (Bregler Collection).

4. In 1896 Riter Fitzgerald, from the relatively limited pulpit of *The Evening Item* (Philadelphia), had called Eakins "one of the foremost painters of the time" ("Thomas Eakins. Exhibition at Earle's Opens To-Day," *The Evening Item* [Philadelphia], May 12, 1896, p. 1). Such declamations, common in the 1870s and early 1880s in nationally circulated periodicals, were rarely seen in the 1890s. Frank Jewett Mather, Jr., explained this dearth in 1931: "In a generation that sorely overvalued brilliant handling, Eakins simply offered nothing that could be talked about or written about, and was naturally neglected. Today, I trust, we are more interested in what is expressed than in the rhetoric of expression, and Eakins is coming into his own" (*Estimates in Art, Series II: Sixteen Essays on American Painters of the Nineteenth Century* [New York: H. Holt, 1931], pp. 219–20; quoted in Natalie Spassky, *American Paintings in the Metropolitan Museum of Art: A Catalogue of Works by Artists Born between 1816 and 1845* [New York: The Metropolitan Museum of Art, 1985], p. 624).

5. Eakins to Harrison S. Morris, July 29, 1900, and Morris to Eakins, September 21, 1900; both, Archives, Pennsylvania Academy of the Fine Arts, Philadelphia.

6. Samuel Murray to Lloyd Goodrich, recounted in Goodrich, *Thomas Eakins*, 2 vols. (Cambridge, Mass.: Harvard University Press for the National Gallery of Art, 1982), vol. 2, p. 201. This often-repeated anecdote should be placed next to Eakins's more circumspect, but complex, letter regarding the prize: "I acknowledge the receipt of the Temple Gold Medal, and in thanking you assure you of my appreciation of the motive which led to the establishment of the prize" (Eakins to the Committee on Exhibitions, n.d. [late February 1904], Archives, Pennsylvania Academy of the Fine Arts, Philadelphia; quoted in Goodrich 1982, vol. 2, p. 201).

7. Eakins to Hamilton W. Mabie, November 12, 1908, American Academy of Arts and Letters, New York.

8. See the discussion by Darrel Sewell in John Wilmerding, ed., *Thomas Eakins (1844–1916) and the Heart of American Life* (London: National Portrait Gallery, 1993), pp. 155–56.

9. For a review of the shifting requirements concerning the Associates' portraits at the turn of the century, see Michael Quick, "Introduction," *Artists by Themselves: Artists' Portraits from the National Academy of Design* (New York: National Academy of Design, 1983), p. 15.

10. Among the best examinations of this work is Darrel Sewell's entry in Wilmerding 1993, p. 156.

11. Ibid.

12. Charles Bregler, "Thomas Eakins as a Teacher," *The Arts*, vol. 17, no. 6 (March 1931), p. 383.

13. Eakins to George Barker, February 24, 1906, Joslyn Art Museum, Omaha, Nebr.

14. "Eakins Chats on Art of America. Veteran Painter Vigorous and Enthusiastic as in Days of Past," *The Philadelphia Press*, February 22, 1914, p. 8.

15. Eakins to Edmund Clarence Messer, July 3, 1906, Archives, Corcoran Gallery of Art, Washington, D.C.

16. For some, the background was too empty, "mere vacancy," as Riter Fitzgerald wrote in 1901. Bemoaning the lack of skies, foliage, drapery, or other materials to augment the interest of the picture, he complained: "The modern portrait painters have, as a general thing, no background to their portraits—which I think deprives the picture of considerable interest. When Eakins painted my full length portrait [1895, Art Institute of Chicago] some eight or ten years ago, he painted me sitting in my library, and the books made a capital background, full of suggestiveness, and he painted them as only an artist of superior ability could" ("Thomas Eakins. His Fine Portrait of Leslie W. Miller," *The Evening Item* [Philadelphia], February 16, 1901, p. 8).

17. Eakins to Benjamin Eakins, December 2, 1869, Bregler Collection. Numerous scholars, including Goodrich (1982, vol. 2, p. 182) have

cited the specific precedent of Velázquez's *Pablo de Valladolid* (Museo del Prado, Madrid) for the work.

18. In the small study panel (William A. Farnsworth Library and Art Museum, Rockland, Maine), which has been squared for transfer, the excess cloth in Kenton's suit is equally evident; more so, in fact, in the further leg than in the finished painting, where Eakins reduced diagonal sweeps of material.

19. Ownership of the painting was not unequivocal. Its lender in the early part of the century was frequently listed as Elizabeth Macdowell Kenton, but twice as Kenton himself. Goodrich reported this, along with the fact that the painting stayed at Mount Vernon Street (Goodrich 1982, vol. 2, p. 182). Since Mrs. Kenton lived for extended periods of time with the Eakinses, however, especially after 1910, this does not dispute her possession of it. In 1917, the Metropolitan Museum of Art acquired the painting from Mrs. Kenton.

20. David Sellin, working from Crowell and Macdowell family tradition, wrote that the marriage "barely outlasted the honeymoon" (*Thomas Eakins, Susan Macdowell Eakins, and Elizabeth Macdowell Kenton* [Roanoke, Va.: North Cross School, 1977], p. 30). Undated extracts transcribed by Charles Bregler from Susan Eakins's diaries after November 1901 (Bregler Collection) tell a story at dramatic odds with the quiet, introspective image of the painting:

> Louis strikes Lid in the face and she leaves him immediately and comes over here to us at 11 oclock at night.
> I go over to Kentons this afternoon and Lid tells me of Louis being violent in his action taking her by the throat.
> I go over to Lids who thinks she must leave Louis he is so mean to her We have a confab with all together Lid, Louis Tom, Will [Macdowell, Susan and Elizabeth's brother] and myself and advice her still to have patience.

And then, in an entry dated October 10, 1910, evidently some substantial time after the foregoing: "Elizabeth Kenton comes here from Atlantic City to live with us as Louis will not fulfil the contract agreed upon for Elizabeths support."

21. "Seventieth Annual Salon at the Academy of the Fine Arts. American Art Finely Displayed," *The Philadelphia Press*, January 13, 1901, p. 3.

22. "The Academy's Annual Exhibition," *The Philadelphia Inquirer*, January 13, 1901, p. 11. A closely related review, so close as to seem by the same writer, is Melville E. Wright, "Philadelphia Art Exhibition," *Brush and Pencil*, vol. 7, no. 5 (February 1901), pp. 264–65.

23. Charles H. Caffin, "Some American Portrait Painters," *The Critic*, vol. 44, no. 1 (January 1904), p. 34. This builds upon his interpretation of 1901: "We may find it ungainly in composition, certainly without any superficial qualities of beauty; but its intense realism and the grasp which it suggests of the subject's personality render the picture one of notable fascination" ("The Picture Exhibition at the Pan-American Exposition, Continued," *The International Studio*, vol. 14, no. 56 [October 1901], p. xxxii). Caffin wrote about the work numerous times from 1901 to 1907; for a detailed bibliography, see Spassky 1985, pp. 624–26.

24. See, for example, the entries on the painting by Carol Troyen in Theodore E. Stebbins, Jr., et al., *A New World: Masterpieces of American Painting 1760–1910* (Boston: Museum of Fine Arts, 1983); and H. Barbara Weinberg in Wilmerding 1993, p. 148.

25. She evidently wanted to efface Kenton's identity as completely as possible. In 1917, identifying the sitters in several of her husband's paintings, she called him, opaquely, "Friend of Mr. Eakins" (Susan Eakins to Henry W. Kent, October 14, 1917, Archives, The Metropolitan Museum of Art, New York).

26. One of the most concentrated looks at the painting is Theodor Siegl, *The Thomas Eakins Collection* (Philadelphia: Philadelphia Museum of Art, 1978), pp. 151–53. For a detailed study of the instruments, see Synnove Haughom, "Thomas Eakins' Portrait of Mrs. William D. Frishmuth, Collector," *Antiques*, vol. 104, no. 5 (November 1973), pp. 836–38.

27. The fullest discussion of the now-lost portrait of Culin is in Kathleen A. Foster, *Thomas Eakins Rediscovered: Charles Bregler's Thomas Eakins Collection at the Pennsylvania Academy of the Fine Arts* (New Haven and London: Yale University Press for the Pennsylvania Academy of the Fine Arts, 1997), pp. 210–12. The unfinished portrait of Mrs. Drexel, which was radically cropped by Bregler around 1940 to focus on the figure, is discussed in Phyllis D. Rosenzweig, *The Thomas Eakins*

Collection of the Hirshhorn Museum and Sculpture Garden (Washington, D.C.: Smithsonian Institution Press, 1977), p. 172.

28. Elizabeth Johns, *Thomas Eakins: The Heroism of Modern Life* (Princeton: Princeton University Press, 1983).

29. Eakins to Stewart Culin, May 15, 1901, Archives, University Museum, University of Pennsylvania, Philadelphia; quoted in Siegl 1978, p. 152.

30. It went to the exhibition, but "it exceeded the size limit, and was not hung" (John W. Beatty to Eakins, February 11, 1907). Beatty's letter was prompted when Eakins sought to submit the painting again in 1907, writing "I am sorry to give this trouble but I think the picture is interesting and I would like to show it" (Eakins to Beatty, February 6, 1907; both Carnegie Institute, Museum of Art records, Archives of American Art).

31. Eakins to Leslie W. Miller, February 1, 1901; quoted in *Kindred Spirits: The E. Maurice Bloch Collection of Manuscripts, Letters and Sketchbooks of American Artists* (Boston: Ars Libri, 1992), part 2, p. 28.

32. Leslie W. Miller to Eakins, February 11, 1901, Archives, Philadelphia Museum of Art; quoted in Siegl 1978, p. 152.

33. Eakins to Leslie W. Miller, February 27, 1901, Archives, Philadelphia Museum of Art; quoted in Siegl 1978, p. 143. The portrait is now at the Philadelphia Museum of Art.

34. See Siegl 1978, pp. 141–43. Miller later wrote to Lloyd Goodrich about the work: "Mrs. Gillespie refused to go near him again after he received her one blistering hot day in his studio up three or four flights of stairs in the old Presbyterian Building on Chestnut Street dressed only in an old pair of trousers and an *undershirt!* He wanted her to give him one or two more sittings but she not only refused them, but wanted me to destroy the portrait after it came into my possession,—which of course I didn't do" (Miller to Goodrich, April 23, 1930; quoted in Goodrich 1982, vol. 2, p. 72).

35. L[eslie] W. Miller, "Letter from Philadelphia," *The Art Student*, vol. 1, no. 4 (December 1884), unpaginated.

36. L[eslie] W. Miller, "Water-Color Exhibition at Philadelphia," *The American Architect and Building News*, vol. 11, no. 330 (April 22, 1882), p. 185.

37. See, for example, L[eslie] W. M[iller], "Art. The Awards of Prizes at the Academy," *The American*, vol. 11, no. 274 (November 7, 1885), p. 45; "Art Notes," *The American*, vol. 11, nos. 289 and 290 (February 20 and 27, 1886), pp. 284 and 300; and L[eslie] W. M[iller], "Art, a Question of Methods," *The American*, vol. 12, no. 303 (May 29, 1886), p. 92.

38. "A Revolt at Drexel Institute. Indignation Caused by a Nude Male Model before a Mixed Class," *The Times* (Philadelphia), March 14, 1895, p. 1.

39. For biographical details, see Ernest Knaufft, "Our Art Schools. Philadelphia.—II. The Pennsylvania Museum and School of Industrial Art," *The Art Amateur*, vol. 24, no. 2 (January 1891), pp. 37–38; and Goodrich 1982, vol. 2, p. 182. I am grateful to Karly Whitaker, Williams College Graduate Program in the History of Art (Class of 2001), for sharing her insights into this work, which she has developed into a revealing essay on Miller's and Eakins's competing modes of art education (forthcoming).

40. Quoted in Constance Rourke, *Charles Sheeler* (New York: Harcourt, Brace, 1938), pp. 14–15.

41. Charles Bregler, "Thomas Eakins as a Teacher," *The Arts*, vol. 17, no. 6 (March 1931), p. 383.

42. One Philadelphia critic, referring to Whistler's *Arrangement in Flesh Color and Brown: Portrait of Arthur J. Eddy* (1894, Art Institute of Chicago) when it was on loan to the Pennsylvania Academy in 1904, identified a set of Whistlerian characteristics that could readily be retrospectively applied to the portrait of Miller: "It...is painted in the characteristic gray tones that we have come to associate with this eccentric genius of the brush. The work is done on the coarse-grained canvas that Whistler loved to use and painted in the thin colors that we so often see in his work, and, as may be expected, is exceedingly low in tone" ("Pennsylvania Academy of the Fine Arts. 73rd Annual Exhibition," *Public Ledger* [Philadelphia], January 24, 1904, p. 10).

43. Margaret McHenry, *Thomas Eakins, Who Painted* (Oreland, Pa.: privately printed, 1946), p. 50.

44. See passages from some of Miller's addresses quoted in Ernest Knaufft, "Our Art Schools. Philadelphia.—II. The Pennsylvania Museum and School of Industrial Art," *The Art Amateur*, vol. 24, no. 2 (January 1891), p. 38.

45. Leslie W. Miller to Arthur E. Bye, 1923, Archives, Philadelphia Museum of Art; quoted in Siegl 1978, p. 156.

46. "Art and Artists," *The Philadelphia Press*, February 7, 1901, p. 9.

47. "Leslie Miller's Portrait Pronounced True to Life," *The Philadelphia Press*, February 13, 1901, p. 4.

48. Riter Fitzgerald, "Thomas Eakins. His Fine Portrait of Leslie W. Miller," *The Evening Item* (Philadelphia), February 16, 1901, p. 8.

49. "The Eightieth Exhibition of the National Academy of Design," *Brush and Pencil*, vol. 15, no. 2 (February 1905), p. 76.

50. Arthur Hoeber, "The Carnegie Institute of Pittsburgh," *The International Studio*, vol. 31, no. 124 (June 1907), p. c [100]. Hoeber noted the "sobriety" of the artist, going on to characterize him as "a sturdy workman, in deadly earnest, and capably trained as a craftsman" (pp. c, cii [100, 102]).

51. The portraits of priests have been studied by Evan H. Turner in a brochure for "Yours Truly, Thomas Eakins," a 1970 exhibition at Saint Charles Borromeo Seminary, Overbrook, Pa.; and by William H. Gerdts in "Thomas Eakins and the Episcopal Portrait: Archbishop William Henry Elder," *Arts Magazine*, vol. 53, no. 9 (May 1979), pp. 154–57. See also Evan H. Turner, "Thomas Eakins at Overbrook," *Records of the American Catholic Historical Society of Philadelphia*, vol. 81, no. 4 (December 1970), pp. 195–98.

52. Susan Eakins wrote in her retrospective diary of important dates: "Feb 2 1902 Tom painted Cardinal —— in Washington" (Bregler Collection).

53. Foster (1997, pp. 214–15) has given a detailed formal analysis of the work, as well as an assessment of the changes the composition underwent as Eakins planned it.

54. The university sold it at public auction at New York's Parke-Bernet Galleries on May 21, 1970.

55. "Notable Display of Art To Be Seen at the Academy To-Morrow. Brilliant Display of High-Class Art," *The Philadelphia Inquirer*, January 18, 1903, p. 2.

56. "The Academy Pictures. A Brilliant Exhibition Illustrative of American Art," *The Philadelphia Record*, January 18, 1903, p. 9.

57. Eakins wrote in 1903: "I am the person who painted and presented to the University the full length portrait of Cardinal Martinelli. I am solicited by the Carnegie Institute to exhibit specimens of my best work, and I should like to send there the Cardinal" (Eakins to the Rector of the Catholic University of America, September 16, 1903; quoted in *The Armand Hammer Collection: Four Centuries of Masterpieces* [Buffalo: Albright-Knox Art Gallery, 1978], cat. no. 55).

58. The inscription, written on paper (Bregler Collection) with the letterhead of the Augustinian College of Saint Thomas of Villanova in Villanova, Pennsylvania (now Villanova University), shows that Eakins sought the help of friends more fluent in Latin for his inscriptions—in this case perhaps the Very Reverend John J. Fedigan, whose portrait Eakins had painted in 1902 (Villanova University).

59. By 1911, when Falconio left the office, Eakins was unable to undertake a portrait of his successor. Eakins's views toward the Falconio portrait are complex. As Nicolai Cikovsky, Jr., summarized: "Eakins left no other major painting as partially finished as this one.... It is not clear how Eakins regarded it. In certain respects he treated it as a completed picture. He never destroyed it, never repainted it, inscribed it elaborately on its back (in Latin), and in 1907 [included it on a list of his most representative paintings]. But Eakins never exhibited it during his lifetime, and it is seen leaning unframed against the wall in a photograph of Eakins' studio made about 1910" (in Franklin Kelly et al., *American Paintings of the Nineteenth Century, Part I* [Washington, D.C.: National Gallery of Art, 1996], p. 181).

60. This summary of Elder's life is gleaned from the R[eginald] C. M[cGrane] entry in *Dictionary of American Biography*, ed. Allen Johnson and Dumas Malone (New York: Charles Scribner's Sons, 1946), vol. 6, p. 69.

61. Coadjutor Archbishop Henry Moeller to the Reverend James P. Turner, November 17, 1903, Bregler Collection.

62. Susan Eakins's diary entry for November 25, 1903, transcribed by Charles Bregler, Bregler Collection.

63. Eakins to Frank W. Stokes, December 15, 1903, Hirshhorn Museum and Sculpture Garden, Smithsonian Institution, Washington, D.C.

64. Eakins did, however, consider infusing the work with history through means of a Latin inscription and asked his patron to provide one. Moeller responded in January 1904:

> You must pardon me for not sending sooner the enclosed inscription. I have been very busy and could not sooner attend to the matter. I hope the inscription is not too long....
> Hanc imaginim Riomi ac Ialmi Gulielmi Henrici Elder, Archiepiscopi Cincinnatensis, Dominus Thomas Eakins, benignitatem pictatemque ex vieltu ejusdem Praesulis laboribus actatque bene meriti pictucentem admirans, benevale sponteque mense Decembris 1903 pinxit.

(Coadjutor Archbishop Henry Moeller to Eakins, January 4, 1904, Bregler Collection). Eakins evidently decided not to use the inscription, for the back of the painting is blank.

65. Eakins to Frank W. Stokes, January 3, 1904, Hirshhorn Museum and Sculpture Garden.

66. Francis J. Ziegler, "A Fine Lot of Pictures," *The Philadelphia Record*, January 24, 1904, p. 24; "American Studio Talk: Pennsylvania Academy Exhibition," *The International Studio*, vol. 22, no. 85 (March 1904), p. ccxxxix (the painting was given a full-page illustration in this article); "Pennsylvania Academy of the Fine Arts. 73rd Annual Exhibition," *Public Ledger* (Philadelphia), January 24, 1904, pp. 9–10.

67. A roster of some of the artists on view reveals the significance of the prize. There were clusters of works by such fashionable painters as Cecilia Beaux, William Merritt Chase, Childe Hassam, and John Singer Sargent, as well as the much-respected Winslow Homer and the just-deceased Whistler; such younger men as Charles Hawthorne, Robert Henri, and John Sloan also showed imposing pictures.

68. "Art and Artists," *The Philadelphia Press*, February 14, 1904, p. 6.

69. Gerdts 1979, pp. 156–57.

70. Susan Eakins's diary for 1899 and her retrospective diary of important dates (both Bregler Collection) include visits to the theater and the opera stretching as far back as 1880. The Bregler Collection also includes twenty theatrical playbills from the turn of the century.

71. The principal texts on this painting are Siegl 1978, pp. 157–58; Rosenzweig 1977, pp. 177–78; and McHenry 1946, p. 117. I am also grateful to Katie Price, Williams College Graduate Program in the History of Art (Class of 2002), for sharing her insights concerning the work with me. The description of Mrs. St. Aubyn comes from the stage notes of Clyde Fitch, *Beau Brummel* (New York: Samuel French, 1908), pp. [5], 41.

72. Santje, the actress's stage name, refers to the Keyser family's Dutch heritage, being the Dutch equivalent of Suzanne.

73. *The New York Dramatic Mirror*, May 9, 1896; quoted in Siegl 1978, p. 157.

74. The identification was first made by Milton Kenin on the basis of resemblance to photographs of the judge, then confirmed by the frame's coat-of-arms. See Siegl 1978, p. 159.

75. Foster (1997, p. 418) has stressed the many similarities in format and design between *An Actress* and the portrait of Dr. John H. Brinton (pl. 17).

76. There is no record of Santje performing *Camille* in Philadelphia during the years when Eakins was at work on the picture (Gordon Hendricks, *The Life and Works of Thomas Eakins* [New York: Grossman, 1974], p. 256).

77. The Prince of Denmark was an important role for several of the era's most newsworthy actresses, such as Sarah Bernhardt, who thrived on the transvestite casting.

78. For a discussion of the important role the tea gown played in the development of women's fashion at the turn of the century, see Valerie Steele, *Fashion and Eroticism: Ideals of Feminine Beauty from the Victorian Era to the Jazz Age* (New York and Oxford: Oxford University Press, 1985), pp. 158, 210, 214–18.

79. To judge from the *Study for "An Actress"* of c. 1901 (Hirshhorn Museum and Sculpture Garden), the pose was apparently set from the beginning of the project.

80. For just one of the several discussions of the work that invoke a diagnosis of neurasthenia for this and other of Eakins's sitters, see Kathleen Spies, "Figuring the Neurasthenic: Thomas Eakins, Nervous Illness, and Gender in Victorian America," *Nineteenth Century Studies*, vol. 12 (1998), pp. 85–109.

81. For an explanation and a detailed analysis of Eakins's use of color, see Mark Tucker and Nica Gutman's essay "The Pursuit of 'True Tones,'" in this volume. William J. Clark is but one of several scholars who have evocatively read the strident contrast as a key element of the painting's meaning ("The Iconography of Gender in Thomas Eakins's Portraiture," *American Studies*, vol. 32, no. 2 [Fall 1991], pp. 21–23).

82. McHenry 1946, p. 117.

83. "The Academy's Display. One of the Strongest Exhibitions Ever Shown Here," *Public Ledger* (Philadelphia), December 23, 1895, p. 12.

84. For a detailed consideration of the work, see Robert Wilson Torchia et al., *American Paintings of the Nineteenth Century, Part II* (Washington, D.C.: National Gallery of Art, 1998), pp. 265–68.

85. A plan and perspective study for his signature, which he transcribed to the painting, and, on the verso, the text of the envelope address is in the Bregler Collection; see Foster 1997, p. 418.

86. The fullest treatment of the painting in print is the entry in William Innes Homer, ed., *Eakins at Avondale and Thomas Eakins: A Personal Collection* (Chadds Ford, Pa.: Brandywine River Museum, 1980), pp. 48–49.

87. Goodrich 1982, vol. 2, p. 59.

88. William Innes Homer, *Thomas Eakins: His Life and Art* (New York: Abbeville, 1992), pp. 220–21.

89. See Rosenzweig 1977, pp. 193–94. McHenry (1946, pp. 121–23) recorded a number of Linton's anecdotes.

90. McHenry 1946, p. 121, quoting the reminiscences of Helen Parker Evans.

91. The trials of the Ogden commission, with its extensive correspondence, are recounted in Goodrich 1982, vol. 2, pp. 225–32; see also Rosenzweig 1977, pp. 195–201.

92. Lee's obituary, as quoted in Reynolda House, *American Originals: Selections from Reynolda House, Museum of American Art* (New York: Abbeville Press for the American Federation of Arts, 1990), p. 98. See also Goodrich 1982, vol. 2, p. 232.

93. A. W. Lee to Eakins, January 29, 1905, transcript in the Lloyd Goodrich and Edith Havens Goodrich, Whitney Museum of American Art, Record of Works by Thomas Eakins, Philadelphia Museum of Art (hereafter Goodrich Papers).

94. A.W. Lee to Eakins, September 19, 1905, transcript in Goodrich Papers.

95. Mrs. Walter Copeland Bryant to Lloyd Goodrich, c. 1930; quoted in Goodrich 1982, vol. 2, p. 59.

96. Otto C. Wolf to Eakins, May 21, 1910; quoted in Goodrich 1982, vol. 2, pp. 234, 236. When Eakins asked Schmidt to borrow the painting for exhibition in 1911, Schmidt replied in the negative, noting: "I have had no opinion from any of my friends that the portrait is a likeness of me, although the style and character of the work has been favorably commented on" (Edward A. Schmidt to Eakins, October 13, 1911; quoted in Goodrich 1982, vol. 2, p. 236).

97. In common with Lee, most recent historians have tended either to ignore the work or to criticize it—or the man, or a subjective conflation of the two—harshly. For Sylvan Schendler it was "one of Eakins' most harsh revelations of character, omitting nothing in its delineation of the stiff and the inhuman. . . . Lee's eyes are not simply hard; they hint at the beginnings of self-recognition, the discovery that life had been lost in the pursuit of something else" (Sylvan Schendler, *Eakins* [Boston: Little, Brown, 1967], p. 183). Lloyd Goodrich responded in a parallel fashion: "He looks every inch the ruthless businessman: a predator, witch-burner, hanging judge; and yet he was a builder, an organizer, a public-spirited citizen of his home town" (Goodrich 1982, vol. 2, p. 232). Working from the perspective of Lee's family, the recent catalogue of the institution that now owns the portrait glossed it in a more complex fashion. Characterizing the sitter as "punctual and kind and [with] a deep sympathy for human frailty," the writer concluded: "A Bachrach photograph taken within a few years of the portrait shows Lee as a handsome, portly gentleman with a self-assurance that reflects his accomplishments. In this portrait, however, Eakins, who was often praised for his scientific realism, has converted him into an apparently bitter and disagreeable man, thus projecting onto him his own regrets and failures" (Reynolda House 1990, p. 98). Every portrait—as Oscar Wilde observed—is also a self-portrait. The same is apparently true of every interpretation.

98. As one example, the recent exhibition and catalogue devoted to Eastman Johnson's work—Teresa A. Carbone and Patricia Hills, *Eastman*

Johnson: Painting America (Brooklyn: Brooklyn Museum of Art, 1999)—was exemplary in showing the richness and diversity of his early career. The last quarter century of his production, however, when he was among the most active portraitists of New York's wealthier classes, was virtually unexplored.

99. Kate P. Parker, written around 1947 on the back of her 1906 silhouette of Eakins (Philadelphia Museum of Art); quoted in Goodrich 1982, vol. 2, p. 238.

100. Helen Parker to Margaret McHenry, quoted in McHenry 1946, p. 130.

101. Helen Parker Evans to Sylvan Schendler, September 29, 1969; quoted in Goodrich 1982, vol. 2, p. 242.

102. Eakins's preparations for the canvas included two oil studies: a small quick study on cardboard squared for transfer, as usual; and a larger, more finished canvas that is an unusual intermediary step for the portraits (both, Dietrich Collection).

103. Kate P. Parker, as quoted in Goodrich 1982, vol. 2, p. 238. Helen Parker Evans donated the dress to the Philadelphia Museum of Art in 1961.

104. Ibid. If this is so, they must have been paying close attention to the ornament, since the "dress had been remade and the seams were sewed by machine with a chain stitch" (Helen Parker to McHenry, quoted in McHenry 1946, p. 130).

105. Kate P. Parker, written around 1947 on the back of her 1906 silhouette of Eakins (Philadelphia Museum of Art); quoted in Goodrich 1982, vol. 2, p. 238; Helen Parker Evans to Sylvan Schendler, September 26, 1969; both quoted in Goodrich 1982, vol. 2, p. 242.

106. For the details of this transformation, and its ascription to Eakins, see Johns 1983, pp. 108–110.

107. For a rich and nuanced discussion of the Rush series, in addition to the sources given in the discussion of the 1877 work, see the entry by Franklin Kelly on *The Chaperone* in Kelly 1996, pp. 185–89.

108. Studies are at the Hirshhorn Museum and Sculpture Garden; the National Gallery of Art, Washington, D.C.; and in various private collections.

109. Eakins to John W. Beatty, March 23, 1908, Carnegie Institute, Museum of Art records, Archives of American Art. The description is a close variant of that printed in Goodrich (1982, vol. 1, p. 146).

110. Eakins to John W. Beatty, March 30, 1908, Dietrich Collection.

111. The painting's first recorded exhibition was in 1930: Babcock Art Galleries, New York, "Thomas Eakins," December 15, 1930–January 15, 1931, no. 19.

112. Works connected to a second variant—showing the artist helping the model from her stand, with a third figure standing by with her wrap, are in the collections of Caroline and Sheldon Keck, the Philadelphia Museum of Art, and the Hirshhorn Museum and Sculpture Garden.

113. See Eadweard Muybridge, *Muybridge's Complete Human and Animal Locomotion: All 781 Plates from the 1887 "Animal Locomotion,"* 3 vols. (1887; reprint, New York: Dover, 1979), vol. 1, pl. 133. Van Deren Coke was the first to note the connection between the two images in *The Painter and the Photograph: From Delacroix to Warhol,* rev. ed. (Albuquerque: University of New Mexico Press, 1972), pp. 162–65.

114. Charles Bregler, "Thomas Eakins as a Teacher," *The Arts,* vol. 17, no. 6 (March 1931), p. 383.

115. Johns 1983, p. 113.

116. Goodrich 1982, vol. 2, pp. 258–59.

117. For these and other elements of his twentieth-century fame, see Carol Troyen's essay "Eakins in the Twentieth Century," in this volume.

118. "Eakins Chats on Art of America," *The Philadelphia Press,* February 22, 1914, p. 8.

119. [Henry McBride], "National Academy Lacking in Thrills," *The Sun* (New York), March 19, 1916, p. 9.

120. Susan Eakins, loose diary pages, Bregler Collection.

121. "Obituary: Thomas Eakins," *American Art News,* vol. 14, no. 36 (July 15, 1916), p. 4. For a discussion of the memorial exhibitions in New York and Philadelphia, see Goodrich 1982, vol. 2, pp. 273–78.

122. Autobiographical statement to a publisher (Goodrich Papers), probably for *The National Cyclopedia of American Biography* (New York: James T. White, 1894), vol. 5, p. 421; quoted in Goodrich 1982, vol. 2, p. 6.

"The Pursuit of 'True Tones,'" pp. 353–65

MARK TUCKER AND NICA GUTMAN

1. Autobiographical statement to a publisher, 1893, The Lloyd Goodrich and Edith Havens Goodrich, Whitney Museum of American Art, Record of Works by Thomas Eakins, Philadelphia Museum of Art (hereafter Goodrich Papers); quoted in Lloyd Goodrich, *Thomas Eakins,* 2 vols. (Cambridge, Mass.: Harvard University Press for the National Gallery of Art, 1982), vol. 2, p. 6. Eakins's letter was the source for the information on him published in *The National Cyclopedia of American Biography* (New York: James T. White, 1894), vol. 5, p. 421.

2. Maria Chamberlin-Hellman, "Thomas Eakins as a Teacher" (Ph.D. diss., Columbia University, 1981), p. 293.

3. "In making his sketches for a portrait or a picture of one or several figures, it seems most remarkable to me, when comparing these sketches with the finished pictures or portrait that they were carried out to a conclusion without the slightest change from the basic idea first conceived in the sketch, showing he knew exactly what he wished and intended to do" (Charles Bregler, "Thomas Eakins as a Teacher: Second Article," *The Arts,* vol. 18, no. 1 [October 1931], p. 40).

4. For Eakins's preparatory work, see Kathleen A. Foster, *Thomas Eakins Rediscovered: Charles Bregler's Thomas Eakins Collection at the Pennsylvania Academy of the Fine Arts* (New Haven: Yale University Press for the Pennsylvania Academy of the Fine Arts, 1997), pp. 51–71.

5. Eakins to Benjamin Eakins, March 29, 1870, Goodrich Papers.

6. Lloyd Goodrich noted Eakins's attraction to indirect, layered technique in *Thomas Eakins: His Life and Work* (New York: Whitney Museum of American Art, 1933), pp. 146–49. While the complexity of layering and magnitude of color adjustment vary, there are few finished pictures whose original effect depended on directly applied, unmodified pure colors and high key. *Starting Out After Rail* (pl. 12) is one exception.

7. After extensive study in the 1960s and 1970s, former Philadelphia Museum of Art Conservator Theodor Siegl concluded that Eakins had applied a range of dark films to his painting surfaces (Conservation files, Philadelphia Museum of Art). Other conservators have noted the presence of neutral-toned layers applied over larger passages of paintings to adjust color. See Mark Tucker, conservation report, 1981, *The Pair-Oared Shell* (pl. 4); Alain Goldrach, undated conservation report, *The Schreiber Brothers,* Yale University Art Gallery, New Haven; and Christina Currie, *"The Biglin Brothers Turning the Stake-Boat* by Thomas Eakins: A Technical Study Reveals Surprising Techniques," *American Institute for Conservation Paintings Specialty Group Postprints* (1994), pp. 18–23.

8. *The Crucifixion* (pl. 54), *Shad Fishing at Gloucester on the Delaware River* (pl. 76), *Cowboy Singing* (c. 1892, Philadelphia Museum of Art), and a number of other paintings exhibit a very thin upper layer that gives the surface a pronounced grayish tone. In paint cross sections taken from *The Crucifixion* and from *Shad Fishing at Gloucester on the Delaware River,* this very sparsely pigmented layer consists of discrete dark particles suspended in a colorless matrix. The layer is discontinuous and very thin, typically less than five micrometers, making conventional conservation sampling and micro-analytical methods ineffective for determining the composition and origin of the layer. Preliminary examination, for example, by micro-FTIR and SEM w/EDS of scrapings taken from the layer suggests that natural resin, possibly oil, and carbon particulate are present. However, appreciable amounts of lead white, a sampling artifact or contaminant from adjacent layers, were also detected. Analysis of the layer was further complicated by possible contamination by non-original materials introduced during previous restorations, which may have altered the chemical composition of the layer. For example, preliminary examination of samples from *The Crucifixion* using SEM w/EDS and micro-FTIR revealed the presence of feldspars, possibly from a restorer's abrasive cleaning agent, and, in one instance, proteinaceous material, possibly lining adhesive. Photoacoustic IR, IR mapping, FIB sectioning followed by

TEM and TOF-SIMS analyses of the layer are currently under way. To this date, however, it has not been established whether the layer is an artist-applied film, airborne particulate, a surface change due to some phenomenon of drying or aging, or an alteration of the surface by cleaning agents. The appearance of the surviving film on the paintings suggests a once-uniform distribution, especially over colors light enough for it to be visible. The authors are grateful to Beth Price and Andrew Lins for their work on the analysis of this film.

9. Eakins admired Velázquez's use of a similar technique in *The Fable of Arachne (The Spinners)* (fig. 35): "perhaps he sought his color harmonies repeatedly painting over it, for the color is excessively thick on the neck and all the delicate parts. Finally, he rubbed over it when all was well dried, using tones already prepared" (Spanish notebook, Pennsylvania Academy of the Fine Arts, Philadelphia, Charles Bregler's Thomas Eakins Collection, purchased with the partial support of the Pew Memorial Trust [hereafter Bregler Collection]; authors' translation from the original French). In speculating about Velázquez's technique, Eakins may well have been responding to the accumulation of dark varnish on *The Spinners* and many other paintings he saw in Spain. Such varnish layers were often interpreted as an integral part of the "patina" of old master paintings. Some nineteenth-century artists even used dark toning layers to imitate the unifying effect of "patina," thereby associating their works with venerated older paintings. The dark toning layers applied by Eakins in the last stages of painting may therefore have served not only a tone-adjusting function, but also a historicizing one.

10. [Hillborn T. Cresson], "Eakins Defended: Mr. H. T. Cresson Answers Mr. Bement's Remarks in *The Item* About the Artist...," *The Evening Item* (Philadelphia), February 22, 1886, p. 1.

11. Charles Bregler, "Thomas Eakins as a Teacher: Second Article," *The Arts*, vol. 18, no. 1 (October 1931), p. 38.

12. Letter from Elizabeth La Rue Burton found on the inside of the backing of her portrait by Eakins in the Minneapolis Institute of Arts, dated November 30, 1935, copy in Thomas Eakins Research Collection, Philadelphia Museum of Art (hereafter Eakins Research Collection).

13. Susan Eakins to Charles H. Sawyer, March 16, 1934, Addison Gallery of American Art, Phillips Academy, Andover, Mass. (hereafter Addison Gallery of American Art). In the same letter to Sawyer, curator at the Addison Gallery, she had expressed her fear, based on the appearance of the photograph, that the painting itself had been retouched: "The curious scratchy lights and formless black spaces presented in the glossy print alarm me." After examining the unacceptable contrasts in a second proof print, she made the accusation that "the picture has been painted on by ignorant hands, a small but unmistakable evidence of this outrage, is in the glistening and foolish scratches of white, under the chin and at the wrist" (Susan Eakins to Sawyer, January 19, 1935, Addison Gallery of American Art).

14. Susan Eakins to Charles H. Sawyer, March 27, 1934, Addison Gallery of American Art.

15. Eakins had studied the physiology of the senses at Central High School; see Elizabeth Johns, *Thomas Eakins: The Heroism of Modern Life* (Princeton: Princeton University Press, 1983), p. 53. Eakins could have found direct support for the optical accuracy of his preferred tonal range in the work of Hermann von Helmholtz. Helmholtz's *Treatise on Physiological Optics* (first published in German in 1856–57 and translated into French in 1867), which touches on phenomena observed in painting, was the authoritative source on the subject throughout the decades of Eakins's training and career. The current English edition is *Helmholtz's Treatise on Physiological Optics*, ed. James P.C. Southall, 3 vols. (1924–25; reprint, New York: Dover, 1962). Helmholtz's influential lecture, "On the Relationship of Optics to Painting," published in French in 1878 and in English in 1881 (in *Popular Lectures on Scientific Subjects*, 2nd ser., trans. E. Atkinson [New York: D. Appleton, 1881]) summarized optical, physical, and psychophysical phenomena as they relate to the artist's creation and the viewer's perception of paintings, providing a fascinating theoretical backdrop for the consideration of various movements in late nineteenth-century painting.

16. The enthusiasm for pictures painted with restrained color and keyed low is evident in Henry James's review of the 1876 Paris Salon. James said that Mihaly Munkacsy's *Interieur d'Atelier* "divides with one other work, to my sense, the claim of being the most masterly piece of painting in the Salon" (high praise, since there were 2,095 paintings on view). He continued, "It is composed in what I believe painters call an extremely low key—it is an extraordinary harmony of the deepest tones, unrelieved by a touch of light color or by more than a gleam of high light.... there is nothing cheap or brutal in the artist's dusky accumulations of color... everything is defined, harmonized, and made to play a part" ("Art in France. Letter from Henry James, Jr.," *New York Daily Tribune*, May 27, 1876, p. 3). Another critic, praising William Trost Richards's adoption of a lower key, using opaque watercolor on gray paper—"a new style, based much more upon the idea of a true gradation of light and shade"—wrote, "The picture is strong, and, while the color is not warm nor beautiful, it is rich and effective.... Many persons have not the courage to lower the tone of their pictures to the demi-tints of so many of Nature's shades." (S. N. Carter, "The Tenth New York Water-Colour Exhibition," *The Art Journal*, n.s., vol. 3 [1877], p. 96; quoted in Linda Ferber, "'My Dear Friend': A Letter from Thomas Eakins to William T. Richards," *Archives of American Art Journal*, vol. 34, no. 1 [1994], p. 18). The critic Mariana Griswold van Rensselaer also shared the taste for low-keyed paintings and extreme chromatic restraint. She wrote admiringly of William Merrit Chase's *Portrait of Duveneck* (1875): "It is wonderful to see how well the values [the disposition and relationships of darks and lights] have been given with so restrained a scale, how much richness of effect accompanies so severe a self-denial, and how much 'color' there is in a picture which, literally speaking, shows not a single note thereof" (quoted in Lois Dinnerstein, "Opulence and Ocular Delight, Splendor and Squalor: Critical Writings in Art and Architecture by Mariana Griswold van Renssalaer" [Ph.D. diss., City University of New York, 1979], p. 215).

17. [Hillborn T. Cresson], "Eakins Defended: Mr. H. T. Cresson Answers Mr. Bement's Remarks in *The Item* About the Artist...," *The Evening Item* (Philadelphia), February 22, 1886, p. 1. Lewis F. Day also associated cultivated taste with low tone and popular taste with high-key coloring: "There is one good reason, at least, why the use of low tones should be popularly advocated, and that is, the absence of a cultivated colour-sense among us.... How uncommon the cultivated sense of colour is, even among cultivated people, and how necessary, therefore, some safe rule of conduct is, may be inferred from the readiness with which the terms 'broken colour' and 'low toned' are misunderstood to mean dull or dirty colour" ("Neutral Ground," *The Art Journal* [New York], n.s., vol. 7 [December 1881], pp. 360–61).

18. Eakins to Benjamin Eakins, December 2, 1869, Bregler Collection.

19. Ibid. Eakins would have noticed the marked darkness of Velázquez's paintings in the diffuse daylight of the Prado's galleries. As Velázquez scholar Gridley McKim-Smith notes, "the overall tonality [of Velázquez's paintings] still seems dark when compared with other European paintings," even in late canvases with lighter beige grounds (private correspondence). In addition, Velázquez's paintings were almost certainly more obscured by darkened varnish in Eakins's day than they are now.

20. In the Spanish notebook, Eakins analyzed difficulties with *A Street Scene in Seville* (fig. 32), his first multifigure painting. The passage is confusing, but he seems to have been considering the potential of layered modeling as he perceived it in Velázquez's *The Spinners*: "Velazquez did not paint the folds... of the white doublet *au premier coup* [in one step], for one sees well that the folds are simple *frottis* [thin washes of color] of shadows on the white." Of his own painting, Eakins wrote: "I should have painted my street dance in another way. I should have painted *au premier coup* some sort of red object in the sun and to the right of my figures: the wall and sky, and left it to dry." In the painting, the fall of light is from the left side, so "to the right of my figures" refers to their shaded side. Eakins was proposing, therefore, to apply first the same red for both the lit and shaded sides. He continued:

"Afterwards I would have painted my figures on top, and finally covered the objects on the right which would have given me the tone of the red," meaning, apparently, covering the objects on the right, or shaded side, with a *frottis* of darker tone that would have produced the correct relative shadow tone of the red. Eakins concluded that by this technique, "I would have saved a lot of time and work, and my picture wouldn't have been weak in effect" (Bregler Collection; partial translation from the original French in Foster 1997, p. 47, and authors' translation).

21. By the time Eakins reached Spain, he had already acquired a taste for indirect painting and was looking for evidence of it in the work of painters he admired. He considered Van Dyck's paintings to be weaker than Velázquez's or Ribera's "probably because they were painted *au premier coup*" (Spanish notebook, Bregler Collection, authors' translation). The rich effects of indirect painting suited Eakins's taste, allowing him to paint decisively at the outset and retain the option to make refinements at subsequent stages.

22. Spanish notebook, Bregler Collection, authors' translation.

23. Still, Eakins conceded that "One cannot hope to feel color better than Delacroix." He resolved nevertheless to "profit by [Delacroix's] faults to go much further than he [did]" (Spanish notebook, Bregler Collection, authors' translation).

24. Compare, however, David Liot's observation: "In Delacroix's view, a work's material aspect should be the fruit of expert control, not of a risky spontaneity." To this end, Delacroix had a process, if not aligned with Eakins's particular insistence on cognitive mastery of technique and subject ("The Technique of Eugène Delacroix: A Historical Approach," in Arlette Sérullaz et al., *Delacroix: The Late Work* [Philadelphia: Philadelphia Museum of Art, 1998], p. 387).

25. Eakins's analysis of the methods and effect of indirect painting paralleled Thomas Couture's description of the technique of Titian, "the greatest colorist." Couture even attributed the delicacy of Titian's work to the use of a final neutral glaze (*Méthode et entretiens d'atelier*, 2nd ed. [Paris, 1868], pp. 218–19). Couture's book was fresh in Eakins's memory, for he wrote in 1868 that "it is curious & very interesting. I . . . read it as soon as it came out" (Eakins to Benjamin Eakins, February 1868, Bregler Collection).

26. The pairing of "delicacy and strength" as a criterion by which painting was to be judged evidently persisted in Eakins's thinking and was passed along to others throughout the years. Susan Eakins used the paired terms in her letter to the Addison Gallery of American Art on March 27, 1934 (see note 13). Delicacy, to Eakins, fit in with familiar academic standards: the skillful handling of *valeurs* and especially the middle range of tones, the *demi-teintes*. After his discussion in the Spanish notebook of establishing basic values of light and dark in the beginning stages of painting, Eakins gave a metaphor for the refining role of *demi-teintes*, visualizing the painting process as the pursuit of a unifying continuity by infinite subdivision of discrete larger elements: "Mathematicians could only measure the circle by starting with the square of which one continually doubles the number of its sides" (authors' translation). For a comprehensive discussion of essential academic concepts touched on by Eakins in his writing, see Albert Boime, *The Academy and French Painting in the Nineteenth Century* (New York: Phaidon, 1971).

27. Color terminology was often inconsistent in the nineteenth century. "Values" were sometimes called "light and shade" or "brightness and darkness." "Hues," if distinguished from values, were often simply called "color." Color is now most properly understood to mean the combined attributes of hue, value, and chroma (intensity). On division of values and hues, Couture stated that "Rembrandt is a colorist by the beauty of his values, as Rubens is by the richness of his coloring" (Couture 1868, p. 54). Critics were also accustomed to the distinction. In an 1881 review of Eakins's *Singing a Pathetic Song* (pl. 63), S.G.W. Benjamin wrote, "like most of the paintings we have seen by Mr. Eakins, it conveys the idea that he is far less concerned with color than with light and shade" ("The Exhibitions: Society of American Artists," *The American Art Review*, vol. 2, part 2 [1880–81], pp. 72–73). Helmholtz made an essential distinction between phenomena related only to light intensities and those related to the nature and perception of color in both his *Treatise on Physiological Optics* and in his published lecture

"On the Relation of Optics to Painting." See Helmholtz [1856–57] 1962, vol. 2, part 2, pp. 61–204, and Helmholtz 1881, pp. 94–123.

28. Karl Robert, *Traité pratique de peinture à l'huile: Paysage* (Paris, 1884), pp. 99–100, quoted in Boime 1971, p. 153. Similarly, "It is chiefly to combinations of light and dark that the effect owes its energy, sweetness and charm. . . . Colour of course produces an effect of its own, but it is optically subordinate to those obtained by masses of light and dark half-lights and half-darks" (Paillot de Montabert, *Traité complet de la peinture* [Paris, 1829], vol. 1, p. 153; quoted in Boime 1971, p. 29). Couture wrote that "the most effective color scheme is perhaps that based on an exact observation of values" and "coloring, by the just observation of values, is perhaps the most beautiful; certainly the most distinguished" (Couture 1868, p. 54). Bonnat reduced the priorities of painting to a simple formula for his students: "Values and construction, construction and values" (quoted in Foster 1997, p. 42).

29. Mariana Griswold van Rensselaer, *Six Portraits: Della Robbia, Correggio, Blake, Corot, George Fuller, Winslow Homer* (Boston: Houghton Mifflin, 1889), p. 185; quoted in Dinnerstein 1979, p. 270.

30. J. M. Tracy, "Recollections of Parisian Art Schools," *The Studio*, vol. 2, nos. 27–30 (July 1883), pp. 2, 4. The author also noted (p. 2) that under such coloristic restraint, "the most perfectly satisfactory works were, on the whole, those of a class of men who atoned for indifferent color by correct drawing, neatness, and grace of execution and careful finish, as Cabanel, Gerome, Bouguereau and Merle."

31. William C. Brownell, "The Art Schools of Philadelphia," *Scribner's Monthly*, vol. 18, no. 5 (September 1879), p. 741.

32. Eakins embraced the division and prioritization of value and hue at an early date: "[the artist] learns what [nature] does with light the big tool & then color" (Eakins to Benjamin Eakins, March 6, 1868, Bregler Collection).

33. Helmholtz (1881, pp. 96–97) quantified the discrepancy in daunting terms, citing Wollaston's observation that the difference between the luminosity of the sun and that of a full moon differed by a factor of 800,000; the difference between the brightest white pigment and the deepest black pigment available to the painter differed by a factor of just 100, and in a picture gallery the white pigment in a painting generally showed only 1/40 or less of the brightness of that same white in direct sunlight. Couture (1868, p. 225), speaking of Claude Lorrain's ability to represent convincingly a luminous point, such as the sun, described the most brilliant tone available to the painter as a dull half-tint compared to nature: "it is necessary by the magic of tones to make this half-tint shine like a luminous thing."

34. Spanish notebook, Bregler Collection, authors' translation.

35. A striking parallel to Eakins's arrangement of the value scale is found in descriptions, of which Eakins surely must have known, of paintings by Apelles, the legendary Greek painter of the late fourth to early third century B.C., renowned for his ability to depict remarkable effects of relief and light. Apelles's famous portrait of *Alexander the Great Holding the Thunderbolt* was "considered extraordinary because the thunderbolt and Alexander's fingers seemed to project out of the picture. To achieve this the figure of Alexander was apparently darkened so that the thunderbolt, which may have been given highlights, stood out" (Susan B. Matheson, "Apelles," *The Grove Dictionary of Art* [New York: Grove's Dictionaries, 1996], vol. 2, p. 217). Also, Apelles' painting is the earliest precedent for the use of a thin black varnish (*atramentum*) which both protected his paintings and paradoxically, according to Pliny the Elder, enhanced their brightness (*claritas*). For further discussion of the historical influence on painters of Pliny's account, see Ernst Gombrich, "Dark Varnishes: Variations on a Theme from Pliny," *The Burlington Magazine*, vol. 104, no. 707 (February 1962), pp. 51–55.

36. M. E. Chevreul wrote of tonal painting, "We can also cite as an example of this kind of imitation, a landscape painted from its reflection in a black mirror, because the effect of the picture is very soft and harmonious" (*The Principles of Harmony and Contrast of Colours*, trans. Charles Martel [London: Henry G. Bohn, 1859], p. 109).

37. The necessity and efficacy of this approach was supported both by academic and scientific principles. Boime (1971, p. 151) wrote of traditional practice for the painting of landscapes and interiors: "In both cases the values had to be telescoped because pigment would not

express the highest light nor the lowest dark in nature; and to have the same number of gradations between the highest and lowest notes in the picture, the amount of difference between each value had to be relatively diminished." This is the empirical equivalent of Fechner's Law, which states that sensation varies as the logarithm of the stimulus: "Within a wide range of luminosity the smallest perceptible difference of the light sensation correspond to [nearly] constant fractions of the luminosity" (Helmholtz [1856–57] 1962, vol. 2, part 2, p. 175). The possibility of the painter's lowering the value scale without sacrificing the number or distinguishability of value gradations is supported by Fechner: "when bright objects like the sky and sunlit clouds are viewed through dark gray glasses, none of the gradations of shadow disappear that were visible before nor do new ones make their appearance" (ibid., p. 174).

38. Critics could be unsympathetic to Eakins's tonal scale in rendering sunlight effects. "Another painter who fails in the same effort is Mr. Thomas Eakins, of Philadelphia. 'Shad Fishing at Gloucester on the Delaware' has no strong sunlight in it, although it is plain that sunlight was intended" ("The Academy of Design. Why Members Refuse to Serve on the Hanging Committee . . . ," *The New York Times*, April 30, 1882, p. 3). *Ships and Sailboats on the Delaware* (Philadelphia Museum of Art) is an extreme example of low key in Eakins's landscapes. Despite an overall dark gray tone, it depicts "a still August morning 11 o'clock" (Eakins to Earl Shinn, January 30, [1875], Richard T. Cadbury Papers, Friends Historical Library, Swarthmore College, Pa.).

39. "If I do the strongest lights exactly, and if the shadows would be gray, my picture will not be so affected by the color of the daylight" (Spanish notebook, Bregler Collection, authors' translation).

40. Eakins prefaced this assessment with the general observation that a "picture that is suited for any light can be completely spoiled by too strong a light. Proposition. Too strong a white light has on the colors of a picture that [effect] which silver white would [have]. It destroys the color" (Spanish notebook, Bregler Collection, authors' translation).

41. It was widely understood that too much light destroyed the effect of paintings. For example, in *The Unknown Masterpiece* (1832, first published 1845), Honoré de Balzac wrote, "The two painters left the old man to his raving, and looked about to see whether the light, falling too full upon the canvas that he pointed out to them, did not neutralize all its fine effects" ([London: Caxton, 1899], p. 42).

42. Evidence of tonal adjustments to already-framed paintings has also been found on the *Portrait of Mary Adeline Williams* (pl. 218). Other instances of the practice may yet be encountered in Eakins's work, though the possibility also exists that evidence of such final adjustment was removed in cleanings. On "varnishing day," just before the opening of an exhibition, artists could make such final adjustments to optimize color and key of their paintings in direct response both to the light of the exhibition space and to neighboring paintings. One critic observed that Winslow Homer, finding his picture "quite out of harmony with everything about it . . . varnishes down his large canvas and certainly improves it very much" (Charles DeKay, "Preparing the Pictures, The Artists' Varnishing Day. Annual Exhibition of the Academy of Design," *The New York Times*, March 30, 1879, p. 6). We thank Margaret Conrads for discussing this. Eakins was also sensitive to the relationship between painting and frame or mat, choosing or designing frames that harmonized with the color of pictures. The gilt chestnut frames of *The Concert Singer* (pl. 192) and *Portrait of Professor Henry A. Rowland* (pl. 211) were both given a dark glaze, by Eakins or at his instruction, to better suit the tonality of the paintings. Eakins wrote in 1899: "I always protest against the barbaric splendor of new gold frames which injure all paintings" (Eakins to John W. Beatty, September 20, 1899, Carnegie Institute, Museum of Art records, Archives of American Art, Smithsonian Institution, Washington, D.C.). He was equally concerned with the tone of mats for his watercolors, saying of his 1875 watercolor *A Drifting Race* (private collection): "The mat I think is too blue but I cannot tell till I see where it is hung. The color was very true but the mat may have exaggerated" (Eakins to Earl Shinn, January 30, 1875, Cadbury Papers).

43. The draft is in the Bregler Collection. Foster (1997, p. 136) points out that it may never have progressed beyond "an internal monologue."

44. Eakins had touched on the problem in the Spanish notebook: "If I

place my sketch in a very weak daylight, all the half-tones [*demi-teintes*] tend toward the shadow and appear too black, but if I place it in broad daylight, the half-tones tend too far toward the lightest point and make [the sketch] appear common" (Bregler Collection, authors' translation).

45. Eakins to Jean-Léon Gérôme, draft, 1874, Bregler Collection, authors' translation.

46. Ibid., translated in Foster 1997, p. 135.

47. Ibid., authors' translation.

48. Ibid., authors' translation.

49. Helmholtz described the phenomenon: "If pieces of red and blue paper appear equally bright by day, then with the approach of night the blue gets bright while the red often looks perfectly black. So also in picture galleries toward evening . . . the red colors are the first to fade away, and the blue ones continue visible longest" (Helmholtz [1856–57] 1962, vol. 2, part 2, p. 182). For more on the rapid diminishment in intensity of red compared with blue under conditions of falling illumination see Martin Kemp, *The Science of Art: Optical Themes in Western Art from Brunelleschi to Seurat* (New Haven: Yale University Press, 1990), p. 312. J.M.W. Turner, in his 1818 additions to the fifth lecture on color in painting for the Royal Academy schools, noted: "But as to tone or strength, comparatively *red* possesses the utmost power of attracting vision, it being the first ray of light and the first which acknowledges the diminishing of light" (quoted in John Gage, *Color in Turner: Poetry and Truth* [New York: Praeger, 1969], p. 206).

50. Eakins to Jean-Léon Gérôme, draft, 1874, Bregler Collection, translated in Foster 1997, p. 136. Eakins believed that understanding deep, universal principles facilitated the solution to all problems, however complex, as well as revealing the interrelatedness of apparently diverse concepts. Charles Bregler recorded Eakins's comments in his class notes from 1887: "All the sciences are done in a simple way. In mathematics the complicated things are reduced to simple things. So it is in painting. You reduce the whole thing to simple factors" ("Thomas Eakins as a Teacher: Second Article," *The Arts*, vol. 18, no. 1 [October 1931], p. 384). In an 1868 letter to his father, Eakins implied that even color was reducible to basic principles: "Color is becoming little less of a mystery than it was & more of a study in proportion. When it ceases altogether to be a mystery and it must be very simple at the bottom, I trust I will soon be making pictures" (Eakins to Benjamin Eakins, January 17, 1868, Goodrich Papers).

51. Eakins painted by daylight for his paintings to be viewed by daylight; there is nothing to indicate otherwise. His sensitivity to subtle differences in the quality of daylight suggests that, unlike some other artists, he would not have accepted the artificial illumination of the day (particularly gaslight) for either painting or critical viewing. See Lance Mayer and Gay Myers, "Bierstadt and Other Nineteenth-Century Painters in Context," *Journal of the American Institute for Conservation*, vol. 38, no. 1 (Spring 1999), pp. 56–57. It is also claimed that the Eakins house did not have electric light in Eakins's lifetime (Margaret McHenry, *Thomas Eakins, Who Painted* [privately printed, 1946], p. 60).

52. Eakins to Harry W. Barnitz, May 5, 1884, Bregler Collection. Eakins's use of synaesthetic comparison is conventional. Boime (1971, p. 151) has pointed out that "Couture followed the traditional [academic] precepts on chiaroscuro by transposing the key or pitch of natural lighting. . . . a landscape was painted down, or darker from the pitch of nature, and an interior was painted up, or lighter." Eakins seems to have disregarded the tradition for interiors. A disapproving review of Winslow Homer's 1880 watercolor exhibition at the Doll and Richards Gallery in Boston shows how completely conventional the general landscape precept was: "We are led to believe that Mr. Homer has made a fatal error in trying to match exactly the pronounced hues of unusual effects. He thereby loses the graduated scale of art, which at the best must remain relative and much lower than the scale of nature" ("Artists and Their Work," *The New York Times*, December 13, 1880, p. 2).

53. Quoted in Goodrich 1982, vol. 1, p. 108.

54. W. Douglass Paschall has observed that a parallel attraction to the effects of diminished contrast and subtly modulated, continuous tone that Eakins achieved in his paintings can be seen in his early adoption of the platinum process to print his photographs, with its narrow, gently gradated tonal range, for almost all his photographs conceived or presented as independent works of art. Photographs intended solely as

studies he generally confined to albumen prints. Eakins was using the platinum process by May 1883, shortly after it became commercially available (entry for May 31, 1883, in 1883–88 account book, Collection of Daniel W. Dietrich II).

55. Jules Breton, *Un Peintre paysan: Souvenirs & impressions* (Paris: Alphonse Lemerre, 1896), pp. 209–12; quoted in Boime (1971, p. 29) to illustrate the role in painting of gradation of values in the second half of the nineteenth century.

56. In the period immediately following Eakins's death, some paintings were cleaned in preparation for the 1917 memorial exhibition at the Metropolitan Museum of Art. Records of the work done at this time are brief or nonexistent. Photographs taken in conjunction with the exhibition are the earliest known for many paintings and provide some evidence of earlier appearance (The Metropolitan Museum of Art, New York). Several photographed paintings, including *The Crucifixion* and *The Pair-Oared Shell*, already show obvious results of cleanings.

57. Current universally recognized conservation ethics and standards of practice were nonexistent in the period when many earlier cleanings of Eakins's paintings took place. By these standards, the foremost present requirement of the cleaning of an Eakins painting would be the exacting discernment and preservation of all original layers with which he achieved his painstakingly adjusted and much prized "true tones."

58. Her fears about any cleaning attempt that might be made on *William Rush Carving His Allegorical Figure of the Schuylkill River* (pl. 41) were expressed in a letter to Fiske Kimball, director of the Pennsylvania Museum of Art (now the Philadelphia Museum of Art) of January 21, 1932: "The picture is so delicate that attempts to brighten it up, would be disastrous" (Eakins Research Collection).

59. Conservator Theodor Siegl concluded that the grimy-looking surfaces were frequently original, saying, for example, of *The Meadows, Gloucester* (pl. 88), "the dirty quality of the sky is probably intentional" and of *Cowboy Singing* (Philadelphia Museum of Art), "Eakins probably painted on this at various times, always rubbing the dirty surface with oil or paint medium" (Conservation files, Philadelphia Museum of Art). Eakins's casual pragmatism in using "dirty varnish" to achieve a desired effect is similar to that of Antonio Palomino y Velasco, the seventeenth-century Spanish theorist (though Eakins almost certainly did not know his writings): "I conclude that, above all, the tint that best achieves the effect desired will be the truest and most legitimate, even though it were made of dust from the street" (quoted in Zahira Veliz, ed., *Artists' Techniques in Golden Age Spain* [Cambridge: Cambridge University Press, 1986], p. 164). We thank Gridley McKim-Smith for bringing this citation to our attention.

60. Elizabeth La Rue Burton cited a letter from Susan Eakins as specifying only rectified turpentine, used sparingly, as the solvent for the safe removal of dull or discolored picture varnish from the surface of Eakins's paintings, and mastic in rectified turpentine as the picture varnish to be reapplied after cleaning (letter from Elizabeth La Rue Burton found on the inside of the backing of her portrait by Eakins in the Minneapolis Institute of Arts, dated November 30, 1935, copy in Eakins Research Collection). This advice is most likely based on Eakins's own expectation that turpentine would not damage the surface of his paintings. Precautions to be taken by artists, such as finishing paintings with relatively insoluble surface coatings that could withstand the periodic removal of picture varnish, were advocated in treatises such as J. F. L. Merimée's 1830 *De la peinture à l'huile* (Paris: Huzard). Eakins's teacher Jean-Léon Gérôme is reported to have given students his own recipe for a protective final coating that was said to "[give] the painting the solidity of flint" (Charles Moreau-Vauthier, *The Technique of Painting* [New York: G. P. Putnam's Sons; London: William Heinemann, 1917], p. 139).

61. Siegl encountered this situation in cleaning a sketch for *The Spinner*. Upon removing the picture varnish, he noted that "there was a certain amount of grime embedded in the paint film under the varnish." He explained that "this grime was not removed because it is our understanding that Eakins often applied such grime intentionally and that...it is characteristic of his best work" (Conservation files, Philadelphia Museum of Art).

62. Between painting sessions, Eakins would habitually apply retouch varnish to refresh color that had "sunk" or dried dull. Thomas Anshutz

wrote to John Laurie Wallace on October 2, 1885 that "Eakins has used varnish over the first painting on his portrait and it bore out the second work very well" (typescript in Eakins Research Collection). Eakins also occasionally mixed resinous mediums into his paint to modify its richness or handling qualities. We have seen such yellowish transparent mediums incompletely blended with the wet paint on a number of occasions. The presence of such unpigmented resinous materials within the paint structure increased the vulnerability of Eakins's paintings to the strong cleaning agents sometimes used to remove his toning films. Two accounts indicate the presence of megilp (a resinous paint medium made from mastic resin and linseed oil saturated with drier) in the Eakins studio. Susan Eakins wrote to restorer LeRoy Ireland on October 15, 1914: "Could you help me with those two pictures which I told you I had made the mistake of using a preparation for megilp instead of varnish on" (copy in Conservation files, Philadelphia Museum of Art). Also, D. H. Wilson recalled Eakins showing him megilp while the portrait of his mother, Lucy Langdon W. Wilson, was being painted in 1908–1909 (letter to Theodor Siegl, December 12, 1970, Conservation files, Philadelphia Museum of Art).

63. Dark surface tone is sometimes found most intact where it occurred on sketches, since their status as relatively minor works apparently elicited fewer and less insistent attempts at cleaning.

64. One earlier restorer's report encountered in our research records a typical misinterpretation of an originally and intentionally dark surface layer on an Eakins painting of the mid-1870s: "Varnish [the readily soluble picture varnish on the painting's surface] dissolved and removed which however did not lighten the surface considerably. It appears that the paint-film must have been 'oiled out' at one time before it was relined and varnished, which accounts for the darkening. Only a rather risky, time-consuming treatment could correct this." The restorer nonetheless tried to lighten the painting: "An attempt was made to remove the brown coating by cleaning with Morpholine [a solvent, rarely used in the cleaning of paintings, that has a direct action on oxidized linseed oil films], swelling repeatedly with copaiba balsam and toluene. Some was scraped with scalpel. Almost impossible to remove coating from original." Our analysis of materials on the surface of the Philadelphia *Crucifixion* identified residues of feldspar, the abrasive in scouring powder, which may have been used by another restorer as a last resort in an attempt to clear the surface of its overall dark surface tone. Other instances of scraping with sharp points or blades have also been seen. As utterly unthinkable as these measures seem now, they show how convinced some individuals were that Eakins's surface was wrongly obscured and needed to be revealed.

65. Eakins had specific expectations and standards for the pictorial function of texture. He wrote in his Spanish notebook: "The spinner of Velasquez, while very much impasted, had no ridges to catch the light.... So then pile up the paint as much as I want, but never leave ridges.... The most beautiful things of Ribera and Rembrandt would have suffered [*perdraient*] immensely if they had not paid more attention to texture than anybody else" (Bregler Collection, partial translation in Foster 1997, p. 46, and authors' translation). Interested in the possibilities of texture and bravura handling, he nonetheless objected to gratuitously impasted surfaces or brushwork whose material nature was obtrusive. Eakins's scraping of lower paint layers to level paint texture he considered excessive can be seen in his use of one tool that left fine, evenly spaced parallel scratches in already-set paint. These marks are visible in *John Biglin in a Single Scull*, *The Crucifixion*, and *The Meadows, Gloucester;* the Philadelphia and Ball State University paintings of *Shad Fishing at Gloucester on the Delaware River;* and the sketch for *Arcadia* (Pennsylvania Academy of the Fine Arts, Philadelphia). Eakins viewed texture as absolutely subordinate to modeling. Siegl's hypothesis that dark materials had been "rubbed in [by Eakins] to accentuate the brush marks" or "to enhance texture" is based on an appearance we now attribute to past cleanings (Conservation files, Philadelphia Museum of Art). For example, in a 1917 photograph (The Metropolitan Museum of Art, New York) of *The Crucifixion* (though it can be seen that the painting had already been through a cleaning), the grayish surface tone now present only in the grooves and hollows of brushwork in many places was then more continuous and evenly distributed. The "accentuated" brushmark texture that

Siegl described is in fact the result of further removal of the gray tone from the high points and ridges of the surface in a post-1917 cleaning. In the state documented by the early photograph, with the gray surface tone more uniform, the modeling of the figure appears much more descriptive and convincing.

66. Samuel Murray in McHenry 1946, pp. 102–103; D. H. Wilson to Theodor Siegl, November 25, 1970, Conservation files, Philadelphia Museum of Art.

67. For detailed analyses of Eakins's materials, see Christina Currie, "Thomas Eakins Under the Microscope," in Helen A. Cooper et al., *Thomas Eakins: The Rowing Pictures* (New Haven: Yale University Press, 1996), pp. 100–101; Currie, "The Biglin Brothers Turning the Stake by Thomas Eakins: A Technical Study Reveals Surprising Techniques," talk delivered at Annual Meeting of the American Institute for Conservation, Nashville, Tenn., 1994; Mark Bockrath, "The Conservation of the Paintings," in Foster 1997, pp. 453–59.

68. Conservator Theodor Siegl noted that a transparent red (identified as madder lake in 1972 by Walter C. McCrone Associates, Inc.) used for Eakins's signature on *Mending the Net* had become nearly colorless (Conservation files, Philadelphia Museum of Art). Claire M. Barry noted the same problem with the signature on *Swimming*, in *"Swimming* by Thomas Eakins: Its Construction, Condition and Restoration," in *Thomas Eakins and the Swimming Picture*, ed. Doreen Bolger and Sarah Cash (Fort Worth, Tex.: Amon Carter Museum, 1996), pp. 98–116. Eakins, so attuned to critically adjusted tonal balances, was also concerned about undesirable shifts in those balances as his paints aged. Thomas Anshutz wrote to John Laurie Wallace on October 2, 1885, that "We have not succeeded in solving the darkening paint question yet." In a letter of November 4, 1885, he told Wallace, "We are all making thorough experiments in pigments. In reference to the trouble we discussed while you were here. And in addition are going to put down a series of patches of color and at the end of a year will match them with color from the same tube. Which is the most reliable way to detect a change" (both, typescripts in Eakins Research Collection).

69. Technical and documentary information gathered in the course of this study has been applied to the recent restorations of a number of paintings, most notably *The Pair-Oared Shell* (pl. 4), *Sailboats Racing on the Delaware* (pl. 10), *The Crucifixion* (pl. 54), *Mending the Net* (pl. 85), *Between Rounds* (pl. 215), and the Philadelphia Museum of Art and Ball State University paintings *Shad Fishing at Gloucester on the Delaware River* (pls. 72, 76).

70. Cecilia Beaux, *Background with Figures* (Boston and New York: Houghton Mifflin, 1930), p. 98.

71. Ibid., p. 97. In the paragraph following, Beaux wrote: "Color, however, in Eakins's work is far from being absent." The painting she used as an example is *The Pair-Oared Shell*, whose color is not indeed absent, but is by any standard restrained. The description of the painting shows her standard and admiration to have been based upon color's evocative power rather than its brilliance: "a strong puller in the sliding seat looms out of the ember mists of a hot evening on the Schuylkill. Vital human action and the fascination of an August sun's last effort in vaporous twilight meet without friction" (p. 97).

"Eakins in the Twentieth Century," pp. 367–76

CAROL TROYEN

Several colleagues have made helpful suggestions that have significantly improved this essay. I am especially grateful to Elizabeth Johns, Gilian Shallcross, and Cynthia Purvis.

1. J. McLure Hamilton and Harrison Morris, "Thomas Eakins: Two Appreciations," *Bulletin of the Metropolitan Museum of Art*, vol. 12, no. 11 (November 1917), p. 222.

2. Eakins to Morris, April 23, 1894, Archives, Pennsylvania Academy of the Fine Arts, Philadelphia.

3. He lectured at the Women's Art School of Cooper Union and at the National Academy of Design in New York; at Philadelphia's Drexel Institute of Art, Science, and Industry; and at the Art Students' League of Washington, D.C.

4. For the Earles Galleries exhibition, see Evan H. Turner, "Thomas Eakins: The Earles' Galleries Exhibition of 1896," *Arts Magazine*, vol. 53, no. 9 (May 1979), pp. 100–107.

5. *The Philadelphia Press*, February 16, 1901, p. 4; and *The Pennsylvanian*, February 16, 1901, p. 4. The professional achievements of the 1890s were, unfortunately, accompanied by a continuation of Eakins's personal difficulties of the 1880s involving nude models and troubled young women. See Kathleen A. Foster and Cheryl Leibold, *Writing About Eakins: The Manuscripts in Charles Bregler's Thomas Eakins Collection* (Philadelphia: University of Pennsylvania Press for the Pennsylvania Academy of the Fine Arts, 1989), pp. 99–122.

6. Whereas the lateness of Eakins's election to the National Academy of Design is often cited as evidence of his mistreatment by the artistic establishment, a number of major artists, among them Albert Pinkham Ryder, likewise were chosen when they were in their fifties. More remarkable, indeed unprecedented, was his selection as an Associate and an Academician within the same year.

7. In 1897, the Pennsylvania Academy of the Fine Arts bought *The Cello Player* (pl. 206) for five hundred dollars. Eakins gave the National Academy of Design his *Self-Portrait* (pl. 229) and *Wrestlers* (The Columbus Museum of Art, Ohio) in 1902 and his *Portrait of Edward W. Redfield* (National Academy of Design, New York) in 1905. In 1913 Charles Dana gave his portrait by Eakins to the Pennsylvania Academy, and in 1916 the Metropolitan Museum of Art bought *Pushing for Rail* for eight hundred dollars, the first of eleven works by Eakins that the museum would purchase over the next decade. During this period, those same institutions acquired five major oils by William Merritt Chase, five by George Inness, and nine by Winslow Homer.

8. For example, the *Portrait of Professor William Smith Forbes* (1905, Jefferson Medical College, Thomas Jefferson University, Philadelphia), commissioned by Forbes's students at Jefferson Medical College, and that of John B. Gest (1905, The Museum of Fine Arts, Houston) ordered by the Fidelity Trust Company, of which Gest was president; see Elizabeth Johns, *Thomas Eakins: The Heroism of Modern Life* (Princeton: Princeton University Press, 1983), pp. 144–69.

9. See Joseph DeCamp to Eakins, about March 1, 1913, The Lloyd Goodrich and Edith Havens Goodrich, Whitney Museum of American Art, Record of Works by Thomas Eakins, Philadelphia Museum of Art (hereafter Goodrich Papers); and Eakins to Kendall, February 23, 1905, Collection of Daniel W. Dietrich II.

10. J. Carroll Beckwith wrote in 1907 that Eakins's portrait of him "has been greatly admired by many of my friends and should add to your laurels" (Beckwith to Eakins, September 9, 1907, Goodrich Papers). See also William H. Lippincott to Eakins, April 20, 1895: "I very much appreciate the compliment you paid me in wishing to paint my portrait and now your still greater compliment in presenting the portrait to me makes me happy" (Goodrich Papers).

11. Susan Eakins to Clarence Cranmer, July 4, 1929, Archives of American Art, Smithsonian Institution, Washington, D.C. (hereafter Archives of American Art).

12. Johns 1983, pp. 150ff. Although Eakins had a number of prominent sitters, for the most part, Philadelphia's nationally known leaders went elsewhere for their portraits—railroad magnate A. J. Cassatt commissioned John Singer Sargent to paint his portrait; financier Jay Cooke sought out William Merritt Chase.

13. Lloyd Goodrich, *Thomas Eakins*, 2 vols. (Cambridge, Mass.: Harvard University Press for the National Gallery of Art, 1982), vol. 2, p. 215.

14. Eakins served on the jury for the Carnegie International from 1899, on the Pennsylvania Academy jury from 1901, and for the art display at the Louisiana Purchase Exposition in 1904. Regarding his service to the Academy, curator Gilbert S. Parker described him as "a most tolerant man when on a jury" (Goodrich 1982, vol. 2, p. 201). In 1909 John Sloan noted, "Thomas Eakins's opinion is the only one on the jury that's worthwhile" (quoted in Lloyd Goodrich, *John Sloan* [New York: Whitney Museum of American Art, 1952], p. 30).

15. "Hovenden and Rothermel: Thomas Eakins Talks of Two Great Artists Now Lying in Death," *The Philadelphia Press*, August 17, 1895, p. 4.

16. Eakins counseled them to "frequent the life schools," "learn the laws of perspective," and "be a student of nature always." He concluded his statement with the offer "if you ever come to Philadelphia, bring me some of your work" (Eakins to Edmund Clarence Messer, July 3, 1906, Archives, Corcoran Gallery of Art, Washington, D.C.).

17. "Eakins Chats on Art of America," *The Philadelphia Press*, February 22, 1914, p. 8.

18. "Discreet Pictures Seen at Academy," *The Philadelphia Inquirer*, February 18, 1914, p. 14.

19. [Sadakichi Hartmann], "Art and Artists," *Musical America*, vol. 1 (October 29, 1898), p. 31. In perhaps the first article to equate Eakins with the ever-popular Winslow Homer, the adventurous critic Sadakichi Hartmann called them "the only two men who are masters in the art of painting" and emphasized the strength and power of their work in contrast to the "suave, sensuous style of a Dewing or a Thayer."

20. Charles H. Caffin, "American Studio Talk: The Picture Exhibition at the Pan-American Exposition," *The International Studio*, vol. 14 (October 1901), p. xxxii. See also Samuel Isham, who was disappointed by Eakins's work "because of his neglect of the beauties and graces of painting" (*The History of American Painting* [New York: Macmillan, 1905], p. 525).

21. Charles H. Caffin, *The Story of American Painting* (New York: Frederick A. Stokes, 1907), pp. 232–33.

22. Sadakichi Hartmann, *A History of American Art*, 2 vols. (Boston: L. C. Page, 1901), vol. 1, p. 203. Hartmann was echoing views of Eakins expressed by their mutual friend Walt Whitman, who famously referred to him as "not a painter…[but] a force" (Horace Traubel, *With Walt Whitman in Camden*, 9 vols. [Boston: Small, Maynard, 1906], vol. 1, p. 284).

23. "7000 View Art Works at Academy. Attendance Records of Last Ten Years Broken by Sunday's Visitors to Exhibition of Pictures and Statuary," *Public Ledger* (Philadelphia), March 16, 1914, p. 15. Seeking to capitalize on the excitement generated by Eakins's art, a review of the following year's Academy show conspicuously mentioned his paintings in the headline: "Academy Opens 110th Exhibition…Eakins' Portrait of Mrs. Talcott Williams Among Distinguished Paintings in Show," *The Philadelphia Inquirer*, February 7, 1915, section 2, p. 2. See also "Agnew's Portrait Show's Sensation," *The Philadelphia Inquirer*, February 22, 1914, section 6, p. 12.

24. Henri to Barnes, February 1914, Archives, Hirshhorn Museum and Sculpture Garden, Smithsonian Institution, Washington, D.C.

25. Barnes to Eakins, February 27, 1914, Goodrich Papers.

26. "Agnew's Portrait Show's Sensation," *The Philadelphia Inquirer*, February 22, 1914, section 6, p. 12.

27. Susan Eakins apparently worked on her husband's last two paintings: a posthumous portrait of President Rutherford B. Hayes (1912–13, Philipse Manor Hall, Yonkers, N.Y.), commissioned by noted collector Thomas B. Clarke, and a full-length image (later cut down) of Dr. Edward Anthony Spitzka (c. 1913, Hirshhorn Museum and Sculpture Garden), professor of anatomy at Jefferson Medical College, which Goodrich believed was done on Eakins's initiative. See Goodrich 1982, vol. 2, pp. 260–62.

28. "Thomas Eakins," *American Art News*, vol. 14, no. 36 (July 15, 1916), p. 4; Curtis Wager-Smith, "The Year in Art: Philadelphia," *American Art Annual*, vol. 13 (1916), p. 33.

29. Lewis Mumford, *The Brown Decades: A Study of the Arts in America 1865–1895* (New York: Harcourt, Brace, 1931), p. 189.

30. Our notion of Eakins as an American realist has been tempered in recent years, as greater attention has been paid to "the subtlety of Eakins' creativity within the tradition of academic naturalism" (Foster and Leibold 1989, p. 127). See also Kathleen A. Foster, *Thomas Eakins Rediscovered: Charles Bregler's Thomas Eakins Collection at the Pennsylvania Academy of the Fine Arts* (New Haven: Yale University Press for the Pennsylvania Academy of the Fine Arts; , 1997).

31. Goodrich 1982, vol. 2, p. 279.

32. Ronald G. Pisano, *A Leading Spirit in American Art: William Merritt Chase, 1849–1916* (Seattle: Henry Art Gallery, University of Washington, 1983), p. 16.

33. Seymour Adelman, *The Moving Pageant: A Selection of Essays* (Lititz, Pa.: Sutter House, 1977), p. 164, quoted in Foster and Leibold 1989, p. 6.

34. Correspondence makes it clear that both William Sartain and Bregler submitted their essays on Eakins to Susan Eakins for review; see Susan Eakins to William Sartain, about July 5, 1917, Historical Society of Pennsylvania, Philadelphia; and Foster and Leibold 1989, p. 320. She carefully vetted statements by *Sun* critic Henry McBride, politely corrected his transcription of a comment about Eakins by Gérôme, and provided an account of Eakins's days in Paris that McBride subsequently quoted verbatim.

35. Susan Eakins to Horatio Wood, April 2, 1917, Pennsylvania Academy of the Fine Arts, Philadelphia, Charles Bregler's Thomas Eakins Collection, purchased with the partial support of the Pew Memorial Trust (hereafter Bregler Collection); quoted in Foster 1997, p. 1.

36. This photograph appeared in the first of Charles Bregler's two articles on Eakins ("Thomas Eakins as a Teacher," *The Arts*, vol. 17, no. 6 [March 1931], p. 378). It was Susan Eakins's favorite, almost certainly made by her (Susan Eakins, retrospective diary, entry for September 5, 1880, Bregler Collection). She described Eakins as he appears there as "a slim figure in the garden" (Susan Eakins to McBride, October 16, 1917, McBride Papers, Archives of American Art), though whether she intended it for publication or simply as a memento is not clear.

37. Susan Eakins to McBride, September 25, 1917, McBride Papers, Archives of American Art.

38. The show was one of a number honoring the generation of artists just passing from the scene: in the years leading up to the Eakins memorial, the Metropolitan had mounted exhibitions commemorating Augustus Saint-Gaudens (1908), James McNeill Whistler (1910), Homer (1911), and Chase (1917), and would present a show of Albert Pinkham Ryder's work early the next year.

39. "I have always felt inadequately represented in the Metropolitan Museum. Hearing that the Museum was now buying some American pictures I have hopes that something of mine may be included" (Eakins to Burroughs, January 12, 1910, Archives, The Metropolitan Museum of Art, New York). See also Goodrich 1982, vol. 2, p. 265. Until then, the sole work of his at the Metropolitan Museum of Art was *The Chess Players* (pl. 19), which he himself had donated in 1881.

40. [Henry McBride], "National Academy Lacking in Thrills," *The Sun* (New York), March 19, 1916, p. 9. Marc Simpson kindly supplied me with this article.

41. *The Philadelphia Inquirer*, November 4, 1917, p. 15; *The Philadelphia Inquirer*, November 11, 1917, section 4, p. 8; and Henderson to Lewis, November 6, 1917, Archives, Pennsylvania Academy of the Fine Arts, Philadelphia.

42. The most curious contribution to the emerging image of Thomas Eakins was Gilbert Parker's. In his essay he included an account of Eakins's defense of a fellow citizen against "two toughs" who were menacing passers-by on the Walnut Street Bridge: "As Eakins walked across the bridge, he cocked the revolver in his pocket. The thieves evidently heard it, for one said to the other, 'Let him go by, we'll get the next.'" Eakins then escorted the other traveler to safety. With this tale, Parker sought to immortalize Eakins as heroic, manly, and concerned for others without fear for himself ("Here was a man")—a sort of Lone Ranger *avant la lettre*. Parker thus set the stage for a mythology that would focus on Eakins's character as much as his art (Gilbert Sunderland Parker, "Thomas Eakins, Realist," *Memorial Exhibition of the Works of the Late Thomas Eakins* [Philadelphia: Pennsylvania Academy of the Fine Arts, 1917], p. 10).

43. Later critics would drop this theme in favor of a more purely native view of Eakins but would perpetuate the associations made here and elsewhere with more distant old masters, especially Rembrandt and Velázquez.

44. Bryson Burroughs, "Introduction," *Loan Exhibition of the Works of Thomas Eakins* (New York: The Metropolitan Museum of Art, 1917), pp. v–viii, and J. McLure Hamilton and Harrison Morris, "Thomas Eakins: Two Appreciations," *Bulletin of the Metropolitan Museum of Art*, vol. 12, no. 11 (November 1917), pp. 218–22. The theme of Eakins's neglect was quickly picked up by other commentators. The writer for *Current Opinion* called him "one of [America's] most neglected geniuses" ("Thomas Eakins: Another Neglected Master of American Art," *Current Opinion*, vol. 63, no. 6 [December 1917], p. 411). See also

Alan Burroughs, "Thomas Eakins, The Man," *The Arts*, vol. 4, no. 6 (December 1923), pp. 303–304.

45. Henry McBride, "News and Comment in the World of Art," *The Sun* (New York), November 4, 1917, p. 12, and November 11, 1917, p. 12. The importance of associating Eakins with Cézanne was perceptively analyzed by Elizabeth Milroy in a paper, "The Death and Resurrection of Thomas Eakins," presented at the 1983 annual meeting of the College Art Association. I am grateful to Lily for sharing her paper with me.

46. This was the second of two Eakins exhibitions mounted by the Brummer Gallery. The first, held in the spring of 1923, was an impressive display of thirty works by Eakins, including such now-celebrated oils as *William Rush Carving His Allegorical Figure of the Schuylkill River* (pl. 41), *Mending the Net* (pl. 85), and *Swimming* (pl. 149), as well as five watercolors. The catalogue included statements by Bryson Burroughs and artist and critic Walter Pach. The Brummer Gallery, which the Paris-based art dealer Joseph Brummer opened on East 57th Street in 1921, specialized in the type of art that had been sought after by the avant-garde—ancient art, African masks, Gothic sculpture—as well as the work of modern French painters. It was an unlikely venue for Eakins, but the fact that he had two shows there was an indication of the growing perception of his relevance to the modern art world.

47. Henry McBride, "Modern Art," *The Dial*, vol. 80 (January 1926), pp. 77–79.

48. Cranmer posed for the timekeeper in the foreground of *Between Rounds* (pl. 215) and for *The Timer* (1899, private collection). He also advised Eakins on the positions assumed by the figures in *Wrestlers* (1899, Philadelphia Museum of Art, and the finished canvas in Columbus). See Theodor Siegl, *The Thomas Eakins Collection* (Philadelphia: Philadelphia Museum of Art, 1978), pp. 149–50, nos. 97–98.

49. Shortly after their purchase, many of the works bought by these collectors were donated to the Yale University Art Gallery, New Haven, or the Addison Gallery of American Art, Phillips Academy, Andover, Mass.

50. In 1920 the Academy showed "Paintings and Drawings by Representative Modern Masters," and the following year it presented "Paintings and Drawings Showing the Later Tendencies in Art." It also put on a series of exhibitions dedicated to Philadelphia's old masters. A show of Thomas Sully's work was held in 1922, followed by Charles Willson Peale in 1923, and John Neagle in 1925.

51. A typewritten inventory in the Robert Henri papers, headed "Paintings by Thomas Eakins at Mount Vernon Street," includes a list of paintings "With Penn Athletic Club," among them *Between Rounds* (pl. 215), *Wrestlers* (Philadelphia Museum of Art), and *The Pair-Oared Shell* (pl. 3); Henri Papers, Archives, Pennsylvania Academy of the Fine Arts, Philadelphia.

52. Robert Henri to "Miss Crager-Smith" [probably Curtis Wager-Smith], March 23, 1919, quoted in William Innes Homer, *Robert Henri and His Circle* (Ithaca, N.Y.: Cornell University Press, 1969), p. 179.

53. "Eakins was a very great man, and the works he has left are very great works. The fact is beginning to spread into consciousness all over the country... [and] it is Philadelphia's opportunity. Eakins lived and worked all his life through in Philadelphia.... If Philadelphia wishes to do herself proud she will collect his works, house them beautifully either in a house apart, or in special galleries attached to a greater museum. The Philadelphian can point to Eakins's work and say, 'Here is an artist of our own. This man was of us, lived here, and it is here amongst us that he did this work. We are proud" (Henri, quoted in Dorothy Grafly, "What the Artistic World is Doing: Academy Fellowship Fosters Plan to Purchase Eakins's Works as Monument to Artist-Scientist," *Public Ledger and North American* [Philadelphia], February 21, 1926, "Society and Arts" section, p. 10). Henri also offered to come to Philadelphia to speak in favor of the plan, and suggested establishing a "'Friends of Art' organization of the wealthy at so much a head" (Henri to Butler, February 11, 1926, Henri Papers, Archives, Pennsylvania Academy of the Fine Arts, Philadelphia). Butler's efforts were also reported in the national art press. See "Philadelphia Plans Eakins Museum," *The Art News*, vol. 24, no. 22 (March 6, 1926), p. 3; and Grafly, "Notes: In Philadelphia," *The American Magazine of Art*, vol. 18, no. 4 (April 1927), pp. 210–11.

News of this plan inspired Bryson Burroughs to put in a bid for some of the pictures. He wrote Susan Eakins of a "long cherished

ambition" of his "to install three special galleries" at the Metropolitan, "one to be devoted to your husband's work....I want to suggest to you that if you could arrange your will so that a number of his pictures could become the property of this Museum after your death we could be sure that the usefulness of his work would be perpetuated." But Susan Eakins remained steadfast in her desire to keep the works in Philadelphia (Bryson Burroughs to Susan Eakins, July 7, 1927, quoted in Goodrich 1982, vol. 2, p. 281).

54. Robert Henri to Albert C. Barnes, February 1914, Archives, Hirshhorn Museum and Sculpture Garden. See also George Bellows: "Thomas Eakins exhibition proves him to be one of the best of all the world's masters. The greatest one man show I've ever seen and some of the very greatest pictures....'Dr. Gross' must equal 'The Night Watch.' 'Man at Table' good as the best of Renoir and Cézanne" (Bellows to Henri, November 16, 1917, Henri Papers, Beinecke Rare Book and Manuscript Library, Yale University, New Haven). Guy Pène du Bois likened Eakins's *Antiquated Music (Portrait of Sarah Sagehorn Frishmuth)* (pl. 224) to Rembrandt's *Aristotle Contemplating the Bust of Homer* (The Metropolitan Museum of Art, New York) in "The Art Galleries: Three Strong Men and Five Aesthetes," *The New Yorker*, vol. 6, no. 6 (May 17, 1930), p. 97. Edward Hopper admired Eakins's "simple visual honesty" in "John Sloan and the Philadelphians," *The Arts*, vol. 11, no. 4 (April 1927), p. 170.

55. Henri was responding to Burroughs's request for help in publicizing the show. The letter was later reprinted in Henri's influential memoir, *The Art Spirit* (Philadelphia and London: J. B. Lippincott, 1923), p. 86.

56. Henri (1923, p. 87) praised Eakins's "unswerving adherence to his ideals."

57. "Chase's studio is an atelier; this is a workshop" (Eakins, quoted in Goodrich 1982, vol. 2, p. 8). These photographs of the studio feature William O'Donovan, Eakins, and Samuel Murray talking animatedly over a bottle of wine. Scattered around the studio are O'Donovan's bust of Walt Whitman, photographs, paintings, plaster casts from the Academy days, and so forth—a compendium of past and current projects typical of a working artist's studio.

58. This analysis of Henri's studio is drawn from the excellent discussion in Sarah Burns, *Inventing the Modern Artist: Art and Culture in Gilded Age America* (New Haven and London: Yale University Press, 1996), pp. 75–76.

59. Samuel Swift, "Revolutionary Figures in American Art," *Harper's Weekly Magazine*, vol. 51 (April 13, 1907), p. 534; quoted in Rebecca Zurier et al., *Metropolitan Lives: The Ashcan Artists and Their New York* (Washington, D.C.: National Museum of American Art, Smithsonian Institution, 1995), p. 205.

60. Goodrich, writing in 1929, referred to the "spare, sensitive muscularity" of his pictures in "Thomas Eakins, Realist," *The Arts*, vol. 16, no. 2 (October 1929), p. 82. Henri (1923, p. 86) described the *Portrait of Leslie W. Miller* (pl. 225) as "an honest, respectful, appreciative, man-to-man portrait."

61. Lloyd Goodrich, *Reginald Marsh* (New York: Harry N. Abrams, 1972), p. 43.

62. She was pleased with his choices, which were among the pictures Henry McBride had characterized as "successes for artists" the decade before. "Your two pictures illustrate well the Eakins work, always the same quality from start to finish" (Susan Eakins to Reginald Marsh, November 15, 1928, Marsh Papers, Archives of American Art). Cranmer asked Marsh to tell McBride about his purchases, for the sake of publicity (Cranmer to Marsh, October 24, 1928, Marsh Papers, Archives of American Art).

63. Susan Eakins to Marsh, December 20, 1929, Marsh Papers, Archives of American Art. For at least the first year of the project, Marsh was Goodrich's partner in preparing the monograph, as Goodrich acknowledged: "I am writing a book on Thomas Eakins, with the assistance of Mr. Reginald Marsh" (Goodrich to Walter Pach, May 1, 1930, Goodrich Papers). Marsh wrote some of the initial letters in quest of photographs of Eakins paintings. More significant was Marsh's loan of five hundred dollars to Goodrich so he could begin work on the book. This was the sole financial support for the project until Juliana Force of the Whitney Museum offered him a salary to write the monograph, which bears a dedication to Marsh.

64. Susan Eakins to George Barker, July 9, 1936, quoted in Foster and Leibold 1989, p. 308.

65. Lloyd Goodrich, *Thomas Eakins: His Life and Work* (New York: Whitney Museum of American Art, 1933), p. 143; and Goodrich 1929, p. 72.

66. "The offer is exactly what I want, and had hoped to accomplish some way," Susan Eakins wrote to Samuel Murray (about November 29, 1929, Archives, Hirshhorn Museum and Sculpture Garden). The story of the gift of the Eakins collection is told in detail in Evan H. Turner's introduction to Siegl 1978, pp. 7–8, pp. 149–50.

67. Dorothy Grafly, "Loan Exhibition of Eakins Work at Philadelphia Museum of Art," *Art News*, vol. 28 (April 5, 1930), p. 19. That the museum regarded the acquisition as a coup is reflected in curator Henri Marceau's essay in the Museum's *Bulletin:* "Coming at a time when widespread interest in the art of Eakins has placed his pictures in greater demand than ever before, the importance of this gift to the Museum can hardly be overestimated" ("An Exhibition of Thomas Eakins' Work," *Pennsylvania Museum Bulletin*, vol. 25, no. 133 [March 1930], p. 3).

68. Henri Marceau, "An Exhibition of Thomas Eakins' Work," *Pennsylvania Museum Bulletin*, vol. 25, no. 133 (March 1930), p. 3.

69. Forbes Watson, "Editorial," *The Arts*, vol. 3 (January 1923), p. 1. See also Avis Berman, *Rebels on Eighth Street: Juliana Force and the Whitney Museum of American Art* (New York: Atheneum, 1990), pp. 186–87.

70. The Whitney Studio Club (which became the Whitney Studio Galleries in 1928) was dedicated to collecting and exhibiting the work of young American artists in those years. When it became the Whitney Museum of American Art in 1931, it expanded its mandate and sought to "assemble a truly representative collection of American art" (Forbes Watson, "In the Galleries: The Whitney Museum," *The Arts*, vol. 16, no. 9 [May 1930], p. 627). To that end, in the early 1930s Juliana Force, the Whitney's energetic director, bought two works by Eakins, *Portrait of Riter Fitzgerald* (now Art Institute of Chicago) and *The Biglin Brothers Racing* (now National Gallery of Art; Berman 1990, p. 285). At the same time, the Addison Gallery of American Art opened on the campus of Phillips Andover Academy in Andover, Massachusetts; its stellar collections featured three great Eakinses—*Elizabeth at the Piano*, *Portrait of Professor Henry A. Rowland*, and *Salutat*—from the collections of Thomas Cochran and Stephen C. Clark (pls. 13, 211, 214).

71. "A New Art Museum," quoted in Alfred H. Barr, Jr., *Painting and Sculpture in the Museum of Modern Art, 1929–1967* (New York: Museum of Modern Art, 1977), p. 620.

72. Frank Jewett Mather, Jr., "Thomas Eakins's Art in Retrospect," *International Studio*, vol. 95 (January 1930), p. 47.

73. Walter Pach, "A Grand Provincial," *The Freeman*, vol. 7 (April 11, 1923), p. 112, and William Howe Downes, "Thomas Eakins," *Dictionary of American Biography* (New York: Charles Scribner's Sons, 1930), vol. 5, p. 592.

74. Eakins was included in a Phillips Collection exhibition of "American Old Masters" in 1928. See also Forbes Watson, "In the Galleries: The Whitney Museum," *The Arts*, vol. 16, no. 9 (May 1930), p. 625.

75. Walter Pach, "A Grand Provincial," *The Freeman*, vol. 7 (April 11, 1923), p. 112, and Pach, "American Art in the Louvre," *The Fine Arts*, vol. 20, no. 1 (May 1933), p. 20. See also Gertrude Vanderbilt Whitney: "So easily did he discard the regulations of his French training that we forget his masters" ("American Influence on Foreign Painting," *Arts & Decoration*, vol. 13, no. 4 (September 1920), p. 231).

76. Frank Jewett Mather, Jr., "Winslow Homer," *Sixth Loan Exhibition, New York, May 1930: Winslow Homer, Albert P. Ryder, Thomas Eakins* (New York: Museum of Modern Art, 1930), p. 8.

77. This theme had already been sounded with the Pennsylvania Museum's show. Francis Henry Taylor, the museum's young curator of medieval art, called that exhibition a "jubilee for all persons who are interested in American art and its relation to the modern movement" (Taylor, "Thomas Eakins—Positivist," *Parnassus*, vol. 2, no. 3 [March 1930], p. 20).

78. Alfred H. Barr, Jr., "In 1930," in Museum of Modern Art 1930, p. 6.

79. Frank Jewett Mather, Jr., "Winslow Homer," in Museum of Modern Art 1930, p. 8.

80. Goodrich 1929, p. 72.

81. Forbes Watson, "In the Galleries: Ryder, Eakins, Homer," *The Arts*, vol. 16, no. 9 (May 1930), p. 633.

82. Goodrich 1929, p. 83.

83. Ibid., p. 76.

84. Mumford 1931, p. 97.

85. Ibid., pp. 98, 100.

86. William Howe Downes, "Thomas Eakins," *Dictionary of American Biography* (New York: Charles Scribner's Sons, 1930), vol. 5, p. 591. See also Harrison S. Morris, *Confessions in Art* (New York: Sears, 1930), pp. 33–34.

87. Walter Pach, "A Grand Provincial," *The Freeman*, vol. 7 (April 11, 1923), p. 112.

88. "Medals and rewards of which he had plenty he thought an impertinence and treated with contempt" (Francis Henry Taylor, "Thomas Eakins—Positivist," *Parnassus*, vol. 2, no. 3 [March 1930]) p. 20.

89. Morris 1930, p. 32. Van Rensselaer saw Eakins as "not only not a gentleman in the popular acceptance of a 'swell,' but not even a man of tolerably good appearance or breeding" (Mariana Griswold van Rensselaer to Sylvester Koehler, June 12, 1881, Koehler Papers, Archives of American Art; quoted in Lois Dinnerstein, "Thomas Eakins's 'Crucifixion' as Perceived by Mariana Griswold Van Rensselaer," *Arts Magazine*, vol. 53, no. 9 [May 1979], p. 143).

90. Goodrich 1929, p. 74.

91. Goodrich 1933, p. 143.

92. Forbes Watson, "In the Galleries: The Growth of a Reputation," *The Arts*, vol. 16, no. 8 (April 1930), p. 566.

93. Mumford 1931, p. 215.

"Eakins as a Writer," pp. 377–84

WILLIAM INNES HOMER

1. Eakins to Frances Eakins, "Good Friday," 1868, Archives of American Art, Smithsonian Institution, Washington, D.C. (hereafter Archives of American Art).

2. Eakins to unknown recipient, October 15, 1867, handwritten copy by Susan Eakins of lost original, The Lloyd Goodrich and Edith Havens Goodrich, Whitney Museum of American Art, Record of Works by Thomas Eakins, Philadelphia Museum of Art (hereafter Goodrich Papers).

3. Eakins to Benjamin Eakins, October 27, 1866, Pennsylvania Academy of the Fine Arts, Philadelphia, Charles Bregler's Thomas Eakins Collection, purchased with the partial support of the Pew Memorial Trust (hereafter Bregler Collection).

4. Ibid.

5. In a letter of September 24, 1867, he criticized her for spelling knee "nee," but in the same letter, Eakins spelled rhythm "rythm" (Eakins to Frances Eakins, September 24, 1867, Archives of American Art).

6. Eakins to Frances Eakins, October 30, 1866, Bregler Collection.

7. Eakins to Benjamin Eakins, "Monday night," February 1868, Bregler Collection.

8. Eakins to Caroline Cowperthwait Eakins, April 1, 1869, Archives of American Art.

9. Eakins to Benjamin Eakins, March 6, 1868, Bregler Collection.

10. Eakins to Benjamin Eakins, May 9, 1868, Collection of Daniel W. Dietrich II.

11. Spanish notebook, Bregler Collection; typescript translation by Samuel L. Borton from original French in Thomas Eakins Research Collection, Philadelphia Museum of Art.

12. Ibid.

13. Eakins to Earl Shinn, undated [1875 or 1876], Richard T. Cadbury Papers, Friends Historical Library, Swarthmore College, Pa.

14. Eakins to James P. Scott, June 18, 1883, Bregler Collection.

15. Eakins to James P. Scott, July 11, 1883, typescript by Lloyd Goodrich, Goodrich Papers.

16. Eakins to Dr. Jacob Mendez Da Costa, January 9, 1893, typescript by Lloyd Goodrich from lost original, Goodrich Papers. Eakins destroyed the first portrait and later painted another (fig. 207).

17. Eakins to Susan Eakins, July 31, 1887, Bregler Collection.
18. Eakins to Susan Eakins, "Sunday Morning" [1897], Bregler Collection.
19. Eakins to Susan Eakins, August 3, 1897, Bregler Collection.
20. Eakins to Dr. Henry A. Rowland, September 3, 1897, Addison Gallery of American Art, Phillips Academy, Andover, Mass. (hereafter Addison Gallery of American Art).
21. Eakins to Edmund Clarence Messer, July 3, 1906, Archives, Corcoran Gallery of Art, Washington, D.C.
22. The longer, more finished version of the manuscript is owned by the Philadelphia Museum of Art. The shorter one is in the Bregler Collection.
23. William Dennis Marks, "The Mechanism of Instantaneous Photography," in University of Pennsylvania, *Animal Locomotion. The Muybridge Work at the University of Pennsylvania—The Method and the Result* (1888; reprint, New York: Arno Press, 1973), pp. 14–15.
24. Thomas Eakins, "The Differential Action of Certain Muscles Passing More Than One Joint," *Proceedings of the Academy of Natural Sciences of Philadelphia*, vol. 46 (1894), pp. 172–80.
25. Susan Eakins to Lloyd Goodrich, January 6, 1932, Goodrich Papers.
26. Eakins to Dr. Henry A. Rowland, September 2, 1897, Addison Gallery of American Art.

Selected Bibliography

Ackerman, Gerald M. "Thomas Eakins and His Parisian Masters Gérôme and Bonnat." *Gazette des Beaux-Arts,* series 6, vol. 73 (April 1969), pp. 235–56.

Adelman, Seymour, and Susan P. Casteras. *Susan Macdowell Eakins, 1851–1938.* Philadelphia: Pennsylvania Academy of the Fine Arts, 1973.

Berger, Martin A. *Man Made: Thomas Eakins and the Construction of Gilded Age Manhood.* Berkeley: University of California Press, 2000.

Berkowitz, Julie S. *"Adorn the Halls": History of the Art Collection at Thomas Jefferson University.* Philadelphia: Thomas Jefferson University, 1999.

Boime, Albert. "American Culture and the Revival of the French Academic Tradition." *Arts Magazine,* vol. 56, no. 9 (May 1982), pp. 95–101.

Braddock, Alan C. "Eakins, Race, and Ethnographic Ambivalence." *Winterthur Portfolio,* vol. 33, nos. 2–3 (Summer–Autumn 1998), pp. 135–61.

Buki, Zoltan, and Suzanne Corlette, eds. *The Trenton Battle Monument: Eakins Bronzes.* Trenton: New Jersey State Museum, 1973.

Bolger, Doreen, and Sarah Cash, eds. *Thomas Eakins and the Swimming Picture.* Fort Worth, Tex.: Amon Carter Museum, 1996.

Chamberlin-Hellman, Maria. "Thomas Eakins as a Teacher." Ph.D. diss., Columbia University, 1981.

Clark, William J. "The Iconography of Gender in Thomas Eakins's Portraiture." *American Studies,* vol. 32, no. 2 (Fall 1991), pp. 5–28.

Cooper, Helen A., et al. *Thomas Eakins: The Rowing Pictures.* New Haven: Yale University Art Gallery, 1996.

Danly, Susan, and Cheryl Leibold. *Eakins and the Photograph: Works by Thomas Eakins and His Circle in the Collection of the Pennsylvania Academy of the Fine Arts.* Washington, D.C.: Smithsonian Institution Press for the Pennsylvania Academy of the Fine Arts, 1994.

Davis, Whitney. "Erotic Revision in Thomas Eakins's Narratives of Male Nudity." *Art History,* vol. 17, no. 3 (September 1994), pp. 301–41.

Dinnerstein, Lois. "Thomas Eakins' *Crucifixion* as Perceived by Mariana Griswold van Rensselaer." *Arts Magazine,* vol. 53, no. 9 (May 1979), pp. 140–45.

Domit, Moussa M. *The Sculpture of Thomas Eakins.* Washington, D.C.: Corcoran Gallery of Art, 1969.

Fink, Lois Marie. *American Art at the Nineteenth-Century Paris Salons.* Cambridge: Cambridge University Press for the National Museum of American Art, Smithsonian Institution, 1990.

Foster, Kathleen A. "Realism or Impressionism? The Landscapes of Thomas Eakins." *Studies in the History of Art,* vol. 37 (1990), pp. 68–91.

———. *Thomas Eakins Rediscovered: Charles Bregler's Thomas Eakins Collection at the Pennsylvania Academy of the Fine Arts.* New Haven: Yale University Press for the Pennsylvania Academy of the Fine Arts, 1997.

Foster, Kathleen A., and Cheryl Leibold. *Writing About Eakins: The Manuscripts in Charles Bregler's Thomas Eakins Collection.* Philadelphia: University of Pennsylvania Press for the Pennsylvania Academy of the Fine Arts, 1989.

Fried, Michael. *Realism, Writing, Disfiguration: On Thomas Eakins and Stephen Crane.* Chicago and London: University of Chicago Press, 1987.

Goodrich, Lloyd. *Thomas Eakins: His Life and Work.* New York: Whitney Museum of American Art, 1933.

———. *Thomas Eakins.* 2 vols. Cambridge, Mass.: Harvard University Press for the National Gallery of Art, 1982.

Hatt, Michael. "The Male Body in Another Frame: Thomas Eakins' The Swimming Hole as an Erotic Image." *Journal of Philosophy and the Visual Arts* (1993), pp. 8–21.

Hendricks, Gordon. "A May Morning in the Park." *Philadelphia Museum of Art Bulletin,* vol. 60, no. 285 (Spring 1965), pp. 48–64.

———. *The Photographs of Thomas Eakins.* New York: Grossman, 1972.

———. *The Life and Work of Thomas Eakins.* New York: Grossman, 1974.

Homer, William Innes. "Who Took Eakins' Photographs." *Art News,* vol. 82, no. 5 (May 1983), pp. 112–19.

———. *Thomas Eakins: His Life and Art.* New York: Abbeville Press, 1992.

———. "New Light on Thomas Eakins and Walt Whitman in Camden." In *Walt Whitman and the Visual Arts,* edited by Geoffrey M. Sill and Roberta K. Tarbell. New Brunswick, N.J.: Rutgers University Press, 1992. First published as "New Documentation on Eakins and Walt Whitman in Camden," *Mickle Street Review,* vol. 12 (1990), pp. 74–82 (special issue on Whitman and the Visual Arts).

Homer, William Innes, with the assistance of John Talbot. "Eakins, Muybridge and the Motion Picture Process." *The Art Quarterly,* vol. 26, no. 2 (Summer 1963), pp. 194–216.

Homer, William Innes, ed. *Eakins at Avondale and Thomas Eakins: A Personal Collection.* Chadds Ford, Pa.: Brandywine River Museum, 1980.

Hoopes, Donelson F. *Eakins Watercolors.* New York: Watson-Guptill, 1971; New York: Watson-Guptill, 1985.

In This Academy: The Pennsylvania Academy of the Fine Arts, 1805–1976. Philadelphia: Pennsylvania Academy of the Fine Arts, 1976.

Johns, Elizabeth. "Drawing Instruction at Central High School and Its Impact on Thomas Eakins." *Winterthur Portfolio,* vol. 15, no. 2 (Summer 1980), pp. 139–49.

———. *Thomas Eakins: The Heroism of Modern Life.* Princeton: Princeton University Press, 1983.

———. "Thomas Eakins and 'Pure Art' Education." *Archives of American Art Journal,* vol. 23, no. 3 (1983), pp. 2–5.

Kaplan, Sidney. "The Negro in the Art of Homer and Eakins." *The Massachusetts Review,* vol. 7, no. 1 (Winter 1966), pp. 105–20.

Kimmersle, Constance. "Thomas Eakins' Exploration of the Mechanism and Laws of Human Expression and Understanding in Themes of Mental Effort and Creative Activity." Ph.D. diss., University of Pennsylvania, 1989.

Leibold, Cheryl. "Thomas Eakins in the Badlands." *Archives of American Art Journal,* vol. 28, no. 2 (1988), pp. 2–15.

Lubin, David M. *Act of Portrayal: Eakins, Sargent, James.* New Haven: Yale University Press, 1985.

———. "Modern Psychological Selfhood in the Art of Thomas Eakins." In *Inventing the Psychological: Toward a Cultural History of Emotional Life in America,* edited by Joel Pfister and Nancy Schnog. New Haven and London: Yale University Press, 1997.

McHenry, Margaret. *Thomas Eakins, Who Painted.* Oreland, Pa.: Privately printed, 1946.

Milroy, Elizabeth. "Thomas Eakins' Artistic Training, 1860–1870." Ph.D. diss., University of Pennsylvania, 1986.

———. "'Consummatum est . . .': A Reassessment of Thomas Eakins' *Crucifixion* of 1880." *Art Bulletin,* vol. 71, no. 2 (June 1989), pp. 269–84.

———. *Guide to the Thomas Eakins Research Collection with a Lifetime Exhibition Record and Bibliography.* Edited, with contributions by W. Douglass Paschall. Philadelphia: Philadelphia Museum of Art, 1996.

Morand, Anne. "Sources of Genius: Influences for Thomas Eakins's Portrait of Frank Hamilton Cushing." *Gilcrease Journal,* vol. 2, no. 2 (Autumn 1994), pp. 44–60.

Onorato, Ronald J. "The Pennsylvania Academy of the Fine Arts and the Development of an Academic Curriculum in the Nineteenth Century." Ph.D. diss., Brown University, 1977.

Panhorst, Michael. *Samuel Murray: The Hirshhorn Museum and Sculpture Garden Collection, Smithsonian Institution.* Washington, D.C.: Smithsonian Institution Press, 1982.

Parry, Ellwood C., III, and Maria Chamberlin-Hellman, "Thomas Eakins as an Illustrator, 1878–1881." *American Art Journal*, vol. 5, no. 1 (May 1973), pp. 20–45.

Parry, Ellwood C., III. "The Thomas Eakins Portrait of Sue and Harry; or, When Did the Artist Change His Mind?" *Arts Magazine*, vol. 53, no. 9 (May 1979), pp. 146–53.

Prown, Jules David. "Thomas Eakins' *Baby at Play.*" *Studies in the History of Art*, vol. 18 (1985), pp. 121–27.

Rosenzweig, Phyllis D. *The Thomas Eakins Collection of the Hirshhorn Museum and Sculpture Garden.* Washington, D.C.: Smithsonian Institution Press, 1977.

Schendler, Sylvan. *Eakins.* Boston: Little, Brown, 1967.

Sellin, David. "The First Pose: Howard Roberts, Thomas Eakins, and a Century of Philadelphia Nudes." *Philadelphia Museum of Art Bulletin*, vol. 70, nos. 311–12

(Spring 1975), pp. 5–56. First published in *Annual Report, Board of Trustees, Fairmount Park Art Association*, 1973; reprinted in *The First Pose: 1876, Turning Point in American Art; Howard Roberts, Thomas Eakins, and a Century of Philadelphia Nudes* (New York: W.W. Norton, 1976).

———. *Thomas Eakins, Susan Macdowell Eakins, and Elizabeth Macdowell Kenton.* Roanoke, Va.: North Cross School, 1977.

Sewell, Darrel. *Thomas Eakins: Artist of Philadelphia.* Philadelphia: Philadelphia Museum of Art, 1982.

Siegl, Theodor. *The Thomas Eakins Collection.* Introduction by Evan H. Turner. Philadelphia: Philadelphia Museum of Art, 1978.

Simpson, Marc. "Thomas Eakins and His Arcadian Works." *Smithsonian Studies in American Art*, vol. 1, no. 2 (Fall 1987), pp. 70–95.

Torchia, Robert Wilson. "*The Chess Players* by Thomas Eakins." *Winterthur Portfolio*, vol. 26, no. 4 (Winter 1991), pp. 267–76.

Truettner, William H. "Dressing the Part: Thomas Eakins's Portrait of Frank Hamilton Cushing." *The American Art Journal*, vol. 17, no. 2 (Spring 1985), pp. 48–72.

Turner, Evan H. "Thomas Eakins: The Earles' Galleries Exhibition of 1896." *Arts Magazine*, vol. 53, no. 9 (May 1979), pp. 100–107.

Walter, Marjorie Alison. "Fine Art and the Sweet Science: On Thomas Eakins, His Boxing Paintings, and Turn-of-the-Century Philadelphia." Ph.D. diss., University of California, Berkeley, 1995.

Weinberg, H. Barbara. *The Lure of Paris: Nineteenth-Century American Painters and Their French Teachers.* New York: Abbeville Press, 1991.

Werbel, Amy B. "Perspective in the Life and Art of Thomas Eakins." Ph.D. diss., Yale University, 1996.

Wilmerding, John, ed. *Thomas Eakins (1844–1916) and the Heart of American Life.* London: National Portrait Gallery, 1993.

Acknowledgments

This exhibition and its catalogue are manifestations of a multifaceted project relating to Thomas Eakins that began at the Philadelphia Museum of Art five years ago. Its goal was to organize and catalogue the matchless research collection relating to Thomas Eakins that had been bequeathed to the Museum in 1987 by Lloyd Goodrich; to conserve and rephotograph all of the works by Eakins in the Philadelphia Museum of Art in anticipation of the publication of a new handbook of the Museum's Eakins collection; and to prepare this exhibition. As a result, we have had an opportunity to study Eakins's works in an unusually thorough and wide-ranging way. Our initial work was made possible by generous grants from The Henry Luce Foundation, Inc., The Robert J. Kleberg, Jr. and Helen C. Kleberg Foundation, The Pew Charitable Trusts, the National Endowment for the Arts, The William Penn Foundation, The Women's Committee of the Philadelphia Museum of Art, and an endowment for scholarly publications established by grants from CIGNA Foundation and the Andrew W. Mellon Foundation at the Philadelphia Museum of Art. The exhibition is made possible by Advanta and Strawbridge's.

We have been exceptionally fortunate in securing loans. Our lenders kindly have agreed to everything we requested, except in a few cases of direct conflicts of dates. We thank them most gratefully and would like to recognize especially the Amon Carter Museum, Ball State University Museum of Art, and the University of Pennsylvania for lending their paintings for extended periods of study. We also would like to thank Morris Stroud and Richard York for their help in securing a key loan.

Many individuals have given their time to make Eakins's works in their collections available for our research. For facilitating access to works of art and for aiding in their examination, the Department of American Art, the Conservation Department, and the catalogue authors would like to thank first of all Cheryl Leibold, who was boundlessly cooperative in making the Charles Bregler Collection and the Archives of the Pennsylvania Academy of the Fine Arts available for study.

Phyllis Rosenzweig also gave generously of her time to show the large collection of Eakins's work at the Hirshhorn Museum and Sculpture Garden, Smithsonian Institution. We also are most grateful to Margaret Conrads, Wanda M. Corn, Daniel W. Dietrich II, Eric Greenleaf, Maxine Lewis, John Medveckis, Harvey S. Shipley Miller, and J. Randall Plummer. We would like to thank Jane Myers, Amon Carter Museum; Judith E. Throm, Archives of American Art, Smithsonian Institution; Judith Barter, The Art Institute of Chicago; Alain Joyaux, Ball State University Museum of Art; Linda Ferber, Brooklyn Museum of Art; Barbara Ward Grubb, Mary Leahy, Eric L. Pumroy, and Kathleen Whalen, Bryn Mawr College, Mariam Coffin Canaday Library; Sarah Cash and Dare Hartwell, The Corcoran Museum of Art; Ellen Sharp, The Detroit Institute of Arts; Stephanie Craighead and Theresa Stuhlman, Fairmount Park Commission; John Carr, Fairmount Park Preservation Trust; Joseph Binford, The Free Library of Philadelphia; Anne Morand, Gilcrease Museum; James Demetrion, Hirshhorn Museum and Sculpture Garden; Lee Arnold and Jordan Rockford, Historical Society of Pennsylvania; Gordon Baldwin, Julian Cox, Anne Lyden, and Weston Naef, The J. Paul Getty Museum; Jennifer Ambrose, James Greene, Philip Lapsansky, Jennifer Sanchez, John Van Horne, and Sarah Weatherwax at The Library Company of Philadelphia; Heather Lemonedes, Jeff L. Rosenheim, and H. Barbara Weinberg, The Metropolitan Museum of Art; Michael Beam, The Mitchell Museum at Cedarhurst; Michelle Delaney and Shannon Perich, National Museum of American History, Smithsonian Institution; Dr. Adrienne Noe, National Museum of Health and Medicine of the Armed Forces Institute of Pathology; Barbara Katus, Gail Rawson, Lorena Sehgal, and Sylvia Yount, Pennsylvania Academy of the Fine Arts; Charles S. Moffett, Eliza Rathbone, and Lily Steele, The Phillips Collection; John Hallmark Neff, Reynolda House; D. Scott Atkinson, San Diego Museum of Art; Julie Berkowitz, Thomas Jefferson University; Edward J. Flax, Martin F. Weber Co.; and Michael Kelly, Wichita State University Libraries.

In addition to the lenders, many other owners of Eakins's works and related materials have welcomed us. For their assistance, we would like to thank: Peggy and Lewis Aumack, Dr. and Mrs. William W. Clements, Jr., Celia Eldridge, Mr. and Mrs. Robert S. Hillas, Charles Isaacs, Robert and Peggy Macdowell Thomas, Mr. and Mrs. R. Lee Mastin, Elmer and Marjorie Pratt, David Sellin, and Kenneth Vorce. We would also like to thank Joanne Kuebler, Mary LaGue, Judy Larson, and Mark W. Scala, Art Museum of Western Virginia; Rick Wester, Christie's; John V. Alviti, The Franklin Institute; Joseph R. Struble, George Eastman House/International Museum of Photography and Film; Penelope Smith and Brandon Rude, Joslyn Art Museum; Joseph Fronek and Virginia Rasmussen, Los Angeles County Museum of Art; Todd Smith, The Mint Museum of Art; Margaret M. O'Reilly, New Jersey State Museum; Betty Krulik and Ira Spanierman, Spanierman Gallery; and Zenon Ganziniec, Wadsworth Atheneum.

For their aid with myriad research questions and for invaluable help in securing catalogue and other research photographs, we would like to thank the following: Linda Bantel, Joan Barnes, Eric Baumgartner, Perry Benson, Jr., Samuel L. Borton, Alan C. Braddock, Josephine R. Bull, Jeffrey Cohen, Patrick David Connors, Midge Eachus Cooper, Charles Cresson, Osborn Cresson, Lee Ann Daffner, Mr. and Mrs. James Dallett, F. Miles Day, Martha K. Denniston, the Dodge Family, David Dufour, Dorothea M. Dunifon, Margaret Deger Eachus, Kathleen Foster, Michael Fried, Ron Frishmuth, Benjamin A. G. Fuller, Paul and Harriet Fussell, Paula F. Glick, Hugh D. S. Greenway, Mary R. Hillas, Caroline Stephens Holt, S. Leonard Kent III, Kenneth Kloss, Robert Fulton Kurtz, Mack Lee, Janet Lehr, Michael Lewis, Leslie Lichtenstein, Michael McCue, Gridley McKim-Smith, Elizabeth Milroy, Col. Merl M. Moore, Jr., Mary Panzer, T. Sergeant Pepper, Carolyn Pitts, Cynthia Purvis, Karen Quinn, Henry M. Reed, Gainor and Nancy Roberts, Robert Sanders, Mr. and Mrs. Norman M. Schofield, Robert Schwarz, Gilian Shallcross, Marc Simpson,

Linda Stanley, Patricia Tanis Sydney, Daniel Wolf, Erving and Joyce Wolf, and Gaile K. Wood. The following people also provided invaluable assistance: Robert McCracken Peck and Carol Spawn, The Academy of Natural Sciences; Virginia Dajani, American Academy of Arts and Letters; Terri Tremblay, American Antiquarian Society; Scott DeHaven and Roy E. Goodman, The American Philosophical Society; Daria D'Arienzo, Amherst College; Milan R. Hughston, Amon Carter Museum; Mark Taylor, Arden Archives; Bruce Laverty, Athenaeum of Philadelphia; Kathy Marquis and Malgorzata Myc, Bentley Historical Library, The University of Michigan; Teresa Carbone, Ruth Janson, and Deborah Wythe, Brooklyn Museum of Art; Charles Greifenstein, College of Physicians of Philadelphia; Wanda Magdeleine Styka, Chesterwood; Marisa Keller, The Corcoran Gallery of Art; Philip N. Cronenwett, Dartmouth College Library; Harriet Meminger, Delaware Art Museum; Michael E. Crane, Mary Galvin, and Tara Robinson, The Detroit Institute of Arts; Peter Kayafas, Eakins Press Foundation; George Tselos, Edison National Historic Site; Margaret Moore Booker, Egan Institute of Maritime Studies; Theresa Stuhlman, Fairmount Park Commission Archives; Irene D. Coffey, The Franklin Institute; Richard Boardman and William Lang, Free Library of Philadelphia; Lenore Rouse and Becky Simmons, George Eastman House/International Museum of Photography and Film; Eliza Callard, Germantown Historical Society; Melanie M. Halloran, Harvard University Archives; Amy Densford, Hirshhorn Museum and Sculpture Garden, Smithsonian Institution; Sally Stassi, The Historic New Orleans Collection; Jackie Burns, The J. Paul Getty Museum; S. Christine Jochem, The Joint Free Public Library of Morristown and Morris Township; Brad Gernand, Library of Congress; John Peterson, Lutheran Theological Seminary; Jack Judson, Magic Lantern Castle Museum; Catherine Merwin Mayhew, Martha's Vineyard Historical Society; Jane Spottheim, Maryland Institute, College of Art; Lu Harper, Grant Holcomb III, and Marjorie B. Searl, Memorial Art Gallery of the University of Rochester; Deanna Cross and Jeri Wagner, The Metropolitan Museum of Art; Paul Richelson, Mobile Museum of Art; Sophia Hewryk, Moore College of Art and Design; Patricia J. Albright, Mount Holyoke College Archives; Laurence des Cars, Musée d'Orsay; Elizabeth Oldham, Nantucket Historical Association; Elizabeth Anderson, National Museum of American Art; Brandon Brame Fortune and Alan Fern, The National Portrait Gallery; Richard Cohen, Bill Patterson, and the members, Philadelphia Sketch Club; AnnaLee Pauls and Margaret Sherry, Princeton University Libraries; David L. Kencik and Martin E. Petersen, San Diego Museum of Art; Kim Walters, Southwest Museum; Helen Dark, Spring Hill Public Library; Polly Armstrong, The Stanford University Libraries; Sid Berger and Gladys L. Murphy, Rivera Library, University of California, Riverside; Daniel Meyer, University of Chicago Library; Annette Stott, University of Denver; James Curtiss Ayers, Martin J. Hackett, and Mark Frazier Lloyd, University of Pennsylvania Archives; David S. Azzolina, Heidi Heller, and Alan Morrison, University of Pennsylvania Libraries; Alex Pezzati, The University Museum of Archaeology and Anthropology, University of Pennsylvania; Richard Guy Wilson, University of Virginia; Caryl Burtner and Dr. David Park Curry, Virginia Museum of Fine Arts; Anita Duquette, Whitney Museum of American Art; Mary Nelson, University Libraries, Wichita State University; Suzanne Warner, Yale University Art Gallery; Christine Weideman, Yale University Library; and Margaretta Richardi, Zoological Society of Philadelphia.

For analytical support, the Department of Conservation would like to express their appreciation to Douglas Yeats; to William Romanow and Fred A. Stevie of Cirent Semiconductors; to Ron M. A. Heeren of MOLART; to Peter Eastmen of Rohm & Haas; to Lucile Giannuzzi of the University of Central Florida; and to Janice Hickey Friedman and Marsha Bischel of the Analytical Laboratory, Winterthur Museum.

This exhibition and catalogue exist because of the dedicated work of many people whose talents comprise one of the major resources of the Philadelphia Museum of Art. In the American Art Department, W. Douglass Paschall had a hand in every aspect of the exhibition: coordinating research, assisting with the selection of photographs and arranging for their framing, providing information to the catalogue authors and the editors, and ultimately reading and fact-checking the entire catalogue manuscript. Audrey Lewis assembled all the photographs for the publication, and Amanda Clifford provided assistance with myriad details and handled much of the correspondence relating to the exhibition. Kathleen Brown, Mike Hammer, and Akela Reason helped with research and organization of the exhibition in its early phases.

The scope of the Eakins project offered the Museum's Conservation Department an unusual opportunity to exercise the range of their expertise, and they took full advantage of it. In the field of decorative arts and sculpture, Melissa Meighan undertook research into Eakins's methods and materials and into the complexities of dating casts of some of his sculptures. She organized a program of major treatments for most of Eakins's sculptures in the Museum's collection, with Sally Malenka, Holly Salmon, Julie Solz, and Catherine Williams.

Mark Tucker and Nica Gutman pursued extensive investigations of Eakins's painting techniques and working methods, and, with Teresa Lignelli, carried out major treatments of paintings in the Museum's collection and elsewhere, assisted by Pam Betts, Nancy Croft, Elise Effmann, and Mathew Skopek. Works on paper were examined and treated by Nancy Ash, Dana Mossman Tepper, and Faith H. Zieske. The conservators received technical support from Beth A. Price and benefited from the advice and encouragement provided by Andrew Lins. The progress and finished results of all conservation processes were recorded photographically by Joe Mikuliak, who also devised a technique for scanning the original glass negatives for many of Eakins's photographs and printing them for exhibition. Reconsideration of the framing of Eakins's paintings also was part of the conservation project, and Michael Stone repaired many frames, provided useful information about others, and constructed several new ones, including the re-creation of a spectacular frame for *The Crucifixion*. He was assisted by Dean Kahn. Gary Hiatt matted and framed the majority of the large number of photographs and works on paper. A video project, funded by a grant from The Andrew W. Mellon Foundation, was conceived by the conservators to present their discoveries in the context of Eakins's life and work. In cooperation with members of the Conservation and American Art Departments, Suzanne Penn wrote the script and directed the video.

In the library and archives, Allen Townsend, Susan Anderson, Josephine Chen, Lilah Mittelstaedt, and Jesse Trbovich were unfailingly patient and helpful with innumerable details of research.

Graydon Wood and Lynn Rosenthal photographed all of Eakins's works belonging to the Museum and to many of the lenders, utilizing new digital photographic equipment purchased with a grant from the Women's Committee of the Philadelphia Museum of Art. Conna Clark, Stacy Bomento, Kate Laepple, and Terry Fleming Murphy catalogued this photography and dealt with questions of rights and reproductions relating to the exhibition. Mary Wasserman organized the thousands of slides that were generated by the project.

The daunting task of editing and producing a catalogue for a large exhibition with many contrib-

utors fell to Jane Watkins and Richard Bonk, and they carried it out with extraordinary patience and finesse, assisted by Jane Boyd and Jessica Murphy. Graphic materials were designed and produced by Matthew Pimm, Jane Spencer, and Maia Wind.

To realize the exhibition in its physical form, Suzanne F. Wells coordinated planning for the entire project and administered the budget, assisted by Krista Mancini. Packing, insurance, transportation, all unusually complicated by the fact that the exhibition will take slightly different forms at each of its three venues, were arranged by Irene Taurins and Sara Detweiler Loughman, assisted by Clarisse Carnell, Michelle Povilaitis, and Trine Vanderwall.

A capacious and elegant design for the exhibition spaces and the lighting was conceived by Jack Schlechter, assisted by Andrew Slavinskas. Construction was planned by Joseph Revlock and carried out by Anthony Abruzzese, Jim Batten, Donato Colavita, Merv Crawley, Carmine Deluca, Carmen DiGiorgio, Nick Fanty, Krzsztof Heljak, Jesse Moore, James Murphy, Joe Naimoli, Kirk Pavoni, Steve Ponti, John Redding, Rich Reyes, Jim Torpey, and Robert Venezia. For the installation proper, Martha Masiello and Michael A. McFeat planned the schedule for unpacking and installing Eakins's work and carried it out, assisted by Erin Boyle, Randall Cleaver, David Gallagher, Eric Griffen, Anthony Horney, George Johnson, Alane Salvatore, and Laura Singewald.

Danielle Rice, Elizabeth A. Anderson, and Caroline Cassells prepared the audio tour, brochure, and lecture series that accompany the exhibition.

Alexa Q. Aldridge, Betty J. Marmon, Kim Sajet, and Linda Jacobs secured funding for the exhibition, and Charles Croce and Norman Keyes devised the program of marketing and public relations that accompanied the exhibition.

Other departments of the Museum have provided useful information and assistance. We would like to thank especially Dilys E. Blum and H. Kristina Haugland in the Department of Costumes and Textiles, and Innis H. Shoemaker and Katherine Ware in the Department of Prints, Drawings, and Photographs.

Overseeing it all, with an eye for both the small detail and the big picture, was Anne d'Harnoncourt, whose commitment to every aspect of the Eakins project from the beginning has made this exhibition possible.

Besides the individuals named above, many others provided advice, encouragement, support, and tangential information of all kinds. For this, individual authors would like to thank Kenneth Finkel, Neil Harris, Jules Prown, Jonathan Weinberg, Vida Welsh, as well as Marion Stroud-Swingle and the Acadia Summer Arts Program, Doug Munson and Toddy Munson of the Chicago Albumen Works, and the Philadelphia Girls Rowing Club.

Finally, all of the authors would like to express their indebtedness to William Innes Homer for providing each of them with copies of Eakins's known letters; to Elizabeth Johns, whose book, *Thomas Eakins: The Heroism of Modern Life*, published in 1983, signaled a new era in Eakins research; and finally to Lloyd Goodrich, who wrote the first biography of the artist and whose research and writings continue to be invaluable resources for anyone interested in the life and career of Thomas Eakins.

Works Not Illustrated

1880s

Circle of Thomas Eakins (attributed to Susan Hannah Macdowell), *[Thomas Eakins at About Age Thirty-Five]*, 1880.
Gelatin silver print, 6¹¹⁄₁₆ x 4¾ inches.
Thomas Eakins Research Collection, Philadelphia Museum of Art. Gift of Mrs. Elizabeth M. Howarth, 1984.
See also pl. 52

Thomas Eakins, *[George W. Holmes]*, 1880s.
Albumen print, 4⁹⁄₁₆ x 3⅜ inches.
The J. Paul Getty Museum, Los Angeles (84.XM.155.8).
See also pl. 95

Circle of Thomas Eakins, *[Thomas Eakins, Nude]*, c. 1883.
Albumen print, 9¹⁵⁄₁₆ x 6⁹⁄₁₆ inches.
Pennsylvania Academy of the Fine Arts, Philadelphia. Charles Bregler's Thomas Eakins Collection, purchased with the partial support of the Pew Memorial Trust (1985.68.2.462).
See also pl. 112

Circle of Thomas Eakins (attributed to Thomas Pollock Anshutz), *[Thomas Eakins and John Laurie Wallace, Nude]*, c. 1883.
Platinum print, 10¹⁄₁₆ x 8¹⁄₁₆ inches.
The Metropolitan Museum of Art, New York. David Hunter McAlpin Fund, 1943 (43.87.23).
See also pl. 113

Thomas Eakins, *[John Laurie Wallace, Nude, Playing Pipes]*, c. 1883.
Platinum print, 9¹⁄₁₆ x 6¹³⁄₁₆ inches.
The Metropolitan Museum of Art, New York. David Hunter McAlpin Fund, 1943 (43.87.21)
See also pl. 117

Circle of Thomas Eakins, *[Women's Modeling Class at the Pennsylvania Academy of the Fine Arts]*, c. 1882.
Albumen print, 3⅜ x 4¾ inches.
Wichita State University Libraries, Kansas. Charles Grafly Papers, Special Collections.
See also pl. 122

Thomas Eakins, *[Woman in a Laced-Bodice Dress in Eakins's Studio]*, c. 1883.
Platinum print, 9³⁄₁₆ x 5⅞ inches.
The Metropolitan Museum of Art, New York. David Hunter McAlpin Fund, 1943 (43.87.14).
See also pl. 124

Thomas Eakins, *[Two Women in Classical Costume in Eakins's Studio]*, c. 1883.
Platinum print, 7¾ x 9⅜ inches.
The J. Paul Getty Museum, Los Angeles (84.XM.155.38).
See also pl. 126

Thomas Eakins, *[Two Female Students in Classical Costume in Eakins's Studio]*, c. 1883.
Platinum print, 8¹³⁄₁₆ x 6⁹⁄₁₆ inches.
The Metropolitan Museum of Art, New York. Gift of Charles Bregler, 1941 (41.142.3).
See also pl. 127

Circle of Thomas Eakins, *[Thomas Eakins and Male Nudes at the Site of "Swimming"]*, 1884.
Platinum print, 6⅝ x 9 inches.
Hirshhorn Museum and Sculpture Garden, Smithsonian Institution, Washington, D.C.
Transferred from Hirshhorn Museum and Sculpture Garden Archives, 1983 (83.18).
See also pl. 148

Thomas Eakins, *[Differential-Action Study]*, 1885.
Platinum print, 3¹⁄₁₆ x 2¾ inches.
Pennsylvania Academy of the Fine Arts, Philadelphia. Charles Bregler's Thomas Eakins Collection, purchased with the partial support of the Pew Memorial Trust (1985.68.2.407).
See also pl. 156

Thomas Eakins, *[Male Nude, Possibly Bill Duckett, at the Art Students' League of Philadelphia]*, c. 1889
Platinum print, 9³⁄₁₆ x 8¹¹⁄₁₆ inches.
The Metropolitan Museum of Art, New York. David Hunter McAlpin Fund, 1943 (43.87.20).
See also pl. 170

Thomas Eakins, *[Female Nude at the Art Students' League of Philadelphia]*, c. 1889.
Platinum print, 2¹³⁄₁₆ x 5¼ inches.
The Metropolitan Museum of Art, New York. David Hunter McAlpin Fund, 1943 (43.87.25).
See also pl. 171

1890s

Thomas Eakins, *[Susan Macdowell Eakins, Nude, with Billy]*, 1890–92.
Platinum print, 3⁹⁄₁₆ x 4⁵⁄₁₆ inches.
Pennsylvania Academy of the Fine Arts, Philadelphia. Charles Bregler's Thomas Eakins Collection, purchased with the partial support of the Pew Memorial Trust (1985.68.2.549).
See also pl. 197

Index of Illustrated Works by Thomas Eakins

443

Photographs supplied courtesy of the lenders and owners, except the following:

Art Resource, New York: figs. 18, 28, 30, 31, 34; Cathy Carver: pl. 14; Christopher Foster: pls. 97, 102, 106, 123, 127, 132, 147, 161, 179, 180, 188, 209; Dietrich Collection: figs. 144, 157; Fototeca Nazionale, Rome: fig. 36; Frick Art Reference Library, New York: fig. 86; Carl Kaufman: pls. 7, 40, 205, 213; Joseph Levy: pl. 212; The Library Company of Philadelphia: figs. 47, 50; Joe Miku-liak: pls. 60, 61, 62, 70, 71, 73–75, 77–84, 136, 152, 153, 155, 159, 160, 162, 163, 169; figs. 118, 119; Private Collection: fig. 156; Réunion des Musées Nationaux: fig. 34; figs. 18 (G. Blot / C. Jean), 28 (Bulloz), 30 (Jean Schormans), 31 (Hervé Lewandowski); Lynn Rosenthal: pls. 52, 55, 56, 65, 67, 68, 69, 86, 87, 89, 92–95, 98–100, 103, 111, 116, 128–131, 133, 140–44, 168, 169, 174, 176, 182–187, 189, 198, 208, 222, 223, 234, 236, 241, 243; figs. 20, 21, 24, 33, 44, 48, 53, 80, 136, 144, 153, 157; pp. xxiii (center), xxv (center and right), xxxvi (all), xxxvii (left and right), xxix (center), xxx (right), xxxiv (center); Lee Stalsworth: pls. 20–27, 64, 101, 104, 117, 150, 151, 154, 177, 199, 200–202, 216, 232, 233; figs. 2, 62, 82, 16, 195; pp. xxiv (right), xxv (left), xxxiii (right), xxxv (right), xxxix (left); Joshua White: pl. 226; Graydon Wood: pls. 2–4, 10, 15, 33–38, 41, 44, 46–51, 53, 54, 72, 76, 79, 80, 82, 85, 88, 120, 121, 149, 174, 175, 191, 192, 204, 215, 218, 224, 225, 228, 230, 231, 240; figs. 138, 141.